Va Va Voom!

Bombshells,
Pin-ups,
Sexpots and
Glamour Girls

By
Steve Sullivan

RHINO

GPG

GENERAL PUBLISHING GROUP
Los Angeles

D1092352

Publisher, W. Quay Hays
Editor, Harold Bronson
Assistant Editor, Bob Hyde
Managing Editor, Colby Allerton
Art Director, Kurt Wahlner
Production Director, Nadeen Torio
Color and Pre-Press Director, Gaston Moraga
Cover Design, Catherine Vo Bailey and Kurt Wahlner
Copy Editors, Jessie Simon, Robin Berger and Ellen Alperstein

Artwork is courtesy the Steve Sullivan collection, except as noted below.

Bob Bethia: Lili St. Cyr on pages 276, 278, 279, 280-281, 282, 284, color insert; Harold Forsko: Betty Brosmer
on pages 187, 222; Don Frailey: Candy Barr on pages 252, 256, 261; Peter Gowland: Jayne Mansfield on pages 51(r),
55, Mamie Van Doren, 81, Julie Newmar, 107, 112, 115, Diane Webber, 234, 237(l), 240, 243; Ron Kingman: June
Wilkinson, color insert; Bunny Yeager: Bettie Page on pages 188, 191, 192, 195, 196-197, 198, 201, 202-203, 204,
205, 206, 209, 210, 213, color insert, Bunny Yeager on pages 226, 228, 229, 230, 231, 232, color insert,
Diane Webber on pages 236, 237(r), 238, 239(r), 241.

Va Va Voom is published by General Publishing Group, Inc.,
2701 Ocean Park Blvd., Ste. 140, CA 90405, 310-314-4000

ISBN 1-881649-60-1

Library of Congress Catalog Card Number 95-077537

10 9 8 7 6 5 4 3 2 1

Printed in the USA

Contents

Va Va Voom: (vä vä voom´), *interj.*
1. any of a number of emotions set into motion by the vision—either in person, on stage, on screen or on paper—of a vibrant, healthy and often abundantly endowed female; **2.** WOW!

Introduction

From the time I first conceived *Va Va Voom* about five years ago, I envisioned it as a tribute to, and celebration of, some extraordinary women who have not received the appreciation they deserve. Now, after getting to know many of them through interviews and follow-up conversations, I understand more fully that the reality of these women is far more complex and fascinating than the public images they conveyed.

As a student of motion pictures and show business, and a collector of 1950s and '60s men's magazines and other publications, I had long been mystified by the fact that women whom I regarded as glamour legends were relegated to a few sparse lines in reference books, if they were mentioned at all. I wanted to learn more about the lives of these women—not just the hype dreamed up

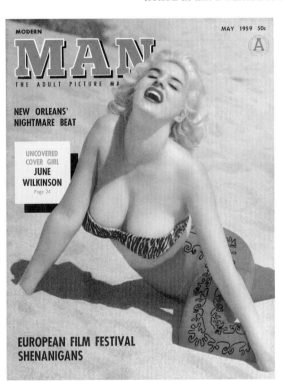

by magazine editors—and I figured there has to be a lot of other collectors and fans who did, too. The thousands of files I had accumulated on classic glamour girls over a 20-year period provided a start, but I knew that interviews would provide the core of the book.

My first interview in Hollywood was with June Wilkinson, followed by Russ Meyer and Mamie Van Doren. I traveled to Texas to meet with Candy Barr, interviewed Bunny Yeager in Miami and Tempest Storm in Atlanta, and then it was back to Los Angeles for Stella Stevens, Julie Newmar, Sheree North, Betty Brosmer, Dixie Evans, Peter Gowland, and many other remarkable personalities who unfortunately couldn't be squeezed into this volume due to space limitations.

I want to thank every person who gave me so many hours of their time. June Wilkinson and her friend Mike Sather helped get the project off the launching pad and offered constant encouragement. My British friend Neil Kendall was an important supporter from the start, assisted on a few of the Hollywood interviews, and offered valuable help with the Jayne Mansfield chapter. Jim Carlin of Vienna, VA generously allowed me to take over 1,000 pages of notes from his magazine collection, and also ventured to New York to meet with Meg Myles. I acquired great quantities of magazines from two outstanding dealers, Warren Nussbaum of Flushing, NY and Michael Blessing of ARS in Santa Clarita, CA. My thanks also go to *Fond Memories* publisher Bob Schultz; Betty Brosmer collector Harold Forsko; Candy Barr aficionado Don Frailey; Mamie Van Doren Fan Club leaders Bob Bethia and Joe Doyle; collectors Ron Kingman, Bruce Dey, John Guzman and Dale Hilk; *Tease* publisher Greg Theakston, and Bettie Page authority Art Amsie. And this book would not have been possible without the efforts of my agent Stan Corwin or the editorial work of Colby Allerton (GPG) and Bob Hyde (Rhino).

Readers who want to learn more about the wonderful world of glamour are invited to check out my bimonthly publication, *Glamour Girls: Then and Now*, which is published by legendary photographer Bunny Yeager and features many all-new interviews with fabulous females of the movies and magazines from the '50s to the '90s. For more information, write me at P.O. Box 34501, Washington, D.C. 20043.

The research and writing of *Va Va Voom* has been an adventure, and my life has been enriched by having the opportunity to meet so many unforgettable and talented people.

Steve Sullivan

The Movie Bombshells

Always a revealing if imperfect mirror of society, Hollywood in the 1950s reflected a new generation's desire to confront issues of sexuality more directly than ever before. Prevailing standards still required discretion, however, and the resulting need for erotic suggestiveness—showing just enough on screen to unleash viewers' imaginations—may have helped to make the decade's screen stars uniquely provocative.

No other decade produced more legendary movie sex symbols than the '50s. Marilyn Monroe embodied every quality of sensuality that Hollywood could conceive, and such stars as Jayne Mansfield, Mamie Van Doren and Stella Stevens followed in her wake. European filmmakers were able to go further in exploring sexuality than their American counterparts, and this freedom saw its most tantalizing expression in Brigitte Bardot.

It seems hardly coincidental that the 1950s' unprecedented flowering of memorable sex goddesses coincided with the last great decade of Hollywood's studio system. For all of its drawbacks, this system enabled studios to slowly develop and train promising starlets, who would achieve their breakthroughs through a combination of specially-tailored roles, cheesecake photos and carefully orchestrated publicity campaigns. The wonderfully wacky publicity gimmicks of '50s stars is just as essential to the tale told in "Va Va Voom" as the movies themselves.

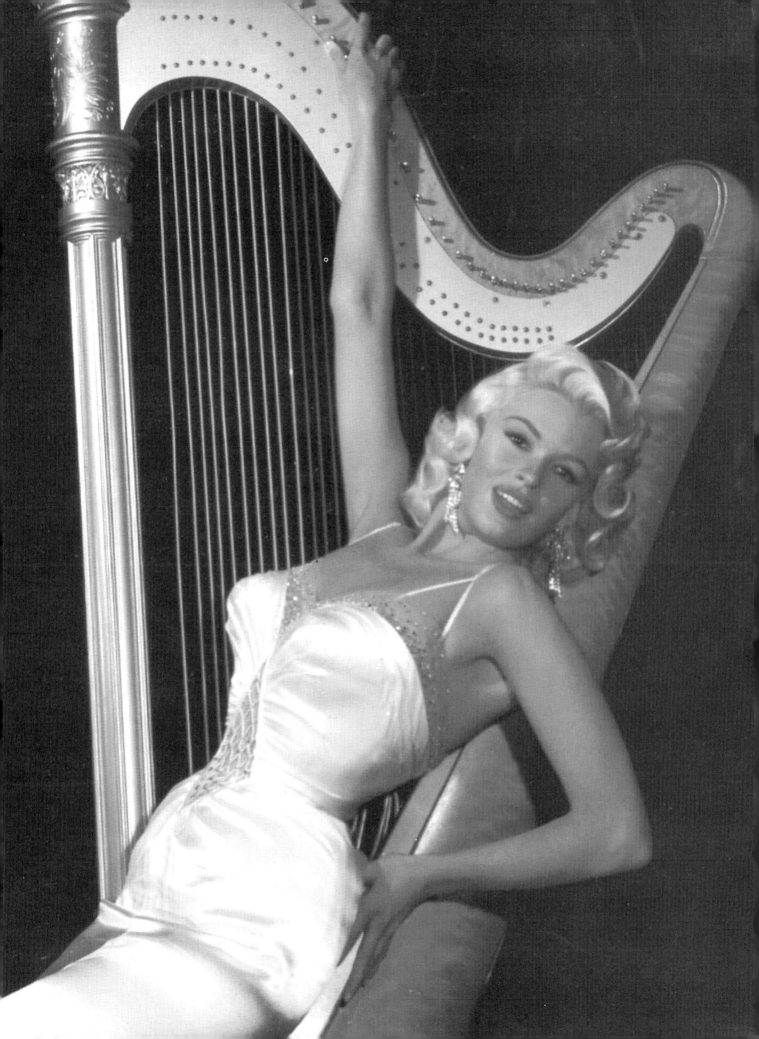

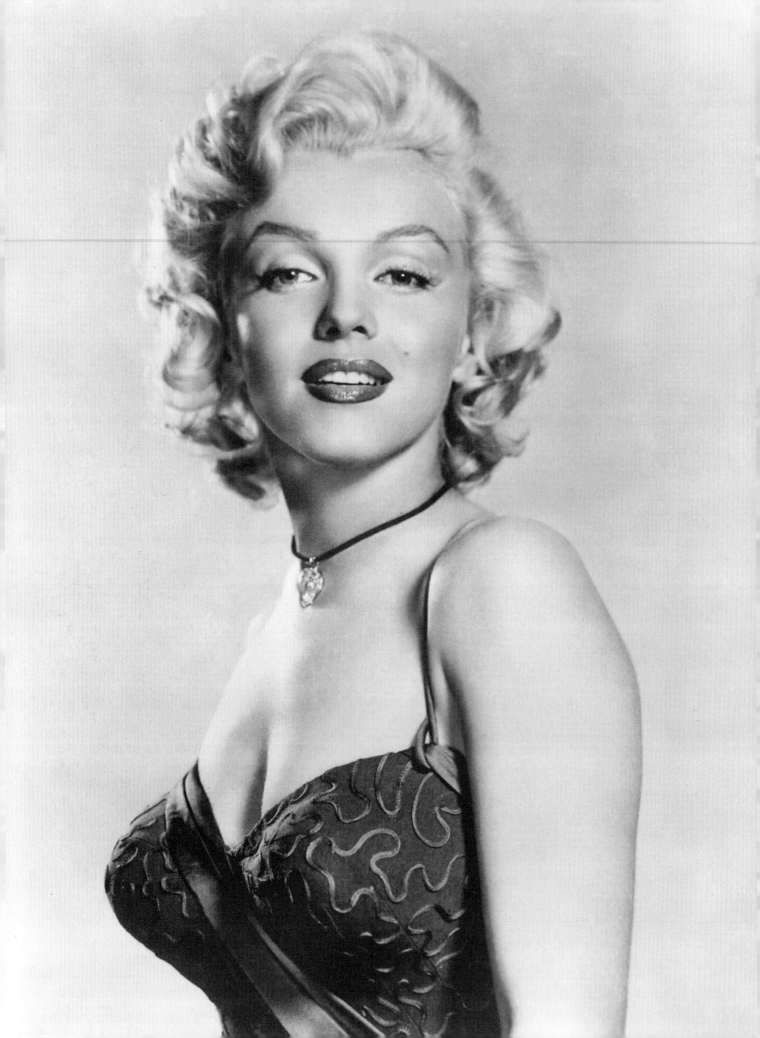

She is the foremost pop-cultural icon of the 20th century, her name and physical image serving as symbols of timeless Hollywood glamour and the particular tension between sexuality and innocence that marked America in the 1950s. Yet even at the peak of her fame she was also a haunted young woman terrified of performing and desperately uncertain of the very qualities that had made her a legend. Few entertainers have provided pleasure to more people over the past 50 years than Marilyn Monroe, and fewer still have left behind a sadder story.

When considering sexuality in postwar movies and other popular media, the influence of Marilyn Monroe is so vast and pervasive that it seems all-encompassing. Virtually every woman profiled in this book had to deal with the presence and impact of Marilyn in some significant way; some were promoted as direct competitors to Monroe, others as contrasting alternatives. She is the standard by which all other glamour queens are measured, but—as we understand far better 33 years after her death—it is a standard that will never again be achieved. Marilyn's combination of sensual beauty, aching vulnerability, saucy humor, and aura of joy emerging out of sorrow left us a wondrous and singular legacy.

The facts of Marilyn Monroe's early years are so familiar by now that only the barest outline will be offered here. Her mother, born Gladys Pearl Monroe, worked as a motion picture negative cutter, and had divorced Edward Mortenson one year before the birth of Norma Jeane. Unable to quit her job and temperamentally unsuited to the demands of motherhood, Gladys gave Norma Jeane to the first of several foster homes within two weeks of the child's birth. After years of increasing personal difficulties, Gladys was admitted to a rest home and then to Los Angeles General Hospital in 1934; she would be in and out of mental institutions for years thereafter. The combination of her mother's condition, Norma Jeane's knowledge of the dementia that had killed her grandfather and the fact that her grandmother also died in an asylum left the girl with a lifelong fear that a similar fate awaited her.

As detailed in Donald Spoto's definitive book, "*Marilyn Monroe: The Biography*," Gladys' best friend and co-worker Grace McKee was the formative influence in Norma Jeane's first 16 years, filling the girl's mind with visions of future stardom. "Grace was captivated by Jean Harlow," Marilyn later said, "and so Jean Harlow was my idol." She would recall to Pete Martin of the *Saturday Evening Post* (1956): "I used to play act all the time. For one thing, it meant I could live in a more interesting world than the one around me."

In September 1935, Norma Jeane was transferred to the Los Angeles Orphans Home; from her bedroom window she could see the lighted sign of the RKO movie studio. After brief stays with Grace and new husband "Doc" Goddard and various relatives, she found a more lasting and affectionate home starting in late summer 1938 with Edith Ana Lower ("Aunt Ana"), the aunt of Grace McKee Goddard, and a Christian Science practitioner.

In Marilyn's uncompleted autobiography (first serialized in 1954 by Ben Hecht and later expanded by Milton Greene in the book "*My Story*"), she recalled the fantasies she entertained as a youngster while attending church. "No sooner was I in the pew with the organ playing and everyone singing, than the impulse would come to me to take off all my clothes. I wanted desperately to stand up naked for God and everyone else to see. I had to clench my teeth and sit on my hands to keep myself from undressing. Sometimes I had to pray hard and beg God to keep me from taking my clothes off. My impulse to appear naked and my dreams about it had no shame or sense of sin in them. Dreaming of people looking at me made me feel less lonely."

Marilyn Monroe

Born Norma Jeane Mortenson June 1, 1926
Los Angeles, California
Died August 5, 1962

Known as "little mouse" and "Norma Jeane—the human bean" as a young girl, she blossomed at the time she entered eighth grade at age 13. In her July 1962 *Life* interview with Richard Meryman, she recalled that when her beauty first emerged, "suddenly, everything opened up. . . I had this long walk to school—2½ miles to school, 2½ miles back—it was just sheer pleasure. Every fellow honked his horn—you know, workers driving to work, waving, and I'd wave back. The world became friendly."

As recounted by Jim Dougherty in his 1953 bylined article for *Photoplay* and his 1976 book "*The Secret Happiness of Marilyn Monroe*," Norma Jeane was living with the Goddards, who had previously been neighbors of Dougherty's family. Dougherty (then 20) was working the night shift at Lockheed Aircraft, and soon struck up a romance with the attractive teen-ager. When the Goddards decided to move to West Virginia, and couldn't take Norma Jeane with them, Grace asked him if he'd like to marry her lovely ward. Because Ana Lower couldn't afford to keep her for long, Grace said that unless Norma Jeane was married she would have to return to the orphanage. He agreed, and the couple wed on June 19, 1942 just after her 16th birthday.

Dougherty wanted a traditional marriage—"I'm the captain and my wife is first mate"—not realizing that she had very different ideas. In 1943 he joined the Merchant Marine and was sent to Catalina as a physical training instructor; they lived there for a year. She would wear skimpy bathing suits and figure-hugging sweaters, eventually leading to her husband's displeasure. "She knew she had a beautiful body and knew men liked it, and didn't mind showing a little bit of it." Before long, he was exhibiting jealousy over the male attention she was generating.

Birth of a Model

After a year at Catalina, Jim shipped out, and Norma Jeane got a job in April 1944 inspecting parachutes for the Radioplane Company. Army photographer David Conover became the first photographer to shoot the emerging beauty while she was working at the aircraft plant in Burbank around year's end. onover, assigned to the First Motion Picture Unit at the Hal Roach Studio in Culver City, had been directed by Capt. Ronald Reagan to take morale-boosting photos of attractive women in war work. Moving down the assembly line at Radioplane, he was immediately struck by the curly haired "half-child, half-woman." His photos of the fresh-faced teen-ager later appeared in *Yank* and *Stars and Stripes*.

Before he was shipped out to the Philippines in summer 1945, Conover referred her to commercial photographer Potter Hueth; Hueth, enthused by some color transparencies he shot of her, brought Norma Jeane to Emmeline Snively. On August 2, 1945, Norma Jeane applied for acceptance at Miss Snively's Blue Book Model Agency, quartered at The Ambassador Hotel on Sunset Boulevard. Snively later wrote that Norma Jeane "was cute-looking, but she knew nothing about carriage, posture, walking, sitting or posing." The 19-year-old was dazzled by the magazine covers on the walls, and longed to see herself there as well. "Marilyn was so naive, so sweet and so eager to succeed that my heart went out to her at once," Snively remembered. She had an "all-American kind of personality—cute, wholesome and respectable. There was no sultry sexiness about her, except that her clothes were a little too tight across the chest." She stood 5-foot-5, weighed 118, and measured a robust 36-24-34. The only way she could pay the $100 tuition for three months of instruction was by making payments from future assignments.

After quitting her defense plant job and enrolling with the agency, she got her first job as hostess at a aluminum exhibit at the Los Angeles Home Show; the pay was $10 a day for nine days. In a 1962 interview, Marilyn recalled that she was fired from her second job, modeling sports clothes on Malibu Beach for a well-known catalogue. "Later, I found out the reason. They said no one would ever look at the clothes in their catalogue. 'It's just that you have more than the usual amount of sex appeal. Too much to make a fashion statement,' Miss Snively explained to me."

In late September, Norma Jeane had the first of many memorable photo sessions with Bruno Bernard, soon to become famous as Bernard of Hollywood. "I had never seen a model, beginner or pro, who was so at ease in front of a camera," Bernard wrote 40 years later in his book *Requiem for Marilyn*." "Her instinct for the requirements of the camera, when coupled with the almost acrobatic flexibility of her body and the lightning-like change of her facial expressions, made her a textbook example of what makes photogenic beauty as compared to natural beauty."

A photographer arranged to get her a permanent to straighten and bleach her previously frizzy hair a golden blonde in late 1945, and she began to land even more frequent swimsuit modeling jobs in magazines such as *See*,

Laff and *Click*. She was earning an average of $150 a week and talked eagerly about her movie aspirations. The Blue Book Agency shot a silent film of her modeling a swimsuit; when Jim Dougherty returned to California on leave, Norma Jeane told him it had been the most exciting day of her life.

Andre de Dienes was the next nationally known photographer to discover the wonder that was Norma Jeane, much to the discomfort of her husband. The 32-year-old native Transylvanian was impressed by her "well-rounded yet coltish body" and "unpolished beauty" when she first posed for him, sitting in the middle of Route 101 outside North Hollywood, and, later, in a beach photo session. In early December, de Dienes picked up Norma Jeane at her Aunt Ana's home to take her on a modeling expedition into the Mojave Desert. The month long journey ultimately crossed thousands of miles into Arizona, Nevada and Oregon, and not surprisingly the photographer fell utterly in love with his subject. The fruits of their journey and subsequent photo sessions were seen in numerous magazine layouts and de Dienes' wonderful 1985 book "*Marilyn Mon Amour*."

In a 1960 interview with writer Jack Rosenstein, she said sex was part of her first work assignments. "When I started modeling, it was like part of the job. All the girls did . . . and if you didn't go along, there were 25 girls who would." In the eyes of a still desperately uncertain young woman who hungered for stardom, the man with the capability to capture her beauty for the world exceeded all others in importance, and the greatest gift she could offer was her body.

By this time Norma Jeane had moved out of her mother-in-law's home. Infuriated by her Christmastime modeling trip just after his return home, Dougherty forced the inevitable showdown in January 1946. "I just told her that she would have to choose between a modeling career and maybe the movies or a home life with me like we had in Catalina." She resisted making a choice, but in truth she had already made her decision even as he was recalled to duty in the Pacific.

In February she had her first sessions with legendary pin-up artist Earl Moran; the photos weren't published until the 1954 Brown & Bigelow calendars. In its January 1987 issue, *Playboy* unveiled stunning topless photos of Marilyn taken during her almost-monthly sessions at Moran's Sunset Strip studio from 1946 to 1949; at the time she earned $10 an hour. Moran would photograph his models and then select the most provocative shots to use as the basis for a charcoal outline leading to a final pastel portrait. "Emotionally, she did everything right," Moran would later say. "She expressed just what I wanted. Her movements, her hands, her body were just perfect." Indeed, it is astonishing that it took four decades for these photos to become public, for they are among the most magnificent Monroe pictures ever taken. Not only do they present her perfectly curvaceous body in all its glory, but they also capture the essential Marilyn magic in the full flush of youth: playful, teasing, radiant, and utterly at ease in her near-nakedness before the camera.

When Dougherty was briefly stationed at Shanghai in late May, he received legal papers from Las Vegas informing

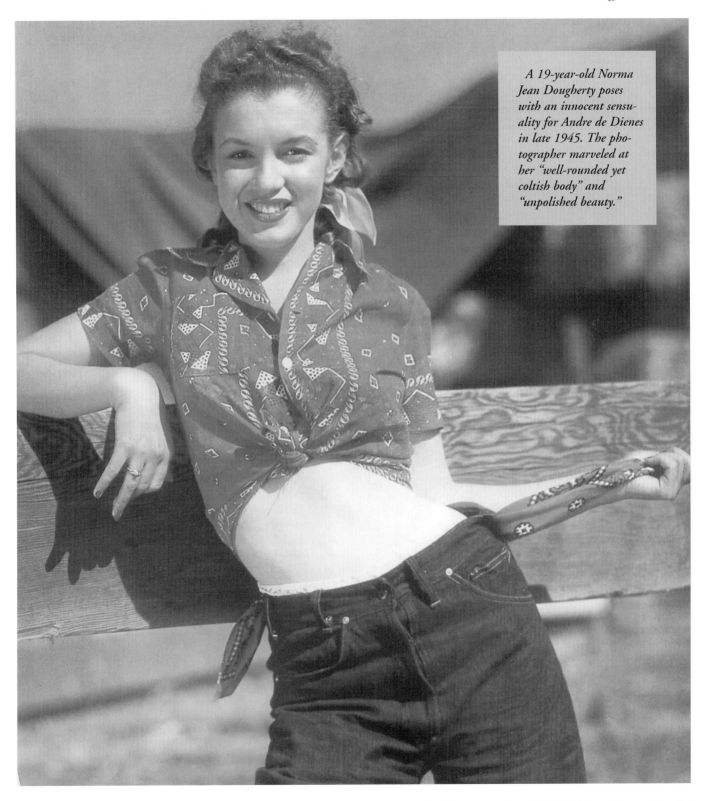

A 19-year-old Norma Jean Dougherty poses with an innocent sensuality for Andre de Dienes in late 1945. The photographer marveled at her "well-rounded yet coltish body" and "unpolished beauty."

him that Norma Jeane was suing him for divorce. "I felt as though I'd been hit on the head with a steam shovel," he wrote. Following his return home a month later, she told him she wanted a movie career, and that the studio had told her she must be divorced to have a contract. The divorce was finalized on September 13.

With thanks to compiler Clark Kidder, whose splendid book *"Marilyn Monroe UnCovers"* filled many gaps in this list, Marilyn's most significant pre-1950 magazine appearances included:

Jan. 1946 *Douglas Review* (cover as part of two couples enjoying a flight aboard a Douglas Aircraft)

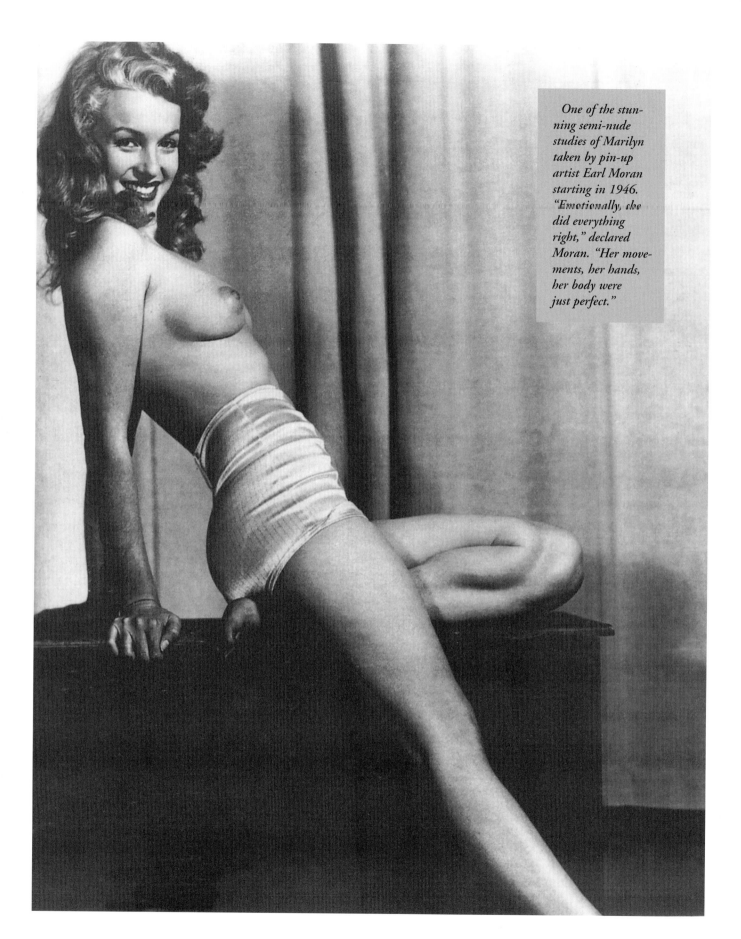

One of the stunning semi-nude studies of Marilyn taken by pin-up artist Earl Moran starting in 1946. "Emotionally, she did everything right," declared Moran. "Her movements, her hands, her body were just perfect."

April 26, 1946 *The Family Circle* (cover of Norma Jeane in Little Bo Peep dress picking up a lamb, shot by de Dienes)

May 1946 *U.S. Camera* (part cover in slacks and sweater in the surf, by de Dienes)

June 1946 *Laff* (cover in two-piece swimsuit); also August issue (cover in orange two-piece swimsuit, by Bernard)

June 1946 *Pageant* (cover on the beach, by de Dienes)

Aug. 1946 *Pour Tous Films* (French; from same session as 5/46 *U.S. Camera*)

Aug. 1946 *Salute* (beaming bare-shouldered cover by Laszlo Willinger)

Jan. 1947 *Laff* (cover in white two-piece swimsuit, by Bernard); also Sept. issue (cover in yellow two-piece suit, by Bernard)

Feb. 1947 *Herald-American Parade* (cover by de Dienes)

June 1947 and July 1947 *Personal Romances* (covers)

Sept. 1947 *Cinemonde* (French; cover in flowered two-piece swimsuit)

Sept. 1947 *True Experiences* (cover steering a boat)

Dec. 1947 *Picture Post* (cover by de Dienes)

Feb. 1948 *V* (French; playful cheesecake cover in culottes and halter top)

Apr. 1949 *Film Humor* (swimsuit picture)

Aug. 1949 *Cover Girls Models* (classic swimsuit cover)

Aug. 1949 *Glamorous Models* (cover, gorgeous beach pin-up)

Sept. 1949 *Hit!* (wonderful cover in sexy yellow two-piece swimsuit, by Bernard; superior shot from the session first seen in Sept. 1947 *Laff*)

Oct. 10, 1949 *Life* (Marilyn is featured with brunette exotic Laurette Luez and six other young starlets shot by Philippe Halsman)

Oct. 1949 *Teen-Age Diary Secrets* (cover in tight sweater, by Bernard)

Dec. 1949 *Foto Parade* (cover in green bikini, by Willinger)

Dec. 1949 *Glamorous Models* (5 full-page, wonderfully playful beach pictures taken by de Dienes during her *Love Happy* promotional tour; text claims she has her own TV show in Los Angeles and is active in the "little theater" movement)

Entree to Hollywood

Emmeline Snively, realizing that her young protege possessed cinematic qualities, arranged with her friend (and talent agency head) Helen Ainsworth, to get Norma Jeane an interview at 20th Century Fox. On July 17, 1946, the would-be starlet met with former actor Ben Lyon, then casting director for Fox. Appropriately, Lyon had co-starred 16 years earlier in *Hell's Angels* with Norma Jeane's idol, Jean Harlow.

Two days later, on the set of *Mother Wore Tights*, an impressed Lyon tested the nervous 20-year-old in a sequined evening gown in a color scene without dialogue. Leon Shamroy, an Oscar-winning cameraman who shot the screen test, told *Esquire* writer Robert Cahn in 1951: "When I first watched her, I thought: This girl will be another Harlow. Her natural beauty plus her inferiority complex give her a look of mystery. . . I got a cold chill. This girl had something I hadn't seen since silent pictures. . . Every frame of the test radiated sex."

The first Hollywood news item on Norma Jeane was Hedda Hopper's column on July 29 following Howard Hughes' plane accident: "Howard Hughes can't be so very ill; he's considering putting Norma Jeane Dougherty under contract. Saw her on a magazine cover." Hughes, then head of RKO-Radio Pictures, had seen her on the cover of *Laff* (photographed by Bernard) and was photographed in an iron lung clutching the magazine; Ainsworth made sure that Hopper—and 20th Century Fox—knew all about it.

On August 24, Lyon beat Hughes to the punch and gave Norma Jeane a one-year contract at $125 per week. He decided upon her professional name when she said her mother's maiden name was Monroe; Lyon said she reminded him of Marilyn Miller, the 1920s Broadway star to whom Lyon was once engaged. "Yeah, that's it. Marilyn Monroe." On September 5, *Variety* briefly noted that Norma Jeane Dougherty had been signed by Fox.

"I didn't go into movies to make money," Marilyn would say disarmingly several years later. "I wanted to become famous so that everyone would like me, and I'd be surrounded with love and affection."

Her first job for 20th was a bit in the comedy *Scudda-Hoo! Scudda-Hay!*, in which she had one line of dialogue (to June Haver) in a crowd scene—"Hi, Rad!" She took classes in acting, pantomime, singing, and dancing, and spent much of her time posing for cheesecake stills. According to Cahn, when Marilyn posed for studio pin-ups in a flesh-colored negligee after the film's shooting, a studio executive recalled that "it was like the Lindbergh home-coming. People were leaning out of every window. And there was Marilyn, naive and completely unperturbed, smiling and waving up at everybody she knew, didn't know or hoped to know."

In August 1947, with just one other small part in the film *Dangerous Years* to her credit after a year, she was dropped by Fox. Studio chief Darryl Zanuck had never met her at the time, and didn't think twice in declining to pick up her option. Marilyn later wrote, "My first contract with 20th Century-Fox was like my first vaccination. It didn't take."

She lived on modeling and unemployment insurance, and studied for 10 months at the Actors Laboratory in Hollywood. One of her friends at the Actors Lab was the woman who would later become filmdom's foremost African-American glamour queen, Dorothy Dandridge. According to Earl Mills' biography of Dorothy (*"A Portrait In Black"*), Dorothy danced for joy when Marilyn won the second lead in a local amateur stage production of *Glamour Preferred* in October 1947. They remained close, enough so that Marilyn called Dorothy in late 1954 when Joe DiMaggio filed for divorce; both women wept.

Marilyn's generous patrons during this period were MGM Talent Department director Lucille Ryman and her husband, actor John Carroll. They were the first of several people over the years to be stunned when Marilyn told them that with all her money going for rent, classes and transportation, she obtained meals by offering herself, for sex, to men driving near Hollywood or Santa Monica Boulevard. "She told me (at their first meeting in 1955) she was the one summoned if anyone needed a beautiful girl for a convention," Lee Strasberg later recalled. "Marilyn was a call girl." It's not certain whether these accounts were true, or merely designed to win sympathy. Gloria Steinem speculated that "Marilyn may have been dramatizing the deprivation of her

background, as she sometimes did, as if to justify her real feelings of being deprived."

On March 9, 1948—acting upon the recommendation of 20th Century Fox executive producer Joseph Schenck, who had become quite enamored of Marilyn—Columbia Studios chief Harry Cohn gave her a six-month contract at $125 a week. Donald Spoto writes that one condition of the contract called for Columbia to permanently heighten her hairline through electrolysis and to make her hair even more blonde. Columbia immediately put her together with drama coach Natasha Lytess, who would become her personal coach and constant companion on the sets, much to the irritation of directors, of all her films until 1955. The two roomed together for a time, and Lytess ultimately fell in love with her student, although this feeling was unrequited—and ultimately manipulated by Marilyn.

Thanks to an audition arranged by Natasha, Marilyn played a burlesque queen in a nine-day quickie, *Ladies of the Chorus*, released in October 1948. The high points were the two musical numbers she performed, most notably a sexy "Every Baby Needs a Da-Da-Daddy" in a black gown slit almost to the hip. Director/screenwriter Garson Kanin (then at Columbia) wrote that Marilyn had a screen test for the Billie Dawn role in *Born Yesterday*, but Cohn refused to even look at it (Judy Holliday would win the Oscar for her 1950 performance as the not-so-dumb blonde). When her six-month option came up, Cohn (whose crude sexual advances she rejected) ordered her dropped from the contract list. "The girl can't act," he declared.

After being introduced to Marilyn, diminutive agent Johnny Hyde, executive vice president of the William Morris Company and a genuine power in Hollywood (and 31 years her senior), quickly fell in love with her; he left his wife and children by mid-1949, and began to dedicate himself completely to her career. For starters, he arranged for a bit of cosmetic surgery, a new wardrobe, and a part as a dancing girl in *Ticket to Tomahawk*. Hyde continued to groom his budding starlet and provide introductions to men in a position to advance her career. Seeing him as a protective father figure, Marilyn's affection and loyalty to Hyde were deep, but she refused to consider his offers of marriage. "I loved him very dearly, but I was not in love with him," she explained. His death in December 1950, before she achieved the stardom he'd sought for her, was a personal blow.

Marilyn's bit part in the Marx Brothers film *Love Happy*—hip-wiggling past Groucho Marx while purring one line of dialogue—was hardly demanding, but did bring the starlet before a wider audience and offered a tantalizing hint of what was to come. The film had already been completed when producer Lester Cowan decided that it need-ed something extra, and hired Marilyn to do the walk-on. "She's Mae West, Theda Bara, and Bo Peep all rolled into one!" Groucho marveled. Upon the film's release in July, United Artists sent her on a five-week promotional tour of eight cities, her first opportunity to develop the press relation skills that would later become masterful.

Marilyn's early filmography:

Scudda Hoo! Scudda Hay! (released Feb. 1948) — One line of dialogue for Marilyn in this rural romantic comedy, and she can just be glimpsed in one scene rowing in a canoe. Filmed prior to *Dangerous Years*, but released later.

Dangerous Years (Dec. 1947) — Bit part as a waitress (and her first close-up) in an ice cream parlor in this tale of juvenile delinquency.

Ladies of the Chorus (Oct. 1948) — Performed two songs for her featured role as a burlesque queen in this little-seen musical. Indicative of its obscure nature is the fact that show business bible *Variety*, which reviews virtually every picture released in the U.S., never even mentioned the film.

Love Happy (July 1949) — Late in the final Marx Brothers film, Marilyn, clad in a figure-hugging evening dress, enters the office of private detective Groucho Marx, asking for his help because "some men are following me." Watching her slink toward the camera in her sultriest manner, Groucho cracks, "Really? I can't understand why." She's on screen for barely a minute, but aside from Harpo's antics she is by far the most memorable thing about the picture.

A Ticket to Tomahawk (April 1950) — Just a dancing girl with no dialogue, and one of five participants in a musical number in this Western.

The Calendar

Veteran Associated Press photographer Tom Kelley first "met" Marilyn when he stopped to check out an accident on Sunset Boulevard. Kelley was dazzled by one of the participants in the accident, a stunning blonde with garish makeup, clad in a low-cut sundress that was two sizes too small. The girl was on the verge of tears, explaining to Kelley that she was late for a modeling assignment and didn't have money for a cab. Kelley gave her a $5 bill and his business card, and said, "Pay me back when you can." She thanked him profusely and hailed a taxi.

Two years later, in September 1948, Marilyn walked unannounced into the Tom Kelley Studio with her modeling portfolio, having made the rounds to other photographers seeking an appointment. She introduced herself, hoping he had forgotten the incident and that she hadn't paid him back. He was hesitant, feeling her look was too bold, but she pleaded, "I really need the work. Isn't there just any little

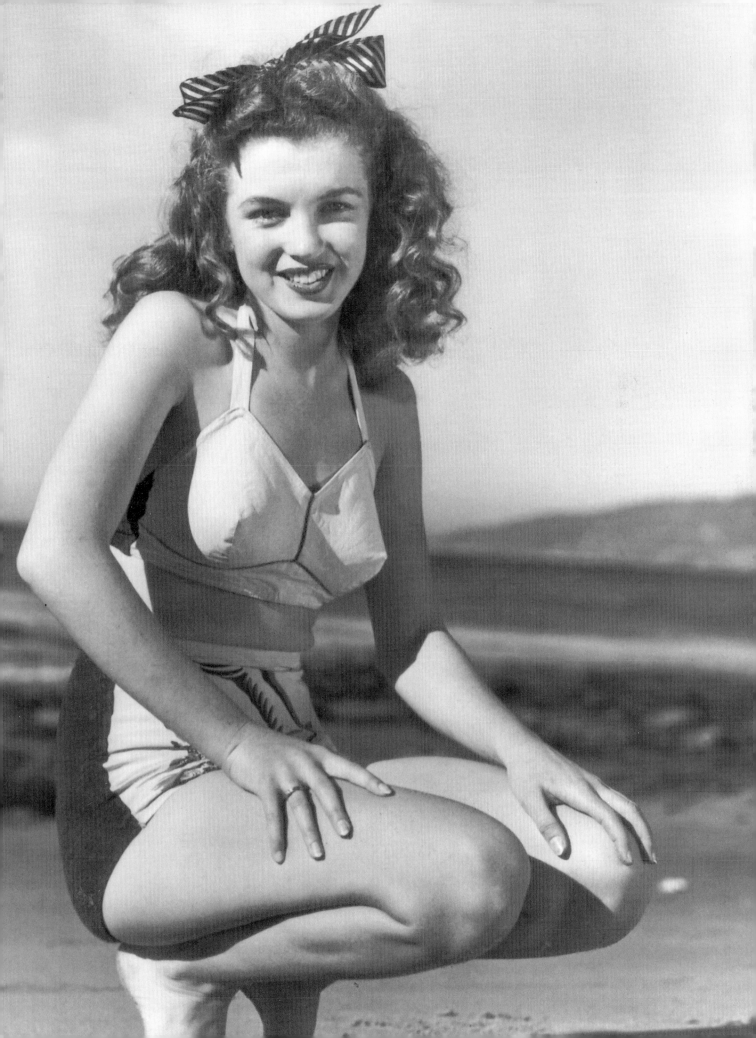

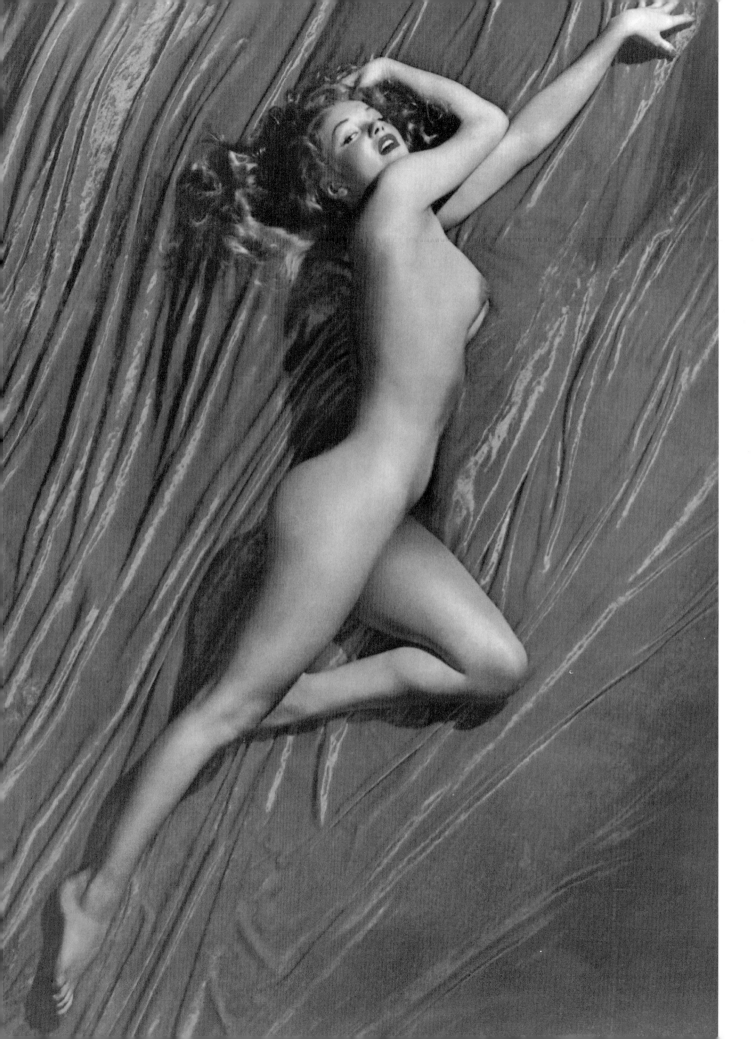

modeling assignment you could use me in?" He agreed and instructed Marilyn to change into a swimsuit after toning down her makeup. She proved to be spectacular, and Kelley immediately gave her the modeling assignment for a Pabst Beer billboard.

Impressed with both her provocative beauty and her professionalism, Kelley told Marilyn he had regular assignments to photograph nudes for calendars, and asked if she would like to pose for one. Conscious of the risk it would pose to her acting aspirations, she quickly declined. Over the next seven months, Kelley photographed Marilyn several more times, one of which produced an Eastside Beer billboard. During one of these jobs, John Baumgarth, owner of a calendar company who was visiting from Chicago, was dazzled by the curvaceous blonde and urged Kelley to ask her again to bare all. The photographer met with Marilyn over breakfast and carefully reassured her that the nudes would be artistic in quality, and that it was unlikely anyone would recognize her. The next morning, on May 27, 1949, she called to accept the offer. After pausing, she said, "I think I owe this to you, Tom," and then hung up.

Kelley scheduled the session for that same evening at 9 p.m., and his wife Natalie picked up a red-velvet stage curtain from a prop house. Marilyn arrived at precisely 9, changed into a robe, and they sat down to talk; her initial nervousness began to dissipate as they chatted. He climbed to the top of the ladder from which the shots would be taken and put Artie Shaw's recording of "Begin the Beguine" on the phonograph. Marilyn, casting aside all inhibitions, swept out of the dressing room wearing only her red pumps, giggling, "Ooh, I just love 'Begin the Beguine!'" She stretched out on the red-velvet stage curtain and he carefully positioned her.

"This wasn't just another girl, this was a girl with an instinct for drama and showmanship," Kelley wrote in a 1956 article. "Her lips parted provocatively, and her body was arched and magnificent. There was a natural grace about her and she fell into poses without the necessity for direction."

Both Kelley and Marilyn sensed that they had created something special; only afterward did she remind him of the car incident, which he had completely forgotten. "I thought that letting you shoot me tonight as you did was a way to show my gratitude," she explained. She signed the model release "Mona Monroe." Marilyn never modeled for Kelley again, but he wrote that she would occasionally drop by the studio to talk. Sometime around early 1952, she came by and asked to see the calendar for the first time. "She studied it carefully, then said she thought it was very good. She was pretty proud of it." The next day, Kelley claimed, she phoned to request 25 calendars, and passed them out to friends on the set of *Clash by Night*.

According to Marilyn's story (told to Liza Wilson) in a 1952 issue of *American Weekly*, "the day I received my eviction notice (from the Studio Club in Hollywood), I called Natalie (Kelley) and said, 'Where and how much?'" This was not true; actually, she had already moved out of her apartment at the Studio Club. Another version of the story,

as related to Maurice Zolotow, is that she needed the money to meet a payment on her new convertible. Donald Spoto declares: "Quite simply, Marilyn posed nude because it pleased her to do so. The shy girl who tended to stutter during first takes of a movie set remembered (or was creating) the dream of her childhood: she was naked and unashamed before her adorers."

Kelley sold the Kodachrome for "Golden Dreams" (posed with both breasts exposed and legs bent) to John Baumgarth, who got exclusive rights to reproduce the color shot for a mere $500. Another nude from the session, "A New Wrinkle"—Marilyn posed in beautiful reclining profile with one arm and one leg extended, actually the more stunning of the two—was sold to Western Lithograph Company of Los Angeles for $250. Baumgarth reaped the benefits to the tune of $750,000, as the calendars sold more than two million copies with endless reproductions over the years. Kelley had shot 22 other nudes of Marilyn that evening, all of which were stolen from the photographer's file cabinet a few years later. One double image nude was published in the December 1956 *Escapade* (see magazine listings); three other pictures—one slight variation on "Golden Dreams" (seen in James Haspiel's book "*Young Marilyn: Becoming the Legend*") and two other versions of "A New Wrinkle"—reappeared in the 1980s. Marilyn's modeling fee for the historic session was $50.

Marilyn was always adept at picking up beauty and glamour tips wherever she could. Shelley Winters wrote in her first autobiography that Marilyn was quite taken with Shelley's openmouthed smile in the film *Larceny*. "Marilyn thought it was very sexy and used that smile forever after. . . I gave it to her with pleasure." Strip queen Lili St. Cyr was one of Marilyn's primary glamour inspirations; Bruno Bernard noted that Marilyn saw Lili perform several times, copied her sinuous walk, and studied her photos.

Included among Marilyn's 1950-51 magazine appearances:

Jan. 1950 *Exotic* #1 (back cover)

Feb. 1950 *Laff* (cover, studio swimsuit shot by Bernard)

Feb. 1950 *Man to Man* (irresistible cover, offering a beaming smile while talking on phone in black bra and panties)

May-June 1950 *Gala* #1 (cover in one-piece swimsuit using an umbrella as a playful prop, by de Dienes)

May 1950 *Glance* (cover in pink two-piece swimsuit)

Sept. 1950 *Photoplay* (1 page color and other pictures as part of article, "How a Star Is Born")

Nov. 1950 *Night & Day* (cover in swimsuit)

Jan. 1, 1951 *Life* (included in a photo essay on starlets, humorously billed in one photo as a "busty Bernhardt")

Feb. 1951 *Cover Girls Models* (full-page color pin-up)

Feb. 13, 1951 *People Today* (cover, "Miss Cheesecake")

March 1951 *Photoplay* (color full-page swimsuit pose plus one page)

Sept. 8, 1951 *Collier's* (the first full-length article on Marilyn, "The 1951 Model Blonde," by Robert Cahn.)

Sept. 1951 *Esquire* (sensational color gatefold by John Florea of Marilyn in completely unbuttoned pink sweater, lying on fur. "Ingenue—the smile of a rising star—the buoyant charm of Marilyn Monroe.")

The Starlet Ascends

Almost immediately after she finished filming a bit part for *Ticket to Tomahawk* in Colorado, Marilyn was invited to read for John Huston in *The Asphalt Jungle*. Huston was fresh from directing the classic *The Treasure of the Sierra Madre*, and Hyde knew that even a small role in one of his films was an ideal opportunity. While making her *Asphalt Jungle* test, wrote Bennett Cerf in 1953, Marilyn "was wearing falsies to make what she probably figured would be a more outstanding impression. . . she said she needed the added confidence they gave her. She got over that."

The Asphalt Jungle was released in early 1950, and Marilyn created an immediate impact as the moll of crooked lawyer "Uncle Lon" (Louis Calhern), reclining on a sofa in tight silk lounging pajamas, rising to passionately kiss Calhern. In just two major scenes, she became one of the most discussed elements in the acclaimed film, as many walked out of the theater asking, "who was that blonde?" MGM had the chance to put her under contract, but passed on the opportunity.

Marilyn's initial impact was expanded later that year when Hyde arranged an interview for her with director Joseph Mankiewicz for a small but pivotal part in the eagerly anticipated film *All About Eve*, which would bring her back to 20th Century Fox. Playing a sexy aspiring starlet, she not only held her own with the likes of Bette Davis and George Sanders, but was already making it hard to keep one's eyes on anybody else when she was on screen.

On May 11, 1950, shortly after viewing the rushes from *Eve*, Darryl Zanuck ordered Marilyn signed to her second contract with Fox, calling for $500 a week with options up to $3,500 a week in the final year. Zanuck was still unconvinced of her star quality, but issued instructions that she was to be written into any picture that could use a sexy blonde. In late 1950, she appeared in her only television commercial, a motor oil ad ("Put Royal Triton in Cynthia's little tummy," she purred).

While the moviemaking traumas Marilyn underwent in later years are well known, they were similarly intense in her starlet days. John Huston noted that she trembled visibly on the first day of shooting for *The Asphalt Jungle*. Zachary Scott would later say that in one scene from 1951's *Let's Make It Legal*, when they were dancing and he brushed Marilyn's back, he could feel her trembling violently and was surprised that the camera didn't pick it up.

These emotions were (understandably) still more pronounced in RKO's *Don't Bother to Knock* (1952), the first time Marilyn was called upon to shoulder a leading dramatic role. After an early career of playing almost entirely decorative parts, Marilyn found the responsibility of carrying sustained and sometimes harrowing scenes with co-star Richard Widmark was enough to place pressure on a fragile young woman still learning how to act. Further intensifying the challenge was the fact that Marilyn, with her deep fear of mental illness, was playing an emotionally disturbed baby sitter. Under the circumstances it is impressive that she was able to pull off even a competent performance. Anne Bancroft, then making her film debut, later recalled that in the climactic scene, as she watched Monroe's character threaten to kill herself before giving up to authorities, she found her eyes unexpectedly flooded with tears upon seeing Marilyn—the frightened young actress, not just the character—"helpless and in pain."

Marilyn's 1950-early 1952 films:

The Asphalt Jungle (May 1950) — Marilyn's first "A" picture opportunity came in this John Huston-directed crime drama playing the luscious mistress of corrupt lawyer Louis Calhern. Her first scene occurs early as she rises in slinky lounging pajamas and gives "Uncle Lon" a passionate kiss. Late in the film, after she fantasizes excitedly about a planned trip to the beaches of Cuba ("Run for your lives, girls—the fleet's in!"), police enter to arrest Calhern for his role in a robbery and murder.

The Fireball (August 1950) — Small role as a roller-skating groupie of Mickey Rooney.

Right Cross (August 1950) — Appears briefly as a sexy model at a cocktail party.

All About Eve (Sept. 1950) — In this classic, Oscar-winning tale of ruthless career-climbing in the theater, Marilyn's first appearance as Miss Caswell occurs just after the film's veteran stage star Bette Davis utters the immortal line, "Fasten your seat belts—it's going to be a bumpy night." Marilyn arrives at Bette's reception on the arm of drama critic George Sanders, who introduces her snidely as "a graduate of the Copacabana School of Dramatic Arts." Later, when she smiles dazzlingly at a powerful producer who offers to get her a drink, the cynical Sanders says approvingly, "Well done! I can see your career rising in the east like the sun." Indeed it was.

Home Town Story (May 1951) — Industrial film that was barely released commercially; Marilyn's in one scene as a receptionist at a newspaper office.

As Young As You Feel (June 1951) — Cast as the provocative secretary to the president of Acme Printing. One of the film's stars, Constance Bennett, uttered the soon-to-be-famous catty wisecrack, "Now, there's a broad with a future behind her."

Love Nest (Oct. 1951) — Supporting role as an ex-WAC who had befriended soldier William Lundigan, and alarms Lundigan's wife, June Haver, when she shows up to rent an apartment in the building owned by the couple. Jack Paar, playing Lundigan's best friend, makes several awkward passes at Marilyn.

Let's Make It Legal (Nov. 1951) — Marilyn has a small

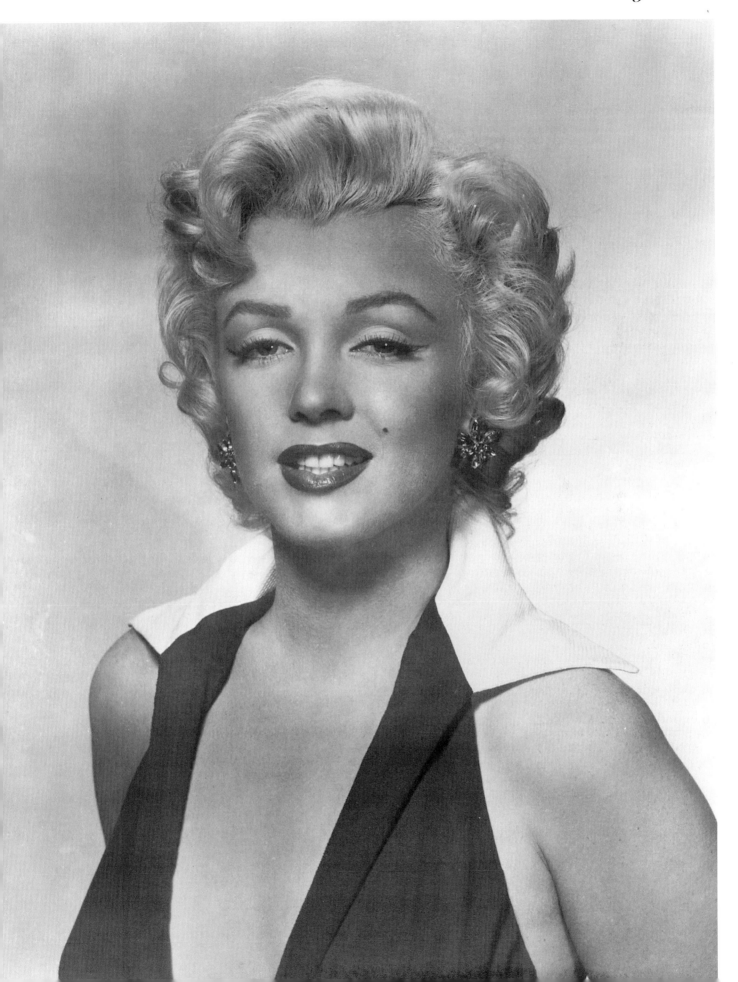

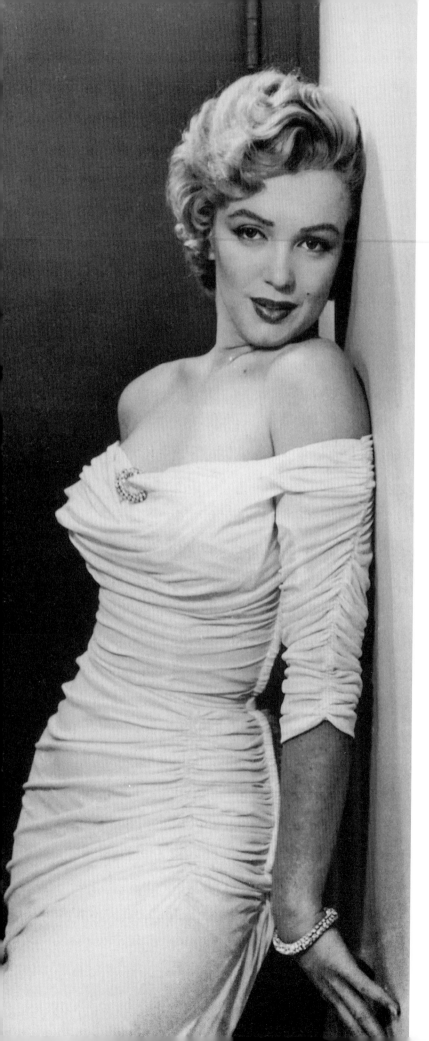

part as a beauty queen (Miss Cucamonga) who is used by Macdonald Carey to distract Zachary Scott from Carey's recent ex-wife Claudette Colbert. Her glamour is played up with scenes in two types of swimsuits, a tennis costume, a tight golf outfit, two slinky cocktail dresses, and a low-cut evening gown.

Clash By Night (May 1952) — Moody dockside drama about Barbara Stanwyck's doomed attempt to find happiness with a California fisherman; Marilyn (on loan for this picture to RKO) is quite sympathetic as a cannery worker and Stanwyck's loyal friend.

We're Not Married (June 1952) — For her subplot in this comedy about six married couples who discover that their unions aren't legal because the justice of the peace didn't have a license, Marilyn is the newly crowned Mrs. Mississippi wed to David Wayne. Upon learning the bad news, she goes on to be crowned Miss Mississippi.

Don't Bother to Knock (July 1952) — Marilyn is Nell, a soft-spoken, serious young woman who begins to behave oddly after being hired to babysit with a young girl at a hotel, trying on the mother's nightgown and jewelry, then enticing a man (Richard Widmark) who watches her dance alone from across the alley. We soon learn that Nell had recently been released from a mental institution and is still haunted by the wartime death of her husband, having delusions that Widmark is her husband reincarnated, capable of killing the girl if she threatens the imaginary romance. Marilyn was in over her head in such a role at this stage of her career, but there are still moments when one is touched by her portrayal of this strange, quite lost creature—particularly during the final scene as she breathes, with a look of desperation in her eyes, "I don't want to harm anybody." The film pulled theater rentals of $1.5 million.

Monkey Business (Sept. 1952) — Totally silly Howard Hawks comedy, but hard to resist with the stellar trio of Cary Grant, Ginger Rogers, and Marilyn. While typecast as a sexy secretary who can't type ("anybody can type," boss Charles Coburn tells Grant after they both admiringly watch her sashay out of the room), she makes the most of every moment on screen. Her first scene with Grant (who plays an absent-minded inventor) is irresistible: she tells him, "I've something I'd like to show you," extends one lovely leg while lifting her skirt above her knee, and says breathily, "Isn't it wonderful?," demonstrating the non-rip stocking Grant had invented. Earned $2 million in rentals.

O. Henry's Full House (Oct. 1952) — In the opening segment of this anthology movie, Marilyn appears as a sensitive streetwalker who is astonished after being treated with respect by vagrant Charles Laughton.

In Germany, editors of *Stars & Stripes* named Marilyn "Miss Cheesecake of 1951." By early '52, the publication was featuring a Marilyn pin-up on its front page virtually every day to meet continuing demand from soldiers. Wartime inevitably generates a market for cheesecake, and just as World War II had been a major factor in boosting Betty Grable's career, the Korean War helped catapult Marilyn to stardom. Lawrence Crown remarks in *"Marilyn at Twentieth Century Fox"* that once pin-ups of her were distributed overseas, her fan mail from troops increased 10-fold, persuading studio heads of her potential with the public. By early 1952, she was reportedly receiving over 3,000 fan letters a week.

News that Marilyn was "the nude blonde in the calendar" became public on March 13, 1952; the calendar had first been issued the year before, but when it was reprinted for 1952, her escalating fame made her readily identifiable. The studio was in a panic, and raised the possibility of cancelling her contract for violating the standard morals clause. After talking with Hollywood columnist Sidney Skolsky, she decided that a bit of creative candor was the best approach to win popular sympathy. Rather than wait for blackmailers or others to break the news, Marilyn took the initiative by spilling the beans in an interview with UPI's Aline Mosby.

"I was told (by Fox) I should deny I'd posed. . . but I'd rather be honest about it," she declared. "I've gotten a lot of fan letters on it. The men like the picture and want copies. The women, well. . . " A bit disingenuously, she claimed, "I was broke and needed the money. Oh, the calendar's hanging in garages all over town. Why deny it? You can get one any place. Besides, I'm not ashamed of it. I've done nothing wrong." Asked at a press conference if she really had nothing on at the time, she beamed, "Oh, yes. I had the radio on." A potential disaster had been transformed into a public relations triumph.

A year-and-a-half later, the calendar nude received new exposure in the first issue of a new magazine published by an ambitious young Chicagoan named Hugh Hefner. After acquiring the rights to use the photo from the locally based John Baumgarth Co. for only $500, Hefner was able to finance the publication of the undated first issue of *Playboy*, which appeared on newsstands in November 1953. Marilyn graced the cover, and her "Golden Dreams" pose—which despite its notoriety had still not been seen in full by millions of eager males—occupied one page as the magazine's "Sweetheart of the Month." "There is nothing quite like Marilyn on this good earth," wrote Hefner in the accompanying text. "She is natural sex, personified. It is there in every look and movement. That's what makes her the most natural choice in the world for our very first *Playboy* Sweetheart."

Appearing in Korea in February 1954, she walked unexpectedly into a building where a huge blow-up of her calendar shot was hanging on the wall. Everyone was embarrassed, except Marilyn; as she related to Sheilah Graham: "Well, I couldn't hide my head in the sand. I had posed for it. So I went to the mike and told them all, 'Gentlemen, I'm deeply honored that you have put my picture in the place of honor.' Everyone laughed and we were all friends. But you know. . . I really was honored."

TV blonde bombshell Roxanne Rosedale of *Beat the Clock* fame recalled in early 1953 that when she first came to New York and went to a wholesale house to model dresses, she met Marilyn. "This girl walked in and started taking off her clothes. She was wearing just a dress, stockings, and a garter belt, and that's ALL! I said, 'Oh, this girl doesn't know what underwear is!'" Roxanne would later play a supporting role in *The Seven-Year Itch*. Natasha Lytess later recalled that Marilyn would habitually roam around her home or dressing room without clothes; Joe DiMaggio would find this habit quite unsettling. "Being naked seems to soothe her—almost hypnotize her," remarked Lytess.

Howard Hawks' *Monkey Business* was certainly a lesser, if amusing, Cary Grant comedy, but Marilyn left an impression as a voluptuous secretary who couldn't take dictation or type but possessed other attributes. Her breakthrough as a full-fledged star occurred a few months later in *Niagara*, where she played the scheming sexpot wife of Korean veteran husband Joseph Cotten. A high point was "the longest walk in cinema history," 116 feet of film. Trailers for the film promoted her as "the tantalizing temptress whose kisses fired men's souls! *Niagara* and Marilyn Monroe—the two most electrifying sights in the world!"

Marilyn seldom looked more radiant than she did on September 1, 1952 in Atlantic City to act as grand marshal for the Miss America pageant, in connection with her promotional tour for *Monkey Business*. She was asked by an Army publicity officer to pose with four career military women to help recruit more females into the Armed Forces. Marilyn was photographed in a startlingly low-cut white dress (with, quite noticeably, nothing underneath) posing with a radiant smile between the uniformed women. After the remarkable photo went out on the wires, the Army belatedly asked the press to kill the shot as too suggestive. As always, Marilyn had her own perspective on the mini-controversy. "I wasn't aware of any objectionable decolletage on my part," she said innocently. "I'd noticed people looking at me all day, but I thought they were looking at my grand marshal badge." The parade the following day produced wonderful footage of her waving happily to the crowd while wearing a black, cut-down-to-the-navel outfit.

On February 9, 1953, at the *Photoplay* awards dinner, where she was honored as the "Fastest Rising Star," Marilyn was sewn into a zipperless metallic gown with a plunging neckline, sans underclothing. In response to Marilyn's so-called "hip-wiggling" when she stepped up to receive the award, Joan Crawford proclaimed that "it was like a burlesque show," declaring that people didn't like to have sex "flaunted in their faces." Betty Grable quickly came to the newcomer's defense. "Why, Marilyn's the biggest thing that's happened to Hollywood in years." Just about to film *How to Marry a Millionaire* with Monroe, Betty smiled and said "I'm not envious of Marilyn. There's room for us all."

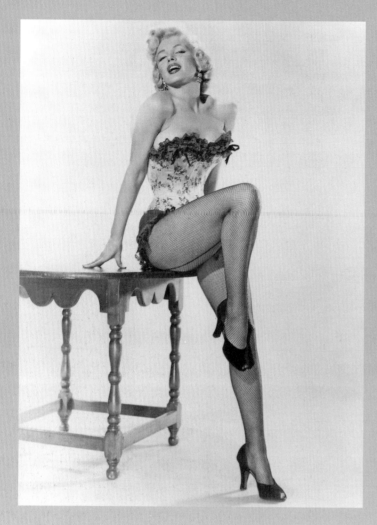

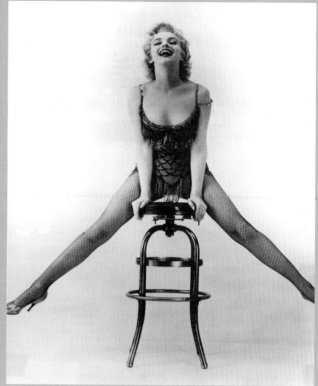

Marilyn was regularly cast as a showgirl or singer in her '50s films, and she invariably made the roles fit perfectly. Her performance as ambitious dance-hall floozie Cherie in Bus Stop *startled critics who suddenly recognized the fragile, sensitive creature dwelling within the sexpot.*

The Ultimate Blonde

When 20th Century Fox purchased the rights to the Broadway smash *Gentlemen Prefer Blondes*, Betty Grable was originally announced as the star. Marilyn's rapid ascent caused the studio to reconsider, and they officially offered her the role of Lorelei Lee on her 26th birthday. It is mind-boggling now to recall that many cynics doubted that she could pull it off. Sure she's sexy, they sniped, but can she sing? Could she ever—as she had demonstrated in early 1952 performing for 10,000 Marines at Camp Pendleton. No other screen actress who ever lived could have endowed Lorelei with the incandescent magic of Marilyn.

When Marilyn and Jane Russell were cast as co-stars, there were predictions of catfights between the reigning glamour queen and the challenger. Jane's far higher salary ($150,000 for the picture vs. only $18,000 for Marilyn) promised to heighten tensions. After a few days of polite but distant relations, however, the ice was broken and a genuine friendship began. Darryl Zanuck had emphasized how vital it was for the film's story that audiences see the affection Dorothy (Jane) had for Lorelei, and this affection and sense of comradeship is clear in the finished product.

In her autobiography, Jane recalled that when Marilyn began turning up on the set late, she learned that her co-star typically arrived hours earlier but would stay in her dressing room, afraid to emerge. "So from then on, I'd stand in her doorway and say, 'Come on, Blondie, let's go,' and she'd say, 'Oh, okay,' in her whispery voice, and we'd go on together. She was never late again." Actually, this was not true; Hawks was aggravated by Monroe's chronic lateness, and by the constant presence of Natasha Lytess. Russell attributed Marilyn's anxiety to her "desperate, desperate desire to be a star." The combination of her insecurity and need to be nothing less than "wonderful" made her a compulsive perfectionist, tirelessly rehearsing for hours and regularly asking to do a scene "just once more" even if the director was satisfied with the previous take.

Blondes was a smash as expected; in the best-remembered review, the *New York Herald Tribune*'s Otis Guernsey, Jr. remarked in awe that Marilyn looked as though "she would glow in the dark." On June 26, Marilyn and Jane were immortalized at Grauman's Chinese Theater. For a young woman who had spent many hours at the legendary theater and like so many others had tried to fit her footprints into those of past stars, it was a special occasion. (Marilyn had humorously suggested that it might be more appropriate to leave the imprints of their breasts and derrieres for posterity.) On September 13, Marilyn made her first live television appearance on the Jack Benny program, singing "Bye Bye Baby" from the *Blondes* score and participating in a comedy sketch.

How to Marry a Millionaire was a rather flimsy romantic comedy compared to the electricity generated by *Blondes*. Remarkably, it was an even bigger box office hit—indeed, it was the most commercially successful film comedy to date—partly because it was heavily promoted as the second CinemaScope production (following the blockbuster *The Robe*). Certainly its most interesting element was the pairing of Marilyn with the woman she was supplanting as 20th Century Fox's #1 blonde sex symbol. Doug Warren's *"Betty Grable, The Reluctant Movie Queen"* told what happened: "Betty saw the eclipse coming, but was philosophical about it by this time. There had always been a blonde standing by, and this time it appeared the standby was a winner. The crew was. . . charged with anticipation when Grable and Monroe had their first encounter on the sound stage. Betty, fully prepared for this, chose a moment when the stage was silent, so everyone would hear her words clearly. 'Honey,' said Betty warmly, 'I've had mine—go get yours.'"

Shooting *River of No Return*, her next film, was an ordeal. The physical demands were bad enough; in addition to the location shooting on the river rapids in Canada, Robert Mitchum and a pale Marilyn had to endure multiple takes of brutal close-up shooting on a studio sound stage with gallons of water splashing over their bodies and steel-tipped arrows whistling inches from their faces. The experience was exacerbated by Otto Preminger's open impatience and sarcasm toward his star. Shelley Winters recalled in her autobiography that Preminger "was terrorizing Marilyn into total immobility." Marilyn referred to *River* as a "Z cowboy movie, in which the acting finishes third to the scenery and CinemaScope."

Co-star Mitchum had worked next to Jim Dougherty at Lockheed a decade earlier, and was proudly shown a nude snapshot of Dougherty's wife. In Roger Ebert's book *"A Kiss Is Still a Kiss,"* he offered the view that Marilyn had agoraphobia, with an acute fear of people and places. She would break out in a rash whenever the director said "action," he remarked. "My theory is, she started to menstruate whenever the camera started to roll. She was that vulnerable."

In the midst of an agonizing experience, Marilyn found solace in a romance that had begun the year before. She had been introduced to Joe DiMaggio on a blind date in early 1952, a year after his Hall of Fame career with the New York Yankees ended. Her total disinterest in sports was matched by his apathy toward show business, but (at least for a time) it didn't matter. Always drawn to older men who offered strength and paternal protection, she found these qualities, along with elegance and effortless sex appeal, in the baseball legend.

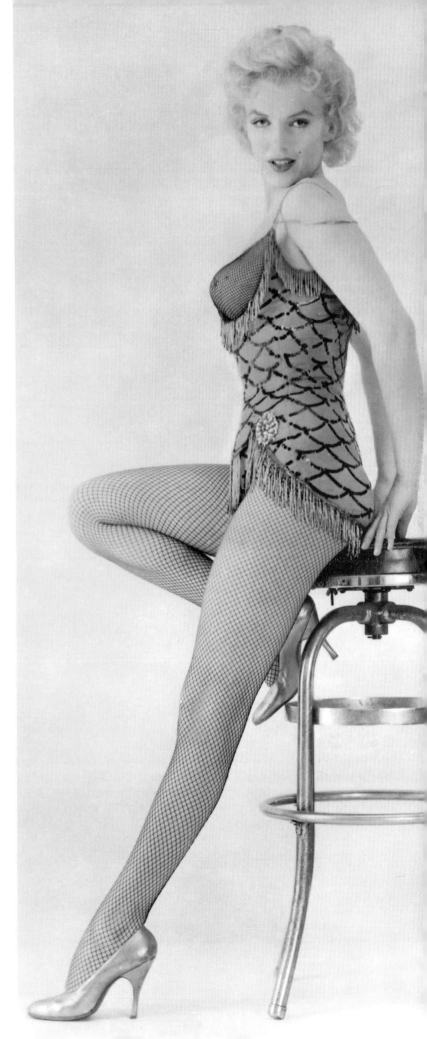

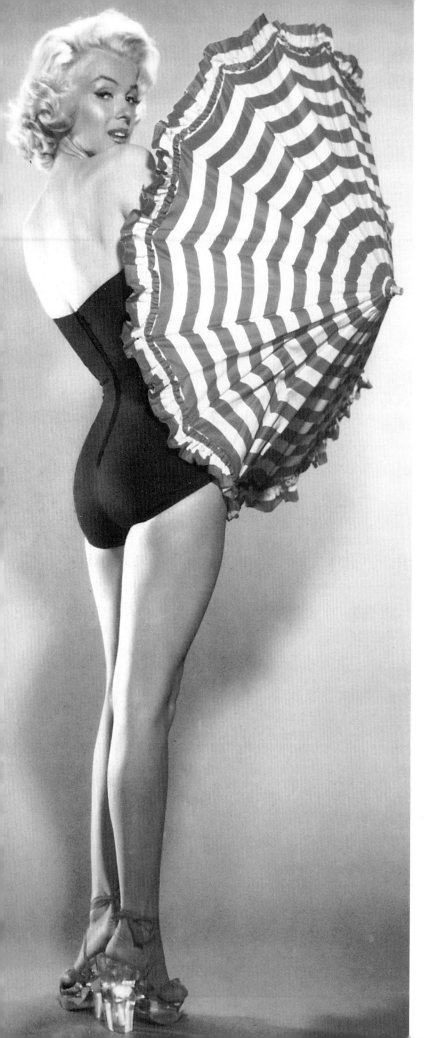

Marilyn Takes a Stand

On January 4, 1954, Marilyn was put on suspension by Fox when she didn't show up for work on the musical *Pink Tights* (aka *The Girl In Pink Tights*), in which she was to co-star with Frank Sinatra in a remake of the 1943 Betty Grable film *Coney Island*. At this point, she was earning $1,250 a week plus bonuses, far less than other top-level stars. The money was obviously a concern, but she insisted that it was the quality of the story that had driven her to take a stand. The character she was to play, she later said, was "the cheapest character I had ever read in a script. What's the use of being a star if you have to play something you're ashamed of?"

Formalizing the union between Marilyn and Joe had been just a matter of time, and the unexpected opening in her professional schedule created the opportunity. They were married on January 14 in San Francisco City Hall in an event hailed as a fairy-tale union of the modern-day goddess and the all-American hero. The studio briefly lifted her suspension if she agreed to return; when she refused again, the suspension was reimposed. On January 28, the newlyweds left for their honeymoon in Tokyo, where DiMaggio was already scheduled to play some exhibitions and help coach two Japanese professional baseball teams. Despite the Japanese passion for baseball and their hero worship of DiMaggio, the throngs that greeted the couple there had an even more fervent interest in the woman they called "Mon-chan" (sweet little girl).

The day after their arrival in Tokyo, the U.S. military's Far East command headquarters asked Marilyn if she would be willing to perform for U.S. troops in Korea. DiMaggio was unenthusiastic about the interruption of their honeymoon, but did not object and she eagerly agreed. It proved to be an electrifying experience, as she played to more than 100,000 soldiers in a dozen performances from February 16-19. Appearing in a skintight, low-cut cocktail dress in near-zero temperatures, she performed "Diamonds," "Do It Again," and "Somebody Loves Me" amidst frenzied cheers and shouts. She could barely be heard in the din, but it didn't matter; both the soldiers and Marilyn had the thrill of a lifetime. Afterward, she told Sidney Skolsky that she had felt neither the cold nor her usual stagefright while on stage. "I wasn't afraid, because I felt every person in that audience was my friend. . . For the first time in my life I had the feeling that the people were accepting me and liking me."

Upon her return to Tokyo, an exhilarated Marilyn recounted her experience to DiMaggio. "It was so wonderful, Joe," she gushed. "You never heard such cheering." "Yes, I have," he responded.

Determined to teach Marilyn a lesson, 20th Century Fox decided to replace Marilyn in *Pink*

Tights with Sheree North, who had recently created a sensation on Broadway in *Hazel Flagg*. Today, Sheree recalls: "I didn't realize the studio was using me to get Marilyn to get into line, since she'd gone on suspension and was in New York to study. I was much younger, highly publicized, and a platinum blonde. So they were using that to threaten poor Marilyn, which was a terrible thing to do. I was totally innocent about the whole thing. . . I certainly didn't feel in competition with Marilyn."

Sheree did her Fox screen test in Marilyn's wardrobe. "They told me those were the only costumes they had around that would fit, and I believed it." Then the studio widely publicized this fact. "My God, every newspaper in the world was there photographing it all. There I was in her costumes—what was poor Marilyn to think but that I was being used to threaten her? I brought it up to the studio and asked, 'are you using me to replace Marilyn? I can't do anything that Marilyn does.' And they said, 'no, no.' And of course, I believed it." "Sometimes, when she would sign autographs (a year later, while Monroe was studying with Lee Strasberg in New York), she would put my name on it!"

Pink Tights was finally cancelled, but several months later, when Marilyn made clear that she would not play a stripper opposite Grable in *How to Be Very, Very Popular*, the studio recast the comedy with Sheree. Her experience making the film was "miserable," and she resolved to quit until Fox officials persuaded her to reconsider. Sheree was also cast in *The Lieutenant Wore Skirts*, yet another film originally intended for Marilyn. When Sheree later met Marilyn after Monroe's return to Hollywood, "we never spoke about what had happened."

Sheree empathized with Marilyn's pill-popping, which would become a debilitating problem in subsequent years. "We were all on pills at the studio. When you started at the studio, you'd be on location, everything was strange and different, and you couldn't sleep. They had what they called a company doctor, who was really a nurse. You'd say, 'I can't sleep,' and he'd say, 'here, take these.' In those days, we didn't know things were bad for you—if a doctor said to take it, you knew it was good for you. The next day, he'd ask if the pills worked, and you'd say, 'they worked great, but I sure feel groggy this morning.' So he'd say, 'here, take these,' and they would be uppers. Everybody got hooked on them, and nobody knew the difference. It was a very easy thing to do."

In June 1954, Fox revised Marilyn's contract for a seven-year term, raising her pay to $100,000 per picture. The suspension was lifted when she agreed to do *There's No Business Like Show Business*, based on the promise that she could star in the film version of *The Seven-Year Itch*. Marilyn was not happy about having to appear in *Show Business*, a very conventional musical in which her role was not pivotal. Nevertheless, her scorching rendition of Irving Berlin's "Heat Wave" stole the picture.

Among Marilyn's major magazine appearances from 1952-54:

March 1952 *Modern Screen* ("Too Hot to Handle?," article with 1-page color shot); also Nov. 1952 issue (full-page color bikini pose and story, "I Want to Be Loved")

Apr. 7, 1952 *Life* (the all-time classic cover—shot by Philippe Halsman—of Marilyn at her sultriest in an off-the-shoulder white dress, leaning against a wall and smiling with eyes half-closed. 2-page story—"The Talk of Hollywood"—includes a small reproduction of her recently exposed calendar.)

June 3, 1952 *Look* (part cover, 3 pages on "Clash by Night")

June 16, 1952 *People Today* (playful cover in white bikini)

June 1952 *Redbook* (full-length article by Jim Henaghan, "So Far to Go Alone!," describing her as "Hollywood's loneliest girl" despite her new stardom)

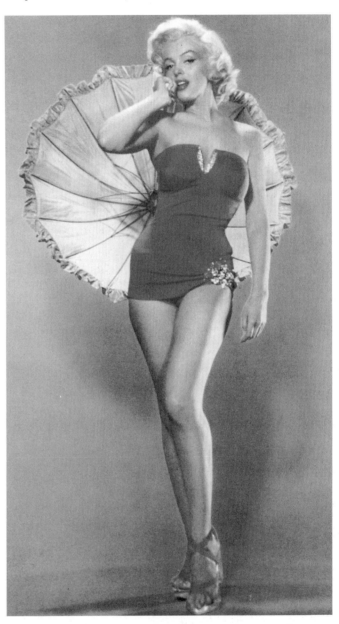

July 1952 *Movieland* (sexy cover in slinky blue dress); also Oct. 1952 issue (cover in yellow bikini)

Aug. 26, 1952 *Look* (5 pictures; "Marilyn Monroe Shows How to Walk" in her tight *Niagara* dress)

Aug. 1952 *Vue* (cover close-up in low-cut yellow top)

Sept. 9, 1952 *Look* (cover in cheerleader attire rooting for Georgia Tech)

Fall 1952 *Movie Pin-Ups* (4 pages, including fine 2-page cheesecake shot)

Nov. 16 & 23, 1952 *American Weekly* (2-part bylined article, "as told to" Liza Wilson, "The Truth About Me.")

Nov. 1952 *British Photoplay* (lovely cover reclining in bed)

Nov. 1952 *Scope* #1 ("Queen of Sex Appeal;" cover is a totally delightful c. 1946 swimsuit shot by Laszlo Willinger)

Dec. 1952 *Modern Screen* ("The True Life Story of Marilyn Monroe" by Jim Dougherty's sister Elyda Nelson, accompanied by a fine 2-page shot of MM lounging in bikini.)

Dec. 1952 *Movie Fan* (cover leaning forward in her devastating red *Niagara* dress, by Bernard)

1953 *Marilyn Monroe Pin-Ups* (full issue, with splendid cover in pink swimsuit)

1953 *Photoplay Pinups* (fine cover in short black negligee holding up mink coat, by John Florea)

1953 *Screen Annual* (cover in "Gentlemen Prefer Blondes" showgirl garb; same shot used for cover of Aug. 1953 *British Photoplay*)

1953 *Who's Who in Hollywood* (kissable cover pose)

Jan. 1953 *Movieland* (cover and 1 page); also March issue (5 full pages of cheesecake), April (thoroughly sultry cover in negligee plus story on her romance with DiMaggio), and October (cover in lingerie)

Jan. 1953 *3-D Hollywood Pin-Ups* (quite sexy swimsuit cover)

Jan. 23-29, 1953 *TV Guide* (beaming cover)

Feb. 1953 *Photoplay* (cover as part of a feature, "Is Hollywood Carrying Sex Too Far?")

Feb. 1953 *Screen Stars* (lovely cover)

March 1953 *Photoplay* ("Marilyn Monroe Was My Wife," full-length article by James Dougherty.)

March 1953 *Redbook* (cover as part of annual movie awards)

March 1953 *Show* (teasing cover as strap comes down on black nightgown)

Apr. 1953 *Films in Review* (cover; she later graced the magazine's cover in Oct. 1956, October 1960, and Feb. 1961)

May 1953 *Cosmopolitan* (cover in frilly black lingerie)

May 1953 *Cover Girls Models* (back cover, 7 swimsuit pictures)

May 25, 1953 *Life* ("Gentlemen Prefer Blondes" cover feature with Jane Russell.)

May 9, 1953 *Picturegoer* (classic sex-queen cover in black negligee; similar pose on cover of May 1953 *Cosmopolitan*)

July 1953 *Esquire* (8-page pictorial celebration and article by Bennett Cerf, 15 total pictures by de Dienes, including 2 pages of beach shots.)

July 1953 *Photo* (teasing cover in yellow bikini)

July 1953 *Picture Scope* (glamorous cover)

Aug. 1953 *Eye* (fine cover reclining in yellow bikini); also Sept. issue (8 pages shooting *How to Marry a Millionaire*)

Aug. 1953 *Picture Post* (British; wonderful *Blondes* shot of Marilyn with Jane Russell and Charles Coburn)

Aug. 31, 1953 *Tempo* (shares cover with DiMaggio)

Oct. 1953 *Modern Screen* (quite lovely bare-shouldered cover, by John Florea)

Oct. 1953 *Movie Stars Parade* (cover)

Oct. 1953 *Movie Time* (6-page photo feature)

Nov. 17, 1953 *Look* (thoroughly gorgeous, sultry cover portrait plus 2 pages, 11 total pictures by Milton Greene.)

Nov. 1953 *Modern Man* (cover swimsuit pose as seen on May 1950 Gala cover, and story by Andre de Dienes, "I Knew Her When")

Nov. 1953 *Motion Picture & Television* (cheesecake cover in yellow swimsuit)

Nov. 1953 *Screen Life* (cover in red swimsuit)

Dec. 1953 *Brief* (cover in black negligee)

Dec. 1953 *Movie Life* (classy cover in white dress)

Dec. 2, 1953 *People Today* (delightfully inviting cover)

Dec. 1953 *Photoplay* (classically sultry cover by John Florea; a 2-page "Marilyn Monroe Pin-Up Calendar" featuring a sensuous full-page lingerie-clad reclining pose; and a story on Marilyn and Joe.)

Dec. 1953 *Playboy* (First Issue, undated on the cover) (waving with an inviting smile on the cover—in a shot from her Miss America Grand Marshal parade,—Marilyn provides the launching pad for a publishing empire with her 1949 "Golden Dreams" nude—presented in color on a single page rather than in a centerfold, and billed as "Sweetheart of the Month" rather than as a Playmate.)

c. end 1953 *That Girl Marilyn!* (mini-digest devoted to Marilyn, with 60 photos and text for half the magazine written by Jane Russell)

Dec. 1953 *3-D Star Pin-Ups* (cover in red swimsuit)

1954 *Marilyn by Sidney Skolsky* (an 82-page magazine by Marilyn's favorite Hollywood columnist, giving her life story along with 100 photos.)

Movieland's 1954 Annual (classic cover in tight purple dress, by John Florea)

Jan. 1954 *TV Life* (cover in showgirl dress)

Feb. 1954 *Movieland* (seductive cover in low-cut black dress); also Nov. issue (cover)

March 1, 1954 *Life* (2 pages entertaining the troops in Korea)

March 1954 *Modern Screen* (gorgeous cover portrait and one fine leg-art shot inside)

March 1954 *Movie Stars Parade* (delightfully sexy cover)

March 1954 *Tempo* (cover in orange swimsuit)

Apr. 1954 *Picture Post* (British; cover in one of her most legendary poses clad in cut-down-to-navel gold dress)

June 1954 *Modern Screen* (sultry, sophisticated cover and story by Earl Wilson, "In Defense of Marilyn"); also Sept. 1954 issue (beaming cover portrait, 1-page color leg-art, and Sheilah Graham article)

May 1954 *Movie World* (fine swimsuit cover)

June 1954 *Movies* (elegant cover in red dress)

June 1954 *Pic* (cover in action singing for troops in Korea)

July 1954 *Modern Man* (2 pages and article by Emmeline Snively, "The Secrets of Marilyn's Life As a Model")

Aug. 1954 *Modern Photography* (cover in yellow bikini)

Aug. 1954 *Movie Life* (alluring cover beginning to pull down a strap of her swimsuit)

Aug. 1954 *Night & Day* (full cover in her low-cut red dress from *Niagara*)

Aug. 1954 *Photoplay* (wonderful 1-page color glamour shot and Sidney Skolsky story on Marilyn and Joe, one of several *Photoplay* features on her during the year)

Sept. 6, 1954 *Tempo* (alluring cover in red negligee)

Oct. 1954 *Art Photography* (cover in white negligee)

Oct. 1954 *Modern Screen* (very saucy cover clad in bathrobe, and article on her new life in New York)

Oct. 1954 *Picturegoer* (cover in classic *Seven-Year Itch* pose)

Nov. 1954 *See* (terrifically sultry cover in frilly showgirl dress)

Nov. 1954 *Screen Stars* (quite beautiful cover portrait)

Nov. 1954 *Screen Stories* (cover in largely see-through white showgirl dress from *There's No Business Like Show Business*)

Nov. 8, 1954 *Tempo* (seductive cover in low-cut red dress, by Bernard; nearly the same shot used for cover of Aug. 1955 *Tab*)

Dec. 1954 *British Photoplay* (cover in sexy green *Show Business* dress)

A Fabulous "Itch"

Ever since it had become a Broadway hit in 1952, *The Seven-Year Itch* seemed tailor-made for Marilyn. The original George Axelrod script was a comedy of adultery in

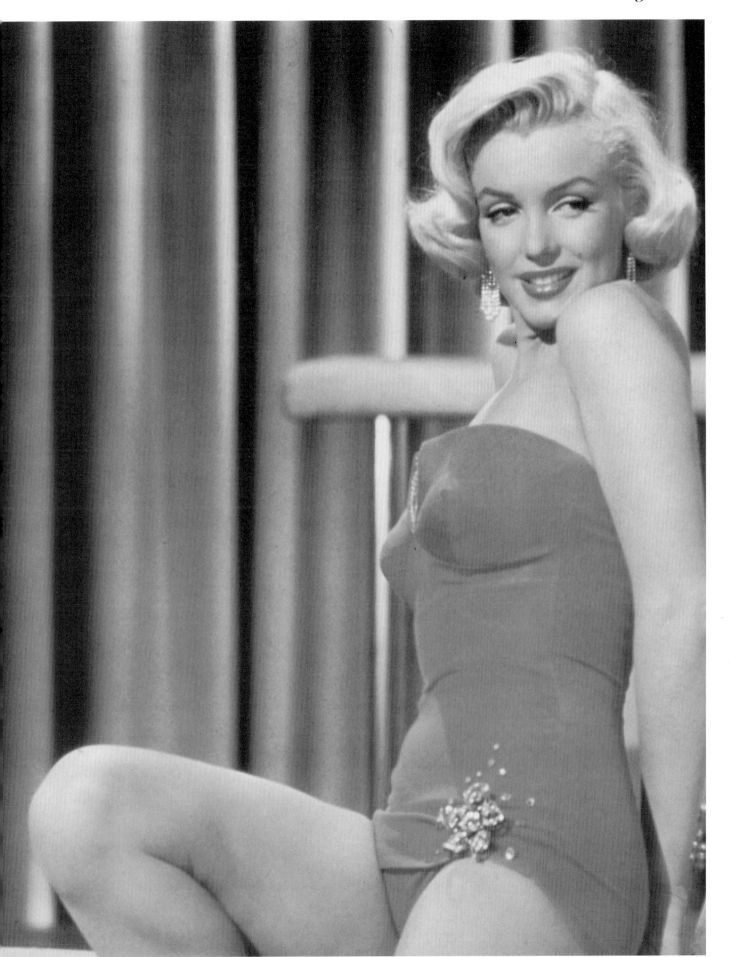

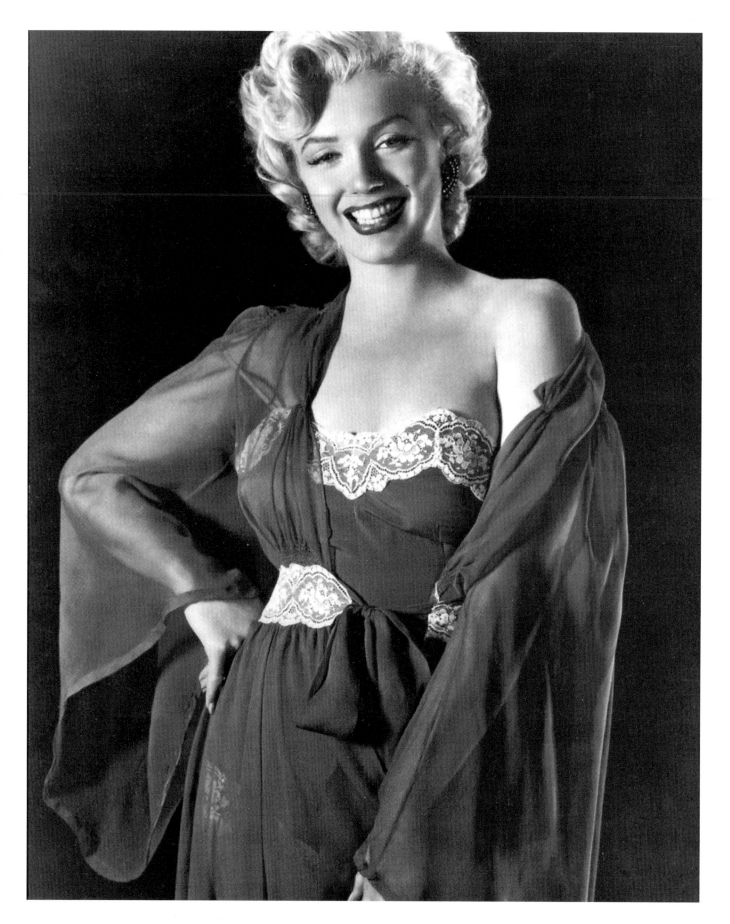

VaVaVoom!

which Tom Ewell's sexy neighbor seduces this middle-aged Everyman while his wife is away for the summer. The film, in deference to prevailing morality, transformed Ewell's acts into mere fantasies.

Marilyn's lack of inhibitions was demonstrated anew in an episode recalled by director Billy Wilder in Anthony Summers' *"Goddess: The Secret Lives of Marilyn Monroe."* For the scene in which Marilyn snuck down a back staircase to visit Tom Ewell, she was wearing a nightdress, "and I could see she was wearing a bra. 'People don't wear bras under nightclothes,' I told her, 'and they will notice your breasts simply because you are wearing one.' Marilyn replied 'what bra?' and put my hand on her breast. She was not wearing a bra. Her bosom was a miracle of shape, density, and an apparent lack of gravity."

The New York filming of the renowned skirt-blowing scene took place at 4 a.m. on Sept. 15, 1954. Over 90 photographers were snapping away during the 30-second sequence, in which the wind machine beneath the grate lifted up her skirt for at least 15 takes. (Because of street noise, the version of this scene used in the film was shot later on a sound stage.) Close to 2,000 onlookers cheered her on from behind police barricades with cries of "higher, Marilyn. . . higher!" Joe DiMaggio was watching with columnist Walter Winchell from the outskirts of the crowd, and Wilder noted the "look of death" on his face. Marilyn wore slightly transparent white silk panties, and photographer Frank Morse, who was shooting stills of the scene, recalled hearing one spectator shout out after one take, "Chees, I thought she was a real blonde." "DiMaggio hears it too, and this is his wife," said Morse. A seething DiMaggio quickly left.

Returning to the couple's hotel room later that morning, Marilyn found DiMaggio silently waiting for her; he exploded in anger. She tried to explain, "It was my job, Joe." He said he was returning to California the next day and stormed out of the apartment, slamming the door behind him. Their marriage had been troubled almost from the very outset; the events in New York simply hastened the inevitable end. On October 6, Marilyn and her attorney Jerry Giesler announced the couple's separation.

Maurice Zolotow relates that Marilyn was (again) often late on the set during this difficult time in her life, and had trouble remembering lines, but would generally nail them on the eighth or tenth take. The film ran three weeks late and cost $1.8 million due to Marilyn's delays, but Wilder was satisfied that her sensational performance made it all worthwhile. In 1956, Wilder would tell *Saturday Evening Post* reporter Pete Martin, "She has what I call flesh impact. It's very rare. Three I recall (who had it) are Clara Bow, Jean Harlow and Rita Hayworth. Such girls have flesh which photographs like flesh. You feel you can reach out and touch it."

Perhaps no other entertainer of the '50s felt a closer personal connection with Marilyn than stripper Dixie Evans, although they never met. Dixie, a rising star on the burlesque circuit, was persuaded by burly theater chain owner Harold Minsky in 1952 to do a takeoff on Marilyn following MM's emergence. Almost overnight, Dixie reached new heights of success as "the Marilyn Monroe of Burlesque,"

masterfully mimicking Marilyn's speech and mannerisms in slightly risqué adaptations of Monroe movie scenes. "I'm the exact same age as Marilyn, and she was at the height of her fame," Dixie recalls. "People couldn't see or talk to or touch her, but they could go down the street and see me!" The connection went a step further when Joe DiMaggio came to see her act in Miami in 1955, and went out with Dixie afterward.

In 1956, Monroe's lawyer, Irving Stein, wrote Dixie threatening to sue because her act was allegedly damaging the star. Eventually the suit was dropped, but not before Dixie had received still more valuable publicity. It did not diminish her admiration for the woman who had become central to her career. "I wasn't making fun of her, I was just trying to make a living in my own crazy way. I adored her, I cherished her. I hung onto Marilyn out of loyalty when these new girls came along like Bardot and Jayne Mansfield." Dixie says she felt a powerful bond with Marilyn, and sensed her loneliness. Sometimes, Dixie would see a picture that she thought was of Marilyn, only to discover that it was actually one of her own photos; their identities had virtually merged in her mind. "I had this strange feeling of being tied together, yet torn apart."

In late 1958, when Dixie learned that Marilyn had suffered another miscarriage, she sent a heartfelt letter wishing her a speedy recovery. Three weeks later she received a reply: "My dear, dear Dixie—Among all my many friends and acquaintances over the world, your telegram has been of the greatest comfort to me at this time." Dixie felt elated and honored. "I did want to meet her, throw my arms around her and hug her. But I didn't want her to think I was getting too familiar, so I didn't write back. I deeply regret that." As Marilyn's personal problems mounted in the next two years, Dixie finally decided to discontinue her Marilyn act. "I refused to impersonate a sick girl."

Marilyn's films during this period:

Niagara (Jan. 1953) — After an opening shot of the Falls, we see Marilyn (who was actually nude under the covers) lounging in her hotel bed. Shortly thereafter, when she walks to the store clad in a tight blue dress, we gawk for about 20 seconds as she does her derriere-swaying "horizontal walk" down the street. She is a young temptress bored with her older, emotionally troubled war veteran husband (played by Joseph Cotten). At an outdoor party that night, as Jean Peters watches Marilyn hit the dance floor in a spectacularly low-cut, clinging red satin dress ("cut down so low you can see her kneecaps!" declares an angry Cotten), she murmurs, "get out the fire hose!" Everyone stares as MM sways and sings to the music, setting out to inflame Cotten while plotting for her young lover to murder him. Cotten turns the tables, kills the man, and finally goes after her. This is the only film in which Marilyn played an evil, calculating character, and while it does not suit her style she is convincing—and utterly alluring.

Although the film's rentals were fairly modest at $2.3 million, its grosses of $6 million exceeded its cost almost five times over. Marilyn's box office magic was already being established.

Gentlemen Prefer Blondes (released June 1953) — The film gets off to a roaring start as Marilyn and Jane Russell

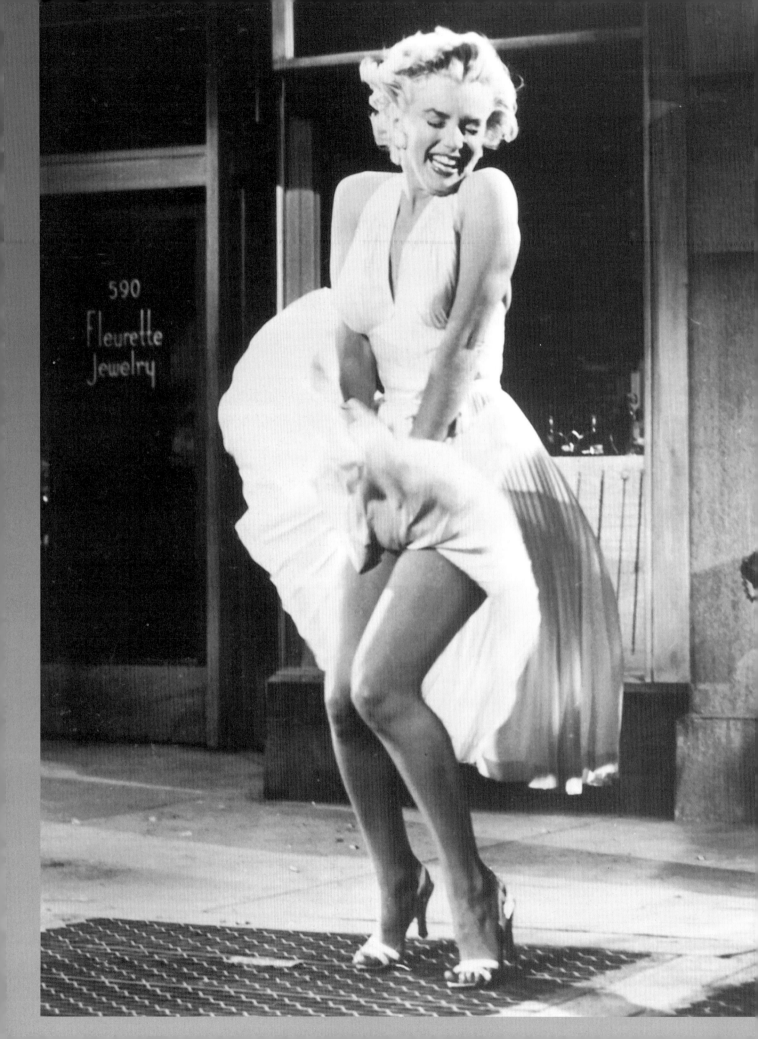

The Seven Year Itch *offered the Marilyn Monroe performance that perhaps lingered longest in male fantasies, as the sweet innocent with the bombshell body who seemed oblivious to the impact she had on every man who saw her. On September 14, 1954, Marilyn made pin-up history while filming on New York's Lexington Avenue as a wind machine lifted up her skirt in one of the era's most famous series of photos. Tom Ewell served as a perfect foil, as seen below in their "Chop Sticks" duet.*

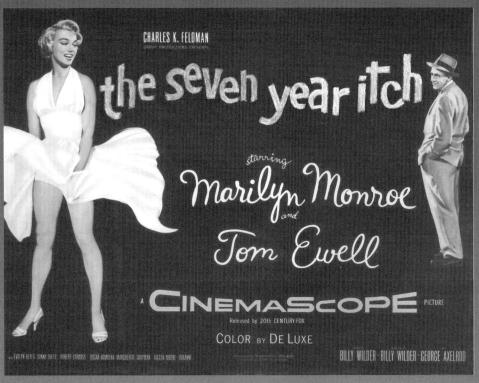

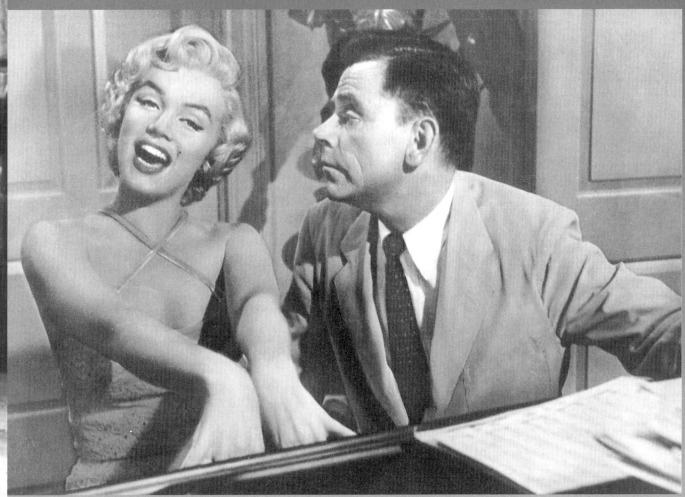

(in skintight red sequined dresses) sing "Two Little Girls from Little Rock" before the opening credits. "Bye Bye Baby" shows both girls in their element—Lorelei (Marilyn) singing intimately to her millionaire boyfriend, and Dorothy (Jane) performing while ogling the Olympic athletes on their cruise ship. The two loyal friends team up to save Lorelei from scandal. The duet "When Love Goes Wrong" demonstrates the warm camaraderie they share. "Diamonds Are a Girl's Best Friend" is a production number to top them all, with Marilyn in a stunning pink evening gown, winking, wiggling her torso and smiling dazzlingly as she cavorts with a legion of dapper gentlemen. Her character as a gold-digging sexpot may be one-dimensional, but MM as Lorelei generates such radiant charm that it's impossible to avoid smiling even on the 10th viewing. The film's rentals of $5.1 million placed it #9 for the year.

How to Marry a Millionaire (Nov. 1953) — Frothy little romantic comedy about three models (Marilyn, Betty Grable and Lauren Bacall) who decide to lure wealthy prospective husbands by teaming up to rent a luxurious New York penthouse apartment. It has not dated well, but Marilyn is a comic delight as a hopelessly myopic beauty who'd rather go through life bumping into walls than be seen in glasses by a potential mate—until fellow specs-wearer David Wayne persuades her otherwise. "I've never seen anyone in my whole life who looked less like an old maid," he assures her. The fourth biggest hit of 1953 with rentals of $7.3 million and grosses of $12 million.

River of No Return (April 1954) — Playing a saloon singer in this sluggish if picturesque Western drama opposite Robert Mitchum, Marilyn failed to truly register on screen for one of the few times in her career. Even though poorly received, the picture still fared reasonably well at the box office with $3.8 million.

There's No Business Like Show Business (Dec. 1954) — The pairing of MM and Donald O'Connor in this showbiz tale is laughable, but at least she gets to perform three good Irving Berlin numbers. In addition to the steam generated by Marilyn in "Heat Wave," in a strapless black bikini top and open skirt revealing black bikini panties, Berlin said her rendition of "After You Get What You Want, You Don't Want It" was definitive. A medium-level hit with rentals of $5 million.

The Seven-Year Itch (June 1955) — Marilyn as the ultimate male fantasy (simply known as "The Girl"), with Tom Ewell as the lucky dreamer. Ewell's first full meeting with his new summertime upstairs neighbor is utterly irresistible as the delectable model enthusiastically demonstrates her "Dazzledent" commercial, and launches into a playful piano duet of "Chopsticks;" when he begins to act out his fantasy by kissing her and they both topple over backward, she responds to his apology by sighing philosophically, "happens to me all the time." And of course, after he takes her to a monster movie on a sweltering night, Marilyn then cools herself unforgettably atop the subway grate. Despite all his fantasies, Marilyn is the picture of seductive innocence, except for the moment when she discovers a trap door allowing easy access between the two apartments, and notes, "we can do this all summer" with a suggestive arching of her eyebrow. While not a showcase for Monroe the actress, the picture is still a delicious guilty pleasure. The year's #12 hit with $6 million in rentals.

Exit to New York

Ever since her first meeting with celebrity photographer Milton Greene a few years earlier, Marilyn had discussed her concerns about the lack of control she had over her career. Other stars not only earned more money, she said, but were able to insist upon scripts that were suited to their talents and aspirations. Delightful (and commercially successful) as her performances had been in *Blondes*, *Millionaire*, and *Itch*, there was a certain sameness to the characters. Was she capable of something more? She was determined to find out.

At the end of 1954, she and Greene set into motion their plan to rectify the situation by creating Marilyn Monroe Productions. She made the announcement at a January 7, 1955 press conference in New York, declaring, "I am tired of the same old sex roles. I want to do better things." Thanks to a loophole found in her contract, she was able to achieve her long-sought independence from 20th Century Fox. "My fight with the studio is not about money," she said a few months later. "It is about human rights. I am tired of being known as the girl with the shape. I am going to show them I am capable of deeper acting."

Toward that end, she had moved to New York full time, and in March began studying at Lee Strasberg's renowned Actors Studio. Donald Spoto offered the view that Strasberg's emphasis on intensive self-exploration, while clearly helping to make her a better actress, proved "disastrous" for Marilyn, on a personal level, in other ways. Already plagued with feelings of inadequacy and troubled by her childhood, she may have been left less able to move on in her life, and even more dependent on others such as Straberg and her psychotherapists, by the process of obsessively reliving past traumas. A line in Marilyn's unfinished autobiography illustrates her fragility: "I knew I belonged to the public and to the world, not because I was talented or even beautiful, but because I had never belonged to anything or anyone else."

Her biographer, Maurice Zolotow, felt that "morbid introspection was feeding Marilyn's insanity." Her various psychoanalysts from 1955 onward "opened a Pandora's box of long-buried resentments and ancient injuries and Marilyn was unable to patiently 'work through' these. As these confusing events were brought to the surface, she felt pain and went immediately to her painkillers. More and more, her sense of herself and of other persons became blurred."

Julie Newmar, who studied at the Actors Studio during this period, recalls seeing Marilyn there, although the two women didn't meet. "Lee Strasberg was infatuated with her; he loved her talent." Julie confesses, "I'm not the Marilyn type. I didn't identify with her at all—I didn't come into the world with the problems that she had." Ironically, Julie

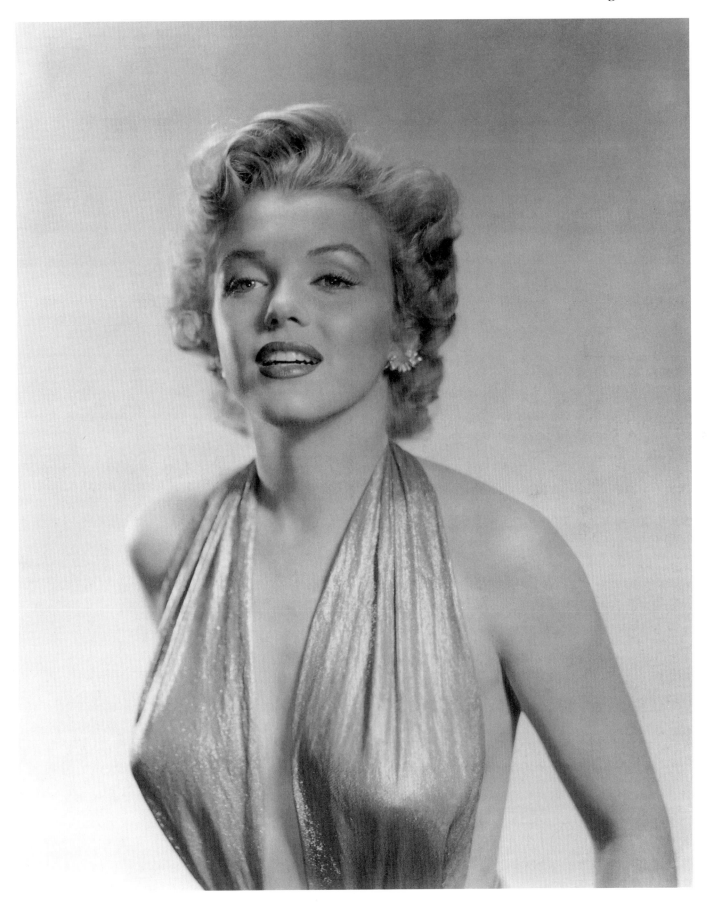

VaVaVoom!

today lives in the leafy Los Angeles suburb of Brentwood near the home in which Marilyn died.

Cindy Adams' book *Lee Strasberg, "The Imperfect Genius of The Actors Studio,"* detailed Marilyn's work with the legendary teacher. When Strasberg realized her emotional problems, he suggested working with Marilyn at his home. "Shrinking from special attention, she'd huddle quietly alone in a corner or in the last row trying hard not to be seen," Adams wrote. "The studio furnished an umbrella of protection and she was grateful for every kindness." Marilyn and Lee "were destined for one another. She lacked belief in her own selfhood. He made her feel talented and worthy. He was her mentor and teacher. He was her father/deliverer. . . With Lee she felt safe." Strasberg was utterly taken with this frightened creature's powerful aura; as he observed, "there was this great white light surrounding Marilyn."

Clad in baggy clothes and wearing a plain scarf on her hair, she'd walk around the area unnoticed. But everything changed immediately when "I felt like being Marilyn for a minute." "She had simply cranked up the charisma, the come-on, the light and there it was—the magnetism that was Marilyn Monroe." Gloria Steinem wrote in her book, *"Marilyn: Norma Jean,"* that in 1956 she (Steinem) went briefly to the Actors Studio. "I remember feeling protective toward this famous woman who was older and more experienced than I; a protectiveness explained by the endlessly vulnerable child who looked out of Marilyn's eyes."

On December 31, 1955, Marilyn Monroe Productions entered into a new contract with Fox under which she would make four films at $100,000 each and receive a $500 weekly allowance during production, a separate annual salary of $100,000, and the freedom to appear in pictures at other studios.

Part of Marilyn's new life in New York included attending Broadway shows. In October 1955, she attended the opening of George Axelrod's *Will Success Spoil Rock Hunter*, starring Jayne Mansfield in a thinly disguised parody of Marilyn, and Marilyn later made clear to the playwright that she was not amused. The following February (as described by James Haspiel in *"Marilyn: The Ultimate Look at the Legend"*) Marilyn attended the Broadway opening of the Paddy Chayevsky drama *Middle of the Night* (produced by Joshua Logan). Kim Novak also attended, "turning around to stare at Marilyn throughout the intermission. Marilyn was capable of inspiring awe, even in other sex symbols."

During 1954-55, 20th Century Fox had acquired the rights for William Inge's Broadway hit *Bus Stop*, holding it for Marilyn until their dispute was resolved. In mid-December 1955, the studio orchestrated a leak that it was considering Mansfield for the role of ambitious dance-hall floozie Cherie if it couldn't reach agreement with Monroe; today the thought of anyone other than Marilyn in the part is simply unimaginable.

Joshua Logan recalled in his book, *"Movie Stars, Real People, and Me,"* that when the studio asked him to direct Marilyn in *Bus Stop*, he was skeptical, believing she couldn't act. He thought again when Lee Strasberg told him that among all the hundreds of actors with whom he had ever worked, "there are only two that stand out way above the rest. Number one is Marlon Brando and the second is Marilyn Monroe." Upon meeting her, Logan was immediately convinced that Marilyn would be the perfect Cherie.

Logan called her "the most completely realized and authentic film actress since Garbo. Monroe is pure cinema. Watch her work. In any film. How rarely she has to use words. How much she does with her eyes, her lips, her slight, almost accidental gestures." Marilyn "was a totally satisfying professional during all the shooting in Phoenix," he declared in his memoirs. "She was always on time." Logan's recollection was kind; Zolotow writes that Marilyn's difficulty remembering lines often required 10 or more takes, although the results were invariably outstanding. "Her hillbilly accent was impeccable. It was as though she had been working on this character all of her life. . . I think she was at some kind of peak in her emotional as well as intellectual life."

Completing the film on the studio back lot and stages, Logan decided to have Marilyn perform "That Old Black Magic" live, instead of lip-synching the number as done in virtually every other movie musical number. "I knew Marilyn would fail if she had to resort to that mechanical way of reproducing the song." It was shot live with two cameras and a hidden orchestra. "Eventually we had a memorable musical sequence, primarily because we gave a great artist, a superb comedienne, the freedom to perform the way she felt."

Logan writes that Marilyn "played with feverish concentration." He soon realized that she would lose this concentration when there were interruptions, and that she instinctively "turned on" when the camera started rolling. "I invented a new technique for filming Marilyn. I would let Marilyn play a scene, and then without cutting, I would. . . turn her head to the position it was in when she started the scene, and I'd say, quietly, 'Action—go ahead.' All this time the film would be rolling. And by the third or fourth take I could cut together a magic scene."

When Logan decided to film the last big love scene in a giant close-up, Marilyn was giddy with excitement, and the result was one of the most indelible moments in the entire Monroe filmography. For the earlier scene in which Bo bursts into her room to rouse her for the rodeo, Marilyn insisted that she should be nude under the covers, as in *Niagara*, because it was a sexual scene, and Logan agreed.

Before *Bus Stop*, the prevailing female attitude toward the Monroe they saw on the screen and in cheesecake stills was one of either jealousy or loathing. The fragile, sensitive creature they saw in Cherie went a long way toward changing this attitude. Natalie Wood later remarked: "When you look at Marilyn on screen, you don't want anything bad to happen to her. You really care that she should be all right—happy." The film gave Marilyn the most glowing reviews of her career, and it remains a black mark on the motion picture academy that her remarkable performance was not nominated for an Oscar.

Marilyn, Miller and Olivier

Marilyn and Arthur Miller had first met in December 1950 when the playwright visited the set of *As Young As You Feel*, and saw her alone and crying after a take. Marilyn deeply admired the talent and character of the man who wrote *Death of a Salesman*, and would again fall under the spell of a slightly older man whom she viewed as a source of protection. Long anxious to expand her intellectual horizons, she also felt Miller could help her on this quest. They exchanged correspondence, and starting in mid-1955, were together at every opportunity. He was touched by the pain he saw in her. "You're the saddest girl I've ever met," Miller told her—a personal exchange (like so many others between them) that would be utilized in the script he intended as a gift to her.

On June 29, 1956, soon after Miller had waited out the Nevada residency requirement for his divorce, he and Marilyn were married in a New York civil service followed by a religious ceremony. The marriage took place just before the U.S. House of Representatives—still in the throes of Cold War fever—voted to cite Miller for contempt for refusing to name other writers who had attended Communist Party meetings a decade earlier. Miller's stance heightened Marilyn's admiration, which she boldly expressed publicly despite her studio's nervousness; the fight was later won when the contempt citation was dismissed in court. Almost immediately after the wedding, they left for London, where she would begin work on *The Prince and the Showgirl*.

The Sleeping Prince was originated in London in 1953 with Laurence Olivier and his wife Vivien Leigh. Marilyn and Milton Greene saw it as an ideal vehicle for their first independent production. The pairing of seeming opposites—the century's most acclaimed Shakespearian actor and director with Hollywood's foremost sex symbol—was so unlikely that it seemed irresistible. The alliance proved to be a miscalculation, particularly the decision to hire Olivier as director as well as co-star.

Olivier was disdainful of Lee and Paula Strasberg and "The Method," ensuring a certain tension from the very outset. "I refused to treat Marilyn as a special case—I had too much pride in my trade—and would at all times treat her as a grown-up artist of merit, which in a sense she was," he declared in his 1982 memoir, "*Confessions Of an Actor.*" "Her manner to me got steadily ruder and more insolent," constantly turning to Paula, who had replaced Natasha Lytess, for coaching or encouragement. "A very short way into the filming, my humiliation had reached depths I would not have believed possible." Despite all the ill feelings the experience had left, he realized, when he saw the film 25 years later, that "Marilyn was quite wonderful, the best of all."

By most accounts, Olivier entirely lost Marilyn's trust when, in setting up the first scene, he directed his leading lady, "All you have to do is be sexy, dear Marilyn." From that point onward, she saw his attitude as one of condescension, and she felt Miller offered little if any support. Nevertheless, she is at her loveliest in the film and gave a delightful performance under difficult circumstances.

After completing work on *Prince*, Marilyn settled into a period of quiet domesticity with Miller at their cottage in Long Island, and, later, in a new country home in Connecticut. In a move encouraged

Beware of Danger
JULY 4th.

by her husband, she took over full control of her production company by pressuring a reluctant and bitter Milton Greene to sell his stock in the company. While continuing to work with Lee Strasberg, she showed little interest in new film projects. A primary reason for this inactivity was impending motherhood, an event she had long anticipated. On August 1, 1957, Marilyn was rushed to the hospital after collapsing in pain and the six-week pregnancy, which was tubular, was terminated.

During the next several months, she was twice saved from barbiturate overdoses, which Miller and friends feared were despairing suicide attempts. Each time, Marilyn's spiritual resilience led her to rally; she seemed to have an infinite capacity to plunge into terrifying emotional depths, and climb back with renewed energy. For all the love and care Miller lavished upon her, however, the darkness continued to beckon. Marilyn often exchanged original poems with her friend, poet/playwright Norman Rosten, and she sent him this fragment, written in 1958, which was published after her death:

Help Help
Help I feel life coming closer
When all I want is to die.

A sampling of Marilyn's key magazine appearances from 1955-58:

1955 *Inside Hollywood Annual* (sultry cover)
1955 *Modern Screen Pin-Ups* (fine lingerie cover)
1955 *Movieland Pin-Ups* #1 (2 pages, 4 pictures, including superb full-page color pose)
1955 *Pin-Ups Past & Present* (cover, 5 pages, 19 cheesecake pictures)
1955 *Screen Annual Pin-Ups* (classic cover in short black nightie, and 1 inside pin-up)
Jan. 1955 *Focus* (excellent leg-art cover in short black nightie)
Feb. 1955 *National Police Gazette* (cover in *Seven-Year Itch* skirt-blowing pose)
March 1955 *Modern Man* ("I Photographed Marilyn Monroe In the Nude!" cover and 6-page feature by Tom Kelley relating the story of the historic session, although it oddly doesn't include any nudes); reprised in *Modern Man Annual* #5 1956.
March 1955 *Rave* (4 pages and full article)
May 30, 1955 *Life* (feature on *The Seven-Year Itch*)
June 1955 *Modern Screen* (very sultry cover portrait and story by Earl Wilson, "In Defense of Marilyn"); also Oct. 1955 issue (seductive cover)
June 1955 and Dec. 1955 *Movieland* (covers)
June 4, 1955 *Picture Week* (cover riding the pink elephant at Mike Todd circus benefit)
July 1955 *Behind the Scene* (sexy cover feature)
July 1955 *British Photoplay* (quite sensational cover as she pulls down the straps of black swimsuit)
July 1955 *Redbook* (cover story)
July 1955 *See* (cover in black swimsuit)
Aug. 1955 *Tab* (brassy cover in *Niagara* red dress, by Bernard)
Sept. 1955 *Movie Stars Parade* (teasing cover)
Sept. 1955 *Playboy* (cover and one page riding the pink elephant)
Nov. 1955 *Movie Show* (cover)
Nov. 1955 *Tempo* (leggy, seductive cover); also Dec. issue (outstanding leg-art cover)
Dec. 1955 *Filmland* (cover)

Dec. 1955 *Rogue* ("A New Aspect of Marilyn Monroe" 5 pages, 6 sexy pictures by de Dienes)
Feb. 1956 *Movie Stars Parade* (cover)
March 1956 *National Police Gazette* (cover feature on her "Secret Life")
April 1956 *Esquire* (4 pages of photos by Eve Arnold; Arnold would later shoot some renowned semi-nudes of Marilyn in October 1960)
May 1956 *Look* (cover and color feature by Milton Greene)
May 5, May 12, and May 19, 1956 *Saturday Evening Post*: ("The New Marilyn Monroe" 3-part series by Pete Martin)
May 14, 1956 *Time* (cover feature on her career up to *Bus Stop.*)
June 1956 *Man to Man* (cover, slightly more radiant variation on Aug. 1954 *Night & Day* cover in her *Niagara* red dress)
June 1956 *Modern Man* (cover in dress almost ready to slip off, and 2 pages)
June 5, 1956 *Picture Week* (cover)
July 1956 *Elle* (cover by Milton Greene)
July 1956 *Screen Stars* (radiant cover)
Aug. 27, 1956 *Life* (feature on *Bus Stop*)
Aug. 1956 *British Photoplay* (elegant cover)
Oct. 1956 Photoplay (cover shots from *Bus Stop* and feature, "The Story of a Legend That Became a Woman")
Nov. 1956 *Modern Screen* (cover story on marriage to Arthur Miller)
Dec. 1956 *Escapade* and *Escapade's Best* 1957 (double-exposure centerfold from her Tom Kelley calendar session, with an image of a nude Marilyn lying flat on her back superimposed on a pose similar to the famous "Golden Dreams")
Dec. 1956 *Tab* (cover in yellow bikini)
Feb. 1957 *She* (13 pages, 21 pictures as part of "Battle of the Blondes")
April 1957 *Movieland* (first-rate cover portrait)
June 3, 1957 *Life* (color layout on *The Prince and the Showgirl*)
July 1957 *Screen Stories* (cover feature on *The Prince and the Showgirl*)
Oct. 1, 1957 *Look* ("Marilyn's New Life" 6 pages of Marilyn in New York)
Fall 1958 *Sunbathing Review* (cover, vintage portrait by de Dienes)
Dec. 22, 1958 *Life* (Marilyn portrays Jean Harlow in tight white nightgown—Marlene Dietrich—in leggy *Blue Angel* attire, Clara Bow—in full '20s flapper mode,—Theda Bara—looking every inch the man-eating "vamp"—and Lillian Russell—astride a bicycle in low-cut showgirl outfit—for photographer Richard Avedon.)

"Hot" Times

In the spring of 1958, after two years away, Marilyn made her return to Hollywood when Billy Wilder sent her the outline of the screenplay he was writing with I.A.L. Diamond, *Some Like It Hot*. In one sense, the role of Sugar Kane was a throwback to the simple sexpots she'd hoped to leave behind; but with Wilder's direction and Tony Curtis and Jack Lemmon as co-stars, she realized it was at least an opportunity for a commercial hit. It proved to be considerably more.

Wilder had been disdainful of Marilyn's studies in New York when interviewed by Zolotow in 1956. "They're trying to elevate Marilyn to a level where she can't exist. She will lose her audience. She is a calendar girl with warmth, with charm. . . Marilyn's whole success is that she can't act. She's going through a bad evolution. If she takes it seriously, it is

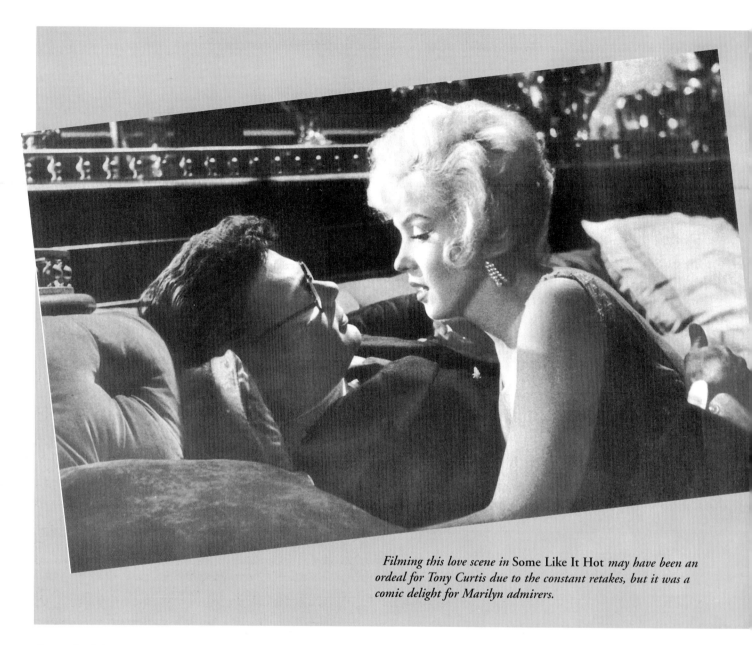

Filming this love scene in **Some Like It Hot** *may have been an ordeal for Tony Curtis due to the constant retakes, but it was a comic delight for Marilyn admirers.*

the end of Monroe." After completing *Some Like It Hot*, Wilder admitted he had been wrong, but still had misgivings. "She has become a better actress, a deeper actress, since Strasberg. . . I'm still not convinced she needed training. God gave her everything. The first day a photographer took a picture of her, she was a genius."

Wilder was baffled at her constant lateness. Zolotow wrote sympathetically in his biography of the director: "How was Wilder to know her inner torments?. . . How was he to know that she lived with a powerful fear inside her guts—a fear of people, a fear of work, a fear of living, a fear of involvement, a fear of intimacy—while also needing love and acting and friendship?" As a result of her growing isolation and feelings of inadequacy during the filming, she was taking ever larger amounts of barbiturates for sleep.

The director saw that Curtis was at his best on the early takes and—especially in high heels and padded cos-

tumes—would begin to weaken thereafter just as Marilyn was warming up. Wilder acknowledged that he had to go with her best takes, "even if other actors suffer, because when Monroe is on the screen the audience cannot keep their eyes off her." The director later declared, "I've never met anyone as utterly mean as Marilyn Monroe. Nor as utterly fabulous on the screen, and that includes Garbo." Curtis wrote in his autobiography that the filming was going smoothly until midway through the production, "when she just lost all control—too much alcohol or pills or too much I don't know what. Emotionally, she was devastated. . . She was truly incapable of memorizing the simplest lines."

One scene in which Marilyn had only one line required 48 takes. "When she got those eight words out, you can bet your ass it was printed," recalled Lemmon. On the other hand, one of her longest scenes, in the train berth with Lemmon and the other "girls" piled inside, required only a

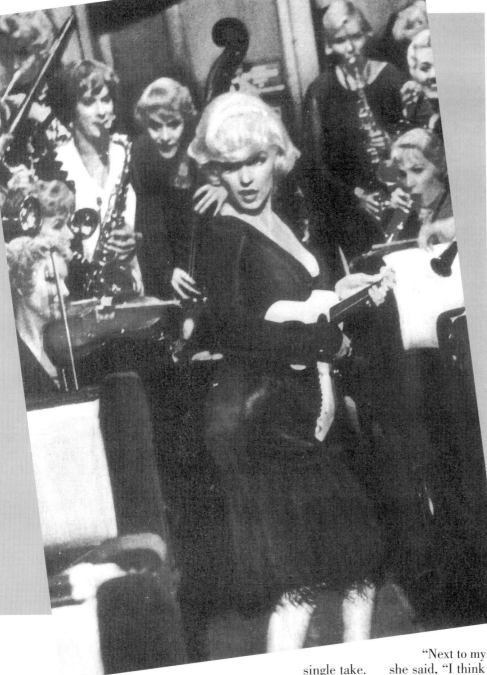

miscarriage on December 16, after which she was wracked with guilt from the possibility that her pill-taking may have been the cause. Miller initially blamed Wilder for the miscarriage, suggesting that he had overworked Marilyn. Wilder responded by telegram that if Miller had been the director and "subjected to all the indignities I was, you would have thrown her out on her can, thermos bottle and all, to avoid a nervous breakdown. I did the braver thing. I had a nervous breakdown." Wilder finally offered an apology, and a few months later said he would even be willing to direct Marilyn again.

All the acrimony was quickly set aside, if not forgotten, when *Some Like It Hot* was acclaimed by critics as one of the greatest film comedies of all time, and embraced by audiences as a smash hit—the biggest of Marilyn's career. It was also her most profitable by far, because she was guaranteed eventual payment of $100,000 plus 10 percent of the picture's gross proceeds.

After several months back in her New York routine, including work at the Actors Studio and private classes with Lee Strasberg, Marilyn accepted a new film project with director George Cukor that would become *Let's Make Love*. Gregory Peck bowed out as the male lead when he saw the role diminished, and after other stars passed on the part, Cukor suggested French actor/singer Yves Montand, whom Miller knew well as the star of the French production of Miller's play *The Crucible*. Marilyn's enthusiasm was even more palpable. "Next to my husband and along with Marlon Brando," she said, "I think Yves Montand is the most attractive man I've ever met."

During the shooting of the film, the already frayed Miller-Monroe marriage approached the breaking point. Marilyn and Montand were often seen holding hands on the set; her ardent pursuit led to a fiery but short-lived affair while Miller and Montand's wife, actress Simone Signoret, were away. *Let's Make Love* proved a disappointment in all respects; the fact that Marilyn was overweight, affected by her increasing use of barbiturates, and frequently at odds with Cukor didn't help matters. Once again, however, she created indelible moments of magic, most notably with a performance of "My Heart Belongs to Daddy" that threatened to extinguish memories of Mary Martin's trademark rendition.

single take.

Curtis' crack that kissing Marilyn was "like kissing Hitler" was uttered while the cast and crew (minus Marilyn) were watching rushes. Of course, when she learned of the remark, Marilyn's paranoia deepened.

The picture was completed on November 6, 1958; it took six extra weeks to shoot and went over budget by as much as $500,000. The total production cost was $2.8 million, then very high for a comedy. Wilder told journalist Joe Hyams after the film was completed: "I'm the only director who made two pictures with Monroe. It behooves the Screen Directors Guild to award me a Purple Heart."

Wilder and Arthur Miller had been at odds over Marilyn's behavior, and publication of the Hyams article triggered a war of telegrams. Marilyn suffered her second

Significant Monroe magazine appearances from 1959-62 included:

March 1959 *Cosmopolitan* (cover feature on *Some Like It Hot*)

Apr. 20, 1959 *Life* (classical cover portrait by Richard Avedon, and 4-page feature on *Some Like It Hot*)

Nov. 9, 1959 *Life* (cover as she jumps exuberantly for photographer Philippe Halsman)

July 5, 1960 *Look* (cover feature on Marilyn and Yves Montand in *Let's Make Love*)

Aug. 15, 1960 *Life* (cover of Marilyn being nuzzled by Montand, with feature on *Let's Make Love*)

Dec. 1960 and Oct. 1961 *Modern Screen* (cover stories)

Dec. 1960 *Playboy* ("The Magnificent Marilyn," a 4-page, 14-photo tribute, including a double exposure nude from the Tom Kelley session when the photographer neglected to change film between poses, a delightful semi-nude from the same period, and a leggy breakfast-in-bed shot by Andre de Dienes.)

1961 *Modern Man Yearbook of Queens* (3 pages, 6 pictures)

Jan. 13, 1961 *Life* (4-page feature on *The Misfits* with Clark Gable on cover)

Jan. 31, 1961 *Look* (Marilyn and Gable in a cover feature on *The Misfits*, mainly devoted to Gable)

July 1961 *Modern Man* (3 pages plus story, "Battle of the Blondes" with Marilyn and Jayne Mansfield interviewed separately)

Oct. 1961 *Sir Knight* Vol. 2-10 (inside cover, 3 pages and article, "The Revolt of Marilyn Monroe")

June 22, 1962 *Life* (cover in blue bath towel, and 5 pages—3 color—on her skinny-dip for *Something's Got to Give.*)

Aug. 3, 1962 *Life* (her final interview, by Richard Meryman.)

Aug. 17, 1962 *Life* ("Memories of Marilyn," with a lovely July '62 portrait by Lawrence Schiller gracing the cover and 9 pages of classic photos.)

Oct. 1962 *Films In Review* (career retrospective by Robert Roman)

Marilyn's Life Story (48-page magazine tribute published shortly after her death.)

Dec. 1962 *Silver Screen* (cover, 7 pages of photos, and two articles on memories of Marilyn.)

"The Misfits"

Ever since 1957, when it was suggested that he adapt his short story, *The Misfits*, into a screenplay, Miller had envisioned it as his special gift to Marilyn: a film role that would capture her essential qualities, particularly her reverence for life, and provide her with an acting challenge worthy of her abilities. Work on the script dragged interminably even as the Millers' marriage decayed. After six months of work on *Let's Make Love*, an exhausted Monroe had to begin work on the new project with barely a break. Nevertheless, anticipation ran high for a film teaming Marilyn with Clark Gable, the man once envisioned as a fantasy father by a young Norma Jeane; and a stellar supporting cast including Montgomery Clift and director John Huston, who had helped launch her in *The Asphalt Jungle*. Producer Frank Taylor told *Time*: "This is an attempt at the ultimate motion picture." Each actor in the cast, he declared, "is the person they play."

It became such a nightmarish experience—due, partly to a Miller script drawn so blatantly from the splintering couple's real-life conversations, and filtered through the bitterness Miller now felt—that acting out the scenes was acutely painful for Marilyn. Through unending rewrites and the brutal physical demands of shooting in the Nevada summer, her physical and mental health underwent more severe strain than ever before.

Jane Ellen Wayne writes in *"Clark Gable: Portrait of a Misfit"* that Marilyn "was terrified at the thought of working with" the legendary star. The night before her first scene with Gable, she gulped down so many Nembutals to sleep that it took two hours to rouse her from bed (a ritual that would be repeated throughout the production). Then, after taking some uppers, "she still couldn't face Gable, knowing she was two hours late. . . Shaking, nauseous and weak, Monroe reported to work with an entourage of 14. She took one look at Gable and rushed to the honey wagon to throw up." She finally faced her idol and apologized for being late. "You're not late, honey," he said, smiling and putting his arm around her, whispering in her ear. He talked to her softly, and she giggled. "I was in heaven," she told Clift afterward. "He told me I was worth the wait. . . I loved him at first sight. I adore him."

According to Wayne, Gable playfully flirted with Marilyn, but he had no intention of being unfaithful to his wife, Kay. She was excited by their bedroom scene when he kisses her good morning. "I was so thrilled when his lips touched mine. I wanted to do it over and over," she sighed to her staff. "Then the sheets dropped and he put his hand on my breast. It was an accident, but I got goosebumps all over. Everything he did made me shiver. That night I didn't need a sleeping pill, but I dreamed of seducing him." Because it was entirely appropriate for the character of Roslyn, both she and Huston wanted the take used with her breast momentarily exposed, but due to censorship concerns it was clipped from the final film.

For all the problems on the set, Gable was an unabashed Monroe admirer. "I think she's something different to each man, blending somehow the things he seems to require most. . . Marilyn is a kind of ultimate, in her way, with a million sides to her. She is uniquely feminine. . . from the way she talks to the way she uses that magnificent torso. She makes a man proud to be a man."

In his memoir *"An Open Book,"* Huston wrote that Gable never uttered a word of complaint about Marilyn's tardiness (nor about delays caused by Huston's drinking and late-night gambling). Marilyn was obsessed with the need to get enough sleep so that she would look her best, leading to a constant increase in pill-taking. "She seemed to be in a daze half the time. When she was herself, though, she could be marvelously effective. She wasn't acting—I mean she was not pretending to feel an emotion. It was the real thing. She would go deep down within herself and find it and bring it up into consciousness."

Huston and others have asserted that she suffered a breakdown on August 26, 1960, which forced the picture to close down for two weeks. In fact, production had been temporarily shut down while the director scrambled for cash to cover his nightly gambling debts, and Marilyn took advantage

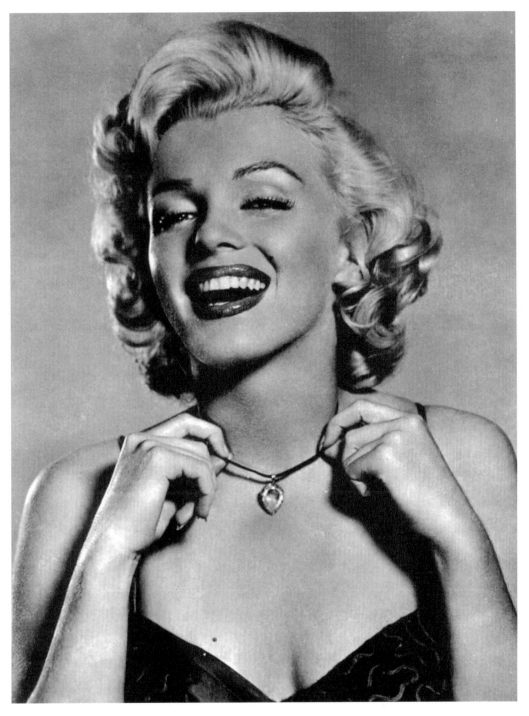

months after his death, his wife Kay said, "It wasn't the physical exertion that did it. It was the horrible tension, that eternal waiting, waiting, waiting. . . He'd get so angry waiting that he'd just go ahead and do anything to keep occupied. That's why he did those awful horse scenes where they dragged him behind a truck." Marilyn was crushed when people interpreted this comment to mean that her tardiness had contributed to the death of her idol.

She locked herself in her apartment, pulled down the shades and stayed alone for days in grief, and told friends she had considered suicide. On February 5, her psychoanalyst had her admitted to the Payne Whitney Clinic, the psychiatric division of the New York Hospital, where—in a terrible miscalculation—she was placed in a locked and padded room. Terrified by the possibility that her worst nightmare was coming true, Marilyn was able to get out a few days later through the intervention of Joe DiMaggio, and rested until early March in a private hospital room. John Clark Gable was born in March, and Marilyn was delighted when Kay invited her to the christening and told her, "Clark never said an unkind word about you." Huston wrote: "It was as though a tide had turned in her life, and was now beginning to run out."

of the break to return to Los Angeles for a badly needed rest at a private hospital; but she was to receive all the public blame for the delays. When she returned, the tardiness continued but Gable remained encouraging, even saying he'd like to do another picture with her. At the end of shooting, Gable congratulated producer Frank Taylor. "I now have two things to be proud of in my career, *Gone With the Wind* and this."

The Misfits had a total cost of $3.95 million, the most expensive black and white film ever made at the time. On November 5, one day after the completion of shooting, Clark Gable suffered a heart attack and died 12 days later. Three

Marilyn's latter-day filmography:

Bus Stop (released August 1956) — Marilyn is Cherie, an enchanting but painfully untalented "chantoosie" at a Phoenix saloon who "just wants to be somebody." Brawny young cowpoke Bo, an innocent in the ways of women, is in town looking for an "angel," and is astonished when he sees Cherie's wonderfully awful rendition of "That Old Black Magic" in a sequined gown with tattered fishnet stockings. She's charmed when he forces the rowdy customers to respectfully listen, but horrified at his intention to carry her off like

one of his roped calves into marriage. Her frightened effort to escape by bus fails, but after the bus riders are snowed in at a diner Bo finally sees reality. Cherie admits, "I ain't the girl you thought I was" and that he's better off without her, and they share their first serious kiss. When the awed bronc-buster tells her, "I like ya just the way ya are," she murmurs tearfully, "that's the sweetest thing anyone's ever said to me." Her lovely face filling the screen with a look of longing, Cherie declares, "I'd go anywhere in the world with you now." Marilyn's finest hour as an actress. The film was the year's #15 hit with rentals of $4.25 million.

The Prince and the Showgirl (May 1957) — Set in London in 1911, it's the tale of a pompous European grand duke's (Laurence Olivier) effort to seduce an American showgirl, and how their relationship shifts when she turns out to be shrewder than expected. A slow-moving romantic comedy, but Marilyn is at her very loveliest and has some fine comic moments, such as when she turns the tables on Olivier and becomes the seductress. It was Marilyn's least successful film at the box office since her star breakthrough, with puny rentals of $1.5 million; co-released by Marilyn Monroe Productions and Warner Brothers.

Some Like It Hot (Feb. 1959) — It would have been a hysterical comedy just on the strength of Tony Curtis, Jack Lemmon, and the Wilder-Diamond script about two Prohibition-era musicians who go into drag to escape gangsters. The magical presence of Marilyn—as Sugar Kane, a gorgeous singer who always gets "the fuzzy end of the lollipop"—carried the film up one more level to transcendent classic status. Who could possibly resist her intimate "girl talk" with Curtis and Lemmon, her energetic efforts to seduce Curtis in his millionaire guise, or her cooing rendition of "I Wanna Be Loved By You"? The very real vulnerability Marilyn provided made her characterization endearing as well as a comic delight.

The biggest smash of Marilyn's career, its $8.1 million in rentals (and grosses exceeding $15 million) placing it #3 for the year. Marilyn won the Golden Globe award as Best Actress in a Comedy or Musical. It was her first of two films for United Artists (along with *The Misfits*).

Let's Make Love (Aug. 1960) — The combination of a generally unfunny script and Yves Montand's uncomfortable performance make this film very slow going, except for MM's wonderful "My Heart Belongs to Daddy." However, even second-rate Monroe found an audience, with total rentals of $3 million; only three 20th Century Fox films did better this year.

The Misfits (Jan. 1961) — Marilyn is former "interpretive dancer" Roslyn, who is in Reno for a divorce; not certain what to do with her life, she agrees to stay on when wooed by Clark Gable as rugged cowboy Gay. It's difficult to know where to draw the line between Marilyn and Roslyn, a woman who enchants every man she meets but whose desperate emotional fragility, insecurity, and the foggy haze which seems to envelop her makes it difficult for her to accept happiness or to find peace. Like everyone else Roslyn encounters, Gay too has lost his way, a proud cowboy who has been reduced to capturing horses to be used for dog food. Venturing into the mountains with Gay and his friends, she is horrified to learn the purpose of the trip. After a furious struggle to capture the mustangs, Gay finally releases them to Roslyn's relief, deciding that "I've just gotta find another way to be alive." As he drives away with Roslyn in the final scene, she asks how he finds his way back in the dark. "Just head for that big star straight on. The highway's under it. It'll take us right home."

A slow-moving drama in which dialogue too often takes the place of an actual story, "The Misfits" is nonetheless often quite moving; Marilyn is convincing, although certainly not at her best. The film was the #20 hit of the year with rentals of $3.9 million.

The Final Act

On January 20, 1961—deliberately selecting the day of President Kennedy's inauguration to avoid publicity—Marilyn flew to Mexico to secure her divorce from Arthur Miller. Soon afterward, she remarked: "I'm going to be myself from now on. Never will I let any man make me over again into the kind of person he wants me to be. This has happened three times now, and it has brought me unhappiness and failure in my marriages."

According to both Summers and Sinatra biographer Don Dwiggins, Marilyn was enthralled with the singer, and in 1961, six years after their initial flirtation, the relationship became more serious. Sinatra wanted her to star with him in a musical remake of *Born Yesterday* for his own company. Marilyn had no intention of marrying again, however, and continued to see DiMaggio on a frequent basis; Joe was by her side when she had surgery in late June due to an acutely inflamed gallbladder.

Restless to return to work, she planned to star in a fall 1961 television production of Somerset Maugham's *Rain* in the role of Sadie Thompson, but NBC finally shelved the project. Ready to open a new chapter in her life, Marilyn moved back to Los Angeles in August, and in January 1962 purchased a modest but comfortably secluded home in suburban Los Angeles near Santa Monica.

Stella Stevens—who began her career as one of the most notable blonde starlets labeled as 'the next Marilyn'—had only one contact with the icon. "The only time I ever saw her, she was drunk," Stella remembers. "She was at a party, and was being helped to a table because she was tipsy. She was drinking champagne with a Mexican man, and was wearing a very revealing purple sequined gown cut out over the cleavage." This may have been the Hollywood Foreign Press Association awards dinner on March 2, at which Marilyn was honored as "the world's favorite female star." Monroe attended the event with her Mexican friend Jose Bolanos, and behaved erratically due to a combination of alcohol and barbiturates. By this time, Marilyn's reliance on drugs supplied by her doctor and her psychoanalyst had reached alarming proportions.

Owing 20th Century Fox another picture under her contract, Marilyn agreed to star in a romantic comedy remake of the 1940 Cary Grant film *My Favorite Wife*, retitled *Something's Got to Give*. She had misgivings from the outset about its incomplete script, but despite the fact that at $100,000 she was earning only one-third the amount paid to both her co-star Dean Martin and director George Cukor, she was determined to make the best of yet another bad situation. Shooting began on April 23, but Marilyn's fragile health—colds, a sinus infection, throat problems, severe headaches, and her ever-present insomnia—caused continual delays.

Peter Harry Brown and Patte Barham in "*Marilyn: The Last Take*" document the desperate financial straits in which

Fox found itself in 1962, due largely to the catastrophic delays and cost overruns on the Elizabeth Taylor-Richard Burton epic *Cleopatra*. By that spring, production had shut down on every other Fox film but the Taylor and Monroe projects, and officials were desperately economizing and selling assets in order to stay afloat. As a result, the studio was anxious to recoup at least part of its losses through Marilyn's demonstrated box office appeal, but would not tolerate another costly fiasco.

Something's Got to Give producer Henry Weinstein recalled that a fearful Marilyn often stopped at the studio gate and threw up before she was able to enter a sound stage; she had been known to do this before performances as far back as 1949, but it happened more frequently than ever during her final two films. "Very few people experience terror," remarked Weinstein. "We all experience anxiety, unhappiness, heartbreaks, but that was sheer primal terror."

Despite her physical and emotional maladies and the film's script problems, the surviving footage demonstrates that Marilyn performed some of the most delightful—and most moving—scenes of her career during this misbegotten project. She played a woman returning home after being shipwrecked on an island to find that her husband, presuming she was dead, has remarried and that her young children barely remember her. Watching (in the one-hour Fox documentary of the same name) the scene in which Marilyn sees her children for the first time in five years demonstrates just how far she had advanced as an actress of emotional depth; as the close-up shows the mixture of love, pride and longing in her eyes, no viewer can be left untouched. Had it been completed, the evidence suggests that while *Something's Got to Give* may have been a mediocre movie, it would have provided a strong showcase for a maturing Marilyn moving into a new phase of her career.

Marilyn had received studio permission weeks earlier to participate in the May 19 birthday gala for President Kennedy at Madison Square Garden, but during the week before the event an edict went down that she could not go due to the delays on the picture. An hour after she left on May 17, Fox attorneys filed a breach-of-contract notice against their star. Outraged but determined not to back down, she poured herself, on the evening of the 19th, into a stunning flesh-colored body stocking studded with sequins. After being introduced by Peter Lawford in reference to her legendary tardiness as "the late Marilyn Monroe," she sang perhaps the most sensuous version of "Happy Birthday" ever heard as 15,000 Democratic supporters looked on. The next day she flew back to Los Angeles, and returned to work.

It is not the role of this book to delve with any detail into the question of Marilyn's alleged relations with President John F. Kennedy and/or Attorney General Robert F. Kennedy. Paula Strasberg told journalist James Haspiel that she and Lee had locked away personal letters from JFK to Marilyn in a safe deposit box, although their contents were unknown. Hollywood columnist Earl Wilson reported in "*Show Business Laid Bare*" that he spoke to three people who claimed to have acted as "beards" for the couple.

Actress Terry Moore has stated that Marilyn told her she was involved with both Kennedy brothers. Columnist Sidney Skolsky, still Marilyn's closest Hollywood confidante, said Marilyn told him in the summer of 1962 that she had secretly been with JFK on more than one occasion. Anthony Summers, in "*Goddess,*" quoted several sources as having seen Marilyn and JFK in private trysts at Peter Lawford's beach house and elsewhere, before and after his election. Donald Spoto, in his exhaustively researched account, concluded that Marilyn and the President had a one-night affair on March 24, 1962 at Bing Crosby's Palm Springs home, but that aside from meeting briefly three other times, this was the full extent of their relationship.

Paula Strasberg dismissed the idea that Robert Kennedy had ever been involved with Marilyn; Skolsky and Wilson agreed. Fred Lawrence Guiles' 1969 biography "*Norma Jean*" was one of the first books to allege the affair, without naming names. Former Sen. George Smathers and various others interviewed by Summers and in the BBC documentary *Say Goodbye to the President* claimed to have knowledge of a 1962 affair with the Attorney General which RFK cut off, but the credibility of some of these individuals has been called into question. Historian Arthur Schlesinger wrote that Robert Kennedy "came to inhabit the fantasies of her last summer." After investigating all the claims, Spoto labeled assertions of an RFK-Monroe relationship, beyond four platonic meetings and several brief phone conversations during the summer of 1962, as "unfounded and scurrilous."

On May 23, the film's most celebrated scene was shot. Marjorie Flecher, Marilyn's wardrobe mistress, described it to *Playboy*: "Marilyn was so cute when she did that swimming sequence. . . (Cukor) asked her if she would do it nude, and told her he'd watch the camera angles so that there'd be nothing indelicate about the scene, in which she was supposed to playfully take a midnight swim in the pool, aware that her husband, Dean Martin, was peeking at her. She said yes, without being coy about it. When she saw the rushes later she roared at herself and said, 'I actually look like a good swimmer. Who'd guess that I'm just a dog paddler?'"

Agnes Flanagan, Marilyn's hair stylist, remarked: "After she made the swimming sequence, she asked me, 'Do you think it was in bad taste?' I told her there was nothing suggestive about it at all. Her figure was more beautiful than it had ever been. A perfect body like Marilyn's looks beautiful nude, and beauty is never vulgar. Her animal magnetism, though sometimes flamboyant, always had an appealing, childlike quality which seemed to be poking fun at the very quality she symbolized." Indeed, Marilyn had rarely looked more breathtakingly lovely than she did at this time, aided by the loss of more than 15 pounds through a crash diet undertaken in preparation for the film. Her publicists' claims that she currently measured 37-22-35 appeared entirely believable.

Cukor and Marilyn knew the glimpses of nudity would not make it into the final print. They also understood full well, however, that the stills snapped by photographers

Lawrence Schiller and William Read Woodfield in a special half-hour session after she climbed out of the pool—appearing to enjoy every second as she let her robe slide down—would create sensational press coverage. She convinced the studio to relinquish its rights to the stills to help maximize the publicity. Money wasn't the issue; "I'll be happy to see all those covers with me on them and not Liz," she gleefully remarked to Schiller.

Following completion of a pricelessly comic shoe store scene with Wally Cox on May 31 and a similarly amusing sequence the following day with Cox and Martin, there was a brief 36th-birthday celebration for Marilyn on the set, and work shut down for the weekend. Cukor told studio officials that in addition to her many absences for health reasons, much of Marilyn's completed footage was unusable—a statement that seems mystifying today. On June 7, Fox filed suit against Marilyn Monroe Productions and Monroe herself for $500,000 (later increased to $750,000), alleging that she had breached her contract by showing up for work only 12 out of 33 shooting days, saddling the studio with an out-of-pocket loss exceeding $1 million. When Weinstein learned about the lawsuit, he angrily submitted his resignation as producer. "This was a purely political move," he told Brown and Barham. "They couldn't get rid of (Elizabeth) Taylor, so they decided to show they were strong men and fired Monroe—in Taylor's place."

As Marilyn tried to recover from the shock of being fired, Fox tried to recast her part to salvage the picture. Kim Novak wouldn't even consider taking Marilyn's place, and when the studio tried to hire Lee Remick for the part, Dean Martin declared publicly that he would not complete the film with anyone other than Monroe. Within 10 days, Fox executives realized that they had disastrously miscalculated and began negotiations to get Marilyn back. Marilyn's telegram sent in late June to Robert Kennedy and his wife declining a dinner invitation described her battle in political terms: "I am involved in a freedom ride protesting the loss of the minority rights belonging to the few remaining earthbound stars. After all, all we demanded was our right to twinkle."

Meanwhile, in the midst of predictions that her career was over, Marilyn bounced back and was ready to fight for her future. As always, photographers would serve as her allies. One of Marilyn's most memorable picture sessions was shot on June 23-25 by *Vogue* fashion photographer Bert Stern. After running through a wardrobe of fashions, Stern suggested that she simply wrap herself in a bedsheet, and after sipping some Dom Perignon, the sheet soon slipped away for a series of mostly-nude studies, some of which would not be published for 20 years. "Not bad for a girl of 36, eh?" she said slyly.

In July, Marilyn was discussing a special Christmas-issue cover of *Playboy* for which she would be photographed posing with a white fur, bare in the back as would be revealed through a reverse image on the inside cover, with Lawrence Schiller. She finally decided against the idea, and her friend and publicist Pat Newcomb telephoned Hugh Hefner to cancel the proposed photo session. On August 3, however, Marilyn directed that some of her nude-swim photos (the ones too revealing to be used in *Life*'s front page feature) should go to *Playboy*. Schiller and Woodfield received an envelope with the designated photos the day after her death. During three meetings in early July, she conducted what would be her final interview, with Richard Meryman for *Life*. The following week, she and Sidney Skolsky met regarding her old friend's longtime dream project of a Jean Harlow film biography starring Marilyn.

On the last weekend of the month, she was the guest of Peter Lawford and his wife at the Cal-Neva Lodge, a casino hotel partly owned by Sinatra, overlooking Lake Tahoe. Various accounts have asserted that Marilyn overdosed on barbiturates that weekend and had to have her stomach pumped at a nearby hospital. Donald Spoto concluded that this never happened; instead, Marilyn reached a key decision during her time at the lodge: to remarry Joe DiMaggio, with a scheduled wedding date of August 8.

By the end of July, Fox had made the decision to revive *Something's Got to Give* with Marilyn, and she was enthusiastic about the prospect of returning to work. On August 1, she was re-signed for the picture at an upgraded salary of $250,000, with Jean Negulesco (director of *How to Marry a Millionaire*) set to replace Cukor at the helm. While plans were underway to resume production in early September, Marilyn had also decided to appear in a new comedy with Dean Martin called *I Love Louisa*, and scheduled a meeting on that project for Monday, August 6 with director J. Lee Thompson.

The events surrounding August 4, 1962 have been dissected thoroughly elsewhere; Spoto's account appears definitive. She spent much of the afternoon with her psychoanalyst, Dr. Ralph Greenson, who asked Marilyn's housekeeper, Eunice Murray, to stay there overnight; she appeared heavily sedated when she visited Peter Lawford's beach house in the late afternoon and said she did not feel up to attending a dinner party there that night; and spoke cheerfully by phone with Joe DiMaggio, Jr. just after 7 p.m. At about 7:45, when called by Lawford and urged again to come over, she disturbingly asked him in a slurred and gradually less audible voice to say goodbye to his wife, "say goodbye to the President, and say goodbye to yourself." When the alarmed actor tried to call her back, the operator told him the phone was off the hook or out of order. After Lawford made other frantic calls to friends, Marilyn's attorney reached Mrs. Murray, who offered assurances that all was well. At about 10:30 p.m. (as first confirmed by Anthony Summers), her public relations representative, Arthur Jacobs, was informed during a concert at the Hollywood Bowl that Marilyn was dead, and he immediately left for her home; Greenson was also at the scene by that time. Mysteriously, the police were not notified until 4:25 a.m.

The official conclusion of the county coroner was probable suicide through barbiturates and chloral hydrate. Spoto's investigation, however, found that this was contradicted by the medical evidence and inconsistent with the happy developments in Marilyn's life during the preceding

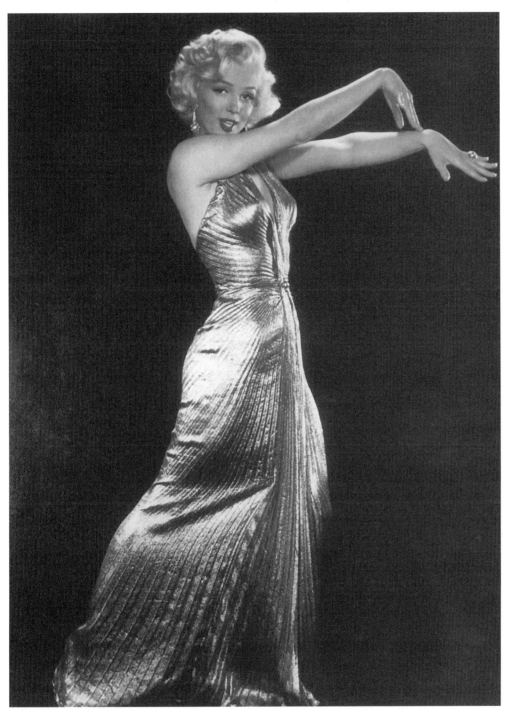

ning to lapse into unconsciousness. The author charged that Greenson and Murray fabricated a story to cover the accident, and arranged Marilyn's room to fit the scenario. (Those readers inclined to pursue darker conspiracy theories, which will not be repeated here, are advised to read Summers' *"Goddess."*)

Writes Spoto: "Something brave, new and maturing was emerging in her those last few months. . . she was finally taking control of her life" and "banishing the crippling ghosts that had so long surrounded her." Hauntingly, on the last afternoon of her life, she had begun writing a letter to DiMaggio: "If I can only succeed in making you happy, I will have succeeded in the biggest and most difficult thing there is—that is, to make one person completely happy. Your happiness means my happiness, and. . . " The letter was never completed.

Sheree North was on Broadway in the musical *I Can Get It for You Wholesale* when Marilyn died. Nearly two decades later, she would portray Marilyn's mother in the TV movie *Marilyn: The Untold Story.* During the research and shooting of the film, she came to believe the reports of mysterious comings and goings at Marilyn's home on the fateful night. "Something funny was going on. So I don't think she took her own life. Just look at everything that was going on in her life then—she'd never

days. His conclusion: Marilyn's death was a horrendous accident resulting from the combination of some Nembutal prescribed by her doctor (without Greenson's knowledge), and a sedative enema of chloral hydrate as a sleep inducer, arranged by Dr. Greenson and apparently given by Eunice Murray. Marilyn "did not know that a chloral hydrate enema could be dangerous, even fatal, as a sequel to Nembutal," declared Spoto. John Miner, who was deputy district attorney of Los Angeles County in 1962 and liaison officer for the chief medical examiner, told Spoto his belief that when Marilyn received the final call from Lawford, she was begin-

been trimmer, she looked fabulous, she was furnishing her home. She was doing everything that was positive and upbeat. This was just not someone who was going to take her own life. There had always been someone else running her life. For the first time, she was taking charge of her life."

Following a hair-raising plane ride in the late 1950s, Marilyn mused to British journalist Donald Zec what would be an appropriate epitaph for her when the time came. She paused, and suggested: "I'll settle for this. Here lies Marilyn Monroe—38, 23, 36." Meant to be humorous, the comment

reflected her conviction that no matter how exceptional her film performances, the primary source of her popular appeal was still her body. She confided to the head of her studio in July 1962: "I'm a failure as a woman. My men expect so much of me, because of the image they've made of me and that I've made of myself, as a sex symbol. Men expect so much, and I can't live up to it. They expect bells to ring and whistles to whistle, but my anatomy is the same as any other woman's. I can't live up to it."

"The simple fact, terrible and lethal, was that no space whatever existed between herself and this star," wrote Arthur Miller in his memoirs. "She was 'Marilyn Monroe,' and that was what was killing her. And it could not be otherwise for her; she lived on film and with that glory forsworn would in some real sense vanish."

In her final interview for *Life*, she remarked, "I never quite understood it—this sex symbol—I always thought symbols were those things you clash together! That's the trouble, a sex symbol becomes a thing. I just hate to be a thing. But if I'm going to be a symbol of something I'd rather have it sex than some other things they've got symbols of."

"The people made me a star—no studio, no person, but the people did," she declared. To the talk that she may be finished in films: "It might be kind of a relief to be finished. It's sort of like I don't know what kind of yard dash you're running, but then you're at the finish line and you sort of sigh—you've made it! But you never have—you have to start all over again. . . I now live in my work and in a few relationships with the few people I can really count on. Fame will go by and, so long, I've had you, fame. If it goes by, I've always known it was fickle." Two days after the interview was published, Marilyn was dead.

Stella Stevens admired Marilyn on screen, "particularly in *The Seven-Year Itch*—even more than *Bus Stop*. . . She was just stunning to me. . . Marilyn Monroe was a hard act to follow, but she presented me with all the ideals that made me brave. It deeply disappointed me when I thought she had committed suicide. Being such a loner myself, and during the first few years I didn't get to work a lot, I would sometimes get depressed, and I feel like I had fought against those same urges. I wanted to be my own heroine to save my own life, and I wanted her to be a heroine to me and not give in to such a thing (as suicide). I hoped against hope that it was not true, because she had too much to live for. I don't know to this day, nor does anyone, what really happened. Maybe that's for the best. This woman is eternally beautiful and eternally mysterious."

The ultimate miracle of Marilyn, perhaps, is that she had a unique capacity for evoking joy in others even while struggling to overcome sorrow and inner demons that would have crushed a lesser soul long before. Having demonstrated the courage and will to repeatedly defeat the darkness before, she seemed on the verge of a more lasting victory when the end came.

Dwelling on the tragic mystery, however, distracts us from the true meaning of her life. For anyone not alive during Marilyn's prime, and jaded by more than 30 years of unending hype, it is easy to believe that she was more myth than reality. Just erase the legend from your mind; spend several hours with a VCR watching her finest work, and realize all over again that more than any other actress—more than Garbo, Harlow or Hayworth—Monroe could dominate the screen and hypnotize any viewer. It is her joyous spirit that still endures on virtually every frame of film and every photographic image on which she appeared, and will never be extinguished.

Since 1962, significant Marilyn magazine features have included the following:

Winter 1963 *Modern Man Annual* (3 pages, "Last Look at a Queen")

Feb. 1963 *Photoplay* (cover feature including 5 pages and 7 pictures devoted to her photo session with Bert Stern.)

Aug. 1963 *Photoplay* (The first major Monroe conspiracy article, "Her Killer's Still at Large" by Martha Donalson.)

Jan. 1964 *Playboy* ("MM Remembered," a splendid 10-page pictorial tribute, including a full-page reprise of "Golden Dreams" and 4 pages, 7 pictures, shot for *Playboy* by Lawrence Schiller and William Read Woodfield as she emerges from her *Something's Got to Give* nude dip.)

Aug. 7, 1964 *Life* ("What Really Killed Marilyn," cover portrait taken in 1954, and long article by Claire Boothe Luce)

Sept. 8, 1972 *Life* ("Remember Marilyn," cover and 4 pages of photos.)

Jan. 1975 *Cosmopolitan* ("Legacy of a Sex Goddess")

1979 *Celebrity Skin #1* (6 pages)

May 1979 *Playboy* ("The Private Life of Marilyn Monroe," adapted from the book by Marilyn's former maid Lena Pepitone with William Stadiem)

1981 *Playboy Leading Ladies* (6 pages)

Oct. 1981 *Life* (classically glamorous cover, "Mania for Marilyn")

Aug. 1982 *Life* ("The Unseen Marilyn," 7-page cover feature presenting Bert Stern's previously unpublished June 1962 photos of Marilyn.)

Dec. 1985 *Hollywood Studio Magazine* (cover and 5 pages, one of the magazine's many 1980s features on Marilyn)

Jan. 1987 *Playboy* (A historic revelation; 8 pages of totally sensational topless shots of a 19-year-old Marilyn posing for artist Earl Moran, along with the Moran calendar pastels that her enchanting form inspired. Best of all are a full-page photo of an utterly radiant Marilyn, clad only in shorts, striking a classic leg-art pose with her seated body stretched out, and an oversized foldout of Marilyn clutching a towel to her nude body as she glances at a small television set; on the reverse of the foldout is her original centerfold.)

Aug. 1987 *Hollywood Studio Magazine* (special issue largely devoted to Marilyn, with cover, centerspread, and 21 pages)

June 1991 *Los Angeles* (article by Marion Charles on Marilyn's nude session with Tom Kelley, with full-page color nude)

August 1992 *Life* ("The Last Interview," her late-July 1962 session with Richard Meryman, accompanied by photos taken that month by Allan Grant.)

Aug. 10, 1992 *People* (cover feature, "Marilyn and the Kennedys," excerpting the book "*Marilyn: The Last Take*")

June 1993 *Los Angeles* (Bruno Bernard's "*Marilyn Journal*," adapted from the book "*Bernard of Hollywood's Marilyn*")

Jan. 1994 *Playboy* (2 pages, 5 excellent pictures)

Aug. 1994 *Interviu* (15 pages of her finest glamour photos)

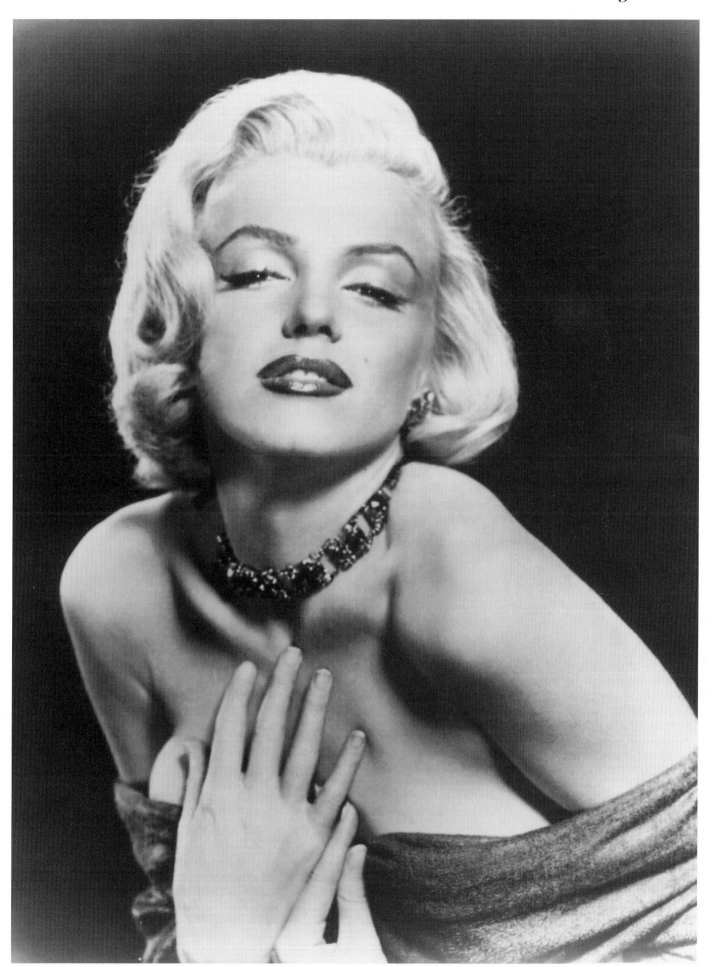

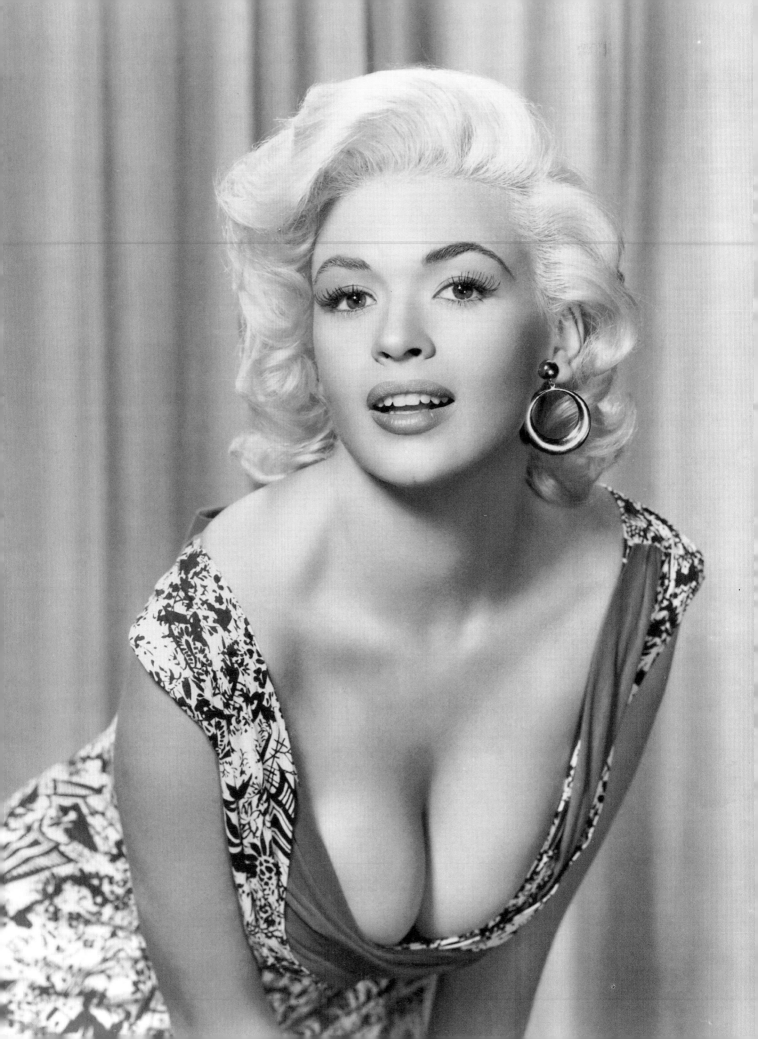

When it came to 1950s Hollywood glamour and excess, Jayne Mansfield was the ultimate queen. Thousands of other girls came to Tinseltown during that decade dreaming of stardom and determined to do what was necessary; but none could match Jayne's ferocious drive and willingness to do absolutely anything, no matter how outrageous or shocking, to attain that goal—and she had the goods to back it up. It is virtually impossible to imagine the Golden Age of Glamour Girls without this platinum phenomenon.

It is extraordinary to consider that 28 years after her death, Jayne's sex-symbol allure shines more brightly than that of anyone else besides Marilyn Monroe, based on the author's recent surveys of international cinema/glamour fans. This enduring popular appeal may seem odd to a neutral observer looking only at her professional credits. After all, Jayne starred in only two genuinely successful films and one Broadway hit; a long string of movie flops fills out the rest of her resume, accompanied by an unending campaign of self-promotion. Logically, one had every reason to expect following her death that Jayne would be regarded a generation later as little more than a fascinating if minor symbol of '50s pop culture; a footnote to postwar Hollywood history. Instead, she is more fondly remembered than all but a few of her contemporaries. Why?

Perhaps one answer is that even considering all the problems that accompanied her final years, one cannot think of Jayne Mansfield without smiling. Others who reached the pinnacle she attained viewed stardom as a burden to be endured; Jayne revelled in every glorious moment of it. No other sex symbol had such genuine adoration for her fans, or basked in every aspect of the Hollywood experience, the crass and the crazy as well as the glitzy. She never forgot for an instant how desperately she'd wanted to be where she was, and no amount of disappointment could steal away her joy and zest for living.

The pampered only child of Herbert and Vera Palmer, Jayne grew up in Phillipsburg, New Jersey. Herbert Palmer was a highly successful and ambitious young attorney, law partner to future New Jersey governor Robert Meyner and a man with his own political aspirations. She was three when he suffered a fatal heart attack while driving Jayne and Vera en route to Easton. Within about a year of his death, Vera met traveling mechanical engineer Harry Peers, and the two were married in 1939, moving to Harry's home in Dallas.

"We were fairly well off, and I had most of the things that a normal kid has, until I discovered movie fan magazines," Jayne later recalled. "Then I wanted to be a movie star and have Cadillacs, minks, and swimming pools." The first star she sought to emulate was Shirley Temple. Vera was always supportive of her daughter's aspirations, but the ferocious ambition was all Jayne's.

"I started developing when I was ten," Jayne claimed implausibly to one interviewer. "I was terribly sensitive about it—at 17, my bust was already 40 inches. Now, it's bread and butter." She remarked in another interview: "I never felt awkward, just very special. I had what the other girls didn't—and what all the boys wanted!" However, from neutral accounts and existing photographs, it would appear that the teen-aged Jayne was an attractive but unexceptional brunette. A "B" student at Parkland High School, Jayne had a number of friends but seldom went out on dates; she was hardly a campus queen.

On May 6, 1950, soon after learning she was pregnant, the just-17-year-old Jayne married Paul Mansfield, nearly three years her senior and (according to Jayne in a later interview with Earl Wilson) "the handsomest boy in our crowd. . . He was a terrific party boy and had the most beautiful eyes. . . I think I married him for those eyes." She graduated from high school, and gave birth to Jayne Marie on November 8.

That fall, Paul entered the University of Texas at Austin, and after Jayne joined him there, they rented a small campus apartment. Since the couple couldn't afford a babysitter, she would take Jayne Marie to classes with her. Her schedule was grueling. When not attending classes, she worked from 7 to 11 each evening as a receptionist at an Austin dance studio, sold books and family photo albums door to door to help pay her way, modeled, and slept only four hours a night.

In the summer of 1951, while Paul was at ROTC training, Jayne left her daughter with Vera and ventured to Los Angeles for special dramatic studies at UCLA. While there, she reached the finals of the "Miss Southern California of 1951" contest. Newspaper accounts of the event led to a disapproving letter from Paul, and Jayne resigned. After completing her summer semester, she headed back east. At this point Jayne was starting to blossom and seek out her own flamboyant identity, and Paul didn't like what he saw.

Early the following year, Paul was drafted, and Jayne joined him during training at Camp Gordon in Augusta, Georgia. There, she was named Miss Photoflash of 1952—the first in a long series of beauty titles she would hold. "The other officers' wives didn't seem to realize that I was a movie starlet in training," she later recounted for the benefit of reporters. Jayne provided some thrills for the drill teams by doing ballet exercises on the lawn in a skintight swimsuit, and turning up at the base swimming pool in a velvet bikini.

She also participated in several shows at the camp. Jayne's thespian debut had occurred Sept. 21, 1951 in the Austin Civic Theatre's production of *Ten Nights in a Barroom.* Her biggest show at Camp Gordon was a presentation of

Jayne Mansfield

Born Vera Jane Palmer, October 19, 1933,
Bryn Mawr, Pennsylvania
Died June 29, 1967

Anything Goes.

In early 1952, Paul was sent to Korea and Jayne returned to Dallas. She attended classes (including drama) at Southern Methodist University, earning money by modeling. She was voted Miss Bluebonnet Belle, Miss ROTC Unit, and Miss Sweetheart of Phi Psi. The increasingly curvy young beauty modeled for women's art classes at SMU, occasionally in the nude but usually in a leotard with nothing underneath. She also had at least one nude posing session with a Dallas photographer. The not-entirely-reliable book, *"The Wild, Wild World of Jayne Mansfield,"* states that the nude photo session took place in Austin for a company that made a Hawaiian cake mix, that Jayne posed topless in a hula skirt, and that she earned $250. (*Playboy* later ran one of her university art class poses, with the brunette Jayne sitting demurely nude holding a guitar on her lap.)

She also struck up a friendship with Baruch Lumet, father of film director Sidney Lumet. He suggested acting classes at the Dallas Institute of Performing Arts, which he had founded; but when she confessed that she could barely afford a babysitter, let alone acting classes, Lumet took pity on the girl and gave her free lessons. This led to an October 1953 role as a floozy in a local production of *Death of a Salesman*, and a couple of roles in local TV plays. Milton Lewis, head of talent at Paramount Studios, came to see a performance of *Salesman* at Lumet's request and told him, "Baruch, let me know when she's ready to come to Hollywood."

Jayne was, of course, thrilled at the news, and Lumet prepared her for a screen test as Joan of Arc in a scene from George Bernard Shaw's *Saint Joan*. In early April 1954, Paul returned home and grudgingly agreed to carry out a promise he had made to Jayne: the family would pack up their red Buick and go west so that she could seek out her Hollywood dreams. She would later recall that upon crossing the California border, she got out of the car, kissed the ground, and proclaimed, "I am home!"

She arrived in Hollywood without an agent or influential friends. Wasting no time on preliminaries, she called Paramount and announced, "I want to be an actress. I've modeled and won beauty contests. What do I do?" Visit the talent department, they replied. On April 30, she met with Milton Lewis, and tested at Paramount as Joan of Arc. Afterward, she reported, "The man who saw it said I was a good actress, but my figure was taking his mind off the character. And if it would take his off it, it would take everybody's." At the advice of her first agent, Robert Schwartz, Jayne bleached her hair blonde. A few days later, she tested again in the piano scene from *The Seven-Year Itch*, but this test also led nowhere.

Jayne posed for a photographer at Grauman's Chinese Theatre, her hands atop Marilyn Monroe's handprints. While awaiting her big break, Jayne registered with the Emmeline Snively Blue Book Modeling Agency—the same one that had helped Marilyn get her start several years earlier. The Hartung shirt company hired her for a series of ads in which she posed in various stages of semi-undress.

One of Jayne's first jobs involved modeling for General Electric, around a pool with six other girls. A photographer at this session was quoted by Raymond Strait in *"The Tragic Secret Life of Jayne Mansfield"*: "G.E. notified me that they had to cut her out of the picture because she looked too sexy for 1954 viewers. Her breasts were too big, they told me, and they just couldn't use her." She was also a model for pin-up calendars, including one for showman Earl Carroll. In addition, she sold kitchen ware door to door, worked as a hat-check girl, sold candy at an L.A. movie theater (earning $35 a week!), and served as a seating attendant at Grauman's. And she raced to casting offices at every report of a job possibility.

As Jayne persevered with unwavering determination in her drive for stardom, Paul Mansfield, anxious to end this experiment and return to Dallas, gave her the marriage-or-career choice in the fall of 1954. For Jayne, there could only be one answer. Paul tried to win custody of Jayne Marie by arguing that his wife's unclad pin-ups made her an unfit mother, but his motion was denied.[1] Jayne jokingly explained to one interviewer, "He didn't photograph well with me"—a quote she later disowned. The newly free Jayne became a habitual party-crasher, often boasting to male guests that she wore no undergarments. Soon after Paul left, she entered into an off-and-on affair with actor Steve Cochran, who lived across the road.

According to one account, Jayne landed her first TV acting job after waiting impatiently in the casting office for three consecutive days. Finally, she scribbled a note on a card and had it delivered to the producer. . . and was hired 30 seconds later! The card read simply "40-22-34." Those statistics, adorning Jayne's 5-foot-5½, 117-pound frame, could hardly fail to impress. Jayne's first professional appearance came on October 21, 1954, a small part on TV's *Lux Video Theater* in a live broadcast of *The Angel Went AWOL*. She earned $300 for ten lines of dialogue as "the girl at the piano."

On the strength of this appearance, photographer Frank Worth was able to fulfill his promise to get Jayne a movie role. Producer Burt Kaiser, a friend of Worth's, was about to begin work on a film requiring the services of a sexy young thing, and Jayne auditioned for and received her first motion picture role in Kaiser's *Hangover* (later retitled *Female Jungle*) that November.

The film was completed in two weeks, and "led to nothing." Upon seeing the picture for the first time in New York, her eyes filled with tears. "I loved seeing me up there on the screen. I was filled with a chill. I had finally made it and I wanted to stay there. 'I love you, Jayne Mansfield,' I told my 'image.' 'I'll work hard for you! Nothing or no one could ever make me let you down.'"

Back selling candy to make a living, Jayne got a screen test at Warner Brothers, and again performed the same scene from *Seven-Year Itch*. Jack Warner, however, was out of the

1 The divorce wound its way slowly through the legal system; Jayne appeared in court October 26, 1956, but the final decree did not come down until January 11, 1958, just before her marriage to Mickey Hargitay.

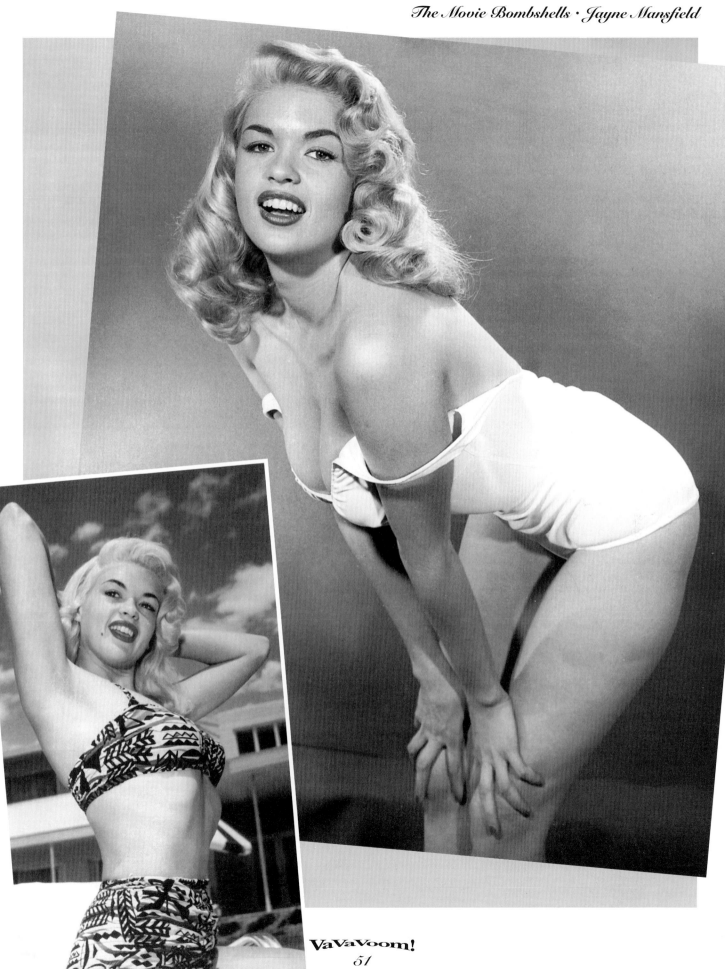

VaVaVoom!

country at the time; lamented Jayne, "He probably didn't even see the chest—I mean the test."

In early December 1954, Jayne engaged as her press agent Jim Byron, then an eager young publicity man for Ciro's nightclub on the Sunset Strip and actress Marilyn Maxwell. It was to be one of the most important steps in the making of a star. The two proved a perfect match: Byron, filled with outrageous ideas, and Jayne, ready and willing to do anything. His first publicity stunt was dressing Jayne up in a sexy Santa outfit and sending her around to newspaper offices dropping off bottles of Scotch. Syndicated columnist Earl Wilson vividly recalled the episode. "I was sitting all alone at my desk in the AP office on a day before Christmas. All of a sudden, I felt a warm kiss on the back of my neck. . . Looking up, I gazed on a beautiful young blonde, 21 at most, with the most beautiful pair of breasts I had ever seen. They were falling out of her low-cut dress. Then she bent over and gave me a warm kiss on the lips. I kept my eyes open because I couldn't take them off those gorgeous breasts. 'Here's a present from Jim Byron,' she said, and wiggled out the door."

Photographer Eddie Rocco later recounted how he gave the budding starlet some early tips on how to be a sex symbol. Because of the unflattering way she was dressed, Rocco suggested that she ought to get herself a pair of falsies. After learning how best to present her natural assets by showing off her cleavage, she grilled the photographer incessantly on how to become a star. When he expressed the view that Marilyn's nude calendar wasn't necessarily the route to success, Jayne disagreed. "She seemed to feel that when it came to stardom, everything goes," he wrote. Rocco advised her to forget the casting couch and concentrate on cultivating publicity to fight her way to the top. It was a lesson she learned all too well. As she said later in a ghostwritten biographical article: "I decided early in life that the first thing to do was become famous—I'd worry about acting later."

Today, Alice Gowland recalls when she and husband Peter photographed the then-unknown starlet for the first time that December: "A publicity man had called to arrange for a session. The first thing she did was run into our neighbor's car with her car," she laughs. "You couldn't help but like Jayne, because she was so adorable and

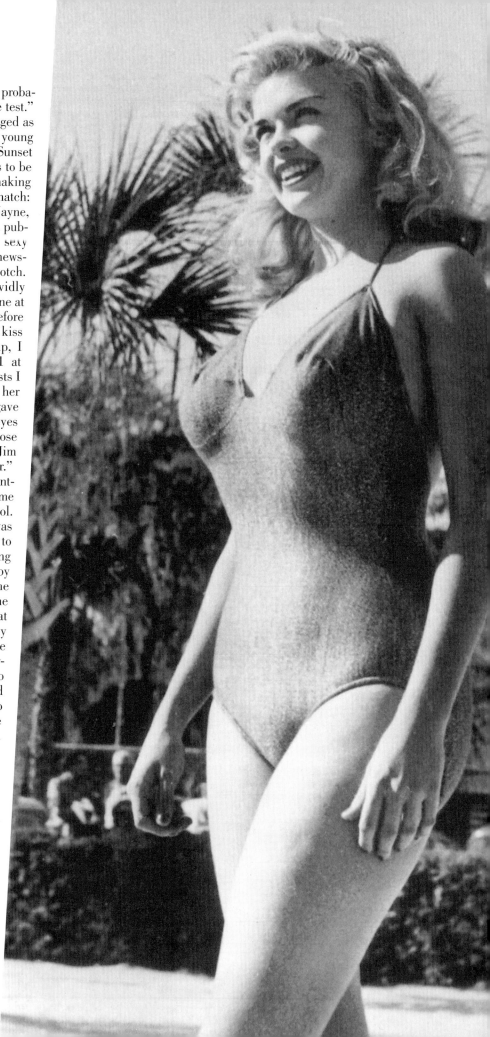

sweet. She was wearing a tight yellow dress. We took some test pictures, and afterwards I told Peter, 'That girl will never make it.' He's kidded me about that ever since. I liked her, but I thought she was just too flashy."

Two nights later, Jayne's agent called to ask if she could borrow the spectacular tight red lame swimsuit she had worn for the session, as she was about to fly out to Florida to do some publicity for a movie. The suit had been designed by supermodel Barbara Osterman. "So we left it in our mailbox for her and she picked it up. The next day, her pictures were all over the papers, with stories saying how she had outshone Jane Russell."

A pretty young starlet posing in a bathing suit, Jayne Mansfield already had more than just a winning smile and figure, but also a ferocious determination to be a star.

The appearance had been set up by Byron in connection with a Howard Hughes press junket for his new film *Underwater*. She had no connection to either the picture or RKO Studios, but (by his account), Wilson arranged to have Jayne take his seat on the plane by personally calling Hughes. "After I described Jayne, he agreed on the spot." Photographer Frank Worth has a different recollection, which he related for Mansfield fan club members in 1987. He'd been friendly with Jayne due to his acquaintance with Burt Kaiser, and hoped to become her manager. According to Worth, he convinced an RKO representative to allow Jayne on the junket. The only two women scheduled to appear were Debbie Reynolds and Mala Powers, neither particularly well endowed; Jayne, he knew, would give the press boys something more to work with.

Jane Russell hadn't shown up yet in Silver Springs; she had just flown out from London where she was finishing another picture. A horde of photographers was prowling about looking for something to shoot, and Jayne, posing at poolside in that sizzling one-piece suit, fell in the water, broke a strap (as carefully planned beforehand), and "came up bouncing" as cameramen scrambled for the best angle. "It's wonderful what a red bathing suit can do, plus happening to be in the right place at the right time," she later noted succinctly. "The bathing suit was skintight. Not much cleavage, but no one seemed to mind."

For some reason, the suit has usually been described incorrectly as a bikini, despite the photographic evidence to the contrary, and was so portrayed by Loni Anderson in the TV movie *The Jayne Mansfield Story*. Alice Gowland also disputes part of the story: "I'm 90 percent sure that the bathing suit she borrowed was not red lame. It was a yellow suit with green polka dots, made of silk jersey. We did have a plain red suit at that time, too, but I think it was the yellow one she borrowed." Peter Gowland continues: "A few days later, she called to say how grateful she was. Other girls wouldn't bother. But she was so nice—everybody loved Jayne."

Jayne's big splash was reported in the January 12, 1955 issue of *Variety*, which noted that the newcomer "proved to be worth her weight in cheesecake." The trade periodical also gave Jayne the label that was to haunt her throughout her career: "a road company Marilyn Monroe."

The *Underwater* appearance would be Jayne's breakthrough. The flashy blonde who had been knocking on so many doors without a response was suddenly deluged with calls in a matter of days. At this time, Byron got her to hire Bill Shiffrin as her talent agent. In an interview with Martha Saxton for her book "*Jayne Mansfield And the American Fifties*," Shiffrin recalled his initial meeting with the new blonde bombshell: "When I first saw her I honestly thought I saw two miniature dirigibles followed by a gorgeous blonde in a golden dress. Can you imagine? A table for three and two dirigibles."

Howard Hughes' longtime aide Walter Kane was anxious to make Jayne the latest lovely bauble in the Hughes movie empire, as Byron and Shiffrin negotiated with Hal Wallis and Warner Brothers. The bidding war concluded when Jayne signed with Warners, the same company that had just rejected her. The less-than-lucrative deal, which she had accepted against Shiffrin's advice, called for $250 a week for six months with options to renew. Nevertheless, she felt she had made it. The lesson was not lost on Jayne: Publicity pays off.

"The thing about Jayne is that she never seemed sexy to me, which is strange because that's the image she was selling," remarks Peter Gowland. "She always came across to me as a mother, because she had all these children and animals around her all the time." Gowland says he rarely worked with so totally cooperative a model. "She would do anything. So eager to work."

Shortly after that initial session, Gowland photographed Jayne for a *Pageant* magazine cover, and they went on to work together two or three more times. "We became really good friends with her," says Alice. "She just loved to pose. She had boundless energy."

Alice marvels at the passionate following that Jayne still commands to this day. "I think it may be because she had both an innocent quality and a devil-may-care attitude. She was outrageous in her dress and style, yet she was charming at the same time. And she was completely attainable. All of those things made her attractive."

Within days of Jayne's *Underwater* stunt, organizations were virtually falling over themselves to bestow honorary beauty titles upon her, and she and Byron were only too happy to oblige. Throughout 1955 and beyond, Jayne and Byron used beauty titles as a stepping-stone to fame: she was Miss Negligee, Miss Nylon Sweater, Miss Freeway, Miss

Electric Switch, Miss Geiger Counter, Miss 100% Pure Maple Syrup, Miss July 4th, Miss Fire Prevention, and Miss Tomato, among others.

Jayne never missed a trick when it came to cultivating anyone who could help her get publicity. On one occasion when she was representing a negligee company, she obtained the home phone number of every male at the press party. A secretary called their wives and got their sizes; a few days later, every one of them received an expensive negligee courtesy of the manufacturer, with Jayne's compliments attached.

"Ever since I was a little girl, I was convinced I would be a star. I haven't got there yet, but I will. It's 80% determination and 20% talent. I'm the girl with the built-in drive," she declared. "The real stars are not actors or actresses. They're personalities. The quality of making everyone stop in their tracks is what I work at."

Jayne's signing by Warners in early February 1955 occurred immediately after she was introduced to much of America as that month's *Playboy Playmate of the Month*. This began a relationship that was to endure to the end of Jayne's life, and would include six full-length nude or semi-nude pictorials. ("*The Wild, Wild World of Jayne Mansfield*" amusingly claims that 20th Century Fox had suggested Jayne as a candidate for *Playboy* and had even OK'd the photos, when in reality she was more than a year away from her association with the studio.)

Jayne's first two films for Warners were *Illegal* and *Pete Kelly's Blues*. Her studio chair on the set of *Illegal* did not bear her name, but simply the figures "40-21-35 1/2." The part in *Pete Kelly* came about after producer-director Jack Webb used Jayne for a walk-on in his TV series *Dragnet*.

According to authors James Robert Haspiel (a longtime friend of Jayne's) and Charles Herschberg, a brief romance with director Nicholas Ray brought Jayne onto the set of *Rebel Without a Cause*. (This romance may have actually occurred a bit later, since Jayne tried out for *Rebel* almost immediately after signing with Warners.) While she did test for the lead female role of Judy opposite James Dean, publicity items went out claiming that she would appear in the film, and her official studio biography went so far as to list it among her credits. The role of Judy, however, went to Natalie Wood. That fall, Jayne appeared in an episode of the ABC-TV series *Casablanca*.

After all the hoopla that had preceded her start at Warners, Jayne was unhappy with the roles she was getting at the studio. For its part, Warners saw her as a cheap, sexy starlet with more chutzpah than taste or talent, and Jayne did little to dissuade them of this notion. She busied herself with an endless series of pin-up photo sessions, and, after Shiffrin showed the director her test for *The Seven-Year Itch*, got a studio loan-out to play a featured role in an independent production, *The Burglar*, for a salary of $5,000.

While shooting the film in Philadelphia, she got the news that Warner Bros. had terminated her contract. Jayne's public version of the story was that her attorneys arranged for her release at her request. But later, in such accounts as her book "*The Wild, Wild World of Jayne Mansfield*," she

Before the glare and pressure of stardom, Jayne could still enjoy the simple girlish pleasure of frolicking in the surf. Photographer Peter Gowland's wife and partner Alice Gowland marveled at Jayne's willingness to do whatever was necessary to please the man behind the camera. "She just loved to pose. She had boundless energy."

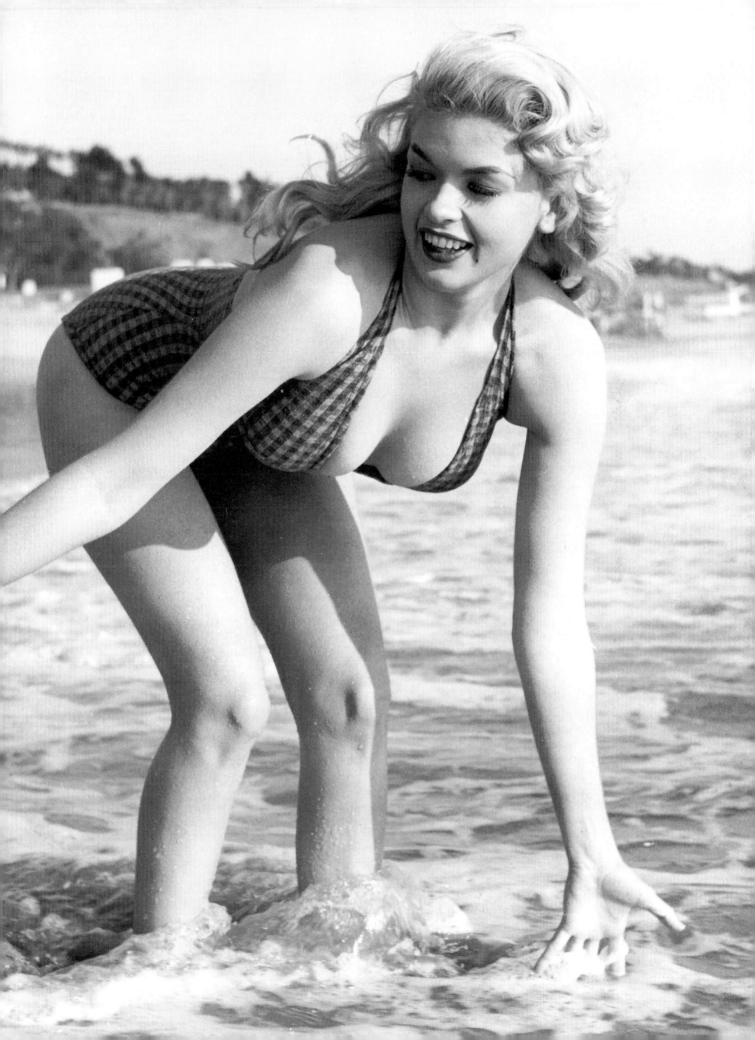

confessed the truth. "It was the most terrible moment of my life," she confided to John Maynard. "I don't think I thought about suicide, but there was no hope left. Everything had turned gray and empty."

Jayne's early filmography:

The Female Jungle (aka *The Hangover*) — Jayne is third-billed in her film debut (behind Lawrence Tierney and John Carradine) as nymphomaniac actress Candy Price who is strangled by psycho Burt Kaiser (who also produced the film). A Grade-Z production, but a girl's got to start somewhere. Filmed in 1954, the picture was not released until June 1956 after Jayne scored on Broadway, and the publicity was recast to focus on her.

Illegal (1955) — In this crime melodrama starring Edward G. Robinson, Jayne has a good supporting role as racketeer Albert Dekker's hip-swinging former mistress, nightclub singer Angel O'Hara, who appears in court to clear Nina Foch of murder. The picture's concluding shot is of Jayne's chest, against the background of the courtroom. Co-written by W.R. Burnett, who wrote the original story for Marilyn Monroe's breakthrough film, *The Asphalt Jungle*. Released in October 1955.

Pete Kelly's Blues (1955) — Jack Webb's re-creation of the 1920s jazz-and-gangsters scene in Kansas City has a small role for Jayne, who is on screen for 20 seconds as a red-haired cigarette girl.

The Burglar (1955) — In Jayne's first genuine co-starring role, she's the half-sister of thief Dan Duryea, and is with him during a big heist. A crooked cop decides to kidnap her with the stolen jewelry as the ransom, but even after Duryea hands them over he is murdered. Filmed in 1955, released in April 1957.

Hell on Frisco Bay (1956) — Bit part for Jayne in solid crime drama, as a sexy blonde in one scene set in a cocktail bar with star Alan Ladd. Like *Illegal*, this film also co-stars Edward G. Robinson. A 1955 studio bio for Jayne listed *The Darkest Hour*, which may have been the working title for *Hell on Frisco Bay*.

On To Broadway!

Easing Jayne's anguish at being dropped by Warners was the fact that another totally unanticipated opportunity had just come her way. George Axelrod, author of *The Seven-Year Itch*, had been holding Broadway tryouts for girls to fulfill his vision of a Monroe-styled bombshell-to-end-all-bombshells in *Will Success Spoil Rock Hunter?*... but no one quite measured up to his ideal. He had written the part with budding starlet Mamie Van Doren in mind, but Mamie turned it down without ever testing, as did Marilyn Maxwell; Abbe Lane, Sheree North and Denise Darcel were reportedly considered as well. Writer Charles Lederer slipped Axelrod a photo of Jayne and Shiffrin's New York representative, Marty Baum, made a sales pitch; bells went off, and immediately the summons went out.

New York was a less-than-thrilling prospect to Jayne.

"It was like Iceland in my estimation and only Hollywood was IT!" Desperate for the movie stardom that she felt was slipping beyond her grasp, she was fearful of being trapped in totally unfamiliar territory 3,000 miles away from the only life she wanted. Her advisers practically had to beg her to do it. A year of pin-ups and rotten roles had not achieved her dream; Broadway would prove to be the ticket.

Shiffrin "told me to wear the tightest dress I could find and underneath the dress I should wear the tightest, smallest bikini I had. Axelrod took one look at me and flipped." The play's leading man, Orson Bean, later described the love scene he played with Jayne at her tryout: "When I came to, I asked for the number of the truck." Axelrod realized in a flash that the search was over. Back in Philadelphia, she was informed the next day that the part was hers.

In an appearance before Sabin Gray and Jayne's fan club in 1991, Bean recalled that in its original version, *Hunter* was "a serious play about a young man who sells his soul to the devil and then loses it." Tina Louise starred opposite him in the show's Philadelphia tryout. The show was overhauled as a comedy, Tina dropped out, and Jayne came aboard. Walter Matthau was also featured. As it was presented on Broadway, the play was a wicked satire on the movie industry; it would take a very different form in its film adaptation.

After landing the role, Jayne stayed in Philadelphia to complete *The Burglar*, while the cast of *Hunter* waited and the scheduled opening was postponed. No one quite knew what to expect from this publicity-mad Hollywood starlet in the midst of seasoned theatrical veterans, but for whatever Jayne lacked in acting polish, she more than compensated with high-octane drive and bravado. Any misgivings she may have had were hurled to the wind as she totally inhabited the role. "From the first day of rehearsal, I became Rita Marlowe. She is brassy and extroverted, refreshing and direct, and not entirely oblivious of her bombshell of a body. The role gives me a chance to act on stage the way I would like to behave off-stage."

The show opened on October 12, 1955. Its curtain-raising scene was also its most famous, with Jayne lying face down on a massage table with only a towel on. Eight times each week at the Belasco Theater (with two shows on Saturday), Jayne dazzled packed houses not only with her form (as "Broadway's Biggest Towelful"), but her comic timing as well. Critics were lukewarm about the play, but not about Jayne. "Sex-on-the-Rocks!" raved one reviewer. And with Jayne, there was always the tantalizing element of the unexpected; Axelrod noted, "There is absolutely no chance, whether by design or by coincidence, that Jayne will ever do two shows alike."

Jayne "was totally guileless," Bean remarked in 1991. "She was crazy like a fox and knew exactly what she wanted." He would occasionally be invited into her dressing room where she sat totally nude, and she chatted away oblivious to his embarrassed efforts not to stare. "She wasn't being seductive with me, quite the contrary—she was almost totally unaware of the fact that she was naked."

Meanwhile, Jayne set out to do what she knew best:

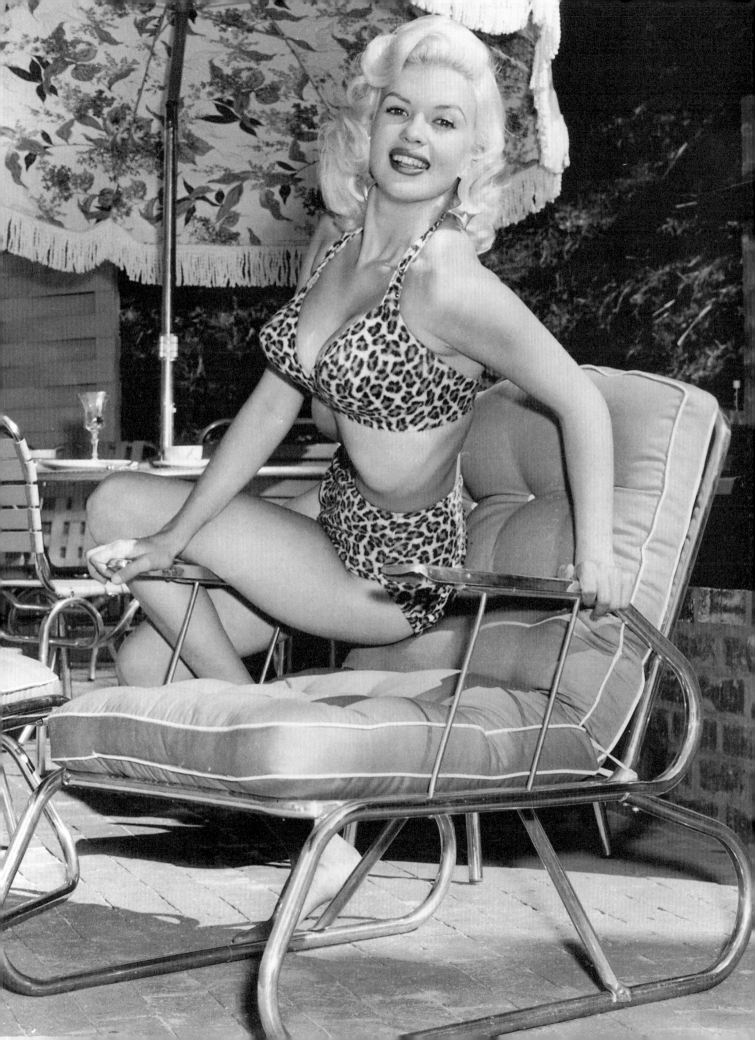

cultivate publicity. But this time, her round-the-clock, no-holds-barred media onslaught was launched upon a town that for all its sophistication had never seen anything quite like it. New York was bowled over, and a continent away, Hollywood—at last—was paying attention as well.

"I am extremely cooperative where publicity is concerned," Jayne once noted in one of the all-time understatements. "I believe a girl should be written about thoroughly." Throughout the Broadway run of *Rock Hunter*, Jayne was unrelenting in seeking publicity for the show and herself. "That's about all I did when I wasn't [on stage], sleeping or eating. I did layouts. I cooperated, you might say." Indeed, her saturation publicity reached the point where one New York daily actually posted a bulletin declaring that, until further notice, her picture was not to appear again in the newspaper.

No store or restaurant opening was too small for Jayne to make a guest appearance. Supermarket openings—typically for several thousand dollars in cash and merchandise, which neatly supplemented her Broadway income of $350 per week—would remain a Mansfield specialty into the 1960s. On one occasion, she posed in a bikini on a New York street during an eleven-degree cold wave. Every appearance contributed to the show's regularly packed houses. "This only comes once in a lifetime and I've got to make the most of it."

Jayne suggested to the show's producer, song-writer Jules Styne, that she might be overdressed in its massage scene. "Don't you think (the towel) is much too big for me?" she asked. Styne, however, insisted that the towel stay on to cover her mighty torso.

"I'm very ambitious and absolutely single-minded, and Jayne is Number One," she declared forthrightly during this period. "What I want and have always wanted is to be a movie star, and if I couldn't have done it one way, I would've in another. [Stars] don't usually talk like that, do they? Well, I do… who was going to look out for Jayne but Jayne? I'm the do-it-yourself girl." As Axelrod remarked of his star: "This dame is an unstoppable force with an absolutely monomaniacal drive to be a movie star."

On December 12, at New York's Astor Hotel for a screening of the film *The Rose Tattoo*, Jayne came face-to-face for the first time with the inspiration for Rita Marlowe and the rival who, although Jayne would rarely acknowledge it, obsessed her. Marilyn was seated at the main table with her teacher Lee Strasberg when Jayne approached, accompanied by eager photographers. Pictures were taken but no formal introductions were made, and Jayne moved on. James Robert Haspiel and Charles Herschberg recount: "As the confusion of the moment passed, Monroe and Strasberg resumed their discussion, while from across the room Jayne Mansfield continued to gaze (at Marilyn) admiringly." Whatever her public remarks may have indicated, by all accounts Jayne was in awe of Monroe.

Not long after the play's opening, with prospects of movie stardom looking up, Jayne met with MGM head honcho Dore Schary about a possible contract. The discussion, however, led nowhere, probably due to the restrictive nature of her contract with the show. Meanwhile, Jayne found a powerful ally in Hollywood gossip columnist Louella Parsons, who in January predicted that Jayne would become the foremost big-screen star of 1956.

Jayne's new celebrity led to a May 4, 1956 interview with Edward R. Murrow on the CBS program *Person to Person*.

Early 1956 also saw her as a mystery guest on *What's My Line?* and (briefly) as a panelist on a weekly quiz show, *Down You Go*. She was additionally featured in two NBC 90-minute specials; in one, the musical comedy *The Bachelor*, broadcast on July 15, Jayne turned in a breathless performance of "Heat Wave," a song closely associated with Monroe.

Jayne was attending Mae West's show at the Latin Quarter with Styne on May 26, 1956 when she first laid eyes on Mickey Hargitay, one of Mae's musclemen. Styne asked what she wanted for dinner, and she responded, "I'll take the beefsteak on the end," looking straight at Mickey. After the show, he joined them at their table. "It was love at first

sight." A hulking 6-foot-2, 245-pound Hungarian, Mickey had held the titles of "Mr. Universe 1955" and "The World's Most Perfectly Built Man." "I just wanted to find out if it was true," Jayne told columnist Walter Winchell. "You see, I'm a big girl and Mickey is the only man I've met who is big enough to satisfy me," leaving no doubt that she had more in mind than muscles.

The next day, Mickey accompanied Jayne to Brooklyn where she was crowned Blossom Queen, and quickly the new romance became public knowledge. The notoriously

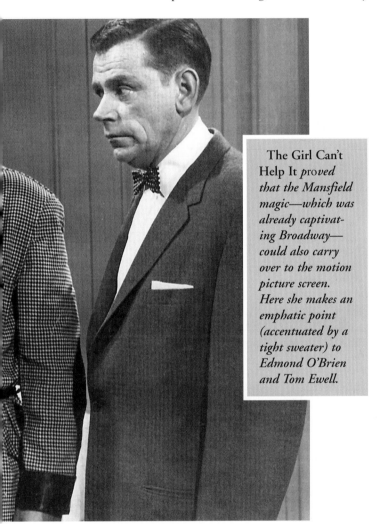

The Girl Can't Help It proved that the Mansfield magic—which was already captivating Broadway—could also carry over to the motion picture screen. Here she makes an emphatic point (accentuated by a tight sweater) to Edmond O'Brien and Tom Ewell.

possessive Mae was not about to take this lying down, so shortly thereafter she called a press conference in Washington, D.C., instructing Mickey to say that he and Jayne were together purely for publicity. Instead, he proclaimed that "I am very much in love with Jayne Mansfield and I think she is with me. We have serious plans. This is not just publicity." After a brief silence, one of Mae's massive bodyguards knocked Mickey out of his chair with a surprise blow, and reporters scrambled. True love reigned, and Jayne had a new publicity bonanza.

With Jayne's star rapidly ascending, 20th Century Fox went after the hottest new blonde on the scene. Fox had

been in litigation for a year with Marilyn Monroe as Marilyn sought control over her career, and the studio had already hired Sheree North to take her place in two films. While executives saw the possibilities in this platinum dynamo, they were also extremely wary of a one-woman publicity machine to whom bad taste was just a valuable means to an end. They also wanted nothing to do with a show that ridiculed their very livelihood, and so the courtship with Jayne was a delicate one.

James Haspiel helped Jayne prepare for a screen test, and remarked later that "I was not impressed by her histrionic ability. In fact, at one point in the test script where she recited the line, 'You men are all alike—you take one look at a girl and your buttons go pop-pop-pop!', her emphasis on the words 'pop-pop-pop!' caused me to break up." The actual screen test—using a scene from John Steinbeck's *The Wayward Bus*—evidently went better, for Fox tried to buy out her run-of-the-show contract.

Raymond Strait related how Styne employed Irving "Swifty" Lazar to play both ends against the middle between Jayne and Fox, secretly asking Frank Tashlin to write a screenplay for *Hunter* as an independent production and then approaching Anita Ekberg to play the role of Rita. This persuaded Jayne to reject the studio's initial proposed contract—which would not have included a film version of *Hunter*—and led Fox to buy out the show for $120,000. Once the film rights were sold, Jayne felt she could no longer resist the lure of a studio contract and signed with Fox for seven years at $60,000 annually, in addition to whatever she earned for each film. Shiffrin shook his head in exasperation, convinced that his over-eager client had sold herself short once again. But in any event, Jayne was now free to usher in the big-screen superstar phase of her career that had been her goal from the outset.

Meanwhile, *Hunter* continued to run; late that year, Bean left to be replaced by Tom Poston, and the show moved to the Schubert Theatre. The September 5, 1956 *Variety* reported that even though Jayne was itching to return to Hollywood, Styne and Axelrod intended to hold her to the contractual commitment to remain with the show until the following July 1. As it turned out, barely one week after the story appeared, the deal with Fox was cut and Jayne took her last bow on the Schubert stage. On September 15, after 452 performances, Jayne left the show to pursue her destiny.

After watching Jayne's screen test for Fox, director Josh Logan remarked that it was the first film he'd ever seen in which "the actress rubbed her bosom against the camera lens." The test was said to have "made the party circuit in Bel Air long before Jayne arrived at Fox."

Jayne's first picture under her new contract with Fox was a spectacularly auspicious debut. In the hands of brilliantly imaginative director Frank Tashlin, *The Girl Can't Help It* became one of the landmark films of the 50s: totally campy and over-the-top, but with a visually rich humor and a hard-rockin' soundtrack that provided a wonderfully apt symbol of the era. And Jayne was its greatest asset of all (see

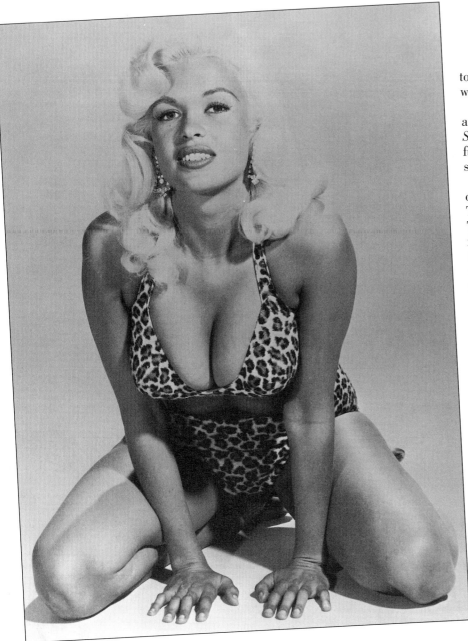

to snidely refer to her as "the American workingman's number one turn-on."

In early 1957, Jayne made her first appearance on *The Ed Sullivan Show*—playing the violin—providing further affirmation of her ascendant status.

The eagerly-anticipated film version of *Rock Hunter*, again directed by Tashlin, proved to be worth the wait. There were a number of changes made from the original show, most notably that the object of ridicule became television instead of the motion picture industry; Fox would have none of that. The film also made the character of Rock Hunter (who was referred to, but never seen, in the play) a leading role to accommodate the comic talents of Tony Randall, and eliminated the play's Satan-in-disguise character. Changes and all, the big screen *Rock Hunter*—which surprisingly earned only about half as much at the box office as *The Girl Can't Help It*—was a rousing pop culture success.

Years later, Randall offered the view that Jayne's continuing caricature of Marilyn Monroe "became an old joke very fast; and then, it became a tragic joke." Randall,

Apparently ready to pounce, Jayne strikes a memorably seductive pose in her famous leopard-skin bikini.

filmography). The film earned total domestic rentals of $3.2 million, placing it among the year's 20 biggest hits (though slightly behind Marilyn in *Bus Stop*).

"I play a girl that has the most outrageous body in the whole world, but who is totally unaware of her sex appeal," she explained. "The only thing she wants is to be a wife and mother. But sex interferes all the time. You could say that this character is really like me. That is why this is such a perfect part for me—I really understand this character."

Jayne's hopes were high that her role in the film adaptation of *The Wayward Bus* would help establish her as a serious actress. It may have been less than successful in this regard, but did provide a useful change of pace from her already stereotyped persona. During the filming, Jayne and co-star Joan Collins—two polar opposites of sex appeal—posed for some delightfully contrasting profile shots. Joan looks as if she can't wait for the photo session to end, while Jayne, as always, appears to be loving every minute of it. In her autobiography, Joan had little to say about Jayne except

however, also said he preferred working with Jayne to his role supporting Marilyn in *Let's Make Love*. "At least Mansfield tried to be a professional," he remarked. "She'd show up and rehearse and work and shoot it. At that, she was good. And she had some humor about her."

Sex symbols are often the subject of criticism regarding their professionalism, but there was none of that from Tashlin. "Her instinct is unerring," he raved. "She never blew a line. She was perfect." While Tashlin appreciated Jayne's appeal, he still professed bafflement at it. "The immaturity of the American male—this breast fetish!" he exclaimed in an interview with Peter Bogdanovich. "Imagine a statue with breasts like Mansfield's! Imagine that in marble. We don't like big feet or big ears, but we make an idol of a woman because she's deformed in the breasts. There's nothin' more hysterical to me than big-breasted women—like walking leaning towers!"

In May Mann's Mansfield biography, Tashlin recalled:

"One day she came into my office wearing a striped, tight sweater. 'Jayne!' I exclaimed with a slight impatience. 'Why do you wear a tight sweater like that with stripes? Don't! It looks so phony!' She protruded out like she had her old laundry packed inside her bra. 'But, it's all me!' she protested innocently, and started to pull up her sweater. 'It's all me!' 'Stop, I take your word for it,' I said."

Jayne's most significant 1955-57 magazine appearances—considerably edited here for space purposes—included:

Feb. 1955 *Playboy* (The famous centerfold that helped launch Jayne has her poised on a high chair in an open white shirt)
Apr. 6, 1955 *People Today* (cover, 5 pages)
Fabulous Females #1 1955 (8 full-page cheesecake pictures)
Aug. 1955 *Night & Day* (3 pages, 7 pictures)
Sept. 1955 *Movie Stars Parade* (hot bikini photo as the photographers' favorite at the May 23 opening of the Dunes hotel in Las Vegas)
Nov. 21, 1955 *Life* (on the cover along with Broadway's other top young stars)
Dec. 1955 *Nugget* (2 pages, 3 pictures, including classic cleavage shot)
Feb. 1956 *Movieland* ("New Blonde—Old Story")
Feb. 8, 1956 *People Today* (cover, classic pose leaning far forward in bikini)
Feb. 1956 *Playboy* (2 pages, 4 color pictures by Hal Adams, including terrific full-pager as she pulls her pink pajama tops above her breasts; and personality profile by Earl Wilson)
Mar. 1956 *Modern Man* (inside cover, semi-nude)
Apr. 1956 *Modern Man* (cover, 4 pages, 9 sexy photos focusing on *Rock Hunter*)
Apr. 23, 1956 *Life* (full-length cover feature, "Broadway's Smartest Dumb Blonde," including 9 cheesecake photos)
Spring 1956 *Cabaret Yearbook #2* (6 pages, 9 pictures: "Strip Tease Comes Back to Times Square")
May 1956 *Suppressed* ("Will Success Spoil Jayne Mansfield?")
1956 *Earl Wilson's Album of Showgirls No. 1* (cover in low-cut gown plus 2 pictures)
June 27, 1956 *People Today* (8 pages)
July 1956 *Photographers' Showplace #1* (terrific cover in sexy low-cut negligee and 2 pages)
Aug. 1956 *Cabaret* (splendid cleavage cover, 8 pages, and 19 pictures)
Aug. 1956 *Glamorous Starlets #3* (part cover, 18 pages, over 40 cheesecake pictures)
Fall 1956 *Glamour Photography #4* (cover of Jayne in low-cut dress, poised on all fours to show off her cleavage; also 2 pages)
Oct. 1956 *Whisper* ("Jayne Mansfield: CC of MM")
Nov. 1956 *Backstage Follies* (cover in bikini)
Nov. 1956 *Jem No. 1* (4 pages, 6 pictures)
Winter 1956 *Cabaret Quarterly #5* (classic cover pouting sexily while crouched in bed in low-cut white negligee, and back cover)
1957 *Big-As-Life Pin-Up* (21"x62" life-sized poster of Jayne in bikini)
1957 Calendar *Jayne Mansfield & Her Friends* (Jayne accompanies the months of January and April)
1957 *The Jayne Mansfield Pin-Up Book* (quite sensational full-length magazine with 100 pictures of Jayne—many quite revealing—and text by John Maynard)
1957 *Modern Man Yearbook* (5 pages, 9 pictures)

Jan. 1957 *Quick* (good cleavage cover)
Jan. 1957 *Rave* (12 pages: "The Success Story of Jayne Mansfield")
Feb. 1957 *Modern Screen* (5 pages, "My Love Life")
Feb. 1957 *Photoplay* (5 pages: "All She Wants to Be Is a Movie Star")
Feb. 1957 *Playboy* (5 pages, 15 pictures by William Read Woodfield, including 2 topless shots)
Feb. 1957 *Screen Stories* (7 pages focusing on *The Girl Can't Help It*)
Feb. 1957 *She* (8 pages, 11 pictures in the "Battle of the Blondes")
Feb. 1957 *Silver Screen* ("Will She Top Shirley Temple?")
Feb. 1957 *X-citement in Pictures* (5 pages with an abundance of cleavage)
March 1957 *Movie Stars Parade* ("What Jayne Mansfield Hides")
March 1957 *Photoplay* (lovely cover and 4 pages)
Apr. 1957 *Inside Story* ("How Jayne Mansfield Teased Her Way to the Top")
Apr. 1957 *Movie Stars Parade* ("Can Jayne Escape Those Glamour-Girl Blues?")
May 1957 *Jem #4* (quite sultry color foldout plus 4 pages, 8 total pictures)
May 1957 *Scamp No. 1* (splendid color cleavage-oriented centerfold plus 2 pages, 6 total pictures)
May 1957 *66 #19* (66 pictures of Jayne)
Summer 1957 *Cabaret Quarterly #7* (cover in bikini bottom and halter top, leaning over)
June 1, 1957 *Saturday Evening Post* (5 pages: "She Will Do Anything for Publicity")
July 1957 *QT* ("Will Jayne Mansfield Get Hollywood in Trouble?")
Sept. 1957 *QT* ("How Sophia Made Jayne a Big Bust")
Oct. 1957 *Movie Stars Parade* (article by Mickey Hargitay: "The Truth About Jayne and Me")
Oct. 1957 *Silver Screen* ("Jayne's Other Dimensions")
Oct. 1957 *Top Secret* ("When Jayne Mansfield Out-Bosomed Sophia Loren")
Nov. 1957 *Playboy* (3-page photo feature: "Loren vs. Mansfield," with two sexy solo shots of Jayne and two of the rivals' meeting at Romanoff's)
Dec. 1957 *Movie TV Spotlight* (cover feature: "Is Jayne Mansfield Too Hot to Handle?")
Dec. 1957 *Photoplay* (5-page "as-told-to" article by Jayne's mother: "Will Success Spoil My Jaynie?")

The Girl Who Would Do Anything

No Hollywood star of the era was the subject of more titillating stories than Jayne. One of the most widely circulated tales concerns her efforts to persuade Elvis Presley to perform two songs in *The Girl Can't Help It*. As the story goes, Col. Tom Parker said Elvis' minimum price for doing the numbers was $50,000. Jayne flew to Memphis to try and talk Elvis into lowering his price, and after supposedly spending the night with him, she flew back to Hollywood and called his agent to say a deal had been arranged. The agent replied, "The price is still $50,000." Jayne later commented ruefully, "I think I've been had."

Naturally, the Mansfield-Monroe comparisons began as soon as *Rock Hunter* took off. Rather than being flattered, Jayne professed to be miffed. "There's no comparison," she

declared. "Marilyn's only thirty-eight; I'm forty!" On another occasion, she responded to critical barbs by saying scornfully, "They treated me as if I were only a 36." At a New York cocktail party, Zsa Zsa Gabor sniped at Jayne, "I don't see what you've got that's so devastating." Replied Jayne, "Honey, beside me you look like Tony Randall!" For Jayne, the tape measure always provided the final word.

No Hollywood glamour girl was ever more fiercely proud of her figure and more zealously protective of its dimensions. *Life* magazine recounted a 1956 fitting for a mink coat at which the designer called out her bust measurement as a mere 39 inches. "Forty!" cried Jayne in anguish. The designer checked his tape measure again and repeated the original figure. She paled visibly, then said, "Well, this is a tight brassiere." Judging a male beauty contest in 1957 in which the winner had a 50-inch chest, Jayne quipped, "It's enough to give a girl an inferiority complex!" On another occasion, she said, "I was a 40, but now I'm a 41—honest. I didn't do anything special to get bigger, either. Maybe it's the climate here? Mickey is a 52, but I think that's too big for a girl, don't you?"

"I have a ridiculous body. My waist is practically invisible, and my bust is floundering around somewhere in the 40s. And there's no point in discussing the rest. It's a wild body, and I'm just sick of it for being so unusual. . . The only good thing about it is that it's a commercial body." When discussing her figure with even the most casual acquaintances, Jayne would typically add, "But I'm firm all over."

Jayne was never in any doubt that her body was her greatest asset. "It got me where I am. I must have a very photogenic figure. . . so there's no reason for covering it up." Her attributes were God-given and "there to exploit," she noted. "Why shouldn't I use what I have?" Who could ever forget Jayne's candid assessment: "If I didn't have a large bust measurement, I'm sure people would talk about my small one. So what's the difference? I'm glad I have a large one. . . I don't mind at all when people stare at me. In fact, I love it. There isn't much point in trying to be glamorous if nobody will appreciate it." Jayne elaborated in 1957 in one of her most self-revealing quotes: "With a figure like mine, a girl is certain to attract attention. . . I find it pleasing and necessary that men look at me." "Jayne was possessed with her cleavage—her big breasts," said *The Girl Can't Help It* producer Frank Tashlin. "They seemed to be her security."

The popular image of Jayne Mansfield as the queen of Hollywood bosoms is one that makes Russ Meyer chuckle in disdain. "She didn't have big boobs," he says today. "In fact, when I shot her, her boobs were not in great shape. . . they had stretch marks, they were just not good-looking." When Meyer photographed Jayne on the beach, "I wouldn't shoot her breasts. She just created an impression of being big, partly because she had a big rib cage, but she really wasn't. She was much smaller than (Anita) Ekberg." Meyer acknowledges frankly that "for me to shoot a girl and really get excited, she had to have really big tits," and he says Jayne simply didn't qualify.

Not a week went by in 1956-57 without a new semi-nude or otherwise revealing magazine layout on Jayne.

During one 14-month period during this time, Jim Byron estimated that her picture appeared in newspapers and magazines at least 36,000 times. For anyone else seeking a legitimate career in Hollywood, these provocative appearances might have been bad news, but not for Jayne. Once, when it was discovered that a company was selling sexy photos of her without authorization, Jayne was asked if she wanted to obtain an injunction to halt distribution of the pictures. "Injunction—are you kidding?" she quickly replied. "Send out more pictures. There must be somebody, somewhere who doesn't have one. Men, women, children, grandmothers! We were meant for each other!"

Within a short time, Jayne became known as "The Girl Who Would Do Anything" for publicity. "We ran her like a railroad," her publicity man once remarked. "We gave her a schedule at 6 a.m. and away she went." According to one account, a New York reporter, scheduled to interview Jayne in a hotel room, was startled to find her "splashing away in a bathtub with some 30 agitated members of a fan club shooting away with box cameras."

Jayne's filmography during her prime period:

The Girl Can't Help It (1956) — "The girl can't help it, she was born to please," sings Little Richard. "She's got a lot of what they call the most." The role of Jerri Jordan was tailor-made for Jayne. She's the girlfriend of ex-mobster Edmond O'Brien, who's determined to make her a star and hires down-on-his-luck agent Tom Ewell to do the trick. Ewell's big client, lovely Julie London, has left him, and he's desperate enough to take up the offer. Jerri's really a homegirl who wants nothing more than to become a wife and mother, but her body has the strangest effect on men as she struts innocently in skintight dresses—making the milkman's milk bottle erupt, melting the iceman's ice, causing another onlooker's eyeglasses to shatter, etc. The music (including Fats Domino, the Platters and Gene Vincent) is terrific, Jayne is delicious, and Frank Tashlin's direction pulls it all together in delirious fashion. Released in December 1956.

The Wayward Bus (1957) — Jayne is a stripper named Camille, and during a troubled bus journey on which the passengers come to terms with their personal problems, she becomes the unlikely companion of traveling salesman Dan Dailey. Also along for the ride is co-star Joan Collins. Quite deliberately not a glamorous role for Jayne, although she looks beautiful, but one of her better ones in this Steinbeck adaptation. Released in May 1957.

Will Success Spoil Rock Hunter? (1957) — Eager young television adman Rock (Tony Randall) is desperate to persuade glamorous movie queen Rita Marlowe to endorse the lipstick his company is representing. Rita has her own agenda, to make boyfriend Mickey Hargitay jealous, so she goes along and plays up mild-mannered Rock as her new lover, creating a popular sensation that turns his world upside down. Jayne is essentially playing herself here, as a publicity-hungry sexpot, and as such is spectacularly successful, aided by the wonderful Randall and (again) Frank Tashlin.

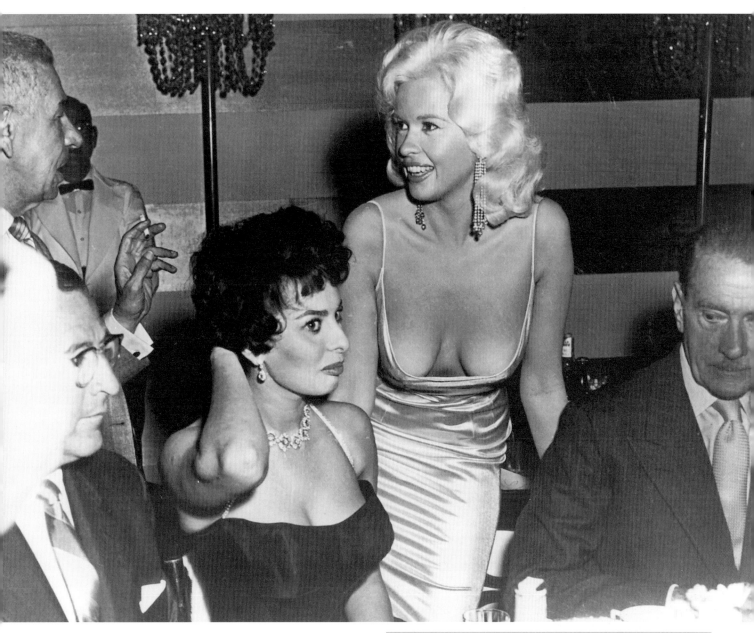

The Loren Confrontation

Perhaps no single episode of Jayne's career better exemplifies its essential character than her famous confrontation with Sophia Loren. Romanoff's Room in Hollywood was playing host to a lavish reception on April 13, 1957 to commemorate Sophia's first American film. As the evening got underway, with the air thick with celebrities, kleig lights and flashing bulbs, Jayne chafed anxiously as Sophia remained the center of attention. British journalist Donald Zec, in his biography of Sophia, describes what happened next:

". . . Jayne Mansfield took the mandatory deep breath for bulging starlets and launched herself like an Intercontinental Ballistic Missile toward the center table. She had prepared herself well for the confrontation, wearing a flimsy dress, the neckline dropping to her navel. She also announced to newsmen within earshot—she was coming

On April 17, 1957, Jayne came away the winner in a mammary showdown with Sophia Loren, but some saw her behavior as brazen. "I only wanted to . . . prove to her that we've also got bosoms in Hollywood," Jayne said innocently.

through loud and clear at a distance of fifty feet—that 'All this is me. I got absolutely nothing under this dress 'cept what nature intended.'

This said, and adding, 'Watch this!', which was as close as she could get to 'Geronimo!' on the night, she lolloped over to Sophia's table.

Jayne reached Sophia's table, positioned herself behind the guest of honor, leaned over to provide photographers with an abundance of what they were looking for, and

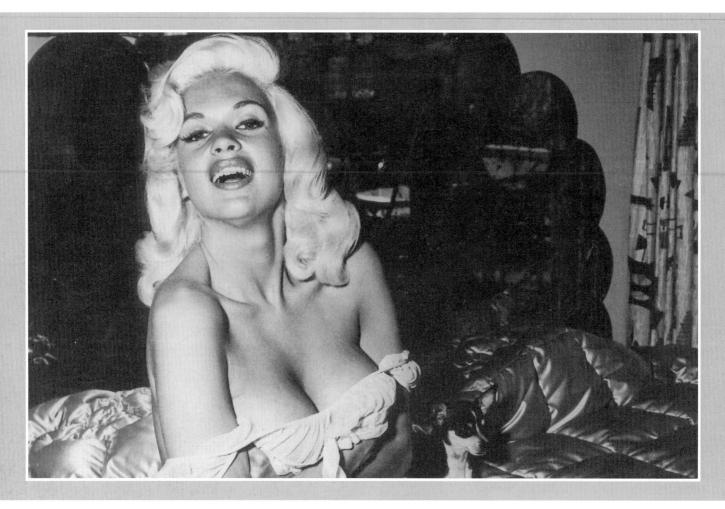

murmured, Welcome to California. I'm sure glad to see you, Miss Loren. Sophia graciously said hello in both Italian and English; then she gasped as she found herself gazing into Jayne's cavernous cleavage. Whether Sophia's stunned reaction was in response to the American's superior physical firepower or her sheer audacity depends on which side you believe.

Clifton Webb, accompanying Sophia, turned at her gasp. His gasp was even louder, bringing cameramen on the run to focus on the epic Mansfield display. Red-faced, Webb turned back to face the cameras, as did Sophia. Jayne stood directly behind Sophia's chair for five minutes while the photographers happily fired away and the Italian quietly seethed. Jayne returned to the bar. She's a silly girl. I only wanted to make her welcome and prove to her that we've also got bosoms in Hollywood. Five minutes later, Jayne repeated the whole thing for the benefit of newsreel men who'd missed it the first time. This time, Sophia was prepared for her, quietly delivering a choice Italian epithet," Zec writes.

It was a moment for the ages. There is probably no single photograph that better exemplifies the sex-symbol wars of the 50s than the shot of Sophia casting an uneasy look down at her tablemate as JM smiles dazzlingly for the cameras. Just after the photos that reverberated around the world were taken, Jayne "inhaled herself out of the dress completely," as one writer put it. Renowned Hollywood glamour photographer Earl Leaf captured it on film, but United Press killed the picture.

Afterward, Sophia said disapprovingly that she would never wear such a revealing dress. Jayne swiftly responded: "Maybe she can't afford to wear dresses like this. You know if you wave a flag it has to have something to hold it up. It doesn't just stay up by itself." The publicity was sensational, but Fox issued a stern reprimand to its irrepressible star.

After completing her fourth film in a year, Jayne went on a whirlwind 40-day European tour planned by the studio. Upon her September 1957 arrival at London Airport, she proclaimed: "I am 41. . . 18. . . 35. I'm tanned over every little inch of me!" Jayne was set to be presented to Queen Elizabeth at the royal command film performance, and announced that a "sensational" dress had been designed for the occasion that "should outdo anything that girls have worn on past occasions." However, to Jayne's chagrin, her pre-event mammary display failed to create much of a stir among the British public. This in turn led one newspaper to run a rear-view shot of her to illustrate that "male interest is shifting."

Faced with this negative press, Jayne wound up wearing a demure dress at the royal event. Another round of articles proclaimed that Jayne was "a bloody bust," and one

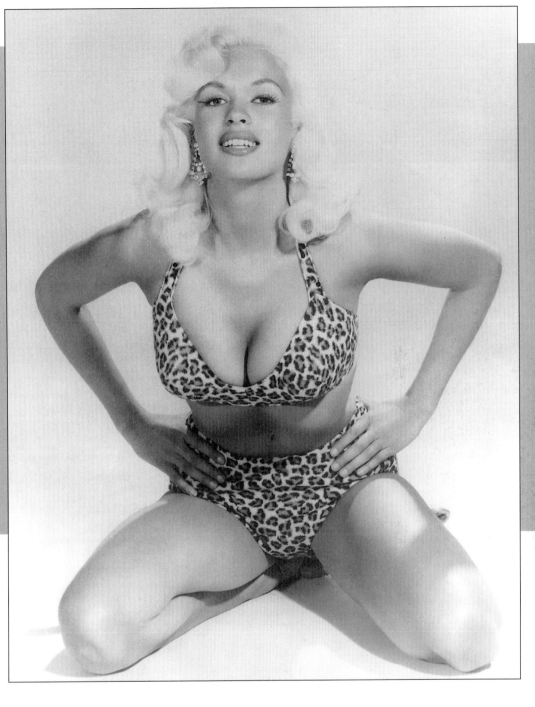

Jayne never forgot how desperately she had wanted the stardom that was now hers; perhaps no other star found such pure joy in living out her Hollywood dream. She also never lost sight of the fact that sex appeal was at the heart of her success. To the very end of her career, Jayne could always be relied upon by photographers to happily strike cheese-cake poses until the film ran out.

columnist posed the question, "Has The Bust Had It?" Despite all the barbs, Jayne drew a crowd of 5,000 in one London appearance, and unquestionably expanded her British following.

It was during this visit that Jayne encountered the woman who would become her foremost British bosom rival, 17-year-old (and 43-22-36) June Wilkinson. June was performing at the Embassy club in London, and upon discovering the custom-made cufflinks being sold which bore June's photograph, Jayne bought a pair. Today, June recalls meeting her after the show (the only time they met), and being flattered that Jayne had purchased the cufflinks—"until I heard that she had pulled my picture off and put hers on!" Jayne then gave the cufflinks to Mickey as a Christmas present. There was only one problem: Jayne hadn't realized that it was impossible to convert the carved "JW" to "JM."

While the press hinted at a Mansfield-Wilkinson rivalry, due largely to Jayne's well-known jealousy of any sex symbol more spectacularly endowed than herself, June says she felt no rivalry, and that Jayne was never a role model. "I thought she was fun, but I was never a fan of hers . . . She was always a caricature of a sex symbol. When you're doing a caricature and it's supposedly for real, that's not what I enjoy."

Just six months after the great Mansfield-Loren confrontation, another "Battle of the Bosoms" occurred in late October with an unknown Italian starlet named Angela Guy. Jayne was in Rome for a press conference when the attractive 23-year-old Italian blonde burst in, whipped off her coat to display a shapely although not voluptuous figure in undergarments, and declared, "Am I not much better than she is?" The answer in this case was "no," but before it could be put to the test Angela was hustled off by police. Jayne said she would have been glad to pose alongside the

interloper after the press conference and let photographers decide, although the opportunity never came.

One of the most sensational public appearances of Jayne's career came that same month when she appeared with Mickey at the Screen Publicists' Association's Ballyhoo Ball at Paramount Studios. Jayne generated gasps with her leopard-skin bikini, and her provocative poses on stage, while hundreds of flashbulbs fired away, produced some of the hottest of all clothed Mansfield pictures. In the big climax, Mickey (in his own leopard-skin swim trunks) held her horizontally aloft above his head, the pose that would grace so many of their later public appearances.

"The first step was to get all the men all stirred up. That's about completed. The next step—the one I'm working on now [late 1957]—is to get all the women stirred up. After that, I'll take a crack at the intellectuals."

Ever eager to market herself, Jayne scored big with the hot water bottles shaped in her curvy image, a creation of gag-product inventor Don Paynter. It was well known that every morning Jayne would scour the newspapers looking for a mention or a picture which would then be ceremonially stored in her voluminous scrapbooks. Even Byron worried about this, remarking a few years later, "If she could have emphasized her comedic talents rather than her personality . . . then maybe Jayne could have become a better actress."

Actor Jim Stewart later recalled in an interview with *High Society* magazine that Jayne and Byron would regularly plant "blind items," such as "Does Kazan want Jayne Mansfield for the lead in *Baby Doll?*," with gossip columnists to keep her name in the papers. Soon thereafter, "when we were driving, she'd always want to stop to get all the papers and read the columns and look for her name. Then she'd say, 'Oh, God, Kazan wants me for *Baby Doll!*' It was her own plant and she didn't know it!"

Eliot Stark, one of Jayne's press agents, remarked on her genius for publicity: "She has the perseverance of a Sisyphus, the press presence of a master politician, the timing sense of an all-American quarterback, and the planning and tactical skills of a Napoleon."

No account of Jayne's life would be complete without reference to her self-professed IQ of 163. There can be no doubt that she was an extremely shrewd woman in a number of respects, but claims that she possessed a genius-level intelligence are completely unsupported. If Jayne's assertion was true, her career takes on an added level of sadness considering how such a gift was squandered.

For Jayne, the ultimate proof of her acceptance as a full-fledged movie star was her selection by Fox as co-star to Cary Grant in *Kiss Them for Me*. She knew that the film was no classic, but that hardly mattered—little Vera Jayne Palmer was going to be on the big screen with Hollywood's ultimate icon, one of the same larger-than-life stars she had dreamed about as a little girl. She was also persuaded to do the film against the advice of others by Fox's promise that she could star in her fantasy project, *The Jean Harlow Story*—an empty promise designed solely to mollify her.

Working with Cary Grant, Jayne was so awed that (in the words of one crew member) "she was like a tourist on her own set." As the co-star in one of the few Cary Grant films to flop at the box office, Jayne's professional status was taken down a peg, but her celebrity burned brighter than ever.

Kiss Them for Me (1957) — Cary Grant is one of three Navy flyers on holiday in San Francisco during World War II. There, they meet voluptuous Jayne and svelte Suzy Parker. Uneven comedy-drama; for Jayne fans the most cherished moment is during the big party scene when a well-built brunette walks past her and says, "Thirty-nine," to which Jayne thrusts out her chest and proudly replies, "Forty!" Released shortly before Christmas.

Sheriff of Fractured Jaw (1959, Brit.) — Enjoyable Western spoof in which an English gun manufacturer (Kenneth More) decides to do business in the frontier town of Fractured Jaw, and falls in love with Jayne, who runs the local hotel/saloon and knows how to handle herself with a pair of six-guns. When the cowardly More is elected the new sheriff, comic trouble ensues. Directed by Raoul Walsh. Jayne's songs are lip-synched by Connie Francis.

Living Out the Dream

On January 13, 1958, Jayne and Mickey were married in a spectacular wedding which became a publicity extravaganza, at the Wayfarer's Chapel in Palos Verdes. Twentieth Century Fox had tried to discourage first the relationship and then the marriage, but once Jayne made it clear how strong their love was—and how steely her determination was—the studio decided to help make it a true event. Jayne's wedding gown was a floor-length, skintight bell-bottomed pink lace gown that was fashioned at Fox, and attendance was limited to 100 "close friends," almost all of whom turned out to be reporters, photographers and press agents. Several thousand enthusiastic well-wishers cheered the newlyweds outside.

After their Miami honeymoon, Jayne and Mickey hit Las Vegas for a six-week engagement at the Tropicana. This was the debut appearance of Jayne's breathtakingly transparent net sequined dress, later adapted for her film *Too Hot to Handle*. Patrons got more than their money's worth as they gawked at the Mansfield breasts and other body parts inadvertently exposed while Mickey swung her about the stage.

After the wedding, the couple moved into her dream mansion on Sunset Boulevard, known thereafter as the Pink Palace. Originally owned by Rudy Vallee, it was located in the Holmby Hills section of Beverly Hills, just a short drive from the heart of Hollywood. She had purchased the house two months earlier for the then-princely sum of $76,500. Over the next few years, it was redesigned and reconstructed by Mickey, and even though many of its furnishings were provided for free (courtesy of companies aggressively persuaded by Jim Byron and Jayne to contribute their products for the publicity value), the couple still poured hundreds of thousands of dollars into the place.

There, she was able to live out all those girlhood

fantasies, and was able to give free rein to her outlandish image of how a movie star ought to live. This included the famous heart-shaped swimming pool with Mickey's giant carved inscription "I Love You, Jaynie" on the bottom in two-foot-high gold mosaic tiles; eight bedrooms and 13 baths; a grand-scaled pink mink living room; heart-shaped bed and fireplace; a pink Cadillac[2] (Mickey's gift to her after the birth of their son Miklos), a pink Jaguar, a red Lincoln convertible and a white Eldorado Cadillac; a closet full of minks (white, pink and black); twice-weekly baths in pink champagne, and more. The home

The boudoir was always a favorite setting for a Mansfield photo session, offering ample opportunities to show off the physique in which she took such pride. "A 41-inch bust and a lot of perseverance will get you more than a cup of coffee—a lot more," she quipped.

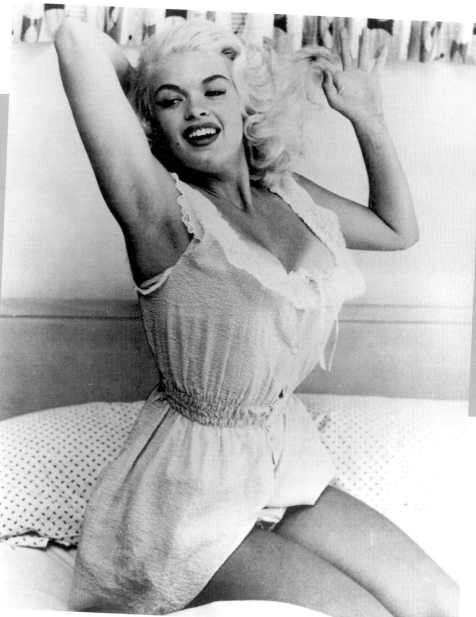

was later owned (in succession) by Ringo Starr, Cass Elliot of the Mamas & Papas, and then, for many years, by singer Englebert Humperdinck.

Passionate pet-lover Jayne gave the full run of the palace to her menagerie, which contained two Great Danes, four Chihuahuas, one Scottie, four monkeys, several cats, two parakeets, and a turtle. During this period, MGM wooed Jayne with a pink Cadillac, a pink Jaguar, pink rhinestone phones, and a three-year supply of pink champagne to bathe in, but she remained under contract to Fox.

After a year off the screen, Jayne's next film was *The*

Sheriff of Fractured Jaw, shot in England and Spain and directed by one of Hollywood's most respected veterans, Raoul Walsh. The picture caused barely a ripple in American theaters, but it was pleasant enough and did Jayne's career no harm. She filmed *Sheriff* while pregnant with Miklos (Mickey, Jr.), who was born in December 1958. While filming *Sheriff*, she was offered the lead female role in another European production, *The Loves of*

Hercules, which she accepted on the condition that Mickey play Hercules. It was filmed over a year later, with Jayne once again pregnant (with Zoltan) during the shooting in early 1960.

During an early 1959 visit to Brazil, enthusiastic fans ripped part of Jayne's dress off at the Copacabana Hotel in Rio de Janeiro while tearing hand-picked roses that had

2. According to Sabin Gray, Jayne's '57 pink Caddie turned up nearly three decades later in Aretha Franklin's video for "Freeway of Love."

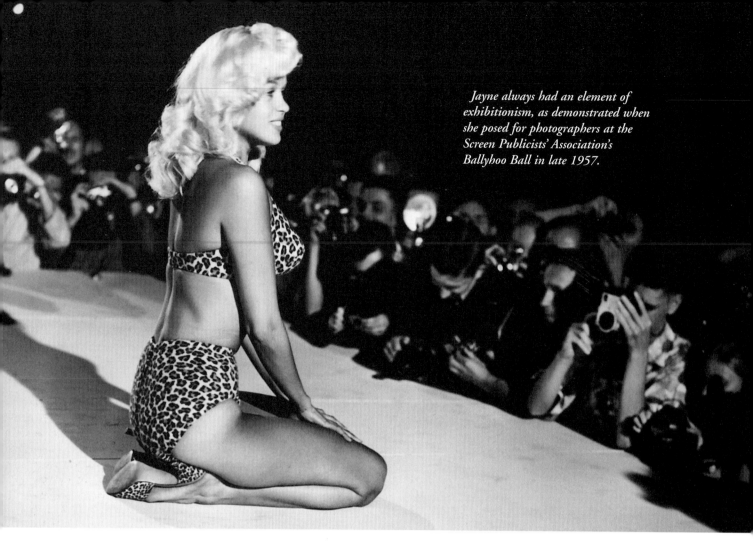

been sewn atop her cleavage. It began simply with several dancers plucking flowers for souvenirs, but when the flowers were gone someone unzipped the dress and souvenir-hunters tore it to shreds. Since Jayne, as always, was wearing nothing underneath the dress, the crowd was treated to plenty of exposure. The cheesecake paparazzi had endless opportunities to snap near-topless pictures before Mickey took off his jacket and wrapped it around her, escorting his blushing wife through the crowd. Jayne obliged with a smile, both hands covering her breasts. "The boys just got a little excited," she said later. Jayne also reportedly caused a three-car collision near the beach during her excursion in Rio by distracting drivers as she cavorted in a bikini. Similarly, on a European trip, Mickey lifted Jayne above his shoulders so that she could pick grapes from a tree. Just as the photographers positioned themselves, her dress strap broke and she immediately became front-page news on all the European tabloids. Jayne loved every minute of it.

Right around this time, the Rev. Billy Graham made Jayne a symbolic figure by declaring, "The present generation knows more about Jayne Mansfield's statistics than the Second Commandment which orders that 'thou shalt not make thee any graven image.'"

Jayne concluded the 1950s by going on her second Christmastime USO tour with Bob Hope. Two years earlier, she'd accompanied his troupe to the Far East; in his book *"I Owe Russia $1200,"* Hope joked about how she was a knock-

out at Wake Island when she went for a dip "in a pink angora bikini studded with rhinestones and pearls." A 1959 journey to Alaska was considerably more rugged. "There's never a dull moment with Mansfield in the Yukon," Hope recalled. "If she bows, she could start an avalanche." Hope was so impressed with Jayne that he invited her back for a third tour in 1961 in Greenland. According to his humorous account, on a night when the area was battered by 100 mph arctic winds, Jayne became hysterical because she'd lost an earring in the snow—and a thousand G.I.s promptly dashed outside with flashlights searching for the diamond bauble. Jayne could never say no to an appeal for help—or to an opportunity to perform before thousands of screaming servicemen.

Jayne's 1958-59 magazine appearances included:
Jan. 27, 1958 *Life* (3 pages on Jayne and Mickey's wedding)
Jan. 1958 *Modern Man* (cover lying in low-cut nightie talking on her personalized phone, and 2 pages)
Jan. 1958 *Night & Day* (terrific cleavage cover)
Feb. 1958 *Playboy* (5 pages, 6 semi-nude studies by William Read Woodfield: "The Nude Jayne Mansfield")
Apr. 1958 *Inside Story* ("Why Hollywood Is Closing Its Doors on Jayne Mansfield")
Apr. 1958 *Modern Screen* (9-page article/interview by May Mann on Jayne's wedding)
Apr. 1958 *Silver Screen* ("Jayne Mansfield's Marriage Gamble")
c. 1958 *Jayne Mansfield: Spotlight On the Stars No. 1* (British pocket magazine devoted to Jayne with cover plus 14 pages of

cheesecake poses, by Barry Kramer)

Oct. 1958 *Photo Life No. 1* (centerspread and 5 pages: "Is Jayne a Bust in Hollywood?")

Dec. 1958 *Night & Day* (cover standing outside in very low-cut white negligee)

Dec. 1958 *Playboy* (1 page, 2 pictures)

Jayne Mansfield 1959 Calendar (12 color shots)

Modern Man 1959 Yearbook of Queens (back cover, 4 pages, 10 pictures, including a 3-picture sequence from the Loren confrontation)

Playboy Playmate Calendar 1959 (1 page)

Playgirl Calendar 1959 (Jayne on cover in white mink bikini but not inside)

Dec. 1959 *Tab* (6 pages: "What Jayne Mansfield Really Did in Rio")

The Sixties: On the Way Down

As the new decade began, Jayne's "legitimate" movie career was essentially over, even though it would be several years before she realized it. From this point on, she would appear in a series of low-budget European "B" movies designed to show off as much of the Mansfield anatomy as possible, but providing little display of her comedic talents as an actress.

There were plenty of reasons for the low regard in which 20th Century Fox now held Jayne, among them the succession of box office flops, the crazy stunts, and their executives' doubts about her acting ability. Nevertheless, the studio's treatment of a star who had made it considerable money in at least a few films can be fairly described as tawdry. Raymond Strait recounted how Fox would regularly receive $250,000-$300,000 a picture for each loanout, while Jayne would simply continue to get her regular salary. Her requests for a new contract were unavailing. Incredibly, when Jayne finished *The Loves of Hercules* while pregnant, Fox put her on suspension without pay until she was again available for work. After giving birth to Zoltan and her subsequent children, she made a point of returning to work within days of being released from the hospital.

In 1960, Fox loaned her out to do two independent gangster thrillers in England. In *Too Hot to Handle*, Jayne played a stripper in a seamy Soho nightclub. In what was considered an "adult shocker" for its time, she performed in a totally transparent evening gown with rhinestone clusters barely covering her breasts and buttocks. Two versions of the dress were made, one for European consumption and one for American audiences. To avoid censorship problems, Jayne suggested, "someone should cover the offending areas with a spray gun." The retouching of the negatives would have cost more than the entire budget of the film. As it was, the actors called a halt to the movie when the money ran so low that they were not getting paid. 20th Century Fox came through with the necessary $250,000 to rescue the floundering melodrama after Jayne called collect. After completing two more European films in which she was forced to work 16 hours a day, Jayne hurried back to Hollywood.

In late 1960, Jayne was honored on Ralph Edwards' *This Is Your Life*, and, although clad in a bursting playtex dress, was given the big buildup as a domesticated mother and housewife. Jayne's love for her children was beyond question,

but particularly as her career descended and her personal problems mounted, the responsibilities of motherhood often took a back seat to other concerns. Around this time, Fox lined up a major movie, *It Happened in Athens*, for Jayne, but her high hopes were dashed again when the project fizzled.

Jayne and Mickey headlined at the Dunes in Las Vegas in December 1960. In an act called "The House of Love," Mickey perfected his adagio dance skills by whirling Jayne around his body effortlessly. Jayne performed in scanty showgirl costumes, rhinestone swimsuits and spiked high heels. For her services, she commanded $25,000 per week, the highest amount ever paid to a performer in Vegas at the time. The act proved such a hit that Jayne extended her stay and 20th Century Fox Records subsequently released her show as an album, *Jayne Mansfield Busts Up Las Vegas* (FX-3049), in 1962. As 1960 ended, Jayne couldn't be happier.

Betty Brosmer, the hourglass-figured blonde who was one of the 1950s' top pin-up models, today remembers meeting Jayne and Mickey at a 1960 New Year's Eve party at the Dunes. "She was really out there, on Cloud Nine," Betty recalls. "People were looking at her, and she was just playing to her audience." However, the times were changing, and Jayne decided to drop her endlessly inventive publicity agent Jim Byron and Hollywood contact Bill Shiffrin in an attempt to carve out a more sophisticated image. Gone were the days when Byron and Jayne would market her used bathwater for $10 a bottle, or pose for gag shots by cranes reading "Danger, Excess Frontal Overhang." The new Jayne announced that she wanted to study acting in New York, a la Marilyn. "Maybe I'll do a Russian play." She hired the high-powered public relations firm Rogers & Cowan to build the new image. Along the way, however, someone told Jayne they need a new "Queen of the Desert Rodeo" in Tampa. . . and she took the next plane out to Florida instead.

In a typical day, Jayne would tell a group of mothers, "Sex has nothing to do with body proportions," and later quip to a reporter, "a 41-inch bust and a lot of perseverance will get you more than a cup of coffee—a lot more." She simply wanted to be all things to all people. "My job," she remarked at one time, "is to appeal to everybody. Men look for sex appeal, women for identification, and children for a fairy story figure. I hope to get across all three. . ."

Jayne's reliance on racy publicity had set her on the path to fame, but it would also prove to be her downfall. On one occasion in Las Vegas, she spent a night with a prominent agent and a chorus boy, only to be discovered by the agent's wife. A stormy divorce trial led to a cash settlement for the wife. Afterward, Jayne excitedly bet her assistant Raymond Strait that "no other star was worth $100,000 for an hour in bed." She was simply never able to differentiate between the private and the public life, even after it hurt her career.

Jayne's early-1960s filmography:

Too Hot to Handle (1960, British, released in the U.S. as *Playgirl After Dark*) — Jayne is stripper Midnight Franklin, hapless partner of crooked nightclub owner Leo Genn. After being blackmailed by a rival strip club owner, Jayne and

friends expose the double dealings of the strip racket to the London authorities. Jayne sings three numbers in her sideless, backless, topless fishnet dress. "Under the naked glare of the spotlights, the girls who rock the night as tease queens strut their stuff!" enticed the ads. Jayne's two musical numbers are hot stuff indeed, although the rest of the film is actually rather tame, and enabled her to do some fairly convincing "straight" acting. Directed by Terence Young, who later introduced moviegoers to Agent 007 in *Dr. No*.

The Challenge (1960, Br., aka *It Takes a Thief*) — Jayne is the ruthless leader of a gang of thieves tracing stolen loot in the London fog. She "adds some hilarity to the proceedings undulating beneath a brunette wig and snarling like fury," one reviewer remarked. Most memorably of all, Jayne appears in black lingerie and has her first movie topless scene in this grim melodrama when an angry Carl Mohner starts ripping off her clothes. Anthony Quayle co-stars. Jayne sings "The Challenge of Love" over the opening credits.

The Loves of Hercules (1960, Italian; aka *Hercules and the Hydra*) — A must-see Mansfield movie. See Jayne play a helpless princess and an evil Amazon queen. See Jayne spreadeagled between two trees as Hercules throws axes at her. See Jayne menaced by a seven-foot ogre. And don't miss the valley of talking killer trees. Mickey Hargitay plays Hercules; both their voices are atrociously dubbed, and her bust is so padded out that it's a miracle she was able to stand.

The George Raft Story (1961; aka *Spin of a Coin*) — Biography based on Raft's extraordinary life, starring Ray Danton. Jayne (who is second-billed), Julie London, Barbara Nichols and Barrie Chase appear at varying interludes as his girlfriends. Jayne portrays sexy movie queen Lisa Lang, patterned after Betty Grable.

It Happened in Athens (1962) — Jayne is Eleni Costa, a famed Greek actress who is to marry the winner of the marathon at the 1896 Olympics. Since she is much desired, every able-bodied man in Greece sets out to win her. Expecting her lover to triumph, she is shocked when a poor shepherd boy crosses the finish line first. The highlights of the film are Jayne's revealing gowns and lingerie. Filmed in 1960, not released until two years later.

Jayne's filmography of the 1960s was summed up by one critic as "one of the most consistently awful in cinema history." However, the Europeans didn't seem to think so; in Rome, she was honored as Italy's most popular actress in 1962. During the ceremony Jayne was knocked to the floor in a vicious cat-fight with a jealous rival, Alma de Rio, who felt she deserved the award. It was the first in a series of violent encounters Jayne was to have throughout the '60s. It seemed that if she didn't invent a publicity stunt, someone else would provide it for her. As her publicist said, "agents lost respect for her. They forgot she had talent because of the schlocky things she'd do."

On a second honeymoon with Mickey in Nassau in February 1962, a suspected publicity stunt almost proved fatal. Jayne had been water skiing with Mickey when a hotel publicist, Jack Drury, spotted a shark. Jayne panicked and fell from her skis. Mickey and Drury managed to capsize the little boat in the ensuing panic. Hours later when the three

didn't show up for a press conference to announce her next picture, a massive sea rescue was launched. The discovery of the partially submerged boat, which had been hastily abandoned, sent newsmen dashing to send out the word that "Jayne Mansfield is Feared Dead."

Almost 12 hours later the three were discovered, all suffering from exposure and shock. The press treated the episode as a hoax that had backfired on Jayne. Pictures of a teary-eyed Jayne being reunited with her family at least provided a rewarding end. The affair slightly recalled an interview Jayne had given the previous year in which she described a planned publicity stunt that never came off: she was to fly with an actor friend over the southern California desert, land, and then get lost. Then-agent Jim Byron vetoed the idea. Regardless of whether the Nassau incident was a revision of this scheme or the real thing, it gave Jayne the worldwide attention she so cherished.

Scarcely recovered, Jayne and her family toured 23 states on an extraordinary promotional tour for the Raft film, which was to be her last featured role in a major Hollywood film. While the box office rewards were minimal, Jayne was happy that "at least it was a quality production. It's different and I'm proud of my work in it."

On July 3, 1962, 20th Century Fox, to no one's surprise, announced that they were not picking up their option on Jayne's contract. None of her films had been successful in over four years, and the failure of *It Happened in Athens*—in addition to her own offscreen antics—proved the final straw. As she had done when dropped by Warners seven years before, Jayne told everyone she was "delighted" by the action.

Marilyn Monroe's death the following month placed Jayne even more in the public eye as a possible successor. Jayne felt pressured, looking with concern to her own future as a sex symbol; her escalating marital problems with Mickey didn't help matters. Her love affairs always created their own excitement, and Enrico "Boom Boom" Bomba, a portly film producer in Rome, provided the passion that seemed so necessary to her life. So if movie roles of note wouldn't arrive, she could compensate with publicity, romance, and pin-ups. Later, it would be drugs and alcohol.

Bomba would serve as Carlo Ponti to Jayne's Sophia Loren, at least in her imagination. They would form their own production company with tailor-made starring vehicles for Jayne. This would be her opportunity to forsake the sex and become a serious actress, she hoped. Kurt Frings was to become her new manager—the same Kurt Frings who managed Elizabeth Taylor, one of the few actresses Jayne openly admired.

At the outset of 1963, Jayne's career was clearly in decline. When her feverish imagination calmed down enough for her to see the light, she realized this. "Once you were a starlet. Then you're a star. Can you be a starlet again?," she asked.

Jayne's magazine appearances from 1960-62 included:
Modern Man 1960 Yearbook of Queens (cover reprise of her Winter 1956 *Cabaret Quarterly* white negligee pose)

Feb. 1960 *Playboy* (6 pages, 15 pictures: "The Best of Jayne Mansfield," a 1955-59 retrospective including 2 pages of semi-nude shots in her *Too Hot to Handle* see-through outfit)

Apr. 1960 *Modern Man* (3 pages: "Mansfield Dance Makes London Broil" as Jayne performs with Mickey)

Modern Man 1961 Yearbook of Queens (4 pages, 10 pictures, including one sensational cleavage shot in underwear and towel as she clutches her breasts together)

Mar. 1961 *Modern Man* (superb glamorous cover, 3 pages, 8 pictures: "Mansfield Revisited")

July 1961 *Modern Man* (3-page feature on the "Battle of the Blondes," with Jayne and Marilyn facing off in photographs and comments about one another.)

Aug. 1961 *Sir Knight Vol. 2-8* (inside cover and 4 pages, 11 sexy pictures from *Too Hot to Handle*)

Fall 1961 *Fling Festival #7* Fall 1961 (cover, 7 pages, 12 pictures; "My Life, My Loves")

Jan.1962 *Hush-Hush* ("Jayne Mansfield's Disgraceful Battle of the Bosoms")

Sept. 1962 *Whisper* ("Jayne and Mickey: Biggest Pair of Boobs in the Business?")

The Nude Route

Since *Too Hot to Handle*, Jayne's films had come and gone with little notice from the general public. That same fate would not await *Promises, Promises*,[3] thanks to her decision to become the first big-name star to take it all off on the big screen. After a dozen films as a comic actor (including *Gentlemen Prefer Blondes* as Marilyn's meek lover), Tommy Noonan had turned producer/screenwriter as well, and persuaded Jayne that baring all, if only in a couple of scenes, was not only necessary to the plot, but would prove box office dynamite. Since Jayne would receive 10% of the film's profits, this was all the inducement she needed.

To help assure that outcome, Noonan also convinced Jayne to allow *Playboy*, her longtime ally, to shoot behind-the-scenes nudes for a sensational pictorial designed to generate excitement for the film. Jayne not only agreed to the plan, but did the pictorial without compensation. Considering that the June 1963 issue of *Playboy* (with a cover proclaiming "The Nudest Jayne Mansfield") became the biggest seller in the magazine's history to that point—its press run of two million flying off the newsstands so quickly that individual copies were going for $10—this may not have been the wisest business judgment in her life. Later she admitted, "I was a little off, wasn't I? I could have been paid $20,000 for a centerfold sitting."

On the actual day of shooting, Jayne consumed a magnum of champagne before her big nude scenes. According to Raymond Strait, Jayne's longtime personal secretary and author of *"The Tragic Secret Life of Jayne Mansfield,"* she had asked for a closed set. "But it was more like front row in the Follies with cameras." The resulting footage got the film banned outright in Cleveland. Hugh Hefner was charged with obscenity for publishing the layout, particularly for the shots of a nude Jayne writhing in bed. The jury was divided—seven for acquittal, five for conviction—and the case was dismissed. Jayne appeared at a Cleveland press conference and declared that she was indeed not obscene. "The

only complaints I've heard are that the scenes are not nearly long enough!" She went on to cattily remark: "Why don't we all just put on our neck-to-ankle gowns and go back to the caves? I'm sure the wives of these officials, who probably do not have my physique, are somewhat behind these actions." All the juicy publicity wasn't quite enough to make the film a hit, although it ran for 15 weeks in Los Angeles and enjoyed box office success in several other cities.

For the next several years, a 100-foot, 8mm silent film was advertised in men's magazines as "Jayne Mansfield Uncensored—The Most Banned! Bared! And Barred Film Ever! For Private Exhibition Only!" While the ads led some to believe this was a previously unseen nudie reel of Jayne, it actually consisted of the familiar scenes from *Promises*.[3]

The decision to do nude scenes in an exploitation film ruined any chance Jayne had of returning to "A"-caliber Hollywood productions, but at least a part of Jayne didn't really care. "It was art for art's sake—my theme for the future," she declared. But Jayne's true theme was doing whatever was necessary to keep herself in the public eye, however kitschy and camp it might be. As a friend once said, "She would rather have done 'Jungle Girl Goes to the Moon' than do nothing."

By mid-1963, Jayne embarked on a series of nightclub tours. Soon Bomba, like Mickey, would be a thing of the past. To massage her ego, Jayne headlined a burlesque act that toured throughout the U.S. She performed a couple of show tunes, did a little stand-up comedy with the audience, and capped the evening with a striptease routine. Upon its debut in Las Vegas, Jayne remarked: "Deep inside every woman there are certain devices to attract a man's attention—devices to attract a man's eyes to what he should be attracted to. I've always sensed this. . . I know the experts say a girl can be just as sexy in high-necked dresses, but that's the hard way. If handled tastefully, cleavage seldom fails. In this strip I do, I have the perfect chance to attract men's eyes, so I want to be just right. It's a challenge." In a bouffant blonde wig, net bra, pasties, and rhinestone G-string cover in black netting, Jayne performed a sizzling tease which earned a standing ovation. "Ooh, this is wonderful. . . I've always thought it's the role of women to spread sex and sunshine in the lives of men. This was the perfect way to do it."

The heavily publicized act was the toast of Vegas. From there it played to enthusiastic crowds in Atlanta, Louisville, Buffalo, and Washington, D.C. Jayne was arrested at the Brandt Inn in Burlington, VT, for indecent exposure and the strip act was pulled after only three shows (for which she earned $7,500). The publicity helped produce sellouts in her remaining appearances on the tour. In between all this, Jayne still had time to give birth to another daughter, Mariska Hargitay, in January 1964. Mariska has since become a successful TV and movie actress in her own right.

"What I sell is not pure sex, but laughs, a satire on it,"

3. The original working title was "Promise Her Anything"

she said of her nightclub act. "I always ask the wives present if I can play with their husbands for a minute, and I only kiss a few bald heads. Everyone seems to enjoy it, as they are all part of it."

Around the spring of 1964, Jayne signed a contract with Art Laboe's Original Sound Records, famous for the sensationally successful *Oldies But Goodies* album series. The contract called for at least four recordings a year, but in fact she made only one 45 for the company (OS-51): the '50s-styled rocker "That Makes It" and a remake of the 1954 Kitty Kallen hit, "Little Things Mean a Lot"—a deliberately ironic selection for the ultimate size queen.[4] The previous year, Jayne had recorded a novelty album for MGM Records, *Shakespeare, Tchaikovsky and Me* (MGM E 4202), in which she did poetry recitations backed by classical music. There was also a British single by Jayne in 1966, "As the Clouds Drift By" (London HL-1014) and a German-language release on Polydor that same year.

During this period, Jayne also turned up frequently on television. In February 1962 she graced an episode of the Fox series *Follow the Sun* called *The Dumbest Blonde*, which garnered excellent reviews. She was featured on two episodes of *Alfred Hitchcock Presents*, including a broadcast that December (titled *The Hangover*) with her *Rock Hunter* movie co-star Tony Randall. One of her best-remembered appearances was a lively one-hour exchange with Zsa Zsa Gabor on Jack Paar's show in January 1963. She also graced the Jack Benny and Red Skelton programs in 1963; Benny did the same comedy sketch with Jayne that he had performed with Marilyn Monroe a decade earlier. In March 1964, she guested on *Burke's Law*.

The most famous line used to introduce Jayne on a TV variety show—originated two decades before by Bob Hope in reference to Jane Russell—was adapted by Dick Cavett as guest host on *The Tonight Show*: "And here they are, Jayne Mansfield!" Jayne generated some humorous publicity in 1964 with a gag "presidential campaign," featuring the inevitable tag line, "The White House or Bust!"

That same year, Jayne, quite appropriately, took over two of Marilyn's most famous roles in road-company versions of *Bus Stop* and *Gentlemen Prefer Blondes*. (She toured the East Coast with *Blondes* again in August 1966.) Her director was the much-younger Matt Cimber, and as was so often the case with Jayne, the professional relationship crossed over into the bedroom. Jayne and Mickey had gone through a rapid succession of breakups and reconciliations during the previous several years, but the end was finally at hand—even though he continued to appear with her on stage.

Jayne was often on an emotional roller coaster during the '60s, and at one low point in 1964 she declared: "I wish it would all end, right now, right here. This minute. What a mess I've made of my life." In true Mansfield fashion, however, she was able to overcome this bout of despair and move on to the next job with rekindled optimism.

The success of *Bus Stop* in the East and Midwest meant that Jayne would open up to bigger audiences on the West Coast. Ideas of a return to Broadway filled her head once again, as she saw renewed evidence of her enduring celebrity status in Los Angeles. That status was given an unexpected boost when The Beatles cited Jayne as the American movie celebrity they would most like to meet, and Jayne got together with the foursome at the Whiskey A-Go-Go. According to Strait's account, the meeting ended when George Harrison sloshed his glass of Scotch at an inebriated Jayne, and instead caught Mamie Van Doren flush in the face.

Meanwhile, the relationship with Cimber was blooming. Together they formed Jaymatt Productions and purchased the rights to "Homesick for St. Paul." On September 24, 1964, they were married; on the day of the wedding, she told a friend, "I think I've made a big mistake."

4. In 1985, both songs turned up on the wonderful 1985 Rhino Records album compilation "Va-Va-Voom! Screen Sirens Sing!"

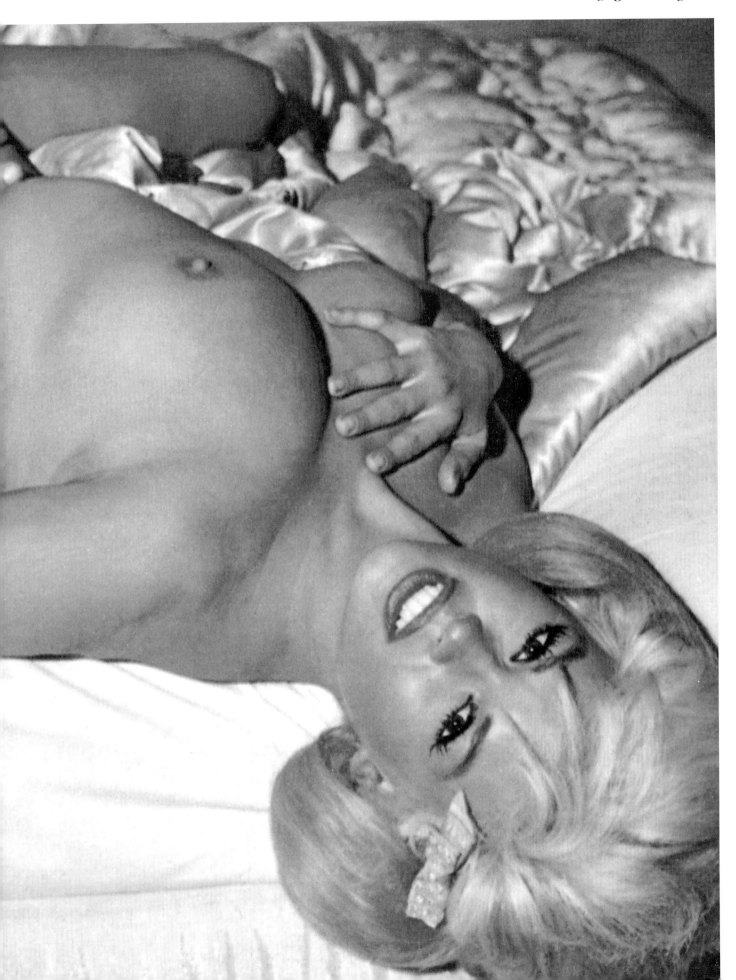

Jayne's filmography from 1962-65:

Panic Button (1962, Ital.) — Maurice Chevalier is a faded Hollywood actor hired by Mike Connors to appear in an awful production of *Romeo & Juliet*, designed by Connors as a money-losing tax writeoff. With Jayne as a no-talent starlet in the role of Juliet, it seems a sure-loser proposition. But the film is celebrated as a wonderful satire—the most one can say of *Panic Button* itself. Not released in the U.S. until 1964.

Spree (1962; aka *Las Vegas By Night*) — Dull travelogue of Vegas celebrities at the Tropicana and the Dunes hotels. Jayne and Mickey appear, and Jayne performs her satire on a strip. This one didn't reach American theaters until February 1967, and then only briefly, apparently due in part to a lawsuit filed by Juliet Prowse and Vic Damone to prevent their names from being used in advertising for the film. After Jayne's death, it received slightly wider distribution.

Dog Eat Dog (1963, Ger.-It.-Yugo.) — Two bank robbers make off with a million dollars, and along with Jayne as a flossy attracted by the money, they head to a remote island in the Adriatic Sea. The three double-cross each other, and after violent confrontations—resulting in death by fire, strangulation in a goldfish bowl(!) and drowning—no one is left alive, except an insane old woman who watches the cash float out to sea. The opening scene is perhaps the best for Jayne fans, as she lets her manager into her room while wearing just a towel.

Promises, Promises (1963) — Jayne and Tommy Noonan, as a childless couple wishing to change that condition, take a cruise to forget their troubles. A couple in an adjacent cabin (Mickey and Marie McDonald) is in a similar situation, and after numerous drinking bouts and partner confusions, both Jayne and Marie end up pregnant—but who are the rightful fathers? Of course, most viewers couldn't care less as they relished Jayne's nude scenes. No fool, Noonan made the most of the two brief scenes by repeating them at various intervals in the film: one with Jayne emerging from the bathroom topless, and another as she tosses and turns in bed. Jayne also sings two numbers. The black-and-white film was made on a shoestring $400,000 budget, and it certainly has a cheap look about it. But for ogling purposes its value is considerable.

Homesick for St. Paul (1964, Ger.) — Musical starring Freddy Quinn as an ex-sailor turned popular singer who is lonesome for his days in Germany. Jayne co-stars as a sexpot star entertainer whom he secretly follows to an engagement in Hamburg, and various adventures follow. Never saw a wide U.S. release, and may be Jayne's most obscure film.

Primitive Love (1965, Ital.) — As an anthropologist, Jayne sets out to prove that the language of love is universal by showing a film of marital practices around the world. When all else fails, she performs a seductive striptease for two stunned and delighted hotel porters to demonstrate her point, and at its conclusion is seen topless briefly from the back. Padded out with a lot of stock footage; saw only a brief U.S. theatrical release in 1966.

The Loved One (1965) — A film advertised as having "something to offend everyone," it certainly did Jayne's fans; her brief appearance as a receptionist (in a scene with the film's star, Robert Morse) was cut from the final print.

Jayne's new image with wild teased hair, heavy black eye makeup, swinging-'60s street clothes and gold go-go boots marked her attempt to make the transition into the new mod generation. Her struggle to come to grips with a transformed popular culture was doomed to failure. As Martha Saxton observed, "In the Fifties, Jayne and American men had conspired to keep sex a secret. By the Sixties the secret was out. . . the wave of sexual honesty deprived Jayne of a persona. She couldn't sell her illicit appeal when the country had taken the sin out of sex."

Cimber was unable to get her the "A" movie roles she still longed for, but arranged a steady schedule of talk shows, guest spots and personal appearances to keep her in the public eye. Ironically, Jayne rejected a potentially rewarding contract for a TV role in *Gilligan's Island*, with Tina Louise taking the part instead.

Jayne temporarily left the Pink Palace for a more sedate New York brownstone. Cimber kept her busy with stage work throughout this period: *The Champagne Complex*, Herman Wouk's *Nature's Way* (a 1965 Canadian tour in which Jayne, the female lead, was pregnant), and *The Rabbit Habit*. After the latter play flopped during a West Coast tryout, derailing hopes of a return to Broadway (and losing a reported $60,000), she opened in January 1966 at New York's Latin Quarter. In one of the city's worst winters, fans lined up around the block, demonstrating to her and the industry that the name Mansfield still possessed star quality; she played to packed houses for nearly six weeks. But then a country-and-western tour Cimber organized to tie in with *Las Vegas Hillbillies* (in which Jayne co-starred with Mamie Van Doren) proved such a disaster that Jayne was mercifully released from her contract after only three days.

Today, Mamie—while more sympathetic to Jayne in retrospect than she was at the time—still has disparaging memories of her old rival. Jayne "was an embarrassment to me—always taking her bra off, dangling her tits in public. She looked cheap. I didn't want people to categorize me with her."

Filled with insecurities and doubts about the future, Jayne poured all her energy and emotion into a Cimber-directed film which she felt offered a great opportunity: *Single Room Furnished*. "My career is moving in a sensitive direction. . . I want to make a big indentation in the world." To her great disappointment, the film could not find a distributor during her lifetime. "It's not necessarily the greatest, but I'm certain this picture would make people sit up and realize what I could do."

DeDe Lind, a 1967 *Playboy* Playmate, had a bit part as a dancer in *Single Room Furnished* and today has only positive memories of working with Jayne. "I admired her a lot. She was very friendly on the set—not a prima donna at all—and very professional."

Jayne's final films:

The Fat Spy (1966) — A cosmetics tycoon is searching for a legendary fountain of youth on a Utopian island. Jayne is the seductive daughter of the tycoon, played by Brian Donlevy.

Las Vegas Hillbillies (1966; aka *Country Music, U.S.A.*) — Ferlin Husky stars as a Tennessee farm boy who inherits a Las Vegas casino. Jayne plays a nightclub entertainer appearing in a dream sequence singing "That Makes It." One of Jayne's worst ever. Since she and co-star Mamie Van Doren loathed one another, doubles were used for the scenes in which they were to appear together.

Single Room Furnished (filmed 1966, released 1968) — Jayne is Eilene, a voluptuous woman admired by her teenaged neighbor Maria. When Maria tries to emulate Eilene, her parents tell her the woman's pathetic story. She had been left penniless and alone after her boyfriend discovered she was pregnant; she died her hair black and became a waitress, but is abandoned by her ruthless boss. She is forced to give up the child for adoption, changes her name yet again, and becomes a prostitute. A new man arrives on the scene, and then shoots himself when Jayne rejects him. Directed by Matt Cimber.

A Guide for the Married Man (1967) — Even though Jayne had only a cameo in this Gene Kelly-directed comedy, it provided her fans with a wonderful last memory of their favorite at her sexy best. Robert Morse, in trying to instruct Walter Matthau on what not to do in carrying out an affair, invokes the example of Jayne's liaison with Terry Thomas. Jayne loses her bra in Terry's bedroom, and they both scramble madly to find it lest the wife discover this evidence of his infidelity. Jayne innocently suggests that if his wife finds it she might think it's hers, as he rolls his eyes at this fantastic notion. Hilarious and fun. The film was released almost simultaneously with Jayne's death.

The Wild World of Jayne Mansfield (released 1968) — The Mondo Mansfield story, with Jayne being ogled in Rome, club-hopping in Paris, visiting a nude massage parlor, judging a transvestites' contest, attending a "bust-off" competition which she unfortunately does not enter, and relaxing in a nudist colony on the Mediterranean. Includes clips from *Loves of Hercules* and her strip in *Primitive Love*. After Jayne's death, a tour of the Pink Palace by Mickey was tacked on.

Hollywood Blue (1970) — A compilation of erotica from past features. Mickey Rooney and June Wilkinson talk about various celebrities, including Jayne in *Promises, Promises*.

Jayne's key magazine appearances from 1963 onward:

Winter 1963 *Modern Man Annual* (classic cover in see-through negligee, and one page)

Feb. 1963 *Modern Man* ("Jayne Talks About Her Love Affair— Italian Style")

Spring 1963 *Modern Man Yearbook of Queens* (3 pages)

May 1963 *Modern Man* (3 pages focusing rather belatedly on the film *Playgirl After Dark*, aka *Too Hot to Handle*)

May 1963 *Adam Vol. 7-8* (5 pages, 13 pictures)

June 1963 *Playboy* (The most famous Mansfield layout of all, "The Nudest Jayne Mansfield"—8 pages and 26 pictures taken behind the scenes of *Promises, Promises* by Bill Korbin; closing full-page color nude of Jayne in bed is a Mansfield classic.)

Nov. 1963 *Hush-Hush* ("The Day Jayne Mansfield Bared Too Much")

1964 *The Best from Playboy #1* ("The Complete Jayne Mansfield" certainly lives up to its title, with 16 pages and 41 pictures, sampling from all of her *Playboy* layouts. There's also the bonus of a sensational, previously unpublished double-page spread of Jayne nude and face down in bed while smiling for the camera during shooting of *Promises, Promises*.)

May 1964 *Modern Man* (3 pages, 9 pictures)

June 1965 *Fling* (cover in bikini)

Sept. 1964 *Naked Truth* ("New Cold War: Bosomy Jayne vs. Fiery Zsa Zsa")

Dec. 1965 *Playboy* (one page and 3 recent topless poses in the magazine's "Portfolio of Sex Stars")

March 1966 *Modern Man* (absolute classic vintage cover in orange polka-dot blouse unbuttoned to reveal ample cleavage, plus 1 page)

Summer 1966 *Modern Man Yearbook of Queens* (2 pages, 6 pictures)

Aug. 1966 *Beau* (cover, repeat of the classic Winter 1956 *Cabaret Quarterly* cover in low-cut white negligee, plus 3 pages)

Sept. 1966 *Eye* (cover with plenty of cleavage; "Jayne Mansfield Says: 'If You Want to Be a Big, Red Hot Mama—'")

Fall 1966 *Figure Photography Quarterly* (classic lingerie cover)

Jan. 1967 *Playboy* (3 pictures as one of the "Sex Stars of the Fifties")

March 1967 *Fling* (superb bikini cover, inside cover, 8 pages, and 24 total pictures, many from *Promises, Promises*)

Sept. 1967 *Modern Man* (4-page career retrospective)

Winter 1967 *Fling Festival* (year-end; a 6-page, 18-picture tribute to Jayne, mostly from *Promises, Promises*)

Aug. 1980 *High Society* (terrific feature: cover, 6 pages, 23 pictures)

Jayne Mansfield Fan Club Newsletter: Sabin Gray published 37 issues of the newsletter from 1982-1991. All are filled with enjoyable Jayne retrospectives, memorabilia, interviews, and items contributed by fan club members.

May 1987 *Hollywood Studio Magazine* ("Hollywood's Saddest Sex Symbol," cover and 6 pages, and article by Brian O'Dowd and Sabin Gray)

1993 *Jayne Mansfield vs. Mamie Van Doren: Battle of the Blondes* (Shake Books edition; 127 pages divided between the bombshells with movie posters, magazine covers, cheesecake shots, and other pleasures)

The End of the Line

To keep the IRS at bay, Jayne traveled farther and farther afield to find work. She toured South America for two months in the summer of 1966 before being stranded in Venezuela for refusing to pay her exit charges for the money she'd made in the country. Jayne contacted American lawyer Sam Brody to help her out of the legal entanglements, including a nasty custody battle over Tony Cimber, her young son with Matt. Brody had been Melvin Belli's associate in the Jack Ruby trial. The fact that Brody had

skillfully sorted out her finances seemed as good an excuse as any to start a wild affair with the lawyer. The unlikely couple had met in September 1966 when Jayne was appearing at the Fremont in Las Vegas. Their first date seemed prophetic: "He lost $20,000 gambling last night and he didn't even care," she told May Mann. Both Jayne and Sam would lose thousands more through various misadventures over the coming months.

When Jayne's son Zoltan was mauled by a lion during a visit to Jungleland, her long vigil at the hospital earned sympathetic press coverage. At one point she was thrown out of the hospital due to her drinking and her violent fights with Brody. A stressed Jayne said wearily at a press conference, "It's been so turbulent, my life. . . It's my destiny." Her choice of words was to be frighteningly accurate.

Jayne's final movie, *A Guide for the Married Man*, saw her as voluptuous as ever in her first major Hollywood production since 1961. After her cameo appearance in the film, Jayne broke away from her latest nightclub tour to the Far East, where she appeared in Bangkok nightclubs and entertained the troops in Vietnam. She arrived in Saigon on February 14, 1967 in a silver miniskirt and black boots, and complied with requests to wear even shorter skirts in the following days. Jayne laughed delightedly when presented with a special "combat bra"—two oversized pink steel pots fashioned together with webbed belts and emblazoned with the unit's insignia.

While Jayne's acting services were unwanted by Hollywood, her body, while a bit heavier than in her prime, was still in demand. She posed near-nude for a German girlie magazine, proving that after 33 years and five children, she remained spectacular. In March 1967, Jayne made her first trip to England in nearly eight years, and her British fans saw a new Mansfield as she struggled to keep in style with the dollybirds of Carnaby Street. There, she delighted photographers by posing in a see-through fishnet skirt worn over a sequined bikini.

She generated a furor in the House of Commons when, clad in a low-cut micro miniskirt, she sat in the chair reserved for the Prime Minister's wife. The British tour, however, proved to be a catastrophe. She performed at clubs in Yorkshire, Scarsborough and Middlesex until the tour promoter terminated her $8400-a-week contract because she was regularly late, and because her unfit condition and "disfiguring black and blue marks from the knees up made it impossible for her to wear the miniskirts called for in performances." Two other club owners quickly stepped in to hire her—for rock-bottom prices. Jayne was denounced as "a goddess of lust" by the bishop of Ireland's County Kerry, and her Irish tour was cut short as well.

More sordid publicity followed after her return to the Pink Palace. Daughter Jayne Marie asked the police for protective custody from her mother and Brody, with an ensuing trial that left Jayne's fans deeply concerned. Links with the Church of Satan and a curse invoked upon her were among the bizarre and negative aspects of Jayne's final few months. Suffice it to say that Jayne's continual optimism, although often strained, kept her afloat.

Although she desperately wanted a chance to relax, Jayne was still so deeply in debt that more nightclub tours were necessary to keep the money coming in. In June, she filled in for old adversary Mamie Van Doren at the Gus Stevens Supper Club in Biloxi, Mississippi. On June 28, by one account, Jayne had actually been scheduled to film the pilot of a talk show with Danny Thomas, but ABC cancelled her appearance when she insisted on a complimentary plane ticket for Brody. Instead, she went to Biloxi.

That day, she wrote to friend and biographer May Mann, "Doing record business down here. . . Samuel sends his love." After her performance that night, Jayne, Sam and three of her children (Mickey, Jr., Zoltan and Mariska) piled into a Buick and drove toward New Orleans, where Jayne was to appear on a TV interview show the following morning. At approximately 2:15 a.m., the road ahead was obscured by the mist of a mosquito-spraying truck in the distance. Before driver Ronnie Harrison could stop, the car plowed under a large trailer truck, immediately killing Jayne, Brody and Harrison. The children were cushioned in the back, and survived.

At the time of her death, Jayne had felt things were looking up with a number of opportunities available, although all were several levels below what she would have considered during her prime. A burlesque house had offered her $20,000 per week for her act with Mickey. A West Coast tour of *Jayne Goes to College* was to have taken her to numerous university campuses. Additionally, producer Al Adamson had signed Jayne for a role in the horror movie *The Castle of Dracula*.

In looking at the life of Jayne Mansfield, there is a temptation to emphasize its tragic element. "There's an old adage: 'Be careful of what you wish for or it will surely come true,'" Jayne once observed. "My dream was to become a glamorous film star, and now I find it isn't worth it." Even though the dream turned sour, however, Jayne could never let it go. If she had known back in 1954 all the adulation, turmoil and heartbreak she would go through in the years to come, would she have chosen a different course? The answer is almost unquestionably "no." This is a woman who so craved the childhood vision of stardom, and derived such pleasure from its attainment, that one can hardly imagine her pursuing any other destiny.

As her old friend Walter Winchell said, "Jayne was an original—a legend in her own lifetime." Her sudden death seemed only to secure that larger-than-life status. From start to finish, Jayne's lavish lifestyle epitomized Hollywood fantasy at its finest. From the pink champagne fountains to the heart-shaped bathtubs, Jayne's spirit captured the essence of the golden age of glamour.

(Special thanks to British collector Neil Kendall for his valuable contributions to this chapter. Thanks also to Peter & Alice Gowland, Russ Meyer, Mamie Van Doren, June Wilkinson, Betty Brosmer, and DeDe Lind for their recollections; to Sabin Gray, founder and president of the former Jayne Mansfield Fan Club, and to Mansfield researcher John Guzman.)

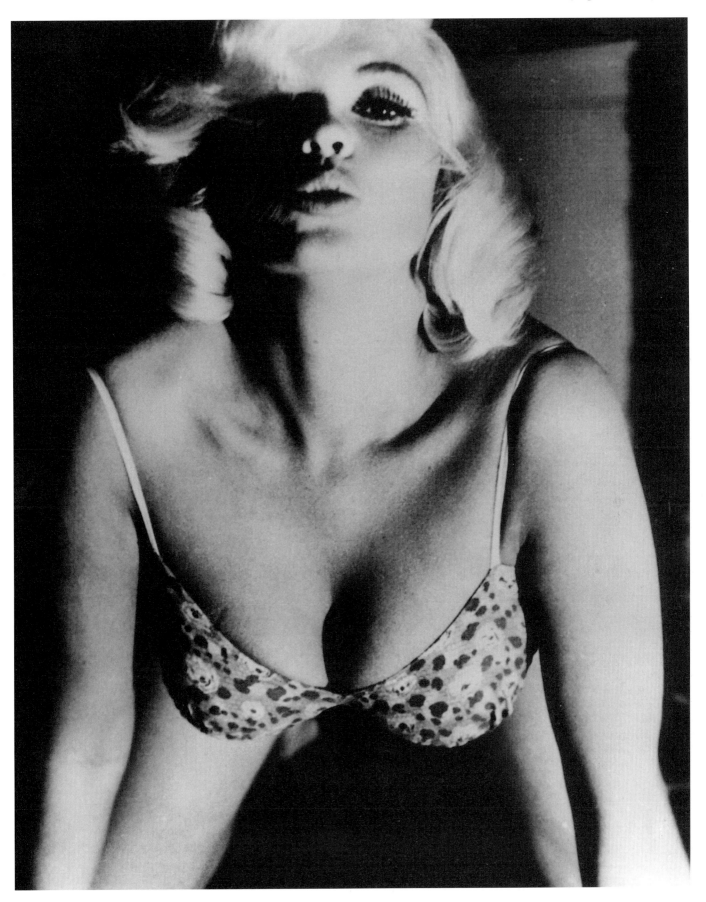

VaVaVoom!

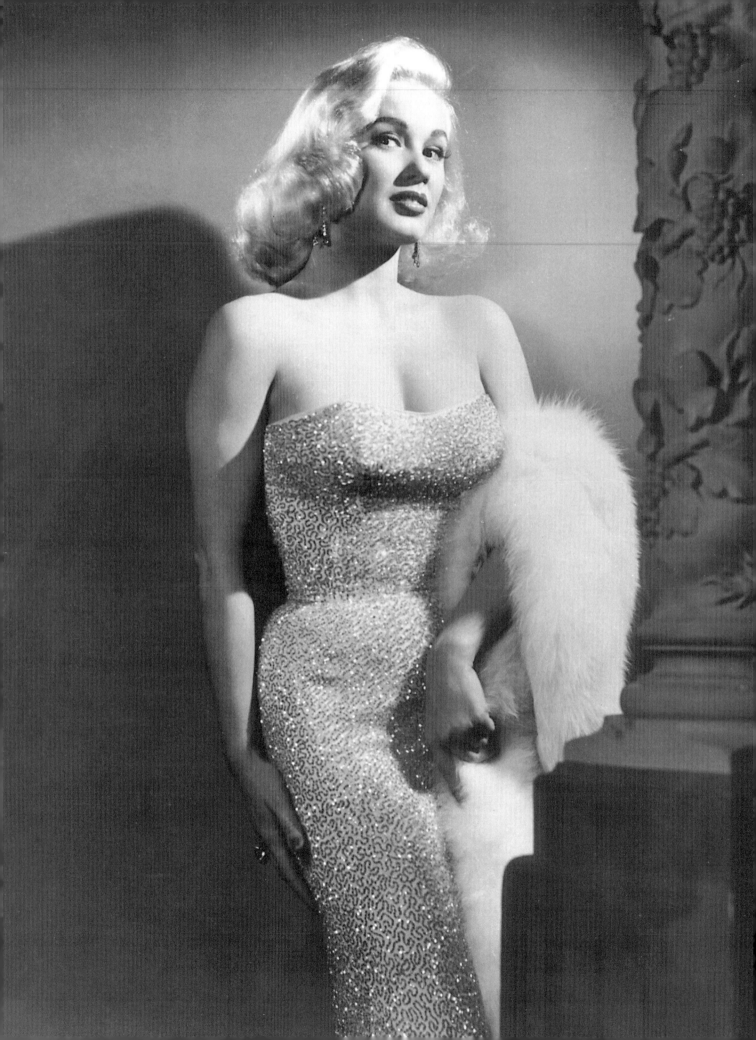

Far from being just another of the Hollywood blondes, Mamie was unique in ways that remain important from today's perspective. Where Marilyn was deeply ambivalent about her bombshell image and Jayne frequently tried to renounce it even while carrying the image ever further, Mamie reveled in her sex-symbol persona with no regrets or excuses. While her two contemporaries were traditional in their musical and pop cultural tastes, Mamie was the first female screen star to identify herself with the emerging phenomenon of rock 'n' roll. And most notable of all, Mamie cast aside hidebound clichés of females as appendages to their men, boldly making clear to studio bosses and the world that she was an independent woman who would do as she pleased. She will forever be identified with the '50s, but Mamie was truly a woman ahead of her time.

Born Joan Olander in Rowena, South Dakota, Mamie developed a love for the distant glamour of Hollywood as a young girl, and when her farm family moved to Los Angeles in 1942, the tinsel and glitter was suddenly spread out before her. In her autobiography, *"Playing the Field,"* she described her professional start at an already-shapely 13 as *Little Joanie, the Flower Girl*, on one of the first television shows (1946) to have been based in Hollywood. At 15, after winning a pair of beauty contests, young Joan came to the attention of RKO Studios—and a sharp-eyed connoisseur of the feminine form named Howard Hughes.

Whatever his eccentricities in other areas, Hughes' judgment in this regard was on target. He got Joan a bit part in a John Wayne aviation epic, *Jet Pilot*, which, despite being held from release at the time, led to brief appearances in other RKO films. She got married, and divorced (to men's sportswear manufacturer Jack Newman, whom she'd met in Hollywood and who proved to have a violent temper), then spent the summer of 1950 as a Las Vegas showgirl. During this period she also posed for the man who made pin-ups a classic art form, legendary illustrator Alberto Vargas; the resulting portrait appeared in the July 1951 issue of Esquire. Vargas had seen pictures of her in several magazines and asked her to pose nude for him. Joan was "thrilled" with the opportunity, and received $250 for the afternoon sitting. She said later she had not hesitated in posing nude: "I've never been ashamed of my body."

It was while playing a sexy showgirl in the short-lived 1951 Broadway musical *Billion Dollar Baby* (billed as "Zaba Olander") that Joan became involved in two of the many high-profile relationships that were to recur throughout her life: singer Eddie Fisher, whom she dated a couple of times, and, more seriously, former heavyweight boxing champ Jack Dempsey. She'd met Dempsey because his restaurant/saloon was near the theater where she was performing, and they were involved in a well-publicized affair for a time.

Returning to California, Joan got her first real manager, the great composer Jimmy McHugh, who also managed several starlets and female singers. A sexy performance as the ingenue in a Los Angeles production of *Come Back, Little Sheba* opened the door for a plum role in the film *Forbidden*, a seven-year deal (with two-year options by the studio) with Universal International—and a name change suggested by UI. As of January 20, 1953 Joan Olander became Mamie Van Doren.

Mamie Van Doren

Born Joan Olander, February 6, 1931
Rowena, South Dakota

Her Early Filmography:

Jet Pilot (made 1949-50, released 1957)—Stodgy Cold War aviation drama starring John Wayne and Janet Leigh, with Mamie in a small role as a WAAF; not released for years afterward because Howard Hughes became hopelessly bogged down in editing 25 hours of film.

Two Tickets to Broadway (1951) — Janet Leigh and Tony Martin star in this pleasant, old-fashioned musical; Mamie is one of many glamour girls playing small roles here, including Joi Lansing and Mara Corday.

Footlight Varieties (1951) — Jack Paar stars; a bit part for Mamie.

His Kind of Woman (1951) — Small role for Mamie as an unnamed girl in a strong, sexy crime drama starring Jane Russell and Robert Mitchum.

Young Joan's early magazine appearances included:

Dec. 1949 *Glamorous Models* (Joan is featured in two full-page bikini shots; the figure that would later dazzle millions was still in the process of developing, but the blonde teen-ager already has a winning smile.)

Apr. 1950 *Cover Girl Models* (6-page layout on rising young starlet Joan).

July 4, 1951 *People Today* (1 picture of Joan being squired by Dempsey.)

1953-1955: Starlet Days

In her biggest role to date, Mamie played a cafe waitress in her first movie under the new Universal contract, *The All-American;* but it would be her second film, *Yankee Pasha*, in which the first significant element in the Mamie legend was born: the "bullet bra." She was neither the first nor the last to wear the outrageously padded concoctions with bullet-shaped cones, conceived as a method to circumvent Hollywood's restrictive Hayes code; if truth be told, Mamie was blessed with natural curves that may have rendered the "enhancement" superfluous. But the bra would become identified with

her nonetheless, so much so that 35 years later, a New York artist would create a three-dimensional bust of Mamie with bullets flying out of her brassiere. Mamie is quick to add that no padding was used in the making of the mold for the artwork: "It's all me. I was identified with breasts at the time, and my breasts upstaged me quite a bit. Because of the way things were at the time, I had to hide them, which was a shame."

By 1953, the brightest new star in the Hollywood firmament was Marilyn Monroe, and while constant comparisons became grating, the two were on friendly terms personally. It would be a few years before Mamie succeeded in escaping from the Monroe shadow to carve out a persona all her own.

Her personal life at the time was highlighted, after Jack Demspey, by 21-year-old Ohio State football star Johnny Mesdea, Ted Stauffer (Hedy Lamarr's ex-husband), Reno millionaire Bill Stead and then renowned playboy Nicky Hilton.. Not long thereafter she met, fell in love with , and in August 1955 married trumpeter/bandleader Ray Anthony.

Meanwhile, in her film career she was working regularly, but lost the dream role of Ado Annie in Oklahoma to Gloria Grahame. Mamie also turned down the lead in Broadway's Will Success Spoil Rock Hunter. "The one mistake I will always kick myself for is not doing *Hunter*," she later said.

Mamie had yet to carve out an identifiable screen image—other than that of another beautiful, bosomy blonde—but that would change in a hurry following the release of *Running Wild*, a film she didn't want to make. After her sensuous singing and dancing performance in this teen exploitation flick, Mamie was to be indelibly stamped into the pop-culture psyche as the definitive "bad girl" who served as the irresistible recruiting agent for juvenile delinquency. She would also thereafter be associated with the most incendiary of musics, rock 'n' roll, beginning a relationship that would serve her well during her comeback some 30 years later.

Mamie's 1953-55 Films:

Forbidden (1953) — Mamie turns up as a singer in a solid drama starring Tony Curtis.

The All-American (1953) — Another Tony Curtis flick, here portraying a troubled college football star; Mamie has her largest role to date as the girl who tempts Curtis at her off-limit bar.

Hawaiian Nights (1953) — No information available.

Yankee Pasha (1954) — Swashbuckling adventure/romance in which a heroic Jeff Chandler rescues Rhonda Fleming from a Moroccan harem. Mamie is featured as harem slave Lilith.

Francis Joins the WACs (1954) — As Mamie notes in her book, none of the contract players at Universal could escape the *Francis the Talking Mule* pictures starring Donald O'Connor, and this was Mamie's turn; she plays Cpt. Bunky Hilstrom. Mara Corday and Allison Hayes are among the other lovely ladies on hand.

Ain't Misbehavin' (1955) — Chorus girl Mamie's hip-swinging helps carry this musical starring Rory Calhoun and Piper Laurie.

The Second Greatest Sex (1955) — Pleasant musical about the women of a small Kansas town who weary of their husbands' brawling and barricade themselves in a fort to protest; Jeanne Crain and Bert Lahr are among the other principals along with Mamie.

Running Wild (1955) — The first of Mamie's many teenage-delinquency films; she's the girlfriend of a car thief, who is ultimately won over by a rookie cop who goes undercover to break up the racket.

Some of Mamie's 1953-55 magazine appearances included:

June 1953 *Screenland* (2 pages and article, "Just Call Me Mamie!," describing her as "the biggest threat to Marilyn that any studio has been able to find so far")

Fall 1953 *Movie Pin-Ups* #5 (2 pages of cheesecake shots)

Sept. 1953 *Piccolo* (cover kissing Richard Long in *The All-American*)

Sept. 28, 1953 *Tempo* (cover, 1 page)

Oct. 1953 *Photo* (inside cover, 8 pages: "Mamie Moves In on Marilyn")

Nov. 1953 *Gala* (2 pages, 3 pictures; Mamie "sizzles more than Marilyn!")

Nov. 11, 1953 *Look* (brief profile)

Feb. 1954 *Eye* (7-page, 13-picture layout, including some fine swimsuit-clad cheesecake shots, portraying Mamie as a new competitor to Marilyn)

Feb. 9, 1954 *Look* (feature: "Call Me Mamie")

Feb. 1954 *Photo* (5 pages, 7 pictures)

Mar. 12, 1954 *Cine Revue* (very glamorous cover portrait)

Apr. 1954 *Silver Screen* (with Nicky Hilton)

June 1954 *Modern Man* (1 page)

Dec. 1954 *Celebrity* (7-picture layout noting Mamie's chief problem: is she too much like Marilyn?)

Jan. 1955 *Movie Stars*

Jan 1, 1955 *Tabloid Weekly News* (cover in low-cut gown)

1955 *Movieland Pin-Ups* #1 (2 pages, 1 leggy color shot)

1955 *Fabulous Females* #1 (6 pages, 8 pictures, outstanding cheesecake)

Feb. 19, 1955 *Picturegoer* (cover, great leg-art shot in shorts and sweater)

March 4, 1955 *Tempo/Quick* (cover in low-cut white dress, and 2 pages)

May 14, 1955 *Picture Week* (cover) May 23, 1955 Tempo (cover in white shorts and dark brassiere)

June 1955 *Photoplay* (gorgeous leg-art cover in slinky, low-cut white dress)

Sept. 10, 1955 *Picturegoer* (cover, curled on chair in shorts and tight blouse)

Sept. 1955 *Span* (4 pages)

Nov. 1955 *Movie Stars Parade* (in "Pin-Up Parade")

Nov. 1955 *National Police Gazette* (part cover)

1956-1959: Queen of the B's

Soon after the birth of her son Perry in March 1956, Mamie was informed that Universal would no longer require her services because her screen image was not exactly consistent with that of a wife and mother. Free to work for other studios, she was soon busier than ever. Her next film, *Untamed Youth*, solidified Mamie's association with rock 'n' roll, much to the discomfort of Big Band graduate Anthony. This led to Mamie's 1957 debut as a headliner in Las Vegas,

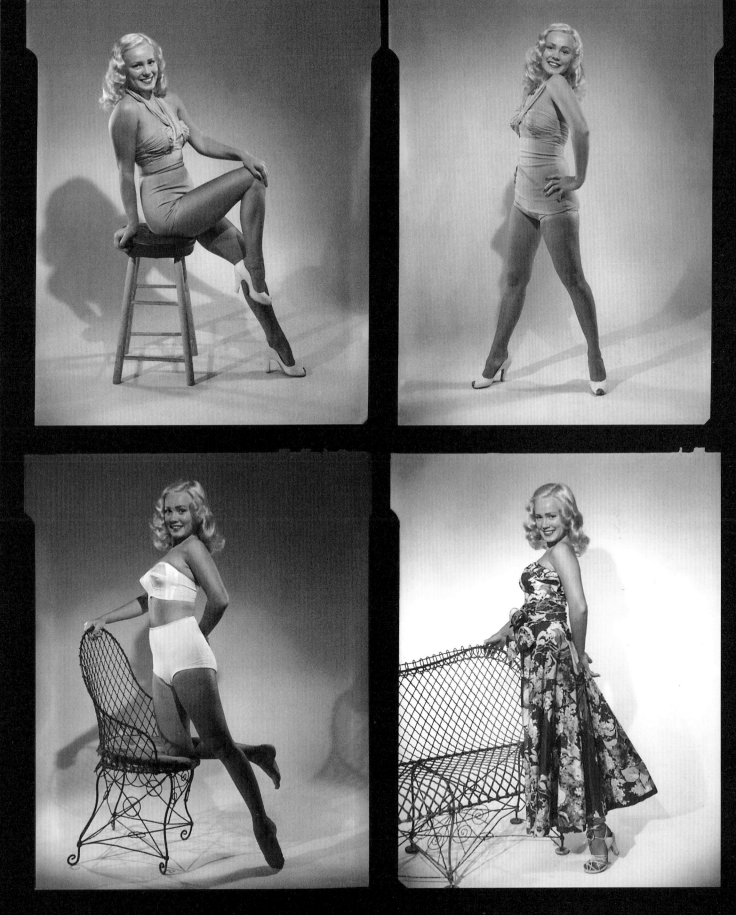

Joan Olander was still a fresh-faced teenager when Peter Gowland photographed her in 1949, but she already showed hints of the lush appeal that would fully emerge a few years later.

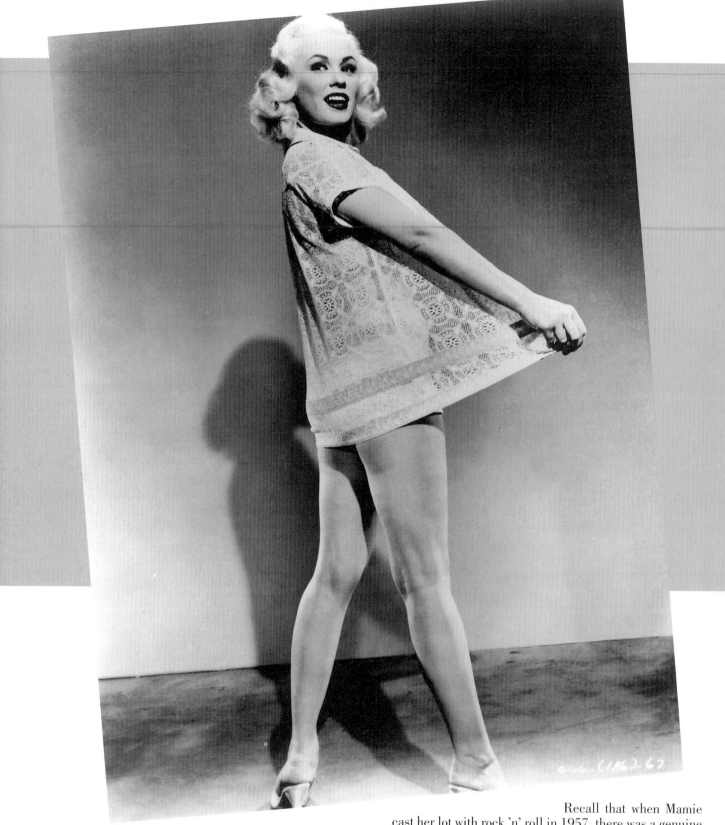

which proved a solid success. She also recorded an EP (extended play) album for Prep Records, singing four songs ("Salamander," "Oo Ba La Baby," "Go, Go, Galypso!," and "Rol in' Stone") from the film's soundtrack. Even though it didn't achieve hit status, "Salamander"—a hard-rockin' if lyrically flimsy number— became a valued item to collectors as a single release.

Recall that when Mamie cast her lot with rock 'n' roll in 1957, there was a genuine risk involved. Many ministers, redneck DJs, and self-appointed moralists were condemning the music as sinful, staging record-burning parties and pressuring corporate sponsors not to support this heathen symbol. Even though many of those censors were hardly likely to be Mamic Van Doren fans in any event, studio execs had to be nervous about one of their stars being linked to such a controversial

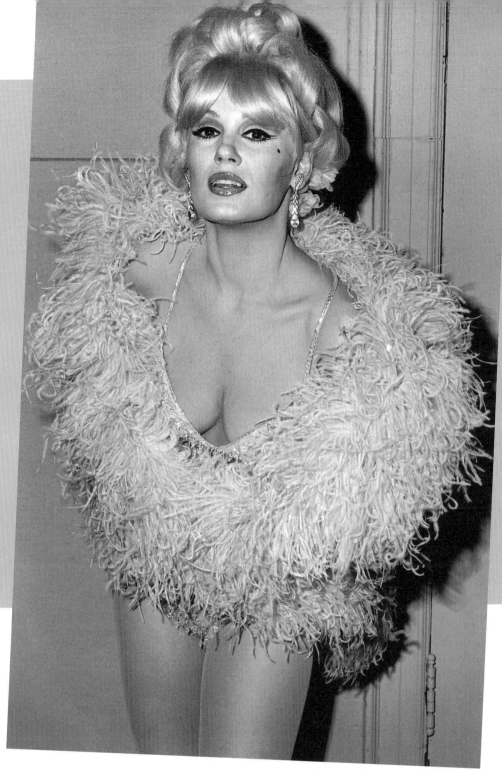

*Mamie's early associ-
ation with rock and
roll provided a quality
that set her apart from
the rest of the '50s
blondes. Equally dis-
tinctive for her time
was Mamie's determi-
nation to live her life
as she saw fit, regard-
less of what studio
executives thought was
appropriate for a star-
let. "I didn't play the
game," she declared.*

new force. Mamie never hesitated, however, and the bond was indelibly forged.

It was during her four-week Las Vegas engagement that Mamie became friendly with Elvis Presley. Going out with Elvis—not long after a near-liaison with rock star Eddie Cochran during the filming of *Untamed Youth*—was, as Mamie herself acknowledged, not exactly acceptable behavior for a proper married lady. But, even as her differences with Anthony increased, she continued to make it clear that nothing was going to stop her from living her own life as she saw fit.

Looking back today at her liberated lifestyle years before the sexual revolution made it acceptable, Mamie notes that she was ahead of her time. "The things they're doing today, I did in the '50s. I didn't play the game. If I wanted a college student or an athlete, I just did it. It didn't

help my career. I didn't drink with the authors like Marilyn. I went to bed with the ones I wanted." In a late-1980s interview on the Playboy Channel, she reflected that her sex drive may have hurt her acting. "Like Hemingway said, 'I left it all in bed.'"

Hollywood's powers-that-be in the 1950s "didn't look at women as anything but brainless bimbos," recalls Mamie today. At the same time, however, industry censors, pressured by the likes of New York's powerful Catholic leader Cardinal Spellman, "were obsessed with not allowing women to be women," forbidding all but the most innocuous

baring of skin or overt sensuality. It is remarkable, perhaps, that moviegoers were permitted to see as much of Mamie as they did.

When Mamie made *Teacher's Pet* with Clark Gable in 1958, it was not only a landmark in her movie career (being, as it was, the first "A" level picture in which she had received significant billing), but a dream come true for the one-time starstruck little girl from South Dakota. The filming led to another extramarital brush with intimacy, and the growing distance between her and Anthony made their breakup later that year inevitable (the divorce would become final in 1961.)

Meanwhile, she was roaring from one film to the next, some forgettable, and others quite the opposite. *High School Confidential;* started Mamie's long association with producer Al Zugsmith, and the teen-exploitation flicks they made together would form the core of Mamie's subsequent reputation as "Queen of the B's." *Confidential* is still rightly regarded as one of the era's definitive camp classics, but three of her other pictures from the period—*Guns, Girls and Gangsters, Girls' Town,* and *Vice Raid*—deserve similar recognition. Trashy? Perhaps, but all remain irresistibly watchable, in a way, more than many supposedly classier '50s flicks are now.

At last, the "three M's" had truly parted company. It's undeniably true that Mamie could not have carried off the mixture of innocence and saucy sensuality that Marilyn achieved in classics like *The Seven-Year Itch* and *Some Like It Hot* (although one can much more easily picture her supplanting Jayne in *Rock Hunter* or *The Girl Can't Help It*). But by the same token, the qualities that Mamie brought to her cult favorites—Mae West-like sassy confidence and naughtiness coupled with her close identification with the teen subculture—could not have been readily duplicated by her two rivals.

Few stars were as ready and willing as Mamie to supply the popular press with the playful, titillating quotes that helped make the decade as flavorful as it was. In 1956 she told photographer Earl Lear: "Sure I'm serious about my career. It gives me a chance to wear expensive, low-cut gowns that make men's eyes pop out of their head."

"I like tight-fitting clothes with as little under them as possible because I like to give my body a chance to breathe," she declared in 1957. When asked on another occasion whether she was afraid of wearing tight dresses that regaled the outlines of her undergarments, she quickly replied: "Of course not! I don't wear underwear." There was, of course, another reason for selecting the most revealing attire permitted by law, and Mamie's reasoning was concise and eloquent: "Stores have showrooms, don't they?"

After appearing in a sexy gown at a movie premiere a couple of years earlier, Mamie was asked if she wasn't a little cold. Her immortal reply: "No. I'm counting on your flashbulbs to keep me warm!"

Mamie's 1956-59 films:

Star In the Dust (1956) — Strong Western starring John

Agar as the town sheriff trying to mediate a battle between ranchers and farmers about whether or not hired killer Richard Boone should hang. Mamie received second billing.

The Girl In Black Stockings (1957) — Intriguing mystery/suspenser starring Lex Barker as a young lawyer who tries to get away from it all in a Utah lodge where curvaceous Mamie is one of the prime distractions—and one of the victims in a spate of murders. The ads touted Mamie as "every inch a teasing, taunting, 'come-on' blonde."

Untamed Youth (1957) — Mamie has called this her favorite film, and little wonder: top-billed in a tale of two gorgeous girls (with Lori Nelson) who are tossed in a prison farm for hitchhiking, she gets to belt out four songs (often clad in a clinging slip) and established herself as the first female movie star associated with rock 'n roll. Mamie says in *Playing the Field* that she copies Elvis' hip wiggles in her performances here, and their impact is seismic. The ads didn't exaggerate when they proclaimed her "the girl built like a platinum powerhouse!"

Teacher's Pet (1958) — By any standard, the finest film of Mamie's career, a delightful newspaper comedy starring the matchless Clark Gable (in one of his last roles), Doris Day, and Oscar winner Gig Young. As stripteaser Peggy DeFore, who terminally embarrasses Gable with her nightclub routine, Mamie performs the immortal "The Girl Who Invented Rock and Roll."

Born Reckless (1958) — Mamie's a rodeo star in love with an aging rider in this routine musical drama, and gets to sing several songs, including "Separate the Men from the Boys."

The Beautiful Legs of Sabrina (1958) — Mamie stars in this Italian film (not released theatrically here) as a gorgeous model who rinds true loge in Rome. In her bio, Mamie notes candidly that a double was used in scenes focusing on Sabrina's legs or "voluptuous rear," as the Italians thought her too skinny in these departments. "To my credit, however," she adds, "from the waist up, I had exactly what the Italians were looking for."

High School Confidential! (1959) — One of the true Mamie/Albert Zugsmith classics, this antidrug tale of juvenile delinquency is filled with unforgettable moments, gut none more unforgettable than the scenes in which the magnificently superstructured Mamie, as the wicked "Aunt Gwen," tempts clean-cut undercover narc agent Russ Tamblyn in skintight outfits that would seduce a monk into a life of sin. Lovely Jan Sterling co-stars. Later reissued as *The Young Hellions.*

Guns, Girls and Gangsters (1959) — Mamie's the whole show here as a voluptuous (what else?) Las Vegas nightclub singer who has a fling while her gangster husband (Lee Van Cleef) is in the slammer, as a prelude to an armored car heist and the breakout and revenge of Van Cleef. Lots of campy fun, including the pretentious narration.

The Beat Generation (1959, aka *This Rebel Age*) — Generally forgettable crime drama starring Mamie with her then-boyfriend, Steve Cochran. Several other glamour girls are also on hand, including Fay Spain (as cop Cochran's wife) and former "Sheena of the Jungle" Irish McCalla. The still from this film of the curvaceous blonde reclining on a

sofa has long been a favorite publicity shot.

The Big Operator (1959) — Mickey Rooney stars as a crooked labor boss under investigation by the Senate: Mamie plays the wife of Steve Cochran, who's rebelling against Rooney and paying the price. Reissued as *Anatomy of the Syndicate*.

Girls' Town (1959) — As described by The Motion Picture Guild, "Another hard-girls-doing-carnal-things exploitation film by Albert Zugsmith." Mamie stars as a bad girl sent to a correctional institution run by nuns—she "didn't know right from wrong, but wanted a thrill a night— every night," blared the ads. Her tight bullet-brassiered blouses were rarely more provocative than here. The supporting cast—like a few of Mamie's other 1958-59 films—includes Anthony, Mel Torme and Paul Anka. (When Comedy Central's *Mystery Science Theater 3000* paid satiric salute to this "turkey" in 1994, Mamie—ever the good sport—showed up to help introduce it.)

Vice Raid (1959) — Mamie is again top-billed, and in top acting form, as a prostitute who goes to New York to help frame a cop on behalf of the mob, and then tries to turn the tables. Made a perfect double bill with *Guns, Girls and Gangsters*, particularly since both feature very similar pseudo-documentary voice-overs trying to lend it all some social significance.

Magazine Appearances During This Period Included:
 1956 *Earl Wilson's Album of Showgirls* (2 pages, 4 pictures)
 June 1956 *Movie Stars Parade* (pictured in towel)
 Jan. 1957 *Show* (superb leg-art cover in black outfit)
 Feb. 1957 *She* (cover, 11 pages on Mamie alone as one of the competitors in the "Battle of the Blondes")
 March 2, 1957 *Picturegoer* ("Jayne vs. Mamie" feature)
 March 15, 1957 *Cine Revue* (glamorous cover in low-cut fur plus 2 pages)
 May 1957 *People Today* (cover, 5 pages, 8 pictures)
 June 1957 *Night & Day* (Mamie is resplendent on the cover in a low-cut white mink)
 July 1957 *Exposed* (cover, 4 pages) July 1957 *Movie

Stars Parade
 Aug. 1957 *Dig* (cover, 4 pages; "Guys' Answer to Elvis?")
 Oct. 12, 1957 *Picturegoer* (cover, white shorts and bulging blouse)
 Nov. 1957 *Ho* (4 pages, 9 pictures)
 Dec. 1957 *Photoplay* (cover, gorgeous glamour shot in tight blue sweater)
 1958 *Paris Frou Frou #56* (absolutely gorgeous cover portrait; French)
 Mar. 1958 *Vue* (cover, 5 pages, 12 pictures)
 May 17, 1958 *Picturegoer* (cover)
 Oct. 1958 *Bold* (cover)
 Oct. 1958 *People Today* (cover)
 Dec. 1958 *She* (sexy Jane-like cover in low-cut frilly red dress plus 6 pages: "First Lady of Sex")
 Feb. 1959 *Glance* (sexy cover emblazoned "Sex U.S.A.")
 Feb. 1959 *Joy for Men* (cover lying on sofa in low-cut gown, plus 3 pages, "The Girl With the Golden Torso")
 Mar. 11, 1959 *Cine Revue* (back cover in swimsuit)
 Mar. 1959 *Girl Watcher No. 1* (2 pages, 3 sizzling pictures by Earl Leaf)
 1959 *Avec Toi Film Roman* (entire magazine devoted to her film *The Beautiful Legs of Sabrina* with hundreds of small stills from film; previously a similar magazine had been devoted to *Untamed Youth*)
 July 1959 *Inside Story* (cover: "The Naked Truth About Hollywood's Sexiest Starlets")
 Aug. 1959 *He* (cover)
 Sept. 1959 *Night & Day* (terrific swimsuit cover)

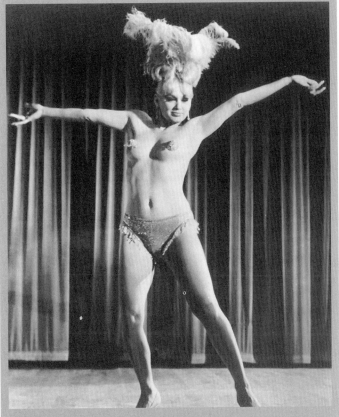

A nearly-bare Mamie belts out "I Used to Be a Stripper Down On Main, Now I'm the Main Attraction On the Strip" in the film Three Nuts in Search of a Bolt.

1960-1964: Decline of the Blonde Bombshells

As far as Mamie's film career went, the new decade began just as its predecessor had ended: with provocatively-titled and colorfully cast films such as *Sex Kittens Go to College* and *The Private Lives of Adam and Eve*. The censor's knife, which had previously cut some shower-room footage from her scene in *Girls' Town*, was active again, and in *Adam and Eve*, for instance, Mamie had to carefully cover not only her breasts (in what was to have been a "semi-nude" scene) but her naval (with a fig) as well! Her third film of the decade, *College Confidential*, would be her last work for Zugsmith and her last film of any kind for the next three years; her continuing association with rock 'n' roll, paired Mamie with rockabilly singer Conway Twitty as a classic "J.D." couple.

Mamie's wild social life continued unabated despite the dip in her acting career, and her autobiography *Playing the Field* notes that Mamie had a busy dance card during this period. After receiving her (uncontested) divorce from Anthony in 1961, she happily showed reporters a large diamond ring from her new boyfriend, L.A. college student Tony Santoro, who had appeared briefly in *Sex Kittens Go to College* as a football player. Soon after, she renewed (and ended) an affair with Steve Cochran and spent at least some time with the likes of Cary Grant and Warren Beatty.

Mamie spent much of 1961-62 on the road doing her new, high-powered nightclub act; the string appeared to be running out on Hollywood films built around blonde bombshells, and this provided her with a vehicle to remain in the spotlight. It also led to a stint in dinner theater doing the musical *Wildcat* (featuring the brassy ballad "Hey, Look Me Over").

In 1962, Mamie announced that she was set to star in and co-produce an independent film called *Kiss Her Goodbye*. "I play a 19-year-old blonde with a mentality of about eight. It's kind of *Lolita* in reverse," she said. (Sadly, the film was never made.) The continuing Monroe/Mansfield comparisons were even more annoying to Mamie than before. "Outside of the fact that we're all females and all blondes, I don't see why they're always comparing me with them," she declared. "After all, I'm incomparable."

The death of Marilyn Monroe in August 1962 hit Mamie hard. Painfully aware that her career was falling into the same kind of downslide that enveloped Marilyn's final couple of years, she realized (as she would later write) that the event signified "the days of the sex goddesses and blonde bombshells had been officially laid to rest."

It was perhaps a mark of Mamie's declining professional fortunes that she was garnering the bulk of her publicity through her never-ending, high-profile romances. In 1963 it was dashing California Angels pitcher Bo Belinsky, to whom she became engaged that spring; the relationship came apart a few months later while Mamie toured in the musical *Silk Stockings*. Shortly thereafter she made the first of many appearances on Johnny Carson's *Tonight Show*, beginning a (somewhat) close relationship with Carson. A more significant relationship (which, like all the others, is candidly discussed by Mamie in her autobiography) was the sporadic affair she had with Steve McQueen in 1964-65, followed the next couple of years by some evenings of passion with football hero Joe Namath. During this period, Mamie, much like arch-rival Jayne Mansfield, toured the country as a nightclub chanteuse, "belting sexy songs" (as one magazine described) "over the bald pates of boozed-up businessmen. . . ."

Mamie's first film in over three years, *The Candidate*, was shot during late 1963. A little-known sidelight of making this movie is that Mamie and gorgeous co-star and *Playboy* favorite June ("The Bosom") Wilkinson joined forces to make a novelty record called *The Girl In the Bikini With No Top on Top*. (A now-forgotten third woman was also said to have participated, although the record and original recording tapes mention only Mamie and June.) Mamie recalls with a chuckle that at the suggestion of the producer and in keeping with

Mamie's essential qualities are captured in this pose: the scintillatingly sexy Platinum Powerhouse, utterly sure of herself and also possessing a saucy, disarming sense of humor.

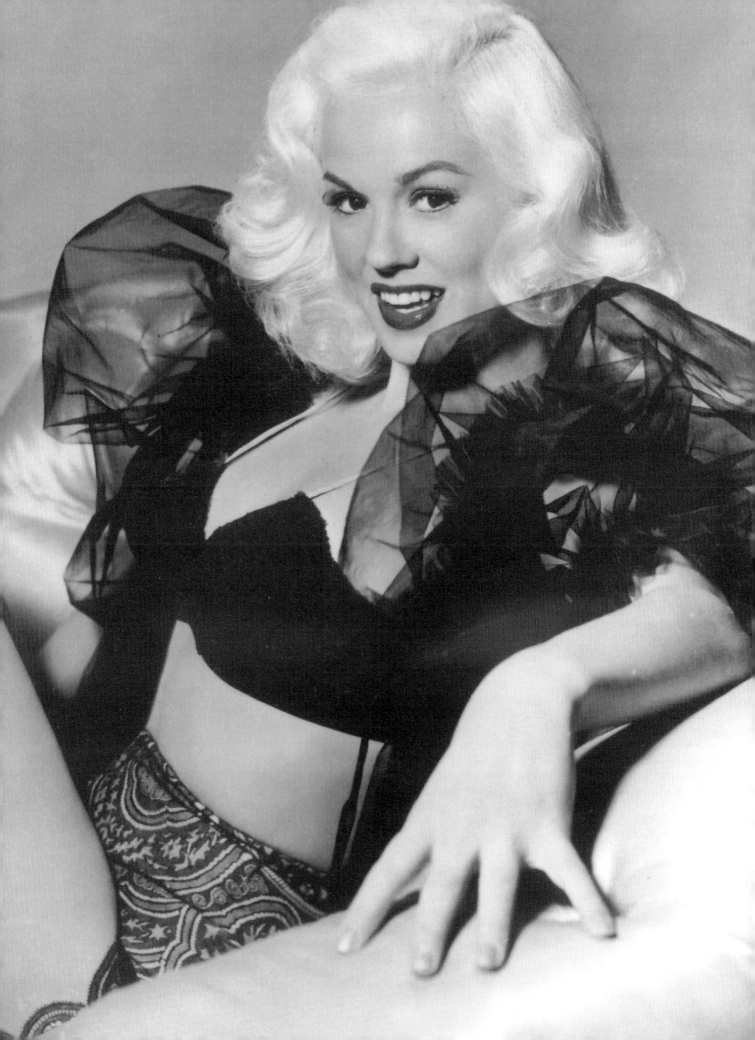

the spirit of the record, the girls removed their bikini tops in the studio and sang with just their sheet music stands in front of them. "There we were, with six gigantic breasts hanging down and a roomful of men gawking," relates Mamie. "The guys couldn't concentrate on anything."

Following close on its heels was the film that garnered Mamie more press than anything she had done in years, *Three Nuts in Search of a Bolt*. It was comic actor/director Tommy Noonan's follow up to *Promises, Promises*, which had been Jayne Mansfield's biggest film in ages due largely to its nude scenes and their widely-heralded promotion in pages of *Playboy*. Noonan sold Mamie on the idea of following the same route, and it proved a winning formula; aided by Mamie's unprecedented two featured *Playboy* pictorials in the space of just a few months, *Three Nuts* was a box-office winner (at least in relation to its modest budget) and gave Mamie's movie career a temporary boost.

Even when she made occasional forays into politics, Mamie didn't change her liberated style. In 1963, she planned a mild striptease in a flesh-colored leotard at a Republican fundraiser in Washington state, but the head of the local party reluctantly vetoed the event when he noted that his wife might object. A Hollywood producer helping to arrange the show remarked, "I was just flabbergasted when I read about Mamie's plans."

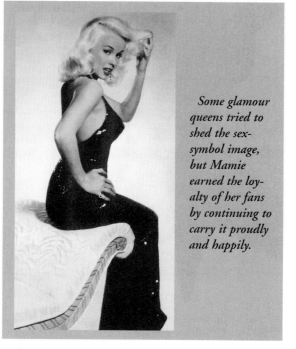

Some glamour queens tried to shed the sex-symbol image, but Mamie earned the loyalty of her fans by continuing to carry it proudly and happily.

In the summer of 1964, Mamie published her first (of four!) autobiographies, "*My Naughty, Naughty Life*," which included some sexy, previously unseen photos of the author in a colorful 32-page insert. It may not have been coincidental that Jayne Mansfield would also be the subject of a provocative and revelatory tome, "*Jayne Mansfield's Wild, Wild World*," published around the same time. Not to be outdone, Mamie followed with a second autobiography a year later, titled (accurately) "*I Swing*."

The opening lines of "*I Swing*" is a classic: "Why is it that the whole world is vertical and all men are determined that I be horizontal? All right, I guess I know!" The book is full of provocative zingers: "When I like a man I like him all the way. . . I'm sure the average girl would have a sexual appetite like mine if she were thrown into the kind of world I am thrown into. So I have no guilt. . . Handsome men with good physiques are always better in the bedroom."

As if these were not enough, Mamie followed in late 1965 with a third paperback sizzler, "*My Wild Love Experiences*." Once again, she demonstrated the ability to grab the reader's attention from the first line: "Let me tell you, with a body like mine, you can be sure I've had some

of the wildest love experiences around." The 30-page section of nude and glamour photos includes some "Jayne vs. Mamie" shots, and the selection of grainy Mansfield pictures from *Promises, Promises* were well-designed so that Mamie appeared to be the undisputed winner.

Mamie's 1960-64 filmography:

Sex Kittens Go to College (1960) — Ah, who could resist it: Mamie's a stripper selected (because of her high I.Q.) by a robot to run a college science department, where she, delectable Tuesday Weld, and Mijanou Bardot (Brigitte's sister) strut their stuff in tight sweaters— Albert Zugsmith strikes again! The European version, in which a complete striptease performance (not Mamie's) is inserted without the slightest context, is particularly weird and wonderful. Classic line from curvy nymphet Tuesday Weld, gazing at Mamie's tight-sweatered form: "Why do you have to be so darn much of a woman?" The promotional tag line: "Never before has the screen had so much fun with a student body!"

The Private Lives of Adam and Eve (1960) — Mamie, Mickey Rooney, Fay Spain, Mel Torme, and Tuesday Weld are among the travelers on a Reno-bound bus who are grounded by a flash flood, take shelter in a church, and share a strange dream in which they are in the Garden of Eden—with Mickey as the Devil! June Wilkinson also makes an appearance.

College Confidential (1960) — One final Mamie/Al Zugsmith epic; Steve Allen stars as a college professor who conducts a scientific survey on the sexual habits of college students, but finds himself brought up on indecency charges.

The Blonde from Buenos Aires (1961) — Argentinean film starring Jean-Pierre Aumont, also not released theatrically in the U.S.

The Candidate (aka *Party Girls for the Candidate*, 1964) — No film with the awesome pairing (so to speak) of Mamie and June Wilkinson can be all bad. Ted Knight is a sleazy U.S. Senator with a hot night life who gets a girl pregnant; when Mamie takes her to an abortionist, he then rapes the girl.

Three Nuts in Search of a Bolt (1964) — A fairly goofy comedy which proves that a little Tommy Noonan goes a long way. But Mamie—in the aptly named role of "Saxie Symbol"—gives everyone their money's worth with her torrid strip routine (singing "I Used to Be a Stripper Down on Main, Now I'm the Main Attraction on the Strip") and her tacked-on nude beer bath scene. The inevitable comparisons between Mamie as seen here and Jayne in *Promises,*

Promises are all to Ms. Olander's advantage.

The Wild, Wild West (1964) — A German/Yugoslavian Western, not released in the U.S.

Significant 1960-64 magazine appearances:

July 22, 1960 *Cine Revue* (cover in low-cut white dress and 2 pages, including full-page sexy pose in bikini)

Aug. 27, 1960 *Picture Show & TV Mirror* (cover in sweater)

Sept. 1960 *On the QT* (cover, "The Day Mamie Embarrassed Ray")

Nov. 1960 *Whisper* (part cover in skin-tight dress, article)

July 23, 1961 *National Enquirer* (terrific blonde-bombshell cover; "Mamie Van Doren: 'I Want to be Wild!'")

Late 1961 *Fling Festival Vol. 8* (sexy 4-page, 7-picture layout; Mamie has seldom looked more dazzlingly blonde and alluring)

Dec. 2, 1961 *Tit-Bits* (British cover, looking hot in bikini)

Jan. 1962 *Adam* Vol. 6-3 (5 pages: "The Lunatic Love Life of Mamie Van Doren")

Summer 1962 *Modern Man Yearbook of Queens* (3 pages, 6 pictures)

Jan. 1964 *Whisper* (with Bo)

Feb. 1964 *Playboy* ("Van Doren Unadorned:" sizzling 7-page, 7-picture layout featuring Mamie irresistibly semi-clad in transparent negligee and other bedroom attire—as it turned out, only a prelude for what was to come.)

June 1964 *Playboy* ("The Nudest Mamie Van Doren" was the hottest Mamie ever seen in print to date; on the cover and in the 6-page, 15-picture layout behind the scenes of *Three Nuts in Search of a Bolt*, she displayed—both in and out of bubble bath—the form divine as never before.)

June 1964 *Adam* Vol. 8, No. 7 (Mamie adorns the cover and a 2-page, 5-picture layout from *Three Nuts in Search of a Bolt*.)

Aug. 1964 *Knight* Vol. 4-8 Oversized magazine with one of the best *Three Nuts* features on the cover and 2 pages, 7 pictures.)

Sept. 1964 *Topper* (Among all of Mamie's nude layouts, this was the most generous in length: the cover plus 9 pages, and 17 pictures in all; every one features Mamie in various states of undress, and looking splendid.)

1965-1969: Going the Nude Route

The splash of publicity Mamie had enjoyed in 1964 helped make it an eventful year for her, but the next couple of years would make it clear that her insight at the time of Marilyn's death was correct: time was passing the '50s sex goddesses by. The abysmal films she appeared in during this period were testimony to that effect, most notably *Las Vegas Hillbillies,* with arch-rival Jane Mansfield—or, perhaps more accurately, without Jayne, since the two did everything possible to avoid any personal contact on screen or off. If Mamie looked vastly better than Jayne by this time, it was little wonder: while Mamie took care of herself and the body that had helped carry her to fame, Jayne—in addition to bearing five children—was drinking and carousing into the morning hours, even as she desperately tried to cling to the mantle of sex goddess-dom. Mamie did her best to retain the mantle, as well, but, unlike Jayne, had her eyes

wide open to the changing world around her.

Life became a bit difficult for Mamie in 1966 when she discovered she was pregnant. A 1987 feature in the magazine *Interview* said the father of the unborn child was "a famous sports figure whose name had to be deleted" from her autobiography. Shortly thereafter, she met and secretly married Lee Meyers, a 19-year teammate of her "ex" Bo Belinsky. In *Playing the Field*, Mamie makes it clear that it was a marriage of convenience; soon thereafter she decided, under the kind of ugly circumstances all too common in the pre-Roe v. Wade days, to have an abortion. The marriage didn't last much longer, and Mamie would write a magazine article the following year on the need for more liberal abortion laws.

"Mamie likes them young," was the line attached to her during these years, and Mamie certainly did nothing to discourage the image. "When a man is young, he doesn't get tired at midnight," she declared in one magazine interview. "I never get tired so I have to have a playmate who can stand the gaff and the hours." To questions about her renowned sexual prowess, she would bat her eyelashes and respond, "I'm no different than any other girl. I do take vitamins, though," before laughing. But even the likes of Joe Namath probably needed vitamins to keep up with her.

An armchair psychiatrist would no doubt conclude that Mamie's attraction to young men was one way of staving off the professional extinction that seemed to be enveloping her. The death of Jayne Mansfield as she dove from a Biloxi nightclub job was another stunning jolt that left her thinking, "Are we all cursed?" It was a dark irony that Mansfield had been standing in for Mamie, who had been forced to cancel her appearance at the club when her New York engagement of *Gentlemen Prefer Blondes* was held over. She later said she "broke out in hives for a week" following Jayne's death.

As her movie roles dwindled, Mamie kept in the public eye during the late '60s with several sizzling semi-nude magazine pictorials that in some cases went beyond her poses for Playboy. These served to prove that age had done absolutely nothing to diminish her renowned beauty or dilute the legendary Van Doren sensual allure.

When Mamie did a nude layout for *Cad* shortly after her *Playboy* appearances, she teased, "I've never really posed nude nude for any magazine. What I did for the other magazine was to peel a little and show a little—just a peekaboo bit, but nothing this bare!" This gorgeous pictorial was photographed by Tom Kelly, who had immortalized the unclad Marilyn some 15 years before. "After this, I'm dropping the nudity bit altogether, because I don't want my public to get tired of looking at me" she proclaimed. Mamie soon reconsidered, showing her all for several other publications during the next couple of years.

In the mid-'60s, Mamie delighted her fans with TV and print commercials for Aqua-Velva shaving lotion ("there's something about an Aqua Velva man"), and kept active with nightclub performances as well, starting with a big 1965 engagement at New York's Latin Quarter. One notable magazine cover in 1968 pictured Mamie the chanteuse cavorting

for Philippines President Ferdinand Marcos in an eye-popping, largely transparent, very low-cut white dress scooped out on both sides at the waist.

Mamie's 1965-1969 Filmography:

The Navy vs. the Night Monsters (1966) — Campy horror film starring Mamie as one of the leaders of a rescue team after a plane from Antarctica filled with ice-age vegetation crashes; they transplant the vegetation, and terrible things start to happen.

Las Vegas Hillbillies (1966) — Jayne and Mamie hit rock bottom. Country singer Ferlin Husky stars as a Tennessee farm boy who inherits a dilapidated Las Vegas casino, where barmaid Mamie helps put together a country music extravaganza.

Voyage to the Planet of Prehistoric Women (1966) — Producer Roger Corman bought a sci-fi film from a Russian company, and director Peter Bogdonovich shot a new story—astronauts land on Venus where they encounter magnificent Mamie—spliced together with footage from the first film. She calls it her "worst film experience." But love her eggshell bikini top!

You've Got to Be Smart (1967) — Perhaps the rarest of Mamie films, neglected in most filmographies, for good reason; she's a "special guest star" in a "rockabilly songfest" featuring nobody you ever heard of.

Her Magazine Appearances From 1965-69 Included:

Jan. 1965 *Modern Man* (more *Three Nuts* nudes, 8 pictures total)

Early 1965 *Cad No. 1* (A truly classic issue for Mamie-lovers—cover, magnificent nude centerfold, 4 other pages, and 9 total pictures by Tom Kelly.)

March 1965 *Caper* (cover, semi-nude pose with white dress fully unzipped)

Spring 1965 *Man to Man Yearbook* (3 pages)

June 1965 *Adam* Vol. 9-6 (2 pages and 4 pictures, including full-page nearly topless, and article: "Mamie Van Doren Passes the Test")

June 1965 *Modern Man* (terrific cover and 3-page, 7-picture mostly nude layout, including a few pictures from the same shooting as the 1964 *Topper* spread)

Nov. 1965 *National Police Gazette* (cover: "Who'll Win the Race to Take Marilyn Monroe's Place?")

Dec. 1965 *Playboy* (three pictures of Mamie as she is featured in the magazine's "Portfolio of Sex Stars")

Jan. 1966 *Man to Man* (cover in tight white blouse, 3 pages of pictures, plus interview)

Feb. 1966 *Escapade* (Sensational cover, largely nude as a specially wrapped Christmas present, and truly classic nude centerfold poised on all fours on a white sofa, plus 4 pages shot by Bill Crispinel.)

March 1966 *Millionaire* (As "Heiress of the Month" and, more expansively, "Sex Goddess of the World," Mamie graces the cover and a spectacular semi-nude color centerfold.)

Summer 1966 *Modern Man Yearbook of Queens* (classic cover topless with hair cascading before her bosom, 3 pages, 6 mostly nude pictures)

Oct. 1966 *TV/Movie Screen* (Mamie and Lee Meyers)

Jan. 1967 *Playboy* (2 pics of Mamie as one of the "Sex Stars of the Fifties")

May 1967 *Cavalcade* (One of the most revealing looks at

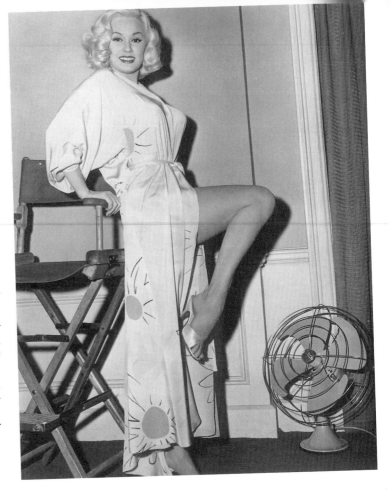

Mamie ever, on the cover and in six undraped pictures within—including a color centerfold crouched on a sofa that is the ultimate treat for connoisseurs of the magnificent Van Doren unadorned.)

June 1967 *Duke* ("Mamie Van Doren Very Naked" is the title, and this 6-page, 13-picture layout delivers with some spectacular color nude shots, some from previous spreads and some brand new.)

June 1967 *Playboy* (1 page)

Aug. 1967 *Gent* (4 pages, 10 pictures from *Three Nuts*)

Winter 1968 *Fling Festival* (cover, 5 pages, 9 pictures, and interview)

Spring 1968 *Modern Man Quarterly* (nude movie photos)

June 1969 *Knight* (Even though the pictures appear to date from the same largely nude shooting as the *Cavalcade* layout above, this 5-page, 8-picture layout has a sizzle all its own, aided by a provocative text.)

1970-1995: Comeback!

Mamie decided to tour war-torn Vietnam in 1968 to entertain the servicemen there; it would make a deep impression on her, and when she was asked to return in 1971, she couldn't refuse. She describes the experience in her book as a "trial by fire," cut short by a prolonged illness, and featuring a whirlwind would-be engagement to an Army major whom she belatedly discovered to be already married.

In late 1972, Mamie entered into another marriage of convenience, this time (her fourth) to a wealthy corporate executive. His subsequent anger at seeing some vintage nudes of Mamie published in a magazine, coupled with his futile attempts at ordering around a woman determined to retain her independence, spelled the end of the ill-fated relationship.

The magnetic attraction Mamie seemed to exert over the most celebrated men in America continued in the early 70s, with a rather abbreviated amorous encounter with Burt Reynolds and an evening with Henry Kissinger. Meanwhile, she continued to tour in shows originated by her deceased rivals (*Will Success Spoil Rock Hunter?*—which had, after all, been written for Mamie—and *Gentlemen Prefer Blondes*). In 1970 she was in the show *See How They Run*, her first totally non-musical stage role. It was on one of these tours in 1974 that she met the man she would marry five years later, Thomas Dixon.

In 1977, she recorded an album for the small Churchill label titled *Mamie As in Mamie Van Doren*, featuring nine songs comprised of familiar country and pop standards. The cover was absolutely irresistible, a hot leg-art pose of Mamie reclining in a white nightgown; on the back cover, she wears a low-cut black outfit with garish red high-top boots.

The great Mamie renaissance began in 1984, starting with a Hollywood celebration of her career that attracted wide national publicity and such a large and enthusiastic turnout that it became immediately clear that she still had a following. . . and that, in fact, a new generation of fans had discovered and fallen in love with her late-'50s classics.

Not long after Joan Collins' much-heralded unclad feature in the magazine, Mamie accepted an invitation in May 1984 to do another nude layout for *Playboy*. "I agreed to do it, just to see how they turned out, and we did a couple of days' shooting," she says. As soon as word leaked out, Mamie's fans eagerly awaited the results. Unfortunately, she had second thoughts afterward and vetoed the layout. "I decided, why go back to the same old stuff I'd done before?" Mamie explains.

That August, she made what was billed as her New York nightclub debut. By 1985, her career was back in full swing. In addition to appearing in her first film in a decade and a half, *Free Ride*, Mamie's original cinematic rock 'n' roll recordings were prominently featured in Rhino Records' LP compilation, *Va Va Voom! Screen Sirens Sing!* The success of this album led Mamie to cut a 12-inch dance single, "Queen of Pleasure" and "Young Dudes." True to form, the back cover of the picture sleeve shows off a sultry Mamie in a low-cut blouse. The single proved popular enough for her to record a steamy follow-up, "State of Turmoil."

Throughout 1985, she performed these and other songs in a series of live appearances in Los Angeles, San Francisco and New York. A performance at Hollywood's Backlot Club, captured for posterity on video by fan club leaders Joe Doyle and Bob Bethia, began with a hard-driving rocker called "Are You Hot for Me Tonight?" As she shook her hips in vintage fashion, Mamie appeared every bit as excited as the delighted onlookers. Her rendition of Ray Charles' "What'd I Say" was accompanied by sensuous moans as she caressed her body, and as she sang the chorus—"baby, shake that thing"—she did precisely that. The show also included an emotional ballad titled "Marilyn" that she wrote herself and dedicated to Marilyn Monroe.

In 1986, Rhino issued *The Girl Who Invented Rock 'n' Roll*, pulling together 12 of Mamie's vintage film vocals. The following year, Mamie was featured in Dweezil Zappa's rock video, *My Guitar Wants to Kill Your Mama*.

The autumn 1987 release of *Playing the Field* (its more colorful original, Zusmith-like title: *Naked In the Rain*) brought a tidal wave of publicity that firmly re-established Mamie as an American cultural icon. Beyond the flavorful retelling of her career, it was Mamie's no-holds-barred discussion of her various celebrity romances—naming "names, places and body parts," as one newspaper account noted—that kept fans and the media buzzing and generated big-league sales.

Sex symbols are eternal, but flesh-and-blood women are not, and in 1989 Mamie decided to get a $10,000 face lift and eye job—and, more remarkably, to talk candidly about it. Her body was still in extraordinary condition, but nearly four decades of life in a turbo-charged fast lane had left their mark on her still-alluring face. To some admirers, Mamie's wrinkles merely served to add character, but she knew all too well that fans who saw her in public expected nothing less than a bombshell despite the passage of time. But ultimately it wasn't the expectations of others that led her to go under the knife; it was her own self-image. "I think people should know that I didn't do this for men," she declared. "I didn't do it for anybody else. I did it for myself. I wanted to feel good about myself."

"I'm experiencing something that none of the other blondes experienced," she had noted a couple of years earlier, "and that's getting old." But in true Mamie fashion, she would do so on her terms.

Today, Mamie continues to live in Newport Beach with husband Thomas, venturing out on occasion for TV roles (*Police Story*), home video appearances (as hostess of Rhino's *Teenage Theater* series of '50s teen delinquent films), and special live performances. A follow-up to *Playing the Field* was put on hold (working title: *Sex Kitten in Vietnam*), as was a TV film that would be based on it; Mamie says Lesley Ann Warren expressed an interest in playing her. Instead, by late 1993 Mamie was working on a novel encompassing her Hollywood and Vietnam experiences.

More movies? Maybe, says Mamie, even though she turned down director John Waters' offer of a featured role in his 1988 film *Hairspray* because she didn't want to play opposite campy drag queen Divine. She played a cameo in a little-seen 1993 film with old friend Steve Allen, *King B*.

Meanwhile, with or without new movies, the blonde dynamo keeps moving forward, ever the ageless sexpot. In December 1991, she performed on stage in Belgium wearing a see-through top with open black vest and short dress. As she belted out a succession of '50s rock classics, the vest would open frequently to offer tantalizing glimpses. Once again, the song "What'd I Say?" inspired her steamiest moments: while shaking her booty to the refrain "baby, feels so good," Mamie opened her blouse to caress her exposed breasts to the roaring delight of the crowd.

In April 1992, she posed delightedly for photographers at an engagement party for agent Jay Bernstein clad in a totally transparent blouse, her 61-year-old form still absolutely sizzling. Early the following year, she underwent her second face lift, and acknowledged that one reason was to live up to the continuing public expectations of Mamie Van Doren, Sex Kitten.

A still more recent public uncoverage occurred in June 1993. While accompanying L.A. television personality Skip E. Lowe to a dinner function, wearing a snazzy tan pantsuit with a bit of cleavage, Mamie was faced with a persistent German photographer. Lowe egged her on: "He wants to get some shots of your boobs, so why don't you let him?" Mamie obliged, smiling dazzlingly while unbuttoning and pulling open her blouse to fully reveal her strikingly full, firm (braless) breasts. She maintained the pose for several seconds as the German and another lucky lensman frantically snapped away.

In early 1993, she recorded a new music CD in Germany for European-only release. One of the selections was her original composition "Marilyn." Later that year, a set of 36 Mamie collector cards was issued by Kitchen Sink Press to help cash in on her never-ending cult appeal, each one containing a classic Mamie photo and her own saucy comments on the back. Also during 1993, the longtime frustration of Mamie fans at the minimal video availability of her films was eased by the release of three MVD camp classics on tape: *Girls' Town*, *Vice Raid*, and *Girls, Guns and Gangsters*. And at year's end she made a brief appearance on the Christmas episode of *L.A. Law*.

An important part of Mamie's life in recent years has been the fight against AIDS. She was one of the first celebrities to make public appearances about the disease back in 1984, served as "Queen of the 1986 Gay Pride Parade" carrying an AIDS sign, and in 1993 participated in a Hollywood AIDS Awareness Walk. As a star with a longtime following in the gay community, she rarely misses an opportunity to make eloquent statements against homophobia.

February 1, 1994 was a long-awaited day for Mamie and her legion of fans, as she was finally awarded her star on the Hollywood Walk of Fame. Mamie beamed happily as the cheers rained down, lounging obligingly for photographers on the sidewalk beside her star.

A more backhanded salute to Mamie's continuing iconic status occurred in the smash 1994 film *Pulp Fiction* when John Travolta and Uma Thurman dine at a lavish '50s-themed restaurant where patrons are served by the likes of "Elvis" and "Buddy Holly." When Uma comments that there are two Marilyn Monroes waiting tables, the keen-eyed Travolta is quick to point out, "No, that one's Mamie Van Doren." The real-life Mamie no doubt roared in delight at the scene, but it had to be an odd feeling for a still-vital 1990s woman to see herself portrayed like a figure in a 1950s wax museum alongside several long-dead legends.

Mamie remains fiercely, and rightly, proud of her enduring beauty and sex appeal. "I could still win popularity contests against 16-year-old girls," she declares. "I'm lucky I had God-given breasts, and they're still as firm as ever. I take care of myself, work out a lot, pump iron, do aerobics, four hours in a gym most days. . . When I take my top off in a jacuzzi, women's mouths drop open."

Mouths have been dropping open at the sight of Mamie Van Doren for some 50 years now. Over that time, however, she's proven that she is far more than a curvaceous sex bomb. Her saucy humor and uninhibited, outspoken honesty are uniquely Mamie's, and help explain why she has retained such a devoted following years after most of her contemporaries have been forgotten. If Mamie is indeed the Last of the Blonde Bombshells, one can hardly imagine a more ideal representative of the species. Long may she reign.

Mamie's latter-day films:

The Arizona Kid (1971) — With Gordon Mitchell; no other information available.

Free Ride (1985) — Starring Gary Herschberger and Warren Herlinger; Mamie introduced her song "Young Dudes" here. Her big scene in this otherwise routine teen-hormones flick is absolutely quintessential Mamie. She's an oversexed high school nurse conducting the annual physical on all the boys, who line up before her and drop their pants, one by one. Displaying ample cleavage in a largely unbuttoned white blouse, Mamie is absolutely beaming with a lascivious grin as she looks over each male specimen—"My, you've grown so much since last September!" she tells one approvingly. She asks each to cough while she grabs their crotch. "Pull 'em up and tuck 'em in," she announces at the end.

King B (1993) — Cameo appearances with Steve Allen.

Selected Mamie Magazine Appearances Since 1970:

Jan 1971 *Fling* ("A Day In the Life of Mamie Van Doren:" 5 pages, 12 pictures, and a provocative interview/article.)

Jan. 1973 *Oui* (interview with Mamie and one leg-art picture)

June 1975 *Escapade* (cover, centerfold)

1979 *Celebrity Skin No. 1* (3 pages of classic '60s nudes)

June 1979 *High Society* (3 pages of splendid late-1960s nudes)

Feb. 1980 *Partner* (interview)

1980 *Celebrity Skin No. 3* (5 small mostly nude pictures)

Apr. 1985 *Hollywood Studio Magazine* (1-page profile, "The Last of the Blonde Bombshells")

May 1985 *People* (featured on Mamie's return to the spotlight under the heading "Sequel")

Oct. 1987 *Interview* (full-length feature pegged to her autobiography)

Dec. 1987 *Hollywood Studio Magazine* (4 pages, 7 pictures celebrating the release of *Playing the Field*)

100 Beautiful Women (1988 *Playboy* special, with one of Mamie's classic 1964 nudes)

Jan. 1989 *Playboy* (1 1964 picture)

Nov. 1989 *Lui* (7 pictures and interview)

Nov. 1990 *Filmfax #23* (cover and full-length photo/interview feature)

1992 *Celebrity Sleuth Vol. 5-2* (4 pages, 17 pictures)

1993 *Jayne Mansfield vs. Mamie Van Doren: Battle of the Blondes* (A delightful 126-page Shake Books offering by Alan Betrock with scores of movie posters, magazine covers, and other items on the two bombshells)

1993 *Celebrity Sleuth Vol. 6-3* (2 pages, 7 pictures, including her '92 see-through poses)

Celebrity Confidential #2 1993 (2 pages, 7 pictures, including 4 topless)

June 1993 *Movieline* (1 page Q&A, along with wonderful new deep-cleavage picture)

March 1994 *Movie Club* (fine vintage cover pose)

Oct. 1994 *Movieline* (excellent vintage nude, and a rather nasty, belated two-page critique of her book)

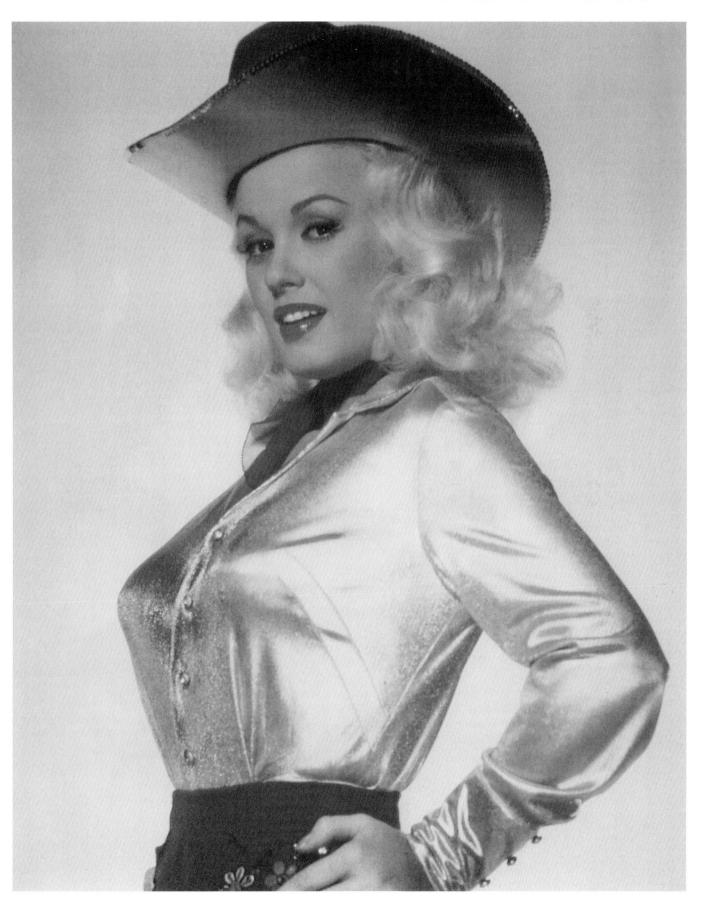

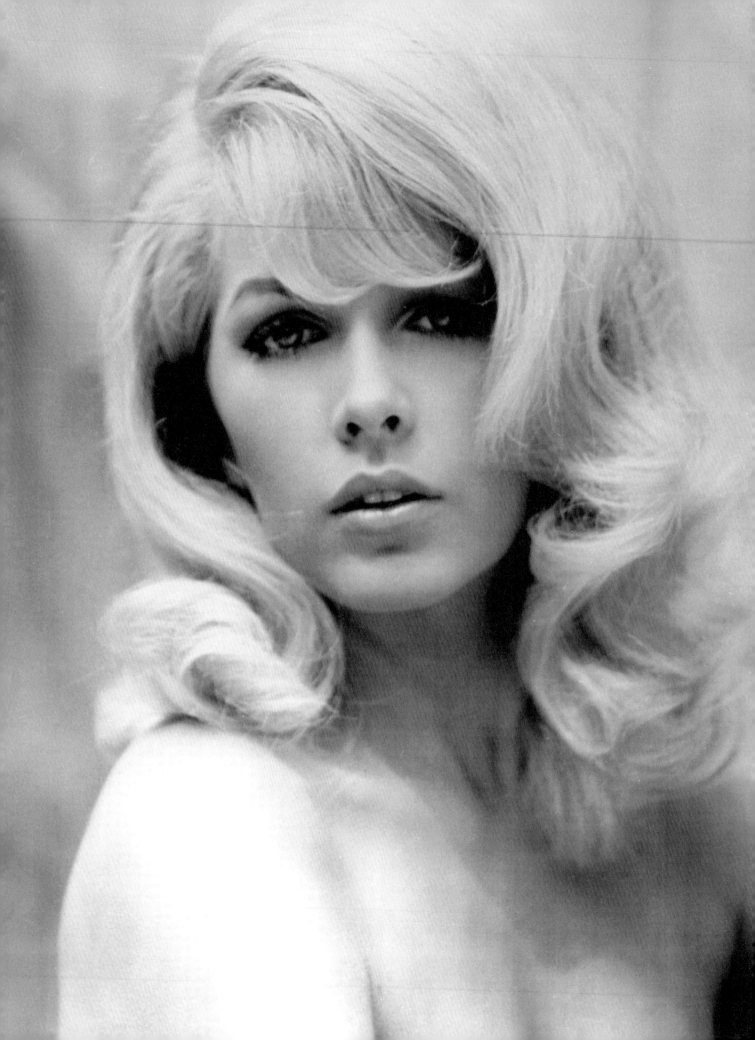

The women whose careers were shaped by the "sex symbol" label have responded in sharply different ways when the initial aura faded. Some, like Mamie Van Doren, have gloried in the image and continued to ride it like a wave all the way to the end. Stella, by contrast, has sought for three decades to parlay the advantages conveyed by her publicity into a far more ambitious career objective. It has not been an easy path, but few women—or men—have brought such ferocious preparation and sheer grit to the task.

To this day, most reference books list Stella's birthplace as the town of Hot Coffee, but that name was actually a joke that no one seems to have gotten. "The name Yazoo City means 'the city of death,' and my press came up with 'the cream of Hot Coffee,' which is a truck stop in Mississippi. It was a joke. Even the people of Yazoo City got quite upset because they thought I was ashamed of my birthplace. I thought it was quite poetic and dramatic to have been born in a place called the city of death, and the move to a place called Memphis, as in Memphis, Egypt. I was always intrigued with Egyptology."

The only child of a factory foreman and a nurse, she moved to Memphis at age four and, pregnant at 15, married her 18-year-old boyfriend Herman Stephens. She divorced him a year later, charging mental cruelty. "I don't think marriage is a good thing," she declares flatly today. "Marriage is supposedly a holy thing in a church, yet it becomes a legal thing in a courtroom afterwards because there's money involved. It's part of the corruption of our society, when there's no balance. I've sometimes thought, wouldn't it be wonderful if there could be a religious divorce ceremony—everybody could go to the same church where you were married, have a big party, you'd break the groom's statuette and he'd break yours, and you'd sling cake at each other," Stella suggests, laughing. "You could make it fun, just get it over with, and call it good. That's so much better than making the children suffer and making everyone miserable because of a bad choice that was made."

Since that first unpleasant experience, "It's never appealed to me to be married. I always thought it was more advantageous to a man than a woman. We're all trained to serve gladly as children, to give joyful service. I think men outgrow that more than women, and lose the ability to give joyful service to others, especially to women, without feeling demeaned by the experience. It doesn't make it easier to live together as men and women."

After the birth of her son Andrew, she enrolled in Memphis State University. "I had a total dread of appearing before people, so I took a public speaking course," she recalls. "I was modeling at the time, and I knew that I had to encounter the public and wanted to know what to say." While taking the course, a boy in the drama club asked her to make some posters to help recruit members. "Finally he asked me if I wanted to join—but warned me, 'if you do you'll get hooked because there's nothing like acting and you'll never want to do anything else.' I said I couldn't think of anything I'd rather do than something in life that doesn't have limitations. I saw a live possibility for me as an individual that I didn't see in any other field, living in Memphis and having a small child."

Stella's first starring role occurred at the university in a production of *Bus Stop*, where she bleached her hair blonde for the role (made famous by Ms. Monroe) of Cherie. One local critic was less than enthralled, writing: "She has less poignancy than Miss Monroe, but she brought equivalent endowments to the role." Others, however, were more impressed. She was discovered working as a model in a local department store by a visiting press agent. Soon after, 20th Century Fox offered her round trip air fare for a Hollywood screen test, but Stella—exhibiting the feisty independence that would prove one of her distinguishing characteristics—declined and paid her own way in order to remain unobligated.

"I wanted to pay my own way, and usually in my life I do pay my own way. It was my declaration of independence. I thought it gave me a stronger bargaining position, and would make them respect me more. I did get the contract, and I wrote my own screen test, from the Harold Robbins novel *79 Park Avenue*. Writing was a great love of mine—since I was so shy and couldn't speak to people, I thought I could learn to write my thoughts out."

Fox signed Stella with the intention that she would play the lead in a film about 1930s blonde goddess Jean Harlow (a picture Jayne Mansfield desperately wanted to make as well). "I was discouraged by everyone I met who knew and loved her from playing that role, hoping that they never made that movie." In fact, the project didn't come to fruition for six years, when Carroll Baker and Carol Lynley appeared in two rival versions. There can be no doubt that Stella would have made a vastly more compelling Harlow than either of the aforementioned actresses. Still, she has no regrets. "I knew it would never have been my greatest role. It would have been just another performance."

Today, Stella says there were three women who were "idols" of hers when she first came to Hollywood. One was Betty Grable: "She sang, she danced, she did everything. I loved Betty Grable." Another favorite was the woman Stella would so often be compared to. "I loved Marilyn Monroe, and I came to learn that she hated Betty Grable, because she had been compared with Betty and wanted to fill her shoes at Fox."

Another favorite was Mae West. "Why wouldn't I adore her? She wrote comedy in film roles for herself, exactly what I wanted to do." In one magazine interview, Stella remarked,

Stella Stevens

Born Estelle Eggleston October 1, 1938, Yazoo City, Missouri

"The first woman I knew of who had a mirror over her bed was Mae West, and she was an idol of mine. I wanted a mirror that would outdo Mae West. By golly, I got it." But her appreciation was not returned. Stella did a Mae West musical tribute in a 1960s Bob Hope-Bing Crosby TV special, surrounded by bodybuilders and clad in a clinging beaded gown and large picture hat. Roddy McDowall later told her that Mae had seen it and "hated me with a black hatred for the rest of her life. She hated for anybody to do her. She took it as an insult rather than tribute." Nevertheless, Mae "was certainly one of a kind. As a sexual comedienne, in particular, she was a role model I looked up to."

Since the Harlow project didn't materialize at the time, Stella worked as a chorine in her first two films, *Say One for Me* and *The Blue Angel*. In early 1959 she left the shooting of Fox's remake of *The Blue Angel* to return to Memphis and whisk her son Andy to Beverly Hills. A year later, her ex-husband returned the favor by allegedly "snatching" the boy and taking him back to Memphis. The child-custody battle finally ended with a court order granting Stella the right to keep Andy 10 months of the year. Later in 1959, after six months of work, Stella's contract was dropped by Fox. "During that entire time, no one had told me to pick up a work card and punch in, so there was no record of my having worked a day—that's why I was dropped."

With tiny roles in two films to her credit and the Fox contract gone, Stella was a starlet in need of a new launching pad. She found it in *Playboy* magazine. At the time she posed, the magazine could honestly claim to having helped put one genuine star, Jayne Mansfield, on the road to fame. Stella Stevens gave *Playboy* a success story it would be able to cite for years to come—although she labels these claims "nonsense."

"I didn't know anyone else in town outside of 20th Century Fox since I had been working all the time," she explains. "So a photographer [Frank Schallwig] and his wife told me I would be paid $3,000 if I would pose for a *Playboy* centerfold. Having no other way of making money, I said yes, I would do that. I posed very uncomfortably—not really wanting to do it, but desperate for money. Then *Playboy* sent a contract with $500 and explicit instructions that if I was to get the other $2,500, I would have to work as a hostess at Playboy parties for 25 months. That was not part of any understanding I'd had." She refused, and it was the beginning of what became a bitter relationship with the magazine.

After her centerfold appearance, Stella found herself the object of controversy (including a series of sermons against

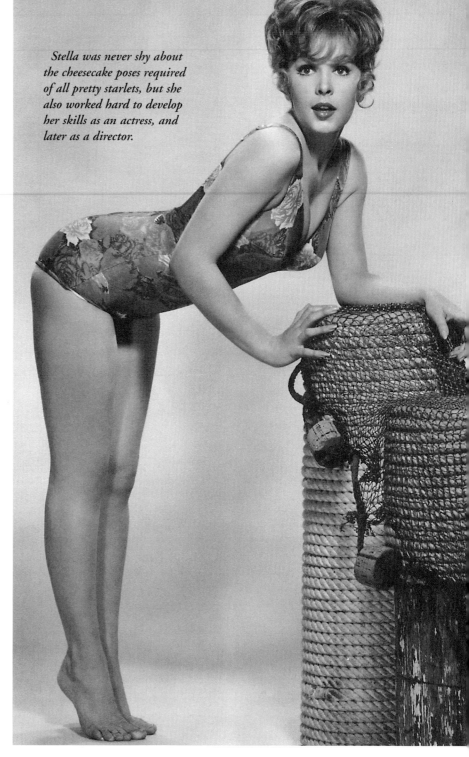

Stella was never shy about the cheesecake poses required of all pretty starlets, but she also worked hard to develop her skills as an actress, and later as a director.

nudity by a local preacher) back in Memphis. "I may not have gone over too well with the Tennessee Baptists, but it certainly didn't hurt my career any," she later remarked to one interviewer. "I think the people who condemn (nudity) are probably the least psychologically fit to make judgments about anything." When asked in a subsequent interview for another magazine whether she thought these and other nude poses had helped or hurt her career, Stella replied, "Honey, you wouldn't be talking to me now, if it were not for those nude shots."

Today, she feels differently. When asked if her Playmate appearance did her career any good, she replied sourly,

"other than having a lot of people tell me they jerked off to my pictures, it hasn't enriched my life. . . It was something I had to fight tooth and claw—to tell people, those are only photographs, I can pose like that, but that is not me." Because of her appearances in *Playboy*, she says, "other important magazines wouldn't run photos or articles on me—only other 'stroke books.'"

Five years later, Stella made a lavish return appearance in *Playboy*. "We had an agreement that if we would take some new photographs to replace the old ones, which were just inferior, they would send me back all the old negatives except the centerfold. But they didn't return them." Still, she posed for one final, quite extraordinary nude layout in the January 1968 issue, one of the most beautiful photo features ever to appear in *Playboy*. She remarked at that time: "People are accepting nudity much more than in 1965. . . but I don't believe it'll ever be taken for granted. It's the element of surprise, however slight, that makes nudity so appealing—and that's good." After the 1968 pictorial, she told *The New York Times*, "If you've got ten million people seeing you in a layout like that. . . and half of them remember the name Stella Stevens and buy tickets for your movie, well, you can't buy that kind of publicity." Today, Stella jokes, "I think the quality of my pictures was too good for them."

The momentum generated by her *Playboy* debut was further augmented by a role she landed before the magazine appearance, the part of Apassionata Von Climax in the hit film version of *Lil' Abner*. Friend and fellow actress Tina Louise had originated the role on Broadway. "Tina and I are good buddies—she would tell me, 'Stella, if it hadn't been for me, you wouldn't have had a career!' I'd say, 'I know, Tina, I owe it all to you,'" she chuckles. "All she had to do is say, 'Yes, I'll play Apassionata,' and I'd have been out of a job."

Stella's magazine appearances before 1965 included the following:

January 1960 *Playboy* ("Dogpatch Playmate" including a 10-picture layout with convincing portrayals of Marilyn Monroe and Kim Novak, and semi-nude.)

July 1960 *TV & Movie Screen*

1961 *Playboy* Calendar (Stella graces the month of March, bare but guarded by a Great Dane)

Jan. 1961 *Playboy* (1 picture)

June 1963 *Cavalier* (6 pages, 8 pictures, including a few semi-nudes as a sexy Twenties style flapper)

Sept. 7, 1963 *Saturday Evening Post* (Stella graces the cover plus two pages as one of the "fair-haired Hollywood girls")

Sept. 26, 1964 *TV Guide* ("Stella Stevens Visits Ben Casey")

Stella, Elvis and Jerry Lewis

One of Stella's first high-profile roles came when she played opposite Elvis Presley in *Girls! Girls! Girls!* One might have expected this to be a special experience for a girl from Memphis, but it turned out to be a disappointment. . . . "Elvis had made a lame pass at me in Honolulu and evidently he was embarrassed about it ever after—he found it difficult to even talk to me. I was not impressed."

In sharp contrast was Stella's biggest film hit of the '60s, *The Nutty Professor*. Nearly three decades later, many Jerry Lewis cultists regard this as his masterpiece—and one that helped her earn Golden Globe honors as a "Star of Tomorrow." "It was a great experience. I was in awe of Jerry because I was in awe of comedians and still am." One of the primary reasons this film remains a fond memory for Stella is that Lewis, like very few others at the time, encouraged Stella on the dream she had nurtured since she first came to Hollywood: to be a director. "I got to see every daily and every rough cut that I could attend. I got to speak my mind about the picture and how it was edited. I learned more behind the scenes on that picture than I did in front of the camera." Frank Tashlin, who directed Stella's first film *Say One for Me*, was also her mentor in the early years.

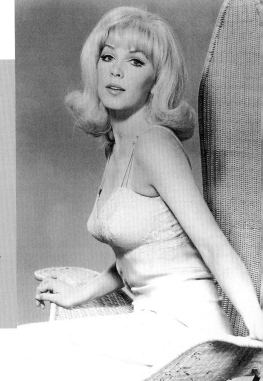

Many admirers viewed Stella as a possible successor to Marilyn Monroe in beauty, sex appeal, and a natural gift for romantic comedy. Physical comedy ranging from pratfalls to fights was also one of her specialties, as seen in The Silencers.

Stella's 1965-69 magazine appearances included:

May 1965 *Playboy* (Stella makes a memorable nude return in "Stella by Starlight," a colorful and revealing 6-page, 7-picture layout by photographer Ron Thal.)

Dec. 1965 *Playboy* (excellent one-page, three-picture nude retrospective on Stella as part of "The Playboy Portfolio of Sex Stars.")

Apr. 1966 Vol. 10-4 *Adam* (back cover, from *The Silencers*)

Jan. 25, 1967 *Variety* (The famous, unprecedented centerfold pose suggesting Stella for an Oscar nomination for *The Silencers*; she is pictured topless with arms akimbo.)

June 1967 *Adam Film Quarterly* (Three pages from *The Rage*)

Fall 1967 *Tiger* (Two pictures and a brief interview.)

Jan. 1968 Vol. 12-1 *Adam* (Cover and four pages focusing on her film *How to Save a Marriage—and Ruin Your Life*.)

Jan. 1968 *Playboy* (The most spectacular Stella layout of all: ten pages and 9 radiant and robust nude pictures by Orlando. A gift of a lifetime for her fans.)

Jan. 1969 *Playboy* (One picture as one of the "Sex Stars of the '60s")
Feb. 8, 1969 *TV Guide* ("Success is a Relative Thing")
Sept. 1969 *Escapade* (Terrific cover portrait in a low-cut top)
Nov. 1969 Vol.13-11 *Adam* (Two pages, three pictures of Stella from *The Ballad of Cable Hogue*.)

As the '60s drew to a close, Stella appeared to be at a crossroads, professionally: she had won widespread praise for her strong performances in a succession of generally mediocre films. While demonstrating her appeal as a comedienne, a sexpot, a romantic lead and a dramatic actress, Stella had not yet carved out a niche for herself. Journalist Joe McGinnis captured her dilemma well. "She is too versatile, and like the same kind of athlete, has suffered from constantly being shifted from position to position." In her career, wrote McGinnis, she "has not really failed. It's just that she has not succeeded . . . There is nothing to remember her by."

Stella's pre-1970 filmography:
Say One for Me (1959) — Small role for Stella in her film debut in a musical comedy starring Bing Crosby and Debbie Reynolds.

Blue Angel (1959) — Unbilled role in remake of the Dietrich classic, starring May Britt.

Lil' Abner (1959) — Energetic, colorful adaption of the Broadway musical and the Al Capp comic strip is enhanced by a red-wigged Stella as Apassionata Von Climax.

Man-Trap (1961) — Stella and Jeffrey Hunter are a suburban couple whose marriage is dissolving, in part because she's a nymphomaniac who drinks martinis from a water pistol.

Girls! Girls! Girls! (1962) — The typical Elvis Presley musical set in Hawaii features Stella as a seductive singer competing with another girl for his attentions.

Too Late Blues (1962) — Fair musical drama (John Cassavetes' first feature film as a director) starring Bobby Darin as a jazz musician trying to rescue Stella, his former girlfriend, who has become a hooker.

The Courtship of Eddie's Father (1963) — Pleasant and popular family comedy with young Ronny Howard trying to find a mate for his widower father Glenn Ford, with Stella playing a red-haired drummer, Dolly Daily.

The Nutty Professor (1963) — Jerry Lewis' most renowned comedy features Stella as a beautiful student with whom Jerry, as a nerdy professor, fails helplessly in love. Stella says today, "I was still very green as an actor at that time (But) It was my first really big break It has become a classic."

Advance to the Rear (1964) — The second film in a year to co-star Glenn Ford and Stella, and it's a comedy winner. Stella on Glenn, "He's an amazing actor. . . . He's mischievous—you never knew what he was going to do next."

The Secret of My Success (1965, Brit.) — Stella's a sexy dressmaker in this silly comedy also featuring Honor Blackman.

Synanon (1965): Strong, realistic drama about the rehabilitation house for drug addicts, one of whom is Stella, with Edmund O'Brien as the ex-alcoholic who opened the house. She recalls this as one of her best dramas.

Rage (1966, U.S./Mex.) — Fairly suspenseful drama starring Glenn Ford and Stella.

The Silencers (1966) — First of the incorrigibly silly Dean Martin outings as secret agent Matt Helm is uplifted by Stella's totally delightful performance as his sexy but klutzy helpmate Gail. Stella

says, "It holds up today as silly but fun. . . . (Gail) was accident prone, but not dumb. . . Physical comedy is a forte of mine, and I wish I could do it more often."

How to Save a Marriage—and Ruin Your Life (1968) — Stella and Dean Martin team again, but with less winning results.

Sol Madrid (1968) — Pretty good adventure flick with David McCallum as a narcotics agent.

Where Angels Go. . . Trouble Follows (1968) — Popular comedy with Stella as a rebellious young nun(!), Sister George, trying to change convent teaching methods against the opposition of Rosalind Russell, the Mother Superior.

The Mad Room (1969) — Stella has the lead role in this drama as the companion of wealthy widow Shelley Winters. When Stella

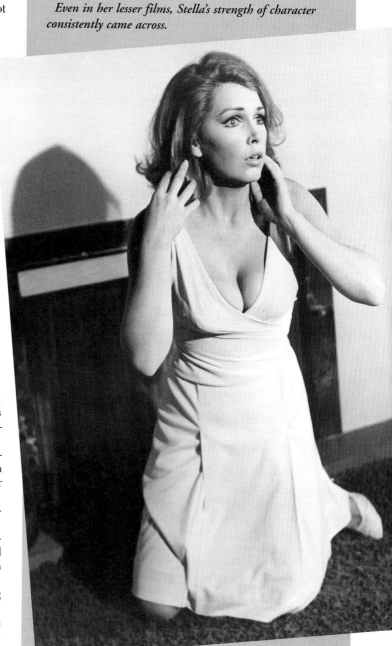

Even in her lesser films, Stella's strength of character consistently came across.

learns that her younger brother and sister are about to be released from a mental institution, she persuades Winters to take them in. Grisly events ensue. Perhaps Stella's strongest dramatic performance until *Cable Hogue*.

"Cable Hogue" and Redemption

The film Stella-watchers had been waiting for came in 1970. *The Ballad of Cable Hogue* demonstrated a poignant quality and depth she had rarely been permitted to show before, as well as the sensual beauty and the fiercely independent streak her fans had long known. As Hildy, the town prostitute who falls in love with grizzled prospector Jason Robards, she was simultaneously arousing and heart-melting—qualities rarely seen in combination since a certain MM. It was a performance that put the doubters to rest and the world on notice: Here was an actress with all the goods, and then some.

Cable Hogue is a film that Stella rightly regards with pride, but also with deep and mixed emotions. Shot in the Nevada desert through long weeks of delay due to the first rains there in decades, "it was a tedious, not very pleasant picture to make. But it was a pleasure to work with Jason Robards." Strange as it seems in retrospect, she was not the first choice for the role of Hildy; nor did the original screenplay call for Hildy to return after leaving Cable following their affair. Their reunion, which was subsequently added to the script, was crucial, bringing their relationship full circle and allowing Hildy to return as a proper lady. Renowned director Sam Peckinpah was to enjoy one of his greatest creative triumphs with the film. Marshall Fine wrote in *"Bloody Sam:" The Life and Films of Sam Peckinpah:* "If *Wild Bunch* was Peckinpah's vitriolic comment on the way of the world, *Ballad of Cable Hogue* was his valentine to how he wished it could be." But his alcoholism, and his reputation in the industry, would cost Stella the full accolades her performance clearly merited.

"When I first saw the film at a screening, I knew that there was not enough in it of my role to even merit a Supporting Actress Oscar nomination. And I cried like a baby. I just wept, to think that I had given so much of myself and my energy to this alcoholic man. I had ended up with a film that was flushed instead of released, and which didn't make any money. It wasn't until later when it showed on TV that it was recognized as a great film. But it did me no good at the time. It was totally buried—the studio hated Peckinpah, and I think they buried it on purpose." Indeed, as the director was to bitterly remark to Fine, "Warner Brothers wrote off *Cable Hogue* after one weekend as a tax loss."

Many scenes that featured the character of Hildy were cut from the final version. "We spent three days filming a comic fight. It was never used because (Peckinpah) couldn't edit it. I was told he was so drunk while editing the film that he had to be carried out. He was his own worst enemy." Stella also felt that Peckinpah's concept of the film was incorrect: "He saw it as a comedy, but I pointed out that in a comedy, the hero doesn't die. We all begged him to let Cable live in the end, to no avail. This was a love story."

Despite her disappointment, Stella agrees with the view that it was perhaps her finest performance to date, in a film she justly calls "very poetic."

1972's *The Poseidon Adventure* provided Stella with the biggest commercial hit of her career. "Even though it was drudgery—dirty, gooky, and wet—we knew we had a great winner on our hands." That same year, she filmed *Slaughter* with Jim Brown in Mexico. The picture was no classic, but she and the all-time football great-turned-actor made a terrific team. "I liked him very much. He was always a gentleman, very courteous and kind to me. We had an understanding that we'd give it our all."

In his autobiography, *"Out of Bounds,"* Brown praised Stella for her professionalism and savvy, and described their big love scene. "The camera started rolling around the bed, and the director said, 'I'll leave it up to you two.' It was the sexiest, hottest, most realistic love scene I've ever done. Stella Stevens was unbelievable. Had they not said cut, we might have done it."

"We were both uncomfortable doing the nude love scenes," relates Stella. "When I saw it recently, I was very disappointed—it was so dark that I couldn't see anything! We shot some beautiful stuff that wasn't used. What happened was that the editors cut 35 mm frames out and sold them to *Playboy*, without our authorization. I imagine our love scenes made the rounds among the studio executives. It's so much work to do one of those scenes, it's not much fun—and you'd much rather that they use them on screen if you take the time to do them and do them well. It's a waste of time otherwise."

An example of Stella's independent streak came in a humorous "presidential campaign" with which she spoofed the political system in 1972. Based in part on a bit of free-love rhetoric and the advocacy of marijuana legalization, the nonexistent "campaign" also prompted her idea for a promotional button, "Stella and Bust!" (not "Stella or Bust," she is quick to emphasize). Another possible campaign slogan, notes Stella laughingly, might have been "Leave It to Cleavage, as my boyfriend Bob always says!"

While the "campaign" was a joke, there was serious intent behind it. "I had a vision that I would be dragged into politics. I care about politics because I care about people. So if people came to me and asked me to run for president of this country, I would certainly consider it. Somebody has to be the first woman president. It's got to be somebody strong, someone who has a regard for human life and also women's lives and livelihood, someone who will take up for children—someone who is very much like me. If I see a woman who is like me and who I could believe in, I would probably support her for president. So far, I don't see anyone I'd like to support.

"My mother's sister used to say, 'Honey, you've pulled yourself up by your own bootstraps.' Well, I've been the only one here to do it. It has been lonely, but it's been beneficial. I'm a very self-sufficient person. Although I love many people as friends, I'm also comfortable being alone. Maybe I could influence more people by directing a really good movie than I could by being president. There's something to

be said for entertaining people and enriching their lives."

The 1975 film *Cleopatra Jones and the Casino of Gold* gave Stella the opportunity to portray an out-and-out villainess—"a total sociopath," in her words. "She had no sense of right or wrong at all, which makes her still more diabolical." She enjoyed filming in Hong Kong, and working with co-star Tamara Dobson, a gorgeous, towering black model who had achieved movie stardom in the first *Cleopatra Jones* adventure film. "Tamara was great to work with. She was very nervous starring in her second film, and would come on the set to watch me work. That was nice, I thought it was very flattering."

The climax of the film was an epic battle between Stella and Tamara. "She was like a young colt when she was on her back, and those long arms and legs coming at you. She's got the reach—I couldn't get near her!" Years later, the two worked together again on the film *Chained Heat*; says Stella, "thank God I didn't have to fight her in that one!"

"I love fights with women!" Stella says with a smile. "I had a terrific fight with Lynda Carter in the pilot film for the *Wonder Woman* series [*The New Original Wonder Woman* in 1975], a great, strenuous piece of physical comedy. I got into fights with Barbara Rush [in TV's *Flamingo Road*] as well as Tamara, Sybil Danning and Linda Blair. I can fight with any woman—just give me a woman and I'll fight her!" she laughs. "There's nothing more fun on screen than two women fighting."

Stella's 1970s filmography

Most minor appearances in made-for-TV movies are omitted for space.

The Ballad of Cable Hogue (1970) — The fourth film in which Stella portrayed a prostitute turned out to be the greatest triumph of her career. Jason Robards, a prospector abandoned and left by his partners to die in the desert, survives by finding water, and opens what becomes a prosperous rest stop for travelers. Hooker Stella falls in love with Cable and joins him in his quest for the good life—while trying to dissuade him from avenging himself on the bandits who had left him stranded—and she is a delight. One spicy detail thought up by Stella was to have Cable's name embroidered on her panties.

The glow in her eyes from being treated with respect for the first time ("I'm gonna be the ladiest damn lady you ever seen") is unforgettable. The scene late in the film in which Robards gives Stella an outdoor bath was much-reproduced in magazines. Her singing (the lovely folk ballad *Butterfly Morning*) adds another poignant element to a wonderful film.

Stella recalls today how the song came about. "I suggested that Hildy was a caterpillar, when she was a prostitute, who blossoms into a butterfly upon her return at the end of the film. The period when she's away in San Francisco is her cocoon stage. So Richard Gillis wrote the song from that idea." During the shooting of the film, Stella had been photographing wildflowers in the desert for an exhibition. This inspired Gillis to write the song's refrain, "Butterfly mornings and wildflower afternoons."

In Broad Daylight (1971, TVM) — Richard Boone, Suzanne Pleshette and Stella star in excellent murder mystery.

A Town Called Hell (Spanish/British, 1971) — Routine Western (also known as *A Town Called Bastard*) despite an interesting cast headed by Robert Shaw, Stella, Martin Landau and Telly Savalas. Stella is after the killer of her husband in a town run by a ruthless Mexican bandit.

Climb an Angry Mountain (1972, TVM) — Excellent drama about tough sheriff Fess Parker and a New York cop facing off against a fugitive Indian holding the sheriff's son hostage; Stella's the female lead.

The Poseidon Adventure (1972) — The biggest box office smash of 1972, this disaster epic set aboard a crippled luxury liner stars Gene Hackman as an action-minded priest, with Stella (as a tough-talking ex-prostitute wed to Ernest Borgnine), Carol Lynley and Red Buttons among the passengers struggling to survive. Working with Hackman was Stella's fondest memory of this film.

Slaughter (1972) — Ex-Green Beret Jim Brown is out to get the killers of his parents and then the syndicate's chief in Mexico. Stella is the girlfriend of the ambitious hoodlum seeking to take over the operation, but she and Brown become passionately involved and she turns against her ex-lover. Violent and not too good, but the interracial love scenes between Stella and Brown heated up screens and generated ample publicity. While she enjoyed working with Brown, Stella recalls it as "a cheap picture. When they brought out the artillery for the big shoot-out at the end, the prop people originally presented just two hand grenades—now that's cheap!"

Stand Up and Be Counted (1972) — Comedy/drama about the impact of the women's liberation movement on relationships in the Denver area. Stella (as the sex-starved wife of a wealthy manufacturer) and Jacqueline Bisset head the cast.

Arnold (1973): Stella stars in this comedy/thriller as the mistress of a deceased nobleman whom she married posthumously to inherit his fortune.

Linda (1973, TVM) — In the title role, Stella is in high gear as a scheming wife who murders the wife of her lover and then tries to frame her husband for the crime.

The Day the Earth Moved (1974, TVM) — Earthquake thriller starring Jackie Cooper and Stella.

Honky Tonk (1974, TVM) — Stella and Richard Crenna star in remake of the Clark Gable-Lana Turner love triangle tale of a dance hall girl, a con man and a respectable lady.

Cleopatra Jones and the Casino of Gold (1975, U.S./Hong Kong): The sequel to the hit "blaxploitation" flick *Cleopatra Jones* again stars Tamara Dobson as the towering crime-fighter off to Hong Kong to battle druglords. Stella has a juicy, campy role as "the Dragon Lady," the leader of an international narcotics operation, and she plays it to the hilt. She is one of the most formidable female villains yet seen on the big screen. A real treat for any Stella fan—particularly her climactic showdown with Tamara.

Stella relates that the film's original director was fired because he had "planned too much and couldn't adapt to changes," so the second-unit director took over and did a solid job. "I learned from that experience that you've got to

plan everything ahead, and then be ready to throw it away and make it up as you go along."

Kiss Me. . . Kill Me (1976, TVM) — Stella stars as the D.A.'s special investigator who allows herself to be bait to trap a psycho killer.

Las Vegas Lady (1976) — Stella has the title role as "Lucy," who enters into a scheme with Stuart Whitman to steal $500,000. Supporting role for Andrew Stevens.

Nickelodeon (1976) — Peter Bogdanovich comedy about the early days of motion pictures stars Burt Reynolds as a cinematic leading man and Ryan O'Neal as an accidental film director. Stella is the top-billed adult female (so qualified because of Tatum O'Neal).

Wanted: The Sundance Woman (1976, TVM) — Katharine Ross reprises her "Butch Cassidy" role in this sequel; featured role for Stella.

Charlie Cobb: Nice Night for a Hanging (1977, TVM) — Shipboard-horror outing, with Stella and John Forsythe among the stars along for the ride.

Murder In Peyton Place (1977, TVM) — Mystery-drama reuniting some members of the TV cast.

The Manitou (1978) — Horror flick in which Susan Strasberg discovers, ah, a 400-year-old medicine man growing on her back, and Tony Curtis is unable to dispel the evil spirit.

Friendships, Secrets and Lies (1979, TVM) — Stella, Tina Louise, and Paula Prentiss are among seven college sorority sisters who relive a horrible, long-buried campus secret; all-female cast and virtually all-female production. According to Stella, the film's original director was fired following the first week, and "after that we more or less directed ourselves."

As previously noted, Stella's driving passion since her arrival in Hollywood was to become a director. Since the (male) Hollywood powers-that-be were not breaking down her door with offers, she decided in 1978 to get the ball rolling herself with a 90-minute documentary, *The American Heroine*. Acting as director-producer-writer-interviewer, and financing the entire project out of her own pocket, Stella wanted to tell the story of "ordinary women who are heroines in their everyday lives. I was profiling the kind of women that I knew growing up in the South, who inspired me to be what I am."

She began in the Peruvian city of Cuzco, the oldest city in the Western Hemisphere, and widely known as "the navel of the world," which seemed appropriate given the nature of the project. "We shot in Ecuador, the Galapagos Islands, the Appalachian mountains, in Texas, then across to California, meeting heroic women from all walks of life." She used students at the University of Texas at Arlington as her crew; in return, they got college credit. Three of these students later stayed at her home until they could get established professionally in Hollywood, and she notes proudly that all three did find work in directing or cinematography.

In 1981, after three years of work interspersed with a continuing role on the TV series *Flamingo Road*, Stella tried to find distribution for the film, with the Public Broadcasting System her main objective. PBS turned it

down, and the documentary would be shown only at film festivals in Texas, North Carolina and Mississippi. "I was to make it, and I'm pleased with it as a film, and proud of it as a woman. When we screened it in Texas, a 12-year-old girl came up to me and hugged me and said, 'Thank you for giving me some role models of women to look up to.' She had tears in her eyes. I was told afterward that the girl had just come from taking a lie-detector test about her stepfather molesting her. Well, that satisfies me more than anything." The final outcome of the project was "quite frustrating, but it was a step in the right direction."

Stella's confidence in her ability to direct was bolstered by the experience. "I've worked with some of the best, and some of the nastiest, directors in the business. One of the reasons I wanted to be a director was that I knew the difference between the good ones and the bad ones, and I knew I could be great at it, with compassion and love for acting, instead of disdain. I love to bring out the best in other people. If you can transcend the mundane and ordinary, and create a magical illusion of artistry, that's why I'm in the business—to let people see things in a new way that they'll never forget."

The documentary served a second important purpose besides furthering her aspirations to be a director. "This was a period of my life when I was trying to win over a female audience that had hated me on sight for over a decade. Every female that I knew hated me because of my appearances in *Playboy* magazine, and the possible threat I posed to their husbands, or some silliness like that. Women hated me and never even thought that I was one of them. And so I made a concerted effort—in *Stand Up and Be Counted, Friendships, Secrets and Lies*, and *The American Heroine*—to let women know that I was a woman, and not a female impersonator. Because that's how I had been made to feel, to dress up and be the next Marilyn Monroe. . . And now, I get as much fan mail from women as from men. Women feel comfortable meeting me, they're not put off as they were before based on a preconceived motion of what I would be."

When she wasn't working on realizing her dream of feature-film directing, Stella was writing film roles for herself. In 1977, she tried to market a screenplay she'd written for her son Andrew and herself titled "Leto," the mythological goddess changed into a wolf by Hera. The plot concerned a female anthropology teacher who is scratched by a werewolf and becomes one. "People looked at me as if I was a werewolf," she recalls about her unsuccessful efforts to sell the project. "I was laughed at and turned down by everyone I went to for help."

These activities occurred at a time when Stella was undergoing a major change in her life: After more than a decade-and-a-half in Hollywood, she purchased and moved onto a 101-acre ranch in the Okanogan National Forest in rural Washington state. One of the reasons for the move was the Hollywood drug scene. "I was bothered with so many people snorting cocaine around me. It was everywhere—I thought it was the beginning of the end for these people, and I had to get out. I'd done a lot of drugs during the 'drug era,'

but those were hallucinogenic drugs like mescaline, peyote and LSD. I hated destructive drugs like heroin and cocaine and would never allow that sort of thing around me. I saw too many friends around me die. I wanted more out of life."

Another reason for the big move was Stella's desire to write. "I bought it thinking that it would be a perfect place for me to write. The cabin, the pot of coffee, the fire, the mountains. Well, I couldn't even write a grocery list!" she recalls with a rueful laugh. "All I did there was play. I camped out, I hiked, I drove all over the state of Washington and explored every nook and cranny of the desert and the mountains. And I made many friends." She also bought an island off the coast of southwestern Canada. "It was the most healing thing I could have done at that point in my life. Even though I didn't write anything there, maybe I write better now for having been there. It was like a second childhood." Stella owned the ranch for 12 years, selling it in 1988.

Stella's return to episodic prime-time television took place in 1981 in the soap opera *Flamingo Road*. She was featured as Lute-Mae Sanders, head of the local casino/bordello in Truro, Florida. "It was a wonderful ensemble, with 14 regulars, and we turned out an excellent show." After NBC received some nasty mail from the powerful right-wing Moral Majority, they quickly transformed Stella's character from a madam to the owner of an elegant restaurant. (Her comments about the now-defunct "Majority" are scathing.) The series was canceled after one year, despite a devoted following. "Brandon Tartikoff (then the head of NBC programming) told me years later that he was sorry they had dropped the show, that they had made a mistake."

In 1979, Stella appeared in the pilot film for the series *Hart to Hart*, starring Robert Wagner, the second male lead in her film debut 20 years earlier, *Say One for Me*. Other TV work since 1980 included guest appearances on *Fantasy Island*, *The Love Boat*, *Highway to Heaven*, *Murder, She Wrote*, *Magnum P.I.*, the HBO series *Dream On*, and (in 1992) *Dangerous Curves*.

A memorable, reassuring appearance during this period was as a sexy movie star visiting Vermont and attempting to seduce the very-married Bob Newhart in the CBS comedy series *Newhart*. The NBC daytime soap opera *Santa Barbara* provided a featured comedy role for Stella starting in 1989 as meddlesome mother Phyllis Blake. Most recently, in the fall of 1991, Stella made a typically indelible impression on an episode of NBC's *In the Heat of the Night* as the long-ago (and much younger) lover of Carroll O'Connor's Police Chief Gillespie. It turned out that during their extramarital fling, Stella's character had a daughter by Gillespie; sadly, Stella was murdered by her husband by the end of the episode, leaving O'Connor to come to terms with their daughter. She also guested on the ABC series *The Commish* in 1993, the revival of *Burke's Law* (1994), and, in 1995, an episode of the United Paramount Network program *Marker*.

Another recent project of Stella's is a female version of Neil Simon's *The Odd Couple* that she first did in 1987 in a 13-week theatrical run in Toronto with the late Sandy Dennis. Subsequently, she has done the play with two different Canadian actresses for Stage West theaters in Canada. Each time, Stella portrayed the character of Olive, a loud, boisterous New York TV news producer. "I'd like to do more theater, but my entire life has been geared toward directing films. If you direct a movie, it's out there forever. If you do a play, it's a fleeting moment."

Stella's always-active love life has found a new focus the past several years in Bob Kulick, a rock guitarist and composer. The two had met in 1983 while both were working on a film (ultimately shelved) called *Rock and Roll Hotel*. Stella later told *People* magazine: "I walked into the Power Station, and Bob got an immediate erection. I guess he held that thought for 14 months" until they got together again and moved in together. The age difference mattered little to her: "He seemed to be old enough to know what he was doing, and that was good enough for me." It was her relationship with Kulick (then based in New York), and her determination to break through as a director in Hollywood, that led Stella to sell her Washington ranch in 1988.

Stella's Filmography From 1980

Selective with regard to her many TV movies:

Children of Divorce (1980, TVM) — Drama about the effects of divorce on three families; Barbara Feldon and Billy Dee Williams are among those featured along with Stella.

Flamingo Road (1980, TVM) — The pilot film for the TV series, with Morgan Fairchild, Stella and Barbara Rush are the most striking cast members.

Twirl (1980, TVM) — Stella is top-billed in this satirical comedy dealing with parental pressure on youngsters competing in a national baton-twirling contest, a variation on the film *Smile* about teen-age beauty pageants.

Chained Heat (1983) — Notorious and popular exploitation film with Linda Blair as an innocent girl serving time in a sadistic women's prison. The awesomely formidable foursome of Stella, Sybil Danning, Tamara Dobson and Edy Williams are among Linda's adversaries; hard to resist with that lineup. "It was a cheap, low-budget piece of junk," is Stella's succinct recollection. "They claimed bankruptcy after it was done, even though the film made money, and cheated everyone out of their money."

Power, Passion & Money (1983) — Michelle Pfeiffer stars as a glamorous young starlet who enters an affair with a married man (Darren McGavin).

Wacko (1983) — Spoof of teen-age slasher films featuring Stella with Joe Don Baker and George Kennedy.

Women of San Quentin (1983, TVM) — Stella stars with Debbie Allen as one of the few female guards at the notorious prison.

Amazons (1984, TVM): Preposterous but occasionally enjoyable TV flick in which a female surgeon stumbles upon a secret organization of women trying to take control of the government; Stella and Tamara Dobson (in their third film together) are among the ambitious amazons, with Stella as the high priestess.

No Man's Land (1984, TVM) — Stella stars as a female sheriff out West with three lovely daughters (including Donna Dixon) and

adversaries including a desperado and foreign revolutionaries. Modestly enjoyable proposed series pilot. "That wasn't picked up as a series because the network said, 'the Western is dead,'" remembers Stella. "They were proved wrong by *Lonesome Dove*—Westerns will never be dead."

The Longshot (1986) — Comedy starring Tim Conway and Jonathan Winters.

A Masterpiece of Murder (1986, TVM) — Bob Hope (in his first TV movie) and Don Ameche star in this forgettable comedy as an over-the-hill detective and a retired master thief.

Monster In the Closet (1986) — Hailed in Leonard Maltin's movie guide as a "perceptive and funny homage to 1950s sci-fi flicks" as a reporter and a female scientist team up to track down and destroy "California monsters who pop out of closets and kill people."

Adventures Beyond Belief (1987) — Elke Sommer and Stella are featured in tale of an irreverent motorcyclist chased across Europe for a murder he didn't commit.

Fatal Confessions: A Father Dowling Mystery (1987, TVM) — Prelude to Tom Bosley's TV series; Stella again plays a madam.

Man Against the Mob (1988, TVM): George Peppard stars in detective drama (and series pilot) set in 1940s L.A.; Stella portrays the chief villain.

Down the Drain (1989) — Farce about an unscrupulous criminal lawyer and his colorful clients; Andrew Stevens stars, with Teri Copley supporting and Stella in a cameo as a dark-haired Italian woman with a baby.

The Guest (1989) — Stella plays the Mother Superior of a Brazilian convent.

Jake Spanner, Private Eye (1989, TVM) — Robert Mitchum stars; Stella, Terry Moore and Sheree North are among the stellar cameo players.

Mom (1990) — Absurd vampire film in which Stella plays a wild red-haired hooker named Beverly Hills.

Exiled (1991): Dramatic role for Stella as a paraplegic mother.

Last Call (1991) — In this film, Stella did what she calls "one of the hottest love scenes I've ever done, making love with a guy on a pool table." The guy happens to be her daughter's lover.

The Terror Within II (1991) — L Andrew Stevens directed this horror flick, with Stella as Kara, the doctor in an underground lab who delivers a mutant alien baby from a raped woman.

South Beach (1992) — Stella appears as the sexy mistress to a gangland lord.

Feature Film Director, Present and Future

In 1989, after 30 years of constant preparation, Stella was finally given the opportunity to direct her first feature film, a comedy called *The Ranch* about a yuppie (played by her son Andrew) who inherits a Western ranch. "After I brought the film in on time and within budget, they said thank you, we don't need you anymore, and all but threw me off the picture. They changed the ending and ruined the film." The picture went straight to video without a theatrical release, and the company subsequently went bankrupt—"they deserved it." In her judgment, the company's conservatism also contributed to the film's failure: "Every time I tried to shoot someone with their top off, they edited it out. So it's like a children's picture. I couldn't get any semblance of

sex into it."

While noting the sensual nature of roles (like 1991's *Last Call*) that continue to come her way, Stella emphasizes that she doesn't seek out such parts. "That's the only thing that makes me money. I have to live, like everyone else." She objects to people who look down their nose at roles with a strong sexual component. "Look at Sharon Stone in *Basic Instinct*—that was a great role for a woman that happened to be sexual in nature," she points out. "What difference did it make if she was naked or not—it was beautiful to look at, and the entire story was a good one.

"In this day and age, why would anyone go to a movie that doesn't have nudity in it?" she asks. "I tried to put it into the one I shot (*The Ranch*), and they cut it out because they were prudish. I know what sells. Sex and nudity sells movies—it always has, it always will. That's why we're making movies, to sell tickets. You think I'd be ashamed to be Sharon Stone in that picture now? I'd be as happy as anybody could be. I don't know why people are still shocked by nudity, but they'll buy tickets for it."

In addition to her many professional projects, Stella is writing a book on health and nutrition that will spell out her lifelong theories on "personal regeneration." Still an exceptionally beautiful woman who looks many years younger than her chronological age, Stella is certainly living testimony to those theories. But her focus remains on her craft. As an actress, "I still haven't had a 'greatest role,' although Hildy in *Cable Hogue* came close. Other than that, everything else has been duck soup. That one great role may yet appear, and perhaps I might be able to provide myself with one."

Meanwhile, the quest continues. She has found three film properties that she'd like to direct: a comedy, a thriller, and a serious look at teen suicide. "All of the experience I've accumulated the last 30-odd years tells me that I am a good director. At least I'm stubborn, that's one quality you can give me. I never stop trying." Indeed, Stella's sheer force of will is such that anyone betting against her future as a feature film director would be a fool. "I'm just starting my life now. All this other stuff has been prelude to what I think I'm capable of achieving in the years to come."

Since 1970, Stella's magazine appearances have included: *Knight* Vol. 8-7 Nov. 1970 (full-length interview, led off by a splendid full-page shot of Stella in her low-cut *Cable Hogue* hooker attire)

Nov. 1970 *Playboy* (1 picture from *Cable Hogue*)

Dec. 1970 *Playboy* (1 semi-nude picture in the *Sex Stars of 1970* feature)

Oct. 1972 *Playboy*: *Brown White and Black* includes three steamy pictures of Stella with Jim Brown in the film *Slaughter*.

Dec. 1972 Playboy (1 revealing picture in *Sex Stars of 1972*)

Dec. 1973 *Playboy* (1 vintage shot in *Sex Stars of 1973*)

Jan. 1974 *Playboy*: Gag nude centerfold of Stella fooling around while doing her 1960 Playmate layout, with crossed eyes and tongue sticking out—the picture that inspired her $7 million lawsuit.

Celebrity Skin #1 1985 (2 pages, 8 pictures)

Jan. 1989 *Playboy* (1 picture)

Nov. 1990 *People*: Three-page feature on Stella, focusing on her current romance with Bob Kulick.

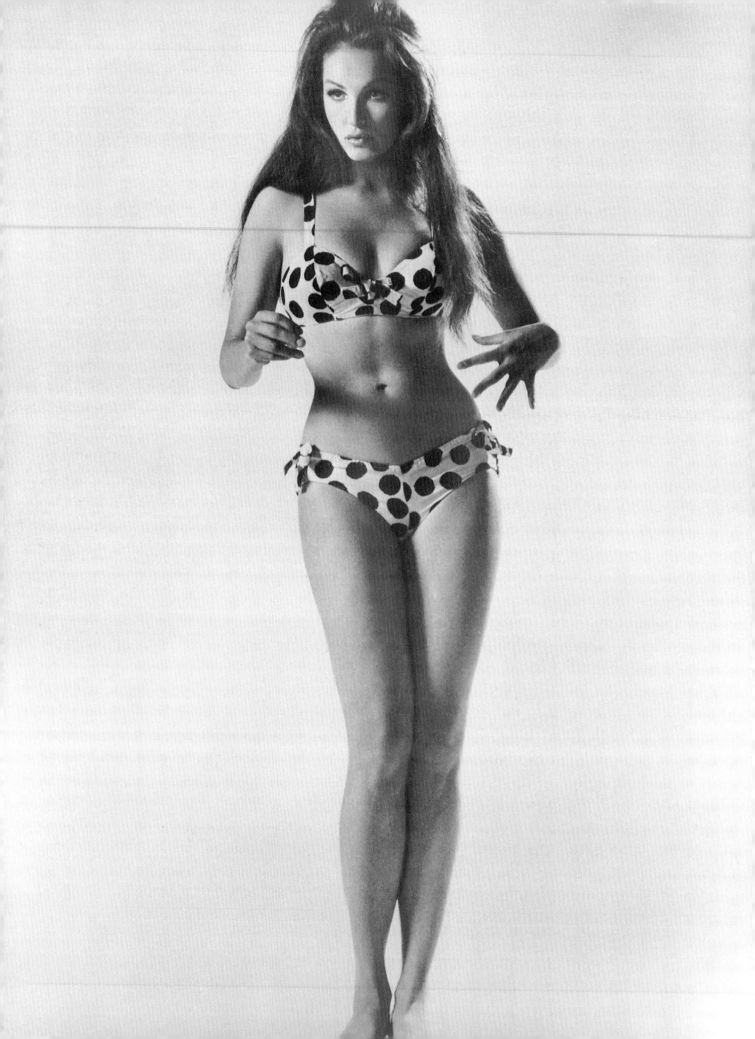

The woman whose most acclaimed role was that of the world's most physically and intellectually perfect female is, in real life, so extraordinary in many ways that she has sometimes appeared to be a stunning representative of an alien race—but a race we would gladly welcome as conquerors.

From any possible perspective, Julie Newmar is a woman whose very presence is so overwhelming as to dominate any setting. The classic contours of her face, imposing height and magnificently structured form would captivate the most demanding sculptor; her seductive voice possesses a strangely hypnotic power, and the keenness of her mind and richness of spirit further enhance the impact. Her stage, screen, and modeling career have made Julie one of the modern era's foremost sex symbols, but this is but one element of a quite singular lady.

Much like her character in *The Marriage-Go-Round*, Julie Chalane Newmeyer came from remarkable stock. Her father, Donald Newmeyer, was a professor of engineering at Los Angeles City College after having been a second-team All-American in football at the University of California and playing briefly with the Chicago Bears. Her mother of Swedish descent, the former Helene Jesmer, was a beautiful Ziegfeld *Follies* dancer for a six-month period. "What she was unable to finish in her lifetime, I have been able to do," Julie says today. "I picked a wonderful set of parents."

"I inherited an inner dynamism from my parents," recalls Julie. "There was a gentle expectation of achievement, not an ugly outside pressure. There was a genuine acquiescence by my brother and I to please our parents." As a little girl, Julie rose at 7:00 each morning to practice the piano. "Even if one doesn't become a concert pianist, that knowledge evolves into an appreciation for the arts." But her predilection for dancing was particularly evident from the age of five, and this was the career toward which she aimed by way of private lessons. In her witty self-written resume, Julie recounts her stage debut, at age seven, as *Alice in Wonderland*. Then, "eight years of unemployment followed."

Julie's mother once told an interviewer that she encouraged Julie's dancing—not because she wanted her to go into the theater, but because "a girl her size should know how to walk and move gracefully." Indeed, Julie reached her full 5-foot-11 stature when she was in high school. She said she began taking ballet lessons so that she could overcome her self-consciousness. Shyness, according to Julie, "is the reason why most girls become actresses. The thing that turns them into a star is the need to become loved and accepted."

Julie was very much aware of being an extraordinary child. "I always had a feeling of being on the outside, of not being like the others. I wouldn't have known what a social life was. I was always taller and younger than my peers, but emotionally, I was certainly underdeveloped. Socially, I was a misfit—no, a non-person. Very studious, very serious. School was not a social event for me." Because of this, Julie poured all her energies into her art.

In a 1986 interview with Bruce Dey for the magazine *Pixtrader*, Julie remarked:

"I remember starting dancing training with ballet with Ernest Belcher who was the father of Marge Champion, wife of Gower Champion. (The Champions were one of Hollywood's great dancing teams.) And I loved ballet; I took private lessons and then I took Spanish dancing lessons when I was about 10. I was very good at that, oddly enough. Flamenco dancing, especially, which I did in concert at the Philharmonic in Los Angeles with a real dance company from Seville (Spain). . . I also studied acrobatics, tap and even had one lesson with the famous Ruth St. Denis. I've also studied and danced in Paris with Najinska, Nijinsky's sister, so ballet was really my foundation and I love it! I still do it today. . . take three classes a week. And oh, it's hard. But I do it because it's hard."

Flamenco dancing was "a passion that was quite deep in my heart," she says today. "Also, it was very sexual, and that was a no-no. A passion came out of my body that I had never felt before. It was extraordinary. I do think that was my sexual debut. The sexuality came to life in the dance."

After her high school graduation, Julie went to Europe with her mother and younger brother for a year long "cultural tour," taking in all the great museums and cathedrals. During her stay in Spain, she and her mother attended a bullfight. A matador spotted the stunning teen-ager in the stands and gave her both ears of a vanquished bull; her mother threw the ears in the gutter outside the plaza de toros.

Following her ballet studies in France and Spain, Julie—at age 15—was prima ballerina of the Los Angeles Opera Company for several performances. "I was discovered in a bar, of all places!" she laughs. "My dance teacher knew the producer of the company and told him, 'That's the girl—use her.'" Her rapidly developing height and physique enabled her to cut a startling figure on the dance stage; due to her height, she was "never in the chorus."

Julie attended UCLA for six weeks, studying dance, French, classical piano, and philosophy. While there, she was "prevailed upon" to do a piano recital for the student body. The L.A. native, however, quite naturally had begun to look toward Hollywood as a suitable vehicle for her talents, and at that point the opportunity arrived. She was signed by 20th Century Fox.

Julie's motion picture debut came at the age of 17 in the 1952 musical *The I Don't Care Girl*. She was unbilled and if you blinked you'd miss her part in a specialty dance number,

Julie Newmar

Born Julie Newmeyer August 16, 1935
Los Angeles, California

but it was a start. Her first real opportunity came the following year with *Serpent of the Nile*, portraying a golden statue come to life and performing a tantalizing dance. In preparation for this role, "I went into libraries to research Egyptian art. I looked at vases, paintings, to put together movements that would capture the essence of who those people were." And then, after all that striving for authenticity, "they decided to paint my body gold—that kind of brought it into the 1950s standard!" she laughs. "I was wearing a two-piece swimsuit, but they took care to cover my ever-so-dangerous belly button. Oh, it was ever so licentious, my belly button!" That offending body part was covered with Scotch tape when the suit kept slipping due to her movements.

This was followed by the still bigger break of a good supporting role in the blockbuster MGM musical *Seven Brides for Seven Brothers*, which also showcased her dancing skills. "Working with (choreographer) Michael Kidd was a great opportunity, although he gave the best dancing to the boys. They did backflips off wooden horses, they jumped off rooftops, they danced with axes—while the girls did sweet little pirouettes."

While under contract to Universal Studios at this time, Julie served as a "dance double" for some actresses in musicals. She also taught dance classes, and one of her students was another noted Amazonian beauty, Anita Ekberg.

One of Julie's fondest memories of her beginnings in Hollywood was working with the great choreographer Jack Cole, whose reputation had been forged during the 1940s in four films (including the classic *Gilda*) with Julie's "screen idol" Rita Hayworth, and who also worked with Marilyn Monroe in her most famous musical sequences. Julie appeared briefly in two Cole-choreographed films (see filmography) and was featured in his stage production of *Follies*. "He was the best choreographer I ever worked with. Brilliant! Hard! Difficult!. . . I remember at Fox when they couldn't get a stuntman to do a certain stunt, they would just call up and ask for a Jack Cole dancer because we could do anything and we would for Jack Cole."

During this period, Julie recalled, she dyed her hair red to emulate Rita, whose father Jose Cansino taught her Spanish dancing. "She was my dream goddess. She was the most beautiful woman in cinema, ever." Despite working with Rita's father, she says she was "too frightened" to meet the goddess herself. But late in Rita's life, Julie wrote a heartfelt letter to Miss Hayworth's daughter, relating how much Rita had meant to her.

"Thank God for the movies and the way they made them back then. I was lucky to grow up then. Private lives were kept private, so public personas (of actors) were always upstanding." She finds it more difficult to be truly entertained by movies today. "It has to come from a divine source. In a sense, I am the movies. My life is so interesting, and movies are generally for the young." Ideally, Julie observes, "movies mirror the way we are, have been, what we'd like to be, our dreams and hopes—we get to see it all for a few dollars on the screen. And in an hour or two, all the problems are resolved. When you're young, movies are a

guide for living. But after 45 years or so, you get the hang of it. Movies are no longer as necessary for that purpose."

Julie's early filmography

(She was billed as "Julie Newmeyer" from 1952-54)

The I Don't Care Girl (1952) — Although Julie is not listed in the credits of this musical starring Mitzi Gaynor, she turns up briefly as a specialty dancer (with Jack Cole's choreography).

Just for You (1952) — Julie made an appearance in this musical/comedy starring Bing Crosby and Jane Wyman, although she is not listed in the credits. She appears in a specialty-dancers sequence with a USO troupe. (Today Julie recalls that Crosby "tried to subtly seduce me in the dressing room.")

Serpent of the Nile (1953) — Clad in a bikini and covered head to toe in gold metallic paint, Julie's sensuous dance as a statue come to life—enticing Mark Antony (Raymond Burr!) into Cleopatra's (Rhonda Fleming) clutches—is a memorable highlight of this otherwise routine historical drama.

Slaves of Babylon (1953) — Julie performs a red-hot sabre dance in drab Biblical drama.

Seven Brides for Seven Brothers (1954) — Howard Keel and Jane Powell star in the rousing, rollicking musical classic; Julie is one of the seven enchanting young beauties who are abducted to become the brides of the roughshod brother ranchers. "They were the five greatest male dancers in the world," Julie exults in admiration.

Demetrius and the Gladiators (1954) — According to one account, Julie appeared (unbilled) in this popular follow-up to *The Robe*.

Three for the Show (1955) — The appeal of Betty Grable, the dancing of Marge & Gower Champion, and the choreography of Jack Cole are the saving graces of this otherwise routine musical. Julie is unbilled, but appears in a dance sequence.

Lil' Abner (1959) — Delightful filming of the hit musical, with all its original zest and fun intact; Julie is Stupefyin' once again, with *Stella Stevens* taking over the role of Appassionata.

The Rookie (1959) — Dreary Tommy Noonan military comedy vehicle, with Julie as the movie-star girlfriend of the base's master sergeant, and one of the principals who winds up falling off a carrier to Japan and washed ashore on a desert island. Julie remembers this low-budget outing as "great fun;" uncharacteristically, her character here was a "dumb blonde."

The Marriage-Go-Round (1960) — The film is not as successful as the Broadway show, although Julie's a delight as Swedish sexpot Katrin Sveg; James Mason and Susan Hayward take over the roles of the professor and his determined wife. "I loved James Mason, he was wonderfully helpful," Julie recalls. "But the film lacked that effervescence, that champagne quality of the play."

For Love or Money (1963) — Julie, Mitzi Gaynor and Leslie Parrish are the lovely daughters of millionairess

Thelma Ritter, who is determined to marry them off; Kirk Douglas stars in so-so comedy.

In her early film appearances, Julie was generally billed under her real name of Newmeyer, although nearly all 1953-54 magazines identified her as "Charlane Jesmer" (first name usually misspelled) after her mother's maiden name. From the very outset of her career, she was a favorite of men's magazines; certainly a breathtaking 5-foot-11 brunette whose 38-23-38 figure (later slimmed down to 37-22-37) was regarded by some as "the shapeliest torso in filmdom" was a natural for cheesecake photographers. Most of these early pictorials featured Julie in tights or other dancing attire working out on the beach or in other outdoor settings.

Peter Gowland photographed some of these memorable early layouts, and he and his wife Alice vividly recall working with Julie for the first time in 1953. "Julie was, and is, wonderful," says Alice. "We ran into her on the beach, and everyone there was staring at her. She was so tall and beautiful—her hair was blonde then—and wearing a tiger-skin bikini. She had a way of standing out in a crowd!" Naturally enough, studio executives were eager to take full advantage of Julie's natural attributes and had her participate in publicity stunts and more cheesecake poses; she was only willing to go along to a point, however.

In the 1955-56 season, she was set to take up where her mother left off in a lavish new Broadway edition of Ziegfeld's *Follies* that starred Tallulah Bankhead and featured choreography by Jack Cole. Julie was clad in a startlingly brief showgirl outfit consisting of a few shimmering rhinestone loops about her breast and thighs that revealed all but a few vital inches of her magnificent body. "I was next to naked," she recalls. "The curtains opened on me, in five-inch heels. My costume wouldn't stay on, unless it was wetted down so the sufel would cling to my body." Bea Arthur was one of the other principals in the show, which also featured voluptuous brunette singer Micki Marlo, numerous top comedians and an array of beautiful women including Miss America and Miss Sweden.

The show ran into financial problems, however, and closed in Philadelphia that May. "Sometimes a show is so overloaded with talent, they don't know what to do with it," says Julie. Despite the show's failure, Julie got two cover appearances in *Theatre Arts* from it. According to some published accounts, the Schubert Brothers recruited Beatrice Lillie to replace the departed Tallulah, and *Follies* made it to Broadway at the Winter Garden for a short run. According to Julie, however, that version of *Follies* never saw Broadway.

The day after the show closed in Philadelphia, Julie flew off to Cuba, where she met Errol Flynn. "He was a sweetheart, a lovely man. With only two years to live, his great charm and kindness were still there, even after years of debauchery. I was so innocent, I wouldn't have known a brothel if I'd seen one—and that's where they took me, to a brothel! We had a private performance by 'Superman' (a Cuban performer of sexual acts), and Errol and I were asked to participate. I was quite uncomfortable, and so was he. In

hindsight, it was pretty extraordinary. But I wasn't mistreated in any way. They just thought I was beautiful and come along, please. Well, heck, I had a great body, that was why they wanted me around," she says jokingly.

"I remember getting into this limousine at the beach (in Havana)," she continues. "Four or six of us were in the back, and sitting in the front with the chauffeur was an entire group of mariachis, serenading us everywhere we went!" She laughs delightedly at the memory. "How they all got in there in the front seat with their big instruments, I'll never know! It was like being in a movie."

Julie made her Broadway debut as the ballerina in Cole Porter's *Silk Stockings*, a musical adaptation of the classic Greta Garbo film *Ninotchka*. Directed by the great George Kauffman, the show was a long-running hit, and Julie stayed with it for about a year. The role was not a big one—"it was a holding place in my career"—but it was a step forward.

Julie's pre-1957 magazine appearances included:

Oct. 1953 *Photo* (The 18-year-old beauty's national magazine debut is a 6-page layout under the name Charlane Jesmer doing exercises on the beach in black leotard; her figure is already remarkable.)

Nov. 1953 *Night and Day* (Julie's on the cover (in tights and bulging blouse), plus on two pages in leggy ballerina attire as "Charlane Jesmer.")

June 1954 *Cover Girls Models* (inside cover plus 4 pages of leg art, as "Chalane Jesmer," mostly in tights and halter top while exercising on the beach; "Sea Nymph")

Sept. 1954 *Photo* (6 pages)

Dec. 1954 *Eye* (9 pages and 14 pictures of "Julie Newmeyer" in a variety of indoor and outdoor poses, mostly in tights, plus two in bikini and one in a towel; "Ballerina On the Beach")

May 1956 *Man's Way* (4 pages of boudoir leg art)

May 1956 *Man's World* (4 pages of beach pictures)

Aug. 1956 *Cabaret* (inside cover as "Showgirl of the Month," lovely portrait in tight, low-cut sweater)

Sept. 1956 *Mr. Excitement* #2 (cover, 4 pages, 7 pictures, dancing in skintight outfit)

Nov. 1956 *Gala* (2 pages of familiar beach pictures in tights; called "Julie Newman")

Dec. 1956 *Playboy* (two spectacular pictures of Julie from the musical "Follies")

Breakthrough on Broadway

Fortunately, she did not have to wait long before returning to the Great White Way. The fall of 1956 brought the role in a musical production of *Lil' Abner* that would truly establish Julie as a star.

With Tina Louise as Apassionata Von Climax and Edie Adams as Daisy Mae, the array of top-line pulchritude was as abundant as any show in Broadway history; but as the aptly named Stupefyin' Jones, the woman so beautiful that she turned men to stone with a mere glance, Julie was the bombshell to end all bombshells. On stage for only 90 seconds (at a salary rate of $40 a minute), Julie nonetheless had all the denizens of Dogpatch (not to mention audiences) open-mouthed as she shimmied across the stage in a breathtaking black nylon mesh outfit that left precious little to the imagination. Later in the run of the show, she would remain on stage for six minutes. The show was a smash hit, and so was Julie.

Tina Louise, with whom Julie shared a dressing room, was "gorgeous" and made a "marvelous" Apassionata. And Julie was a great admirer of Edie Adams and her husband, the great TV pioneer Ernie Kovacs. One of her fondest memories of the show was the night Kovacs gave Edie a birthday party complete with mariachi band, which left Adams crying tears of joy.

Recognizing Julie's unique qualities, Broadway producers wasted little time in giving her a full-fledged featured role suitable for her attributes. If *Lil' Abner* put Julie on the precipice of major stardom, *The Marriage-Go-Round* in late 1958 carried her over the top. Anita Ekberg was the producers' original choice for the role of a tall, voluptuous Swede, but she was unavailable. Agent Lester Shure happened to see an eight-foot picture of Julie outside the St. James Theatre where *Lil' Abner* was playing, and he recruited her for the part.

Her hair dyed blonde, she played a Swedish Nobel Prize winner's 18-year-old, perfect-specimen daughter who resolves to have a genetically perfect and intellectually superior child without going through the bother of love or marriage. She travels to New York, selects a startled professor (portrayed by Charles Boyer), and solemnly announces to him, "I've come thousands of miles to see you—I want you to be the father of my child." That Boyer is married (to Claudette Colbert) is only a slight complication; to the ravishingly gorgeous and brilliant character portrayed by Julie, this is a minor inconvenience at most, and as Claudette prepares to do battle for her man, Julie calmly explains why the effort is futile: "I am younger, prettier, stronger, bigger, and more intelligent than you. Don't fight it." When Boyer's character threatened to spank her at one point, Julie responded: "Ooh, violence! How exciting!"

One of the show's most memorable scenes had Julie march into the professor's den wearing only a towel, with—like Jayne Mansfield in *Rock Hunter*—presumably not a stitch on underneath. As she remarked at the time, some male theatergoers would attend repeated performances in the hope that the towel might slip. Julie notes today, however, that she was wearing a bikini bottom under the towel and "two dots of eyelash glue" over her breasts. "When you're on the stage sitting six feet from the audience and directly above them—it would have been distracting, to say the least, to wear nothing. You do not want to cause consternation."

According to some published accounts, Claudette Colbert was less than pleased by the intense attention Julie received, particularly during the bathtowel scene. "How, she wondered, could she get her lines across to an audience totally absorbed in waiting for the towel to fall off and reveal the Newmar lass in her natural state?" Julie emphasizes that "I was not in competition with Claudette Colbert. I didn't try to upstage her—it was her show. She's a very classy, smart lady, I always admired her." Julie observed that it took all of Miss Colbert's star quality to remain the focus of attention at center stage while this statuesque young beauty sat at stageside with her towel "slipping lower and lower."

Indeed, whether she intended it or not, Julie was the focal point virtually every moment she was on stage. "She writhes across the stage, jiggling in several directions at the same time," marvelled one writer. Once, she drew a large, heavily perfumed handkerchief out of her bosom, and dangled it temptingly under Boyer's nose. On another occasion, she presented him with a nude statuette of herself. In addition to the famous towel, at different points in the show "she wears a knit garment resembling a knee-length sweater, a tight yellow skirt that threatens to split at any moment, a pair of black lounging pajamas with absolutely no back (and very little front) from the waist up, and, at one point, nothing at all" (at least as described, while she is offstage, supposedly sunbathing).

Reviews for the show—and Julie—were almost uniformly positive. This included *The New York Times*, which described her character as "a Wagnerian seductress with a wonderful sense of humor and overwhelming physical candor." Not only was the show a hit, but in 1959 Julie was honored with the Tony Award as Best Supporting Actress (Dramatic). "It was a marvelous part for me. The dialogue is dated now, but it was absolutely dead-on for its period, concerning our attitudes toward marriage and flirtation. It was left to the audience's imagination whether Boyer ever slept with her. The part called for a physical mastery, that big-girl look. Being good at accents, and having a Swedish grandmother to boot certainly helped. That role did a great deal for me." She was so convincing in the role that at least one subsequent motion picture encyclopedia actually listed Julie as Swedish.

The only minor drawback to the star-making role was the fact that Julie had to dye her dark hair blonde. "With my natural hair I look evil," she teasingly told the press. "That I like." Today, she says she actually enjoyed being a blonde, but observes quite accurately that "blondeness didn't suit me as well as redness or as a brunette. It doesn't match my personality." Today, her hair is a light reddish brown.

Throughout this period, Julie was an object of fascination for the press, not only for her beauty but her distinctive personal style as well. The Mansfields and Ekbergs of the time would proudly recite their vital statistics as personal achievements, but Julie knew better. "It's no achievement to be beautiful," she told reporters. "It was an inheritance from my mother. I won a number of Miss-Something-or-Other contests, things like 'Miss Maple Syrup.' It's what else you have that's important."

Indeed, Julie has always taken her intellectual pursuits with a seriousness equal to the enthusiasm of her sensual stage and film performances. Quite fluent in French, she would habitually drive while listening to a tape recorder to help her learn Italian and Spanish. As a little girl, she had a picture of Einstein on her wall. Today, she remarks: "If you don't evolve, you die. If I was the same person now that I was then, I would be wearing a mask. Changing is profoundly important."

She consolidated her latest triumph by reprising both her Broadway successes in the film versions of *Lil' Abner* and *The Marriage-Go-Round*. In 1960, Julie made her television debut in an episode of the *South Pacific*-based ABC series *Adventures in Paradise*. One guest appearance on Perry Como's program, a scorching, hip-swinging dance routine, was a corker. She also became a favorite guest on interview shows; in later years, she often graced *The Dick Cavett Show*. By 1961 she was a big enough star to be featured on CBS' *Person to Person*.

In 1963, Julie hit the road in the national tour of the smash Anthony Newley musical *Stop the World, I Want to Get Off*. In addition to the film *For Love of Money*, she appeared as a blonde devil, complete with horns, in an episode of Rod Serling's *Twilight Zone*. In the Serling-scripted episode, "Of Late I Think of Cliffordville," she grants a rich old man his wish to return to the town he had known as a youth, in exchange for his personal fortune (he had already relinquished his soul). Expecting to cash in on his knowledge of the future and make it big all over again, he learns a bitter lesson.

Julie's first network television series, *My Living Doll*, debuted in the fall of 1964. As Tim Brooks and Earle Marsh describe it in *The Complete Directory to Prime-Time Television Shows*: "This comedy introduced the ultimate in male fantasy, a sexy, curvaceous, female robot programmed to do anything she was told—absolutely anything." Designed as the greatest achievement in space-age technology—powered by solar batteries strategically located in her back (not in her bosom, as some sources have claimed)—Julie was left in the care of base psychiatrist Bob Cummings, who passed her off as his niece, moved her into his house, and trained her to be the "perfect" woman.

Time described the show as "a one-joke show, but the joke is a knockout." The magazine's description of Julie's character virtually hyperventilates in its enthusiasm, but, considering the subject, this is more than understandable: "She is, more or less, the empire sex building. She is 6 feet tall. She is over a yard in circumference at the chest. Her thews are soft, her sinews are taut: her thighs, her eyes—her total form is a monument to the aspirations of man. She could not have been made anywhere but in a factory."

Julie brought the same full-tilt commitment and thoughtfulness to the role that she has brought to all her endeavors. "Rhoda is the ultimate consciousness," she said at the time, "the ultimate reality, the ultimate freedom. She is the quintessence of humanness. As I play her, the robot is coming closer to the ideal of humanity, and the humans around it are coming more and more like robots." The show ran for one year.

"It was absolutely the most challenging part I ever had to play," declares Julie. "Because how do you play a piece of machinery? I had been studying at the Actors' Studio (for a time in the '50s, she attended sessions with Marilyn Monroe, among others), and from that I learned that you didn't pretend you were a robot, you became one. It took me 13 episodes to truly get the consciousness of the character. I didn't try to be funny, so that what was funny came out naturally. . . The difficult thing about the part is that the audience won't turn on to you unless there's some quality they can identify with. The fact that (the robot) didn't wear many clothes could only be interesting up to a point."

Efrem Zimbalist, Jr. had been the original choice for the psychiatrist role because "they wanted to play it straight," and in retrospect she wishes they had gone in this direction. Cummings "came across as overly cutesy," and she feels a more subtle approach would have been better. "The show could have been quite marvelous if they had been correct in the casting." She notes proudly that Isaac Asimov—the spiritual father of all robots in modern science fiction literature—wrote her a fan letter of sorts that was published in *TV Guide*. Sadly for latter-day fans who would love to see episodes of *My Living Doll*, CBS destroyed the master prints of the show because it didn't have sufficient storage space; only some inferior "copies of copies" still exist.

The Catwoman Strikes!

Julie's next TV role proved even more memorable. In 1966-67, she appeared in five two-part episodes of the short-lived pop-cultural/camp phenomenon *Batman* as the seductive Catwoman, who would sorely test the stolid Boy Scout demeanor of her male caped-crusader adversaries. Eartha Kitt and Lee Meriwether would go on to play Catwoman, but Julie firmly placed her imprint on the role. Ronald L. Smith noted in *Sweethearts of Sixties TV*: "At last, Julie's unique and expressive voice was used as a key to her character. It can register gently lilting calm one minute, passionate intensity the next. She could be as gleeful as a child when taunting Batman; cool and intellectual when plotting a crime; and dryly humorous in both triumph and defeat."

Over the years in a zillion reruns, more people have seen Julie as Catwoman, perhaps, than in all her other roles combined. This is not at all displeasing to her. "Catwoman was exceptional because it was so well written," she has said. "I keep referring to the Batman show and the characters in it as something larger than life wherein it required an almost choreographic treatment. I remember choreographing an entire sequence with Batman in which I was. . . mmm. . . trying to seduce him. . . slide down a bannister, use a fur. It was a whole sequence, about six minutes. All done in one take and entirely choreographed because cats have so many striking and unexpected movements. It was very lucky I had that kind of background. So Catwoman required exactly what I had."

Looking back today, Julie says the casting of the show was "perfect, dead-on. The writing was fabulous, it created

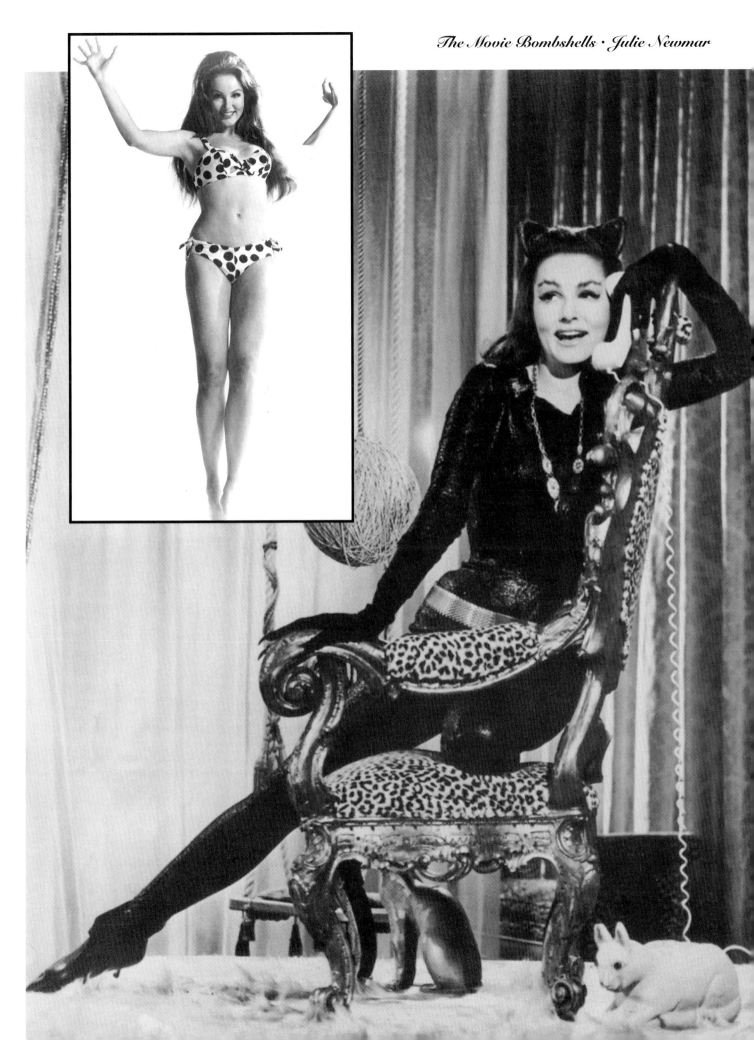

a kind of magic for us. The dialogue was sensational. I loved the physicality of it; the part was 75 percent danced, and only 25 percent acted. With that devious sense of comedy on top, you had a sort of triple whammy." She studied the movement of cats for the role, after Gypsy Rose Lee's sister June Havoc gave her two cats. "They have an inner sense of rhythm that people don't have. Cats look as if they're going to eat you up, or throw you out of whack. I tried to emulate how they sit on a windowsill, and how they lick milk from a saucer—not with your tongue, in those days on TV!" she laughs.

Julie loved seeing Michelle Pfeiffer (as Catwoman) sensuously lick Batman's face in the 1992 film *Batman Returns*. "They would have stopped the cameras if I'd done that!" Despite her admiration for Michelle's performance—"she's a divine actress, light years ahead of others in Hollywood"—Julie did not care for the movie. "It's not a fun film, and not at all appropriate for children." In fact, she walked out in the middle of a screening.

"I was more than a human being, I was part animal. That in itself is fascinating. We don't know what animals are going to do. The characteristics of Catwoman were so dynamic. Women had not been given roles with these standout qualities of insouciance, that take-charge attitude. Catwoman is one of the major roles for a female in films or TV." She paused thoughtfully. "How wonderful it would be if I could get another such role. Not Catwoman, but a role that has the kind of power delivery that she had. Wouldn't that be fun? Oh, I'd love that!"

In the fall of 1967, Julie turned up in an episode of another classic TV series, *Star Trek*. In "Friday's Child," she portrayed Eleen, the pregnant wife of a deposed ruler on the planet Capella IV who is saved from death by Captain Kirk. Dr. McCoy delivers the child, and the previously resentful Eleen names the newborn son—and new ruler—after him. "That wasn't a role that I savored, wearing a 400-pound gown as a dragon queen," she says. Over the years, Julie has guested on a wide range of TV series, including *Route 66*, *The Beverly Hillbillies*, *Bewitched*, *The Monkees*, *Get Smart!*, *Love American Style*, *Fantasy Island*, and *Hart to Hart*. In 1970, while appearing as a beauty queen in an episode of *McCloud*, she created quite a commotion while filming a scene in a bed in the middle of Times Square (don't ask why); such a large crowd formed that police had to be called in to cordon off the area.

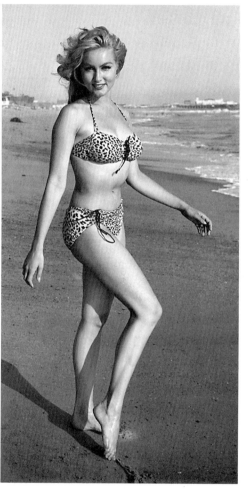

Another well-remembered episode was a 1973 *Columbo* outing titled "Double Shock." She is a beautiful physical fitness enthusiast whose wealthy and much older fiancee is murdered by his nephew. Julie is then pushed off a balcony when her fiancee's will—leaving her the bulk of the estate—is discovered. Two years later, she turned up in a similarly-titled episode ("Aftershock") of the Rock Hudson series *McMillan and Wife*.

Six years after her last motion picture appearance, Julie returned with a pair of relatively inconsequential films in 1969. Of considerably greater interest to her many male admirers, however, was the fact that Julie also appeared in two nude layouts for *Playboy*, both of which served to remove any possible doubts that her impossibly perfect physique was every bit as astonishing unclad as it was clad. (Julie notes today that technically, she did not actually pose for either pictorial, as both were shot on the set of films she was working on. But the pleasure for readers was still the same.) Calling the magazine "a good product," Julie says, "I would love to see a gorgeous nude of me, although I wouldn't do it now. A beautiful portrait, not a fuzzy picture taken from 400 yards away."

Julie's latter-day films:

MacKenna's Gold (1969) — Gregory Peck portrays a sheriff entrusted with a map detailing the location of a mythical valley of gold. This Western's highlight features Julie, as an Apache maid, swimming nude—a scene which far more people saw in the pages of *Playboy* than in the movie itself.

The Maltese Bippy (1969) — Flop comedy starring Rowan & Martin of *Laugh-In* fame, with Julie and Carol Lynley as the lovely feminine interests.

(In 1969, Julie worked for a few weeks in London with Zero Mostel in a film comedy that was never completed, to her disappointment. "Isn't he funny! His eyes, his flesh, even his fingernails were funny!" She was to play all the female parts in the film. Afterwards, she developed mononucleosis, "I think from sheer depression.")

Up Your Teddy Bear (1970) — Julie's a toy company director who wants to buy dolls created by shy salesman Wally Cox, and will stop at nothing.

The Feminist and the Fuzz (1972, TVM) — Julie portrays a hooker in this comedy starring Barbara Eden and David Hartman (as the mismatched police officers), and Farrah Fawcett.

A Very Missing Person (1972, TVM) — Detective thriller co-starring Eve Arden and Julie.

Terraces (1977, TVM) — Soap opera about various people living in a highrise; Julie looks magnificent as always.

Evils of the Night (1983) — Even the reunion of Broadway *Lil' Abner* co-stars Julie and Tina Louise can't save this outing, which also stars John Carradine. It's one she prefers not to recall: "One does not always make the right choices."

Hysterical (1983) — Attempted spoof of horror movies "starring" the Hudson Brothers.

Love Scenes (1984) — Sometimes provocative and entertaining tale of an actress (Angel Tompkins) who is persuaded by her director husband to star in an X-rated film; Julie does a wonderfully campy turn as the Mae West-like star who writes the film's screenplay.

Streetwalkin' (1984) — While reviewers were not kind to this tale of a hooker with a heart of gold, Julie describes it as "an excellent film, not at all exploitive, and written and directed by a female documentary maker. . . The production (by Roger Corman) was cheap, but it was enormously challenging for me to study prostitution."

Body Heat (Dance Academy) (1987) — Musical drama staged as a contemporary Romeo and Juliet; Julie portrays a "dance master" at a ballet studio, a role tailor-made for her.

The Monster Squad (1987) — Brief appearance in this moderately clever, kid-oriented horror film.

Nudity Required (1989) — It's a silly little B-movie about two surfer dudes who pass themselves off as young Hollywood moguls in order to romance gorgeous starlets. Julie, however, is a treat as a Russian diplomat who somehow winds up in their film. In addition to some sequences of Julie exercising in tights, there's also one discreet semi-nude scene as she takes a shower with one of the fellows; Edy Williams is also featured.

Ghosts Can't Do It (1990) — Julie has a supporting role in this Bo Derek outing.

During the 1970s, Julie divided her professional time between television, movies and the stage. She revived *The Marriage-Go-Round* and added some new spice by at last removing that towel for a few delightfully revealing seconds. "While I was walking offstage, I did drop the towel. Big deal." In addition, she performed in road tours of *Damn Yankees* (Julie seemed absolutely born to play the seductively evil Lola, and to perform an intoxicating version of "Whatever Lola Wants, Lola Gets"), and *Dames at Sea*. Also, in a summer theater tour on the East Coast, she played the role of Adelaide in *Guys and Dolls*.

"I think I was better than the dancing parts I did," she says reflectively. "Some of my best dance parts—'Damn Yankees,' 'Stop the World,' 'Irma la Douce'—were created for Gwen Verdon, so they were the best by definition." Nothing gives Julie greater pleasure than to see a great dancer at work. "To be a great dancer is awesome. To physicalize something that is art, to do both, is wonderful. After I saw Nureyev for the first time, dancing with Margot Fontein at the Metropolitan Opera, I sat there as everyone in the audience left, and cried. I cried for five days. I was so moved, it left me absolutely drained."

Combining her ingenuity and body consciousness, Julie created a special pantyhose design in 1976 which lifted and shaped the derriere. She demonstrated it in *People* magazine for photographer Susan Wood, viewed from the side (with arm strategically placed) in the pantyhose and nothing more. During the same period, she also secured patents on brassiere designs and a garter belt.

On August 5, 1977, the longtime bachelorette beauty married Texas attorney John Holt Smith. The two had met in 1975, but the relationship became serious in early 1977 after proceedings for Smith's divorce from his first wife began. He proposed to her at New York's 21 Club. Shortly after the marriage, *People* magazine wrote a rather superheated account of the couple's passionate romance. Julie describes the story as "almost totally untrue." On the subject of romance, however, she remarks that her lifelong spiritual journey has always been interconnected with health and vitality of body: "That's why sex was so great for me."

Julie retired from show business, settled in Fort Worth, and had a child, John Jewl Smith, at age 48. (Interestingly, Stella Stevens—Julie's co-star in the film version of *Lil' Abner*—sold the newly married couple their home in Fort Worth.) But when the marriage came to an end in 1983 (the formal divorce came three years later), she appeared in a couple of quickie films. Unhappy with the results, she turned her energies to establishing a real estate business. Indeed, her biographical entry in *Who's Who in Entertainment* begins: "actress, real estate developer."

This business began when Julie's mother left her a few properties, and she decided to branch out by developing her own projects. "It's like being a producer because I'm the money, I own the property, I hire the architects, the designers, the contractors," she says. "I direct everything. I'm the casting director!" She remarks, "We come and go, but real estate stays. It's totally opposite from show business. Show business is magic, but this is real."

Of course, to her many ardent admirers, one Julie Newmar is worth more than a hundred Donald Trumps, and thankfully she has diverted some of her attention from real estate to keep a hand in show business. And lest anyone think she had neglected physical culture, in 1984 she posed for a series of glamour portraits by master lensman Peter Gowland that are utterly stunning in beauty. Clad alternately in a teenie bikini or lingerie, the 48-year-old Julie—her waist appearing even more taut and wasp-like than in her youth, her dancer's legs every bit as firm and shapely as ever—made the calendar seem either a liar or a complete irrelevancy. Next to the mature Julie Newmar, virtually any 20-year-old beauty would appear hopelessly outmatched. Today, at age 60, that has not changed at all.

During the early 1980s, Julie jumped out of a plane for a skydiving segment on TV's *Wide World of Sports*. "It was a lot of fun, I loved it. The first time was totally without fear. The second time, I thought to myself, this is a little bit

dangerous. The third time, I knew it was dangerous, but I did it. It's an act of mental coordination."

In 1985, she directed a play in Houston called *Duke*. "It was a marvelous comedy, which I prefer because comedies have layers. You start with the truth. . . you start with the drama and then you add extra instruments in the sense of comedy having the lighter touch or the different point of view." The foray into directing seemed natural for a woman who has always devoted intensive research and thought into every role she plays. "Most of my work is deeply psychological. I put huge amounts of background work into understanding each character." She also continued to appear occasionally in films in the last half of the '80s, as detailed in the filmography. In 1991, she did a production of *The Women* in Flint, Michigan, playing the fast-talking Rosalind Russell role. "God, that was entrancing! It was a fabulous part, one of the best things I've ever done. I never thought I could be that mean!"

When Julie stops to catch her breath from real estate dealmaking, acting and directing, she is a lovingly devoted gardener, cultivating what she calls "the most beautiful garden on the west side of Los Angeles." In addition to continuing her dancing, she also enjoys playing her Steinway piano. And Julie is a proud mother; her son John (who is deaf), now 10, is a budding artist.

"I find that the value in life is the doing of it, the living of it. The sweetness of my life is family, my child. That's the greatest movie of them all. I started my family when most people are retiring!" she laughs. "When you wait for something as wonderful as a child, you treasure it all the more."

Among Julie's magazine appearances from 1957 onward were the following:

1957 *Bachelor's Pin-Ups #1* (2 pages)
1957 *Peter Basch's Photo Studies* (Some of the hottest pin-ups ever taken of Julie: partial cover and three inside, semi-nude pictures over three pages, topless with one arm partially obscuring her bosom.)
Jan. 14, 1957 *Life* (feature on "Lil' Abner")
Apr. 1957 *Bachelor* (5 pages, 13 pictures)
Apr. 1957 *Male Point of View* (8 pages of splendid leg art)
July 1957 *Nugget* (inside cover and 4 pages; includes one particularly sultry swimsuit pose, and one startling "grabber" in a totally see-through negligee)
Nov. 1957 *Night and Day* (2 pages)
Dec. 1957 *Glance* ("Giant of Sex Appeal")
Dec. 1957 *Rex #3* (cover, 2 pages)
Dec. 1957 *Tab* (5 pictures, including one full-pager, from "Lil' Abner")
Candid Photography #369 (2 pages)
1958 *Touch No. 1* (4 pages, 14 pictures)
Feb. 1958 *Escapade* (cover in slinky red dress)
June 1958 *Tab* (gorgeous cover in white swimsuit, and 2 pages of "Lil' Abner" poses)
July 1958 *She Pin-Up Annual* (cover)
Dec. 9, 1958 *Look* ("Big Girl on the Marriage-Go-Round")
1959 *Peter Gowland's Glamour Camera* (6 pages of very striking beach bikini shots and indoor leg-art, taken while her hair was blondified for "Marriage-Go-Round." Best of all are some very sexy,

classy glamour portraits in low-cut negligee. A quarter-century later, the two would reunite for some equally memorable photographs.)
Feb. 8, 1959 *New York Times Magazine* ("Quantities of Qualities")
Apr. 1959 *Photo Life* (5-page layout from the now-familiar beach shooting in tights)
June 1959 *Mr.* (4 pages)
July 1959 *Zest* (2 pages, 3 pictures in Stupefyin' Jones attire: "38-23-38 and Talent, Too")
Jan. 1960 *Ogle #6* (Julie at her very hottest: 3 pages, 7 very revealing semi-nude and lingerie poses)
Nov. 7, 1960 *Life* ("Lithe, Limber, Long-Legged Lovely;" gorgeous in feature on the film version of "Marriage-Go-Round")
1961 *Escapade Annual* (3 pages of leg art)
1961 *Modern Man Yearbook of Queens* (3 pages, 11 pictures, including Gowland's terrific glamour shots and some equally memorable examples of Julie's modern dancing technique)
Apr. 1961 *Photo Life* (Perhaps the single sexiest magazine layout on Julie until her later nude pictorials for *Playboy*; 4 pages, including 4 semi-topless shots taken from the Jan. 1960 *Ogle* session.)
May 1961 *Swank* (cover, 4 pages)
1962 *Knight* Vol. 3-9 (5 pages)
Feb. 2, 1963 *TV Guide* (four-page feature depicting Julie's exercise and beauty regimen)
June 6, 1964 *Saturday Evening Post* (cover in feature on celebrities' favorite cookout recipes)
Dec. 4, 1964 *Time* ("The Electronic Tomato;" delightful interview/feature)
Dec. 12, 1964 *TV Guide* ("Everyone's Living Doll")
July 10, 1965 *TV Guide* ("Painting a Living Doll")
Oct. 1965
Men's Digest (3 pages)
Winter 1967 *Modern Man*
May 1968 *Playboy* (3 pages and 9 pictures, all but two featuring a stripped-down Julie from her nude dip in *MacKenna's Gold*.)
Sept. 1969 *Playboy* ("37-22-37 Meets 50-47-50" is a 4-page layout with Julie and Zero Mostel from a never-released film they started, *Monsieur Lecoq*; Julie is delightfully undraped on three pages, including a very sexy/playful shot of the two together in the bathtub as Zero seems ready to make a wish with Julie's legs.)
Dec. 1969 *Playboy* (1 picture in "Sex Stars of 1969")
Feb. 14, 1970 *TV Guide* (Julie shakes up New York City while filming an episode of *McCloud*)
Feb. 14, 1977 *People* (Julie reveals her special pantyhose design in spectacular photos)
Sept. 17, 1977 *People* (4-page feature on the beautiful newlywed)
1986 *Celebrity Sleuth #2* (4 pages, 14 pictures, including a few early semi-nudes)

In 1992, Julie Newmar fans received an unexpected and utterly delightful treat when she appeared in a music video by George Michael, "Too Funky." She was contacted by fashion designer Thierry Muglier, who was to direct the video in conjunction with a grand fashion show in Paris showcasing some of his more outrageous creations. Michael himself ended up directing the four-minute video. Julie appears about halfway through, in a long brunette wig and clad in a skintight rubber outfit by Muglier. She looks quite magnificent even as she follows the story line by arguing violently with another model backstage before emerging onto the runway. Then, she does the splits and rolls over on her back

to see the truth; funny, delightful. . . like me, both beautiful and ageless; a sandbox goddess, born to play with; an immortal; a life giver; a healer. Carole Lombard Lives!"

Asked where this sense of boundless enthusiasm and passion for life comes from, Julie pauses thoughtfully before replying. "I'm not religious, but I am quite spiritual. I talk straight to God, I don't go through dogma. I think these deeper principles came to me as a young child fortunate enough to have a mother who drove me to Sunday school each week. All the valuable qualities of character were instilled in me then. That absolutely cannot be learned in school."

Without a knowledge of who you are in the deepest sense, after a certain point in life you lack the vision, the perception, to go on. You need to gain the ability to express unconditional love, because that's all you ever want from another human being. I have to be connected to something more than myself, to the realization that we are all one. That's a treacherous voyage inside, to tell the truth. Whose truth are you telling—your parents'? You finally have to be able to tell your own truth. Once you do, then you have a chance of connecting to another, or to an audience, which is the union that we all seek."

(Special thanks to Julie Newmar for her time and cooperation, and also to collector and publisher Bruce Dey for his assistance.)

before the excited audience.

Julie says it was the first time she had ever modeled on a runway, and with the large crowd and video crew it proved an "incredible" experience. It also led to a fashion layout in *Talkies* magazine in Europe. No one watching her performance could have dreamed that it was a 56-year-old woman knocking 'em dead in such athletic and sensual style. Three years later, she modeled for Muglier again in a modified catsuit.

Julie Newmar is a woman of many special qualities, but perhaps none is more special than the constant sense of breathless enthusiasm and wonder she brings to everything she does. This—and her wonderfully other-worldly aura— was aptly conveyed when she described her "dream" role:

"There is a film I will be doing weekly in which I have a part that is magic, adored by people, surrounded by light; the latest cinematic techniques; a fabulous character never done before; new age; alive, vibrant, very real. Her raison d'etre is

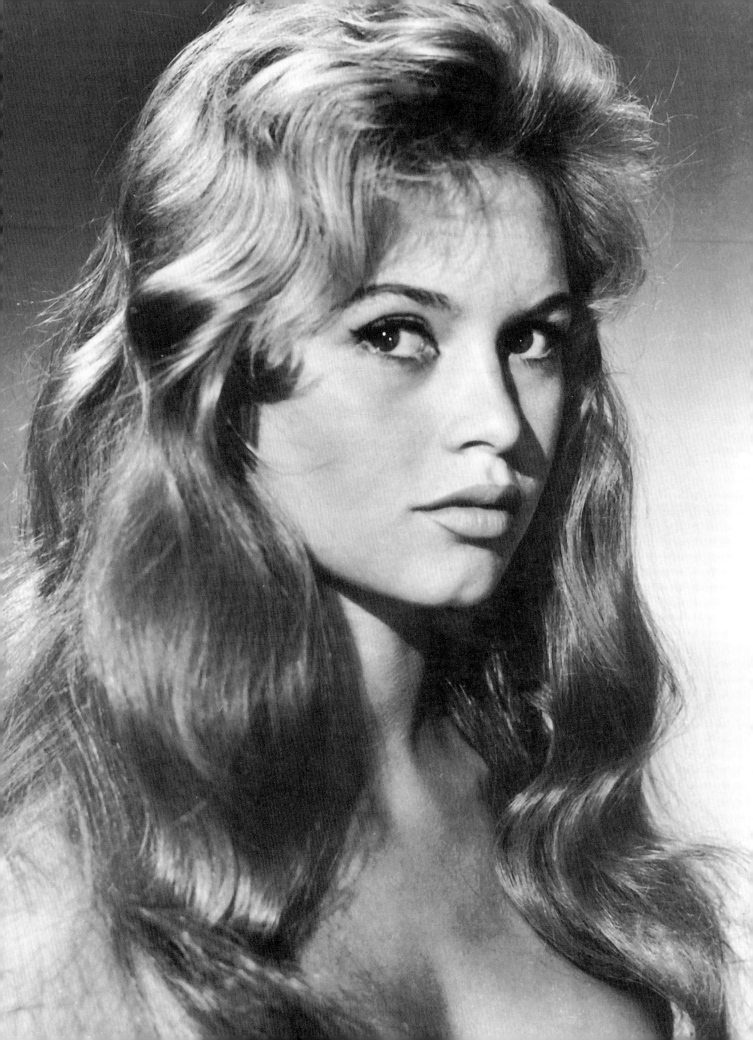

Brigitte Bardot is the primary cinematic symbol of the sexual revolution launched in the late 1950s. It is not a role she sought out, but she executed it with a brilliance far exceeding any of her individual movie performances. Whereas Marilyn Monroe represented the fantasy woman/child and Jayne Mansfield was a glamorized parody of sexual attributes, Bardot symbolized the brazen, unadulterated sexual appetites of youth. This is why she disturbed just as many people as she excited, and why she ranks among the most culturally influential figures of her time.

Brigitte's childhood was comfortable and sheltered, complete with private schools and governesses. Her father Louis, a chemical engineer, managed Charles Bardot & Company, a business started by his father, and one of the largest manufacturers of liquid oxygen in France. Brigitte and her younger sister Mijanou were encouraged by their mother Anne-Marie to take up dancing, and Brigitte demonstrated talent at an early age.

In 1947, a barely 13-year-old Brigitte was allowed to take the entrance examination at the National Conservatory of Music and Dancing. Out of 150 youngsters—nearly all more experienced—she was one of eight ballet dancers selected. Uninterested in school, she pursued ballet energetically. In her spare time, she modeled in local fashion shows with a ballet theme, and her first published fashion layout appeared in March 1949. The founder of *Elle* magazine spotted the layout, and asked Brigitte's mother if she would allow the youngster to appear in the publication. Madame Bardot was wary of allowing her daughter to be recognized as a professional model. Brigitte appeared on the cover of the May 2, 1949 issue of *Elle* identified (per her mother's instructions) as only "BB."

The *Elle* cover was spotted by renowned film director Marc Allegret, who sensed a special quality in "BB." He persuaded the magazine to connect him with the family of its fetching new model in hopes of arranging a screen test. Brigitte's parents opposed the idea of thrusting her into a hazardous new world that might carry her away from a dance career, but finally she talked her mother into accompanying her for an interview at Allegret's apartment. There, she met the director's ambitious young assistant, a former reporter for *Paris Match,* named Roger Vadim. Immediately, Vadim was taken with the girl's fresh-faced beauty, and she was swept away by his looks and sophistication. He agreed to coach her for the screen test in July 1949. She didn't get the part, but a few months later they began dating, and Brigitte announced to her shocked parents that she and Vadim were engaged. After they opposed the wedding, she attempted suicide in mid-1952. Finally her parents acquiesced to the relationship with Vadim, although insisting that marriage wait until her 18th birthday. They were wed on December 20, 1952.

Brigitte Bardot

Born September 28, 1934
Paris, France

Brigitte had already embarked upon a movie career. After continuing to model during 1950-51, she landed the title role in the film *The Lighthouse Keeper's Daughter* (later released in the U.S. as *The Girl In the Bikini*), shot during the summer of 1952. Her biographer Jeffrey Robinson (*Bardot: An Intimate Portrait*) writes that because Brigitte was not yet 18, director Willy Rozier had assured her father that she would not appear in anything more revealing than a bathing suit. Louis Bardot was displeased when he discovered that Brigitte appeared throughout the picture in a startlingly brief bikini, and outraged when he saw still photos that he regarded as lewd. Rozier agreed to have a judge see the film before it was released, and the official held that the film was not indecent. The matter was reopened, however, when the film debuted in December 1952 in Morocco, accompanied by huge posters showing BB virtually nude with her name written across the top. Louis Bardot's lawyers obtained a court injunction against further use of the poster.

The resulting publicity (helped along by Vadim) helped establish Brigitte as a rising young starlet.

"During those first few years together, Brigitte and Vadim developed an extraordinary partnership," wrote Robinson. "He formed her, shaped her, brainwashed her and brought out something in her that no one—least of all Brigitte—ever realized was there. . . He taught her how to put on that famous pout. He watched her all the time, the ultimate voyeur, and taught her how to be watched, how to become the ultimate exhibitionist. He taught her how to put her clothes on and how to take them off."

Soon after their wedding, Vadim began an energetic publicity campaign to create the ultimate nymphette, handing out revealing postcard photos of BB to reporters and friends in the movie business, saying, "you should see the ones of her in my private collection." He also spread tales of nude swimming, wild parties on deserted beaches, and impromptu stripteases. "Vadim didn't care what the world thought about his wife as long as they thought about her," remarked one magazine. He promised Brigitte, "I will make you the unattainable dream of every married man."

The Cannes Film Festival in April 1953 marked Brigitte's introduction to the world as a budding sex bomb, following her (uninvited) skirt-twirling entrance to an elegant luncheon. "In that one instant," a businessman observed, "she destroyed the petticoat industry of France by proving she doesn't wear one." She showed off her 5-foot-7, 35-20-35 form while posing for 3,500 U.S. Navy sailors on the aircraft carrier *Midway*. Photos of BB and Kirk Douglas on the beach were carried by the wire services around the world. Universal and Warner Brothers talent scouts offered her movie contracts, but she refused, declaring an aversion to Hollywood that she would never relinquish. "If I have to

live there," she said, "I'll die."

BB made her first English-language movie appearance in 1955 with the British comedy *Doctor At Sea*, featuring a memorably steamy shower sequence for which she removed the flesh-colored panties she was initially given to wear—the first nude scene in a British film, although her nudity was concealed on screen. Upon the picture's release, she was officially dubbed a "sex kitten." Also that year, she earned $300 a week for appearing in *Helen of Troy*; during filming in Rome, for economic reasons, she shared a room with future sex goddess Ursula Andress (then a 17-year-old starlet), and Vadim later wrote about the three of them sleeping in the same bed.

Kim Novak was to be the star attraction at the 1956 Cannes festival, but Bardot—not yet a star despite her growing publicity—stole the show from her, prancing about in tight skirts with a low neckline and unkempt hair. While photographers snapped Novak who was posing in a low-cut dress, suddenly Brigitte elbowed her way in and leaned across the lap of a director she'd never met, "giving her clinging, slashed-to-the-waist dress the perfect position to out-cleavage Kim," according to one account. On the beach, her bikinied form dazzled photographers, and she posed in Gary Cooper's arms. At her first big press conference, BB was happily posing when Novak walked in. Photographers rushed off to greet the American star, and a pouting Brigitte flounced out of the room. Cannes festival officials were upset with Bardot's aggressive tactics, but the next year, after she'd made it big, they invited her back. She couldn't find the time.

Brigitte's top early magazine appearances included:
 May 8, 1949 *French Elle* (cover, being fitted for a demure dress)
 May 31, 1952 *Paris Match* (cover in a high-necked red blouse)
 Dec. 31, 1952 *People Today* (cover, looking pert in ballet tights)
 Apr. 1953 *Vue* (3 pages in bikini, "Sultry Savage")
 Winter 1953-54 *Paris Life* (2 swimsuit pictures, "New Beauty Discovered")
 Nov. 1955 *Night & Day* (3 pages, 11 teasing pictures)
 1956 *Europe's Top Pin-Ups* #3 (title page and 4 pages, 7 pictures)
 June 1956 *Focus* (cover, 2 pages)
 Aug. 1956 *The Dude* (#1; 4 pages)
 Late 1956 *66* #11 (66 photos)

"And God Created Woman"

Vadim had done a skillful job of building up Brigitte, but needed the right vehicle, ideally tailored to his wife's unique qualities, to achieve her breakthrough. In early 1956, he approached producer Raoul Levy with the idea of chronicling the amoral world of the female beat generation in Paris. The two men hammered out a script in four days under the title *And God Created Woman*. The history of sex in cinema was about to take a critical turn.

The opening scene of *And God Created Woman* became one of the decade's most famous movie sequences, as Bardot sunbathes in her backyard with her bare backside on display. *Time* magazine remarked that "her round little rear glows like a peach, and the camera lingers on the subject as if waiting for it to ripen." In the movie, the whole town is talking about the shameless young hussy's public displays, and her adoptive mother forces her to leave home. Watching the provocatively dressed nymphette tempt male admirers with every move she makes, one man remarks, "That girl is like a colt that needs breaking in." She must marry in order to avoid going back to the orphanage, and a young man (Jean-Louis Trintignant) is more than willing. Their love scenes are torrid, including one in which she rises from bed, opens her blanket, and teasingly invites her new husband to join her. The honeymoon ends after she boldly seduces her brother-in-law, her raw sensuality overpowering any concern about the consequences. As her incensed husband looks for her, BB wanders into a bar and launches into a sizzling dance, sweeping across the floor and thrusting her hips. When her husband walks in and begs her to stop, she climbs atop a table and dances even more suggestively, running her hands up her bare legs and tossing her hair back. He pulls a gun, and when stopped from shooting her, slaps her several times; they go home together at the film's conclusion. Especially in 1956, this is pretty fiery stuff.

Vadim and Bardot had fallen out of love by the time *Woman* began filming. It appeared to observers that he deliberately set out to incite an affair between Brigitte and Trintignant with the director's insistence on intensely realistic love scenes; she accepted the dare by taking the film's sexuality to its limit, and continuing to clinch in bed with her leading man even after Vadim shouted, "Cut." Sure enough, the film's stars fell in love, with Trintignant the first of many married men with whom BB became involved. The affair would be short-lived, however. Trintignant explained, "She is a lost child. She has everything to make her happy and yet she is unhappy. . . I cannot bear it, when I'm embracing her, to think of all the leering millions who would like to be in my place." Brigitte and Roger were divorced in December 1957.

Vadim reflected later: "I thought she was a wild sunflower—insolent, proud, striking. I thought she didn't need a stick for support—only the sun after rain. But she was a rose, like all other beautiful women. If I had treated her as a rose instead of a sunflower, she would have been easier to live with as a wife. But her true violence would have appeared sooner or later."

Woman had its Paris premiere in November 1956, and initially did only modest business. Due to the film's eroticism and the absence of an established star, Levy had to struggle to arrange for distribution in the United States. It took several months to expand beyond art houses into mainstream U.S. theaters, but then the box office was astonishing. Many theaters kept the film to top business for up to 15 weeks; it played for nearly a year in New York. By 1958, it had earned theater rentals (the money paid by theaters to the motion picture company for use of the film) exceeding $3 million, making it the biggest foreign-language film in U.S. cinema history to that date. The film was also a sensation in European and Asian markets. After the international furor the picture was re-released in France and finally became a domestic smash.

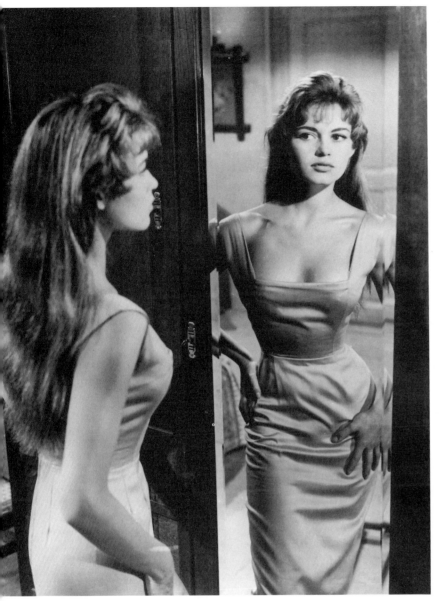

Vadim and Bardot could have scripted the controversy generated by their ribald creation. In early 1958, the Philadelphia police confiscated prints of *Woman*; cinema managers who showed it in Cleveland were arrested; the picture was banned in Lexington, Kentucky and declared obscene by the censorship board in Memphis; Dallas censors sought unsuccessfully to ban it; and a Los Angeles theater had to go to court twice in order to restrain the police from interfering with the film's exhibition. The sexuality stirred the ire of censors, but what appeared to unnerve others the most about BB was her don't-give-a-damn attitude, exemplified by her unkempt hair, absence of makeup and careless attire. Traditionalists believed the accepted rules of society were breaking down around them in the wake of rock 'n' roll and the beat movement, and Bardot became a convenient symbol.

In a remark that sounded carefully manufactured by Vadim, BB was quoted as saying: "I am the typical young

French girl—I am the epitome of the immorality of the youth of France!" The comment stirred widespread controversy in her native country, and led to public denunciation of the fast-rising star. Jehovah's Witnesses in France announced that she was eternally damned. A Soviet diplomat was incarcerated in Moscow for carrying 3,000 bootleg photos of BB in his dispatch case. In 1959, a Vatican exhibit at the Brussels World Fair featured a life-sized portrait of Bardot as a symbol of evil; after several days it was removed because it drew the largest crowd at the exhibit.

Vadim enjoyed his Svengali reputation, but knew perfectly well that if Bardot had not been a force of nature to begin with, his brilliant packaging and publicity could not have galvanized the world as it did. "She has no talent," he said at the time. "All she has is genius." There was far more to it, however, as he observed years later. "It is precisely because she was not the product of anyone's imagination that Brigitte was able to shock, seduce, create a new style and explode in the world as a sex symbol," he said. "She was born with the ability to arrive somewhere and turn the atmosphere electric."

From her bedroom-tousled hair, enormous hazel eyes and bee-stung lips to the undulating curves of her youthful form, Brigitte represented a breed of sex symbol quite different than what Americans had seen before. *Time* noted in late 1957: "From the neck up. . . she looks about 12 years old, and bears a striking resemblance to Shirley Temple at that age." Another magazine remarked in 1958 that BB ". . . gives the impression that she doesn't realize she's being naughty, but she exudes an aura that someone has described as 'depraved innocence.' The onlooker gets the impression that the poor girl is doing the things she does because she doesn't know good from bad." Pablo Picasso met her during the 1956 Cannes festival, and declared: "She is a moppet. A baby. She has the lips and eyes of a little girl. And underneath it, I feel the shyness."

When Stephen Boyd was signed by Vadim to co-star with BB in *The Night Heaven Fell*, he accompanied the director to his ex-wife's home to be introduced to Bardot. Boyd recalled what happened next when he was ushered into BB's bedroom: "She was lying there quite nude. When she first saw us, she jumped up—still completely uncovered—ran to me and threw her arms around my neck. She said she knew we'd get along beautifully together. And we did." This coziness didn't last long, however; Boyd lost 21 pounds during the stress-filled filming, and reported that "she wore me out with her temperament." At one point, she disappeared from the film's Spanish location, and he had to take 10 days to track her down in Paris while the production waited. The actor found her "provocative, temperamental, tantalizing, tender, a mediocre actress, and thoroughly

impossible as a person. I love her, sure. Who could help it? But I'll never do another picture with her." In this sex thriller released in early 1958, BB's form was on display in several shower sequences, one scene in which she peels off her soaked dress in a river, and another in which Boyd tears her dress off. U.S. censors snipped the hottest scenes, but her legend ascended another notch.

French film icon Charles Boyer had a more agreeable experience with Brigitte in *La Parisienne* (1958), calling her a "quick study" who was well-prepared and eager to learn. The highlight of this comedy for BB-watchers came when her pearls break, and she scrambles about the floor in a tight, low-cut dress to recover them with Boyer's gallant assistance. Her cheesecake fans took special pleasure in another scene in which she paraded about in her trademark bath towel.

The year 1958 saw yet another well-remembered Bardot performance in *Love Is My Profession*. As a prostitute arrested for robbing a jewelry store with a toy pistol, Brigitte confessed to famous lawyer Jean Gabin that she had no money, and offered her body in the form of payment, lifting her skirt to display her wares, sans underwear. Moviegoers couldn't get enough of Bardot; in a historical rarity for a non-English-speaking actor, she was ranked among that year's top 10 box office stars in the U.S.

Toni Howard described BB in a 1958 *Saturday Evening Post* profile: "The long golden hair, the childlike rounded and dimpled chin and malicious, sensual mouth, a body at once slender and overdeveloped, at once infantile and of astounding sexuality—here is the heady twofold pull of baby-doll, the ripe physical seductiveness of the eternal adolescent. Add to this a certain catlike grace and an equally catlike expressionless stare, and you have the myth of Brigitte Bardot in all its 'eroticism and realism.'" Her huge stylistic influence triggered fears (according to another writer) of "a world of baby-faced trollops with messy hair hanging. . . over budding young bosoms."

Seeking to ride the crest of the wave, producers reissued at least five of her previous films that had barely been seen before in the U.S. Seeing a pop phenomenon in the making, CBS offered BB $50,000 to

make a three-minute appearance on *The Ed Sullivan Show*, to no avail. As the picture broke wide open, Bardot's asking price was $150,000 per film, making her France's highest-paid film star ever.

Brigitte remarked that she didn't wear lipstick because it made a mess on the person she kissed. When it was suggested that she could wipe off the lipstick before kissing, she fixed the reporter with a pitying look and said, "But when I want to kiss, I want to kiss. Immediately. When I have the desire, I do not want to stop and wipe my lips."

The turbulence of Bardot's love life exacted a price. In early February 1958, the day after her breakup with (married) French singer Gilbert Becaud, she reportedly took an overdose of sleeping pills in a suicide attempt; her manager claimed she simply had food poisoning. BB soon rebounded to begin a new romance with Italian actor Raf Vallone, but soon he returned to his wife. That August, she announced her engagement to young guitarist Sacha Distel, which was called off a few months later.

In summer 1958, *Variety* ran a premature ad by Columbia Pictures for a new Bardot-Frank Sinatra film, proclaiming *Paris By Night* as "an earth-shaking motion picture event." The film was to be the first of several movies to be made by Bardot's company under an exclusive contract with Columbia; Vadim wrote a proposed script for the musical, which he'd also planned to direct. The project finally fizzled when Sinatra decided he didn't want to work in Paris, and Brigitte wouldn't come to the United States.

The childlike quality of BB (itself a nickname which is pronounced like "baby" in French) remained even after the rush of fame carried her into the international jet set; even into the 1960s, she was known to keep teddy bears at her home, and to clap her hands in pleasure when a director would tell her a fairy tale to act out, as a device to get the best performance out of her. Always emotional, she would cry easily and couldn't bear to be left alone.

Perhaps no group embraced Bardot more enthusiastically than Europe's "beat generation" and neo-existentialists, who were drawn to her fierce independence and desire to live for the moment without

regard for the future. Publicity slogans such as "Bardot does not act—she exists" played to this audience, and also to the broader public that found this approach intriguing. She would reiterate the same attitude several years later: "I don't give a damn about society. I don't live in sin, I live in purity! . . . I love freely, I give freely, and I leave freely when love is gone." Cynics noted that her tousled hair was kept photogenically unruly by a full-time hairdresser.

In early 1959, she told *Newsweek*: "I am now spending my life trying to erase the Bardot legend. . . I am now more anti-Bardot than anyone else in the world." Asked by columnist Art Buchwald to explain, she replied: "I am not against myself. I am against the Bardot the public thinks I am. It is a false Bardot." What is the real Bardot? "I am sexy but at the same time I am anti-sexy. I am a woman and at the same time I am a little girl. I am always two persons at the same time. I like being famous and at the same time I hate it. I am what you would call a contradiction."

Inevitably, whenever a pop phenomenon takes the world by storm, a backlash sets in; for Brigitte, the backlash came in 1959, leading one writer to assert that "the Bardot vogue is ebbing fast. . . she has just about had it as a glamour star. At 25 she is washed up because she has relied on sex to hold her audiences." The initial frenzy may have faded, but Bardot was far from finished.

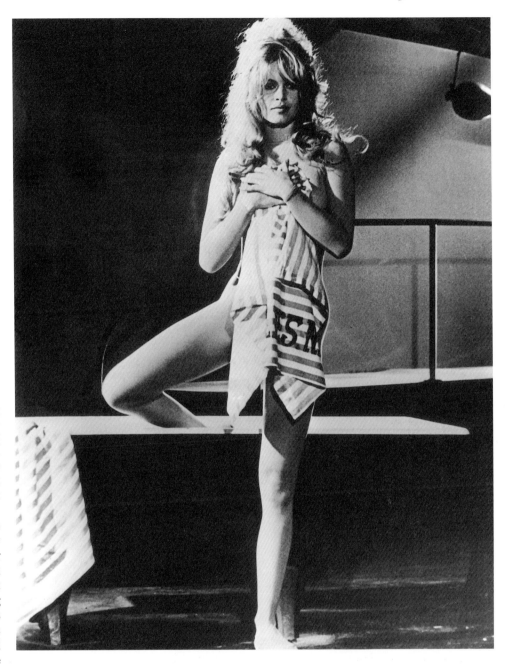

In response to this anti-Bardot wave, BB and producer Raoul Levy set out to make her first sexless film since her breakthrough, *Babette Goes to War*. "This time, I am going to be a girl without anything unhealthy or equivocal about her, and I am going to be good at it if it kills me," she declared. "I want to be cute and tender and warm, in the hope that people will forget the idea that I am a brainless, bosomy girl. I can be more than that." The film was a commercial disappointment, however, and BB concluded that she needed to play to her strength of sensual eroticism. "I should not drop those parts of my personality that the public loves," she said. Levy objected to this approach, saying BB has "years of successes ahead of her as an actress, not as a striptease artist."

Sex symbols had seldom been the subject of scholarly discourse before feminist author Simone de Beauvoir's essay in the August 1959 *Esquire*, "Brigitte Bardot and the Lolita Syndrome," which was expanded into a book a year later. "Seen from behind, her slender, muscular dancer's body is almost androgynous," de Beauvoir wrote. "Femininity triumphs in her delightful bosom. The long voluptuous tresses of Melisande flow down to her shoulders, but her hair-do is that of a negligent waif. The line of her lips forms a childish pout, and at the same time those lips are very kissable. She goes about barefooted, she turns up her nose at elegant clothes, jewels, girdles, perfumes, make-up, and all artifice. Yet her walk is lascivious and a saint would sell his soul to the devil merely to watch her dance."

De Beauvoir noted the unique quality of Bardot's screen sexuality. "Her eroticism is not magical," she observed. "In the

game of love she is as much the hunter as she is the prey. The male is an object to her just as she is to him. In her role of confused female, of homeless little slut, BB seems to be available to everyone. And yet, paradoxically, she is intimidating."

"She is neither depraved nor venal. . . she is blooming and healthy, quietly sensual," declared de Beauvoir. "It is impossible to see in her the touch of Satan, and for that reason she seems all the more diabolical to women who feel humiliated by her beauty. . . To say that 'BB embodies the immorality of an age' means that the character she has created challenges certain taboos accepted by the preceding age, particularly those which denied women sexual autonomy. In France, there is still a great deal of emphasis, officially, on women's dependence upon men. The Americans. . . have seen nothing scandalous in the emancipation symbolized by BB. . . Brigitte's eyes, her smile, her presence impel one to ask oneself why, why not. Are they going to hush up the questions she raised without a word?. . . I hope that she will not resign herself to insignifice in order to gain popularity. I hope she will mature, but not change." Brigitte later pointed out her favorite passage in de Beauvoir's analysis: "A free woman is just the contrary of an easy woman."

The general female population's opinion of Brigitte, however, probably corresponded more closely to the view offered by novelist Marguerite Duras: "Bardot represents the unexpressed desires of males for infidelity," she asserted. "Many women do not like Brigitte. . . They see in her, disaster."

Brigitte's major 1957-59 magazine appearances included:
July 1957 *Esquire* (4 pages on *And God Created Woman*, including one nude pose lying on her stomach)
Sept. 1957 *Nugget* (inside cover and 3 pages of beach candids)
Oct. 1957 *Jem* (4 pages, 6 pictures)
Nov. 18, 1957 *Life* ("U.S. Gets a Look at Brigitte," 7-photo feature)
1958 *Brigitte* (48-page special magazine with over 100 photos)
Jan. 7, 1958 *Look* ("Bardot Conquers America," 4-page photo feature)
March 1958 *Playboy* (4 pages, 7 photos, "The Best of Brigitte")
June 14, 1958 *Saturday Evening Post* ("The Bad Little Girl")
June 30, 1958 *Life* ("The Charged Charms of Brigitte Bardot")
July 1958 *Pic* (6 pages)
Sept. 1958 *High* (5 pages, 12 pictures)
Nov. 1958 *Playboy* ("Peekaboo Brigitte," 4 pages, 16 photos)
Dec. 1958 *Rogue* (4 pages, 9 pictures)
Dec. 1958 *Silver Screen* ("Tempestuous Sex Kitten")
1959 *Modern Man Yearbook of Queens* (title page and 3 pages, 8 pictures)
1959 *The Best of Brigitte Bardot* (67-page collection with more than 100 splendid photos, and text by Eugene Tillinger)
March (1959?) *Dare Vol. 3-7* (11 pages, "The Bardot Influence")
March 1959 *Modern Man* (inside cover, 3 pages)
Apr. 1959 *21* (4 pages, 10 photos)
June 1959 *Climax* (6 pages, 12 photos and article)
June 1959 *Escapade* (enchanting cover with BB caught in mid-pucker, lovely 1-page color portrait, and article)
July 1959 *Modern Man* (6 pages, 14 pictures)
Aug. 1959 *Esquire* ("Brigitte Bardot and the Lolita Syndrome" by Simone de Beauvoir)
Dec. 1959 *Playboy* (3 teenie-bikini photos and one teasing beach nude, part of a feature on the wave of "imitation Bardots")

The Maturing of a Sex Kitten

In June 1959, Brigitte married actor Jacques Charrier, her leading man in *Babette Goes to War*. It was an ill-fated union almost from the outset; he survived two suicide attempts, was frantic when separated from her due to his military service, and intensely jealous of her other leading men during sizzling love scenes. "I knew it wouldn't be easy being the husband of the sex symbol of the era," he said later. "But I never thought it would be such a trial." In January 1960, she gave birth to their son, Nicolas. Brigitte in essence gave up her young son to live with her parents within weeks after his birth. "I am in no sense a mother," she said frankly. "I am not made for that role. I regret it, but it's true." For years thereafter, she would see Nicolas only occasionally. In 1973, she confessed, "I am not adult enough to take care of a child. I need someone to take care of me."

According to de Beauvoir, Bardot, like James Dean, possessed "the fever of living, the passion for absolute, the sense of the imminence of death." These words assumed an ominous ring on September 28, 1960, her 26th birthday, when Bardot made her third known suicide attempt. Moments before allowing a reporter a bedside interview at a rented Riviera villa, she swallowed a bottle of sleeping pills. After telling the reporter, "I want to be alone—to examine my conscience," he left, and she groggily slashed at her wrists with a razor blade before passing out. (Some cynics suggested that it was not a coincidence that the character she was playing in her latest film, *The Truth*, committed suicide by cutting her wrists.) Her marriage with Charrier was on the rocks, and the birth of their son had made little difference; also, she was weary of the relentless hounding by the press that made a private life all but impossible. Found unconscious, Brigitte emerged from the hospital—with bandaged wrists—a few days later. The couple finally divorced in 1962, and Charrier was awarded custody of Nicolas.

"I had messed up everything," she said in 1965 of her suicide attempt. "I was a young, foolish girl, and I had damaged so many people. I damaged them through carelessness and stupidity and foolishness, and I had nothing left to live for. That was the day my adolescence ended. . . Now, I want to live forever."

La Verite (*The Truth*), released at the end of 1960, proved to be BB's proudest professional achievement. This tale of a woman who kills her lover was Oscar-nominated for best foreign film, and she later called it the only time "where I truly felt I was a real actress." She then earned a hefty $350,000 for *A Very Private Affair* (1962). The film's storyline as written by its director Louis Malle, to Brigitte's great discomfort, was filled with episodes taken from her own life, as she played a young beauty who discovers the man she loves is married, then attempts suicide.

After turning down many television offers, in January 1962 Brigitte began an annual tradition of starring (for free) in French TV variety specials in which she would sing, dance, and do whatever struck her fancy—"my gift to the French people." She concluded her first 90-minute special performing a modest striptease in a musical production

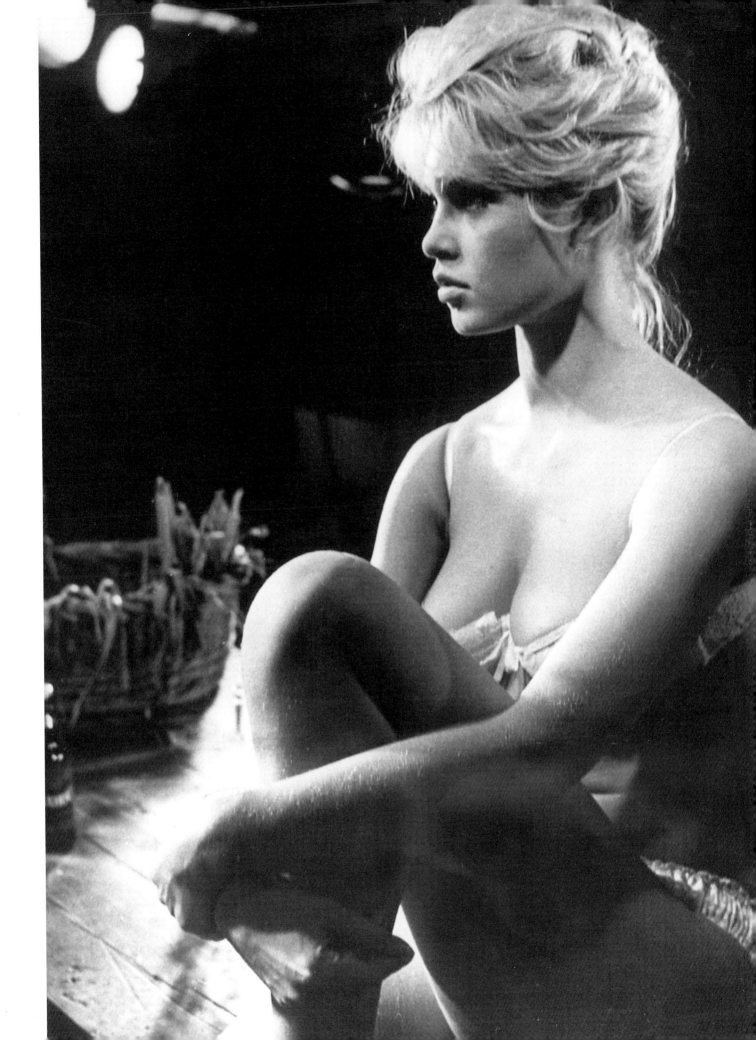

number, winding up sprawled on a white bear rug.

Contempt (1963), directed by Jean-Luc Godard (and co-produced by Sophia Loren's husband Carlo Ponti), was at least a partial success for Brigitte. BB's opening sequence is classically Bardotesque, as she lies nude in bed, asking her husband if he thinks her feet, ankles, thighs, backside, and hair are pretty. "And my breasts? Aren't they the prettiest part of me?" she asks. The film chronicles the gradual collapse of their marriage, and the slow-moving story produced mixed reviews, although it showed again that Bardot could be credible in a dramatic role tailored to her personality.

Brigitte's reverence for animals began early; Vadim had noted that he couldn't compete with his then-wife's affection for her menagerie of dogs and canaries. In 1964 she put her passion to work by campaigning successfully for a French animal rights law that was quickly dubbed "the BB law." "The innocence and honesty of animals reassured her," Vadim once remarked.

None of Brigitte's pictures after 1958 had earned U.S. theater rentals of more than $1 million, in part due to her refusal to promote the films here. Finally, in December 1965, she embarked on her first U.S. tour to promote *Viva Maria*, and proceeded to charm reporters at every stop. Her arrival in New York, however, was almost spoiled when Sophia Loren departed Kennedy Airport at the same time BB arrived. When a female reporter at the New York press conference asked if she was tired of being called a sex kitten, Brigitte smiled and replied, "But I adore being called a sex kitten!" When she proclaimed, "I want to be myself," she was asked, "And what is yourself?" In response, she threw her arms back, took a deep breath outlining her bosom, and said, "Look!" to the delighted laughter of reporters. *Viva Maria* was not a hit, but its pairing of Bardot with worldly French star Jeanne Moreau provided a few delightful moments, particularly in their teasing musical numbers together.

Brigitte married again in 1966, to millionaire industrialist/playboy Gunther Sachs; in an effort to avoid a media circus, they flew to Las Vegas for the wedding. The marriage ended in 1969, and BB continued to take up with a succession of lovers, mostly boyish and dark-haired. Her films were playing to declining audiences, but the '50s goddess reached a new generation of admirers during the late '60s with a hot-selling poster of her straddling a huge motorcycle clad in a micro-miniskirt and her breasts pushing through her leather jacket.

She dabbled in music during the late '60s with several recordings, including one ("Do You Want to or Not?") that became a smash hit in France. In January 1968, Brigitte and Serge Gainsbourg recorded the original version of "Je t'Aime, Moi Non Plus" (I Love You, Me Neither), described by Jeffrey Robinson in his Bardot biography as "four minutes and 20 seconds of very slow, very grinding music with non-stop, very heavy groaning." The startlingly sexual record was not commercially released, but several months later Gainsbourg re-recorded it with Jane Birkin and enjoyed a huge international hit.

American TV had been anathema to Brigitte despite many offers until she agreed to star in an hour-long NBC special that was broadcast in December 1968. "How would you like to spend an evening with me?" she asked at the outset, and her songs and dances—enhanced by her ever-riveting physical presence—made the program memorable. Unfortunately, NBC chose not to air a 15-second sequence in which she appeared only in trousers, with arms draped across her torso.

Bardot's films of the late '60s were almost uniformly poor, and the box office returns were steadily diminishing. After years of threatening to retire, she was now thoroughly sick of the business. Seeking an appropriate way to conclude her film career, she turned once again to Roger Vadim as director. The resulting 1973 film, *Don Juan*, generated more publicity than any Bardot film in a decade thanks to her nude bedroom scene with Jane Birkin. Nevertheless, it was a commercial flop. After a glorified cameo role in one more film, Brigitte announced her retirement from the screen in June 1973.

A year after completing their last film together, Vadim noted: "Brigitte still walks in the garden of adolescence. I tried to bring the mature woman out in her when we did *Don*

Juan—and I failed miserably. She doesn't want to grow up. She is 40, yet she needs as much care as a child."

Jane Fonda, like BB a veteran of matrimony with Vadim, admired Bardot from a feminist perspective. "She may have been portrayed as a beautiful sex object, but Brigitte Bardot rules the roost," Fonda told *Playboy*. "She kicked out any man she was tired of and invited any man she wanted. She lived like a man in Vadim's films."

In an interview with Peter Evans for his 1973 book *"Bardot: Eternal Sex Goddess,"* Brigitte was reflective. "Stardom is a house without shades," she remarked. "And if you have no private life, it's impossible to be really happy. There is a French proverb: 'To live happy, live hidden.' Where can Brigitte Bardot hide?"

"I hate to be alone. . . Solitude scares me," she admitted. "That's why I'm always with a lot of friends. I need distractions from the anxious thoughts, the black thoughts." Brigitte acknowledged that ". . . three years seems to be my limit" in relationships. "Without love, I am nothing. I'm finished. . . I need love to live. I want one lover in sight before the other one goes. . . And finally you can see I am emancipated but I am not free. I think like Napoleon. When in love the only victory is to escape." Asked to describe her soul, she thoughtfully replied: "Like a labyrinth. Dark—no light enough for me to find the door to escape, to freedom." Out of her nearly 50 films, she concluded, "I have made only five good ones. The others were trash. . . I tell myself I have spent my youth, and my best years, on stupid things, doing nothing good, and I get sad."

On the eve of her 40th birthday, BB proved her enduring sensual appeal by posing au naturel for her photographer boyfriend, Laurent Vergas, in a layout which ran in the January 1975 *Playboy*. In 1976, the oversized book *"Brigitte Bardot: Woman From Thirty to Forty"* was published, with gorgeous photo studies by Ghislain Dussart (including several nudes) of the maturing Bardot and an introduction by novelist Francoise Sagan of *"Bonjour Tristesse"* fame. "She deemed it an honor to share sex, laughter and love with a man who pleased her and whom she

pleased," wrote Sagan. "This, to me, is the most interesting, compassionate and generous quality in Bardot."

The period immediately following her retirement from movies saw a flurry of activity by Brigitte. In early 1976, she launched a movement dedicated to preserving seals and other wildlife, but folded it and returned all contributions after attracting 100,000 donors, saying she didn't want to run a bureaucracy. She would create a new animal rights foundation a decade later, and launched regular campaigns against adversaries such as the Russian government (for killing baby seals) and the Japanese and Norwegians (for hunting whales). She earned $200,000 doing a French TV commercial for an apparel company. Later in 1976, she served as sponsor for a line of ready-to-wear dresses.

At the end of 1982, Bardot set aside her usual passion for privacy to appear in three one-hour documentaries for French television, *Brigitte Bardot As She Is.* On the eve of her 49th birthday in 1983, "black thoughts" invaded her mind again following the end of another romance. She cancelled a dinner party, took an overdose of sleeping pills, and had to have her stomach pumped at a Saint-Tropez hospital. "I really wanted to die at certain periods of my life," she once remarked. "Death was like love, a romantic escape." Nine years later, there were reports of an accidental pill overdose.

Today, Bardot's animal rights activism is virtually her whole life, aside from her husband of three years, businessman and right-wing political consultant Bernard D'Ormale. She sold off her furniture, movie mementoes, paintings and jewelry to raise $500,000 for her foundation. The Brigitte Bardot Foundation, with 27,000 members in 42 countries, campaigns to protect animals around the world from abuse. In late 1992, she ceded the ownership of her beloved $3.3 million property in St. Tropez to the foundation, persuading the French government to give the organization an elevated legal tax status that would enable its work to go on after her death. The campaign against the torture of animals by the fur industry has been one of her abiding passions; in 1994 she publicly attacked fellow screen goddess Sophia Loren for doing print commercials on behalf of an Italian furrier.

The legend who once vowed to retire when she became "an old woman" of 25 has passed her 60th birthday with equanimity. "I have never had a facelift because I know that at 60 you cannot look 20," she declared. "People have watched me grow old. I have never tried to hide it. . . One day I will die, and when the time comes I will say, 'Fine.'"

Brigitte's major magazine appearances since 1960 include:
1960 *Consort* #1 (cover and 2 pages)
Spring 1960 *Fling Festival* #3 (2 pages, 6 photos)
Summer 1960 *The Vagabond* #1 (cover, 4 pages)
Aug. 16, 1960 *Look* ("Brigitte Bardot: Problem Child")
1961 Modern Man Yearbook of Queens (3 pages, 7 photos)
Early 1961 *66* #45 (cover and 12 pages)
July 28, 1961 *Life* (lovely cover portrait and 2 pages; "France's Far-Out Sex Siren")
Oct. 1961 *Gent* (inside cover, 4 pages)
March 1962 *Sir Knight Vol. 3-3* (4 pages, 8 photos, and interview)
July 1962 *Men's Digest* (cover, 6 pages)
Aug. 1963 *Modern Man* (3 pages, including famous rear-end underwear pose reprised a year later in *Playboy*)
Nov. 1963 *Modern Man* (3 pages)
June 1964 *Lui* #7 (photo feature)
July 1964 *Playboy* (photo feature, "The Sex Kitten Grows Up")
Oct. 1964 *Best for Men* (cover, 5 pages)
Aug. 1965 *Lui* #20 (photo feature)
Dec. 1965 *Playboy* (1 page, 3 photos)
May 1966 *Coronet* (lovely cover portrait; inside, she portrays Charles Chaplin)
Oct. 1966 *Lui* #34 (6 pages, 10 photos, including a few semi-nude studies)
Aug. 1967 *Cavalier* (centerfold in a movie love scene, plus 6 pages, 9 photos and article)
Apr. 1968 *Lui* #52 (cover and semi-nude photo feature)
Jan. 1969 *Lui* (8-page, 10-picture layout of mostly topless poses, a few of which appeared later this year in *Playboy*)
Apr. 1969 *Playboy* ("Bebe Bares All," a classic layout of 8 pages and 11 largely nude photos)
Sept. 1969 *Lui* (6 pages, 7 revealing pictures)
Dec. 1972 *Lui* (6 pages of BB in bedroom scenes with Jane Birkin; a similar layout ran in Apr. 1973 *Oui*)
Feb. 1973 *Gallery* (8 photos, mostly from 1969, and interview)
Jan. 1975 *Playboy* ("Bardot—Incroyable!," 5 pages and 8 photos, including full-frontal nudes)
May 1975 *Cosmopolitan* (profile, "Bardot at Forty")
Jan. 1977 *Mayfair Vol. 12-1* (cover and 6 pages, mostly from her 1974 nude photo session)
1979 *Celebrity Skin* #1 (7 pages dominated by latter-day candid nudes)
1981 *Playboy's Leading Ladies* (6 pages)
Jan. 1989 *Playboy* (a classic flirtatious nude)
Dec. 1992 *Madame* (vintage-1969 cover)
Jan. 1994 *Playboy* (2 pages, 4 pictures)

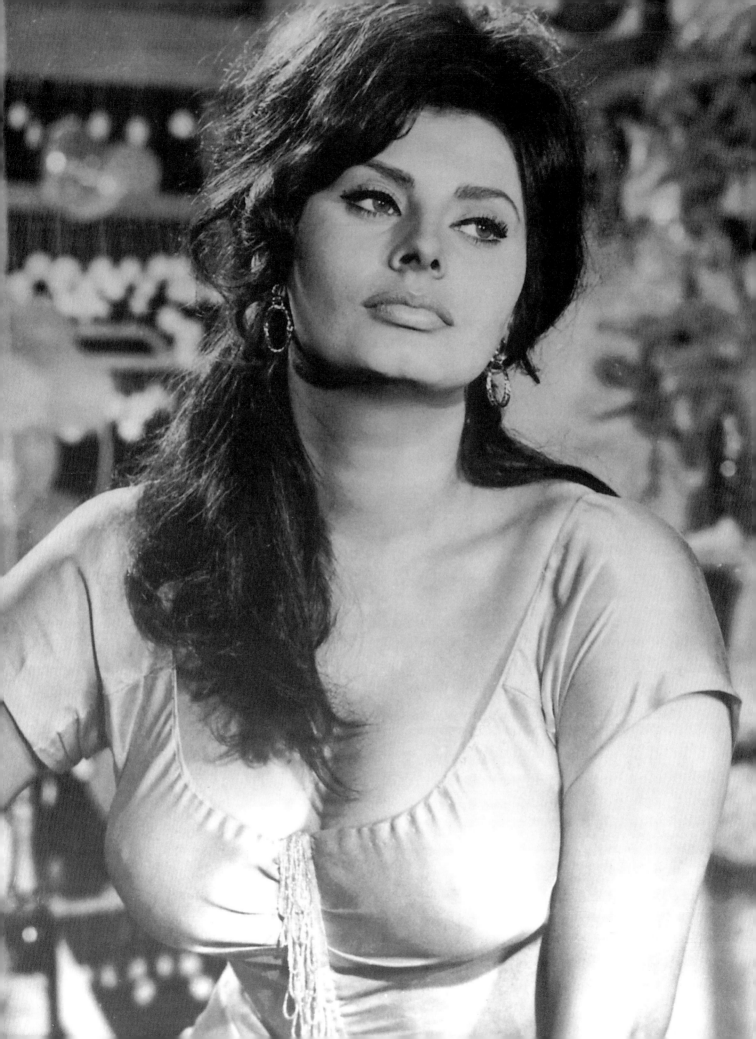

All of the women who achieve renown as sex symbols arouse passion among their admirers, but very few are beloved—deeply admired for their character as well as the qualities more obvious to the naked eye. Sophia Loren achieved this stature long ago, and each passing year seems to ascend it.

Ever since her rise to fame, the Cinderella-like qualities of Sophia's childhood have helped to make her life story compelling. Born in a charity ward for unmarried women, Sophia (her name was originally spelled "Sofia") grew up in the seaside industrial town of Pozzuoli outside Naples. After her younger sister was born in 1938, their father abandoned the family, leaving Romilda Sciolone to raise the two girls at her mother's one-room apartment. "I felt that the stigma of my illegitimacy was tattooed on my forehead," Sophia later recalled. World War II meant even more grinding poverty for the family, with food and clothing desperately hard to come by, along with the nightly terror of air raids. Following the war, "I think we would have all starved to death if it hadn't been for the American GIs who gave us chocolate bars and cans of C-ration," she said. "I was such an ugly, skinny thing, but they seemed to like me." Sophia was teased about her angular looks by other children, who called her "stuzzicadenti" (toothpick).

The teasing ended when she blossomed physically at age 14. "I stopped growing taller and began growing the other way," she wrote in her autobiography. "What a pleasure it was to walk down the street." Her mother brought 14-year-old Sophia to Naples for the "Queen of the Sea" beauty pageant, making an evening gown for her (a la Scarlett O'Hara) out of their living room drapes. Lying about her age to enter the event, Sophia didn't win, but was named as one of 12 "princesses;" her prizes included a railway ticket to Rome and 23,000 lire (about $35). After planning to become a schoolteacher, suddenly other career possibilities were in sight. Mama Romilda—a beauty who had once dreamed of movie stardom for herself—accompanied her daughter to Rome in July 1949 as they embarked on the new adventure. Mother and daughter earned 21,000 lire as two of the 10,000 slave girls in the Biblical epic *Quo Vadis*, but other opportunities were not forthcoming.

In order to stay in Rome, she needed another source of income. Aspirations to become a fashion model were quickly dashed when dressmakers took one look at her fulsome chest and shook their heads. These natural attributes would prove an asset, however. Her first widespread recognition came when (under the name Sofia Lazzaro) she posed provocatively in the *fumetti*—newspaper and magazine strips in which human models acted out soap opera-like plots in fixed poses with dialogue written in balloons. Her typical character was known as "the vamp," a villainous gypsy or Arab typically clad in low-cut necklines and skirts that would regularly be lifted for leg-art purposes. Copies of one issue in which she raised her skirts daringly high were confiscated by police as an "offense against public decency," garnering valuable publicity for the young starlet. The *fumetti* provided regular work between movie bit parts for three years; a few of them turned up later in the British magazine *Tit-Bits*. Also during this period, she was a runner-up in the 1950 Miss Italy pageant.

Later in 1950, Sophia competed in one last beauty pageant, placing second for the Miss Rome title. (Alan Levy's Loren biography dated the event in 1951, but Sophia has written that it occurred around the time of her 16th birthday.) One of the judges was movie producer Carlo Ponti, who had discovered Italy's reigning screen sex symbol Gina Lollobrigida. "I knew immediately she was someone remarkable," Ponti would later write. He gave her a screen test, which was a disaster; but even after several more failed screen tests, he remained convinced of her potential. Ponti gently suggested that in order to make it in movies, she ought to consider having her nose fixed. "I realized, of course, that I looked different from established movie actresses," she wrote. "They were all beautiful with perfect features and I was not. My face is full of irregularities but put all together they somehow work." She declined any plastic surgery, and the idea was dropped forever.

Director Giorgio Bianchi saw the magazines in which she'd appeared, and hired the buxom teen-ager for movie extra work. Most notably among these bit roles, she was a bare-breasted harem girl in *It's Him, Yes! Yes!* (1951). At the time, the topless sequence caused her intense embarrassment, as she noted: "I am not exactly a tiny woman; when Sophia Loren is naked, this is a lot of nakedness." Nevertheless, Sophia was later unashamed of the photo stills from the scene, and several years later (reported Donald Zec in his biography of Sophia), when a surprised William Holden showed her a publication with some of the pictures, she remarked, "I don't think they're dreadful. They look pretty good to me."

For her first major part in a movie, *Africa Under the Sea* (1952), producer Goffredo Lombardo decided to change her name, in part because her former name was too closely associated with the fumetti; having just finished a picture with Swedish actress Marta Toren, he announced that her new last name was Loren. Far more recognition came with her 1953 role as a captured princess used as an Egyptian slave girl in *Aida*; the voice on the soundtrack was not hers, but it was Sophia's robust physical presence that made the film a popular success. Another notable part that year was in *Two Nights With Cleopatra*, later famous because it included Sophia's second and final topless movie scene while

Sophia Loren

Born Sofia Sciolone September 20, 1934
Rome, Italy

bathing. Her early performances did not impress critics, one of whom asserted, "Signorita Loren registers all emotion with her bosom."

Following the success of *Aida*, Carlo Ponti signed the precocious youngster to a personal contract. He bought her clothes, arranged to have her hair and makeup restyled, and encouraged her to learn languages and literature. Her gratitude soon turned to love, although Ponti was married with two children. They seemed the ultimate odd couple—the short, balding 40-year-old producer and the taller, curvaceous 18-year-old starlet—but the love would last. During 1953-54, Ponti hired a Rome press agent who arranged for Sophia to pose for an array of cleavage- and leg-baring cheesecake photos that flooded American magazines, preparing the way for the star emergence to follow.

When Gina Lollobrigida declined to star in a second sequel to the popular film *Bread, Love and Dreams*, which she had previously made with Vittorio De Sica, the actor/director selected the younger and more voluptuous Sophia. "De Sica must be crazy," Gina said to reporters in reference to Sophia's 5-foot-8 height. "The girl is too big for the part. How do you expect that little donkey [in the film] to carry a horse?" Gina's (36-22-35) bust was so renowned that the word "Lollo" became synonymous with "bosom," but the 38-24-38 Sophia's larger chest measurements were widely celebrated in media accounts. At an October 1954 London film festival, a reporter bluntly asked Sophia, "Who's bigger, you or Lollo?" Sophia replied, "It is true that my measurements exceed Gina's, but is that a reason why she should be so furious with me?" Her innocent remark was twisted into such purported quotes as, "I don't think Gina is fond of me, possibly because I have two inches on her." Lollobrigida replied tartly through Hedda Hopper's column, "Sophia's may be bigger, but not better."

The Loren-Lollobrigida feud became a running story for the next couple of years. At the Venice Film Festival in the summer of 1955, the two women crossed paths. When the more-famous Gina didn't acknowledge Sophia, Loren sounded off to the press. Lollo replied: *Basta!* Enough! I don't want to hear anymore about that Neapolitan giraffe!" She would hear much more, however; even though Gina remained a major star well into the 1960s, Sophia would soon permanently replace her as queen of Italian cinema, and as the highest-paid European film star.

Sophia cranked out 18 movies in three years, mostly as earthy, good-hearted teases. In one, *Too Bad She's Bad*, she appeared for the first of many times with a then-unknown young actor named Marcello Mastroianni. It was De Sica's *Gold of Naples* (released in January 1955), in which she starred in one of the film's five episodes as a buxom pizza vendor who leaves her wedding ring at her lover's home, that really caught Hollywood's attention for the first time.

"In my opinion, there isn't any reason in the world to be bashful about a beautiful body," she declared early in her career. "You can't be a hothouse flower if you are going to succeed as a star. You have to fight every inch of the way and give it everything you've got." In another of Sophia's early public comments as stardom beckoned, she declared:

"Besides my green eyes, and as you say atomic bosom, I have something else which will get me to Hollywood." In a quote that followed her for years thereafter, she once remarked of her abundant figure: "I owe it all to spaghetti."

Sophia's top early magazine appearances:
 Jan. 25, 1954 *Tempo* (1 bosomy photo)
 July 1954 *Eye* (10 pages, 17 photos)
 Aug. 1954 *Dare* (inside cover being fitted for a tight halter top)
 Aug. 1954 *Focus* (4 pages of pin-up poses)
 Sept. 1954 *Night & Day* (2 pages of leggy cheesecake)
 Oct. 20, 1954 *People Today* (back cover, 4 pages)
 Nov. 1954 *Bold* (back cover and inside pose in negligee)
 Dec. 1954 *Photo* (7 pages, 11 cleavage and leg-art photos, "Rage of Rome")
 1955 *Europe's Top Pin-Ups* #2 (inside cover, 2 pages)
 1955 *Fabulous Females* (8 pages)
 1955 *Pin-Ups Past and Present* (inside back cover)
 March 1955 *Pulse* (back cover, 3 pages)
 Aug. 15, 1955 *Newsweek* (feature on "Italy's Sophia Loren, a New Star—A Mount Vesuvius")
 Aug. 22, 1955 *Life* ("Europe's No. 1 Cover Girl," cover in diaphanous low-cut white fishmonger attire and 4-page feature)
 Sept. 1955 *Show* (back cover, 4 pages)
 1956 *Europe's Top Pin-Ups* #3 (back cover, 8 pages, 10 photos)
 Feb. 1956 *Nugget* #2 (5 pages, 10 photos)
 Feb. 7, 1956 *Tempo* (cover, 5 pages)
 March 1956 *Personal Story* (18 pages, over 40 photos focusing on her early pin-ups)
 March 1956 *Rave* (cover)
 March 1956 *66* #5 (66 photos)
 Apr. 1956 *Night & Day* (3 pages, 7 cheesecake shots)
 Nov. 1956 *The Dude* #2 ("The World's Most Perfect Body," 4 pages, 8 photos, including 1 of her topless movie stills)
 Nov. 1956 *Saga* (4 pages, 9 photos)
 Dec. 25, 1956 *Look* (4 pages; "Rich and Famous at 22")

A Neapolitan In Hollywood

Having seen her explosive rise to European stardom, American producers in late 1955 signed Sophia to appear in three U.S. films for $200,000 each. The first to reach American screens was *Boy On a Dolphin* (released in April 1957), and it proved to be her breakthrough as a high-caliber star, despite her odd teaming with diminutive co-star Alan Ladd. Portraying a Greek peasant diver who finds a national treasure (the statue of the title), she aroused male libidos around the world standing bare-legged in a soaked, transparent frock after emerging from the water; stills of the scene were among the decade's most frequently reproduced photographs. Producers in her subsequent films took note of this, and seized every opportunity to drench Sophia's curvaceous form. "It seems to me," she chuckled, "that I spent my first five years in the movies having people throw pails of water on me."

Cary Grant's initial skepticism when Sophia was cast as a Spanish guerilla in *The Pride and the Passion* (filmed before *Dolphin* but released in June 1957) ended after meeting her and screening two of her films. He introduced himself by jokingly confusing her with rival Lollobrigida; she

was charmed. After turning aside the advances of the film's other star, Frank Sinatra (who played her lover in the film), Sophia started dining with Cary each night at the production's Spanish locations. Grant saw her as "a child with the wisdom of the ages." She was in love with Ponti, but a thoroughly smitten Grant didn't let that dissuade him. Grant told Sophia that he was prepared to give up everything for her, and proposed marriage even though he was still married to Betsy Drake. "I never doubted for a second that Cary loved me as much as I could hope to be loved by a man," Sophia later wrote. Beset by inner conflicts, she said she didn't dare give him an answer yet, and left for Greece to begin work on *Boy On a Dolphin*.

When Sophia attended a reception in her honor at the Italian embassy in Washington, D.C. in 1957, the back of her tight gown split wide open when she sneezed just as photographers rushed to greet her. A female publicist came to the rescue with a needle and thread, and wide media coverage followed. Unquestionably Sophia's most publicized public appearance of 1957 was the Hollywood reception in her honor that April 13 at Romanoff's Crown Room. Jayne Mansfield nearly stole the show when she introduced herself to the guest of honor by leaning over in her startlingly low-cut gown and (as Sophia wrote) "just by chance one of her ample breasts tumbled out of her dress as the photographers clicked away. Welcome to Hollywood." A more complete account may be found in Jayne's chapter, but Sophia handled the attempted challenge with her usual aplomb.

Grant arranged for her to star opposite him in *Houseboat*, and once again urged that she leave Ponti and marry him. Ponti had finally separated from his wife, but Sophia still wasn't sure whether he was seriously pursuing efforts to annul the marriage. Refusing to take "no" for an answer, Cary actually went to Ponti (according to Grant biographers Charles Higham and Roy Moseley) and offered to do four movies for the producer for virtually nothing if he would give up Sophia. Meanwhile, she confronted Ponti with an ultimatum to make a firm commitment to their relationship.

When *Houseboat* was near its conclusion in September 1957, the news came from Mexico that Ponti's lawyers had finalized his divorce, and had, by proxy, executed his mar-

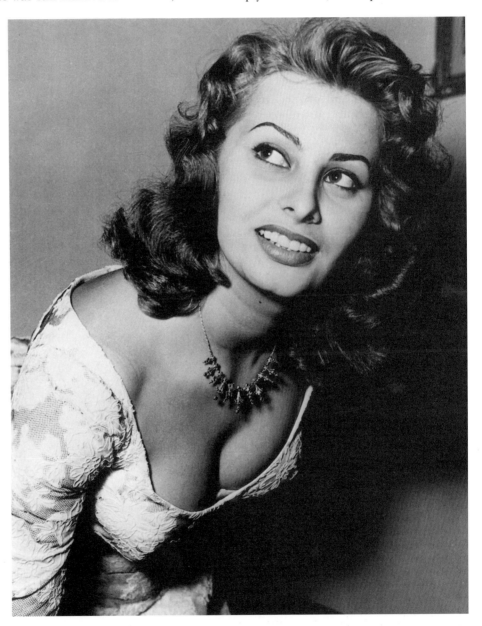

riage to Sophia. Shortly thereafter, she and Cary filmed the wedding ceremony for the picture, an acutely painful experience for the actor. A warm, gentle, romantic comedy, *Houseboat* earned a solid $3.5 million in theater rentals (the same as *The Pride and the Passion*), ranking it among the top 20 hits of 1958.

Reconciled to the fact that Sophia would remain with Ponti, but still deeply fond of her, Grant persuaded Alfred Hitchcock to cast her as the female lead in *North By Northwest*. To his bafflement, she declined the part in the classic thriller, which went instead to Eva Marie Saint.

Ponti's Mexican divorce was not accepted by the Roman Catholic Church, and to avoid confrontation while a domestic controversy grew over their "living in sin," he and Sophia thought it wise to stay out of Italy for most of the next few years. The couple later had no choice but to annul their mar-

riage in order to avoid bigamy charges against Carlo. While pursuing efforts to untangle the frustrating legal dilemma, they continued to live and work together as husband and wife in all but name. In April 1966, Sophia and Carlo, after becoming French citizens for legal purposes, were finally able to marry.

Among Sophia's 1957-1960 magazine appearances:

1957 Modern Man Yearbook of Queens (3 pages)

1957 The Magnificent Sophia Loren (50-page special photo magazine, featuring many early cheesecake poses in short shorts and tight sweaters, and classic shot of her bust being measured)

Feb. 1957 *Modern Man* (cover and 3 pages)

March 1957 *Night & Day* (cover)

March 1957 *Pic* (6 pages)

Apr. 1957 *Esquire* (1 page and article)

May 6, 1957 *Life* ("Sophia Loren Steps Into Hollywood," cover and 8 pages)

May 1957 *Pic* (7 pages)

June 1957 *Silver Screen* (feature, "TNT from Italy")

Aug. 6, 1957 *Look* (cover and 4 pages, "The Americanization of Sophia Loren")

Oct. 1957 *Fling #4* (6 pages, 10 photos and article)

Oct. 1957 *Photoplay* (5 pages shooting "Desire Under the Elms")

Oct. 1957 *Silver Screen* (feature, "Heat Wave")

Nov. 1957 *Playboy* ("Loren vs. Mansfield," with 3 photos of Sophia and 2 shots of her famous confrontation with Jayne)

Dec. 1957 *High* (3 pages of early cheesecake)

Jan. 1958 *Rave* (6 pages, 11 photos)

Feb. 1958 *Modern Man* ("Can Hollywood Seduce Sophia Loren?," 4-page, 9-photo feature including one picture as she teasingly pulls down the front of her low-cut dress)

June 23, 1958 *Life* ("Neapolitan Maid in Manhattan")

Aug. 1958 *Silver Screen* (cover feature)

Dec. 1958 Photo Life (6 pages)

1959 Modern Man Yearbook of Queens (3 pages, 7 cheesecake photos)

Apr. 1959 *Night & Day* (cover)

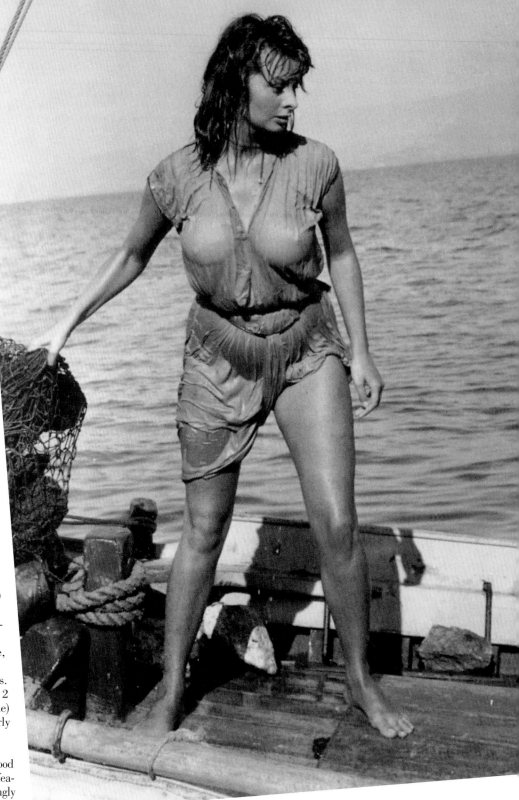

June 1959 *Silver Screen* (cover feature)

Nov. 1959 *Esquire* (4 pages)

Feb. 1960 *Silver Screen* (cover)

June 1960 *Movie Stars* (cover)

Aug. 1960 *Playboy* ("Sophia the Sultry," 5 pages and 11 photos, including 3 topless movie stills)

Nov. 14, 1960 *Life* (gorgeous cover portrait and 2 pages)

"Two Women" and The Striptease

Despite her commercial success in Hollywood, she and Ponti decided to return to making films in their native country. She'd had the opportunity to star opposite such legends as Grant, Clark Gable (*It Happened In Naples*) and John Wayne (*Legend of the Lost*), but she felt the roles were falling into predictable patterns. Ponti had acquired the rights to a novel set in Italy during World War II, and with Vittorio de Sica as director, they set out to make the film that became her greatest artistic triumph.

Upon its release in late 1961, *Two Women* was a stunning revelation to skeptics who regarded Sophia as merely a voluptuous and charming beauty with little acting talent. Tapping into the depth of emotions from her own childhood wartime experience, she turned in a powerful, harrowing performance as a mother struggling desperately to protect her 13-year-old daughter amidst the ravages of war in 1943. After winning Best Actress accolades at the Cannes Film Festival, Sophia proceeded to win the same honor at the Academy Awards—the first ever to an actress in a foreign-language film. Feeling she had no chance of winning, Sophia was in Rome on the night of the Oscar ceremony; Cary Grant called her from Hollywood with the happy news. Just as remarkably, *Two Women* earned $3 million in U.S. theater rentals by 1962. "Before I made *Two Women*, I had been a performer," Sophia wrote. "Afterward, I was an actress."

Making 1962 still more golden for Sophia was the sweeping historical epic *El Cid* (released at the end of 1961), a joint American/Italian production that paired her with Charlton Heston. It proved to be her biggest commercial smash with theater rentals of $12 million, ranking behind only *West Side Story* and *Spartacus* for the year. Three decades later, a restored print of the film would play in theaters once again.

For many Loren admirers, *Yesterday, Today and Tomorrow* (released at the end of 1963) is perhaps the most fondly-remembered of all her films. Sophia stars in both unrelated segments of this Vittorio De Sica comedy, but it is the concluding episode, *Mara of Rome*, that has become legend. She portrays a call girl whose beauty bedazzles not only Marcello Mastroianni, but also a young priest who is training for the seminary. The mother of the prospective priest gets Mara to promise that if the young man returns to the seminary, she'll go a week without sex. Mastroianni has been hungrily awaiting the time when he's alone with Mara; when the moment arrives he literally howls in anticipation and squeals with childish delight, sitting on the bed as she performs the most famous striptease in cinema history. She slowly, smilingly removes her silk stockings, dangling them before her, and undulates while stripping to her black bra and panties before suddenly stopping, because she's made a "holy vow" to abstain for a week. He slams his head against the wall in comic but entirely understandable frustration. "No scene ever gave me more pleasure," Sophia wrote, and her fans certainly agreed. The film earned $4.1 million in rentals to place it among 1964's top 20 hits.

Marriage, Italian Style in 1964 was another rousingly successful teaming with Mastroianni, tracing the relationship across many years between a rich playboy and his mistress; a visual highlight was the sequence in which Sophia (as a prostitute) jiggled in an exceptionally brief, transparent "spider costume." The performance earned her another Oscar nomination. She maintained an intensely busy film schedule, with occasional gems balanced against the mediocrities. Her most popular late-'60s picture was the enjoyable 1966 spy romp *Arabesque* with Gregory Peck. Charles Chaplin's eagerly anticipated comeback as a director in 1967 with Sophia and Marlon Brando, *A Countess From Hong Kong*, was a disappointment. Another 1967 film that deserved a far better fate was the romantic fantasy *More Than a Miracle* (aka *Happily Ever After*); it was seen by few moviegoers, but perhaps never had Sophia looked more breathtakingly lovely. The 1972 film version of *Man of La Mancha* was a heavily-publicized failure, although the blame was not hers. Sophia's appeal was invulnerable to individual box office setbacks, as demonstrated by her 1969 Golden Globe Award as the world's most popular female star.

Like another sex symbol for whom she felt empathy, Marilyn Monroe, Sophia's urgent desire to have children had been frustrated with two (or, by some accounts, three) previous miscarriages. Upon learning in 1968 that she was pregnant again, she spent five months in seclusion at a Swiss hotel in an effort to ensure that the pregnancy would be carried to term. Carlo Ponti, Jr. was born amidst international press coverage in late December, and Edoardo followed in January 1973. Already widely admired by women in a way that her glamorous '50s rivals never were, Sophia's new role of passionately devoted mother further expanded this admiration.

The Pontis' legal difficulties with the Italian government did not end with their French marriage. In 1979, he was fined $25 million by the Italian government for allegedly exporting currency and art works illegally, and was sentenced in absentia to two years in jail. Eleven years later, the government acknowledged its error and returned 250 major paintings to the Pontis that it had confiscated in that case. In 1982, she voluntarily returned to Italy to serve a 17-day jail sentence on a charge of tax evasion.

Dramatizing her own life on screen would have been a sufficiently daunting task when Sophia agreed to star in a $4 million, three-hour 1980 NBC production based on her autobiography, "*Sophia: Her Own Story.*" Making the challenge still more imposing was the fact that Sophia played both herself as an adult and her mother. The production was a critical and ratings flop, but her performance was revealing of both the actress and the woman. Sophia was back in Italy four years later to shoot the NBC movie *Aurora* with her son Edoardo, then age 11, playing her fictional child. Also in 1984, when Sophia couldn't come to terms with CBS for a continuing role in the prime-time soap opera *Falcon Crest*, the network instead gave the part to her old rival Lollobrigida.

Already quite wealthy, Sophia began a series of commercial endorsements in 1978 that included perfumes, soaps, and eyeglasses. Her 1990s print ads for an Italian furrier incurred the wrath of her French glamour-queen contemporary and animal rights activist, Brigitte Bardot.

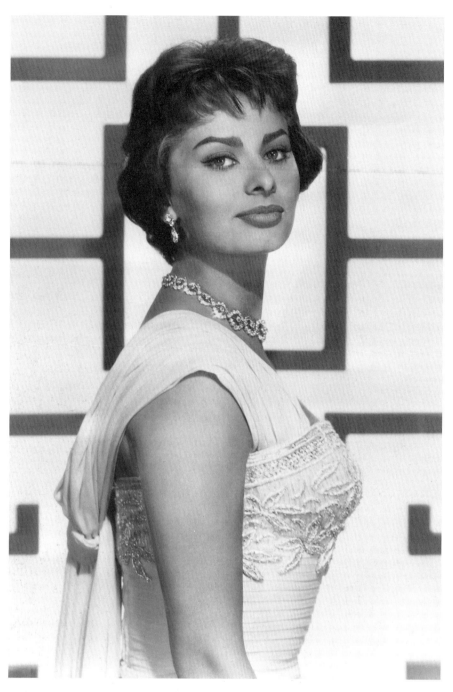

Her appearance in the late-1994 Robert Altman comedy *Ready to Wear*, despite the film's failure in other respects, brought fond smiles to fans as she was reunited with Marcello Mastroianni. Playing former lovers who come together in Paris following the death of Sophia's husband, they have a delightful reprise of the *Yesterday, Today and Tomorrow* concluding scene as Sophia slowly peels off her stockings and garter belt to his eager anticipation. Looking every bit as wonderful as she had 30 years earlier, Sophia disrobes to her frilly black underclothes, turns smilingly to greet her lover—and finds a weary Marcello fast asleep.

For all the astonishment her enduring beauty generates among others, Sophia takes it in stride. "One is born in a certain way, and with a structure that even as years go by, the structure holds," she told *Detour* magazine in 1994. "It's like when you build a house with a good foundation. There is no secret!" There is, however, a philosophy of life that has kept her young. "I'm really 12 years old—I've stayed 12 years old," she declared. "I am so open to new things, and so open to life. Twelve is the beginning of your adolescence, when you really begin to open your eyes to the world, and I still feel that way. It is the light that comes through your eyes that makes you look younger. . . If you're lucky enough to feel like a child, then your life is going to be so much better for you. You can be anything you want to be."

Sophia's best magazine appearances after 1960 have included:

1961 Modern Man Yearbook of Queens (3 pages, 6 photos)

June 1961 *Modern Man* (5 Sophia photos feature on her rivalry with Gina Lollobrigida)

Aug. 11, 1961 *Life* ("Part Goddess, Part Imp, All Woman;" cover, 10 pages of Alfred Eisenstaedt photos and article)

Apr. 1962 *Adam Vol. 6-6* (4 pages)

Apr. 6, 1962 *Time* (cover feature, "Much Woman")

March 8, 1963 *Life* (featured in a fashion modeling layout)

Feb. 15, 1964 *Saturday Evening Post* (cover and 4 pages)

March 1964 *Rogue* (3 pages, 8 photos of her striptease in *Yesterday, Today and Tomorrow*)

Apr. 10, 1964 *Life* (feature on *Yesterday. . .*)

Aug. 1964 *Art Films* (3 pages, 6 photos of her striptease)

Sept. 1965 *Millionaire* (5 pages, including early pin-ups)

Dec. 1965 *Playboy* (1 page, 3 photos)

Sept. 16, 1966 *Life* (cover in her unforgettable "spider" negligee,

During recent years, in a very different vein, she also underwent the emotional experience of traveling to Africa and elsewhere on behalf of the United Nations refugee assistance program.

On March 25, 1991, Sophia had the happy opportunity to make up for her absence from Hollywood on the night of her first Academy Award. Her former co-star Gregory Peck presented Sophia with the Academy's Honorary Award for lifetime achievement, and she was greeted with the only standing ovation of the evening. She held back tears upon seeing the dramatic demonstration of how an illegitimate child of the Naples slums had become one of the revered royalty of Hollywood.

in feature on photographer Alfred Eisenstaedt)

Oct. 1966 *Hollywood Sex Queens* #1 (superb two-page spread of her striptease plus 4 pages and 8 photos)

Oct. 1967 *Jaguar* (4 pages, 12 photos focusing on her topless scenes and very early leg-art poses)

Spring 1969 *Jaguar Spectacular* (4 pages of early cheesecake, including 7 topless movie stills)

Aug. 1, 1969 *Life* (feature on Sophia and her baby)

Feb. 2, 1976 *People* (cover with her children)

Sept. 1976 *Hollywood Studio Magazine* (cover)

Sept. 20, 1982 *People* (part cover as one of "The 30 Best-Dressed People")

Oct. 22, 1984 *People* (cover with her son Edoardo)

Jan. 1991 *Vanity Fair* (feature article with fine new glamour photos by Annie Leibowitz)

Summer 1991 *People* (2 pages as one of "The 50 Most Beautiful People In the World")

Oct. 1993 *Interview* (6 pages of vintage full-page photos plus interview)

July 1994 *Interviu* (Spanish magazine; 9 pages of classic vintage glamour)

Dec. 1994 *Detour* (bosomy current cover photo, 7 pages and article)

One of the most unforgettable movie scenes in Sophia's career was her appearance in a revealing "spider costume" in Marriage, Italian Style *(right). But her underlying dignity always coexisted with the sex appeal.*

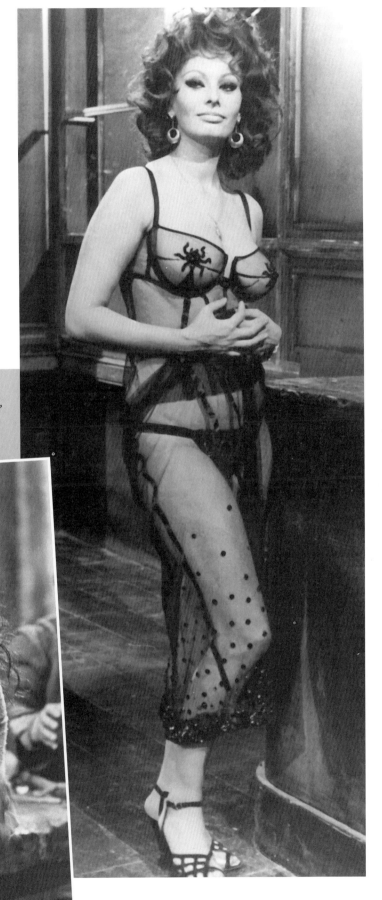

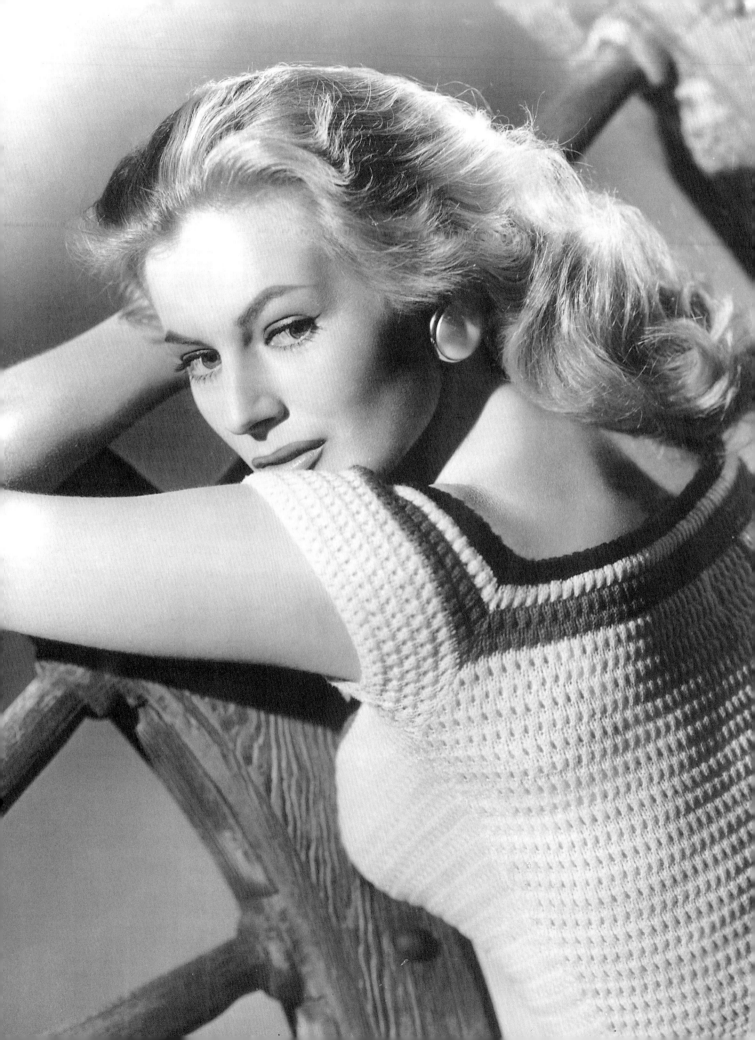

Throughout the postwar era, legendary film director/pin-up photographer Russ Meyer has worked with Hollywood glamour queens (Jayne Mansfield), European femmes fatales (Gina Lollobrigida) and sex bombs of the strip circuit (Tempest Storm). Among them all, none appears to have left a deeper impression than Anita Ekberg. "Anita was really special—spectacular, beautiful," he enthuses today. "She just couldn't take a bad picture."

Until Anita Ekberg came along, the cinematic image of Swedish women was either a Garbo-esque moody exotic, or an Ingrid Bergman-like radiant paragon. Anita introduced a potent new image of the larger-than-life Nordic Amazon quite capable of devouring the average male as a breakfast appetizer.

Anita was born the sixth of eight children (six brothers and one sister) in the seaside town of Malmö. Her father was a foreman for a company that supplied coal to ships entering the harbor. Much of her girlhood was spent carousing with her brothers, and developing both a strong, independent will and a formidable body. When she finished school at age 16, she put the latter to work as a department store model.

Finding the spotlight very much to her liking, Anita went to work at a music hall, appearing onstage in a brief costume to introduce each act. When she moved on to begin modeling in hotel fashion shows, Anita was spotted by fashion photographer Georg Oddner, and at age 19 she was immediately hired and became his favorite model.

In 1951, the budding model was persuaded (her initial reluctance was overcome by her mother and Oddner) to enter the Miss Malmö beauty contest sponsored by a local newspaper. Anita's overwhelming victory did wonders for her then-shaky self-confidence, which soared that August when she won the Miss Sweden title over 27 other contestants. This triumph made possible the realization of a long-nourished dream: a trip to America to compete for the Miss Universe Crown.

Anita did not win that contest, but the Malmö maid's strapping blonde-bombshell dimensions made an immediate impression on a scout for Universal-International Pictures. Shortly thereafter, the no-longer-shy beauty appeared in *Abbott & Costello Go to Mars*, the first of several nonspeaking bit movie parts. Unfortunately, they could not sustain her in Hollywood, and she had no choice but to return to Sweden.

From her first day home modeling for $25 an hour (and taking English lessons), Anita had only one objective: to earn her way back to Hollywood, this time to stay. It didn't take long. In February 1952, she entered a beauty contest in Holland, losing by a single vote. Once again, however, a motion picture talent scout was on hand to assess the abundant pulchritude. Courtesy of RKO, Anita was back in the States three months later.

Anita Ekberg

Born September 29, 1931
Malmö, Sweden

Later, she recalled where her confidence in her Hollywood potential came from. "After looking through American magazines, it occurred to me that I had physical properties that were just as good as Dagmar and a few others. . . I figured my bust line would carry me far. Up to that point, I hadn't paid much attention to my measurements. So you can really say that I owe it all to a tape measure."

While RKO proved another nonstarter for her big-screen ambitions, Anita was met with a far more welcome reception from Bob Hope and William Holden. When Marilyn Monroe couldn't appear for a USO visit to American soldiers stationed in Alaska and Greenland in late 1952, Hope and Holden found a willing substitute in Anita. The shivering troops were warmed up quickly by the sight of the 5-foot-7 blonde's 39½-23-37 curves; by at least one account her appearance triggered a near-riot.

The tour garnered Anita abundant publicity—and a seven-year contract with John Wayne's Batjac Productions—but no film work at first. The same was true of the hyperactive nightlife for which she was quickly becoming known. In between virtually nightly parties and nightclub outings, Anita began to romance Frank Sinatra (whom she dated for a month or so in 1955), Gary Cooper (with whom she spent a "lost weekend" the same year) and Tyrone Power. The latter relationship in particular was said to be serious enough for the matinee idol to consider an offer of marriage. But Anita was determined to let nothing stand in the way of stardom.

In 1955 the Hollywood ice began to break under the relentless approach of the superbly constructed Scandinavian. Pin-up photographers knew that there were few, if any, subjects more alluring than Anita, and by this point hardly a week went by without her divine form gracing at least one publication. In addition to Meyer, the photographer most closely associated with Anita was the great Andre de Dienes, who, in 1956, published an article titled "How I Discovered Anita Ekberg." De Dienes' enthusiasm knew no bounds: "Anita Ekberg could be the greatest of them all. . . . She has the most beautiful breasts in the world, firm and large."

One appearance that attracted a plethora of lensmen was her April stint as the Dream Queen of the New York Art Students' League Ball, for which she was poured into a breathtakingly tight, low-cut gown as "Her Satanic Majesty," a costume complete with horns. Another public near-unveiling occurred at a party that New Year's Eve. As Anita danced, her dress began to slip, and, according to an eyewitness, "underneath it was just Anita."

At long last, legitimate film roles were coming her way. Two years after he had signed her to a long-term contract, John Wayne cast her in *Blood Alley*, in which the form that

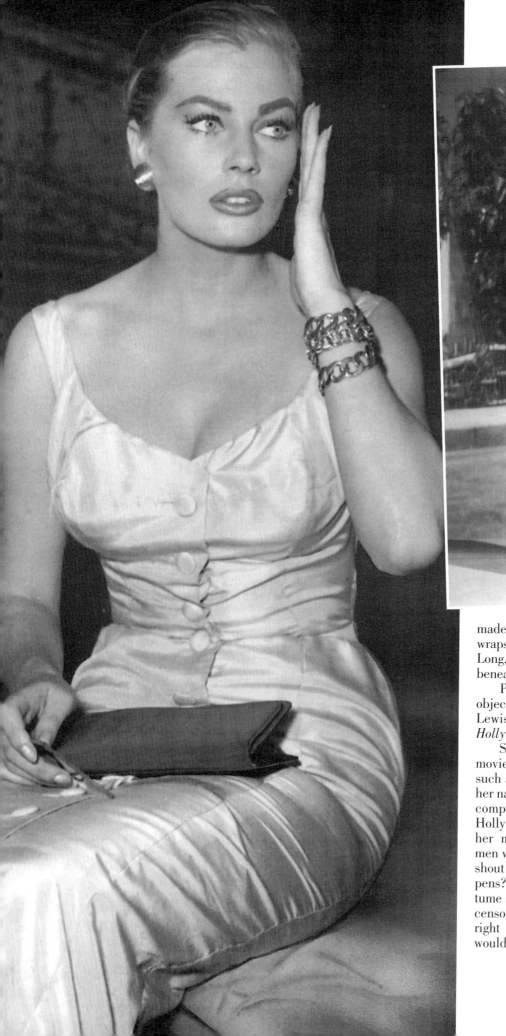

made Anita famous was kept sadly under wraps. Incredibly, Anita was cast as "Wei Long," wearing a black wig and concealed beneath rags from head to toe.

Playing herself, she then served as the object of fantasy in two Dean Martin-Jerry Lewis romps, *Artists and Models* and *Hollywood or Bust*.

Still, Anita wasn't satisfied with her movie roles to date—particularly those, such as *Blood Alley*, which played against her natural strengths. "It's ridiculous," she complained. "When a girl comes to Hollywood, the first thing she's asked is her measurements. If they're good, the men whistle, women sigh and press agents shout them around the world. So what happens? You come onto a movie set in a costume showing a nice line of cleavage. The censor sees you and makes you cover up, right up to the neck." Fortunately, she would not remain covered up for long.

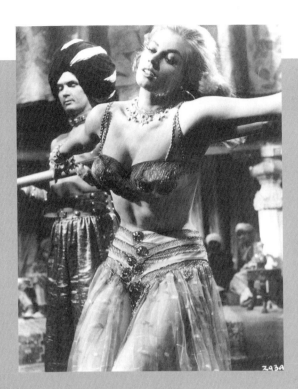

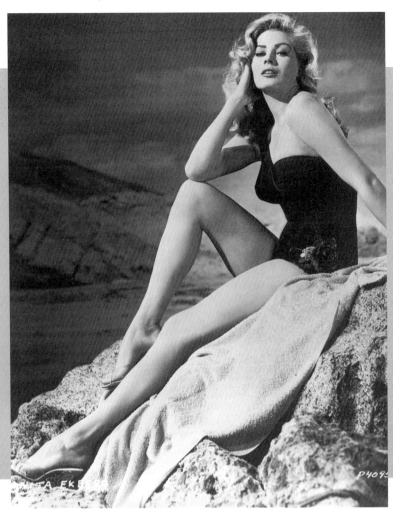

Anita's torrid dance sequence in the 1956 film Zarak *(above) helped establish her status as a top international glamour queen.*

Anita's major 1951-55 magazine appearances included:

Oct. 8, 1951 *Life* (Anita's splashy American debut following her appearance in the Miss Universe contest: "Beautiful Maid from Malmö.")

Oct. 1953 *Night & Day* (cover in jungle-girl bikini)

Nov. 1953 *Night & Day* (cover)

May 1954 *Glamorous Models* (cover, 6 pages)

May 1954 *Photo* (inside cover, 8-page bikini layout)

Oct. 1954 *Eye* (cover in leopard-skin swimsuit, plus 7 pages of beach cheesecake)

Oct. 6, 1954 *People Today* (cover and 4 pages)

1955 *Europe's Top Pinups #2* (cover in blue bikini plus 4 pages)

1955 *Fabulous Females #1* (back cover, 8 pages, 9 total pictures, representing the best of Ekberg)

1955 *Movieland Pin-Ups #1* (cover and 2 pages)

Mar. 1955 *Night & Day* (cover)

Apr. 20, 1955 *People Today* (cover, centerfold and 4 pages)

July 1955 *Movie Stars Parade* ("Miss Excitement")

Aug. 1955 *Man's Magazine* (cover)

Aug. 10, 1955 *People Today* (cover, centerfold, and 4 pages)

Sept. 1955 *Night & Day* (cover, elegantly beautiful in flowing nightgown; also 2 pages)

Oct. 1955 *Eye* (9 pages, 10 pictures, in fine form)

Nov. 1955 *Photo* (9 pages, excellent glamour layout)

Nov. 1955 *Show* (cover, 6 pages)

Nov. 15, 1955 *Tempo* (cover, centerfold, and 3 pages)

Nov. 1955 *Vue* (6 pages: "Hollywood's Torrid Siren")

"Zarak" — and the Bronze Sculpture

A big break came for Anita when she was signed for the featured role of Princess Helene in the all-star production of Tolstoy's *"War and Peace."* While filming in Rome, Anita fulfilled her reputation for world-class partying, including a rumored romance with a prince. A few years later, she recounted the highly successful publicity stunt she pulled after finishing the film. "It was arranged for my strapless evening gown to pop apart in the crowded lobby of a London hotel before a large crowd of witnesses. We had it fixed up for an English magazine to be on the spot to get still pictures of the scene so the magazine could later be banned. Newspapers condemned me at the time for being so tasteless. They claimed I established a new low."

Next came her sexiest role to date in *Zarak* with Victor Mature, featuring a torrid six-minute dance in a harem-girl outfit of strategically positioned transparent lace, putting virtually every delightful square inch of her epidermis on display.

A British publication vividly described the scene: "The night air is heavy, there's the smell of hashish, the pulsating rhythms of primitive music. The lights are dimmed. . . a lonely flute plays. . . and Salma, the Oriental dive dancer, begins to swirl and sway. Slowly at first. Then, with arms

outstretched, hair tumbling wildly over her shoulders, she sways and bends, twists and writhes more and more quickly. . . ." Another magazine remarked that the dance "makes Salome's 'Seven Veils' seem tame as a minuet." Those $25-an-hour modeling days were history—Anita commanded a salary of $75,000 per film.

Publicity photos released prior to the opening of the film had whetted the world's appetite for the movie, and Columbia took advantage of the anticipation with ads in the trade press. "Only 168 Days (and Nights) Till Ekberg Dances for Mature in *Zarak*," one teased. *Back from Eternity* (also released in 1956) was a less memorable film (she played a hooker who survives a plane crash in the South American jungle), but ads for the movie were further testimony to her growing star status: "The jungle was dangerous but. . . OOH, that Ekberg!"

Like nearly every other glamour girl, Anita was loathe to share the limelight. When her beautiful movie stand-in, Ulla Lynn, got front-page coverage in Italian newspapers, Anita made her displeasure known. Her prima donna reputation and occasional potshots at the media earned her the sobriquet "The Bore With the Bust" from one London newspaper. The same publication, however, was dazzled by the cleavage-revealing "double-barreled assault" she launched upon the Royal Film Festival.

The magnificent bodily dimensions that made Anita a human magnet for pin-up photographers were a source of pride—and she was royally disdainful of other would-be sex symbols who failed to measure up to her. "A lot of girls pretend to have a big bust," she declared, proceeding to state the obvious: "I have it. I don't have to undress down to the waistline. I have it."

Indeed. No man is a more experienced connoisseur of the female bosom than Russ Meyer. Having photographed all three women, he declares flatly that Anita was more well-endowed than either Jayne Mansfield or British blonde bombshell Sabrina, even though each of the latter two claimed measurements superior to Anita's 39-and-a-half inches. "No contest," scoffs Meyer.

Of course, Anita's glamour-girl rivals did not agree: With the notable exception of Mansfield, no other sex symbol attracted such fierce and catty competition. American stripper Evelyn ("The Treasure Chest") West (who for years had been claiming a 45-inch bust before finally confessing to "only" 39-and-a-half inches) took a more direct approach in 1958: When Anita appeared at a Miami Beach club with Bob Hope and said innocently, "I'm just an ordinary girl," Evelyn yelled, "You sure are!" and began pelting her with ripe tomatoes.

Such prodigious proportions, of course, did carry some disadvantages. Blouses presented a particular problem. "I just can't seem to find comfortable blouses in stores," Anita lamented. "I put them on and they are too small. They feel too crowded inside."

By this time, Hollywood and most of America was coming to know Anita Ekberg very well. Red Skelton proclaimed her "a woman-and-a-half." "They just don't make them that way no more," admired George Gobel. "When she walks into a room, this tall, blonde, incredibly endowed film actress owns it," declared *Look* magazine.

In his book "*Hi-Ho, Steverino! My Adventures In the Wonderful Wacky World of TV*," Steve Allen describes a sketch on his 1950s show in which he played a Bogart-like private eye. The script called for Anita to enter in a tight gown, sit in his lap and kiss him. But on the live broadcast, Anita's kiss turned out to be startlingly warm, so that "it was difficult to keep my mind on the script work for the next few minutes."

Anita's May 1956 marriage to handsome British actor Anthony Steel was a full-fledged media event. One might imagine that a treasure like la Ekberg would stoke the fires of possessive jealousy in any man, and this certainly proved to be the case with Steel.

A few months before their marriage, Anita posed nude for Hungarian sculptor Sepy Dobronyi. Dobronyi, after fleeing communist imprisonment, founded the Cuban Art Center. He met Anita during a trip to Hollywood and was dazzled. The two went swimming, Dobronyi proved to be a successful persuader and Anita agreed to pose. Dobronyi snapped several photographs of the Swede's astonishing nude figure. Back in Havana he went to work with a blow torch, shaping a startling bronze of Anita standing, her arms raised above her head to brush back her hair, the epic Ekberg bosom jutting proudly outward.

When Dobronyi exhibited the sculpture before thousands in Hollywood, Steel fumed. And when *Playboy* published stunning photographs from Dobronyi's sessions of the totally undraped Ekberg form in its August 1956 issue, he smoldered. (Nearly 20 years later, *Playboy* ran full frontal nude outtakes.)

When Anita and Tony spotted the sculptor at a Palm Beach, Florida, charity event the following February, there was an explosion. The popular version of the episode is that the 6-foot-1 Steel slugged Dobronyi. But the most credible account relates that the jealous husband dragged Dobronyi out of the building, the two men threw chairs at each other

and Anita did most of the damage, striking the sculptor about the head with her long fingernails and high-heeled shoes.

Dobronyi's crime? Allowing Anita to practice what she had preached: "If a girl has a beautiful bust with a nice curve to it, she should be allowed to show her beauty."

Aside from *Zarak*, Anita's hottest film performance of the 1950s came in 1958's *Screaming Mimi*. Playing an exotic dancer, Anita is assaulted in a shower by a knife-wielding killer, then comes under the influence of a possessive psychiatrist. She performs some sizzling striptease numbers (in a club owned by Gypsy Rose Lee) backed by jazz great Red Norvo.

A sampling of Anita's 1956-58 magazine appearances:

1956 Europe's Top Pin-Ups #3 (8 pages, 8 pictures, mostly cleavage)

1956 Figure Quarterly #15 (cover, 3 pages)

Jan. 1956 *Follies #2* (cover, 2 pages)

Jan. 16, 1956 *Life* (bosomy cover portrait)

Feb. 1956 *Art Photography* (cover by Andre de Dienes)

March 1956 *Personal Story #2* (an amazing 14 pages with over 30 pictures)

Apr. 17, 1956 *Tempo* (superb cover, and 1 page)

1956 *Candid Photography* (classic Russ Meyer cleavage shot of Anita behind a towel)

July 1956 *Modern Man* (cover, 6 pages, 10 pictures; "How I Discovered Anita Ekberg," by Andre De Dienes, including one full-pager sliding down a banister bare-legged)

July 1956 *66 #7* Pocket magazine totally devoted to Anita, with 66 photographs and full-length text.

Aug. 1956 *Night & Day* (2 pages, 8 pictures bursting out of her nightgown)

Aug. 1956 *Playboy* (The extraordinary nude layout taken from Anita's famous session with Sepy Dobronyi, a landmark both for *Playboy* and for Ekberg: 5 pages and 5 pictures of Anita, including three nudes.)

Oct. 1956 *Pic* (cover, 6 pages)

Nov. 1956 *Carnival* (cover, 4 pages)

Nov. 1956 *Jem #1* (2 pages color)

Dec. 1956 *Photographers Showplace #2* (cover and 1-page color pin-up)

1957 *Men's Digest #3* (cover, 4 pages)

1957 *Modern Man Quarterly #7* (cover, 8 pages, 16 pictures)

1957 *Modern Man Yearbook of Queens* (4 pages, 7 pictures)

Jan. 1957 *The Lowdown* ("The Ekberg Nude: Why She Did It")

Feb. 1957 *She* (9 pages, 10 pictures in issue devoted to the "Battle of the Blondes")

Feb. 1957 *Silver Screen* ("The Natives Will Be Restless Tonight;" more hot shots from *Zarak*)

Mar. 1957 *Vue* (cover, 6 pages)

1957 *Europe's Top Pinups #4* (cover, 5 pages)

June 1957 *Nugget* (cover, inside cover, 5 pages, 9 pictures;

sexy beach layout of Anita frolicking in a negligee which was rerun five years later by *Playboy*, albeit with much sharper photo quality than here.)

June 1957 *Uncensored* ("The Bore With the Bust")

June 1957 *Rogue* (centerfold clad in nightie and 3 pages, 5 pictures by Andre De Dienes)

July 1957 *Focus* (cover, centerfold, and 3 pages)

July 1957 *Night & Day* (cover)

July 1957 *Sir* (cover, 3 pages)

Nov. 1957 *Modern Man* (cover, 1 page)

Adventure in Rome

Syndicated columnist Earl Wilson, known to some as the "Boswell of Bosoms," later recalled a unique interview/photo session with Anita at his home. Wilson lamented the fact that Anita had chosen formal attire for the occasion, and, agreeing that something else was more suitable, she plunged into his wife's closet. After partially disrobing, oblivious to his presence, she donned some of Mrs. Wilson's intimate apparel, climbed into bed and struck some languorous poses. "My wife's garments were about half as big as Anita, who was an Amazon, and Anita was exposed in sections she wouldn't usually be exposed in," wrote Wilson.

Among all of Anita's many party-girl escapades, the one that achieved legendary status occurred in November 1958 in Rome. The affair, to celebrate the birthday of a friend of socialite Peter Howard, was decorous until Anita got up to dance. She removed her shoes and stockings, then launched into what onlookers called a "torrid cha-cha." As she danced, one shoulder strap came down, a zipper broke and most of the seams in her dress split "from the force of the bumps she was doing." The crowd clamored for an encore. Turkish belly dancer Kaish Nanah then took the floor, and Anita challenged her to top the performance. Kaish accepted the dare, and as she stripped down to her black lace panties (accompanied by wild cheers and whistles) the atmosphere became superheated and men hurled their dinner jackets on the marble floor. The episode would later inspire a scene in Anita's most famous film.

A slight variation on these accounts is that Anita's performance had resulted from a humorous dare. She had separated recently from Steel, and was dating a local Italian merchant. He had told her he didn't think she was "overstuffed," but would have to see it to believe it. She took the remark seriously as a dare, and started to strip right then and there. Some say she completely stripped and was hustled back to her hotel wearing a man's overcoat, but most

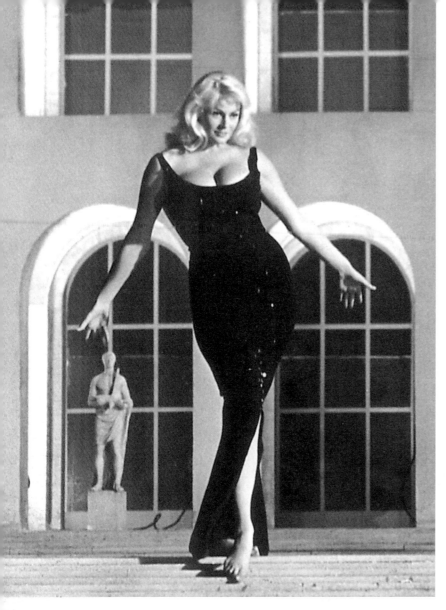

in a debate with American glamour girl Cleo Moore)

Nov. 1961 *Playboy* (classic 6-page, 21-picture layout, partly from the same revealing beach session featured in the June 1957 *Nugget*, plus shots from the 1956 nude session, *La Dolce Vita* and her *Zarak* dance.)

Dec. 1962 *Playboy* (1 picture from 1956 nude session)

1964 *Figure Quarterly #40* (cover)

1966 *Hollywood Sex Queens* (4 pages)

1978 *Lui #177* (remarkable new semi-nude pictures of Anita as part of a lavish multi-star layout by Angelo Frontoni)

La Dolce Vita

Anita's films of the late 1950s had been largely unmemorable, and she was in danger of slipping into the status of merely another bosomy pin-up girl. And then came Federico Fellini's 1961 classic *La Dolce Vita*. Well known for his fond appreciation of the feminine form, Fellini gave Anita her greatest role in a character that was, not coincidentally, very much like herself. In the film, she convincingly portrays a glamorous movie star who makes a regal arrival in Rome to shoot a new film, and quickly captivates tabloid reporter Marcello Mastroianni, who finds himself torn between the seamy stories he covers and his artistic ambitions. Some favorite moments: When asked how she got her start in motion pictures, Anita smilingly wiggles her torso and replies, "Because I discovered a great talent!" At a nightclub with Mastroianni, she kicks off her shoes and launches into a sizzling, swirling dance, after which she is picked up and held aloft Mansfield-style, her bosom (in a low-cut gown) thoroughly impressive. Then Anita and Marcello embark on a private tour of late-night Rome, climaxed by her uninhibited immersion in the waters of a magnificent fountain.

A year later, Vittorio De Sica gave her another delicious showcase as a larger-than-life symbol of erotica in an unforgettable segment of his film *Boccario '70*. In this flavorful three-part comedy, Anita is featured in "The Temptation of Dr. Antonio" as a billboard image come to life in the fantasy of a puritan, reviewed as "a gigantic voluptuary with mammaries exploding across the screen."

The early 1960s turned out to be the brightest period of Anita's film career. After the Fellini outings came the moderately enjoyable Bob Hope comedy *Call Me Bwana*, and the all-star affair, *Four for Texas*. In the latter film, Anita and Ursula Andress are the love interests of Frank Sinatra and Dean Martin. The Motion Picture Guide observes that "Andress attempts to compete with Ekberg in the battle of the busts but loses out by a mile." It was, however, all downhill from there. Anita's post-1964 films, mostly in Italy and Germany, are of little interest, although it was appropriate that Anita was cast as a modern-day Amazon in the 1979 TV

reports agree that it never went that far. Nevertheless, the whole affair wound up in court with a hearing in 1960; charges against Anita (for allegedly encouraging Kaish to strip) were finally dropped.

In 1959, Anita and Tony Steel's stormy marriage came to an end, and she began to date a new succession of handsome suitors. "Since I divorced Tony, I have had fun," she told an interviewer in 1960. As one might expect, Anita had no shortage of male escorts following her divorce from Steel. One of the best-known was rugged Australian-born actor Rod Taylor, with whom she carried out a high-profile romance during the early 1960s.

Anita's significant post-1957 magazine appearances:

Feb. 1959 *Monsieur* (color centerfold in negligee)

Feb. 1960 *Fling #17* (3 pages)

Aug. 1960 *Photo Life* (cover, 6 pages, and colorful account of the notorious Roman party)

Sept. 1960 *Photo* (cover "The Night Ekberg Stripped")

1961 *Modern Man Yearbook of Queens* (3 pages, 8 pictures)

May 12, 1961 *Life* (feature on *La Dolce Vita*)

Aug. 1961 *Modern Man* (3 pictures in a feature pitting Anita

movie *Gold of the Amazon Women.*

By the mid-1960s, the always-epic Ekberg form had expanded considerably in scope. Once magnificently zaftig, Anita became more enormous as time went on. But she was not remotely self-conscious. "It's not really fatness. And a woman does not need to fear that. I'm proud of my breasts as every woman should be. It's not cellular obesity—it's abundant woman-ness."

In 1978, Anita decided to prove her point by posing semi-nude for the Italian photographer Angelo Frontoni.

And, surprisingly, the results were quite pleasing; at age 46 and several pounds above her former "playing weight," Anita remained, proudly, every inch the glamour queen.

Aside from *La Dolce Vita* and to a lesser extent *Boccario*, the films of Anita Ekberg are largely forgotten now—in most cases, for good reason. Her astounding beauty, however, is well remembered, and to her admirers, overshadows her limitations as an actress. She may be a footnote in cinema history, but in the realm of the pin-up she knew few equals.

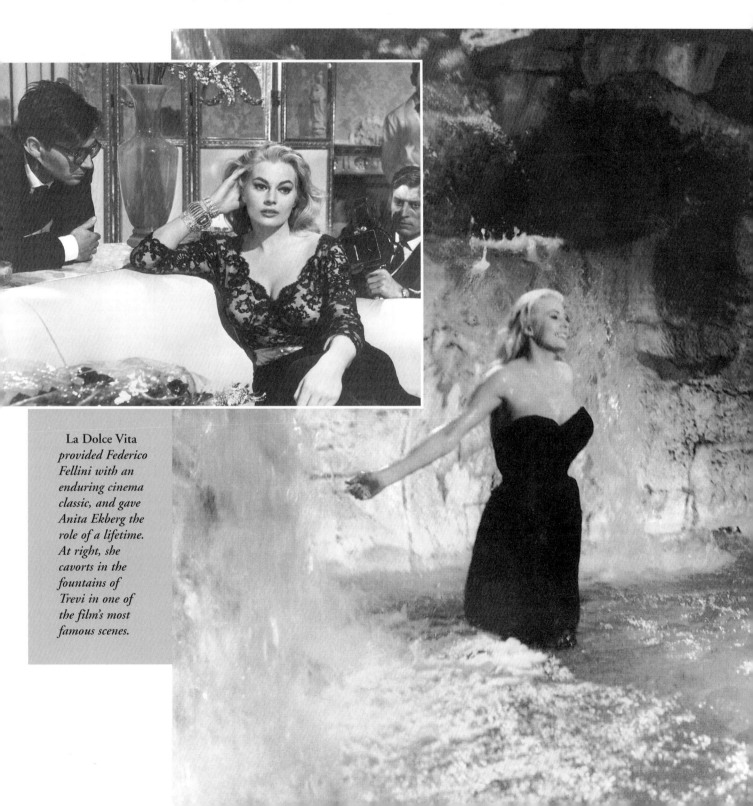

La Dolce Vita *provided Federico Fellini with an enduring cinema classic, and gave Anita Ekberg the role of a lifetime. At right, she cavorts in the fountains of Trevi in one of the film's most famous scenes.*

The Glamour Girls

Before World War II, true glamour queens had only one means to achieve major stardom, and that was the motion picture screen. There were big-name strippers in the 1930s, but they could only break through to a mass audience by crossing over to Hollywood; and pin-up models of the earlier era were almost invariably anonymous. One of the most distinctive elements of the 1950s is that it enabled women to attain stardom through either movies and TV, pin-ups, or the striptease stage, and this diversity helps to explain why glamour aficionados continue to regard the '50s with special affection.

The women profiled in this section earned passionate followings through their success in two or more entertainment genres. June Wilkinson became a sensation in magazine pin-ups and went on to a movie and theater career; Irish McCalla switched from men's magazines to TV and films; and Meg Myles progressed from pin-ups and movies to the dramatic stage.

If there was one quality that distinguished '50s glamour girls from those of other eras, it was a flair for the outrageous balanced against societal norms that imposed a price for going too far. When norms changed a decade later, what was once shocking (and therefore thrilling) became routine. Stars who were willing to boldly test the outer boundaries without quite shattering them provided much of the '50s' excitement.

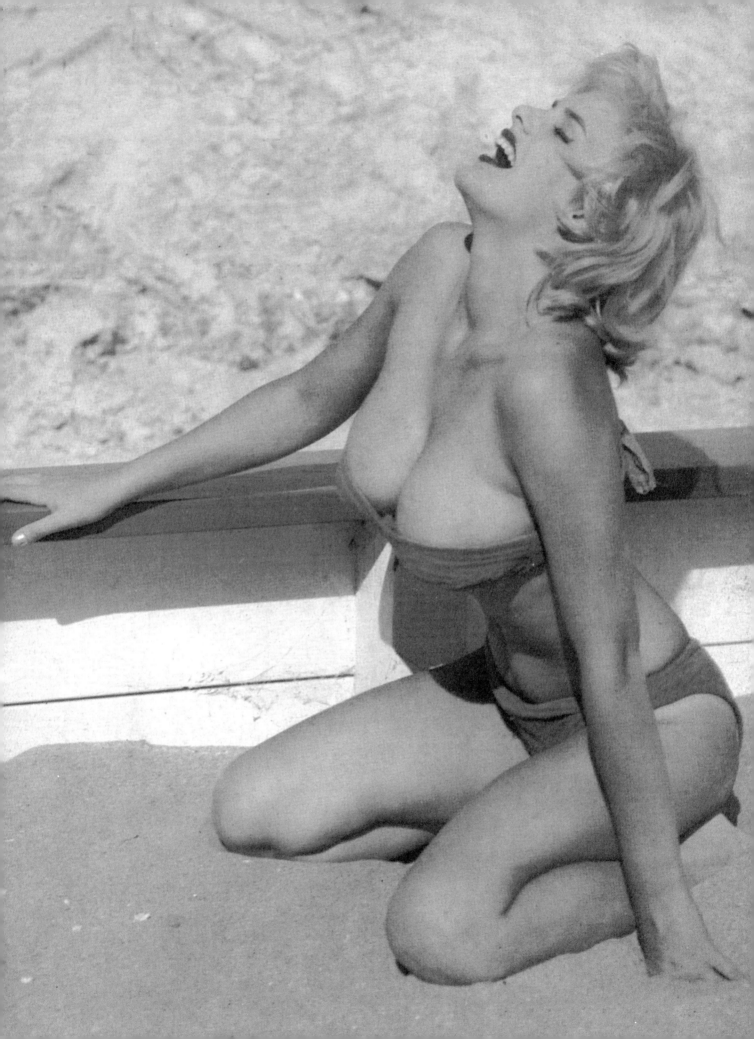

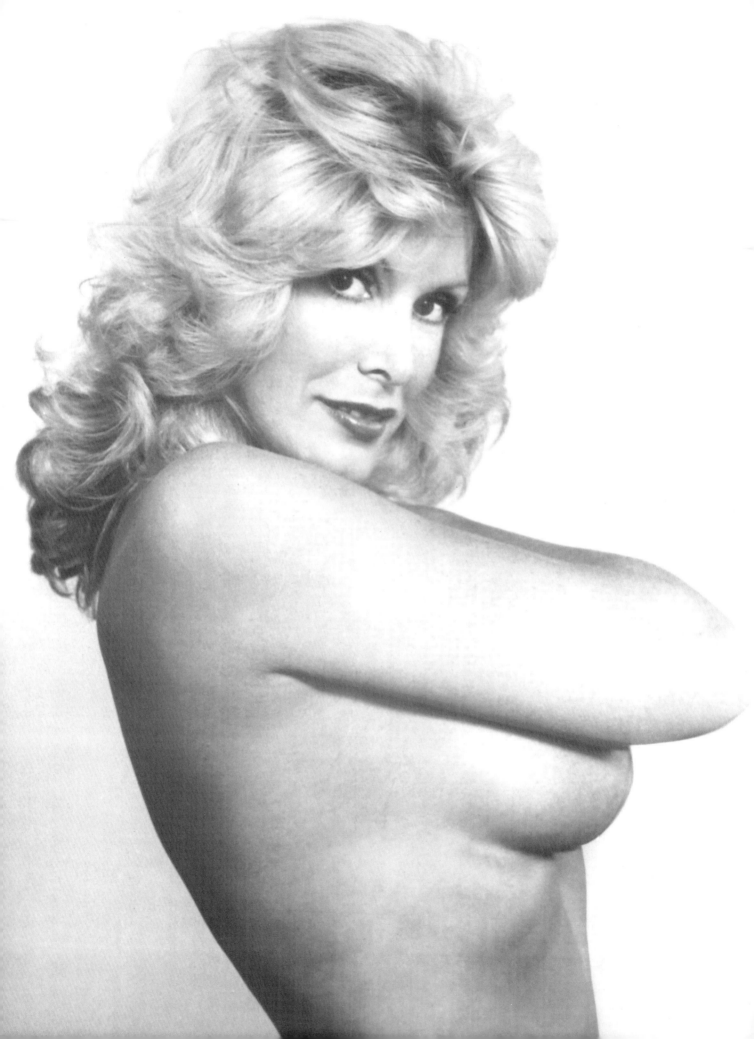

Among all the women whose stories are chronicled here, no one more fully embodies the spirit of this book than the remarkable June Wilkinson. It is not merely that her beauty, figure, robust sex appeal and ardent popular following (based on the author's international surveys of collectors) place her among the half-dozen leading glamour girls of the entire postwar era; rather, and even more impressive, it is the fact that—unlike 99 percent of the women who first rose to fame as nude or pin-up models—she carved out a show business career of great longevity.

But, perhaps above all, her uniqueness stems from the fact that throughout a professional career that is now entering its fifth decade, she has never relinquished an inch of the smoldering physical and sensual allure that first made her a star. Among all postwar stars, perhaps the only other women who have combined unwavering sex appeal and stage/screen success over a similar period of time are Sophia Loren and Joan Collins—formidable company indeed.

A potent stage presence, an adept touch for romantic comedy and sheer resourcefulness are all partial explanations for the career she has enjoyed, but even June would be the first to admit that the initial key to her success was reflected in the nickname by which she has been universally known: "The Bosom."

June Wilkinson

Born March 27, 1940
Eastbourne, England

From Eastbourne to the Windmill

The daughter of an Eastbourne window cleaner, June began her performing career at age 12 in the pantomime *Cinderella*. Staged at the Devonshire Park Theatre on London's West End, the performance featured June in the principal ballet dancer's role. Having taken ballet, tap and ballroom dancing lessons from the age of five—with her mother Lilly taking in needlework to help pay for them—June was absolutely determined to make a career for herself on the stage, and the rave reviews she received that Christmas hastened her along that path.

Press accounts of June's early career were often wonderfully flavorful and fanciful. A few years after this debut appearance, a ghostwritten account of her performance describes how June was given a dress made for a much smaller girl. "On the first night I took an extra deep breath and the dress split from top to bottom," June "wrote." Along similar lines, the account describes another stage role at age 12, at which the producer remarked that it was a pity to hide her under a cloak to play Little Red Riding Hood, and promptly ordered an alteration in the costume. "I must be the only girl who has ever played a schoolgirl Little Red Riding Hood with a plunging neckline," the story declares. "Utter nonsense," laughs June today about this description. Indeed, pictures of the budding starlet show an attractive but otherwise typical, and skinny, 12-year-old girl; this,

however, would change very shortly thereafter.

Seemingly overnight, at age 14, her body underwent the change that would alter her destiny. "All of a sudden, my boobs grew too big to be a ballerina," recalls June. "With my heavy bustline, my dance teacher thought I'd be perfect for the lead dancer at the Windmill Theatre."

Internationally famous as the vaudeville theatre which never closed, even during London's most harrowing days in World War II (as dramatized by the 1945 film *Tonight and Every Night*), the Windmill was a perfect launching pad for June. A week before her 15th birthday in March 1955, she auditioned and was hired on the spot. Her natural skills as a comedienne enabled her to play roles in the theatre's comedy sketches; her dancing ability, particularly an adeptness for jumping splits and high kicks, made her an automatic for the can-can. And certain of June's other natural attributes rendered her ideal for the Windmill's spicier entertainment.

Fan-dancing is an art form that is more difficult than it may appear, but June quickly became highly proficient at it. The Windmill required that girls dance completely nude except for their fans, and June and all other dancers were required to do nude "posing"—standing totally still (and totally bare except for a G-string) on a pedestal. As she had done before, June's mother made all of her costumes; chuckles June today: "Little did she know I didn't really need any costumes!" While a 15-year-old dancing nude might seem startling, it was totally legal and proper in England, provided the girl had completed high school.

In a subsequent interview, June reflected on these early days. "When I was 15 in London, photographers were already shooting through my keyhole, and when I opened the door my prices went up. In those days, school boys learned my measurements before they learned the multiplication tables. My figure was a conversation piece in the pubs."

The combination of June's extreme youth and still more extreme endowments made her the object of considerable jealousy on the part of her fellow showgirls. On occasion, this jealousy would manifest itself in such pranks as sabotaged fans, snipped threads and faulty glue that left vital pieces of fabric to fall loose midway into her act. Audiences were not in the least displeased by the results.

By the fall of 1956, June's fame was extending well beyond the Windmill. One of the first indications of this was a September article in the London *Daily Mirror* which pictured June as a 16-year-old showgirl with a now-41-inch bust. According to the article, June apologized to the Windmill owner because although her bust had measured 40 inches when she started, it was now 41, requiring the theatre to change its records. "I'm still growing, you see," said June. "I'm afraid you may have to change it again." A London *Daily Sketch* article from the period celebrated June

as the focal point of a stimulating new trend: "The Big Top Cult is the most amazing teenage phenomenon of all—girls still in school pushing the sweater-line out to the 40-inch mark. . . show lassies with big measurements getting to the top. . . a Windmill girl who's only 16, but the first, most vital of her vital statistics reads 41½ inches."

That fall, June left the Windmill after an 18-month stay. The immediate cause of her departure was the Windmill's displeasure with her acceptance of an offer to do a television show. June's popularity, however, had reached the stage where she was receiving lucrative offers from cabarets all over London, and the opportunity to strike out on her own could no longer be denied.

June was immediately hired by another club, and began with a variation on the Dance of the Seven Veils. "How I had the guts to do half the stuff I did, I don't know," marvels June today. "While I was doing that, I did the fan dance at another club. I was working at three clubs a night—a 10 pm performance at one club, 12 midnight at the second and 1:30 am for the third. Then the Embassy, the classiest club on Bond Street, offered me an exclusive contract." The contract was arranged by two of London's best-known agents, Leslie and Lew Grade.

It was at the Embassy that June concocted the best-remembered routine of her stripteasing career: clad in a bikini, she would take a position behind a large sheet of non-opaque glass; a row of front-row customers would then take aim, rear back, and fire suction-cup darts in her direction. If a hit was scored over a garment, the garment was removed and the dart guns reloaded and fired again. Delighted audiences at London's exclusive Embassy Club and other venues could always count on unveiling June's entire magnificent 5-foot-6 frame by the end of the evening. When she was stripped down as far as the law would allow, the fellow who scored the final winning shot got a kiss.

One London columnist proclaimed himself "shocked" at June's striptease routine, suggesting that "it's high time Dad took a day off from cleaning windows and came to London to clean up her act." Robin Wilkinson chuckled in response, telling another newspaper columnist, "I'm certainly not going to clean up her act. The only thing I'll clean is the window (of the sheet of glass) so the audience can see my daughter's beautiful body."

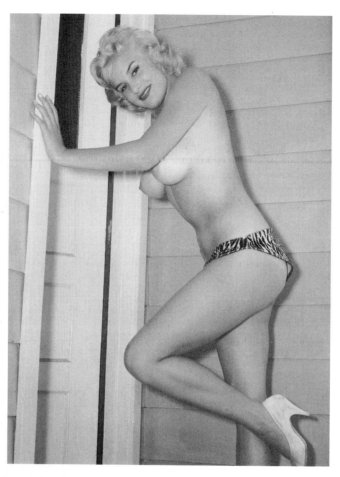

Some of June's semi-nude poses during 1956-57 turned up later in the U.S., but usually under the pseudonym "Beth Bradley." In 1957, her horizons were broadened still further when she got the opportunity to star on a BBC television production called *Pleasure Boat*. During its short time on the air, the show was apparently quite popular and further increased her renown.

By this time, the teen-aged beauty was a national figure, so to speak; according to a bylined article she wrote for a British publication in July 1957, June was receiving 15 marriage offers a month. "Unfortunately, most men who see me dance get the wrong idea about my private life," she related. "'Any girl who strips in front of an audience the way you do can't live a decent life,' they say." A multimillionaire who called himself "the Maharajah" tried to buy her for an evening; an Eastern prince offered her an elephant as the ultimate expression of his affection. Her new fame brought monetary rewards as well: June was earning over 100 pounds a week, 81 more than her father.

"If men love a stripper, there are women who hate her," June wrote in her 1957 newspaper series, *Secrets of a Stripper*. "In this bosom age women seem to be consumed with jealousy about my 42 inches and have tried to prove me a phony. Several have pinched me when I passed them and one even stuck a pin in me. One woman broke into my dressing room one night and demanded to measure my bosom. 'I'm tired of having my husband rave about your figure,' she said. 'I can't convince him you're not genuine.' Normally, I ignore people who doubt my tape measure reading, but on this occasion I made an exception. I used her tape measure and notched up the 42 inches. 'This has ruined my marriage,' she said, and walked away."

This jealousy also extended to other curvaceous starlets. Several months later, when June made her first visit to America, a bosomy blonde named Donna Jean Hand was infuriated by the publicity the British bombshell was attracting. To attract some of her own, Donna burst into a Chicago newspaper office and, in the words of one magazine, "bared her frontal charms and demanded to be measured." When the tape stopped at the 40-inch mark, she declared, "It's quality that counts, not quantity."

When June arrived, one of the photographers on hand to record her arrival happened to have a picture of Donna Jean's tape-measure session, setting the scene for one of the era's classic photographs: June holding up and intently studying the shot of Donna Jean being tape-measured. As June appears to take a deep breath and rear her shoulders back—her mighty 43-inch bosom appearing like twin Everests underneath her tight sweater—she has a hint of a smile on her face as she glories in her three-inch advantage over her rival. Next to June, the otherwise well-endowed Miss Hand is made to look like Olive Oyl.

Still, she was not happy. The opportunities for advancement into the wonderful world of motion pictures, which June longed for, were decidedly limited in England. Her ticket out may have been punched by a classic November 1957 publicity event,

courtesy of a disgruntled dressmaker who tipped off a newspaper reporter to the story. June's observation the previous year about her budding measurements was on target. The 17-year-old beauty, now measuring a full 43 inches, bought a dress from Britain's reigning sex symbol and bosom queen (and chum) Sabrina (41-18-36). Upon trying the dress on, however, June realized she had to have the top altered because "it wasn't big enough." Not surprisingly, June told the London *Daily Mirror*, "because Sabrina has such a pretty figure of 41 on top—or is it 42? But silly little me has a 43. So I had to let it out. After all, I couldn't go around in a dress that small. . . could I?"

In late 1957, a plastics manufacturer saw June dancing at the Embassy and hired her to represent the company at a plastics exhibit in Chicago. Her breakthrough to stardom was at hand.

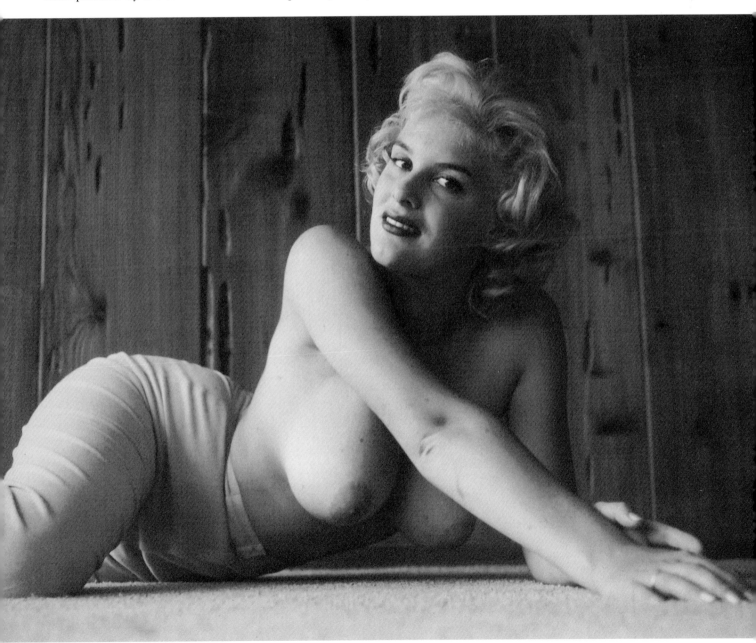

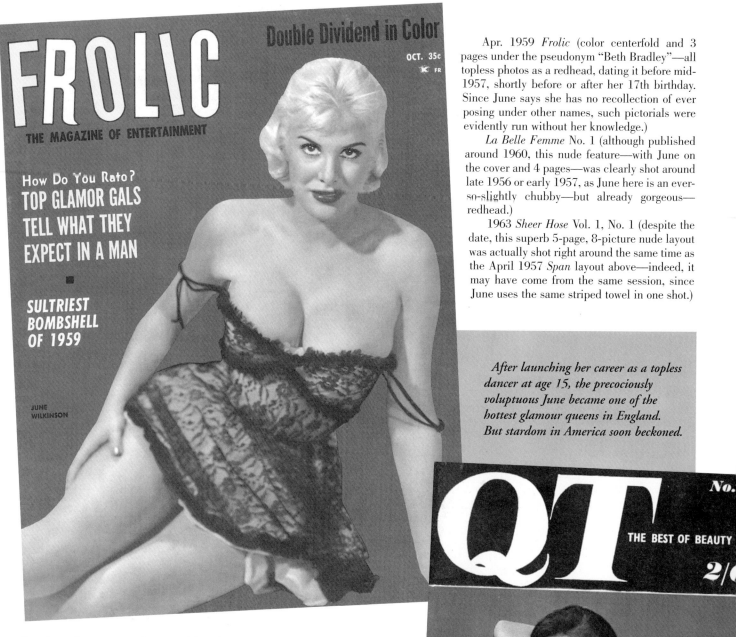

FROLIC

THE MAGAZINE OF ENTERTAINMENT

Double Dividend in Color

OCT. 35¢

How Do You Rate?
TOP GLAMOR GALS
TELL WHAT THEY
EXPECT IN A MAN

SULTRIEST
BOMBSHELL
OF 1959

JUNE
WILKINSON

Apr. 1959 *Frolic* (color centerfold and 3 pages under the pseudonym "Beth Bradley"—all topless photos as a redhead, dating it before mid-1957, shortly before or after her 17th birthday. Since June says she has no recollection of ever posing under other names, such pictorials were evidently run without her knowledge.)

La Belle Femme No. 1 (although published around 1960, this nude feature—with June on the cover and 4 pages—was clearly shot around late 1956 or early 1957, as June here is an ever-so-slightly chubby—but already gorgeous—redhead.)

1963 *Sheer Hose* Vol. 1, No. 1 (despite the date, this superb 5-page, 8-picture nude layout was actually shot right around the same time as the April 1957 *Span* layout above—indeed, it may have come from the same session, since June uses the same striped towel in one shot.)

After launching her career as a topless dancer at age 15, the precociously voluptuous June became one of the hottest glamour queens in England. But stardom in America soon beckoned.

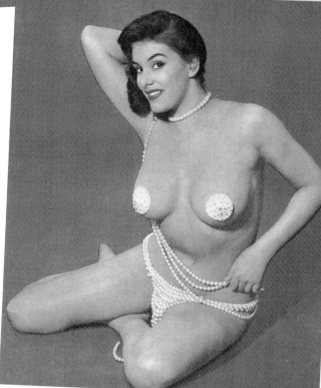

QT

No.

THE BEST OF BEAUTY

2/

June's early magazine layouts (along with later appearances of these 1956-57 sessions) included the following:

c. early 1956 *Beautiful Britons*

March 23, 1957 *Picturegoer*

April 1957 *Span* (17-year-old June is featured as "Dream Girl" in this four-page, five-picture semi-nude layout. The magazine notes that June's then-41-and-a-half-inch bust measurement is "a little in advance of Sabrina," but whether she can capture the same following is "not entirely a matter of figures!")

1957 *June Wilkinson* (The Magazine for Artists & Photographers) (Despite the title, only about half of this digest-sized magazine is devoted to June. But the 12 largely nude pictures here include some genuinely startling poses that are among the most revealing of her career.)

c. mid-1957 *Art & Camera* #1

Nov. 1957 *QT* #2 (cover, centerfold, plus 3 pages, excellent cheesecake layout)

Nov. 1957 *Vue* (this 4-page layout featuring June's "dart" act gave American readers their first good look at the British teen-ager.)

The Glamour Girls · June Wilkinson

VENUS

A Magazine for Adults!

aSn 50¢ VOL. 1 NO. 7

ANOTHER
SPECIAL SELECTION
OF MAN-PLEASING
FEATURES!

June picks up the story:

"We were all sitting around one night—Jimmy McCullough, my mother, and everybody—and I was looking at *Playboy*. And at 17, you're extremely cocky, you think you're God's gift to the world. I looked at the magazine, and said, I think my body's better than anyone in there. Jimmy McCullough suggested, Why don't you call *Playboy*? After dinner, I went back to the hotel and called at midnight. Hugh Hefner was the only one in the office and answered the phone. He knew who I was, and when I suggested the idea to him, he said, I'd love for you to be in the magazine. I went right over to his office, he called a photographer in— at two in the morning—and we shot right then and there."

The reason for the urgency was that June would have to return home to England after making a few more appearances the following day for the plastics company; this would be the only opportunity to pose for *Playboy*. "That was the moment," she explains. "I never even discussed money. I wanted to become famous in a hurry." As she boarded a plane back home, June was secure in the knowledge that she was, truly, on her way to stardom.

June returned to England after her brief but momentous first visit to America, but she was back in the States about three months later. Seven Arts learned about her impending appearance in *Playboy*, and the studio, says June, was less than thrilled. However, officials were smart enough to see an opportunity, and hired the high-powered Rogers & Cowans agency to handle her publicity. "Since I had already posed for *Playboy*, (Rogers & Cowans) figured they might as well make me the most photographed nude in America," recalls June. "They got a hold of Russ Meyer, and had him take a ton of pictures. I didn't get money from any of these, since I was still under contract to Seven Arts. Money was not the issue."

Since June was still only 17, *Playboy* held the pictures until she came of age and ran the nude layout in its September issue. In that now-famous pictorial, titled "The Bosom," *Playboy* declared June to be "the first Bosom worthy of a capital B. . . Compared to the mighty measurements of Miss Wilkinson, Hollywood's most full-blown beauties must go to the foot of the class."

"That was the era before bust jobs, so during that time a bust my size was definitely an oddity," notes June. "A D-cup was very unusual, so that's why (Hefner) named me "The Bosom." In the current era, with bust jobs commonplace, *Playboy* has featured "many a lady with bigger and better bosoms. . . you can't tell them from the real McCoy. Isn't that sad? Why couldn't they pick something I didn't already have, so I could get it?" she laughs. Although June is free to acknowledge she made the most of the fact that her bosom was the biggest of her time, she nonetheless remarks, "I probably shouldn't say this, but I think quality is much more important than quantity. I'd rather have a bust with a beautiful shape than one that's just big." Citing a modern stripper who is known only for her immense endowments, June shakes her head: "I wouldn't even try to compete!" Still, June was very much aware of the advantages afforded by her natural attributes. In a line later appropriated by other bosomy beauties, June gave her succinct response in 1959 to

1958-1960:
"Most-Photographed Nude in America"

June's January 1958 journey to America, to serve as "Miss Plastic Houseware," fulfilled all her dreams and then some. Jimmy McCullough, a publicity man who had brought Anita Ekberg to America, accompanied her, and on June's first day in the States, he got her on the *Today* show. Designer Oleg Cassini was so enchanted with June that he offered her four originals if she would wear one of his dresses to a party. At this party—on her second night in America—she met producer Ray Stark, who offered her a $250-a-week movie contract with Seven Arts.

Following this extraordinary start, June traveled to Chicago to fulfill her obligation to the plastics company.

the proposition that big busts may soon go out of fashion: "Sure they will—when there are no more men."

After making her abbreviated debut film appearance in *Thunder In the Sun*, June took a $500-a-week job with zany bandleader Spike Jones. Appearing at hotels and clubs around the country, June further honed her stage skills and got the opportunity to see America from an unusual vantage point.

Appearing in early 1959 at Hollywood's Ballyhoo Ball to help publicize the release of *Thunder In the Sun*, June made an unforgettable impression by entering wrapped like a mummy and then being ceremonially unwrapped until her bikinied charms were revealed. For the benefit of photographers, she was then held aloft (a la Mansfield) by a muscleman. This single appearance, which graced perhaps hundreds of publications, earned her as much

international publicity as any high-priced studio promotional campaign could dream of doing. "Seven Arts got me the costume and arranged the whole thing," says June. "I just provided the body." Seven Arts released her not long afterward, freeing her up for roles at other studios.

June traveled to Brazil to shoot *Macumba Love* in early 1959. While there, she met producer Marc Frederick, who told her he would love to do a movie with her. This became *Career Girl*, perhaps June's most famous early film. In case anyone doubted that June's popularity as a nude model could be transferred to the big screen, *Career Girl* provided a convincing answer: despite its bare-bones production standards, it played for an unprecedented 42 weeks at the Rialto Theatre on Broadway off Times Square. The reason?

Seen performing with Spike Jones at right, June's swift rise to glamour stardom would lead to an enduring showbiz career.

"All because I dived off the diving board nude," acknowledges June. "You've got to see it to believe it!" proclaimed the ads, which invariably featured June either semi-nude or in startling, plunging neckline.

During her early days in Hollywood, June earned a reputation as a starlet who would go to considerable length to get press attention. This was never better exemplified than at a 1960 party at producer Al Zugsmith's house to celebrate the release of *The Private Lives of Adam and Eve*. Sexy co-star Mamie Van Doren was also present at the party, so June knew it would take some doing to assure she was the center of attention. Her solution, according to various published accounts: diving into the swimming pool in bikini, and emerging topless. As June climbed out of the pool and calmly walked past various dignitaries with her 43-inchers bared (so the story goes), there was a stampede of photographers to capture the moment. Photographers supposedly had June repeat her topless emergence from the pool, and, according to these accounts, she gladly obliged. Today, June says she has no recollection of the incident, and notes that despite all the cameras supposedly clicking away, stories of the episode are never accompanied by pictures (except for one ambiguous shot of June climbing out of the pool, her bikini top askew). Whether fact or fiction, the account is reflective of the sensational press she frequently received during these years.

In February 1960, visiting Chicago for a new *Playboy* layout, June appeared for a week as a Bunny at the newly opened Playboy Club. She then appeared on Hefner's TV show, *Playboy's Penthouse*, and (in the magazine's words) "put her magnificent measurements to work" by balancing two full glasses of champagne above the neckline of her low-cut outfit. "Hef always loved that photo," June chuckles, noting that *Playboy* included the shot in its 40th anniversary book. "Everyone remembers it. I think it's because we see so many pictures of the boobs, and that picture sort of makes fun of them!"

The emerging starlet June made five films in her first two years:

Thunder In the Sun (1959) — June has a minor role (unbilled in most reference sources) in this forgettable Western romance starring Susan Hayward.

Career Girl (1959) — Her first starring role was in a low-budget tale of a sexy young starlet trying to break through in Hollywood and seeking weekend serenity in a nudist colony. The film actually has the pleasant, amateurish charm of a home movie, with June giving voice-overs describing the

The Immoral Mr. Teas (1959) — Famous as Russ Meyer's first full-length feature—and the first nudie film to receive wide mainstream distribution—it is now equally renowned for including a brief cameo appearance by June Wilkinson. Since June was under contract to Seven Arts at the time, Russ was not permitted to show her face or bill her, "I did the film as a favor to Russ, for no money." In the scene, Bill Teas looks up and his mouth drops open and eyes bulge when he sees a pair of giant breasts (June's) leaning out of a window. The camera then cuts back to Teas, who is bouncing a pair of cantaloupes as he acts out his fantasy.

Macumba Love (1960) — Israeli sex symbol Ziva Rodann is the female lead in this tale (shot in Brazil) about an author investigating voodoo practices in South America; June plays the author's lovely daughter. ("Macumba" is a Brazilian ceremony, an "orgy of magic" to exorcise evil spirits.) "Blood-lust of the voodoo queen!" proclaims a vivid ad for the film. "Thrill to the demon-rites of the witch goddess!" While certainly no award-winner in any respect, acting or otherwise, it is a colorful and entertaining diversion, and always a treat on late-night TV.

While seeking fame and fortune in Hollywood, June assuredly did not forget nude modeling; indeed, Rogers & Cowans achieved their objective of making her "the most photographed nude in America."

otherwise silent video (accompanied by cheesy music) of her character's struggle for stardom. And certainly a large part of the film's appeal for Wilkinson connoisseurs is that, in the closing moments, June bares the mighty assets that first brought her to Hollywood.

The Private Lives of Adam and Eve (1959) — Mamie Van Doren and Mickey Rooney are the unlikely co-stars of this decidedly silly film: a flash flood grounds a Reno-bound bus, forcing the travelers to take shelter in a nearby church; there, the travelers share a dream in which they are in the Garden of Eden (with Rooney as the Devil!) When this film was first released in 1960, the Catholic Legion of Decency pressured Universal to pull it back and re-edit some offending scenes (including one of a barely clad Mamie in the Garden). June played a minor role as one of the "Devil's Familiars." Two other noteworthy ladies in this otherwise minor film: teen temptress Tuesday Weld and Ziva Rodann.

June's most noteworthy magazine appearances during 1958-60:

May 1958 The Dude (the first pictorial layout on June to appear in a full-sized American magazine. One's first suspicion is that it was actually shot sometime after she posed for Playboy, because she has already gone blonde here. However, it turns out that June first went blonde in 1957 while performing at the Embassy, and the 4-page, 7-picture semi-nude layout features June's "dart" act from the Embassy. After going "natural" again by the time she went to the States, June was persuaded to go blonde again, this time for good, in late 1958.)

Mid-1958 Mermaid #3 (teasing, sexy cover)

1958 Touch #2 (6 pages, 12 pictures)

Aug. 1958 Jem (the classic Donna Jean Hand photo is featured. "When bigger and better bosoms are made, the English will make them," declares the magazine. "This upright teen-ager is well out in front so far.")

Sept. 1958 *Playboy* (the 5-page unveiling as "The Bosom" that first brought June—still a brunette at this point, when shot several months earlier before her 18th birthday—international fame. It's a good mixture of photos: June in Hef's bed; June clad only in a man's sports shirt (unbuttoned, of course); June in a custom-built swimsuit and a see-through, low-cut negligee; and the unforgettable opening shot of June tucking in a skintight blouse before a mirror with her twin dirigibles exploding across the room.)

Oct. 1958 *Night and Day* (3 pages, 7 pictures: ". . . And Still Growing")

November 1958 *Adam* Vol. 3, No. 1 (one of June's most unforgettable pictorial features, "Beauty and the Bust" took readers on "a very special shopping trip" as June went to buy a custom-made bra, accompanied by that legendary photographic chronicler of epic-scaled bosoms, Russ Meyer. The classic opening shot set the tone: as Russ shoots from floor level, a towering June, her tight white sweater bulging outward, absolutely beams in evident pride as a measuring lady strains to get a tape measure across the mighty expanse of her bosom.)

The accompanying article describes how other models share the men's disbelief at June's endowments. When Russ told curvy glamour girl Sandy Lane (40B-22-36) about June, Sandy replied, "Hah! I'll top her by an inch!" "No you won't, darling," Russ calmly informed her. When Sandy called the following day to ask, "is that 43 bosom for real?," Russ was forced to reply in the affirmative.)

c. late 1958 *My Escort* #3 (cover, 4 pages, 10 pictures)

1959-60 *Adam* calendar (released late 1958; fine, teasing topless portrait)

1959 *Tonight* No. 1 (quite striking, sultry cover pose)

1959 *Rapture* #2 (6 pages, 9 excellent nudes)

Mar. 1959 *Girl Watcher No. 1* (2 pages, "Answers to Your Girl Watching Problems")

Apr. 1959 *Gent* (3 pages, 6 pictures)

Apr. 1959 *Jem* (3 pages, 7 pictures from *Ballyhoo Ball*)

April 1959 *Sir Knight* Vol. 1-7 (in a 6-page, 16-picture layout including the inside cover, June "Goes to a Party" and shakes her booty in volcanic fashion.)

May 1959 *Caper* (cover and 3-page pictorial, 10 pictures in all by Russ Meyer)

May 1959 *Modern Man* (quite spectacular Russ Meyer cover shot—later repeated on a 1966 cover of *Beau*—followed by a memorable 5-page pictorial and biography.

May 1959 *Scamp* (June is the cover girl and featured in a 4-page, 10-picture layout appropriately titled, "Hollywood or Bust.")

June 1959 *Gent* (5 pages, 10 pictures)

June 1959 *Girl Watcher* #2 (even though neither June nor anyone else removed her top in this magazine, it remains one of the most memorable issues in this "Golden Age of Girlie Magazines."

Its tone is set by the classic cover shot of June and Bonnie Logan standing on a street corner all but exploding out of their tight sweaters and casting lascivious looks at the camera, with Bonnie licking her lips.

June 1959 *Glance* (inexplicably identified as "June Wilkerson," June is in magnificent Junoesque form in 5 pictures (including centerfold) bursting out of her tiny bikini outfit from the

Ballyhoo Ball; also featured in August issue.)

June 1959 *Tab* (4 pages from *Ballyhoo Ball*)

Date unknown; c. 1959 *Blaze* #1 (7-page pictorial)

c. 1959 *Figure Studies Annual* #16 (beautiful, stylish cover)

1959 *Fling* #14 (3 pages, 4 pictures)

c. 1959 *Spick* #74 (5 pages)

1959 *Venus* #7 (cover)

Aug. 1959 *Cavalier* (cover, 2 pages)

Aug. 1959 *Gent* (5-page, 11-picture nude layout photographed by Russ Meyer, including some fine color shots.)

Aug. 1959 *Playboy* (a 4-page pictorial, "The Bosom in Hollywood," is most memorable for its shots of June's unveiling at the *Ballyhoo Ball*, and a classic full-page color profile of a genuinely lovely June peering thoughtfully out a window with her shirt open.)

Aug. 1959 *Scene for Men* (5 pages)

Sept. 1959 *Mermaid* (unforgettable 8-page pictorial, "June Wilkinson Dances for You," an expanded version of the layout seen in *Sir Knight* Vol. 1-7. Seen again in *Mermaid Annual* 1960; also, 30 years later, the layout would be recalled with a 3-page layout in *Cad: A Handbook for Heels*.)

Oct. 1959 *Pose* (cover bursting out of a white nightie)

Nov. 1959 *Hi-Life* (cover, 5 pages, 14 pictures)

Winter 1959 *Fling Festival* (this 4-page, 10-picture unveiling of June includes some classic color shots. For overall quality, this ranks among the finest Wilkinson pictorials.)

Dec. 1959 *Mr.* (cover, 4 pages, 13 pictures: "Big Bosom from Britain")

Jan. 1960 *Caper* (3-page layout with the inevitable title "June Is Bustin' Out All Over." Later reprised in *Caper's Choicest* Feb. 1962)

1960 *Modern Man Yearbook of Queens* (3 pages, 7 pictures)

c. 1960 *Blaze* No. 1 (7 pages)

Early 1960 *Plush* Vol. 2-3 (one of June's personal favorite layouts, a 4-pager by Russ Meyer of June adorned only in furs.)

Feb. 1960 *Cavalier* (all-color layout including some genuinely beautiful shots.)

Feb. 1960 *Jem* (title page plus 6 pages, 16 pictures)

March 1960 *Modern Man* (inside cover and pictorial by legendary Andre de Dienes.)

1960 *Follies de Paris/Hollywood* #232 (cover)

1960 *Fling Festival* #3 (5 pages, 11 pictures)

May 1960 *Foto-Rama* (cover: "Who Is the World's Sexiest Girl?")

Date unknown, c. 1960 *Showcase* #1 (June is pictured on the cover topless in a hammock.

1960 *Mister Cool* No. 1 (6 pages)

c. 1960 *Rendezvous With Pleasure* #4 (5 pages)

1960 *Sextet* #2 (4 pages)

June 1960 *Playboy* (June is pictured as a participant at the Photographers and Models Ball.)

June 1960 *Rogue* (a Russ Meyer pictorial of June titled "Scene By the Sea." Several interesting and unusual shots here of a totally nude June, viewed from the rear or side, being posed by Russ.)

Aug. 1960 *Playboy* (feature on the Playboy Club, including June's brief but memorable stint as a Bunny.)

Oct. 1960 *Playboy* (in a "Girls of Hollywood" essay, a small 1-shot of June standing on a street corner.)

Nov. 1960 *Playboy* (2-page layout, "The Bosom Revisits *Playboy*." The full-page opening shot is one of the all-time "grabbers:" June clad in white tights, leaning against a chair with her legs spread wide, her arms pressed against her bare breasts and one finger to her mouth as she smolders with a salacious half-smile on her face.)

Dec. 1960 *Modern Man* (Russ Meyer is the photographer for one of June's most fondly remembered magazine appearances, "The Bosom Buys a Bra," with a splendid bikini cover. We see June being measured for size (43-D) and strap length, checking proportions with the Frederick's of Hollywood designer, who realizes he needs a larger drawing board, and showing off the finished product. There's also a marvelous color, full-page topless portrait. "Never before has so much bosom given so much fame to an actress in so short a time," declares the magazine. It all goes to show that "a brassiere is a brassiere, but you only get out of it what you put into it.")

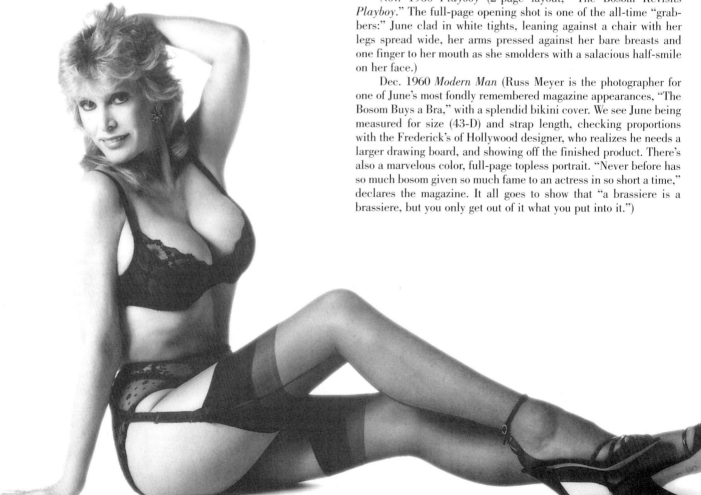

1961-1963: June Explodes in "Pajama Tops"

While June was continuing to land movie roles with regularity, they were almost invariably of the "B" variety, and she sensed the need for a change. Early in 1961, the vehicle for that change appeared in the form of a French theatrical sex farce called *Pajama Tops*. The show dated back to 1954, and various earlier productions had featured the likes of Greta Thyssen and Barbara Eden. When June Wilkinson assumed the role of Babette LaTouche for the first time, however, it was as if it had been written expressly for her.

A silly, convoluted confection of a play, *Pajama Tops* revolves around a French businessman's frantic efforts to conceal a sexy mistress (June, of course) from his wife, with a leering police inspector and a saucy maid also involved in the twists and turns of a storyline filled with mistaken identities and double entendres. But it was the comic panache and breathtaking vision of June (barely clad in a succession of outrageous outfits) that lifted *Pajama Tops* from the routine to something that was anything but.

Very shortly after June's debut with the show at the old Hollywood Canteen, it caught a spark it never had before. When it scored well again in a 15-week run at the 1962 Seattle World's Fair, producers took it on a hugely successful national tour, breaking house records in theater after theater. The show was so successful, in fact, that in 1964, *Pajama Tops* landed on Broadway at the Winter Garden theater for six months. It again played to packed houses, but the producer decided to take it back on the road where the profit margin was higher. After initially earning Actors' Equity minimum in the show, June was now making $600 a week plus 10 percent of the gross, which would later enable her to pull down as much as $10,000 per week due to the play's enormous popularity, and become, reportedly, the highest-paid stage actress in America.

During the early run of the show, June explained to a reporter how she competed for attention with another beauty. "When Fong comes on in that Chinese dress thinking it's her scene, I inhale and let my negligee slip off one shoulder."

When June went to Mexico to shoot *La Rabia Por Dentro*, producers figured they could keep ringing up the big business in her absence, without her hefty salary, by bringing back Greta Thyssen in the role. As June remembers, however, "I got a call 10 days later asking, 'when can you come back?'—because business had gone to practically zero." Having completed her four weeks of work on the film, June agreed to return—at double her original salary—in the middle of the week. "They didn't give me any more problems (about money) after that," she laughs.

In a similar situation over a year later, June had to leave the show again to shoot *The Candidate* and the producers launched a publicized worldwide search for a replacement who could "measure up" to her. The replacement turned out to be none other than Sabrina; June noted pointedly that new costumes had to be made, since Sabrina did not really quite measure up to her. The show closed two weeks later.

La Rabia turned out to be the best-received film of June's career, although it was not seen widely in this country. Shot in Spanish (with June speaking the lines phonetically), the film won wide acclaim in Mexico; 20 years later, June was to make another of her better movies with the same director.

During the early 1960s, June also found time to appear in a number of television shows, including *77 Sunset Strip*, *Alcoa Theater* and *The Garry Moore Show*. In 1966, June made an appearance in the cult classic TV show *Batman*.

In 1962, she began starring in magazine ads (which ran for about three years) for bust-enlargement devices as "the girl with the world's loveliest bustline." Did these bust development techniques help her achieve those magnificent dimensions? asked a 1965 interviewer. "Good heavens, no!" June laughed in response. "I was lucky enough to be born this way. But it will add inches to those poor little lambs who Nature shortchanged. And the course is excellent for girls like myself who are well-developed and who want to keep what they've got in shape."

In 1962, June also proved she was ahead of her time by recording an exercise album titled *Calendar Presents June Wilkinson and Her Physical Fitness Formula*. The cover leaves no doubt about the album's primary appeal, picturing June lounging in bed with her negligee slipping down and ample cleavage on display. Included with the record was a large photo insert with June demonstrating the exercises in a bikini. She laughs while recalling it today: "I didn't really quite know what I was doing at the time. At one point I tell listeners to take a deep breath, but I never tell them to breathe out. Anyone paying attention to my narration would have passed out!" Nearly two decades later, she would take this interest in physical fitness in a new direction.

Sometime around the beginning of 1962, June acceded to the cries that her figure was a work of fine art by posing for a series of nude portraits by artist Violet Parkhurst. The results were stunningly beautiful, and one of the portraits still graces her hallway. Violet made certain that a photographer was also on hand for the session "to prove that my brush was adding nothing to Miss Wilkinson's flowing figure."

June's movies during the 1961-63 period:

Twist All Night (1961) — Also known as *The Continental Twist*. June gets nominal co-star billing as the sexy girlfriend of nightclub owner Louis Prima in a quickie film that was rushed into release to beat the similarly titled Chubby Checker film *Twist Around the Clock*.

The Playgirls and the Bellboy (1961) — The description in *The Motion Picture Guide* is flavorful: "A real oddity. This German black-and-white sex comedy about a voyeuristic bellboy who peers through keyholes at scantily clad showgirls in the hopes of becoming a house detective, has absolutely nothing to recommend it except that a very young Francis Ford Coppola was hired by the American distributor to write and shoot additional color, 3-D nude sequences featuring the likes of buxom June Wilkinson." In truth, the film is considerably less flavorful than suggested by the above description, although charming in its own goofy way. Oddly, June never removes a single garment here, although several of her "girls" do. While enjoyable for the Wilkinson aficionado, it's nonetheless disappointing.

None of this stopped promoters from running playbills emphasizing the film's primary selling points: "*Playboy* Says: Staggering— Magnificent! Sensational Measurements! (43-22-36). . . Millions

Have Read About It—Now You Can See It!" June says today she felt so little connection to the film that she did not even realize the role Coppola played until years later. The fact that her name is misspelled in the credits as "Wilkerson" certainly did not endear her to it.

Too Late Blues (1962) — Bobby Darin and former *Playboy* Playmate Stella Stevens are the stars of this film about a jazz musician who loses his girl after not sticking up for himself in a barroom brawl. (Stella later becomes a hooker.) June makes a brief appearance as a girl at the bar.

La Rabia Por Dentro (The Rage Within) (1963) — In her all-time favorite role, June stars in this U.S.-Mexican film about a stripper and her gigolo boyfriend who plot to steal $80,000. Toward that end, she gets a bank clerk to fall in love with her, and the theft is pulled off; the plan is to make it appear as if the money is lost in a plane explosion, but when June and friend see that it is filled with women and children, they have a last-minute change of heart.

Who's Got the Action (1963) — June has a tiny part as a bride in this sluggish comedy starring Dean Martin and Lana Turner.

Meanwhile, her magazine pictorial appearances continued at a hot and heavy pace:

1961 *Playboy Calendar* (an absolutely spectacular shot of June, (accompanying the month of August, sitting nude on a porch railing with a look of supreme confidence on her face. "Who dares affirm, having seen her all / That good things come in bundles small?")

1961 *Modern Man Yearbook of Queens* (3 pages, 9 pictures)

Feb. 1961 *Men's Digest* (inside cover, 3 pages of beach nudes)

1961 *Touch* Vol. 2-3 ("Bra-Buster" is the thoroughly appropriate title of one of the greatest Wilkinson pictorials of them all, a 5-page, 7-picture layout.)

March 1961 *Inside Story* (cover in sexy bathtub shot)

Spring 1961 *Vagabond* (another memorable Russ Meyer pictorial on June, this one quite different from the rest. In this unique 5-page, 7-picture layout, the fetchingly topless June portrays the faithful girl Friday to photographer Ken Parker.)

1961 *Rapture* Vol. 2-1 (4 pages)

1961 *Cocktail* Vol. 2-1 (5 pages)

1961 *A Pictorial Biography of June Wilkinson* (8½ x 11 magazine totally devoted to June, with text by Samuel Steele. This is a true prize for any Wilkinson aficionado; while the pictorial quality occasionally leaves something to be desired, it is nonetheless a full-length portfolio of largely original, and frequently sizzling, photos. Several shots taken dockside and aboard a boat at Los Cerritos Landing are particularly spectacular and provocative.)

In 1965, June sued the publisher of *Pictorial Biography* for invading her rights of privacy, and ended up winning $75,000—including $50,000 for using her name, and the remainder for breach of contract.

1961 *Rapture* Vol. 2-2 (cover)

1961 *Vixen* #3 (3 pages)

Oct. 1961 *Gentlemen* (cover)

Oct. 1961 *Tab* (June reappears as "Beth Bradley")

Nov. 1961 *Caper* (4 pages)

Winter 1961 *Fling Festival* #8 (very pleasant 6-page, 11-picture layout with a nude June playing to an imaginary audience on stage.)

Jan. 1962 *Caper* (cover photo by Russ Meyer of June in a very low-cut swimsuit sitting on a beach chair as the tide rushes in.)

Jan. 1962 *Picture Scope* (cover, 4 pages)

c. 1962 *Ideal Girls* Vol. 2-1 (aka *Harem* Vol. 2-1) (5 pages)

Jubilee Vol. 1-1 1962 (6-page, 12-picture layout, probably shot a couple of years earlier, is among the hottest in the entire Wilkinson portfolio.

Mid-1962 *Sir Knight* Vol. 3-5 (2 pages, 7 pictures as June poses sexily for portrait artist Violet Parkhurst)

June 1962 *Topper* (5 pages, 12 clothed pictures, "Twisting With June")

Dec. 1962 *Playboy* (in "*Playboy*'s Other Girlfriends," the best photo from June's August 1959 pictorial is featured again.)

Dec. 1962 *Modern Man* (inside cover, 3 pages from *Bellboy and the Playgirls*)

1963 *Good Time Weekly Calendar* (great bikini shot on cover, from same shooting as the May 1959 *Modern Man*)

1963 *Caper's Choicest* (cover and an apparently new 4-page layout by Russ Meyer)

1963 *Coquette* No. 1 (5 pages of superb shots from her 1959 very-blonde period)

1963 *Annual Man's Favorite Pastime* (2½ pages)

Feb. 1963 *Stare* (4-page layout)

1964-1969: On the Road

After making three more films in 1963-64, June wearied of the unchallenging roles she was receiving and decided to leave the big screen behind (for a while) in favor of her increasingly busy (and lucrative) stage career.

In addition to *Pajama Tops*, one of her shows during this period was, appropriately, the Jayne Mansfield vehicle *Will Success Spoil Rock Hunter?* In another, *Fanny*, she got a chance to show off the dancing prowess developed during those pre-Bosom years of training. *Any Wednesday* teamed June with two top comic pros, Tom Poston and Elaine Stritch. When she took it on national tour in the fall of 1965 (taking over the role created by Sandy Dennis), she once again shattered house records everywhere she went, with a play that had been on Broadway several years and had already enjoyed a successful road tour. This was followed in 1966 by three one-act plays, *Three In a Bedroom*, in which she went from teen-ager to middle age.

In the Neil Simon comedy, *Come Blow Your Horn*, co-starring Sylvia Sidney, June's first appearance elicited this description from one reviewer: "Something happens on the stage, like an earthquake or a blast tremor, when a door opens and there she stands in two items of flowered chiffon separated by 12 inches of bare midriff." June also did an extended national tour with this show.

The Candidate was hardly one of the shining jewels in June's movie career, but it did team her for a second time with fellow legendary sex symbol Mamie Van Doren, with whom she is still friendly today. Perhaps even more entertaining than the film itself was a recording session in which June and Mamie sang "The Girl In the Bikini With No Top on Top." What made it particularly memorable was that, at the suggestion of the producer, and in keeping with the theme of the song, both girls whipped off their bikini tops and did part of the recording bare-breasted. Unfortunately for fans of both ladies, the only photos taken of the magical moment show them concealed behind their sheet music stands.

In these years, as she continued to establish herself as a legitimate actress, June was gradually scaling back her

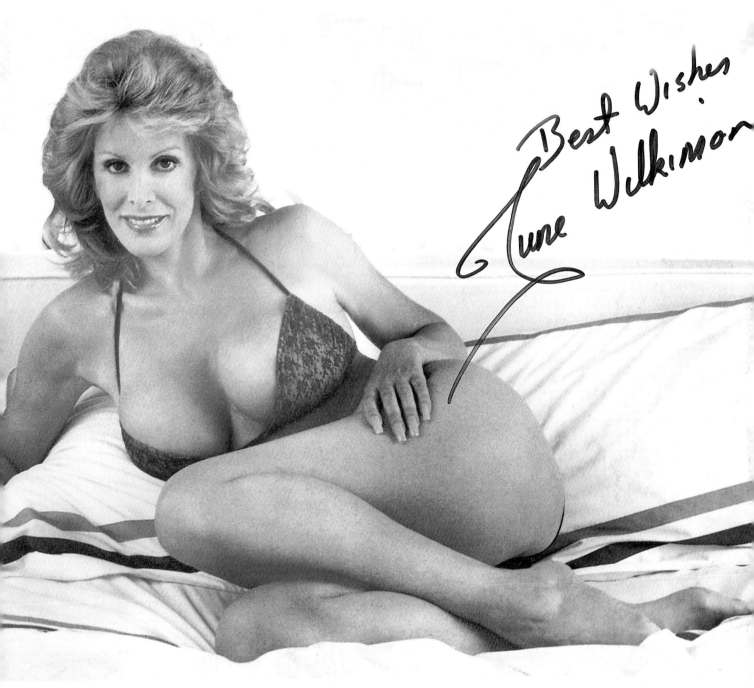

Best Wishes
June Wilkinson

nude magazine appearances. After more than a half-dozen appearances in *Playboy*, she made the decision to stop, she says, despite an open invitation to return again. "My main goal was to be taken seriously as an actress, but people thought I was this little bimbette with a big bust." Looking back, however, she says her decision to stop the magazine appearances was "ridiculous. If there was any damage, it had already been done. (Appearing in *Playboy*) did give me a big audience. I have to thank *Playboy* magazine."

In October 1966, June created her customary stir while making a publicity appearance at Montreal's "Expo '67" world's fair, on which construction was then being completed. Posing in the briefest of bikinis for photographers near

the American geodesic dome pavilion, June "had construction workers on the Expo site snorting and pawing the ground like bulls after a prize heifer," reported one newspaper. She "almost started a riot" when she peeled down to her bikini. "Some could not understand how her tiny bikini top coped with the stress and strain her overflowing bust put on it, and they were all hoping for a structural failure. Unfortunately, the fabric was equal to the mammoth task."

June's films during these years were:

The Candidate (1964; also known as *Playmates for the Candidate*)—Here's how *The Motion Picture Guide* describes this one: "Really sleazy tale of political corruption stars Ted Knight (of

later *The Mary Tyler Moore Show* fame) as a crooked U.S. Senator involved with buxom beauties Mamie Van Doren and June Wilkinson. When it is discovered that the senator has gotten another girl pregnant at a wild Washington party, Van Doren takes the girl to an abortionist. Inexplicably the scumbag abortionist rapes her. Meanwhile, Knight decides to marry Wilkinson, but dies of a heart attack when he sees his betrothed in a stag film. Bottom of the barrel." This was June's second film pairing with Mamie, and featured one topless scene of June in bed with Knight.

June continued to show her all for men's magazine readers, although with declining frequency:

Date unknown, c. 1964 *The Nudest June Wilkinson* (another all-June photo album, with a mixture of bikini, topless and nude shots. Here's the text of an ad for the book:

"June shoots the works in the book they said could never be printed! Finally the girl with the big. . . big. . . big measurements bares all her naked splendor in this fabulous collectors' edition! Took four years to compile and could not be released till now!")

June 1964 *Battle Cry* (fine 4-page, 11-picture layout amply displaying June's charms.)

Summer 1965 *Adam* Vol. 9-7 (cover, 4 pages)

Oct. 1965 *Modern Man* (1 page, 2 pictures and a good interview)

Dec. 1965 *Cad* (June is pictured as one of "The Girls of Hollywood:" an absolutely splendid boudoir portrait.)

Feb. 1966 *Adam* Vol. 10-2 (classic cleavage cover, back cover doing the twist in a tight dress, and 5 pages, including a full-pager in bed with Ted Knight from *The Candidate*.)

March 1966 *Cad* (no nudity here, but June's on the cover and in a sexy and stylish 5-page, 11-picture layout.)

June 1966 *Adam Film Quarterly* ("The Making of a Sex Symbol" is a 7-page, 15-picture feature accompanied by an interview providing an excellent representation of June.)

July 1966 *Beau* (a very welcome (if belated) reprint of one of the most famous June pictorials of all from the Dec. 1960 *Modern Man*, "The Bosom Buys a Bra," on the cover and 4 pages.)

Summer 1966 *Modern Man Yearbook of Queens* (3 pages, 6 pictures)

Sept. 1967 *Beau* (inside cover and 6 pages, a reprise of her session with artist Violet Parkhurst)

Sept. 1967 *Knight* (at age 27, June showed here that she was, if anything, more beautiful than ever. On the cover, she is standing on a Hollywood street corner leaning against a lamppost in a quintessentially 1960s plastic semi-transparent miniskirt with a sort of halter top and long blonde hair cascading down her shoulders. Inside is an article by June—illustrated by a few sexy but clothed photos—paying tribute to her adopted hometown of Hollywood.)

Nov. 1967 *Fling* (in this 4-page, 7-picture layout, all previously published, June regretfully said goodbye to her modeling career.)

Winter 1968 *Fling Festival* (issued within a few weeks of the Nov. 1967 issue above, this edition features a visit with June titled "The Bosom Backstage.")

Apr. 1969 *Knight* Vol. 6-12 (splendid, classy semi-nude cover plus back cover and 4 pages, "The Many Moods of June Wilkinson.")

1970-1979:
Wife, Mother and Star of Bedroom Comedies

It is a tantalizing footnote to glamour-girl history that in 1970, Russ Meyer planned to renew his professional associa-

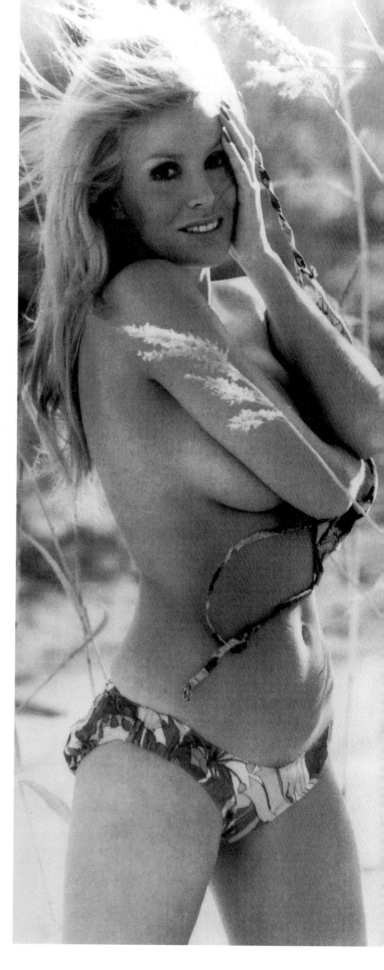

tion with June by giving her a featured role in his first-ever major-studio film production, *Beyond the Valley of the Dolls*. Twentieth Century Fox, however, insisted that Meyer use a sexy young starlet the studio was trying to build up, a brunette named Edy Williams. He took June to lunch to break the news. "It would've been interesting," muses June today.

June gained a new type of fame around 1970 by dating Dr. Henry Kissinger. She was introduced to Kissinger at a Hollywood party given by comedian Buddy Hackett, and they went out twice. Right around the time Kissinger traveled to China, the *Washington Post* carried a story about the dates, placing emphasis on June's notorious past. Kissinger aide Alexander Haig called June to apologize for the article.

Of course, Kissinger was hardly the only celebrity whom June dated. In the late '50s, she had a puppy-love teen-age crush on Paul Anka. During the same time, she also "dated" Elvis Presley (if you could call it that) twice in Hollywood: although on one occasion Elvis sat on his bed and sang to her for a couple of hours, she remembers that both times he spent the majority of the evening hanging out with his buddies and ignoring her. On one of their dates, June startled and intrigued Presley by revealing that she was a virgin. And in 1960, there was a certain nationally known politician who invited June for a late-night rendezvous, which she canceled when intermediaries made it clear that she was expected to stay for the night.

In 1974, June married pro-football quarterback and well-known playboy Dan Pastorini. She met Pastorini at a Houston press party following a performance of *Pajama Tops*, and they were married six months later. Reportedly, the combination of Dan's flamboyance and June's racy past made a number of Houston Oiler fans uneasy, although it undoubtedly titillated a number of others. The two had a daughter, Brahna, in early 1976. The following year, a *Sport* magazine feature on Pastorini pictured a robust and lovelier-than-ever June.

Not long after Brahna's birth, however, Pastorini separated from June, and the two were divorced in 1979. In an interview in *Partner* magazine, not long after they filed for divorce, Pastorini said that at the beginning of their relationship he got a kick out of the open-mouthed stupefication men often displayed upon seeing June. Eventually, he said, he got tired of the "perpetual drooling."

According to Pastorini, "June's main problem with films was always her boobs. No one could get past them to see she was a good actress, so she just quit making movies. She looks even better now than when she posed for *Playboy*. And believe me, she's still got 'em. And they're all hers, too. No operation." Shortly after they were married, Pastorini made June promise not to do any new nude pictorials; ironically, June observes, he himself posed nude for *Playgirl* not long after their separation.

June made only one movie during the 1970s, but remained as busy as ever on the dinner theater circuit. *Pajama Tops* remained her favorite vehicle, and it continued to pack them in throughout the country. In 1978, she half-jokingly referred to it as "my unemployment job. If I ever need

work, I just tell my agent that I'm ready to do *Pajama Tops* again, and I go with a touring company." The end of her long-time relationship with this exceedingly durable production came in the early 1980s, however. The producers obtained the TV rights to the show, and June was set to star in it. Astonishingly, the show's writers—for whom, June notes, she had earned vast amounts of money over 20 years—suddenly decided along with the producer that she was too old for the role and cast Pia Zadora instead. "I've made a point of not doing *Pajama Tops* since," she said in 1990—not knowing that she would later return to the show one more time.

Ninety-Day Mistress provided another solid vehicle for June's talents, a comedy romp about a liberated lady who is unwilling to form a permanent relationship with a man and so has a succession of lovers who must leave after three months. "She elicits a gasp every time she slips into a new and more daring costume," notes one review. "You wonder if the stretch tank-top can cover all that. It does—barely." *Bedful of Foreigners*, in which she played a French sexpot, was another of June's 1970s plays.

By the late '70s, June was a well-established favorite in Las Vegas, where her shows regularly sold out, particularly at the lavish Union Plaza. While there, she made frequent guest appearances on the nationally televised show *Las Vegas Sports Line*; her football predictions frequently proved more accurate than sportswriters and broadcasters.

Her one 1970s film:

Weed (1975) — A film about marijuana smuggling featuring June and then-husband Dan Pastorini; in general release only briefly, but it achieved a second life on video under the title *The Florida Connection*. A rather grim, violent film, its highlights are a couple of poolside scenes with June and Dan; June, in bikini and with shoulder-length blonde hair, looks even more ravishingly beautiful than at any time in her career.

During the 1970s, June did only one known new magazine pictorial. That session from 1971, however, shot by Swedish writer/photographer Mary Ann Greenwood, included a few of the most stunningly gorgeous, sexy and stylish pictures ever taken of her.

June's magazine appearances from 1970 onward:

April 1970 *Knight* (June's final men's magazine pictorial was one of her most extraordinary of all. The 10 pages with 11 pictures shot by Swedish photographer/writer Mary Ann Greenwood, include three magnificently stylish, sexy full-page color semi-nude shots that are among June's personal all-time favorites. Equally important, the pictures are accompanied by a wonderful full-length article on June by noted author and good friend Whitney Stine.)

Jan. 1974 *Playboy* (2 pictures)

1980 *Fling Favorites* No. 1 (3 pages, 8 pictures)

1980 *Celebrity Skin* #3 (3 photos)

1981 *Celebrity Skin* #4 (2 pages, 5 photos)

1992 *Celebrity Sleuth* Vol. 5-2 (4 pages, although 3 photos are actually not of June)

1994 *The Playboy Book: 40 Years* (5 great photos, 3 of them color, in the classic hardcover pictorial history of the magazine.)

Summer 1994 *Femme Fatales* (excellent 7-page interview and photo feature.)

Spring 1995 *Psychotronic Video* (interview)

1980-1995: Time of Growth

The 1980s were a decade of constant activity and professional growth for June. In addition to her still-thriving stage career, June returned to movies with four new films, including the best movie in which she had appeared since *La Rabia* more than 20 years earlier, the comic farce *Frankenstein's Great Aunt Tilly*. A comparison of June's acting in this decade with the performances of her youth left no doubt about the enormous strides she had made. The beauty and sex appeal remain as vivid as ever, but the solid professionalism she brings to every performance has silenced most critics who claimed she had little to offer but a 43-inch bosom.

"Let's face it, you can't survive on just a body," says June. "A body's good for 15 minutes on stage—no matter how good the costume is, 15 minutes is the longest they'll tolerate me if I don't come up with something that's interesting."

Once she put *Pajama Tops* behind her, June's favorite stage vehicle became *Wally's Cafe* with Avery Schreiber. An enjoyable comedy about a hopeless dreamer who drags his wife into the boonies of Nevada to open a diner, it gives June ample opportunity to strut her comedic stuff as a no-talent aspiring movie star who stumbles into the cafe and ends up staying.

June also continued to tour in *Ninety-Day Mistress*. Its most memorable scene: June appears on stage in bra and panties as she attempts to seduce the shy male lead. They kiss, with June pressing her body to his, and he runs his hand down her back. After some thrashing around she winds up sitting astride him, back to the audience. She reaches behind and unhooks her bra, and as her arms move forward with it, the lights go out. A reviewer commented that "there are those lusters-in-the-heart among us who keep hoping the light man will fall asleep some night."

In *The Owl and the Pussycat*, June played a hooker who tames a writer. And in the musical comedy *Olympus On My Mind*, there is an unforgettable moment in which June (in low-cut attire) is hung upside down by a couple of cast members, a delicate maneuver which generated a particular breathless drama each night about what might fall out.

Aerobics provided another area of wide-ranging endeavors for June during the early 1980s. A longtime devotee of aerobic workouts—one of the reasons why today, at 55, June retains a body that would put to shame the majority of Hollywood's most beautiful young starlets—she accepted an invitation to lend her name to one of Canada's first aerobics exercise studios, and before long had sold franchises to seven other clubs across Canada. (A few years later, she sold her interests in the franchises.) By this time one of the best-known actresses in Canada through her frequent stage performances there, June also starred in an hour-long aerobics television special.

June and Hugh Hefner have remained friends over the years, and in 1980 this led to a hilarious picture in *Playboy*, with June beaming while bursting out of her T-shirt which reads, "Itty Bitty Titty Club." June says she bought the shirt in a Dallas shop and wore it to the Playboy Mansion; Hefner insisted the picture be taken "because he couldn't stop laughing."

June's wicked sense of humor, often effected at the expense of her image, is well known to her friends. At various times when June was on the road, for instance, and wanted to retain some anonymity, she would register in hotels under the name "Cinderella Titserella." True to her popular persona, June has a gigantic mirror above her bed, a la Mae West, and alongside it is a most impressive carved bust of her famous torso. And there is no escaping the sex symbol mementos throughout her home: one of the Violet Parkhurst nude paintings adorns a hallway, and a wonderful nude of June from *Pajama Tops* graces a bathroom.

June's films from 1980 onward:

Frankenstein's Great Aunt Tilly (1983) — June plays Frankenstein's mistress in this quite enjoyable romp (set in Transylvania 100 years after Baron Von Frankenstein) shot on location in Mexico City. Donald Pleasance and Yvonne Furneaux co-star.

Talking Walls (c. 1984) — June appears in one of a series of creepy tales about the occupants of a hotel, including a brief topless scene; Sybil Danning and Sally Kirkland are featured in other segments.

Sno-Line (1985) — June co-stars with Vince Edwards in a rather routine drama. For Wilkinson fans, the highlight is a scene in which June responds to Edwards' accusation that she is an FBI agent: "Would I waste this body in a $300-a-week job?"

Vasectomy (1985) — Minor role for June in an undistinguished comedy.

Keaton's Cops (1990) — Lee Majors and Don Rickles are the stars of this comedy in which June has a cameo part.

Today, June Wilkinson lives in Sherman Oaks outside Hollywood and is a doting mother to her lovely daughter Brahna, a competitive tennis player on a full college athletic scholarship. Brahna has appeared in one movie herself. June is a constant whirlwind of activity, even between her frequent stage appearances; still one of the most breathtakingly beautiful women in California, she is always guaranteed to turn heads at film or theatrical premieres.

One such event occurred in the summer of 1990. After this author had separately interviewed June and Russ Meyer, the two arranged to get together for the first time in more than 20 years, and the association that had once made pin-up history was rekindled again. When June and Russ appeared together at a Los Angeles theatrical premiere and were introduced at the reception, one other celebrity in attendance was less than pleased: Meyer's ex-wife Edy Williams. The next day, a nationally syndicated Hollywood columnist reported that Edy flounced out of the theater in a huff, peeved not only at Meyer's escort, but also at being overshadowed by the ever-dazzling and luminous June.

An adventurous soul at heart, June embarked on one of the great adventures of her life in 1993. "My girlfriend Sherry Hackett (wife of comedian Buddy) wanted to see India. Buddy had already been to Calcutta and didn't want to go back. So she called me, and the next thing I know we were on our way from India to Indonesia to Nepal to China to Singapore—we basically went around the world in three months." This was no dilettante's tour; they drove from New

Delhi across India to Bombay and witnessed that country's stark contrasts of wealth and extreme poverty. One of the highlights of the epic journey was their visit to the Tiger Top's Animal Preserve in the Himalayan Mountains. "We had to take a prop plane that let us off in a field, and there was a canoe waiting to take us into the preserve. And I got to ride an elephant there!"

June took a journey of a different sort in 1994, when she returned to her favorite stage vehicle *Pajama Tops* for the first time in a decade-and-a-half. This time, she switched roles from mistress to wife, but anyone concerned that this change would eliminate the sex appeal from her performance need not have worried. Clad in a succession of slinky low-cut gowns that established her still-astounding physical dimensions, June's stage command was very much in evidence as her saucy one-liners generated just as much pleasure as her beauty. The show played to sold-out dinner theaters across Canada in Calgary, Edmonton and Mississauga, just outside Toronto, from April through October.

Maintaining a sex-symbol aura after age 50 while continuing to build respect for one's consummate professionalism and class is not an easy feat; Marlene Dietrich pulled it off, but few have duplicated her accomplishment since then. June Wilkinson is one of those few and special women, and for that alone she should be cherished. In a magazine interview circa 1963, June credited her success to the ability "to make a man glad he's a man." June has never lost this ability, and has been satisfying that hunger for nearly 35 years now. She is a genuine phenomenon, a force of nature if you will, and one can only hope that the force will be with us, continuing to generously share her unique charms, for more years to come.

(Very special thanks to June Wilkinson for her generosity and time; to her good friend Mike Sather for his absolutely invaluable assistance; to collector Jim Carlin for his contributions; and to one of June's most devoted Canadian fans, Ron Kingman, for information from his collection.)

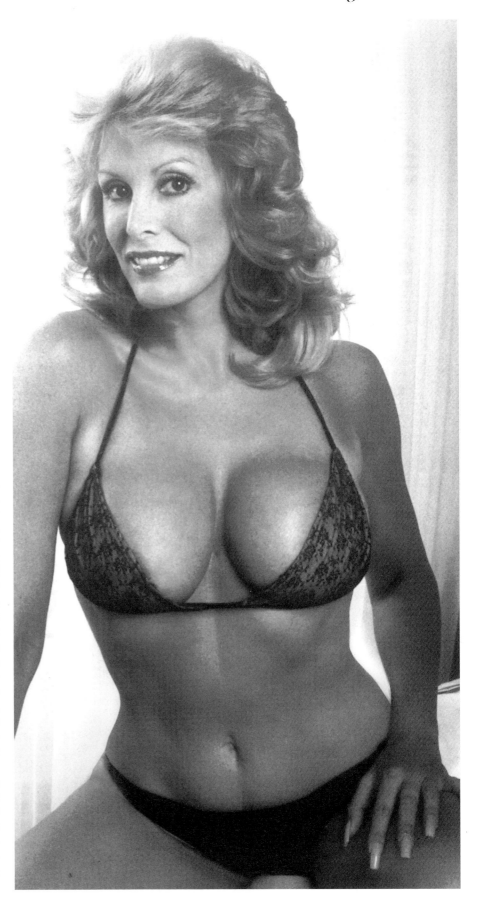

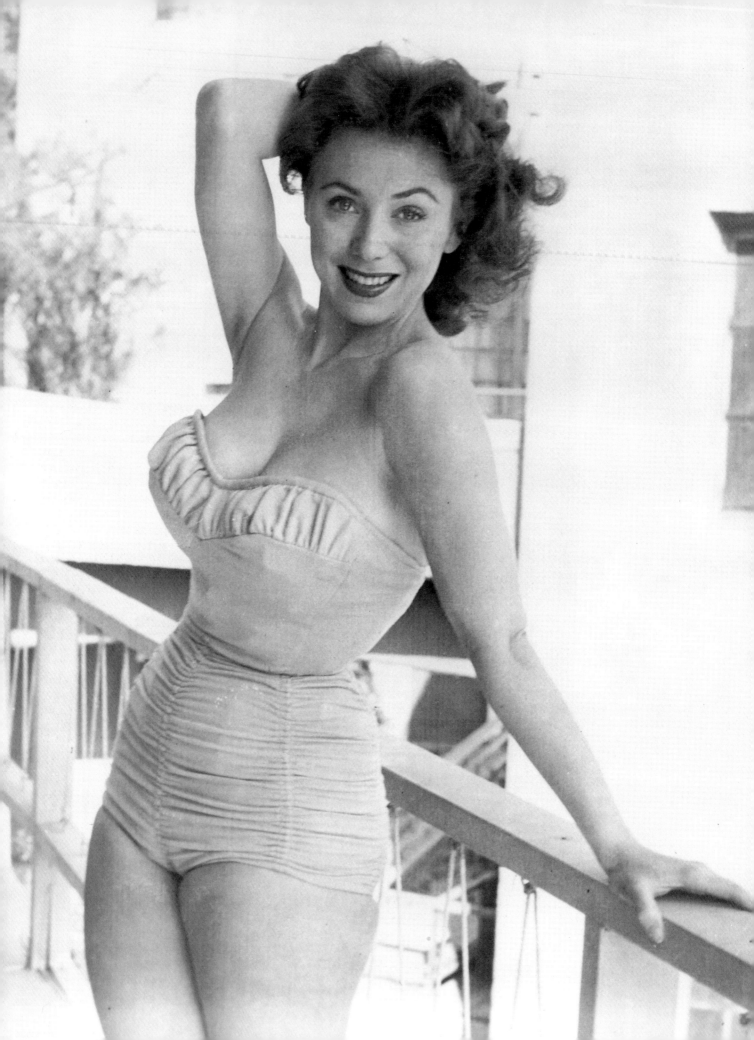

In learning the true life stories of the glamour girls who provided us with so much pleasure in the 1950s and beyond, one recurring theme is that the reality of these women is often far more remarkable and complex than the public images they conveyed. There can be no more vivid example of this than Meg Myles.

During the 1950s, her appearances in hundreds of men's magazines made Meg a nationally known pop-cultural icon. Meg's many fans of that era had only a passing acquaintance with her abilities as an actress and singer, as a relentless promotional campaign (to her chagrin) barely touched upon the rich qualities of this multi-dimensional, voluptuously proportioned woman. Only in succeeding years did the real Meg Myles emerge: an accomplished actress who has placed her personal imprint on some of the greatest and most challenging roles in modern American theate.

Meg grew up in Seattle the daughter of Welsh/Scottish parents. She was born Billie Jean Jones, a name she grew to despise and was quick to change at the earliest opportunity. "My father gave me this name when I was leaving home," she explains today. "He said it was his great grandmother's name—Meggin Myles of Brynmawr, near Eden Vale. He said people were known by their names and their village—thus she was called Meggin Myles of Brynmawr. The village name means 'Top of the Hill,' I am told. The Welsh have a gift for the telling of tall tales." In twisted editorial references, many magazines alleged that the name Meggin means "mountains" or "top of the mountain" in Welsh.

Meg tells how she caught the show business bug at an early age. As a five-year-old, she took weekly dance lessons, specializing in "acrobatic tap." After each lesson her father would take her to the motion picture house next door to the Gallencamp Shoe Store where he worked. She was entranced by what she viewed on the screen, particularly by the magical likes of *The Wizard of Oz*. The seed had been planted.

When she was 10, her family moved to the agricultural community of Tracy, California, about midway between Stockton and San Francisco. Meg attended the College of the Pacific (later renamed University of the Pacific) in Stockton, majoring in drama and physical education. (During school vacations) she sang in local clubs.

As noted, Meg's given name had been a source of exasperation for years; she could tolerate being called "B.J.," the name by which friends knew her, but "Bill" (as she was called by her father) or "Bille" were something else. The breaking point came in high school, when her blossoming beauty earned unwelcome attention. Every day for four years, Meg recalls today, a group of boys would chant at the top of their lungs: "BILLIE JEAN, THE SEX MACHINE!" "It was so humiliating, and in a small town like Tracy things like that—without any action to support them—lead to

rumors that affect your reputation."

It was in a 1952 (Meg's sophomore year) school theater production called *A for Alonzo* that she was discovered by Hollywood talent agent Henry Wilson. Impressed by her talent and beauty, Wilson urged her to consider a show business career. "He invited Jerry Debona (the show's composer/author) and me to audition the material for some of the studios," Meg recalls. "I went, returned and finished my second year at C.O.P." In 1953, after her sophomore year, she set her sights on Hollywood.

Hollywood, 1953-59: Fame and Frustration

Although a screen test at a major studio didn't pan out, Meg landed small parts on television (including a Bob Hope program) and in films, immediately attracting attention. She was hardly pleased, however, that the roles were based more on her anatomy than her ability.

Meg Myles

Born Billie Jean Jones
November 13, 1932 or 1933
Seattle, Washington

"Right from the start of her career, her burgeoning bosom attracted every male eye in her direction," noted *Cabaret* magazine. "In auditions she faded all competition to the limbo. Producers could hardly see any other girl when Meggin Myles stood in a line of aspirants for singing jobs or acting roles." However, as another magazine noted, these early roles tended to be of the "wear a bathing suit and stand in the background" variety. Reading these quotes today, Meg says they are "composed of several active imaginations."

"Over the years, a lot of these fantasy articles have caused me and my family a lot of pain and have harmed the progress of my career," declares Meg. "I have had to try to live down something that I never was to begin with."

The redheaded beauty's 5-foot-5 frame and widely reported 42-24-36 dimensions—statistics that Meg now calls "ridiculous" and exaggerated—often left producers so dazzled that they were unable to see the untapped ability that lay beneath the surface. In 1954, NBC selected her as one of the network's 10 "TVenuses" whose beauty graced various programs.

After every television appearance, male admirers—GIs in particular—deluged studios with demands to see more of Meg. Even as early as the fall of 1954, Meg professed to be worried by this trend. The popular demand, she said at the time, "is great for my ego, but not so hot for my career." She was studying acting, singing and speech in a determined effort to be accepted as a fully trained talent and not just a bosom.

Her impact was felt even more swiftly in magazines. Meg's first known full-scale pictorial in a national publication was in the October 1954 *Man's Magazine*, and for months afterward the publication's letters page was filled with words of astonished praise from readers who had never

laid eyes on such a form. The same reaction would quickly spread to other men's magazines, most notably *Night and Day*. Earl Leaf, the "beatnik" photographer whose work appeared in many of the top magazines of the decade, was often cited as Meg's "discoverer" for pin-up shots after having seen her on *The Bob Hope Show*.

Meg began appearing as part of a nightclub act with Duke Mitchell. She began to find her voice as a singer. Singing in clubs throughout Southern California and in Las Vegas, she honed her skills and attracted a new respect from previously unseeing Hollywood producers. Instead of using her as merely a lovely part of the scenery, Hollywood suddenly realized that vocalist Meg could take command of a big screen.

After a small role in the movie version of *Dragnet*, Meg's first major film role, *The Phoenix City Story*, launched her Hollywood career in a big way in 1955. Appearing on screen for only about five minutes to belt out one song, Meg created such a sensation that a huge publicity campaign for the film was built around her. She embarked on a 44-city tour to plug both the movie and her debut pop recording, "Phenix City Blues." By year's end she had reportedly engendered eight fan clubs, including one each in Japan, Germany and Iceland, and two in Latin America. (Meg says today that this—like many other "facts" about her career reported at the time—was a figment of a press agent's imagination.)

In 1954, Meg made her first recordings on the Sunset label. The tremendous boost her career received due to "Phenix City" enabled her to land a coveted seven-year contract at the end of 1955 with Capitol Records, one of the top labels in the industry. Collectors lucky enough to be acquainted with Meg's recordings know her as a strong, self-assured vocalist equally comfortable with bluesy ballads and uptempo numbers. Her most famous song, "Phenix City Blues," is an atmospheric midtempo piece with a big band and R&B-styled male chorus. Meg's warm, intimate vocal style—and her sensuous reading of the line "I shiver from my eyebrows right down to my feet"—is its highlight.

Meg was now "hot," and at this point cheesecake photos emphasizing her abundant natural assets began to appear in scores of men's magazines from 1955-58. They were quite tame by today's standards—all tight sweaters, halter tops and shorts, low-cut gowns and swimsuits, with no nudity—but by 1956, much of the male population of the United States was well acquainted with the remarkable figure of Meg Myles.

According to Meg, her Hollywood manager Red Doff (who also managed Mickey Rooney) "never insisted on exploitative photos. We sought class coverage. But we were in conflict with other business reps at times over these issues. Photographers always want to shoot pictures. You say yes or you say no, it's that simple. You hope the focus is on your eyes—you can't win them all. I had no idea the pictures would end up in those type of magazines. Most were so innocent that they wouldn't have caused any flap if they had appeared in *Life* or *Saturday Evening Post*." She did not receive a dime for the photographs that would appear in

hundreds of publications around the world; the magazines and photographers reaped the financial benefits.

She recalls one occasion during the *Phenix City Story* tour when a photographer was sent to shoot a layout at New York's Warwick Hotel, where she was staying. After some innocent shots, Meg recalls, "he got ugly, and asked me to bare my breasts. I had my manager and the Paramount rep throw him out. I was then declared 'uncooperative' by the Paramount people." After the Warwick incident, Meg insisted on a female chaperone to "run interference," which the studio supplied.

Other than having posed for the pictures, Meg had nothing to do with the single promotional effort that would most imprint her name upon the memories of so many. Virtually every month over a period of more than three years in perhaps dozens of different magazines, giant advertisements for sexy photo sets of Meg appeared with text such as: "The girl with the big. . . BIG. . . BIG dimensions! Wow. . . Meg Myles is really special!" Meg says today that she had no knowledge of this entire long-running campaign.

One of Meg's most famous magazine appearances was a memorable layout in the May 1956 issue of *Playboy*. This was one of the few such pictorials of which she was aware at the time, but she carefully notes that she never actually posed for the magazine's photographers; the pictures were simply drawn from the many cheesecake shots taken of Meg during this period. She recalls playing gin rummy with Hugh Hefner a couple of times between her performances at the Cloisters in Chicago.

For a fundamentally shy girl who aspired to succeed on her professional merits, the lurid press Meg was receiving at every turn had to make her squirm. Consider this 1957 account: "She publicly challenged Jane Russell—then acknowledged as bustiest belle in the movie colony—to an inch-by-inch showdown. Jane backed off, wisely, claiming that Meg's hangover made her 'feel like a boy.'" It was utter nonsense, of course—"totally untrue," emphasizes an exasperated Meg. (A less sensational but equally fanciful version of the story is that Jane went to see Meg sing with a jazz combo in early 1955, and remarked to her husband Bob Waterfield, "Golly, she makes me feel like a boy!")

Perhaps the epitome of the celebrity Meg's figure achieved—and one of the definitive symbols of the American bosom fixation of the 1950s—occurred when the magazine *Night and Day* sponsored a unique beauty contest in 1957. A number of alluring celebrities and models were pictured from the neck down, and readers were invited to vote for their favorite—by number, as none was identified by name. The goal was to determine the best chest in the land. Solely on the strength of her bust, Meg was the overwhelming winner, chest-besting Jayne Mansfield, Sophia Loren and Anita Ekberg. For months afterward, advertisements promoting her victory proclaimed Meg the "Undisputed Queen of the First Measurement" and "Miss Chest 1957."

Night and Day, exceeded in popularity only by *Playboy* and *Modern Man* among men's magazines at the time, was utterly enraptured by Meg, featuring her more often than

any other woman during the last half of the 1950s. The demand of the magazine's readers for their favorite redhead was insatiable. One letter warned ominously: "Publish more Meg—or GO OUT OF BUSINESS!" The publication was only too happy to oblige. Indeed, at times its editors struggled for words to describe the sheer physical wonder that was Meg: "the incomparable, the queen, the Swiss Alps in every man's dream!"

Meg's size proved both a blessing and a bane. Soon after she started in Hollywood, producers began pressuring her to scale down the very dimensions that first attracted them to her. Purportedly a full 42 inches when she first hit Tinsel Town, Meg was said to have dieted and undergone special exercises to reduce her bustline to 40 inches. When her fans loudly protested through a flood of letters, Meg pledged to go no farther, telling the studio: "The boys like me this way." (Today she asserts that she never said any such thing.)

Just as she castigates magazine write ups about her as "phony and designed to titillate," she applies the same description to the innumerable characterizations of her bust size. Despite all photographic evidence to the contrary, Meg insists she was never as large as 42 inches, or for that matter even 40 inches. "That would make me bigger than Dolly Parton!" she protests.

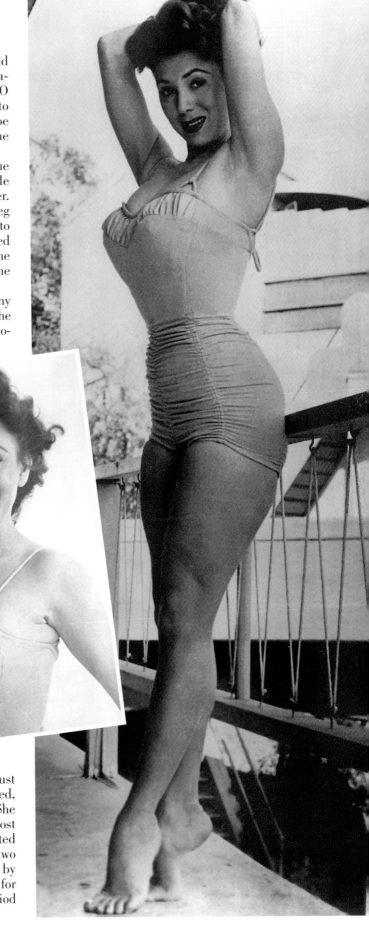

Meg was now traveling in high circles. Later in 1957, she generated further publicity through her friendship with Sammy Davis, Jr. As Meg tells it, the story was blown out of proportion as a result of an open house held at Davis' home not long after he lost his eye, and Frank Sinatra, Judy Garland, Tony Curtis and Janet Leigh were also in attendance. Meg happened to be sitting on the couch next to Sammy amidst the large group of people and was photographed. The pictures were cropped, however, to make it appear as if the two of them were alone. The scandal magazine *Confidential* was one of the first to run the picture along with heated innuendo.

To understand the furor this friendship generated, one must remember the ugly spirit of barely concealed racial prejudice that permeated the country just beneath the surface during that time. After the article appeared, Meg learned that members of her family were being harassed. She says the mean-spirited rumors surrounding the relationship cost her a coveted appearance on *The Ed Sullivan Show*, and resulted in her contract being dropped by Capitol Records. The last two remaining singles recorded for Capitol were later purchased by Liberty. The tabloid stories also may have been responsible for the fact that she made only one movie during the 1956-60 period when her fame was at a peak.

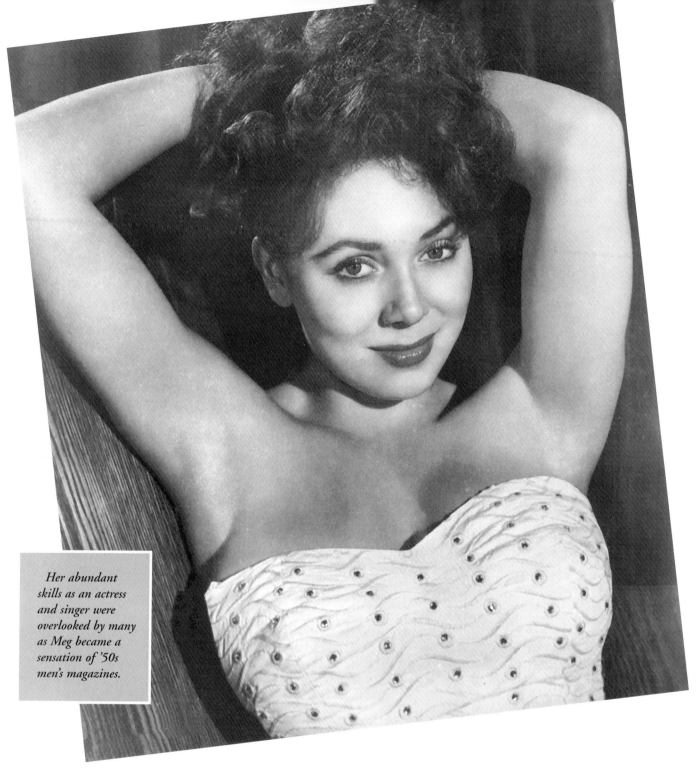

Her abundant skills as an actress and singer were overlooked by many as Meg became a sensation of '50s men's magazines.

"I'm sorry that was so blown up by the press," says Meg. "I could never understand why people couldn't be more tolerant of black-white friendships." Meg remains friendly to this day with Sammy Davis' mother. "I wanted to sue [the magazine], but my manager explained that it wouldn't help. You see, Sammy was the important person in this little drama, and I was expendable."

She recalls her one late-'50s movie, *Calypso Heat Wave*, with fondness. Not only did she receive significant screen time in contrast to her previous releases, but there was plenty of flavorful calypso music and a spirit of fun. "The point of interest is that Joel Grey and I played sweethearts, which

is, after all, amusing," she notes.

Despite the paucity of film work, it was a busy period for Meg. During the mid-to-late-1950s, she was on the road singing in clubs for about 40 weeks per year. "I want to be liked for my singing, not for my build," she was quoted as saying at the time. "I know many people came to see me— but they stayed to hear me." Meg went out of her way to dress conservatively so that audiences would focus entirely on her performance rather than her body.

The Sullivan show cancellation aside, Meg frequently appeared on television; she was evidently a favorite of Steve Allen. In 1957, Allen introduced her on his prime-time variety

series by declaring, "Now here's something for the boys!" She proceeded to sing "My Melancholy Baby," one of her favorites, which she released as a single on Capitol. Allen also featured her more than a dozen times on *The Tonight Show*.

Even after being dropped by Capitol (sadly, she never recorded an album for the label), Meg continued to record elsewhere. The album most treasured by collectors, was *Just Meg and Me*, a 1958 collection of jazz-flavored torch songs and ballads on the Liberty label that teamed her with a band led by the famed jazz pianist Jimmy Rowles. Steve Allen's liner notes set the tone: "Meg's sound is undeniably her own. It's not affected or altered to suit any prevailing customs or styles. It's a simple extension of her speaking voice, which is low, throaty, and, as the saying goes, intimate. Basically Meg is an actress; singing is an extra added attraction, albeit an important one, but it is her flair for the dramatic that is the most noticeable thing about Meg's singing style; it's almost a speaking style, and it indicates a careful concern for the meaning of a lyric."

Just Meg and Me is an after-hours kind of album in the same sense as Sinatra's "In the Wee Small Hours of the Evening." The mood is quiet, intimate and romantic. The opening number, "You Made Me Love You," lends itself to over-the-top sensuality— "give me, give me, give me what I cry for"—but Meg underplays it. "More Than You Know" is a real highlight, beginning with the song's seldom-heard verse; with just Meg, Rowles on piano and a bassist, Meg communicates directly, almost seductively. And talk about seductive— Meg's interpretation of "I Wanna Be Loved" is irresistably inviting, and features an insinuating saxophone solo.

Another album Meg released around 1958-59, titled *Passion In Paris*, on the Tiara label, was actually a budget-priced repackaging of her original 1954-55 recordings for Sunset, and only four selections feature Meg.

By 1959, Meg Myles was fed up with Hollywood, and she moved to New York City. "I finally realized that I had basically wasted six years," she declares. "I should have been in New York all along to pursue serious acting."

Her departure was expensive. Meg learned that she had accumulated six years' worth of debts—agents' commissions, management claims, music fees, etc. All demanded satisfaction prior to her relocating out of town. If it smacked of exploitation, it was the same sort of treatment routinely given recording artists and other performers during the era. "That was just how the system worked then," she says philosophically. Meg eventually paid off the debts, and headed east with an empty bank account, even after earning $40,000 a year (a substantial amount in the '50s) only a couple of years after leaving school.

Meg's early filmography:

Dragnet (1954) — The big-screen version of the classic Jack Webb TV series includes a small role for Meg as a torch singer applying for a job in an agent's office. The role called for Meg to sing dreadfully—her real voice was considerably more tuneful.

The Phenix City Story (1955) — Violent crime drama featuring Richard Kiley based on a prize-winning book about the assassination of the attorney general-elect of Alabama. Meg portrays an (unnamed) saloon singer who performs one song. Her performance of "Phenix City Blues" almost provided her with a hit single.

Battle Cry (1955) — Meg had a small, unbilled role in this World War II drama starring Van Heflin and Tab Hunter.

New York Confidential (1955) — Broderick Crawford stars in this expose of organized crime; small role for Meg.

Calypso Heat Wave (1957) — Meg is third-billed as "Mona DeLuca" in this pleasant trifle built around the calypso fad, including songs by the Hi-Lo's and the Terriers. A young Joel Grey is also featured as her sweetheart.

Meg's most significant magazine appearances:

Oct. 1954 *Man's Magazine* (3 pages, 6 pictures: "The Strange Problem of Meggin Myles;" throughout the next year, letters commenting on Meg and individual pictures of her appeared in the magazine)

Dec. 1954 *Photo* (5 pages of bikini photos)

Sept. 1955 *Show* ("They're Beggin' for Meggin," 6-page layout of a bikinied Meg frolicking in the surf)

Nov. 1955 *Night & Day* (sexy cover)

Dec. 1955 *Night & Day* (cover in low-cut sweater, and 11-photo feature—two with her torso only—titled, "The Password Is 42")

Jan. 1956 *Modern Man* (1 cleavage shot and narrative about Meg's torso)

Jan. 1956 *Saga* (6-page, 10-photo layout proclaiming that Meg is "a shape who could give cards and spades to Marilyn Monroe and still beat her hands down in the oomph department.")

Apr. 1956 *Cabaret* (perhaps Meg's most memorable magazine appearance, featured on the cover and in a 5-page, 11-photo layout and article with the arresting title, "Can a Singer Have Too Much Bosom?")

Apr. 1956 *Carnival* (1 classic cleavage photo)

Apr. 1956 *Picture Digest* (cover)

Apr. 1956 *Pose!* (4-page feature titled "Curves By the Carload")

Apr. 18, 1956 *People Today* (back cover and 6 pages, cleavage-oriented)

May 1956 *Night & Day* (1 page, seemingly topless behind several wine bottles)

May 1956 *Playboy* (3-page, 8-photo feature, "The Lynx With the Lusty Larynx" 2 of the cleavage-accentuating photos are among the most impressive and revealing ever published of Meg)

June 1956 *Male Life* (tight-sweater cheesecake on back cover, and 5 pages)

July 1956 *Night & Day* (inside cover)

July 1956 *Photographers' Showplace #1* (3 pictures)

Aug. 1956 *Glamorous Starlets #3* (8 pages, including the May '56 *N&D* pose)

Sept. 1956 *X-citement in Pictures* (6-page cheesecake layout)

Nov. 1956 *Night & Day* (tight-sweater cover profile)

Nov. 1956 *Suppressed* (cover, with bosomy photo: "Meg Myles' HOT Record!")

Dec. 1956 *Night & Day* (4 pages, 6 pictures)

Dec. 1956 *Photographers Showplace #2* (2 pages by Earl Leaf)

1957 *Modern Man Yearbook of Queens* (2 pages, 4 pictures)

Mar. 1957 *Foto-Rama* (4-page, 6-photo layout posing the question, "Is Meg for Real?")

1957 *Men's Digest #3* (6 pages)

May 1957 *Tiger* (3-page, 5-photo layout shot by Earl Leaf)

May 1957 *Night & Day* (inside cover in bikini, and the first ad

proclaiming her as "Miss Chest 1957")

June 1957 *Inside* (cover and 5 pages, with one of the most fanciful of the era's articles on Meg)

June 1957 *Night & Day* (Meg is announced as "Queen of the First Measurement" contest winner)

Fall 1957 *Cabaret Quarterly* 6 (3 pages shot by Earl Leaf)

Sept. 1957 *Span* #37 (inside cover, 4 pages)

1958 *Night and Day Pin-Up Annual* (cover and ¾ life-size poster)

Feb. 1958 *Night & Day* (glamorous cover)

March 1958 *Night & Day* (centerfold, and 1-page picture pulling up her sweater)

May 1958 *Night & Day* (cover)

Dec. 1958 *Night & Day* (lovely portrait shot on inside cover)

Mar. 1959 *Chicks & Chuckles* (centerfold, 1 page)

Apr. 1959 *Chicks & Chuckles* (2½ pages in bikini)

Apr. 1959 *Glance* (3 pages)

1959 *Sir Knight* Vol. 1-6 ("The Measure of Meg," a 4-page, 9-picture layout and article focusing on how Meg's bosom had brought her both fame and despair; most of the photos had run previously in one or another of the 1956-57 pictorials listed above)

June 1961 *Nugget* (4-page layout titled "The Snipped Dip" features stills taken—without Meg's knowledge—on the set of *Satan in High Heels*, in which she takes a nude swim)

July 1961 *Vue* (5 pages from *Satan in High Heels*)

May 1962 *Swank* (4 pages, 8 pictures)

Spring 1963 *Modern Man Yearbook of Queens* (3 pages, including one of the stills of her nude swim in *Satan*)

Aug. 1963 *Modern Man* (3 pages and 8 pictures from *Satan*)

Fall 1964 *Focus on the Sin-ema* #4 (2 pages from *Satan In High Heels*)

New York, 1959-1995: Meg Proves Her Mettle

Meg arrived in New York in 1959 with little money, no Gotham friends, and a public image that would have to be turned around in order to secure the professional respect she desired most. The cheesecake days were over; the time for serious acting had arrived. By 1960, Meg appeared to have undergone a physical transformation that matched her change of focus: she shed both pounds and the voluptuous look that had so endeared her to fans, emerging with a sleek, lean appearance she has retained to this day.

A newcomer to New York needs a friend, and Meg's chief benefactor was actor Robert Evans. Best known at the time for *The Sun Also Rises* and *The Best of Everything*, Evans would later become one of Hollywood's most powerful executives (overseeing the first two *Godfather* epics) and then a successful independent producer (*Chinatown*). Evans helped Meg get her first apartment, and hoped their relationship would move into the romantic realm; she didn't.

Now living 3,000 miles away, Meg agreed to give Hollywood another chance by starring in the 1961 film *Satan In High Heels*. The film has become a potent cult favorite and perhaps her best-known motion picture. But it is one she prefers to forget. The original title of the film was *Stacey*, the name of her character, and she says that early versions of the script told a fairly straightforward dramatic story. (A later working title for the film was *Pattern of Evil*.) "But as the film progressed, the producer switched the

emphasis and the marketing to exploit the sex angle," Meg recalls regretfully. "I don't even list it on my resume."

One reason for the film's cult following is the popular belief that it includes Meg's only topless scene. But this actually is not the case. The scene in which she is bathing in a river (actually a pond on a private estate) was shot in such a way that relatively little is revealed. However, totally unknown to Meg, somebody—probably an assistant photographer—shot still pictures of her from a different angle. These stills, including a few topless pictures of Meg climbing out of the water, wound up in several men's magazines, much to her disgust. In an interview with syndicated columnist Earl Wilson at the time, Meg expressed regret about the nude scene, saying, "I'm afraid this error will set me back eight years."

"A no-photos edict was posted on the location set," Meg elaborates today. "Only essential film crew members were present. I spent a very long time in the cold water, and alcohol was given to me in a bottle [to help ward off the cold]. Someone snuck those shots of me being pulled out of the water. Where there is a rat—there is a rat. There will always be someone to break the rules."

The press kit for the film contains just the kind of overheated prose that Meg must have dreaded. "The smile. . . the shape. . . the silky softness of an angel. . . But take her in your arms and you'll find a private hell of your own!" it proclaims. The ads quote the *New York World Telegram & Sun*: "Lurid sex. . . tantalizing and provocative." And the ad writers suggest their own blurb for the film: "Motion picture theaters may have to purchase asbestos screens for the showing of the new Cosmic Film release *Satan In High Heels*." The main promotional photo shows Meg from the neck down clad only in a tight black bodice and black net stockings. It was all a million miles away from what this serious young actress had in mind. Incidentally, the soundtrack for *Satan In High Heels* on the C.P. Parker label (named after jazz great Charlie Parker), coveted by some collectors because of the belief that it features vocals by Meg, actually is composed solely of instrumentals featuring jazz guitarist Mundell Lowe. This is a pity because Meg has two big songs in the movie: her notorious dominatrix number (see filmography), and a sultry, smoky ballad called "You Walked Out of My Life," which demonstrated her fine touch for a bluesy torch song.

With her Hollywood years now only a bad memory, Meg plunged ahead to open an entirely new phase of her career. Meg recorded one of her best albums in 1962, *Meg Myles At the Living Room* (produced by Quincy Jones on the Mercury label), at the popular club on New York's East Side. Her nightclub performances during this period showed the skilled and seasoned singer she had now became. They included appearances with a jazz combo that would later became one of the hottest in the country, the Ramsey Lewis Trio (in 1991, she enjoyed a reunion with the group). Unfortunately, the *Living Room* set was her final album release.

After one early engagement at the Living Room, Meg revealed a philosophical side in an interview with *The New York Times*. "I came to the conclusion that if I was a personification of sex, then there was nothing wrong with utilizing

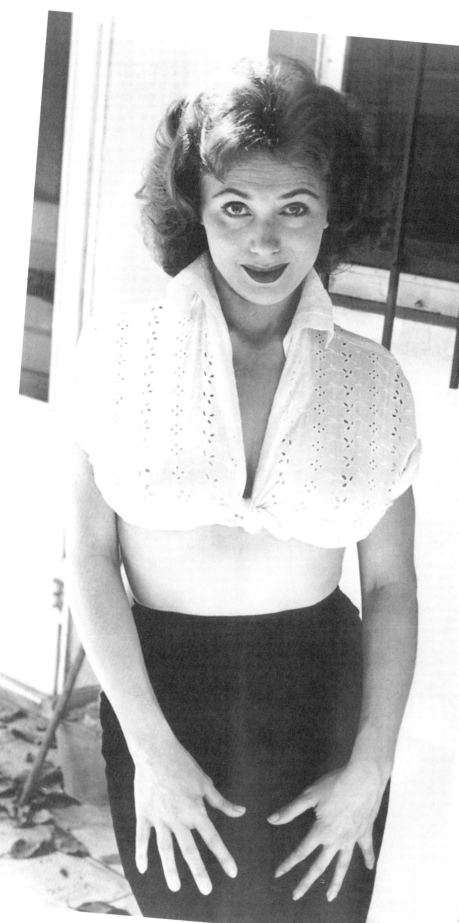

it as long as it did not become the primary thing."

Theater was the next big step. Shortly after her arrival in New York she began to study acting with the legendary Lee Strasberg, and it didn't take long for the lessons to pay off. *Enter Laughing*, a semi-autobiographical comedy written by Carl Reiner of *Your Show of Shows* fame, depicted a starstruck young man's efforts to break into show business. When it hit Broadway in March 1963, directed by Gene Saks (later renowned for directing many Neil Simon plays on the Great White Way), Alan Arkin was launched into overnight stardom. The show ran for exactly a year. Meg later performed the role of Angela in road productions of the show starring John Carradine.

It was an exciting and heady time for Meg. From it she recalls a rising young British comic named Dudley Moore who was also performing on Broadway in *Beyond the Fringe*. The two of them were booked into Max Gordon's Blue Angel nightclub. "This was like a dream come true, to be in a hit on Broadway, and doing a midnight show at the Blue Angel," she recalls. "But this was also the year that the music world changed overnight. Folk music had begun to come into the concert halls and rock was getting louder and louder, and then the Beatles exploded. And nightclubs all across the country started shutting down. That summer, the Blue Angel closed its doors forever, and that was the beginning of the end of my nightclub career."

Meg continued to sing in clubs until 1965. By that time, she says, the cabaret clubs and other showcases for her kind of jazz and ballad singing were closing, leaving a diminishing range of venues. "People didn't want to spend money to go out and see a performance," she laments. It would be 26 years before Meg would sing in concert again.

In 1965, Meg married an ABC-TV producer and director who worked on *The American Sportsman* and other network programs. The couple lived in New York, and maintained a ski cottage in Vermont.

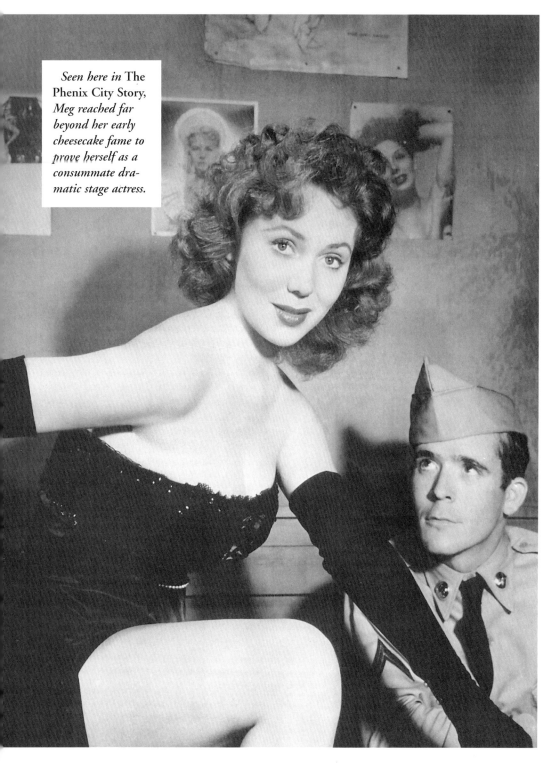

Tennessee Williams' *A Streetcar Named Desire.* After seeing her performance at the Olney Theater in suburban Maryland, a reviewer proclaimed it "a gutsy interpretation" and "moving:" "Miss Myles is an attractive and talented woman, and she employs both of these assets to contrive not only the strongest . . but also the most physically appealing Blanche in my experience."

The following year brought another meaty role, in *A Taste of Honey,* as Helen, described by *The Washington Post* as the "gin-loving, sex-loving, not very maternal, but not-really-rotten" mother whose teen-age daughter is impregnated and abandoned by a black sailor. Meg "gives an exceptional performance," proclaimed a reviewer. "Here is an actress who can be forceful, vivid, vibrantly at the center of things without ever suggesting that she is a hired performer putting on a bravura exhibition. Miss Myles is the real goods."

In 1969, Meg took on the tragic character of Martha in *Who's Afraid of Virginia Woolf,* which had been played by Elizabeth Taylor in the 1966 film. Critics called Meg's performance "full of raw power." In 1980, when she reprised the role in Syracuse, New York, the accolades for Meg flowed like the Niagra: "Myles could purr like a kitten or snarl like a tiger as she played her murderous games to hide the vulnerable little girl she is at heart," declared one critic. "Hers is one of the most demanding roles in contemporary theater, which made her complete mastery all the more rewarding to see."

After 15 years of marriage (no children), they were divorced in 1980.

Meg was moving into her prime as a legitimate theatrical actress. After renewing her acquaintance with Bob Hope by joining his 1966-67 Christmas-season tour of North Africa and the Caribbean, in 1967 she tackled one of the most formidable female roles in all of American theater, Blanche Dubois in

Meg continued to demonstrate her mastery of difficult, significant dramatic roles. In 1972 she starred in an Olney Theater production of Paul Zindel's Pulitzer Prize-winning *The Effect of Gamma Rays on Man-In-the-Moon Marigolds.*

"That fine actress, Meg Myles, is heartbreakingly true in her portrait of a nerve-wracked mother who had to face life too soon," wrote Richard Coe in *The Washington Post*. "It is a definitive reading of the role."

Remaining busy on other fronts as well, Meg appeared in two 1968 films, *Coogan's Bluff* (starring Clint Eastwood) and *A Lovely Way to Die* with Kirk Douglas. Three years later she appeared in *The Anderson Tapes* starring Sean Connery.

Because theater is generally more artistically fulfilling than it is financially rewarding, Meg has followed the examples of many other top actors, with continuing roles in several daytime television serials. The first was *The Doctors*, in which she was featured for six months in the late 1960s as Harriet Wilson. Later, she played Sid for two years on *The Edge of Night*; for one year she was Mavis on *Search for Tomorrow*, and Helen for one year in *Where the Heart Is*. In the early 1980s, she was Joanna for two years in *All My Children*.

Also during the past quarter-century, Meg has performed off-Broadway in *Taken in Marriage* at the New York Shakespeare Festival and in *Cracks*, written by actor Martin Sheen. In regional and repertory theater, her work has included *Critic's Choice* and *A View From the Bridge*. Her vocal skills were apparent in several musicals, including *Pajama Game* (in the lead role of Babe), *No Strings*, by Richard Rodgers and *Gypsy* (as Gypsy Rose Lee).

May 13, 1991, was a proud night for Meg as she sang in concert for the first time since 1965. The occasion was a benefit by Actors Equity to raise funds to combat AIDS, a special cause for Meg who has lost two agents to the disease. Her performance at Steve McGraw's on West 72nd Street was devoted to the songs of Harold Arlen, and Meg was in splendid form, moving from a high-powered rendition of "Get Happy" to a playful interpretation of "Ac-cent-chu-ate the Positive," to a warm and sensuous reading of "That Old Black Magic." She provided comic relief with "Lydia, the Tattooed Lady" (the "lady with a torso that is more-so"), and emotional performances of "A Sleepin' Bee" and "My Shining Hour." Shortly thereafter, she began rehearsals for a new off-Broadway production.

Between professional engagements, Meg continues a hobby that has provided her with much pleasure for more than 30 years, raising dogs. Another favorite pastime is attending horseraces.

For actresses of Meg's age, good roles are hard to come by, particularly during a grimly recessionary period for New York theater. It is a tribute to her considerable skills and professional respect that Meg has been able to ride out the down times and keep moving forward.

Looking ahead, Meg says she would like to develop a one-woman acting/singing show that plays to her strengths as an actress and sidesteps all the tribulations and politicking that go into casting.

Meg Myles' post-1960 filmography:

Satan In High Heels (1961) — How could any glamour-girl aficionado possibly pass up a film with Meg Myles in the starring role and British blonde bombshell Sabrina portraying herself? The film is now available again through Something Weird Video, enabling viewers to see that it's actually quite an entertaining B-movie in which Meg acquits herself extremely well.

Meg portrays a cynical, sultry, ruthlessly ambitious burlesque queen named Stacey Kane who leaves her junkie husband and escapes to New York, where she finds work at a ritzy club as a legitimate singer. She winds up pursued by the club owner, the owner's ne'er-do-well son with whom she's having an affair and, finally, her husband.

In one of the film's most-reproduced scenes (a musical number), she appears in black leather dominatrix riding habit with low-cut top. Sample lyrics: "I'm the kind of woman, not hard to understand/I'm the one who cracks the whip and holds the upper hand/I'll beat you, mistreat you, till you quiver and quail/The female of the species is more deadly than the male."

In the end, she winds up alone and on the street, defeated by her own scheming.

Coogan's Bluff (1968) — Tough, hard-hitting Clint Eastwood police drama (the lead character was used as the model for the long-running TV series *McCloud*). Meg has a supporting role as "Big Red," who tries to rob Eastwood in a honky-tonk hotel room.

A Lovely Way to Die (1968) — Kirk Douglas and European sex bomb Sylva Koscina star in this crime drama; Meg's role is middle-billed as "Mrs. Magruder," the widow of a character portrayed by Ralph Waite.

The Anderson Tapes (1971) — Meg (her last name misspelled in the credits as "Miles") has a supporting role as "Mrs. Longene" in this intriguing crime drama starring Sean Connery and Dyan Cannon.

Touched (1983) — Meg portrays the mother of a girl who escapes from a mental institution with her boyfriend and tries to start a new life.

Meg Myles has traveled a staggering distance from the pin-up girl of the 1950s, who symbolized (against her will) the American breast fetish, to become a universally admired dramatic actress. But for the many fans who have remained loyal to her for three decades, the journey is hardly surprising at all.

As Meg looks back on her career to date, she recalls vividly the pain inflicted by men who saw her only as an assemblage of desirable physical attributes. "When I am walking along a stretch of quiet beach, meditating or looking for pretty shells, feeling the ocean breeze on my body, and some guy comes by and makes rude remarks or gestures that intrude and invade, I would like to have the power to 'vanish' him," she confides. This is why the acclaimed 1991 film *Thelma and Louise* had a particularly profound impact on her, as that very fantasy was played out on screen. "I always thought of myself as glowing from within, and believed that YOU would be touched by THAT which was me."

"I was working with Lenny Bruce once, and he was taken by my exuberance and energy. He asked me what I was on. I didn't even know what he meant."

(Special thanks to Meg Myles for her generous cooperation, and to Jim Carlin, a devoted Meg Myles fan and collector for over 35 years.)

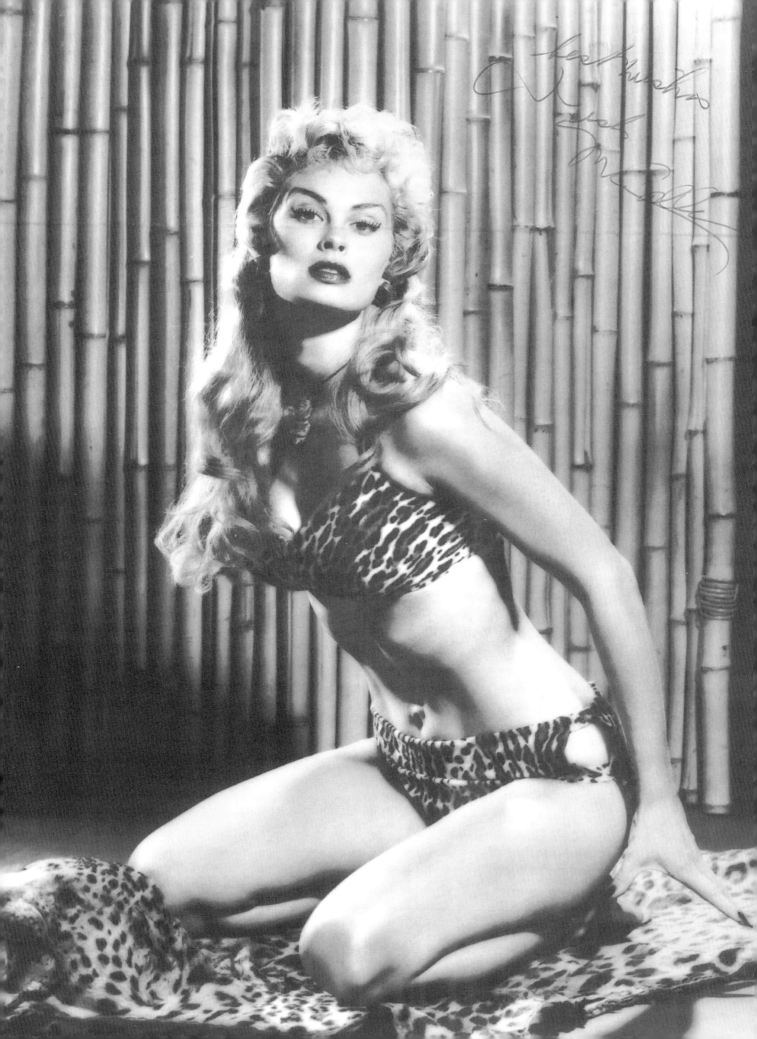

Every woman in this book has at least one claim to fame, but Irish McCalla is one of the select few who earned a passionate cult following in two different genres. After becoming the first great pin-up queen of postwar men's magazines and one of the three or four definitive cheesecake models of the 1950s, Irish was transformed into television's *Sheena, Queen of the Jungle*—and into legend.

Irish Elizabeth McCalla was born in Pawnee City, Nebraska (population: 2,000), the daughter of a meat inspector and one of five sisters and three brothers. She was a bit of a tomboy as a youngster, developing the athleticism that was to serve her in good stead later on. Irish recalls playing softball and basketball, and serving at one point as an assistant lifeguard. While in high school, she studied at a local art institute. "I was only able to study art during my freshman year when we lived in Omaha," says Irish. "Then we moved back to Pawnee City, where there was no art instruction to be had anywhere."

After graduating from high school, she moved to the warmer climes of California, joining a brother and sister, and continued her studies at the Otis Art School in Los Angeles. "I studied there for only several weeks, then I became tired of drawing shaded squares and circles, and quit," she says. "They had me in the beginners class even though at the same time I was painting two 12-foot murals at an expensive restaurant just down the street from the school."

Meanwhile, she went to work at McDonnell-Douglas Aircraft Company (then known as Douglas Aircraft), making "wing-nuts." "I worked for Douglas for about a year-and-a half, I think. I quit when I got married to Patrick McIntyre, my first husband" (the wedding was in June 1951 in Las Vegas). Before their divorce in July 1957, the couple had two sons, Kim and Sean. "While working for Douglas, I also worked part-time at an ice cream parlor—both for extra money and for the hot fudge sundaes we were allowed there!"

It was while skindiving at the beach one summer day in 1949 that the tall, shapely young blonde was spotted by enterprising photographer Bob Wallis. As Irish recalled during a 1989 interview for *The Betty Pages*, the Globe Photo Service in New York acquired the pictures and ran one on New Year's Day 1950, with the caption, "Here's what they're doing in California." Globe quickly signed her up—according to Irish, perhaps the first and only time that the photo syndicate put a model under contract. At about the same time, she was spotted by Navy brass and named "Miss Navy Day."

"I first started serious modeling after complaining to my brother Bill that the girls at the beach and parties were always making remarks about my figure, whispered loud enough so that I could easily hear them," she says today. "The boys always stared when I was in my bathing suit even

though my suit was one piece and lots of girls had started wearing bikinis. When I asked Bill if I should model for girlie magazines, he said, 'If the boys all want to stare, let them pay for it! You need the money. Just don't do anything to embarrass the rest of the family.' And I never did. I'm happy to say that my family has always been right there for me—we are all very close."

Irish's true national debut occurred in the magazine with which she was to become forever identified, *Night & Day*, the foremost publication in the field during the early '50s. Her *Night & Day* premiere occurred in August 1950; the magazine described the young 5-foot-9-and-a-half blonde with the blue-green eyes as "still a comparative unknown." That would not be the case for long.

Just two months after her introduction to an eager national audience, *Night & Day* launched a new magazine, entitled *Eve*, that used Irish as its symbolic central image. While that publication was not long-lived, by early 1951, Irish had become such a popular sensation that *Night & Day* was featuring her imposing physique in virtually every issue. Throughout the next three years, Irish was the queen of *Night & Day*, with perhaps 200 or more photos of her 39½-24½-38 bikinied form on the beach gracing the magazine during that period. During the early 1950s, no other publication was as mammary-oriented as *Night & Day*, and the magazine never neglected to feature the first and most vital of her statistics. Possibly its single most famous photograph of Irish, in fact, pictured her from the neck down, as her bosom (amply filling a tight sweater) is being measured.

In the early 1950s, a 39-and-a-half-inch bosom was considered a thing of wonder, and Irish's admirers regarded it—and her—with awe. In late 1953, Los Angeles ice sculptor Tom Sherbloom decided to offer his own form of appreciation. While Irish posed before him in a swimsuit, Sherbloom molded a block of ice into a perfect likeness, complete with an epic gravity-defying bust. Although destined to melt within a short time, it had done its subject proud.

"I've never understood why it was so important to be bigger-busted than someone else," Irish told Bill Black and Bill Foret in their wonderful 1992 book *"TV's Original Sheena: Irish McCalla."* "I was full grown in height and had a 39-and-a-half-inch bust at age 16 and was very embarrassed by it all. I had a 19-inch waist at that time and could never find a dress that fit right. Later my waist was 24 inches for many years, but I still had most of my clothes made for me." While pregnant with her first son, Irish related that her bosom swelled to over 43 inches "and I was bloody uncomfortable. That is one heck of a lot of weight!" She went on to acknowledge: "But let's face it—if it hadn't been for my measurements I'd have been just another pretty gal

Irish McCalla

Born December 25, 1928
Pawnee City, Nebraska

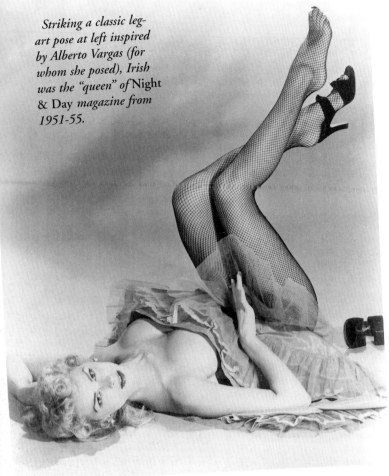

Striking a classic leg-art pose at left inspired by Alberto Vargas (for whom she posed), Irish was the "queen" of Night & Day *magazine from 1951-55.*

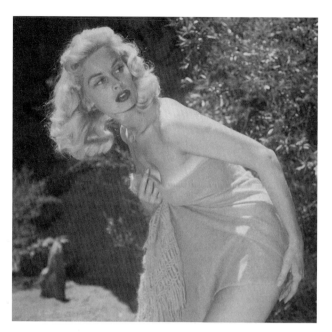

and possibly led an average life which wouldn't have been half as much fun."

The enthusiasm of Irish's pin-up fans knew no bounds. One magazine received over 5,000 letters after doing a feature on her. A few glamour girls before her had become objects of similar adulation; for example, Chili Williams had generated a feverish response after posing in her polka-dot swimsuit in *Life*. But Irish and Betty Page were perhaps the first figure models to become enduring "stars" simply by displaying their curves for the camera, without benefit of a movie to promote.

One of the highlights of Irish's early modeling period was when she was chosen by the great pin-up artist Alberto Vargas to grace one of his calendars. Ironically, Irish had copied his painting style when she was studying art as a schoolgirl. Because she was born on Christmas day, Vargas used her as the December girl; his portrait of Irish ran in *True* and *Cavalier* magazines, and was even used on a deck of playing cards. In a 1980 interview with *The Los Angeles Times*, she called Vargas "a very nice man. I had never modeled nude for anybody else, but I did for him. Plus his wife, who was really sweet, was there all the time." Today, she remains effusive about the master artist. "Alberto Vargas was a very special gentleman of the old-world school. He was always very kind, respectful and had a good sense of humor. In later years, he helped me with my own watercolor painting when I used to visit him."

During her days with Globe, Irish would shoot about three times a month at $10 an hour, or a flat $100 if the agency didn't use her that month. She related to *The Betty Pages* that she was also working as a waitress during this period, after her stint with Douglas Aircraft, "to make a living."

In late 1951, she made her first venture outside modeling with a theatrical travelogue called *River Goddesses*. Irish and four other girls ventured with a woman guide and photographer Dave Sutton (who frequently shot her for magazines) in two rowboats down the Colorado River. The scenery was spectacular, both along the river and in the boats. Also, around the end of 1951, she appeared on a TV show called *Backstage With NTG*, hosted by the renowned burlesque and theatrical promoter Nils T. Granlund.

A seldom-discussed element of Irish's career came in 1952 when she worked as a Las Vegas showgirl at the famous Flamingo Hotel and Casino revue. There, she became good friends with another noteworthy '50s glamour girl, Sheree North, who was then the dance captain for the Flamingo chorus line. Irish continued dancing until well into her first pregnancy. During this period she also toured for the USO in Korea.

A sampling of Irish's significant pre-1955 magazine appearances:

Apr. 1950 *Taboo* (3 pages, 8 pictures skindiving)
Aug. 1950 *Night & Day* (her first appearance in the magazine that was to make her famous; 2 pages, 4 bikini pictures)
Aug. 1950 *Pace* (4 pages, 5 swimsuit pictures during a lobster hunt)
Sept. 1950 *Beauties #1*
Sept. 1950 *Night & Day* (4 pages and 10 bikini pictures)
Oct. 1950 *Eve #1* (Irish graces the cover, lovely in a low-cut top with bare midriff, and 3 pages; the magazine selected her because "of all the women in the world, Irish best portrays the elemental allure of the first woman.")
Nov. 1950 *Eve #2* (gorgeous cover, 3 pages, 11 fine swimsuit shots)

Dec. 1950 *Eve #3* (color cover in bikini, 4 pages, and 8 total pictures)

Jan. 1951 *Night & Day* (cover, 3 pages)

Mar. 1951 *Night & Day* (3 pages)

Apr. 1951 *Night & Day* (cover, 4 pages, 11 pictures)

June 1951 *Gala* (4 pages)

July 1951 *Frolic #2* (3 pages of bikini pictures)

July 1951 *Big Time* (3 pages, 5 beach pictures)

Aug., Nov. & Dec. 1951 *Night & Day* (all 2 to 3 pages)

Sept. 1951 *Night & Day* (cover, 2 pages)

Sept.-Oct. 1951 *Famous Paris Models*

Dec. 1951-Jan. 1952 *Man to Man* (2 pages, 6 of swimsuit shots)

Jan., Feb., July, Aug., & Oct. 1952 *Night & Day* (2 to 3 pages each)

Apr. 1952 *Night & Day* (3 1/2-page feature on Irish frolicking with a monkey—good training for Chim the chimpanzee four years later.)

June 1952 *Night & Day* (the classic N&D profile shot of Irish from the neck down, exploding out of a tight sweater as her bosom is measured)

Aug. 1952 *Pageant* (7 pages)

Sept. 10, 1952 *People Today* (5 pages)

Nov. 1952 *Show* (color cover depicting Irish in a red bikini, and a 5-page cheesecake layout; "Why Fans Love Irish")

Dec. 1952 *Night & Day* (cover and 3 pages, including one shot of her bikinied bosom only)

Jan., Feb., July, Sept., Nov. & Dec. 1953 *Night & Day* (2-3 pages each)

Mar. 1953 *Night & Day* (3 pages, seemingly clad only in fur coat)

May 1953 *Night & Day* (4 pages doing the mambo on the beach)

June 1953 *Night & Day* (3½ pages, 7 pictures in shorts and tight blouse on the highway providing appropriate decoration to road signs—"slow curves," "soft shoulders," etc.)

Aug. 1953 *Night & Day* (another 3½ pages of Irish with her monkey friend)

Oct. 1953 *Night & Day* (3½ pages of Irish working out in swimsuit and in leotard)

Mar. 1954 *Eye* (6-page feature on Irish posing for an ice sculpture)

Apr. 1954 *Photo* (7 pages, 9 glamorous pictures)

May 1954 *Eye* (6-page swimsuit layout)

May 1954 *Foto Rama* (inside back cover and 7 pages)

Aug. 11, 1954 *People Today* ("The Magic Body," cover in red swimsuit, centerspread in *Sheena* outfit and 3 pages)

Sept. 1954 *Eye* (8 pages and 11 pictures of Irish cavorting on the beach in tights, shot by Dave Sutton)

Sept. 1954 *Focus* (7 pages on the beach)

Nov. 1954 *Brief* ("Venus Unveiled," 9 pages of bikini and lingerie poses)

1956-1957: Sheena!

After five years as a pin-up queen, Irish, in late 1953, was recommended by photographer Tom Kelly (famous for his nudes of a young Marilyn Monroe) for the starring role in a syndicated television adventure show about to get underway: *Sheena, Queen of the Jungle.* Bill Feret relates that Kelley "thought she was a natural for the part with her looks, figure and natural athletic ability. She was no stranger to the character, having been an ardent fan of Sheena's comic book

adventures. She'd even practiced the role while her brother played Tarzan. She knew exactly what to expect."

The competition was stiff. Famous striptease artist Lilly Christine, a lithe and athletic figure on stage herself, ardently sought the role. Hollywood blonde bombshell Joi Lansing and exotic brunette beauty Laurette Luez both tried out for the part. And a tall, voluptuous Swedish blonde who was still seeking her big break in Hollywood after several years of struggle was another leading candidate. Anita Ekberg was awarded the role—but then backed out just days before shooting was to begin when she received a juicy film role opposite John Wayne in *Blood Alley*. Second-choice Irish got the panicked last-minute call to step in—and promptly made all observers forget that anyone else had even been

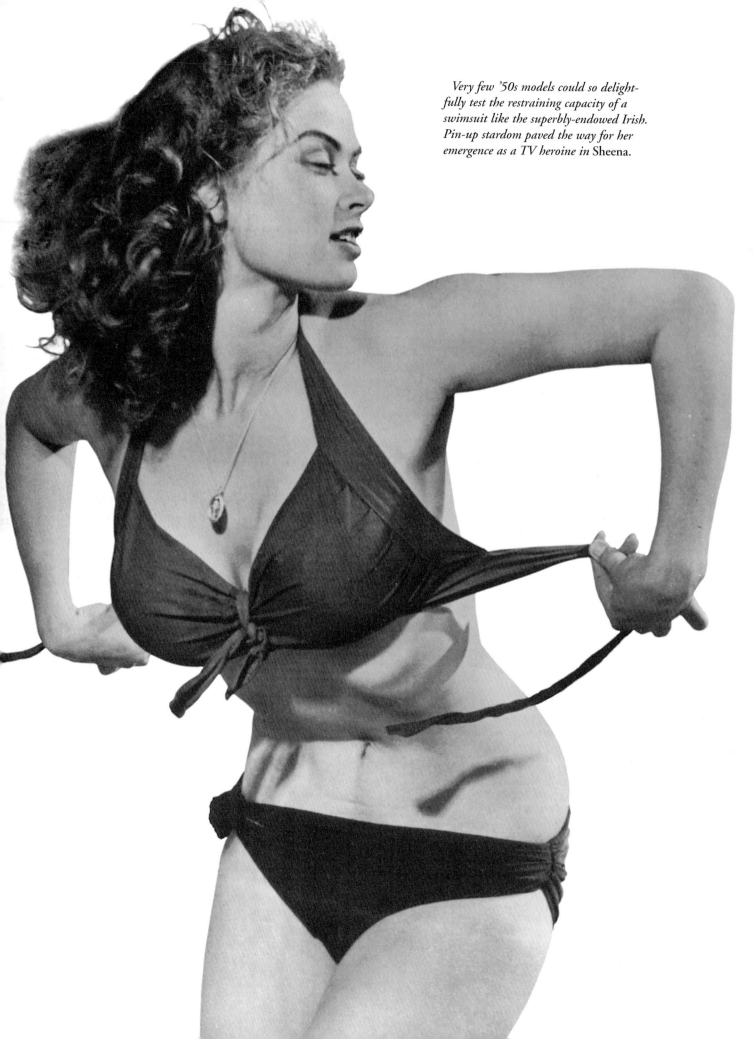

*Very few '50s models could so delight-
fully test the restraining capacity of a
swimsuit like the superbly-endowed Irish.
Pin-up stardom paved the way for her
emergence as a TV heroine in* Sheena.

considered. Considering how much Irish's natural athleticism contributed to the show's success, it seems obvious that no one else could have been remotely as believable in the part.

"Anita Ekberg and I tested on the same day," Irish remembers. "I was pretty sure that she had been chosen before I left there. I had watched while she tested and the photographer told me he thought she had been chosen."

For all the fame she already enjoyed, Irish was at a difficult crossroads in her life when *Sheena* came along. "About that time I was very unhappily married, with two kids, and I wanted a divorce," she recalled for *The Betty Pages*. "I didn't have any way to support the kids." *Sheena*, which paid its star $365 a week plus "several thousand dollars" for each personal appearance, provided the means. (Irish was divorced from film publicist Pat McIntyre in July 1957.

It is often forgotten that *Sheena* went through a long journey from the original tests to its TV debut. When Irish originally tested for the part in 1954—and was pictured in jungle-girl attire in some magazines at the time—the character was slated for a feature movie. It was more than two years later when the vision became reality as a syndicated series. In an interview shortly after her initial test, Irish said the part represented a chance to get away from pin-ups— "I've played second fiddle to my chest long enough."

Twenty-six half-hour episodes of *Sheena* were filmed in the jungles of Cuernavaca, Mexico. Irish made an indelible impression cavorting, along with Chim the chimpanzee and Christian Drake as her friend White Hunter Bob Rayburn, in the low-cut, leopard-tunicked outfit that so delightfully highlighted her world-class figure. There can be no doubt that if *Sheena* had been a network television series rather than a syndicated offering, Irish would not have been permitted to wear such revealing attire. The first episode, "Forbidden Cargo," was broadcast on September 16, 1956; the last, "Touch of Death," was seen on March 17, 1957. The filming conditions were difficult at best, and Irish performed all of her own stunts until she injured her arm by crashing into a tree; thereafter, the stunts were turned over to a male acrobat in a blond wig.

"I became very ill because of bad water and lousy food," said Irish. "I got the amoebic dysentery, better known as the turistas, and lost energy and weight. I had several recurrences of it even after I left the jungle. The good side of it was that during these periods, which sometimes lasted weeks, I actually had to eat fattening foods to keep from getting too thin!"

In addition to her enormous personal appeal, the series had another natural attraction for fans, Irish explained. "The show was very basic in terms of good and bad," she has remarked. "Good always triumphed over evil. Sheena was good."

If Irish's awesome physical presence in *Sheena* outstripped her acting, one must understand that she was a

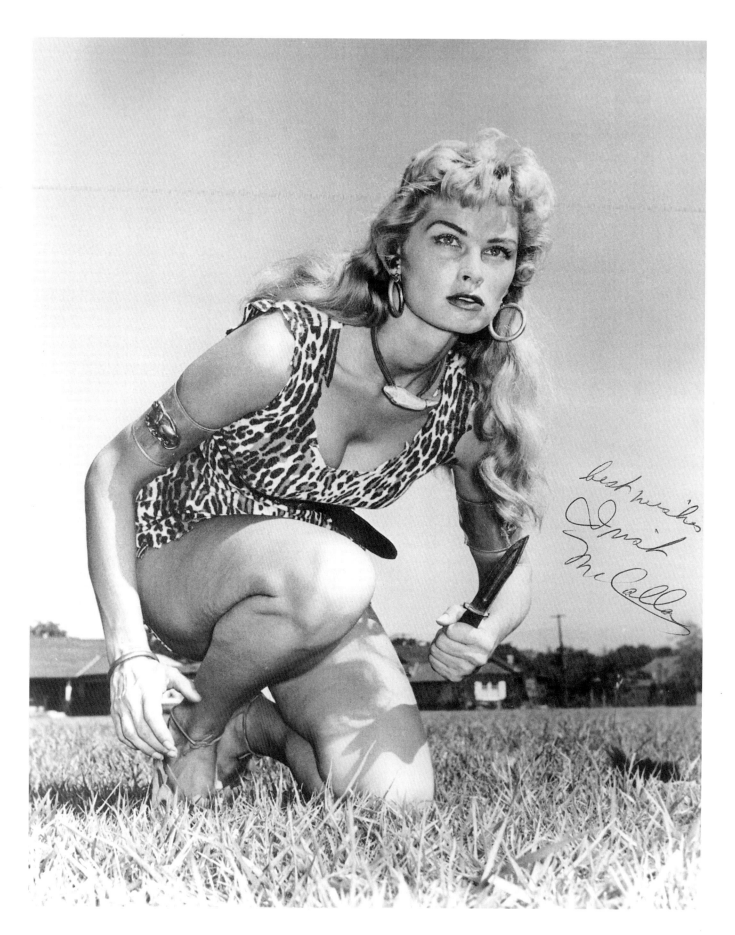

VaVaVoom!

complete newcomer to the field. "Every mistake I learned was on the screen," she told the *Los Angeles Mirror* in 1960. "On the first three shows, I wondered who the guy was yelling at me. I finally found out who he was—he was the director."

"Learning to act in front of everyone was difficult at the time, but even more so when I viewed it on TV later on," she explained. "The crew on the pilot film—the only one shot in color—and the first one we did in the States, were wonderfully helpful to me, when the director yelled at me. They were the ones who explained to me why. I didn't know half of the terms they used on the set or how close the close-up was, for example. I went home at night nervous, exhausted and cried myself to sleep.

"In Mexico, we shot about half of the films during the rainy season. We were supposed to be there only three months, but it took seven-and-a-half months to do the 26 episodes due to bad weather, the inexperienced Mexican crew, many directoral changes, and hiring too many people just because they spoke English and not because they had ever acted before. Thank heavens for the experienced camera crew. And I'd never have made it without the help and encouragement of my leading man, Christian Drake. We became known as 'the Lost Tribe of Ishmael' because the Mexican producer partner was named Ishmael Rodriguez, and all of the ridiculous things that kept going wrong on the set there."

All those travails, fortunately, were rewarded as the show—and Irish in particular—became a sensation with young viewers. "When I returned from Mexico I was surprised to see that everyone seemed to recognize me wherever I went. The show had been on for quite a while by that time. Then, I went on *The Milton Berle Show* with Debra Paget and Elvis Presley, and next on a 21-day tour of the East and South. I was immediately aware of how popular I'd become almost overnight." On the Berle show, Irish as Sheena made her entrance swinging on a vine, and Uncle Miltie did a humorous *This Is Your Life* takeoff depicting the mythical jungle queen's career.

Despite the loyal following earned by *Sheena*, the Nassour Brothers, producers of the series, decided to call a halt. "The Nassour brothers had made a lot of money on several other things, and I think they were hoping that *Sheena* would be a write-off," Irish later recalled to another interviewer. "They didn't expect the success." Irish had backers lined up to continue the show, and tried unsuccessfully to buy the rights. "We'd even had offers to merchandise the character, but the Nassour brothers just weren't interested."

"If I, with the help of my backers, could have bought *Sheena* and merchandised it, it could have run for several seasons as new children grew into it," she elaborated recently. "It was popular in other countries as well, and I did personal appearances in Cuba, Puerto Rico, Australia and Japan, among other places. We could have made a fortune, but the Nassours, for whatever reason, cut it all off.

"Luckily, before I'd signed the contract, Bill Williams (who was then starring in the 'Kit Carson' series) and Jock Mahoney (featured on the 'Range Rider' series) gave me pointers which resulted in the only real money I made on the show. They said to make a demand for more money per week, but go back to their offer if they will give you personal appearance rights. 'That's where the real money is and Hollywood producers haven't figured it out yet,' they told me. It was the best advice I ever received, because I did PAs for several years after I no longer had a weekly studio salary."

While episodes of *Sheena* continued to run on many stations around the country, Irish had to make a living doing something else. She made TV appearances on *The Colgate Comedy Hour*, *The Steve Allen Show*, *The George Gobel Show* (twice), and as herself on Groucho Marx's *You Bet Your Life*. As detailed by Black and Feret, her acting roles during this period included guest shots on *77 Sunset Strip* (as a leotard-clad karate instructor) and *Have Gun—Will Travel*.

Irish agreed to accept a featured role in a goofy exploitation film trading on her fame, *She Demons* (see filmography). Much to her discomfort, this remains her best-remembered role aside from *Sheena*. The 1959 drama *Five Gates to Hell* was her best film, but Irish as a nun was not exactly what her many pin-up fans had in mind. *The Beat Generation*, starring Mamie Van Doren, with a supporting role for Irish, was more to their liking.

After one final film in 1962, Irish's career in Hollywood was over. "I was typecast after *Sheena*," she remarked. "It was almost impossible to get another job." However, the end of her acting career simply provided more time to pursue her real love, painting.

Irish's post-1954 magazine appearances included:
Jan. 1955 *Night & Day* (3 pages in Hawaiian attire doing the hula)
1955 *Fabulous Females* #1 (cover, 2 pages)
Apr. 1955 *Night & Day* (inside cover in fur coat)
Jan. 1955 *Picture Scope* (cover in red tights and 3 pages)
June 1955 *Man's Magazine* (2 pages of those silly but provocative shots featured in the 6/53 *N&D* of Irish's "human road signs")
June 1955 *Night & Day* (terrific 1-page shot of Irish lying on her back in low-cut ballerina outfit, stockinged legs in the air)
Aug. 1955 *Night & Day* (memorable cover of Irish on the beach beginning to pull down her bikini bottom)
Jan. 1956 *Night & Day* (2 pages and 5 *Sheena* pictures)
Jan. 1956 *Vue* (6 pages, 8 pictures in her revealing *Sheena* attire)
Feb. 1956 *Night & Day* (3 pages and 5 cleavage-accentuating pre-*Sheena* pictures. Her "stupendous measurements are well known to *N&D* readers, and it is with nostalgia that they will gaze for perhaps the last time" on her.)
Mar. 1956 *Vue* (cover in skintight blue leotard)
May 1956 *Modern Man* (inside cover)
Jan. 1958 *Uncensored* (3-page pictorial and article)
Late 1958 *Foto* #45 (5 pages of vintage early-'50s outdoor pictures)
Winter 1989-90 *The Betty Pages* #3 (7-page interview/photo feature)
1991 *Celebrity Sleuth* Vol. 5-1 *Women of Fantasy 3* (2 pages, 6 pictures, including one fine cheesecake shot of Irish apparently nude with a small mink barely wrapped around her bosom and midsection.)
Fond Memories issue "J" (Bob Schultz turned over half of his *Bettie Page* fanzine to an Irish tribute, including article by Marianne Phillips and 7 pages of pictures.)

1992 *TV's Original Sheena—Irish McCalla* (By Bill Black and Bill Feret—is a "must" for any Irish fan, a 112-page compilation of wonderful photos, biographical text with comments by Irish, and even a delicious comic strip adventure, "*Irish, Queen of the Jungle.*")

Irish's movie roles:

River Goddesses (1952) — This is a flavorful travelogue down the Colorado River and through the Grand Canyon with Irish and four other lovely ladies, clad in short shorts and halter tops.

She Demons (1958) — In her first "real" film, Irish is top-billed in this tale of a Nazi war criminal who turns beautiful women into monsters on his private tropical island. After their transformation, the women are kept in bamboo cages and do ritual dances in brief animal-skin bikinis. They are saved by an active volcano.

"I'll never understand why *She Demons* was so popular and a cult film!" Irish admits today. She turned down the film director's request for a nude scene in the picture.

The Beat Generation (1959) — Mamie Van Doren and Steve Cochran star in this drama about a cop chasing a man who rapes married women. Irish has a supporting role—in a black wig—as Jackie Coogan's wife. Irish has positive memories of this film, primarily because it enabled her to work with Cochran, whom she had known for several years in charity fundraising activities and social events.

Five Gates to Hell (1959) — In rather unlikely casting, Irish appears in a supporting role as a nun in this strong drama (written and directed by novelist James Clavell) of ten people abducted by guerrillas in Vietnam during the French involvement there in the 1950s.

Five Bold Women (1960) — A U.S. Marshal travels across Texas to bring five female murderers to prison, and en route they have to ward off Indian attacks and the elements. Irish is "Big Pearl." "This is my favorite film other than Sheena," Irish confirmed. "Yet it's the one film of mine that I've been unable to find on video anywhere."

Hands of a Stranger (1962) — A famous pianist's mutilated hands are replaced surgically, and when he discovers he can't play anymore, he goes crazy and vows revenge. Irish and Sally Kellerman have small roles.

The Artist Emerges

With Hollywood behind her, Irish plunged full-time into the painting she had so loved as a young girl. Back in Omaha, one of her watercolors had been chosen for exhibit at the Joslyn Art Museum when she was only 14. During her *Sheena* period, she would spend her spare time on the set painting oil portraits of local characters and fellow actors. After *Sheena*, she studied with Fritz Willis ("for general knowledge and more speed, although I'm still a fairly slow painter"), with Grace Harvey ("for expertise with a palette knife"), and with Carlo Buonora for portrait work. Since the early 1960s, Irish has poured most of her energy into her art.

Irish's particular specialties are Western themes and children. After establishing herself as a successful artist with works in watercolors, oils, charcoal and pastels, she began to make limited-edition plates from her pastel drawings. Among her first were *Feeding the Neighbor's Pony* (featuring two children looking over a fence) and *Cowboys and Indians* (a young cowboy plays the harmonica for a little Indian girl). The latter specialty led her to become a member of Women Artists of the American West.

By 1984 (when she was profiled in the magazine *Collectibles Illustrated*), Irish had created over 1,000 paintings and had eight collector plates and numerous limited-edition lithographs to her credit. One of her plates, *Mail Order Bride*, was voted the co-winner as the "Most Popular Litho of 1978" by readers of *Plate Collector* magazine; in a limited edition series it sold for $75. A 1983 rendering, *Naptime*, was issued in a series of 10,000. She is also known for her ocean scenes and nudes. Irish's paintings have graced the Los Angeles Museum of Science and Industry and the Cowgirl Hall of Fame. Her original oils and pastels have sold for as much as $12,000, although most are priced between $1,500 and $6,000. She also runs her own company, McCalla Enterprises, Inc.

Irish went through two other marriages during these years: to actor Patrick Horgan (divorced in 1966), and Chuck Rowland from 1982-89. After raising her two sons in her hometown of Pawnee City, Irish settled down by the 1970s, doing her paintings in a Malibu home overlooking the Pacific. Upon marrying Rowland, she moved to the mountain town of Prescott, Arizona, and branched out to sell real estate part time.

In 1980, for the first time in 15 years, Irish appeared in public as Sheena at a "superhero" convention in Anaheim, and was overwhelmed with the response of her loyal fans. Since then, she has continued to make occasional appearances—although no longer in jungle-girl attire after 1984—at conventions around the country. During the early '70s, she was told she had cancer, but fortunately the cancerous growth was removed. Despite a subsequent recurrence of the disease—diagnoses of cancer of the groin in 1983 (banished through radiation treatments) and brain tumors the following year and in 1992 (that were also removed)—Irish today remains strikingly beautiful, active and vital: not only is her artwork as vibrant as ever, but she continues to delight her followers by signing autographs (for a modest charge that mainly goes to the American Cancer Society) at several conventions each year. At every show, her unfailing warmth and friendliness make new fans and strengthen the affection of long-time admirers.

In addition to all her other activities, Irish is also now at work on her own autobiography, digging through a lifetime's worth of memorabilia to help recall everything. In this book, "one of the things I want women to understand is how I stumbled into my career. I want them to see that if they'd had big boobs and long blonde hair, the same thing could have happened to them." Despite this typically modest and humorous assessment, no one can dispute that the special qualities she has always possessed go well beyond the physical.

Looking back nearly 40 years after her glory days on screen, Irish still seems amazed at how it all worked out. "I never gave a thought to acting or to modeling. I just did them both because it was a better living than being a waitress or working in a factory. Now, I'm very happy to have done them, as I'm having a wonderful 'late repeated career' doing memorabilia shows and personal appearances. I still can't quite understand why I'm a cult icon, as I'm often told at shows. But it's brought me many more fans who were too young to have seen *Sheena*, and I find it fun and refreshing to talk to them.

"I don't really know what I had that made so many fans so loyal over the years, but I'm very happy for every one of them. What fun to get such attention at my age—a real treat!"

As exemplified by contemporary books, such as Bill Feret's "*Lure of the Tropix*," the bronzed goddesses of the jungle retain a hold on our imaginations to this day. And no jungle goddess could ever match Irish; as she once said herself about her amazing form, "Honey, a figure like mine is like having too much money." The towering, stunningly sculptured, million-dollar blonde image of Irish McCalla remains to most the definitive representation of the genre. For that alone, she will be remembered.

(Thanks to Irish McCalla for her generous cooperation, and to her friend, collector Marianne Phillips of Readlyn, Iowa, for her assistance.)

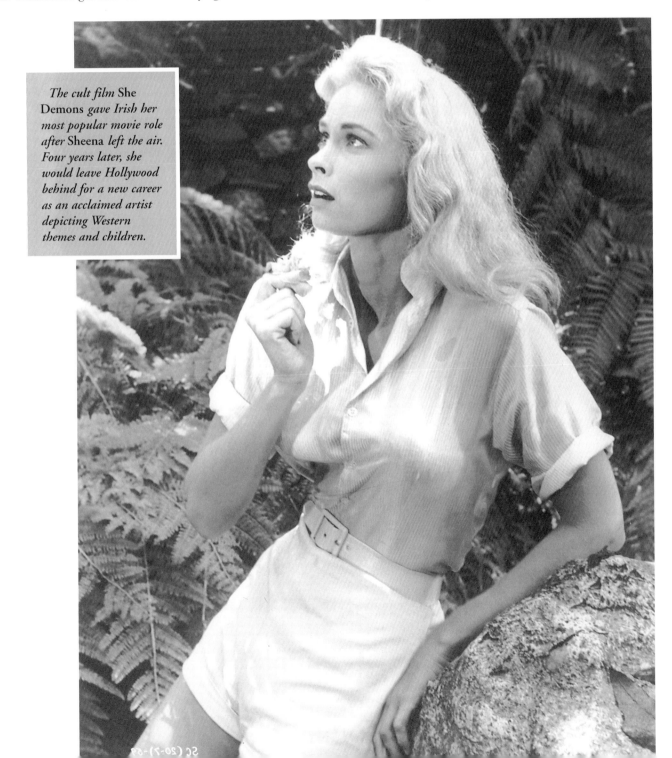

The cult film She Demons *gave Irish her most popular movie role after* Sheena *left the air. Four years later, she would leave Hollywood behind for a new career as an acclaimed artist depicting Western themes and children.*

SC (20-7)-82

The Pin-Up Queens

The 1950s were the golden age of men's magazines, and these publications provided the launching pad for many of the era's greatest glamour queens. Marilyn Monroe and Jayne Mansfield got their start in the girlie magazines, and this was the realm in which Bettie Page and Betty Brosmer became goddesses. For the first time, the names of top pin-up models became almost as familiar as their figures. The girlie magazines provided more than simply a showcase for feminine charms: They offered that extra veneer of fantasy that had once been the exclusive province of Hollywood.

During the peak of the golden era from 1955-58, readers could select from an array of men's magazines more richly diverse than ever before. *Playboy* towered over the field and established the standard for others to follow. *Modern Man* and *Cabaret* offered some of the decade's most gorgeous pictorials; *Fling* and *Night and Day* set the tone for the decade's big-bosom orientation; and a vast array of other publications competed for attention in a wide range of formats (from mini-digest to oversized) and styles for every taste.

The best men's magazines of the '50s delighted a generation with pictorials that sizzled because of the fresh beauty of the women, the commitment of exceptional photographers, and strong production values by publishers who understood that one can be titillating while remaining tasteful.

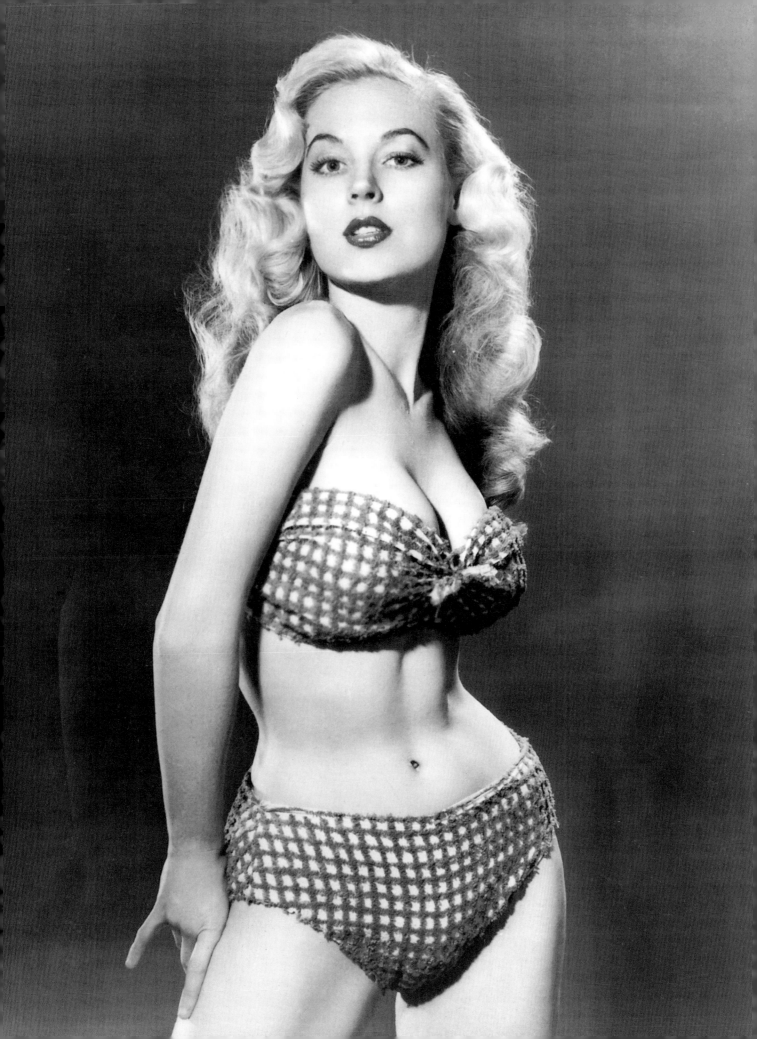

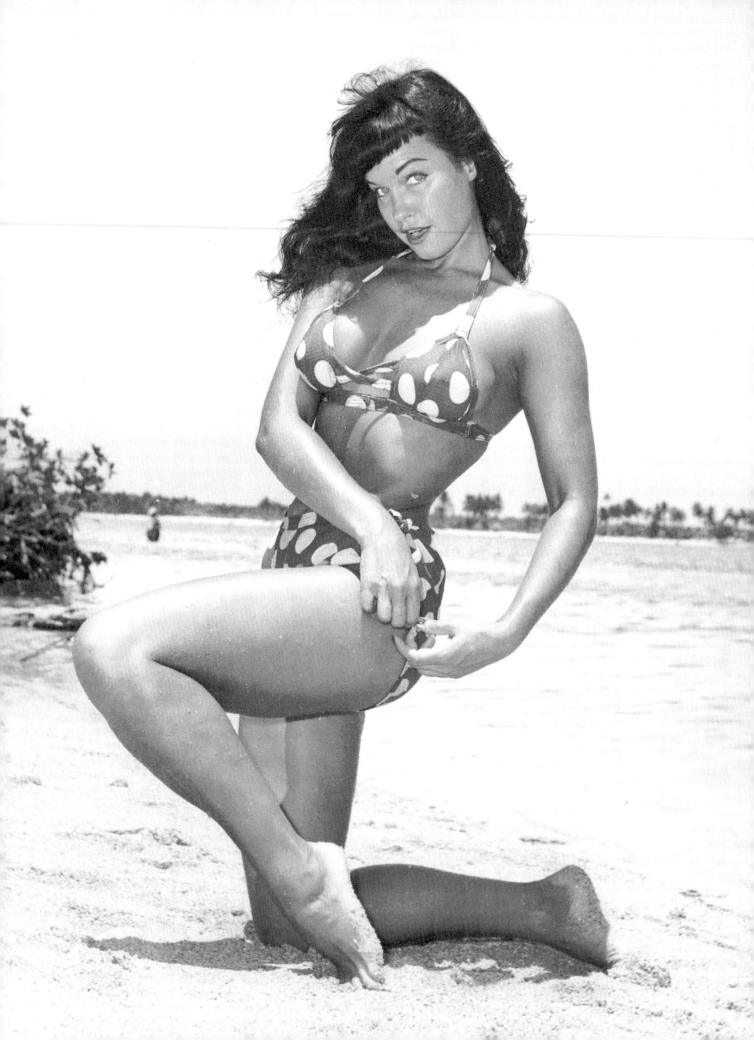

Bettie Page may not have been the most beautiful pin-up model during the golden age of the 1950s; others were more curvaceous, more outrageous, and more sexually magnetic. But it is Bettie Page whose image has endured as a larger-than-life icon of the entire era, to the extent that to many she has come to symbolize the decade just as vividly as Marilyn Monroe and James Dean.

The reasons for this genuinely astonishing cult seem wrapped up both in the fascinating duality of Bettie's photographs, which run the gamut from sunny innocence to sinister darkness, and to the aura of mystery which long enveloped her life following her pin-up days. Because Bettie had the virtually unique capacity to embrace diametrically opposed extremes, viewers could project their own deepest fantasies onto her image to a greater extent than any other model. It is little wonder that in the world of modern fantasy pin-up art, Marilyn's only rival as a direct source of inspiration is Bettie.

Whether based on reality or rooted in our own collective cultural-sexual psyche, there can be no denying that the Bettie Page phenomenon is a central part of the story being explored in these pages.

From Nashville to Manhattan

Born in Nashville (not in the nearby mountain town of Kingsport, as sometimes reported), Bettie had a difficult childhood which she recalled for Robin Leach in a landmark 1992 interview. The family moved around quite a bit, following the jobs of her auto mechanic father Roy to Oklahoma and Texas. When she was 10, her parents divorced largely because her father was "a womanizer of the worst sort." Despite the efforts of her part-Cherokee mother Edna, the hard times of the Depression eventually forced her to place Bettie and her two sisters in a Nashville orphanage for a year in 1933.

Endowed with intelligence and gritty determination equal to her natural beauty, Bettie was a straight-A student at the city's Hume-Fogg High School while maintaining a busy after-hours schedule of debate club, school plays and the editing of both the school newspaper and the yearbook. Extremely studious, she rarely dated in high school although she was much sought-after by the boys. Bettie told Leach that she was "completely crushed" when she barely missed being named class valedictorian upon graduation in June 1940, particularly because the honoree also received a scholarship to Vanderbilt University. She did attend Nashville's Peabody College for Teachers, where she also performed in some 15-minute radio dramas for the Peabody Players Radio Guild. Bettie then put in six unhappy months as a student English teacher at a local high school. In June 1944, she received her B.A. degree. (Those interested in a richly detailed account of Bettie's early years are urged to check out Greg Theakston's *Betty Pages Annual 2*.)

Around 1941-42, Bettie married Billy Neal, a boy she'd been dating for months, in Gallatin, Tennessee just before his induction into the Armed Forces. It was a decision she regretted almost immediately. After he was shipped out in July 1944 for service in the Pacific, she lived in San Francisco with her sister and worked as a secretary. She also made her first unsuccessful efforts to break through in Hollywood.

After meeting Bettie, Art Grayson, head of the small Hollywood Commercial Motion Picture Co. talent agency, took several pictures of her and submitted them to 20th Century Fox, earning her a screen test in 1945. In late-1992 correspondence with Bob Schultz, publisher of the Page fanzine *Fond Memories*, she recalled that Fox made her up to look like Joan Crawford with buns on both sides and heavy mascara and lipstick. The test—done opposite John Russell (known years later as TV's *The Lawman*)—was an utter failure. "I didn't even look like myself on screen," she recalled. Her strong Southern accent was another contributing factor. She makes it clear that she never used the casting-couch approach in an effort to get ahead.

When these efforts fell through, she worked for a time as a secretary and occasional model for Geary Furriers in San Francisco. When Billy Neal returned in April 1946, the couple moved back to Nashville; the marriage soon headed south, and so did Bettie, for about a six-month stay with her sister in Miami. In early 1947, she worked for four months as a secretary in Haiti until a wave of anti-American violence sent her scrambling to board the next flight back to the States. Soon after her return, Bettie and Neal divorced.

By 1948, Bettie was in New York City, where she landed a job as a secretary in Rockefeller Center. With an eye on Broadway, she began taking acting, singing and dancing lessons. A summer 1950 job as an apprentice with the Greenbush Summer Theatre in Nyack, New York provided some practical experience. This would be followed by more summer stock appearances on Long Island and throughout Pennsylvania and upstate New York during the next several years. While she didn't give up until the end of 1957, it soon became evident that acting was not going to provide her route to stardom. Her accent and obvious glamour-girl image limited the types of roles she could play, and her habitual lateness for appointments certainly didn't help. It was in the summer of 1950 that the 5-foot-5-and-a-half-inch brunette began travelling another road, one that would give her more notoriety than she'd ever bargained for: pin-up modeling.

A black policeman and part-time photographer, Jerry Tibbs, is worthy of a key footnote in pin-up history as the man who helped create the "Bettie Page look." He discovered Bettie on the beach at Coney Island in the summer of

Bettie Page

Born April 22, 1923
Nashville, Tennessee

1950, took some photos of her, and suggested that, because of her high forehead, combing her bangs down just above her eyes would create a more flattering appearance. Tibbs was the first commercial photographer to shoot Bettie, and Schultz reports that the historic first published (bangless) pictures appeared on the cover of a Harlem newspaper.

In 1951, she began to make her mark in the Robert Harrison publications which featured cheesecake and leg-art shots, most of these taken by Tibbs, and usually posed and presented in a humorous vein. Very quickly, Bettie became a regular in all of them: *Titter*, *Eyeful*, *Beauty Parade*, and *Whisper*. By this time the Page "look" was firmly established: dark shoulder-length hair with the bangs that would become her trademark; a lovely face with a girl-next-door freshness but an ever-present capacity for flirtacousness; a lean, shapely figure that was more firm and well-toned than voluptuous; and long, killer legs. By this time, she was working full-time as a model and aspiring actress, and had acquired her beloved apartment on West 46th Street near Times Square.

The event that would convert a pin-up sensation into a budding legend is said to have occurred sometime around late 1951. One of Harrison's photographers brought Bettie to the attention of Irving Klaw, New York City's self-styled "Pin-Up King" whose sexy mail-order photo service had rapidly become the biggest in the just-emerging industry. Klaw immediately saw her potential, and quickly Bettie became far and away his hottest attraction.

The Queen of Bondage

While Bettie posed for many traditionally glamorous cheesecake shots for Klaw, it was quite a different category of photographs for which she first became renowned. Ever since the late 1940s, Klaw had catered to a specialized national clientele, supplying pictures of curvy beauties in scenes of bondage, spanking or girlfighting. It was the shortage of such photos from Hollywood that had first led Klaw to begin shooting his own pictures. Betty was to become the Queen of Bondage.

For one who is not a devotee of this genre, its appeal may be elusive, and one can readily understand why it became the object of such intense controversy just a few years later. The spanking photos are merely playful for the most part, with one sexy beauty in lingerie taking another over her lap and spanking her (or, in some cases, wrestling with her); but the bondage shots are something else again. In some, she is simply tied up or chained, or shown struggling to escape. In others, she is spreadeagled (typically in bikini or lingerie) either on the floor or hanging in the air, gagged, with a look of exaggerated but often convincing distress or terror on her face.

The bondage sessions were carefully orchestrated, and frequently involved considerable ingenuity in devising methods of simulated torture into which Bettie and her colleagues would be placed. Irving's sister Paula Kramer always performed the task of tying the girls up—with firm, tight knots—and served as chief photographer for virtually all of the sessions. Basically, it was a more explicit and titillating variation on the "Perils of Pauline" concept that had been a favorite in movies ever since the dawn of the First World War, and which had many literary antecedents: tie the gorgeous girl to the railroad tracks, and see if she can find a way to wriggle free before it's too late. Presumably, the predominantly male purchasers of these photos could imagine themselves as the strapping hero coming to Betty's rescue—unless, that is, they placed themselves in the shoes of the unseen dastardly villain cooking up evil schemes for his imprisoned beauty.

It is important to note that Bettie was much more than just a compliant model in these sessions—she was an active participant during every step of the process. Frequently a layout would be produced in response to written requests from Irving's regular customers, and she and Paula would talk about creating particular shots. Occasionally a well-heeled customer would put up the money for a special bondage or fetish session, and at least one provided the use of his estate for outdoor bondage shots.

"The other models and I enjoyed doing these crazy things," Bettie told Bunny Yeager in their 1993 telephone conversation for *Interview* magazine. "The craziest thing I was asked to do was pose as a pony, wearing a leather outfit, with a head and everything. We just died laughing."

While Klaw sold thousands of BP photos nationwide, Bettie would also become a focal point of his venture into feature-length motion pictures. In the fall of 1953, theater operator/producer Martin Lewis presented Bettie as a supporting performer in his *Strip-o-Rama*, which starred burlesque legend Lili St. Cyr (see filmography for a full description). Its success inspired Klaw to enter the scene with *Varietease* one year later, again featuring Lili St. Cyr as the headliner and Bettie in a single routine. In 1955 she appeared with stripper Tempest Storm in *Teaserama*. "For the first time in filmdom's history, there's real motion in motion pictures, with sixty-five minutes of torrid terpsichore," proclaimed one magazine. Bettie was also featured in a long succession of Klaw film shorts that enlivened many a stag party during the decade.

Watching Bettie on film, one has the sense in nearly all of her routines of a lovely girl standing alone in front of her mirror and rehearsing slightly naughty dance moves. Appearing to be the soul of innocence in spite of her scanty attire, she will wink playfully and conjure up a host of provocative fantasies in the viewer's mind without anything explicit ever appearing on screen. Just watch Bettie's face during any of these little performances: no matter what she is doing, she appears to be having the time of her life, wanting nothing more than for the audience to share in the pleasure she is feeling while dancing and posing. Her smile would melt the coldest heart, and her mouth opens and moves in silent but unmistakable invitation. Then there are her eyes—constantly flashing with excitement and happiness, invariably winking to tease and flirt with her unseen viewers. Even someone who had never seen Bettie Page before could not help but fall in love.

Bettie was reportedly hired to appear on Harold

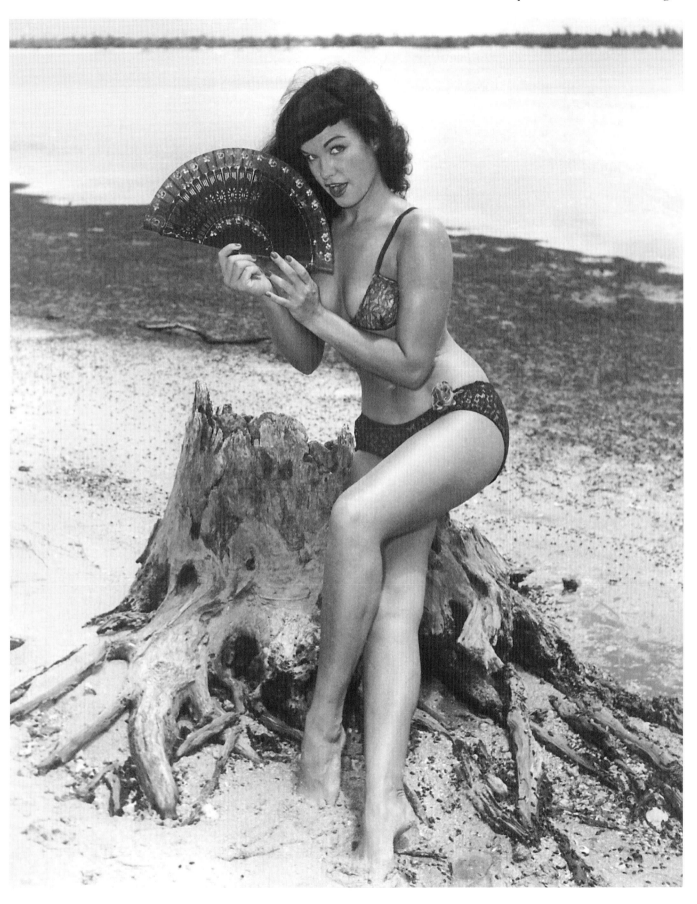

together a Vegas act for her at the Dunes Hotel. She was going to be singing and dancing." This occurred when she was working with Bettie in 1954-55. "It could have been one of those glorified strip acts. I had that feeling, because it was Lili St. Cyr's manager who was trying to do something with her. It didn't seem to be working out. I don't know what went wrong." When Bunny interviewed Bettie, she found out: "The fellows who contacted me about it wanted to have one nude shot as part of the act, and I didn't want to do it. I was studying acting then and I thought it would hurt my career."

Bettie's film appearances included more than 50 Irving Klaw 100-foot film shorts, all circa 1953-54 and averaging five to eight minutes in length. They could hardly be simpler: just Bettie posing and dancing, or struggling in bondage, generally amidst living room furniture, clad in scanties with an occasional prop. The film loops included, among many others, the following, listed in alphabetical order; since all of her work with Klaw was as "Betty" Page, these descriptions will adhere to that spelling.

Betty Gets Bound and Kidnapped: Our heroine's in the bedroom when two women in white bras and panties sneak up and inject her with a knockout drug. The girls tie her up, strip her to bra, panties and stockings, then drag her onto a sofa where they again bind up the helpless beauty.

Betty Page and Her High-Heeled Shoes: Betty in black bra and panties slowly puts on black stockings.

Betty Page in Chains: "Betty is very subordinate and her mistress, portrayed by Roz Greenwood, chains Betty to a chair, and Betty promises to be good and obey. Roz commands her to comb her hair, when Betty pulls Roz's hair. Then Roz spanks Betty." Betty is attired in a leopard-skin bikini.

Betty Page in High Heels: Clad in long kid gloves, black bra and panties, long rolled stockings, and six-inch high heeled patent leather shoes, Betty struts her stuff and performs a sensuous dance.

Betty's Clown Dance (Parts 1 & 2): A playful Betty kisses her stuffed clown, rocks him like a baby, and whispers sweet nothings. In black stockings and tiny bikini underwear, she then dances, toying with her stockings, doing some kicks to show off her high heels. The high point in part 2 comes when Betty hugs the clown as she dances, then cuddles him in her

Minsky's burlesque stage in New Jersey for some shows around 1957, but she never actually did. In his reminiscence of Bettie in the December 1992 *Playboy*, writer Buck Henry recalls going to the theater after seeing ads for Bettie, only to be disappointed when she never showed up. Certainly one can see from her film performances that she would have made an exceptional striptease artist had she wished. Like the best strippers, she made skillful use of props—a hat was her favorite, and a doll in the image of a clown perhaps the most memorable—to suggest tantalizing erotic images. More importantly, however, Bettie conveyed a sense of exuberant joy in what she was doing, and the girl-next-door freshness coupled with saucy sensual hints was only rivaled in the striptease world by Candy Barr.

Bunny Yeager reveals that in addition to Bettie's many other professional endeavors, "somebody was trying to put

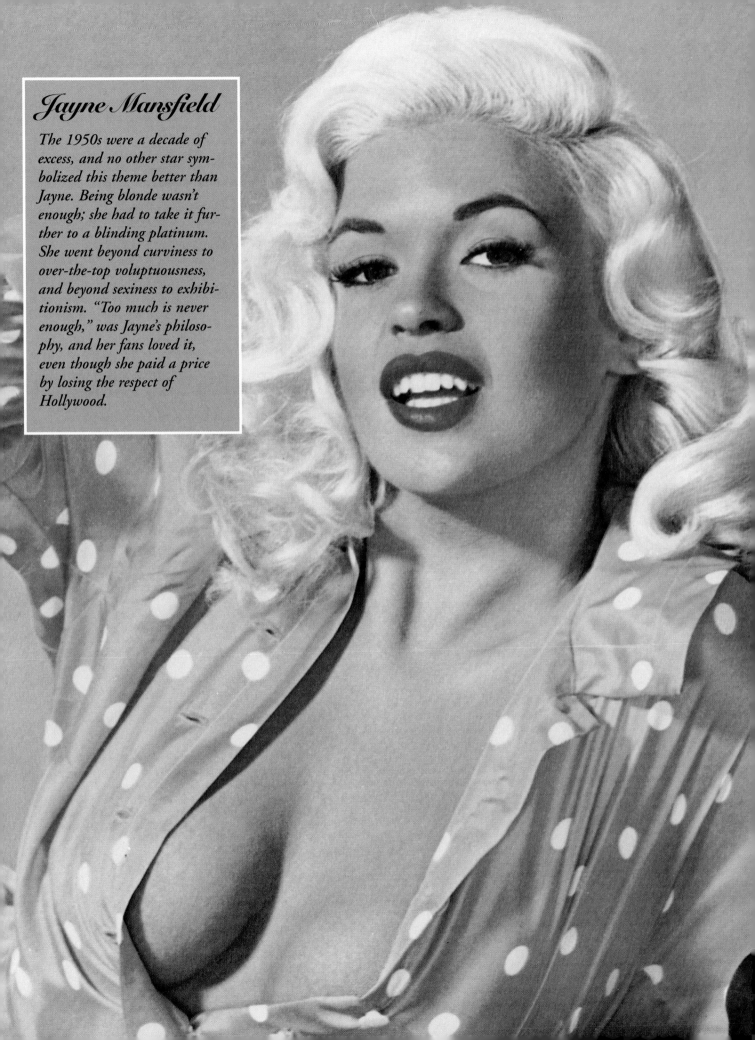

Jayne Mansfield

The 1950s were a decade of excess, and no other star symbolized this theme better than Jayne. Being blonde wasn't enough; she had to take it further to a blinding platinum. She went beyond curviness to over-the-top voluptuousness, and beyond sexiness to exhibitionism. "Too much is never enough," was Jayne's philosophy, and her fans loved it, even though she paid a price by losing the respect of Hollywood.

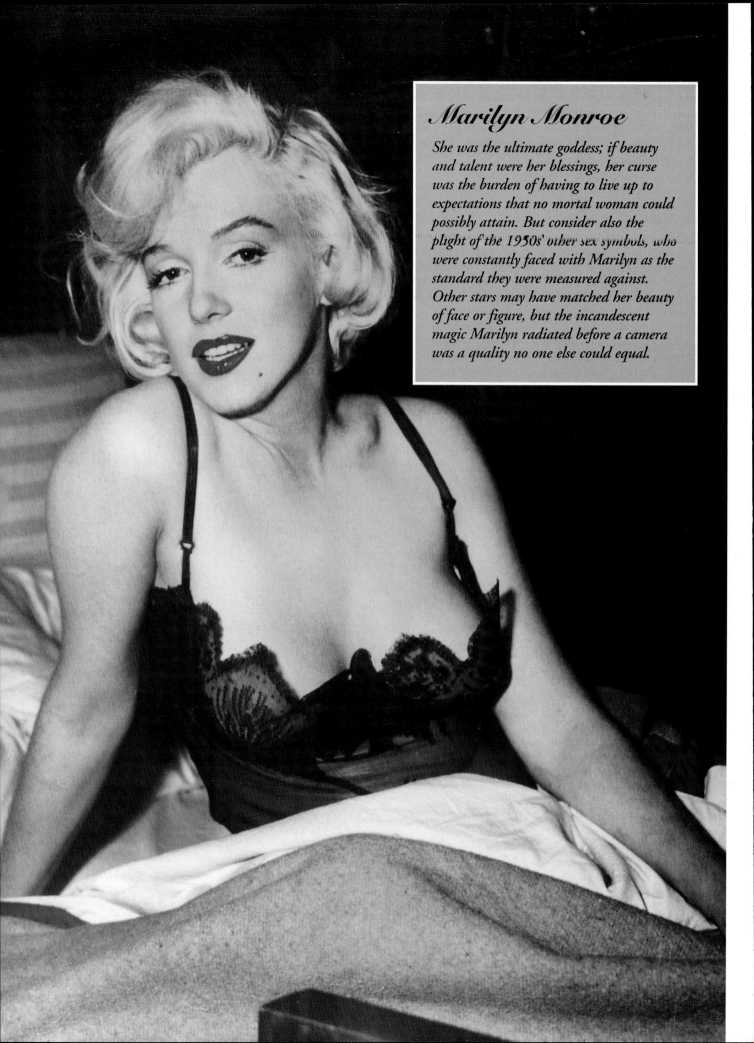

Marilyn Monroe

She was the ultimate goddess; if beauty and talent were her blessings, her curse was the burden of having to live up to expectations that no mortal woman could possibly attain. But consider also the plight of the 1950s' other sex symbols, who were constantly faced with Marilyn as the standard they were measured against. Other stars may have matched her beauty of face or figure, but the incandescent magic Marilyn radiated before a camera was a quality no one else could equal.

Mamie Van Doren

To some detractors, she may have dwelled in the shadows of Marilyn and Jayne; to her fans, however, there was only one Mamie Van Doren. Unlike her rivals, Mamie was in tune with the consciousness of a new rock & roll generation, and the same mindset has enabled her to stay forever young.

Stella Stevens

Even while playing the Hollywood sex-symbol game of seductive film roles and sizzling magazine layouts–and playing it very well–Stella Stevens never lost sight of her higher goals: building a career that would endure, and proving herself as a director. A commitment to her craft and an iron-willed determination have enabled Stella to beautifully stand the test of time.

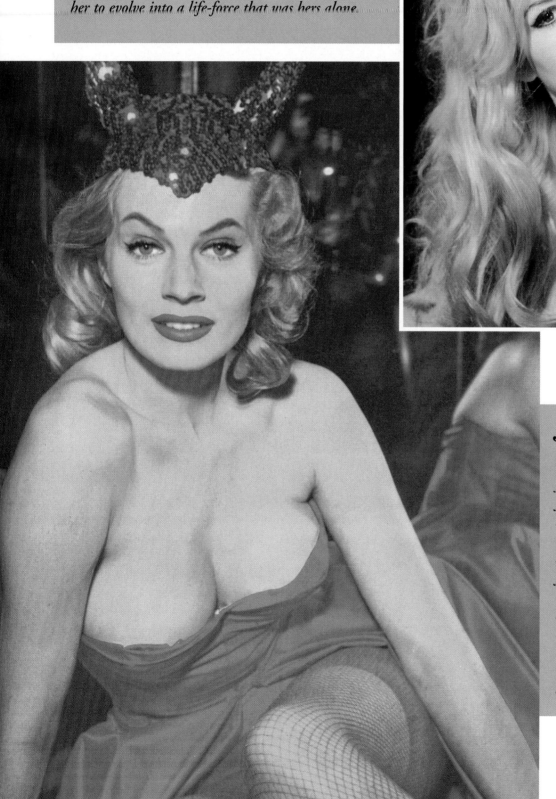

Brigitte Bardot

The woman who ushered in a new era of sexual freedom on screen began as the virtual creation of her husband and director Roger Vadim. But the powerful and utterly unique sensuality of Bardot enabled her to evolve into a life-force that was hers alone.

Anita Ekberg

Some connoisseurs of the female form claimed that for sheer beauty of face and figure, Anita Ekberg outclassed every other star of the 1950s. The fact that she lacked a distinctive screen personality kept her career as a headliner relatively brief, but she provided some unforgettable pleasures along the way.

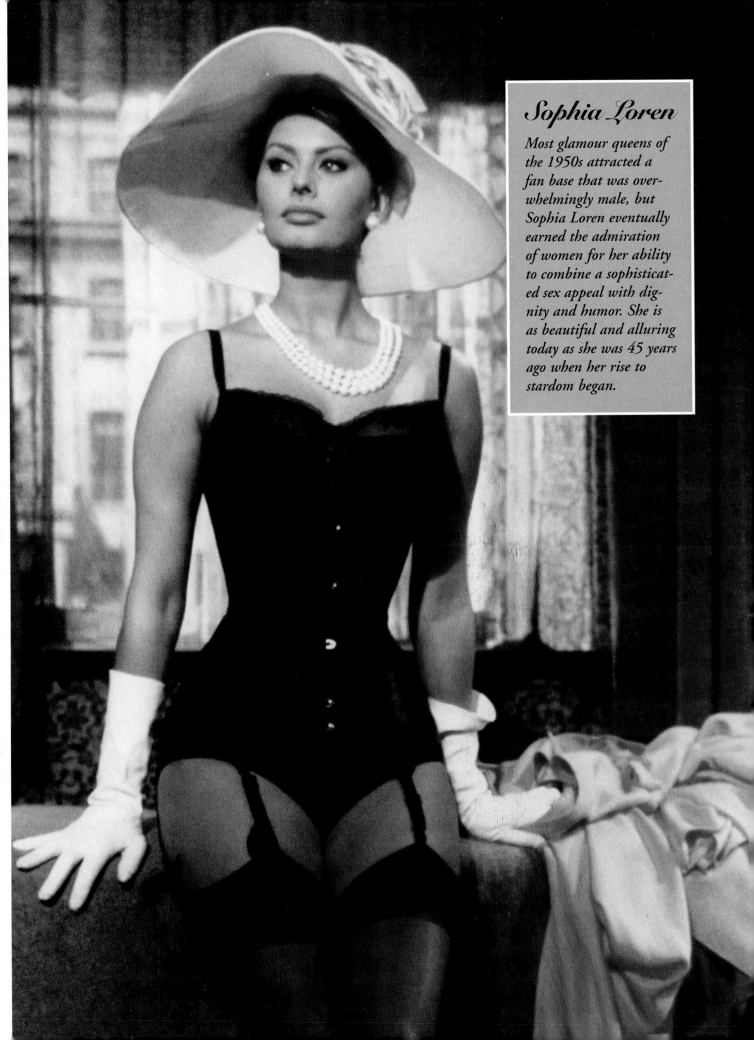

Sophia Loren

Most glamour queens of the 1950s attracted a fan base that was overwhelmingly male, but Sophia Loren eventually earned the admiration of women for her ability to combine a sophisticated sex appeal with dignity and humor. She is as beautiful and alluring today as she was 45 years ago when her rise to stardom began.

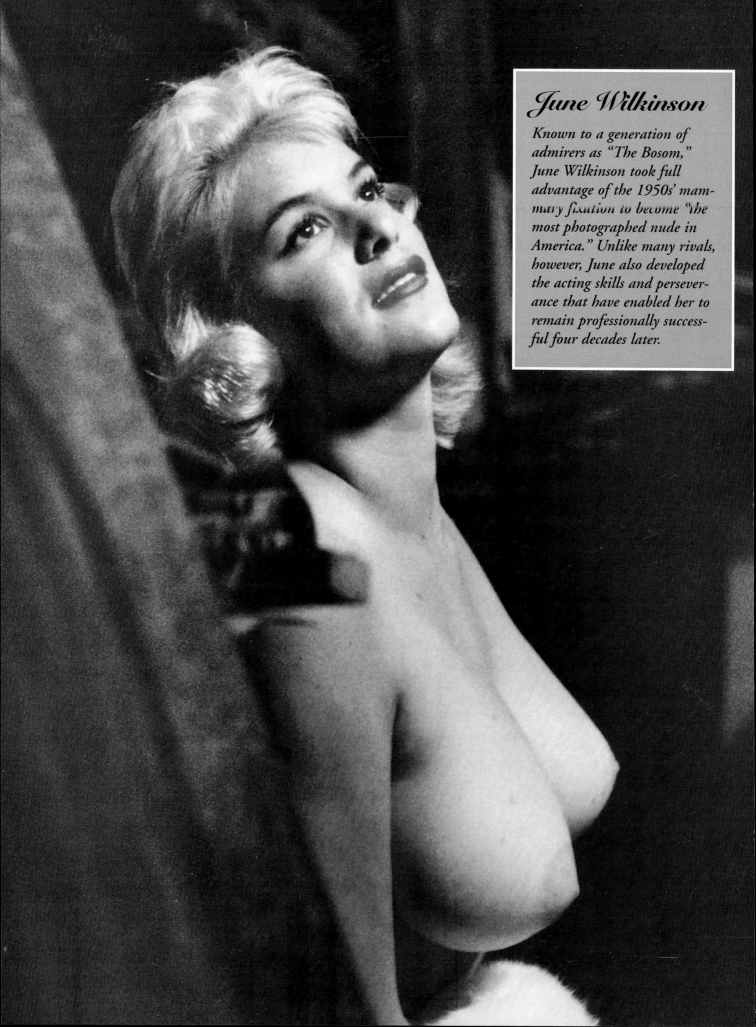

June Wilkinson

Known to a generation of admirers as "The Bosom," June Wilkinson took full advantage of the 1950s' mammary fixation to become "the most photographed nude in America." Unlike many rivals, however, June also developed the acting skills and perseverance that have enabled her to remain professionally successful four decades later.

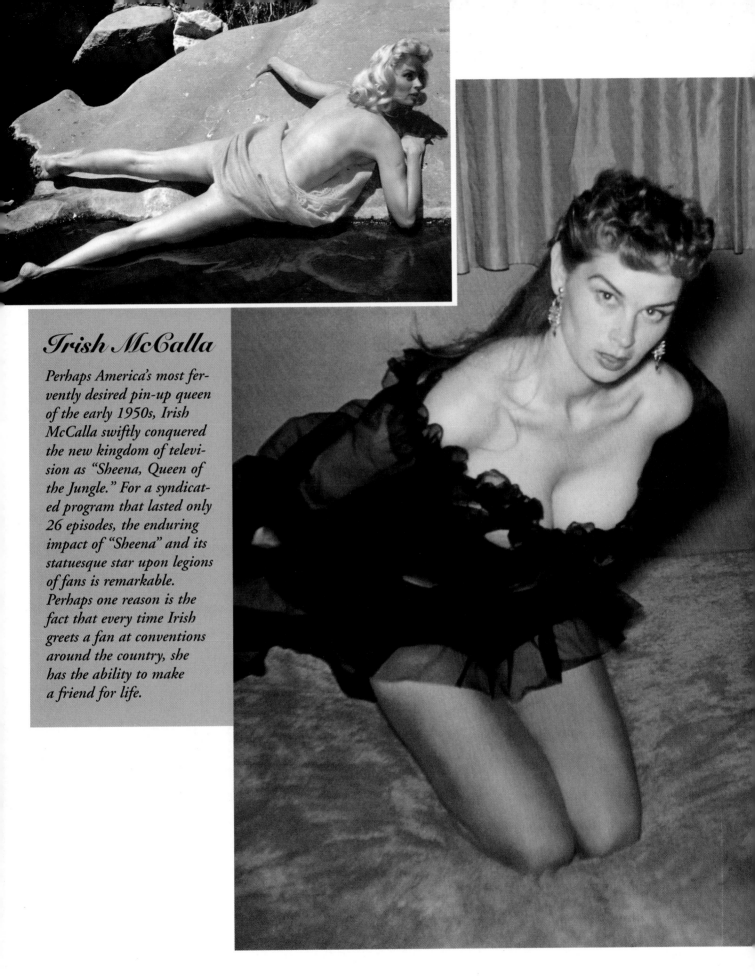

Irish McCalla

Perhaps America's most fervently desired pin-up queen of the early 1950s, Irish McCalla swiftly conquered the new kingdom of television as "Sheena, Queen of the Jungle." For a syndicated program that lasted only 26 episodes, the enduring impact of "Sheena" and its statuesque star upon legions of fans is remarkable. Perhaps one reason is the fact that every time Irish greets a fan at conventions around the country, she has the ability to make a friend for life.

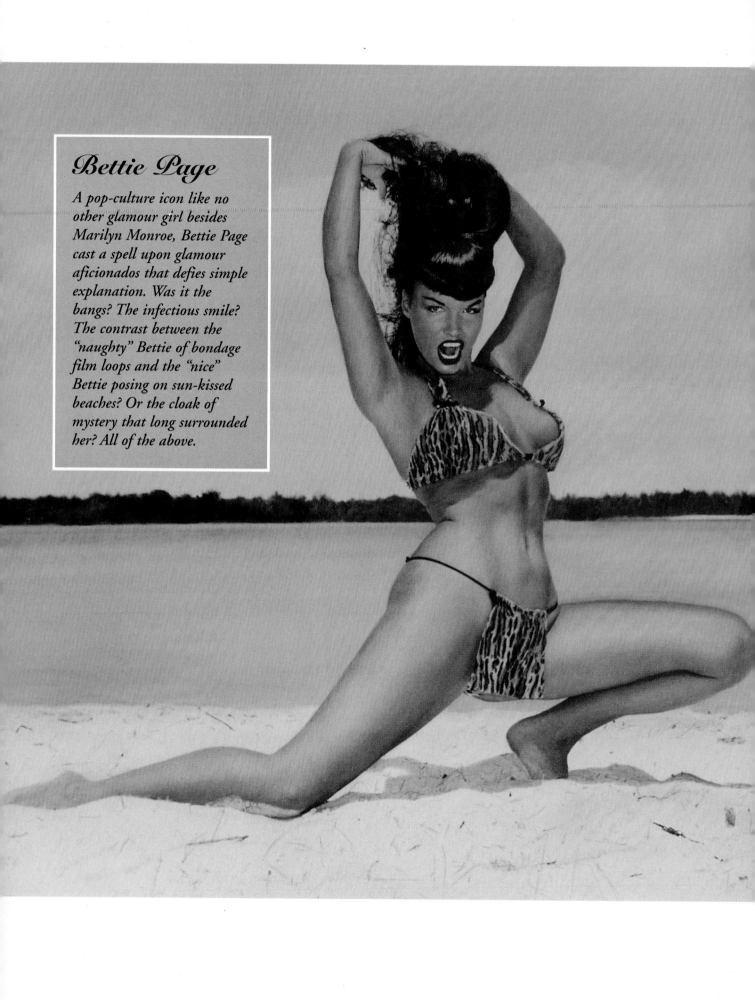

Bettie Page

A pop-culture icon like no other glamour girl besides Marilyn Monroe, Bettie Page cast a spell upon glamour aficionados that defies simple explanation. Was it the bangs? The infectious smile? The contrast between the "naughty" Bettie of bondage film loops and the "nice" Bettie posing on sun-kissed beaches? Or the cloak of mystery that long surrounded her? All of the above.

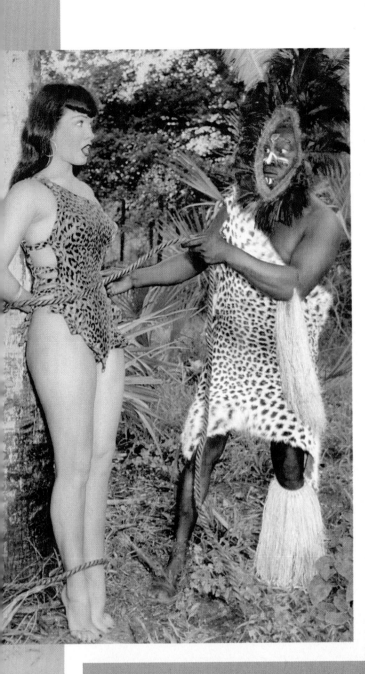

Betty Brosmer

The Golden Girl of the pin-up world, the sources of Betty Brosmer's appeal can be seen in virtually every one of her many magazine covers. She represented feminine perfection: the ultimate hourglass figure with that impossibly tiny waist, impeccable blonde beauty, and a warm California-girl aura.

MODERN

MAN

THE ADULT PICTURE MAGAZINE

OCTOBER 1956 50c

MASTER OF THE SEX STORY

MY BATTLE
WITH THE CENSORS
By VALLKYRA

HOLLYWOOD'S
MOST CHASED CHASTE
PINUP GIRL

Betty Brosmer

Who could resist the attraction of this fantasy girl next door?

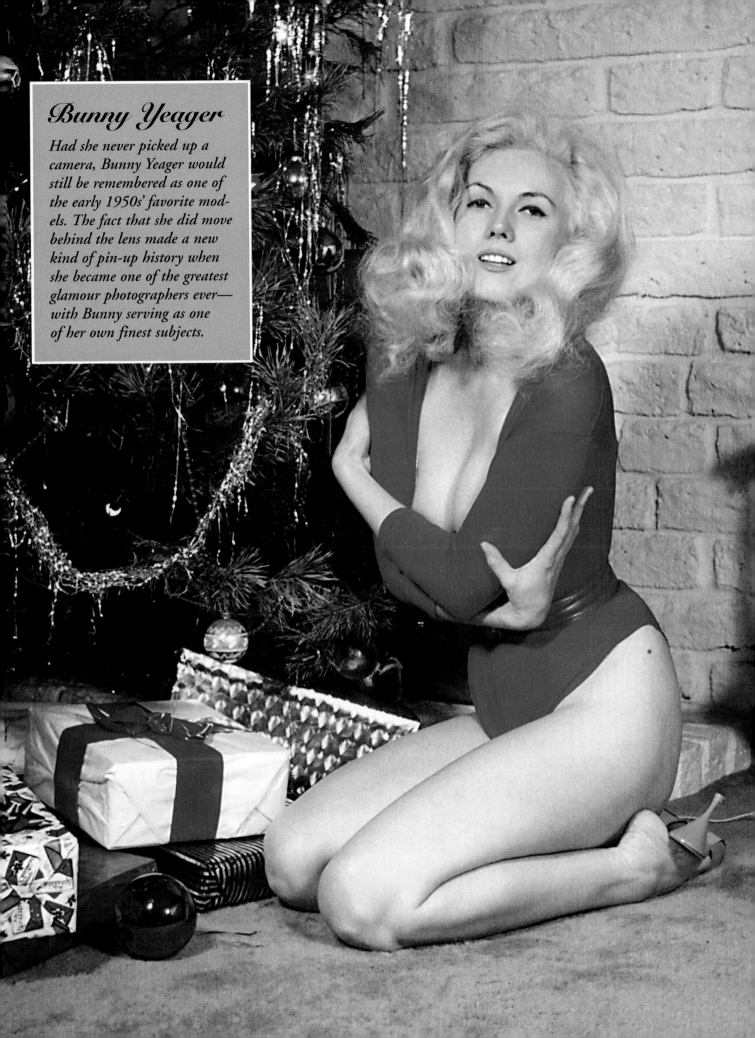

Bunny Yeager

Had she never picked up a camera, Bunny Yeager would still be remembered as one of the early 1950s' favorite models. The fact that she did move behind the lens made a new kind of pin-up history when she became one of the greatest glamour photographers ever— with Bunny serving as one of her own finest subjects.

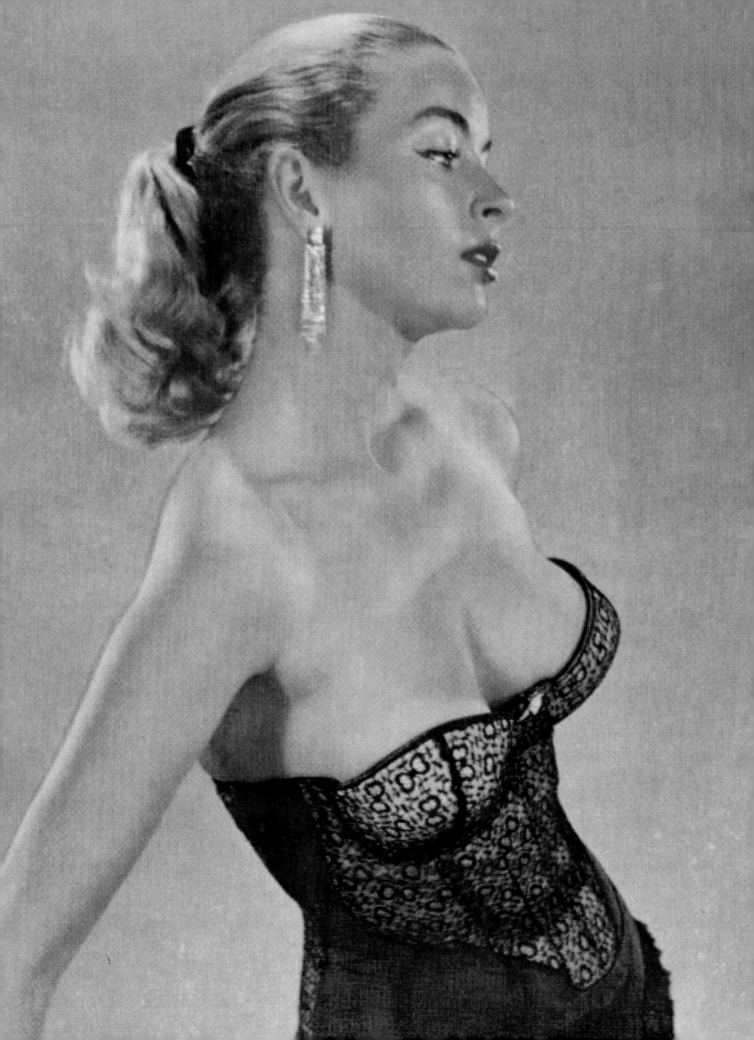

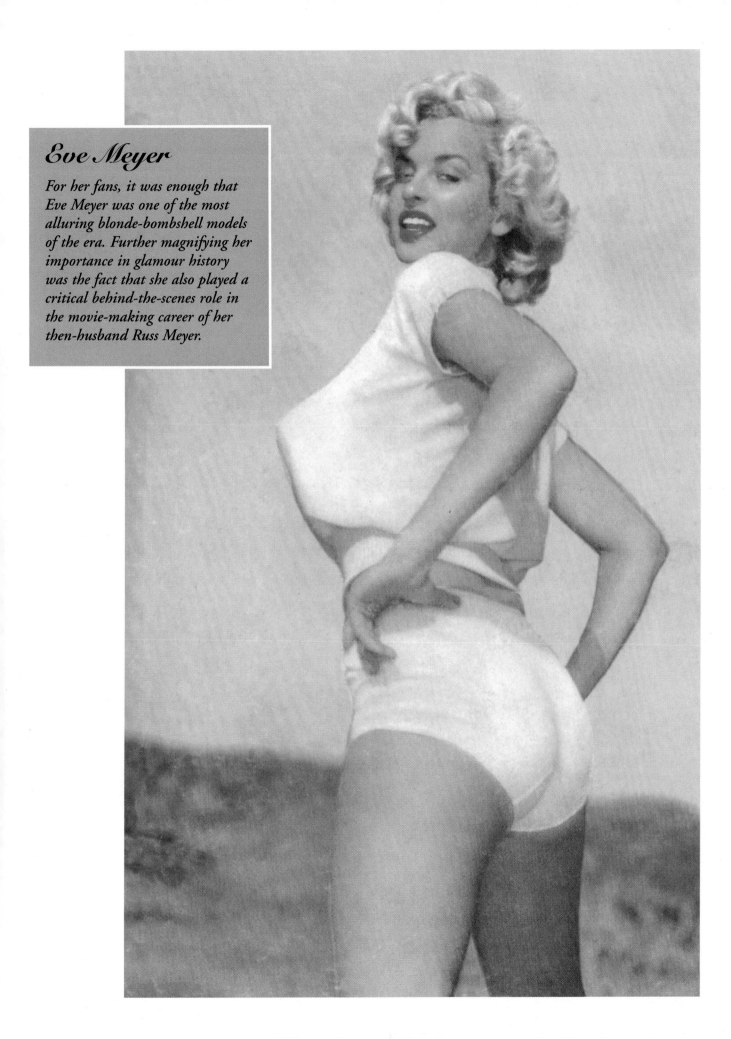

Eve Meyer

For her fans, it was enough that Eve Meyer was one of the most alluring blonde-bombshell models of the era. Further magnifying her importance in glamour history was the fact that she also played a critical behind-the-scenes role in the movie-making career of her then-husband Russ Meyer.

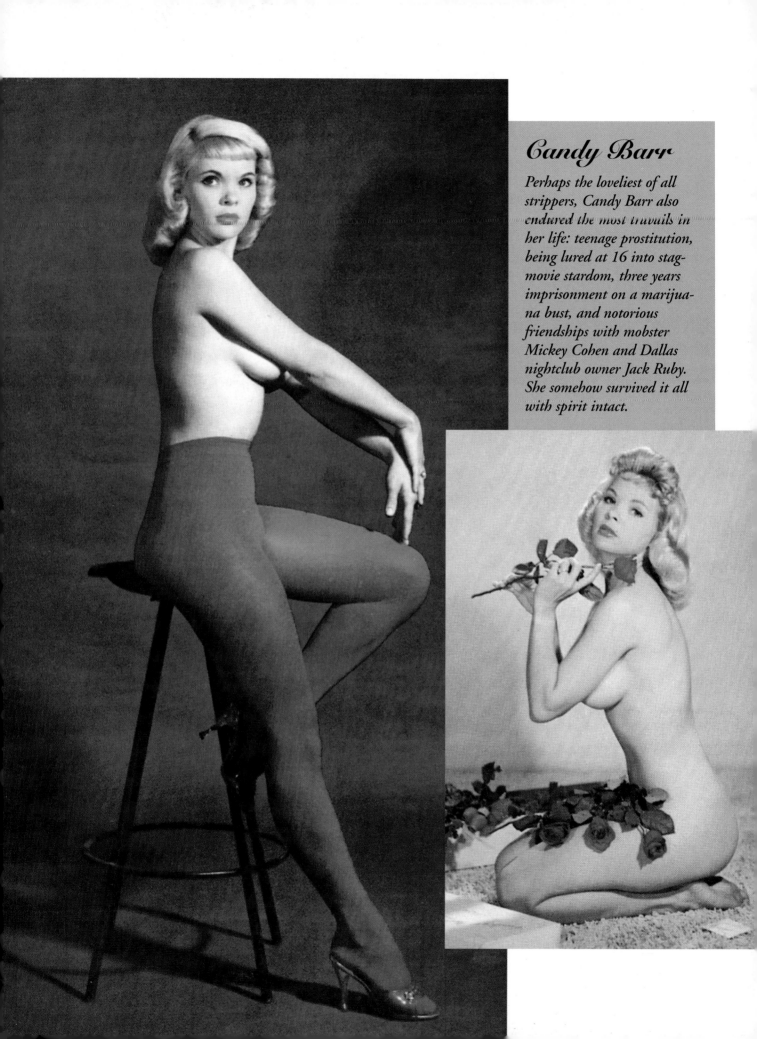

Candy Barr

Perhaps the loveliest of all strippers, Candy Barr also endured the most travails in her life: teenage prostitution, being lured at 16 into stag-movie stardom, three years imprisonment on a marijuana bust, and notorious friendships with mobster Mickey Cohen and Dallas nightclub owner Jack Ruby. She somehow survived it all with spirit intact.

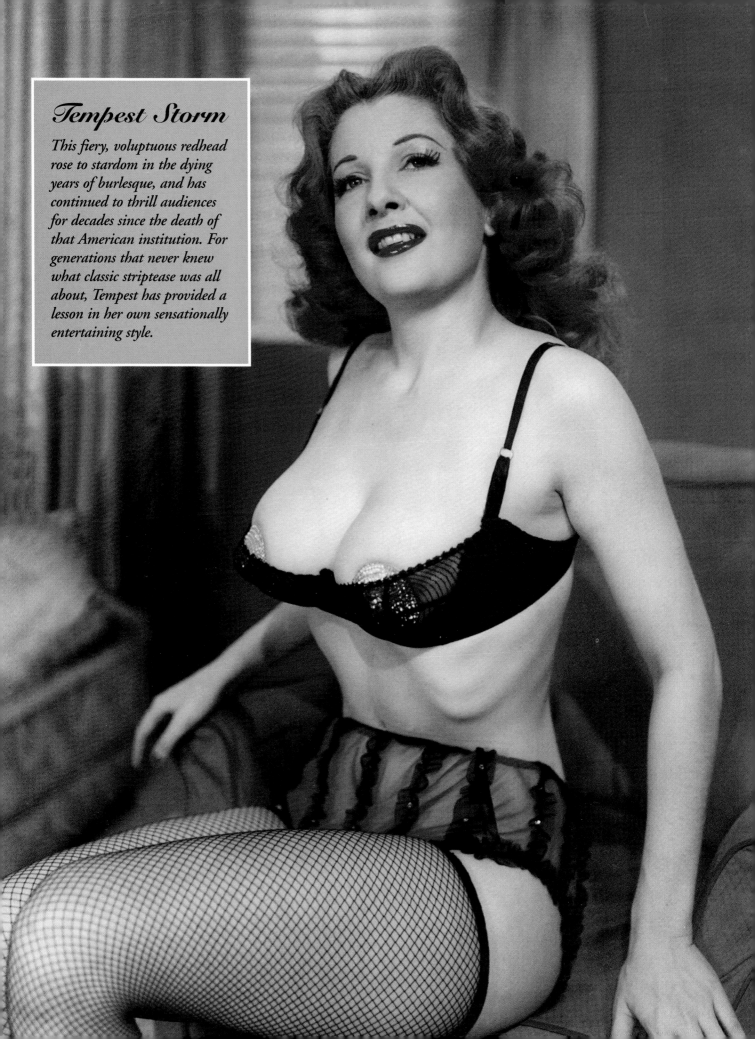

Tempest Storm

This fiery, voluptuous redhead rose to stardom in the dying years of burlesque, and has continued to thrill audiences for decades since the death of that American institution. For generations that never knew what classic striptease was all about, Tempest has provided a lesson in her own sensationally entertaining style.

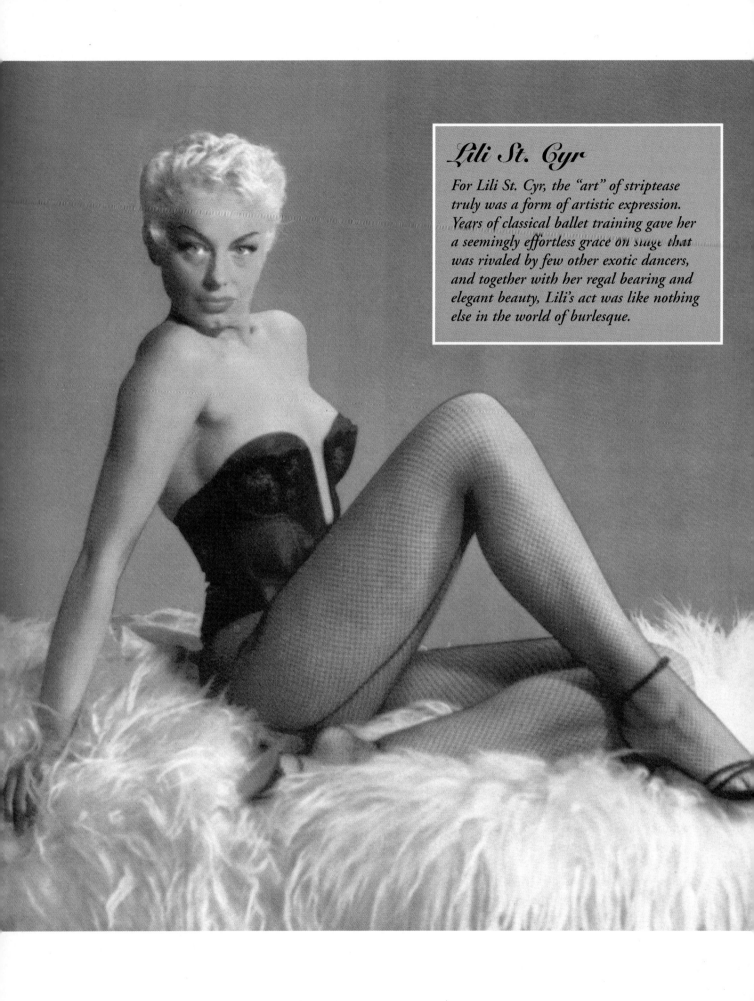

Lili St. Cyr

For Lili St. Cyr, the "art" of striptease truly was a form of artistic expression. Years of classical ballet training gave her a seemingly effortless grace on stage that was rivaled by few other exotic dancers, and together with her regal bearing and elegant beauty, Lili's act was like nothing else in the world of burlesque.

lap as every viewer imagines himself in its place.

Betty's Dance in Black Lace Panties: A delightful change of pace, as Betty emerges from behind the curtains like a stripper, first extending her stockinged leg, then undulating in frilly black bra and panties as she smiles. There are some high kicks in the ever-present high heels, and some playful yet convincing bumps and grinds.

Betty's Exotic Dance in High Heels: In white bra, panties, black stockings, and six-inch high heels, Betty lies on the sofa, rises to touch her toes, undulates energetically, and blows a kiss to the audience. There are frequent closeups of fetishists' beloved stockings and high heels.

Betty's Hat Dance: Clad in black bra and panties and stockings, Betty shimmies sexily with a floppy black hat, placing it over her rear as she shakes, waving it, and using it to cool herself. She fetchingly wears the hat for awhile, does some high kicks, and seems very pleased with herself as she performs a split on the floor. After doing some stretching exercises, she blows a kiss.

Betty's Lingerie Tease Dance (Parts 1 & 2): In a two-piece bathing suit, Betty swirls about, teasingly pretends to start removing her bra, and with a happy smile holds up a succession of naughty underthings, playfully seeing how they'd look on her. That heart-melting smile is very much on display as she wiggles, caresses her body, leans back to show off her limber form, and blows some more kisses.

Captured Jungle Girl: Our heroine, dressed in leopard-skin bra and bikini panties, is captured by model Sima Cairo. "Sima then prepares an elaborate network of ropes and pulley gadgets to which Betty is bound securely and gagged and then raised completely off the floor while spreadeagled hands and feet." This two-part movie, 100 feet each, provided the basis for the best selling bondage stills ever taken of Betty.

Chemise Dance: Betty dances with abandon and happiness in black chemise, dark stockings, and black patent-leather shoes with six-inch high heels. She plays with her stockings, wiggles, and caresses her body.

Dance of Passion: In long black stockings and scanties, Betty "dances especially as if the camera were her boyfriend." Her dancing is particularly sensuous here, including some vigorous hip-wiggling with her back to the camera. As always, she appears to delight in giving her viewers pleasure, with blown kisses and her patented pouting expression.

Delightful Betty Dresses Up: We see Betty walking around in those ever-popular six-inch high heeled black patent leather shoes, putting on stockings and a black satin skirt, and strutting around before going out on a heavy date.

Domineering Roz Strikes Back: Oh no! Roz Greenwood returns as Betty's domineering mistress, cracking her whip while waiting for maid Betty to dress her. Betty dresses Roz up in sweater and short satin skirt, "and when Roz asks how she looks, Betty's gestures make Roz mad enough to pull Betty over her knees and spank her soundly" at the end.

Bettie viewed her fetish and bondage posing for Irving Klaw as just a lark. "The other models and I enjoyed doing these crazy things," she told Bunny Yeager in 1993. "We just died laughing."

Dream Dance by Betty: An intriguing departure, as Betty holds up 8x10 glossies of a couple of fellows—one of them apparently Irving Klaw—kisses the pictures, and dances in black scanties.

Escape Out of Bondage: Opens with Betty securely gagged and bound to an elaborate contraption which leaves her dangling above the ground. She finally succeeds in biting off her ropes, and rubs her numb stockinged legs upon freeing herself.

Flirtacious Dance by Betty: Clad in a white bikini, Betty gyrates with particular energy, with closeups of her wiggling fanny, and does some kicks.

French Garter Fight (1955): Betty and Jackie Lens are in a nightclub; each has only one garter, and they do battle to get the other's.

G-String Dance: Betty performs an exotic dance in a net bra and G-string. This is one of her most energetic and enticing performances, as she rises from the sofa and tosses her lovely torso with gusto, appearing to enjoy every minute.

Hobbled in Kid Leather Harness: Treacherous times once again for Betty. She is forced by model Patricia Midblane to don a specially made kid leather harness, and when Betty is slow, she is spanked. Both girls wear bras and panties with (of course) black stockings.

Joyful Dance by Betty: Well-titled, as this sensuous performance includes more lingering closeups of her beaming face than usual, and numerous kisses blown to the camera as she plays to the audience.

Peppy Graceful Dance: She dances in dark stockings and fancy garters, using a hat as a prop, and at the end thrusts her fanny playfully at the camera.

Pin-Up Beauties Fight: Betty and model June King, both attired in bra and panties with dark stockings, do battle with energetic wrestling and hair-pulling.

Second Initiation of the Sorority Girl: Roz Greenwood is chained up and struggling against tormentor Betty, with both girls in black bra, panties and high heels. Betty commands her to squat down and spanks her as Roz pleads for mercy. Betty wags her finger in Roz's face and forces her to hobble around in leg chains.

Spanish Shawl Dance by Betty: This time she begins fully attired in a long black dress before removing the wrap-around shawl, which she then waves about like a bullfighter as she shimmies sensuously.

Tambourine Dance: Betty, in semi-transparent black bra and panties, shakes and shimmies with maracas and then with a tambourine. After some kicks and loving closeups of her black stockings and high heels, she swivels her hips with abandon.

Tantalizing Betty Dances Again: Betty brushes her long hair, shows off her stockings and high heels, and uses first a black cape, then a black fur, as a prop as she dances. For all the mildly suggestive bumps and grinds, it's that incandescent smile that really does it.

Teaser Girl in High Heels: A glamorous Betty in white nightgown strips down to black bra, panties, stockings and high heels. She combs her hair, fiddles with her stockings, and kicks her legs up teasingly for the camera.

Undressing for Comfort: The dark angel returns home and, finding her room hot and uncomfortable, gets down to bare essentials. "After getting down to her stockings, she suddenly discovers she forgot to pull down the window shades!"

Waltzing in Satin Scanties: Not exactly a waltz, to be sure. She opens a white robe to reveal a black net bra with sequined pasties and her satin panties. After dancing she hugs herself girlishly, and laughs happily at the end as she beckons us closer.

Then there are her three full-length features and latter-day film compilations:

Strip-o-Rama (released October 1953): Bettie appears in a bubblebath scene clad in white bikini, billed as "The Most Daring Bath Scene Ever Filmed," and in a bit with two burlesque comedians as they fantasize about her in an Arabian outfit. Lili St. Cyr is the headliner, with Georgia Sothern and Rosita Royce also performing.

Varietease (released fall 1954): Bettie serves as the opening act in Irving Klaw's first full-length film feature. The burlesque revue's host, Bobby Shields, introduces her as "the sultry siren of the Southland." Clad in a slinky sequined harem outfit with bare midriff, Bettie performs a veil dance that lasts about 7 or 8 minutes. Beaming and winking to the audience, she sashays about the stage to pseudo-Arabian music. When the music switches to a stripper-like theme, she performs a modified hoochie-coochie dance and strikes seductive poses, using her veils as props. Bettie does not appear again in the film, which stars Lili St. Cyr and includes everything from striptease to a comic ballroom dance routine and a female impersonator.

Teaserama (early 1955): Tempest Storm and Bettie (second-billed as "Nation's Number One Pin-Up Queen") are the headliners of Klaw's second feature, as both perform sizzling strip routines (although nothing is really exposed). Once again, Bettie opens the revue in a skimpy red showgirl outfit with black stockings. She does a little soft shoe, shimmies and shakes a bit, performs some medium kicks, and at the end turns her back to the audience and wiggles her fanny.

After a baggypants comic routine featuring Joe E. Ross, Tempest Storm is featured in a sketch depicting the start of the glamour queen's day as she rises from bed. After a moment or two, she claps her hands to summon Bettie in a cute little maid's black skirt with white apron. Bettie helps Tempest put on her corset, adjusts her mistress' stockings and smooths them along her legs, and then combs Tempest's long red hair. After Bettie helps Tempest pull on long black gloves and zip up her evening gown, she mimics Tempest's regal strut mistakenly thinking that she isn't being watched. An annoyed Tempest pulls Bettie's hair in retaliation to conclude the 10-minute sequence.

Happily, Bettie is a constant presence in this film, coming on stage in a succession of sexy little outfits to silently introduce each act (including stripper Cherrie Knight, blonde Klaw model Trudy Wayne, and assorted comics and dancers) with a name card. Near the end she brings her own name card out, looks at it with an adorably startled "who—me?" look, and then performs a 6 to 7-minute routine. Bettie treats us to her favorite poses, hip-wiggling, caresses of her stockinged legs, and endearing facial expressions, first in a black showgirl skirt and then in black bra with sequined gold panties. Like Klaw's first feature, this ran slightly over an hour and was in color.

To the utter delight of Bettiephiles everywhere, both *Varietease* and *Teaserama* were rediscovered in early 1993 by famed B-movie producer David Friedman, and are now commercially available from Something Weird Video in gloriously clear, full-color prints.

Striporama, Vol. 2: For her part in this latter-day video compilation, Bettie performs a "Fireplace Dance." She sits in bikini and stockings by a fireside, looking like an exuberant, teasing vixen, rolling her legs around, then lying down and kicking her legs up. Demonstrating how limber she was, Bettie holds her upper body in the air, almost pulling her bottom up over her head. Short and sweet.

Betty Page: America's Pin-Up is a 1980s film compilation that pulls together many of Bettie's routines from '50s features and film loops: her "hat dance," shimmying in bra, panties and black stockings while using a hat as a sensuous prop; a teasing, sexy variation on the dance of the seven veils; an energetic, straightforward bump-and-grind dance; shaking her maracas to the music; an imaginative and suggestive "clown dance"; one topless sequence; and finally bad-girl Bettie being spanked by another beauty.

Back to Back Betty is a splendid (if grainy) Movie Star News compilation of more than 15 of Bettie's film loops, excluding any bondage performances. Other Movie Star News videos featuring Bettie include *The Bound Beauties of Irving Klaw*, and MSN videos Volumes 3 through 7 which include some Bettie shorts along with various other Klaw models. (Available at Movie Star News at 134 West 18th St., New York, NY 10011-5403.)

The Betty Page Story (1991): Chicago psychotronic film buff Michael Flores' narration to this documentary is admittedly amateurish and contains many factual errors, but this video is nonetheless a "must" for Bettiephiles because of its use of high-quality European prints of numerous BP bondage film shorts, all appearing much sharper than the versions available from MSN.

As Bettie's fame grew, she became the object of a million male fantasies. One of those ardent fans was Warren Nussbaum. In the summer of 1954, he had just completed his service as a paramedic in the Army, and was still in uniform when he had the opportunity to meet his dream girl. "I can still remember when I met Bettie at the Heat Wave nightclub in Greenwich Village," he says wistfully today. "I was 21 years old with stars in my eyes." Perhaps because his uniform caught her eye, Bettie spoke with Nussbaum, and autographed an 8x10 photo for him. Today he is one of the best-known dealers in vintage men's magazines, and that photograph, one of his most prized possessions, is one piece of memorabilia he will never sell.

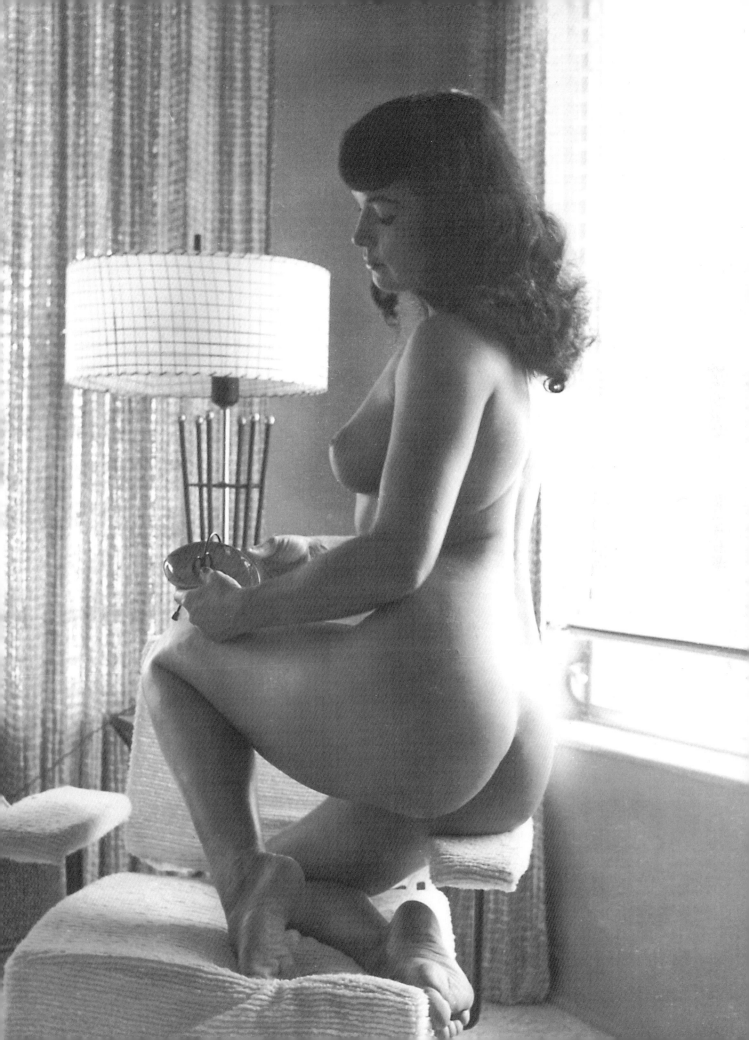

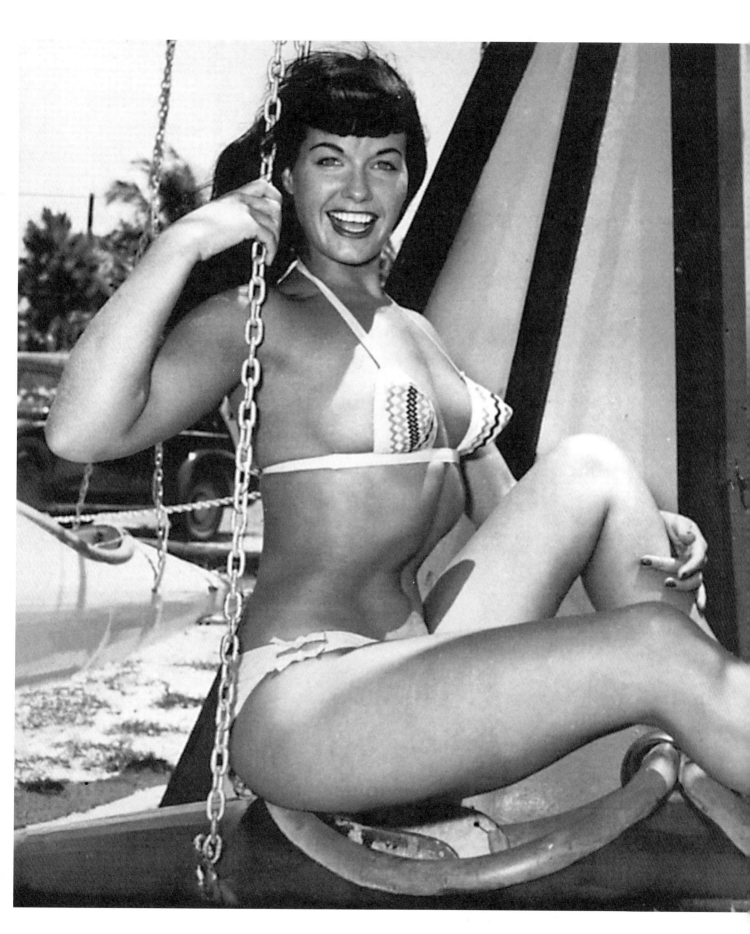

Throughout the early-to-mid-'50s, Bettie continued to pursue her legitimate acting aspirations. She told Greg Theakston in a 1993 interview (for *The Betty Pages* Annual 2), however, that while "I was interested in being an actress . . . I didn't do anything about it. I waited too late in years before I started studying, and I never even tried out for Broadway or off-Broadway." Three plays in which she is known to have appeared were Tennessee Williams' *Camino Real* (staged in Roslyn, Long Island, with Bettie as Esmerelda, the sensual gypsy girl); a production of *Gentlemen Prefer Blondes*, in which she had a small part, and a February 1956 drama entitled *Time Is a Thief*, staged at Manhattan's Finch Playhouse. She played summer stock at the Greenbush Summer Theater in Rockland County in 1952, and at the Seacliffe Summer Theater (Long Island) two years later. Bettie studied acting for about three years with Herbert Berghof, and applied (unsuccessfully) for classes at Lee Strasberg's famous Actors Studio.

Her television appearances are believed to have included a role as a Mexican girl in *Eye Witness* (1953) and appearances on the Steve Allen and Red Skelton variety programs. These, however, are unconfirmed, and Bettie herself recalls only two appearances on TV: a small dramatic role on the *U.S. Steel Hour*, and a bit as "1955's Pin-Up Girl of the World" on a show hosted by syndicated columnist Earl Wilson. During this same period, Howard Hughes contacted Irving Klaw in an effort to add Bettie to his stable of closeted starlets, but she rebuffed a request to meet him.

In addition to her accent and frequent lateness for appointments, Bettie faced another difficulty as an actress: the low timbre of her voice. When Robin Leach played the tape recording of Bettie's recollections on his December 1992 show, most viewers assumed that her low, rather throaty vocal quality was a function of her age. Bunny Yeager notes that in fact, she sounded that way in the 1950s, a characteristic that certainly clashed with producers' expectations in an era of typically high-voiced female sex symbols. But while Bettie Page the actress faced continual frustration, she always knew that she was incapable of failure with the still photographers who clamored for her at every opportunity.

The Camera Clubs: Heaven On a Sunday

One of the most fascinating elements of Bettie's pin-up career was her "camera club" appearances, beginning almost immediately after her modeling career was launched in late 1950. Groups of amateur and professional photographers would arrange weekend shootings in the New York tri-state area, sometimes in studios and occasionally at remote outdoor locations, and hire models to pose. Many of Bettie's camera club sessions were done through the Concord Circle, organized by Jamaican bandleader Cass Carr and headquartered at DeLogue Studios on West 47th Street, not far from Bettie's apartment. No top model participated in more of these sessions than Bettie, who was typically paid $25 for the day, and the results were often startling.

No matter how provocative the Klaw photos became,

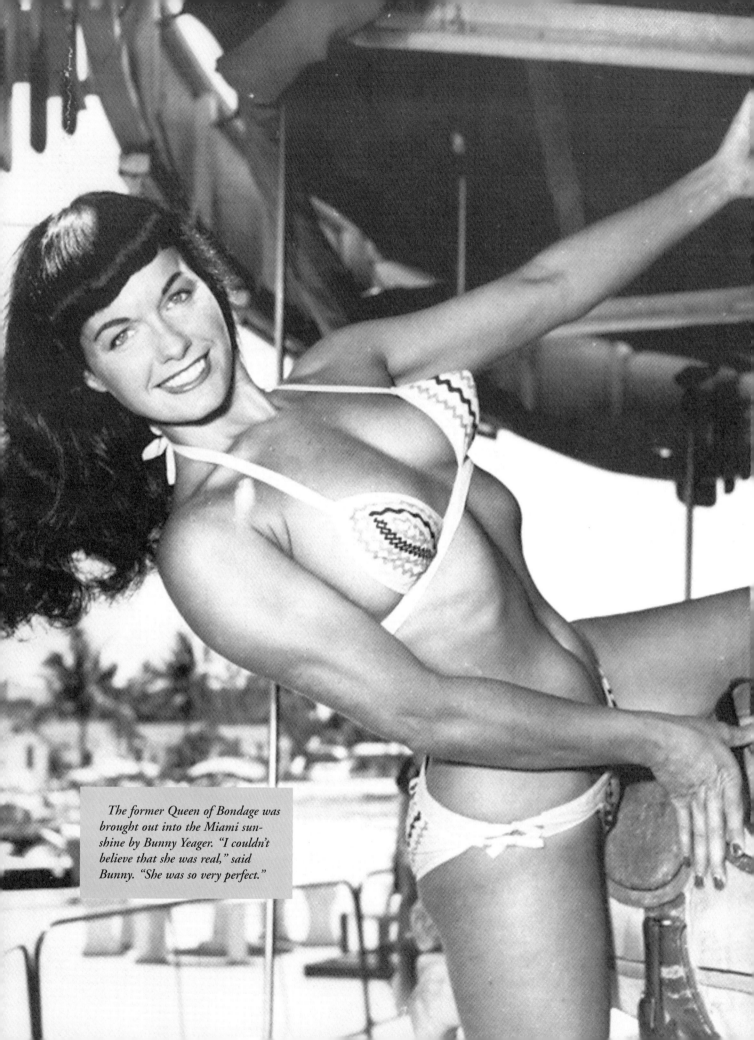

The former Queen of Bondage was brought out into the Miami sunshine by Bunny Yeager. "I couldn't believe that she was real," said Bunny. "She was so very perfect."

none ever involved any nudity in deference to existing legal restrictions. No such limits applied to these private shootings, and Bettie for one had no hesitation to go much further than any magazine would ever allow. More and more of these pictures of Bettie have turned up over the years from the photographers' private collections, and include not only full frontal nudity, but some shots that would raise eyebrows even today. Bettie's camera club appearances continued until the fall of 1957.

Among all the camera club photographers, none took more stunning pictures of Bettie than Art Amsie, a former engineer and independent contractor for the U.S. government and some defense companies. Today, Amsie is a nationally-recognized authority on the great pin-up artist Gil Elvgren, whom he befriended late in the artist's life, and is working on an Elvgren book. A Bettie Page fan ever since he discovered her pin-ups at Movie Star News, Amsie moved to Elmhurst, New York in the summer of 1956 and joined the Concord Circle as soon as he discovered that it would enable him to shoot Bettie. A couple of years earlier, after seeing some 3-D Klaw shots of Bettie, Amsie had been so dazzled that he bought a stereoscopic camera. Now he would have the opportunity to use it on his ultimate subject.

Under the Concord arrangement, says Amsie, "you paid Cass Carr about $10 each for a shooting session, he paid the top model, and we took along five or six amateurs who wouldn't get paid. Cass would then say, if you're interested in this girl, we can set up a studio session. But the guy who took the car to the session didn't have to pay. Bettie used to ride with me. I made sure that she got in the front seat. When 30 guys went, they took about five cars. My car had five people—three guys in the back, and Bettie and me in front. I'd spend almost $10 in gas and tolls to get over to Fire Island, along with the time involved. But it was all worth it to have Bettie in the front seat."

Amsie emphasizes that it was all strictly professional—he never asked Bettie or any of the other models for a date. "We'd mainly talk about news, politics, or whatever, not about photography or anything personal." They would typically leave around noon on a Sunday and take about an hour to get to Fire Island or other designated locale, where Carr would sometimes rent a cabin cruiser. The session itself might run about four hours, and they'd be back by 6 p.m.

"When we'd drive out, the others would say, 'Art, are you going to shoot Bettie?'" he recalls. "And I'd say, 'oh, I've got a whole bunch of photographs of her, I want to shoot the new girls.' Then after I'd shoot several poses of one or two of the new girls, I'd always go back to Bettie. She was so good." From a physical standpoint, Bettie's "best part," he says, was "from the rib cage to the pelvic arch. She had a torso that undulated incredibly. That's one of the reasons I loved her, along with that adorable face."

From a broader perspective, he continues, "Bettie's most important quality was that she put out for everybody. Whether she was working for Bunny Yeager or Art Amsie, she'd give her best." One proof was a raw, windy May session on Fire Island when all the other models were huddling under a blanket; "Bettie was cavorting in the surf for me, looking as if she was having a great time. I got some great shots of her that day. She was so professional. She would put out her best effort for whoever it was, and that made her the absolute, unequalled queen of the pin-ups."

No less an authority than Bob Schultz says that Amsie's 3-D photographs of Bettie (about 150 in all) rank in beauty with the finest work of Bunny Yeager or other top photographers. These were strictly bikini shots, since Carr would not allow nudes after a brief run-in with police a few years earlier. Most of the full-frontal nudes of Bettie from camera club sessions were not from the Concord Circle.

"Bettie was so professional that I wouldn't have to give her posing directions as I would with the other models. I'd just give her some general suggestions and then say, 'Bettie, give me some poses of your own.' And they were great. She was the Babe Ruth, the Michael Jordan of pin-ups, and no one can come close to her. Bettie was the Gil Elvgren of the pin-up models, and for me that's the ultimate compliment!"

In listing Bettie's magazine appearances, we have attempted to be relatively comprehensive for her historic early (pre-1953) layouts, and thereafter have limited ourselves primarily to covers, centerfolds and other "major" appearances for purposes of space. It should be noted that the cover of *Good Photography* #11 in 1949, sometimes cited as Bettie's first magazine appearance, actually pictures model Kevin Daley, who would often be mistaken for Ms. Page. Bettie's pre-1955 magazine appearances (her name usually spelled as "Betty") included:

Oct. 1950 *Art Photography* (1 page)
May 1951 *Art Photography* (1 page)
Aug. 1951 *Eyeful* (3 pages) *Flirt* (2 pages)
Sept. 1951 *Beauty Parade* (1 page)
Sept. 1951 *Whisper*
Oct. 1951 *Eyeful*
Oct. 1951 *Flirt*
Oct. 1951 *Wink* (1 page)
Dec. 1951 *Eyeful* (2 pages—still "bangless" at this point)
Dec. 1951 *Titter* (centerfold)
Dec. 1951 *Wink* (1 page)
Model and Cartoon Parade #53 Jan.-Feb. 1952: The cover of Irving Klaw's semi-annual catalog featured Bettie, and marked the beginning of their historic association.
Jan. 1952 *Whisper*
Feb. 1952 *Flirt* (2 pages)
Feb. 1952 *Wink* (1 page)
Mar. 1952 *Beauty Parade* (2 page, 7 pictures in gag strip)
Apr. 1952 *Eyeful* (2 pages)
May 1952 *Whisper* (2 pages)
June 1952 *Art Photography* (excellent nude study)
June 1952 *Eyeful*
June 1952 *Flirt*
June 1952 *Wink* (1 page)
June 1952 *Titter* (1 page, plus 2-page humorous strip "They're In the Navy Now")
Aug. 1952 *Eyeful* (2 pages)
Aug. 1952 *Wink* (2 pages)
Sept. 1952 *Beauty Parade* (1 page, bangless)

Sept. 1952 *Gala* (2 pages)

Oct. 1952 *Eyeful* (2 pages)

Oct. 1952 *Flirt*

Oct. 1952 *Titter*

Oct. 1952 *Vue*

Oct. 1952 *Wink* (1 page)

Irving Klaw Bulletins #56, 63, 66, 74, 75, 77 (all c. 1953)

Jan. 1953 *Beauty Parade* (2 pages)

March 1953 *Gala* (fine full-page portrait)

Cartoon and Model Parade 72nd Edition (c. 1953): Irving Klaw catalog which includes an extensive account of Bettie's many film shorts, along with her still photos.

June 1953 *Titter* (3 pages)

July 1953 *Beauty Parade* (2 pages)

July 1953 *Gala* (2 pages)

July 1953 *Whisper* (2 pages)

Aug. 1953 *Dare* (back cover, 4 pages featuring Bettie in costume at the Ballyhoo Ball)

Aug. 1953 *Eyeful* (cover in lingerie, long back gloves and high heels; Bob Schultz reports that this was her only cover in all her Harrison-magazine appearances)

Sept. 1953 *Ellery Queen's Mystery Magazine* (cover)

Oct. 21, 1953 *People Today* (4 pages of Bettie demonstrating "how much a girl can discard—and still stay legal at various burlesque houses across the country.")

Dec. 1953 *Titter* (2 pages)

Irving Klaw Bulletins #86, 87, 88, 90, 93, 95 (all c. 1954)

Follies de Paris #150 (c. 1954; 2 pages)

Jan. 1954 *Beauty Parade* (2 pages)

Feb. 1954 *Tale* (1 page, 4 pictures of Bettie girl-wrestling)

Feb. 1954 *Eyeful* (centerfold)

Mar. 1954 *Art & Camera* (2 pages nude, uncredited)

Apr. 1954 *Wink* (comic 2-page lingerie sequence: "They Ain't No Gentlemen!")

July 1954 *Gala* (2 pages)

Fall 1954 *Peep Show* (7 pages)

Oct. 1954 *Bare* (inside back cover)

Oct. 1954 *Brief* ("Miss Irresistable," an absolutely terrific 7-page Bunny Yeager layout of a bikiniied Bettie on a Miami beach; Bettie has seldom looked so gorgeous and sunny)

Oct. 1954 *Eye* (7 pages, 10 lovely pictures)

Oct. 1954 *Frolic* (3 pages)

Oct. 1954 *Modern Sunbathing*

Nov. 1954 *Bare* (sexy cover)

Nov. 1954 *Brief* (6 pages, more Bettie on the beach)

Nov. 1954 *Jest* (cover)

Nov. 1954 *Modern Man* (1 page by Bunny Yeager, a lovely nude crouched on a chair)

Nov. 1954 *Photo* (8 pages, 11 terrific bikini pictures)

Dec. 1954 *Eyeful* (comic sequence of Betty in the slammer, "Pretty Larceny!")

Dec. 1954 *Man's Magazine* (cover, on beach in red negligee, plus 3 pages, 15 total pictures by Jan Caldwell)

Dec. 1954 *Show* (cover, in bikini)

Cartoon & Model Parade #91 late 1954 (splendid lingerie cover of Bettie following release of *Varietease*)

Bunny Yeager Brings in the Sunshine

Meanwhile, as her fame spread, Bettie found herself in demand by virtually every girlie magazine in the country. In the summer of 1954, she was on one of her periodic visits to her favorite vacation getaway, Florida, to visit her sister in Coral Gables when she met a woman who was to help change the course of her career. Bunny Yeager was one of the most popular young models on the Florida scene, but during the preceding year she had begun to explore the other side of the lens as a glamour photographer. She was just starting out, lacking the professional comforts of a studio, and had just begun to make her first sales to magazines with photos of other Miami models such as Jackie Walker and Maria Stinger. When Bunny and Bettie got together, it turned out to be a match made in heaven.

"I couldn't believe that she was real," says Bunny today. "She was so very perfect. Her skin was tanned and flawless—no freckles, moles or blemishes, just satiny smooth. And her hair was shiny black, squeaky clean, and every hair in place. Her makeup was flawless, too; not too much, just enough to bring out her great features. Yes, she was something special, and I realized it the very first time I worked with her." "The trouble with Bettie," she continues with a chuckle, "is that she had her clothes off so fast that you didn't know she had a perfect face! With her features, she could have done magazine covers of just her face."

Bunny knew nothing of the stunning brunette's sensational and scandalous work for the Klaws. Indeed, she says that to this day she has never seen any of Bettie's film shorts. As she told *American Photographer* in 1987, "To me she was a new face and she knew how to pose for the camera. I couldn't get enough of her." The perspective offered by Bunny brought out another side of Bettie that was in sharp contrast to the Klaw sessions. Greg Theakston writes:

"The difference between the Klaw and Yeager photos is like night and day. Up until her Florida work, Betty had mostly done indoor shoots featuring lingerie or ropes and whips. It was a secret world of perpetual night behind locked doors. Most of the Bunny shots were done outdoors, in the bright sunlight with Betty attired in swimwear. Ironically, the outdoor photos show more skin than the indoor shots ever did."

Nearly 40 years later, Bunny still smiles when recalling her work with Bettie. "All the costumes Betty brought with her the first time we worked were storebought. They were all lingerie—no bikinis. She brought several shopping bags full of outfits—net stockings, garter belts, black lace. I wanted to work with her in the nude, but I was a little shy, so I let her start with the things she brought first. Then we did the nudes. These were the things she had used in New York, but to me they were cheap-looking. And I didn't work again with her in those outfits. Everyone had already shot her that way, and it just didn't appeal to me. I felt like I was copying somebody else's work.

"After that, we worked mostly outdoors, in bikinis. I had been designing my own bikinis for years because I needed them for my own modeling, and you couldn't buy bikinis in the stores then. Bettie must have mentioned that she liked to sew because I drew a few sketches for her and asked her if she could make a few outfits that we could work with. She jumped at the chance to please me. I had never met another model who could sew like myself and make posing outfits. It's

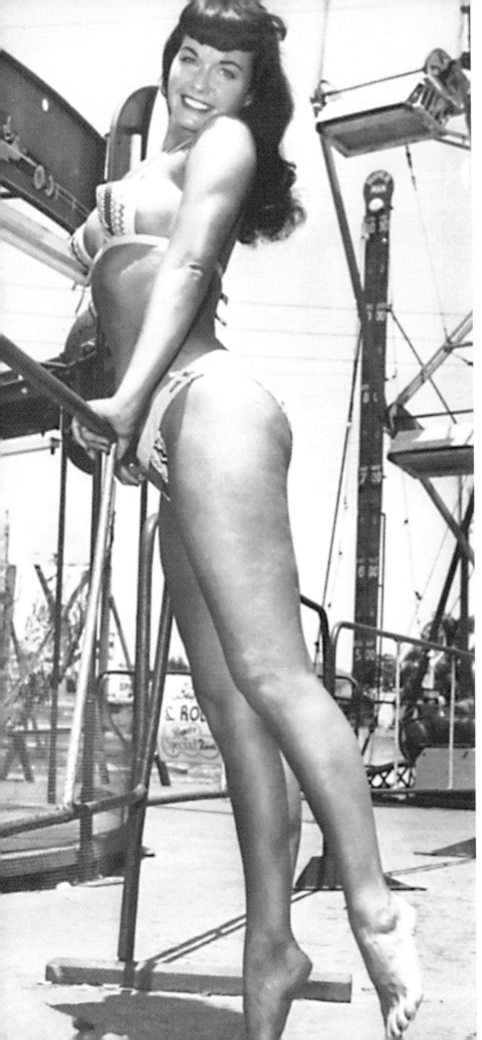

too bad we didn't realize what a great team we could have made as designers! We were both 20 years ahead of our time there. When I found Bettie could sew, it saved me time. All I had to do was suggest and provide materials in the colors I wanted."

As she recalls a typical session, "I always started early because I preferred the early morning light—it's softer and easier for a model to hold her eyes open. And it's cooler to work than any other time of day. I picked Bettie up at about 8:00 a.m. She didn't have transportation. I don't know if she didn't know how to drive (most people from New York can't) or just hadn't bought a car yet. I had assumed when we first met that she was on vacation and I didn't expect her to stay long.

"Our sessions were no longer than two hours at a time. I shot until I felt I had what I wanted. I usually shot about 10 rolls of black & white film and some color. The black & white film was 12 shots to a roll on a Rolleflex camera. The color was shot on 4x5 Ektrachrome film. We didn't use 35 mm—that was considered amateur! Magazine editors preferred 5x5 color; it was almost impossible to get them to consider anything smaller. I'd shoot about 10 sheets of color film, sometimes up to 20. It could get expensive shooting on speculation, hoping to sell later."

Bunny declines to say what she paid her models, but says, "I always paid them the same day they worked for me. No promises—there were too many photographers around who would promise a girl a percentage when it sold; most of those photographers never sold their work. . . Most well-known photographers wouldn't bother to shoot a girl unless he or she thought they could make money selling the photos. We weren't in it to 'play;' we were in it to create and to sell.

"I can only say that Bettie was worth much more than I could possibly afford to pay her. But she loved working with me and never asked me for more money than I gave her. She was never difficult about this. I explained my situation and what I could afford, and that was fine with her. . . I paid girls what I could afford to pay based on what I thought I could create with them. If I was not inspired by a model, I would not work with her."

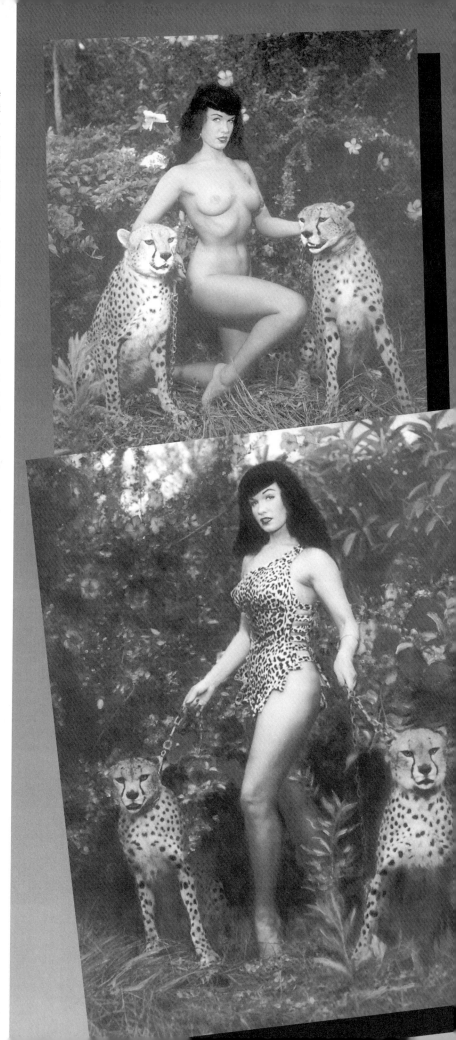

When asked about her most memorable session with Bettie, Bunny doesn't even have to think about it. "The session at Africa USA in Boca Raton was my favorite. I had a really great time that day. I had never been around wild animals like that before. I also liked a set I did on Bettie showing how she looked to different people. You see, we all look different to different people. Our mothers see us as beautiful and wonderful; our doctor sees us in pain and not looking too good; our hair dresser sees us with fly-away hair that never looks right unless they have just done it. The session gave Betty a chance to emote and become different characters. Thinking back on this particular set, I could tell you that Betty would have made a fine actress had she continued to pursue it."

Immediately realizing the potential in her remarkable photos of Bettie, Bunny sent one set of transparencies to an emerging men's magazine in Chicago. Hugh Hefner—already a Page fan—was bowled over and used Bettie as *Playboy*'s Playmate of the Month for January 1955. According to other sources, Hefner paid Bunny $100 and Bettie the princely sum of $50 for this enduring piece of cheesecake history. Throughout her pin-up carer, Bettie rarely earned as much as $150 for a photo session; for all the pleasure she derived from her career and the far greater pleasure she provided others, it certainly profited her little.

When asked if Bettie was habitually late for jobs, Bunny laughs. "You know, until you brought this up, I had forgotten about it! Yes, Bettie was always late. But she was worth waiting for. Why? Well, I think she was a perfectionist about her hair and makeup. It had to be 'just so' and she wouldn't start until it was right. I got used to it. This was one of the reasons I always went to pick her up. I couldn't stand someone keeping me waiting for an appointment. It seemed to speed her up when I came to her. I was always a punctual person, especially as a model I was aware of being on time, so this was something that was hard for me to put up with, but I knew I had to if I wanted to work with her. I don't think she did it intentionally; she just didn't have any concept of time. In a way, it worked to MY advantage. When she worked for me, she didn't watch the clock. She only quit when I told her we were through working for the day."

Thinking over Bettie's key qualities as a model, Bunny remarks that she "could do things with her body. For example, she always posed on her toes, never flat-footed. And she had a very high arch, like she was wearing high

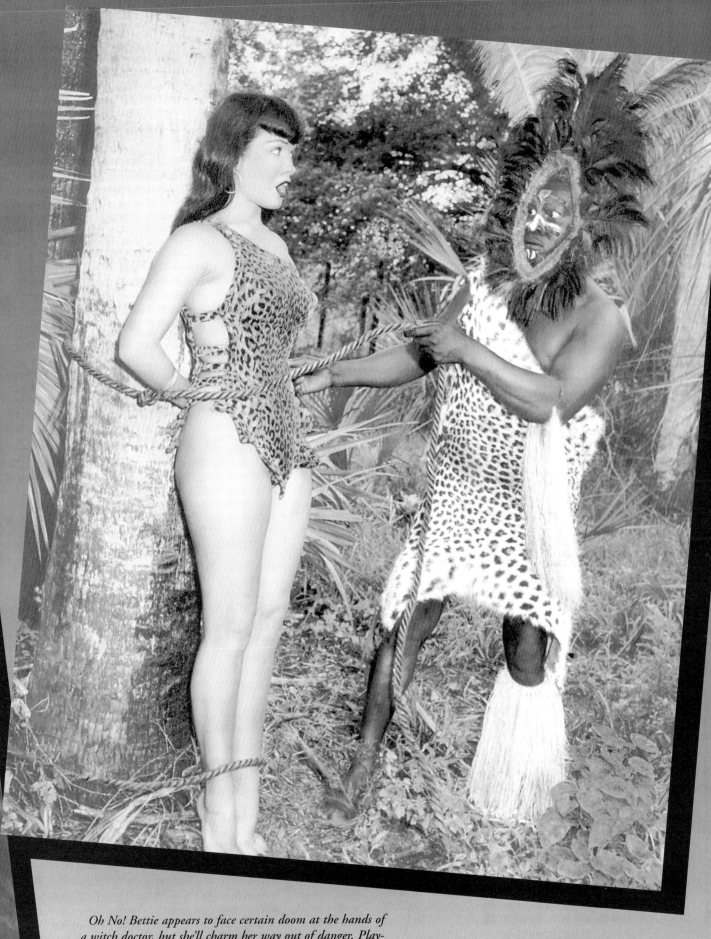

Oh No! Bettie appears to face certain doom at the hands of a witch doctor, but she'll charm her way out of danger. Play-acting poses like these gave her a small opportunity to use the thespian talents she'd once hoped to employ on Broadway.

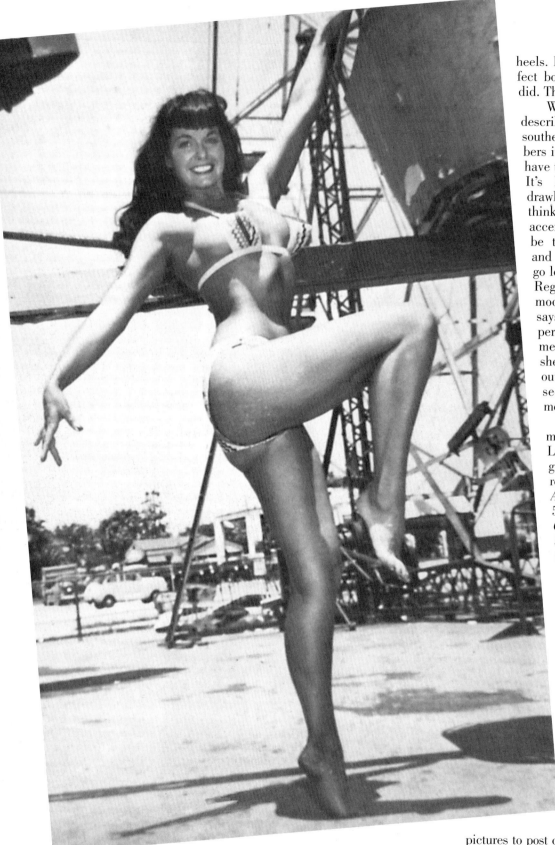

Bettie's qualities as a model included her well-toned body and dancer-like physical grace.

heels. Bettie did not have a perfect body—but she thought she did. That was the difference."

While Bettie has often been described as having a decided southern accent, Bunny remembers it another way: "She didn't have the usual southern accent. It's hard to describe. She drawled her words, but I don't think of it as a real southern accent. One minute she would be talking like a little girl, and the next her voice would go lower and more sensuous." Regarding her most famous model's personality, Bunny says, "Bettie was an upbeat person. She never burdened me with any problems if she had any. She had a good outlook on life. She always seemed to be in a good mood."

In addition to Bunny's many magazine layouts on La Page, her photos of Bettie graced the covers of three record albums: Fats Waller's *Ain't Misbehavin* (Halo-LP 50xxx), *The Best Musical Comedy Songs* (Halo-LP 50245, with a shot from the Africa, USA session), and *Bizet's Carmen for Orchestra* (Acorn-LP 610, with an abbreviated version of the same glamorous pose used on the Fats Waller cover). In 1992, a CD cover for the rock group Thrill Kill featured one of Bunny's renderings of Bettie. "My agent found out they were going to use the picture, which they didn't know was copyrighted, and by golly, he made them pay to use it!" In addition, she sold some Bettie pictures to post card companies, and these were available for many years thereafter.

By the end of 1954, other Miami photographers were getting into the act with their own beach layouts with Betty; foremost among these lensmen was Jan Caldwell, who has been a bit of a mystery to some Page researchers. Bunny Yeager helps clear it up: "Caldwell" was actually a pseudonym for

Bill Hamilton, perhaps Miami's second most successful glamour photographer after Bunny herself. (Among other distinctions, Hamilton was the discoverer of blonde-bombshell model Maria Stinger, who later would be most closely associated with Bunny.) She hypothesizes that he occasionally used the name Caldwell to publish photos without having to pay his agent a percentage. The majority of the commercially-marketed postcards of Bettie are by Hamilton.

The 1955-57 period actually turned out to be Bettie's most frenetically active years as far as national magazine appearances are concerned; virtually every major men's magazine of the era featured Betty at least once, and each appearance brought demands for more. The end, however, was shortly at hand.

Among Bettie's magazine appearances in 1955-56:

Irving Klaw Bulletins #103, 106, 107, 108, 109, 110 (all c. 1955)

Jan. 1955 *Photo:* "Sultry Savage," a much-reproduced 7-page layout by Bunny Yeager of Bettie in jungle-girl attire frolicking in Florida's "Africa, U.S.A."

Jan. 1955 *Playboy:* Bunny's classic centerfold of Bettie as Playmate of the Month, clad only in a festive Santa hat, kneeling by a small Christmas tree and hanging an ornament on the branch while winking at the camera.

Feb. 1955 *Bold* (centerfold)

Feb. 1955 *Breezy* (back cover)

Feb. 1955 *Frolic* (2 pages)

Feb. 1955 *Modern Man* (inside cover in Bunny Yeager bikini shot)

Feb. 1955 *Modern Sunbathing* (cover)

Feb. 1955 *Stare* (cover, 5 pages)

Mar. 1955 *Beauty Parade* (centerfold and 4 pages)

Mar. 1955 *Bold* (cover in bikini)

Mar. 1955 *Cabaret* No. 1 (cover)

Mar. 1955 *TV Girls & Gags* (bikini cover, 1 page)

Apr. 1955 *Art Photography:* Delightful inside cover frolicking in the surf, nude centerfold, and 4 pages, 6 total pictures by Bunny Yeager. One memorable full-pager finds Bettie nude underneath a fully transparent nightie, kneeling and holding a candle aloft.

Apr. 1955 *Eye* (9 pages, 16 pictures)

Apr. 1955 *Eyeful* (centerfold) Flirt (centerfold)

Apr. 1955 *Foto-Rama* (cover, 1 page)

Apr. 1955 *Frolic* (4 pictures of Betty alone and two of Bettie and Tempest Storm together from *Teaserama*.)

Apr. 1955 *Stare* (7 pages)

May 1955 *Art Photography* (cover in leggy showgirl attire, 2 pages)

May 1955 *Cabaret* (inside cover)

May 1955 *Cartoon Comedy* (cover)

May 1955 *Comedy* (6 pages)

May 1955 *For Men Only* (4 pages)

May 1955 *He* (back cover splashing playfully in water, and 1 page on the beach, by Bunny)

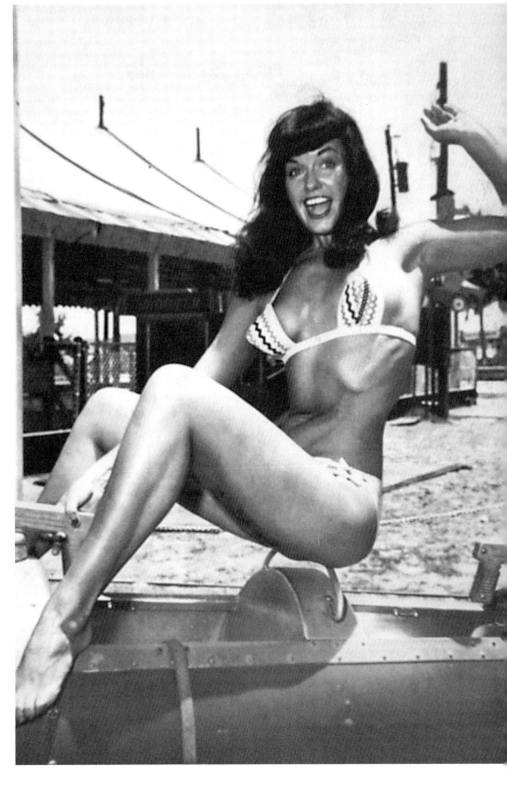

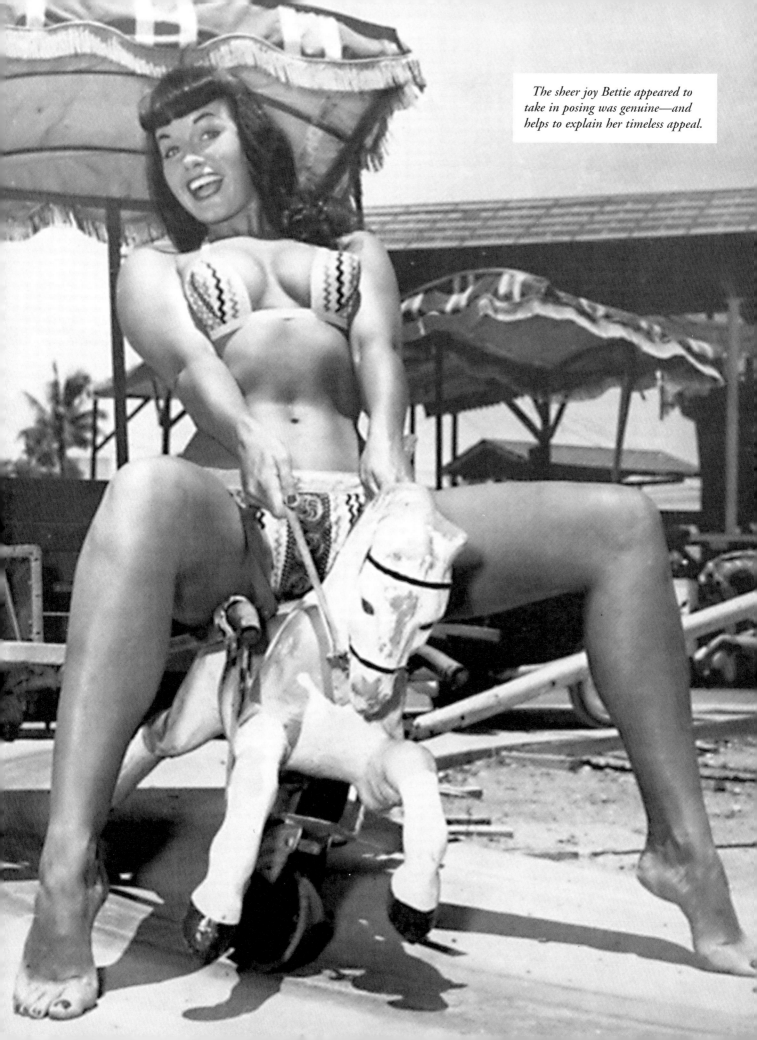

May 1955 *Playboy*

June 1955 *Beauty Parade* (5 pages, 11 pictures)

June 1955 *Male Life* (cover)

June 1955 *Modern Man* (1 page outdoor nude by Bunny)

June 29, 1955 *People Today* (3 pages)

June 1955 *Stare* (cover, 9 pages)

Aug. 1955 *Art Photography* (1 page)

Aug. 1955 *Breezy* (cover)

Aug. 1955 *Chicks & Chuckles* (back cover)

Fall 1955 *Sir Annual* (cover as harem girl)

Oct. 1955 *Beauty Parade* (4 pages of delightful lingerie shots, "What the French Maid Saw!")

Oct. 1955 *Chicks & Chuckles* (cover)

Oct. 1955 *Tab* (6 pages)

Nov. 1955 *Follies* No. 1

Nov. 1955 *Cabaret* (inside back cover, 1 page)

Nov. 1955 *Snappy* (2 pages, including thoroughly spectacular bikini pin-up)

Dec. 1955 *Beauty Parade* (centerfold and 4 pages)

Dec. 1955 *Bold* (centerfold)

Figure Studies Annual #10 c. 1955/56 (4 pages)

Figure Quarterly Vol. 12 1956 (splendid 1-page nude from Bunny's "Africa U.S.A." shooting)

Figure Quarterly Vol. 13 (cover in seductive harem-girl pose, and 1 page)

Pin-Up Photography No. 1 1956 (cover, 1 page)

Feb. 1956 *Art Photography* (1 page, terrific nude by Jan Caldwell)

Feb. 1956 *Beauty Parade* (centerfold, 2 pages);

Feb. 1956 *Gaze* (3 pages)

Mar. 1956 *Escapade* (3 pages)

Mar. 1956 *He* (nice cover in bikini)

Mar. 1956 *Foto-Rama* (4 pages)

Mar. 1956 *Male Point of View* (back cover)

Mar. 1956 *Sunbathing for Health* (cover)

Mar. 1956 *TV Girls & Gags* (centerfold)

Apr. 1956 *Bold* (Betty Page Pin-Up Portfolio: cover and 6 pages in either bikini or lingerie)

Apr. 1956 *Male Life* (inside cover, 6 pages)

Apr. 1956 *Modern Sunbathing* (cover nude on a boat, and superb 5-page Bunny Yeager photo feature on Bettie, "Nude But Not Naked")

Apr. 1956 *Vue* (cover)

May 1956 *Jest* (cover)

May 1956 *Show* (centerfold, inside cover, 6 pages)

July 1956 *Gee-Whiz* (back cover, 1 page)

Aug. 1956 *Rogue* (centerfold and 3 pages by Bunny Yeager)

Aug. 1956 *Sunbathing for Health*

Sept. 1956 *Gent* No. 1 (2 pages, including a splendid topless study on the beach)

Oct. 1956 *Gaze* (cover, 1 page)

Nov. 1956 *Brave* (centerfold, back cover, 4 pages);

Nov. 1956 *Snappy* (back cover)

Attack of the Congressional Puritans

The peak of Bettie's popularity also coincided with the end of her cheesecake career. Age was not the cause of her retirement, although 34-year-old pin-up girls were certainly out of the ordinary. Bettie had always kept herself in magnificent physical condition by working out and carefully rationing what she ate. While she did have to work harder after age 30 to keep her weight down, she probably could have continued posing into the early 1960s had she wished.

But along with the McCarthyism that darkened American politics during the 1950s came a puritanical campaign to purge the nation's mailboxes of materials deemed "obscene." Klaw inevitably became a target of Sen. Estes Kefauver's Congressional subcommittee hearings once the panel had finished exposing the evils of comic book publishers. Klaw was called to testify on May 24, 1955, and was all but accused of being indirectly responsible for a suicide by way of the product he sold. A young man had been found dead while tied up in a position that mirrored a pose (not by Bettie) in a Klaw photograph in his possession, and the politicians grabbed the opportunity to target a convenient scapegoat.

When he invoked his Fifth Amendment constitutional right in testimony, the subcommittee voted to cite Klaw and other witnesses for contempt of Congress. Not long thereafter, the Post Office seized all of his mail. A subsequent appeal to the Supreme Court in November 1956 failed.

While Irving continued to run the New York operation, Paula and her husband Jack Kramer set up another office in New Jersey under the Nutrix name to keep the bondage business outside the reach of the New York City post office. But in July 1956, the Senate closed the loophole Irving had utilized, and four days later the New York postal authorities impounded all his mail.

Klaw continued to face constant pressure from Kefauver and postal authorities. On June 27, 1963, he and Kramer were simultaneously busted and indicted for conspiracy to send obscene materials in the U.S. mail. They were later found guilty, but the U.S. Court of Appeals overturned the jury's verdict. Sadly, in late 1963 before the initial verdict came down, Klaw heeded his lawyer's advice and directed Paula to run thousands of bondage negatives, including Bettie's, through the paper shredder in a plea bargain. Out of the 5,000 bondage photos once sold by Movie Star News, only 1,500 survived—and these only because they had been mistakenly left behind at another location. Klaw died three years later. Paula has been able to continue MSN today as a thriving mail-order business for conventional pin-ups and celebrity shots of the past and present.

In the course of the Kefauver hearings, Bettie herself testified—not on the witness stand in public, but in private session where she was questioned by committee counsel. She recalled for Bunny, "I told them that Irving Klaw was not guilty of any kind of pornography, that he didn't even do nudes." One apocryphal account, however, is too delightful to let pass. According to this imaginary depiction, the senator asked, "Miss Page, just what is your opinion of fetish items such as high heels, black net stockings, and the like?" After a moment of silence, Bettie is said to have brought the house down with her reply, delivered in a rich Tennessee accent: "Why, Senator, honey, I think they're cute!"

Art Amsie recalls that when he photographed Bettie with the Concord Circle in late 1956 and 1957, the one subject she didn't want to discuss was Irving Klaw. "She said,

don't ever discuss that man with me.' She just wanted to put that behind her. The Kefauver hearings had left a bad taste in her mouth. She was being painted with the same brush, even though she didn't see anything wrong with the bondage stuff."

Bettie did not leave New York as a direct result of the Senate hearings; in fact, she continued to pose for Klaw until late 1957. Until the Robin Leach interview, it was believed that her decision to vanish from public view was due to her continuing discomfort over the hysteria surrounding the proceedings. Another reason for her departure, Theakston reports, was the impending demolition of her apartment building on 46th Street near Times Square. Her account, though, is that a pornographer allegedly attached a photo of her face to another woman's nude body in sexually explicit poses. Bettie said she spent her savings buying up and destroying these photos, and then disappeared out of shame and embarrassment.

More important than any of this, however, is that Bettie simply felt she had come to a dead end in her career. Modeling had provided her with the necessary income to keep pursuing her dream of the theater, while also bestowing a fame she'd never anticipated. But as she approached her mid-30s, she was making little headway and was now competing for roles against women 10 or 15 years younger; there seemed little point in continuing. As she told Bunny Yeager in 1993, "I was thinking I should quit while I was ahead."

Bettie's pin-up career was over by the end of 1957, even though photos continued to appear in magazines for years thereafter. She made one final stab that year at finally breaking through with her acting career in New York. When that effort failed, the legend disappeared from public view.

Could Bettie have made it as an actress? Bunny Yeager—an actress herself—thinks so. "She really wanted to be an actress, but she said that because of her accent they wouldn't give her any parts. In those days, you couldn't have an accent (for most acting roles). Today, it wouldn't matter." And for those who look at Bettie's film shorts and conclude that she was limited to conveying very broad, obvious emotions, Bunny notes: "She was directed by somebody to do those things because that's the kind of an audience she was playing for. I think she could have been great as an actress."

Bettie's most noteworthy magazine appearances from 1957 onward included the following:

La Femme Moderne No. 1 (date unknown, c. 1956/57; centerfold)
Adam Annual 1957 (4 pages, 8 pictures of a topless Bettie on the beach)
After Hours No. 1 early 1957 (excellent nude centerfold)
Man's Cavalcade No. 1 1957 (4 pages)
Modern Man Yearbook of Queens 1957 (4 pages of great Bunny Yeager pictures)
Jan. 1957 *Caper* ("Blithe Savage," 4-page layout from the same *Africa, U.S.A.* session first seen in the 1/55 *Photo*.)
Jan. 1957 *Jest* (inside back cover)

Feb. 1957 *Gaze* (back cover, 3 pages)
Mar. 1957 *Foto-Rama* (6 pages, "Why Betty Loves It!" "Men love to look at a well-built girl and I love to be looked at.")
Apr. 1957 *Chicks & Chuckles* (centerfold);
Apr. 1957 *Rugged* #2 (cover, 1 page)
Apr. 1957 *Risk* (5 pages)
Apr. 1957 *Satan* #2 (cover, centerfold, and 2 pages as "Satan's Angel")
May 1957 *Bold* (back cover)
June 1957 *Stare* (inside cover)
Exotique #18 1957 (back cover)
After Hours #4 1957 (1 page by Bunny Yeager)
July 1957 *Comedy* (back cover)
July 1957 *Gee-Whiz* (inside front & back covers, 1 page)
July 1957 *Swagger* (centerfold, back cover)
Aug. 1957 *After Hours* (4 pages and 7 gorgeous outdoor pictures)
Dec. 1957 *Breezy* (back cover)
Dec. 1957 *Joker* (back cover)
Dominant Damsels #1 1958 (cover in dominatrix attire and whip, and 20 inside pictures)
Exotique Photo Album #1 late 1950s (fetish-oriented magazine; cover and superb 1-page leg art, seen later on cover of Bob Schultz's *Fond Memories* issue "E")
Figure Quarterly #20 1958 (two outstanding Bettie nudes)
Hum No. 1 1958 (cover)
New Girl Pictorial #1-11 (date unknown, c. 1958; 3 pages)
Apr. 1958 *She* (cover)
July 1958 *Comedy* (back cover)
July 1958 *Gala* (4 pages)
Aug. 1958 *Gaze* (cover, 7 pages)
Nov. 1958 *Caper* (4 pages)
Bettie Page, America's Foremost Figure Model #26 1959
Perilous Bondage #1 1959
U.S. Glamour Presents Betty Page 1959
Feb. 1959 *Gaze* (4 pages)
Feb. 1959 *Glamor Parade* (lovely bikini centerfold)
Lust Club (1959 "racy" pulp paperback with an illustrated Bettie lookalike on cover)
Moran's Woman (another 1959 paperback novel with a very Bettie-like vixen on cover)
June 1959 *Stare* (cover, 3 pages)
July 1959 *Modern Man* (1 page nude study by Tom Kallard)
Aug. 1959 *Modern Man* (another nude by Kallard—this one a full-frontal shot with either shaved or airbrushed-out pubic hair)
Betty Page c. 1960 (fine digest-sized issue devoted to Bettie, mostly in lingerie; nicely sampled in *Fond Memories* issue "E")
Black Nylons & High Heels Vol. 2-2 c. 1960 (cover, back cover)
Bunny Yeager's Photo Studies 1960
Feb. 1960 *Gaze* (cover)
May 1960 *Snappy* (4 pages)
June 1960 *Gaze* (4 pages)
1960-61 *Betty Page in Bondage*: Seven issues. (Vol. 3 in 1960—with 64 pages and 32 Betty poses—declares: "This book tells how a model feels while bound and gagged when tied. Pictured are some of the most perilous devices to which Betty was bound. Despite all the handicaps, gags and unusual tied-up poses she had to endure, Betty still maintained her sunny disposition when the day's work was over.")
Fantastique featuring Betty Page (c. early 1960s; half of digest devoted to Bettie, with 30 pages of sexy lingerie poses)
Figure Quarterly Vol. 32 1961 (fine 1-page nude by Jan Caldwell)
Rhapsody No. 1 1961 (9 pages)

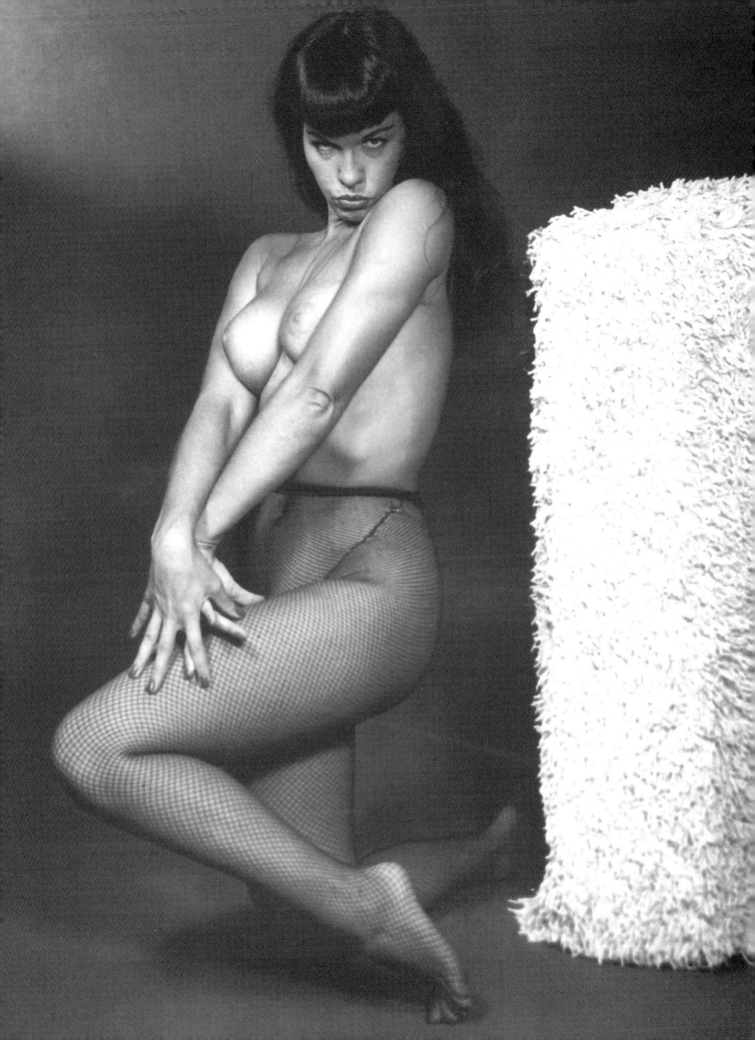

Mar. 1961 *Comedy* (cover)

Dec. 1961 *Modern Man* (1-page outdoor nude portrait by Jan Caldwell)

Presenting: Bettie Page At Home #5 (c.1961; digest magazine with 32 pages of indoor nudes, only one of which is a bondage picture)

Presenting Bettie Page Outdoors (c. 1961; 34 pages of outdoor nudes, Betty at her most delightful).

All New Betty Page c. 1962 (34-page digest-sized edition, filled with topless Bettie lingerie shots)

Betty Page Queen of Bondage c. 1962

Meet the Girls #2 c. 1962 (one-quarter of magazine devoted to Betty)

Focus on Betty Page 1963

June 1963 *Stare* (3 pages)

Devil in Skirts 1964 (back cover)

Feb. 1964 *Laugh Digest* (back cover)

Bunny Yeager's ABCs of Figure Photography 1964

Bunny Yeager Photographs Famous Models 1965

A Nostalgic Look at Bettie Page 1976: Exceptional 58-page, all-Betty magazine, with nearly all pictures either nude or semi-nude. Her bondage and high-heel fetish pictures are given prominent attention.

April 1977 *High Society* ("The Overdue Opening of Betty Page" with open-legged nude camera club poses)

Betty Page: Private Peeks: Four all-Betty issues produced in 1978-80.

The Bound Beauties of Irving Klaw #5 1978 (one-third of issue devoted to Bettie; note that some other editions in this series do not include her)

Catfights Galore No. 1 1983 (2 pages, 11 pictures)

In Praise of Bettie Page (July 1983): All Bettie in color and B&W; good excerpts featured by Bob Schultz in Fond Memories issue "I."

The Betty Pages No. 1 1987: The debut issue is jam-packed with no fewer than 41 pages of Betty photographs reprinted from numerous 1953-57 magazine layouts, plus cartoon strips inspired by Betty.

The Betty Pages No. 2 1988: Greg Theakston instigates "The Case of the Missing Pin-Up Queen" and offers features on *Teaserama* and Irving Klaw.

The Betty Pages No. 3 Fall 1988: Gorgeous Bunny Yeager bikini cover of Betty, with color topless centerfold and 24 pages of BP photos. Includes the second installment of the "Search."

The Betty Pages No. 4 Spring 1989: Part 3 of "Case of the Missing Pin-Up Queen," three pages of Betty in color, and 15 additional pages of BP pictures.

Bettie Page 3-D Picture Book 1989: 32-page book with mostly-nude Bettie shots in 3-D; with introduction by Dave Stevens.

The Glamorous Betty Page: Cult Model 1950s (published 1989) is an Italian large-format illustrated biography with over 100 pages of Bettie, including 14 pages in color; focuses very heavily on her work with Klaw plus Camera Club poses. Vols. 2 and 3 also published.

Sept. 1989 *Genesis* (3 pages, 5 pictures, and article by Greg Theakston)

Nov. 16, 1989 *Rolling Stone* (article on the Bettie phenomenon)

The Betty Pages No. 5 Winter 1989/90: Fine "jungle girl" cover and inside cover, 9 pages of Bunny's "Africa U.S.A." layout on Bettie, and two pages of revealing Camera Club pictures.

Movie Star News, Volume One: Betty Page, the Queen of Curves (1990): Greg Theakston relates the tale of Irving Klaw's emergence as the "Pin-Up King" and his association with the Nashvlle Angel; more than 70 pages of Bettie, with hundreds of miniature reproductions of her poses for Klaw.

Betty Being Bad (1991, with over 25 photos plus text by John Workman)

The Bettie Page cult began while she was shrouded in mystery, but has grown even stronger since her re-emergence.

The Betty Pages Annual (1991): Theakston's masterpiece on the Queen of Curves. A glorious 150 pages on Bettie, with text covering her entire career and featuring interviews with several of Bettie's lovers and friends. And of course, over 200 photos. An absolute "must" for any Page fan, including Greg's splendid original color cover art of his favorite brunette.

The Betty Pages No. 6 1991: All-photo issue—a staggering 50 pages of Bettie photographs, including 3 pages of very-nude Camera Club shots and 4 pages of Walter Sigg's color 3-D slides (with some nudes) shot in 1954. Also Theakston's wonderful cover painting.

The Betty Pages No. 7 1991: Leads off with a wonderful cover art of Bettie by Olivia De Beradinis; continues "The Case of the Missing Pin-Up Queen," with rest of issue devoted to "Bad Girls on Review," from Cleo Moore to Sybil Danning.

Fond Memories: Bob Schultz's quasi-monthly 'zine began publication in late 1991, with each issue devoted to a letter of the alphabet ("B," for example, delves into Bettie's appearances in magazines such as *Beauty Parade* and *Bold*.) Plenty of Bettie pics and updates on the wonderful world of Bettie-ania; most issues also feature delightful pin-up art. Three special editions were published in 1992-93, as noted below. Issue "N" in 1993 reprinted Bettie's handwritten message to FM readers.

The Betty Pages No. 8 early 1992: Movie and video issue featuring helpful rundown of Bettie on film, plus numerous shots of Bettie on the beach.

Feb. 1992 *High Society* (article by Theakston and Leslie Culton, with over 20 photos)

Celebrity Sleuth Vol. 5-2 Spring 1992 (17 photos of Bettie)

Spring 1992 *Good Girl Art Quarterly* (issue devoted to "comic book characters who look like Bettie")

Elegantly Bound (1992): Special issue of Bob Schultz's *Fond Memories* devoted to the all-time favorite Bettie bondage pictures.

Fond Memories Summer Edition 1992: Entire issue features Bettie "in and out of warm weather attire."

Betty Page In Jungleland (1992): Bunny Yeager's own contribution to the BP library is a thoroughly entertaining 33 pages of her Bettie photos set up in gag-strip storyboard fashion, mostly from their famous Africa, USA session; a delight for any fan.

Dec. 1992 *Playboy*: "The Betty Boom," a fond recollection by Buck Henry, with a lavish 8 pages of photos and illustrations.

Betty Page—Queen of Pin-Up (1993): 79-page German volume focusing primarily on Klaw bondage and lingerie poses, along with a fine assortment of Bunny Yeager shots like the "Africa, USA" cover.

The Betty Pages No. 9 1993: Theakston's "farewell" issue with a superb biographical article on the Queen of Curves by Robert Foster, Jack Bradley's Movie Star News portfolio on Bettie, and a feature on sexploitation films.

Fond Memories Bettie/Bunny Issue 1993: Bob Schultz focuses on Bunny Yeager's vast contributions to the Bettie Page legend.

July 1993 *Interview*: Bunny Yeager's two-page interview with Bettie, plus two pages of their photos, and also a photo layout with a Bettie lookalike.)

The Betty Pages Annual/Book 2 Fall 1993: Theakston tops himself; lavish 143-page volume features his extensive interview with Bettie herself, plus an interview with her first husband Bill Neal, hundreds of photos, and Greg's front- and back-cover pin-up art.

The Cult Phenomenon

Until November 1992, the story of Bettie's post-stardom years has been shrouded in rumor and legend; but then Robin Leach succeeded in tracking her down for an exclusive off-camera interview for his syndicated show *Lifestyles of the Rich and Famous*, and the truth finally emerged. After leaving New York, she spent the next few years in Fort Lauderdale, including a four-month period when she was laid up with a volleyball injury. In November 1958, she married Armond Walterson, a young East Indian man she'd met in Florida, and they settled in Key West for a brief, unsuccessful union. She taught elementary school for three months before deciding that it was not for her; she then accepted a secretarial job. On New Year's Eve, 1959, in a time of despair, she "felt someone take my hand and guide me" to a church. "When I turned my life over to the Lord, I felt that the Lord Jesus wanted me to sever my connections with the modeling world."

Bettie ended her second marriage, and in early 1960 headed west to Hollywood—this time no longer seeking stardom, but inner peace. As reported by Robert Foster, she worked as a secretary for a Christian radio station. In 1961 she moved to Chicago and signed on with the Billy Graham Crusade, and also attended Bible school. After further Bible studies in Portland, Oregon, Bettie returned to Nashville in November 1963 to visit Billy Neal. As first disclosed in Theakston's 1992 interview with him, Neal and Bettie were married for the second time following his decision to join her quest for religious salvation. One reason for this marriage was Bettie's (unfulfilled) desire to become a missionary, as divorcees were not accepted. She taught Sunday school, did further secretarial work and studied for a master's degree (leaving before attaining the necessary credits).

When their second time around proved little more successful than the first, she ventured to Miami, where she met and fell in love with telephone company employee Harry Lear. They were married in February 1967, and settled in Hialeah. A 1970 photograph with her entire family (including Lear's three children from a previous marriage), seen on the Leach program, showed a beaming and beautiful Bettie looking very much like the pin-up queen a generation had known and loved. This union, too, was to end in divorce (in January 1972), although the two remained friends.

Afterward, she lived in Hialeah for several years, staying in a separate room of Lear's house. It was during this period that Bunny Yeager was able to locate Bettie when Harry Lear responded to her ad in the *Miami Herald*. She spoke to Bettie on the phone, asking her to collaborate on a possible biography, but Bettie responded that she had become very religious and that the Lord wouldn't want her to do that. In 1978, Bettie settled down to stay with her brother Jimmie in Los Angeles.

While Bettie stayed out of the public view, shrouded in mystery, the cult surrounding her grew. While she had retained a loyal following for years, it would be during the late 1970s and early 80s that the phenomenon began to take on larger dimensions. A series of magazines devoted entirely to Betty, *Private Peeks*, found a substantial audience. Dave Stephens' graphic novel *The Rocketeer*, launched in 1982 and featuring a character directly modeled after

Bettie, became a popular hit. Other illustrators followed his lead and found fresh inspiration in Bettie's vivid image.

When Theakston launched *The Betty Pages* in 1987, bringing together his investigative discoveries with generous photos and illustrations and contributions from other Page enthusiasts (as well as stories of other heroines of "tease"), the dam was ready to burst. Before long, retrospectives on Betty were featured in *Rolling Stone* and on TV's *Entertainment Tonight*. In 1991 the floodtide was fully unleashed, stimulated by the hit movie version of *The Rocketeer*—even though the Page-inspired character played by Jennifer Connelly was substantially watered down, with little resemblence to Betty remaining. The conservative Disney organization decided to de-sexify the character and avoid any bondage connection.

An article ("In Search Of Bettie Page") in the Oct. 11, 1991 *L.A. Weekly* by Karen Essex also contributed greatly to the growing phenomenon. In addition to being wonderfully researched and written, the Essex piece offered a distinctively feminine perspective on the meaning of a fantasy goddess in our society, and the need to live up to that image. Another fine investigative article was provided by Thomas Goldsmith in the April 26, 1992 *The Tennessean*; "Whatever Happened to Betty Page?" featured his interview with her brother Jack and several Hume-Fogg classmates. (reprinted in issue "F" of *Fond Memories*.)

During these years, even those previously unaware that Bettie Page ever existed have accepted her as a cultural icon of 1950s America. Betty Page T-shirts and dresses, filled with images of Bettie in familiar Klaw lingerie poses, have become hot sellers nationwide. In the fall of 1992, Chicago's Prop Theater presented a full-length play, *The Betty Page Story*. Bob Schultz's *Fond Memories* has further expanded the loyal audience of Bettiephiles. And Gerald Casale, formerly with the rock group Devo and a BP devotee for years, was trying to develop a motion picture based on her life—only one of several such proposed projects, including a screenplay authored by Theakston.

Remarkably, Bettie told Leach that she had no knowledge of any of this. Having lived very humbly on her Social Security checks and little else—"I am penniless and infamous"—she also believed she had no legal recourse to reap any benefits from the Page Phenomenon because she had signed away her rights to the photographs. It appears, however, that she may be entitled to a percentage of earnings from all the commercial products built around her. Bob Schultz, Greg Theakston, Dave Stevens, and her fan club president Steve Brewster, among others, began sending her regular checks for their Bettie-related products.

In January 1993, Bettie signed with Chicago attorney James Swanson to begin taking advantage of the many opportunities that awaited her, including an eagerly-anticipated biography. This new legal protection gave her the ability to veto any products that improperly exploited her image, but she remains by all accounts a simple person who has no interest in "cashing in" on her fame. Shortly after her re-emergence, some well-heeled Japanese fans offered her $500,000 to appear at an autograph-signing event in Tokyo, but she didn't hesitate in turning it down.

Bettie seems to have mostly pleasant memories of those glory days. "I was very happy frolicking on the beach and in the ocean." Even as a born-again Christian, she finds any moralizing about nude modeling preposterous, as she told Bunny in 1993: "After all, when God created Adam and Eve, he had them nude in the Garden of Eden. If Eve hadn't tasted the forbidden fruit, they would probably have spent their lives in the nude." As to her sudden realization of the legend she had become: "I haven't the foggiest notion why my pictures and memorabilia are popular once again after all these years, but I am flattered by all of the attention."

This is perhaps the greatest source of happiness to those who love Bettie: Not only is the woman who gave generations of fans so much pleasure finally reaping the benefits she has long deserved, but she is able to receive—and appreciate—the affection that is being showered upon her. The story of a pin-up queen who faced so many disappointments and injustices in her youth has now come full circle, with a happy ending that could not have been foreseen a short time ago.

Ultimately, the Bettie Page phenomenon may boil down to the fact that she successfully embraced both sides of how women are viewed by society. The Bunny Yeager version of Bettie was nice, the gorgeous girl next door who just happened to pose in bikinis (or much less). The Klaw version was naughty, doing strange and forbidden things, but still appearing too fundamentally sweet to be a truly "bad" girl. As long as popular fascination with this duality exists, along with an in interest in the tantalizing feminine tease, Bettie Page is likely to retain a hold on our fantasies for some time to come.

(Special thanks to Bob Schultz and Bunny Yeager for their gracious cooperation, and also to Art Amsie and Greg Theakston for their assistance. For those interested in learning more about—and seeing more of—Bettie, contact Bob for copies of *Fond Memories*—Bettie's personally-endorsed fanzine—at 14622 135th Court NE, Woodinville, WA 98072. Although Greg has drawn the curtains down on *The Betty Pages*, he has launched a new magazine called *Tease*. He can be reached at Pure Imagination, 1707 E. Blake Dr., Marietta, GA 30062. And for information on Bettie's official fan club, Bettie Scouts of America, write to Steve Brewster at 2641 South 53rd St., Kansas City, KS 66106.)

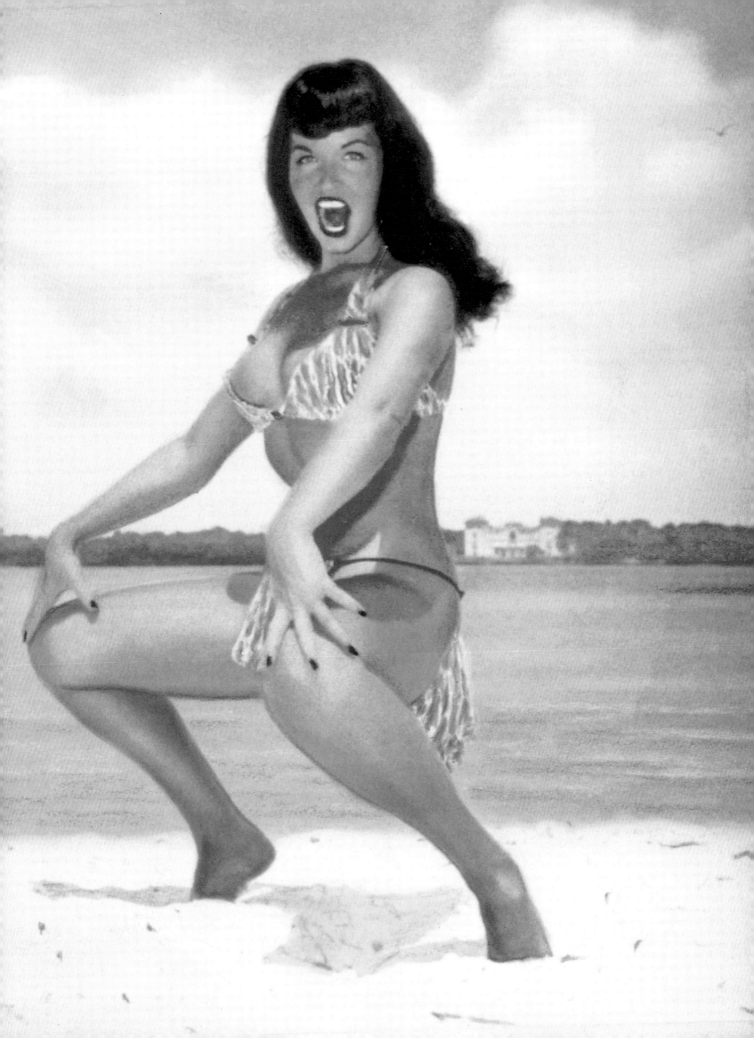

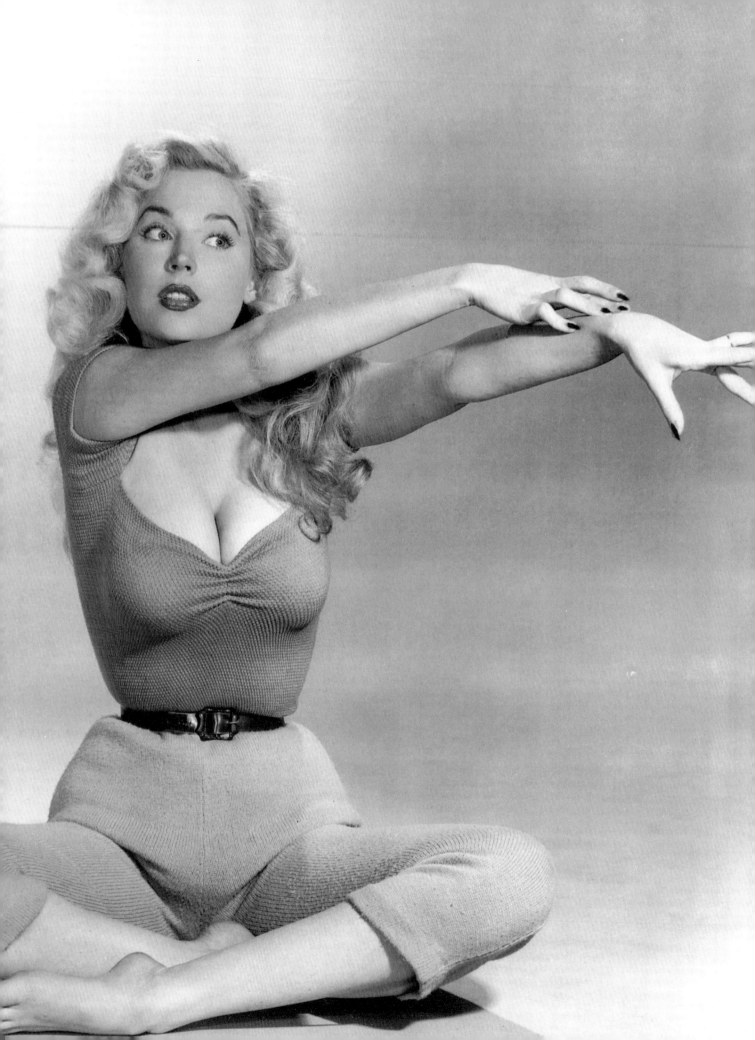

For many pin-up aficionados, there will never be another glamour girl like Betty Brosmer. Her classically sunny, all-American blonde beauty was a worthy counterpart to that of Marilyn Monroe. Her magnificently contoured-beyond-perfection figure was without equal. Further, there was a glow, an incandescence about Betty that was not to be found in any other model. And the total package was so utterly winning that Betty—without ever revealing much more epidermis than one would be likely to see at the beach—was the definitive cheesecake model of the 1950s. Happily, that glow is still very much in evidence nearly four decades later.

Given that the lives of so many glamour queens chronicled in these pages did not turn out quite the way they were planned, the fairy-tale ending to her story has a particular resonance. The woman who inspired a million fantasies in her youth is today, as Mrs. Joe Weider, the definitive symbol of beauty and fitness after 50. The fates could hardly have chosen a more deserving woman to bless.

A Pin-Up Model's Journey

The girl who made her reputation as a California girl beyond Brian Wilson's wildest dreams was born in Pasadena, and from about the age of three grew up further north in Carmel. Although at least one published source gives her birth name as Elizabeth, she says this is incorrect.

Her father, Andy Brosmer, worked in both real estate and the produce business in Watsonville, California (just south of Santa Cruz on the northern California coast) and also did radio sports broadcasts which included giving the betting odds for football games. Betty recalls that he instilled in her a love of sports. "When I was four years old, my dad would show me off. I was like a little computer—I knew every player on every team, their batting averages, and crazy things like who won the World Series in 1929. I think he wanted a boy, and I was his little boy until my brother came long," she recalls, laughing. (Betty was a Red Sox fan because of her Aunt Annie, whom she visited each summer in Maine.) He and Betty's mother, Vendla Brosmer, divorced when Betty was about six, and she lived for a time with her grandmother and her father. When Betty was 9 or 10, her grandmother died and she went to live with her aunt, who had moved to the L.A. area.

At age 11, Betty was "very skinny." Her aunt sent for a body-building course, and by accident, Betty received the boys' set of weights instead of the one designed for girls. After several attempts to exchange them failed, she used the weights and further developed her body. "In grammar school, I was the outstanding female athlete in baseball and kickball," she says proudly. "I was something of a tomboy in

those days, and my hobbies were what boys liked—I collected coins instead of dolls."

The loveliness that was to grace hundreds of magazine covers became evident early; at age 13 a family friend snapped Betty's picture, and the photo wound up in the Sears & Roebuck catalog. At 14, Betty travelled to New York with her Aunt Annie for a two-week vacation, and it was during that summer of 1949 that a legend was launched. Annie happened to meet a top New York studio photographer who commented on the young girl's beauty. Betty posed for some pictures, and one of those shots of her beaming face in a TV set became a full-page advertisement for Emerson televisions. "It ran in *Life*, *Time*, just about all the national magazines, and on billboards for about three years," she recalls. "I didn't get paid—I just got copies of the photographs." Afterward, she and Annie returned to California.

While back in L.A., Betty posed in swimsuits for the two greatest pin-up artists of the era: Alberto Vargas and Earl Moran. She doesn't recall a Vargas painting of her that appeared in *True* magazine around 1950-51. "I can't recognize myself, because he made all his women look alike." By contrast, "I recognize myself in the Earl Moran paintings, because he painted me in the same clothes I was wearing—where Vargas would take them off!" she chuckles. She recalls both artists as "very nice, pleasant, very respectful" men. Indeed, Vargas and his wife wanted to legally adopt Betty. "They were childless, and lived a few blocks away." Betty, however, continued to live with Annie.

When Betty and Annie returned to New York in 1950, the trip turned into a four-year stay. While she was attending Manhattan's George Washington High School, the well-built teenager unexpectedly became a modeling phenomenon. Well-known drapery artist Alfons Bergere begged the shy teenager to serve as a mannequin in Ken Murray's *Blackouts*, a show featuring blonde bombshell Marie Wilson which had previously run for over seven years in Los Angeles and was then playing Broadway's Palace Theater. She was finally persuaded and was immediately signed to a $250-a-week contract. In her segment of the variety show, "I would come out in a bathing suit, and one minute later Alfons Bergere would use the fabrics on stage to create a spectacular gown for me." Betty stayed with the show for about a year, and Bergere, like Vargas, expressed an interest in adopting her. "I must have had something about me that made people want to protect me," she muses.

Hard as it may be to believe, Betty says that before she started modeling, "no boys in school even knew I was alive." But after her pictures began to appear in magazines, "all the

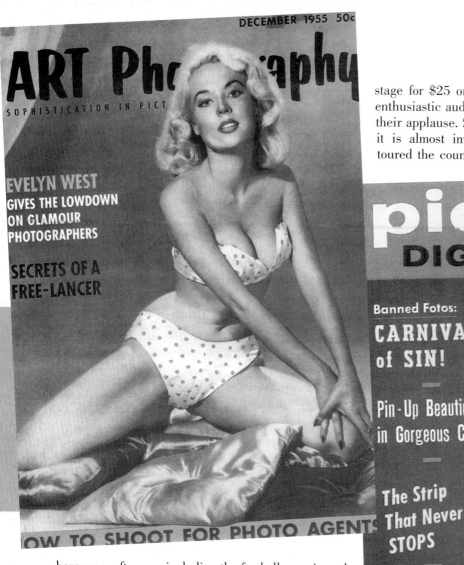

stage for $25 or $50 each and present their wares to an enthusiastic audience, who would determine the winner by their applause. Some 50 times, Betty came away a winner; it is almost impossible to imagine otherwise. She also toured the country as a fashion model for

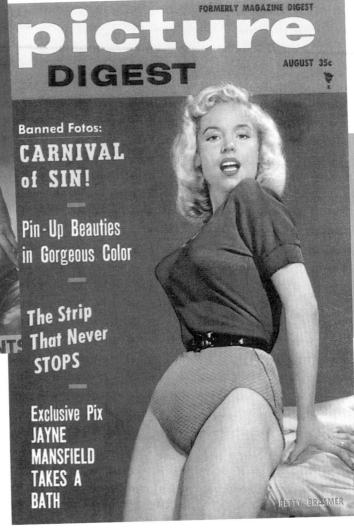

boys were after me, including the football captain and the student body president. Now, what had changed? It was just because I was famous. How does that make you feel?" Between 1950 and 1954, Betty established herself as a commercial and fashion model for many catalogs on behalf of a wide range of products. She was a Canover model for much of this period, starting at a salary of $15 an hour. "They used only very young girls, so they didn't have to pay very much."

Another regular source of income during the early '50s came from posing for the covers of romance and detective magazines and books such as *Detective Stories*, *Homicide Detective*, *True Love Stories*, and *True Confessions*. "I would work practically every day for a time at 480 Lexington Avenue (a building in which many of the top photographers and publishing houses had offices). Almost all the top models worked there. In addition to doing all these covers, I would do much of my catalog and commercial modeling there." Her youth posed no problem at these sessions: "When I was 15, I was made up to look like I was about 25."

Throughout that period, Betty—in between her commercial engagements and numerous "leg art"-type shootings—collected a succession of beauty titles ranging from the quite appropriate "Miss Hour Glass" to (of course) "Miss Leg Art." Typically, she and other hopefuls would appear on

the New York dressmaker of a "plain cotton house dress" (and did not represent a furrier, as is sometimes reported), and visited 44 states, modeling in swanky department stores and appearing on numerous local television shows.

Other beauty titles racked up by Ms. Brosmer during this period included Miss Television, Miss Pretty Girl, Miss Perfect Figure, Summer Queen, Venus de Milo 1952, Miss Supersonic of 1953, Miss Sweater Girl, Pin-Up Queen, Miss Childs Garden, Miss Potato Chips, Miss Jones Beach, Miss Waist and Hips, Miss Cherry Queen, and Miss Blue Eyes. "A lot of those beauty contests were kind of. . . fixed," Betty admits with a smile today. "I felt so sorry for some of those girls. They would get me to a modeling agency and say, 'Are you prepared to do this' for the product, as if they knew I

would win. Some contests were legitimate by applause meter, but where the winner was supposed to advertise a product, they wanted to make sure you could make appearances on their behalf on radio and television." One of the most lucrative titles was Miss California Long-Life Potatoes. "Anita Ekberg was supposed to carry the title, and was to be paid $3,000 for three days. But she couldn't fulfill it, and I got the job at the same salary, even though I was not nearly as famous."

"Miss Television" was unquestionably the most important beauty crown won by Betty, and its outcome, too, had been predetermined. "No one told me I was going to win, but they asked me so many questions beforehand, I figured it out. I was so shocked." All the participants were paid in the

Betty's sunny blonde beauty and hourglass figure represented utter feminine perfection. Years ahead of her time in her health and fitness regimen, she has since become a role model for a new generation of women who are seeking to remain fit and vibrant for a lifetime.

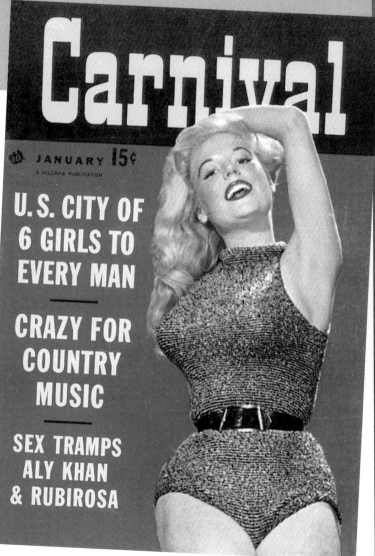

Carnival

JANUARY 15¢

A HILLMAN PUBLICATION

U.S. CITY OF 6 GIRLS TO EVERY MAN

CRAZY FOR COUNTRY MUSIC

SEX TRAMPS ALY KHAN & RUBIROSA

neighborhood of $100 each and were seen by a prestigious audience, so their appearances were not in vain. It was in the capacity of Miss Television that Betty appeared in *TV Guide* and turned up on the Steve Allen, Milton Berle, Jackie Gleason, and Jerry Lester programs.

The "Miss Blue Eyes" title came with a clever publicity gimmick: the sponsoring company ran a contest in which anyone who recognized Betty in New York City—simply on the basis of a photo showing only her eyes—would win $1,000. (Someone did recognize her on the street.) She also made appearances on behalf of the 1951 Humphrey Bogart film *The Enforcer* in conjunction with this title.

In early 1954, Betty returned to California where she attended UCLA and majored in psychology. Truly a modern California girl before her time, Betty was an adherent to Zen Buddhism and Yoga before they became trendy. A few months after her return, Betty made pin-up history when her modeling agency put her together with the great glamour photographer Keith Bernard.

When Betty went to see Bernard, she had an impressive portfolio and a going rate of $100-$200 per day from her New York period; in California, the going rate for models was much lower, averaging $50-$75 a day. "I guess when he heard what I got, it shook him up," Betty recalls, and he offered her what may have been a contract without parallel among 1950s pin-up models. "When he made the contract, he got a third (of all earnings from the photographs), his agent got a third, and I got a third. He didn't want to pay me up front in the beginning, so he gave me the photos. I don't think he realized how popular I would become. Afterward, I think he regretted the contract."

Betty acknowledges that she made "a lot of money" under the terms of the contract; indeed, there seems little doubt that she earned more money through pin-ups than any other model of the decade. Her husband Joe Weider hastens to add—"that's in spite of the fact that she never bared her bosom, unlike many other top models."

The one thing about the contract that she sometimes regretted was that Bernard had the exclusive right to shoot pin-ups of her. She was, however, free to do commercial or fashion work for other photographers, and worked one session with Peter Gowland on print ads for swimwear. "In a way, it was kind of unfortunate, because it limited me," she remarks, but she found Bernard "very easy to work with, very nice. I gave him a lot of ideas. I felt we were partners, because we truly were. Usually, he would go along with them. Sometimes I gave him ideas for posing other models."

She subsequently learned that Bernard would sometimes turn down work for her, because the contract was so lucrative for her. Joe Weider, at that time publisher of *Jem* and *Monsieur* magazines, contacted Bernard repeatedly about obtaining layouts on Betty, but "he kept pushing other models off on him, like Candy Barr," she says. "He could get Candy or other models for maybe $50 or $30 an hour, but

he had to pay me a third of everything. I'm sure if he did it on those occasions, he did it other times as well." (The numerous shots of Betty that did appear in those publications at the time were invariably "stock" photos that were not nearly as expensive as new layouts; the Weider publications ran many all-new covers of Betty starting in 1959.)

Typically, she would work with Bernard about once every two weeks, although the schedule would vary. In between sessions with Bernard, she would do fashion and commercial advertising layouts for other photographers. A normal session would last about two hours, while location shoots could run all day; but, since she was working on a commission rather than an hourly basis, she would often spend more time with Bernard. While most of her work with him was in the studio, she recalls one shooting at a picnic in which she posed in shorts and halter top in and around a tree. "He just decided to shoot some pictures of me there, even though I didn't have on any make-up or anything. It wasn't planned at all. Some people thought they were the best and sexiest pictures ever taken of me. That may have been because they were so natural, not really posed at all."

Betty's most significant magazine appearances from 1950-55 included:

March 1950 *Bold* (centerfold and 2 pages, 3 pictures)
July-Aug. 1950 *Gala* #2 (cover)
Good Humor 1950 (month unknown; 1 page)
Nov.-Dec. 1950 *Famous Models* (inside cover)
Dec. 1950 *Picture Show* (cover)
May 1951 *Glamorous Models* (cover in red bikini)
Sept. 1952 *Candid Whirl*
Jan. 1953 *Cover Girl Models* (3 pages)
Apr. 1953 *French Peep Show*
July 1954 *Focus* (cover in tights)
July 1954 *Vue* (cover, 2 pages, 4 pictures, as "Betty Brasmer")
July 1954 *Focus* (cover)
July 28, 1954 *People Today* (centerspread plus 2 pages, mostly in swimsuit)
Jan. 1955 *Gala* (cover in teenie bikini, 2 pages)
Jan. 1955 *Photo* (10 pages, 15 superb pictures in shorts, tight sweater, and bikini)
Jan. 1955 *Show* (leggy, glamorous centerspread)
Feb. 1955 *Modern Man* (quite gorgeous cover, clad in a low-cut dress, by Keith Bernard)
Mar. 1955 *Art Photography* (inside cover plus two more bikini shots)
Spring 1955 *Figure* (cover in white 2-piece swimsuit)
May 1955 *Bold* (cover)
May 1955 *Modern Man* (superb inside cover)
June 1955 *Picture Life* (5 pages by Bernard)
Figure #5 1955 (cover)
July 1955 *Brief* (6 pages)
Nov. 1955 *Follies* No. 1 (centerfold plus 2 pages, splendid in bikini; as "Betty Brasmer")
Nov. 1955 *Nugget* (Vol. 1, No. 1; cover, inside front & back covers and 2 pages, total of 15 cheesecake pictures by Keith Bernard)
Nov. 1955 *TV Girls & Gags* (cover in swimsuit)
Dec. 1955 *Art Photography* (gorgeous bikini cover)
Dec. 1955 *Bold* (cover in tight white sweater, 6 pages)

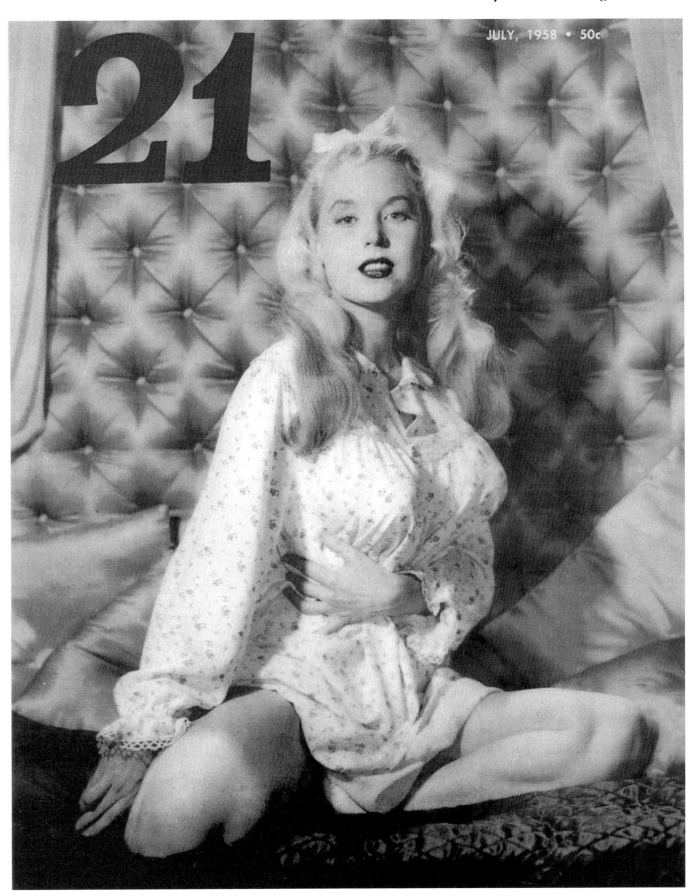

21

JULY, 1958 • 50¢

America's Pin-Up

During the 1955-1959 period, Betty reigned as America's favorite pin-up girl along with her East Coast counterpart, Bettie Page. She appeared at one time or another in virtually every top-quality men's magazine from *Modern Man* and *Cabaret* to *Fling* and *Night & Day*. Many of Betty's admirers have often wondered, "How did *Playboy* ever miss out on her?" The surprising fact is that they didn't. "*Playboy* wanted to use me, and Bernard implied that I would do semi-nude, bare-bust poses," she recalls today. "They sent out Arthur Paul, the art director, who rented me a beautiful place in Beverly Hills for the layout. I wore sort

of a half-bra or low demi-bra with nothing showing, or holding playing cards in front of me, and that's what I thought they wanted." Afterward, however, *Playboy* refused to run the layout because she was not sufficiently bare—and actually filed suit against Bernard for allegedly misleading the magazine. "They even tried to bring me into the suit for all the expenses of flying out, renting the villa, and so on." The suit was finally dropped, and Bernard sold the pictures to another magazine. *Playboy* later approached Betty again, but she declined the offer to bare all.

While it seemed as if cameras lovingly recorded every square inch of her breathtaking 5-foot-5, 112-pound, 38¼-18¾-35¼ body, Betty steadfastly refused throughout her career, in fact, to bare all, a stance which led one magazine to call her "Hollywood's Most Chased Chaste Pinup Girl." The generous cleavage and leg that she willingly displayed were as far as Betty was willing to go. "I was asked by a number of photographers to pose seminude, but I always declined. My main objection was that I never knew who I was going to marry. I thought it would embarrass my future husband and my family. I didn't think it was immoral, but I just didn't want to cause problems for others."

The fact that Betty's "look" was often compared to that of Marilyn Monroe was no accident. "That was the look and the style they wanted, so I accentuated that part of me. But those very smiley, glamorous pictures don't capture my real personality. Maybe my real personality—a bit less effervescent and outgoing—wouldn't have been that saleable. People who saw my pictures may have compared me to Marilyn, but people who met me personally thought I was more a Grace Kelly type."

"When I get in front of a camera—I change," she explains. "Something happens. The same thing happened when I was competing in those beauty contests: my shyness

disappeared, and I played to the audience." Indeed, the contrast between the polite, gentle, soft-spoken real-life Betty and the bold, dazzling tigress seen in many of her photographs could hardly be more striking.

Like any normal girl in her position, Betty enjoyed seeing herself on multiple magazine covers in virtually any given month during the 1950s. "I remember one time in southern California, I went to a newsstand in very plain attire, wearing glasses—even though I didn't need them. Two guys were grabbing magazines with Betty Brosmer, talking excitedly, and there I was standing right beside them."

Throughout the 1956-1960 period, virtually every men's magazine of the era regularly ran advertisements offering mail-order cheesecake photos of Betty. These ads typically featured a seemingly bare Betty standing smilingly behind a sign which read, "Wouldn't you like to see MORE of me?" Reflecting the comparative innocence of the time, other ads breathlessly touted Betty as "the girl with OH SO MUCH photographed in a WATER-SOAKED CLINGING DRESS."

As one might expect, much of Betty's commercial modeling work during the mid-'50s was for swimsuit manufacturers. She worked extensively for Cole of California until she became "too identified" with the company, and later posed for Catalina swimsuits. One of her most memorable advertising jobs was for Chesterfield cigarettes; after doing many print advertisements and having her image grace billboards and the sides of Chesterfield trucks, she appeared on the Milton Berle TV show in a live commercial for the product. "I had never smoked, and when they asked me if I did, I lied. In the live commercial I was sitting with a male model, we clicked champagne glasses, and he lit my cigarette. I inhaled, and almost immediately blew the smoke out. Well, afterward, apparently the company got thousands of letters saying, 'Your tobacco must be horrible' since I looked as if I hadn't enjoyed it. The company threatened to sue me and my modeling agency, although they didn't. That was the last time I modelled for a cigarette company!" she recalls, laughing.

Life-sized cut-outs of Betty advertising Thom McCann shoes, Kodak cameras and an air freshener proved so popular that they continued to appear in stores for years thereafter. Indeed, many are still around today—the fresh, sunny, Marilyn-like image she conveyed in the pictures is truly timeless. "I've seen that air freshener cutout all over the world, even in Cairo!" Betty remarks in delight.

Considering not only her astonishing physical assets but also the fresh, well-scrubbed, gorgeous-girl-next-door glow that seemed to emanate from her, many have wondered how Hollywood missed out on Betty. It was certainly not for lack of opportunity. "Howard Hughes tried to contact me three different times," she recalls. The first time was at a show at El Rancho Vegas in Las Vegas, where Betty shared a stageside table with her aunt while Hughes sat in a shadowy back booth. The maitre d' came to their table and said,

"Mr. Hughes would like you to join him in his booth. He thinks your daughter is very beautiful and could be in motion pictures." He gave them Hughes' card, but Betty never called and left Vegas as planned the next day. "I spoke to some other people who told me how Hughes had ruined the careers of some young girls," she related. On two subsequent occasions, Hughes tried to get in touch with her after seeing Betty in the magazines; the third time, she did meet with the billionaire's assistant, Walter Kane, at the RKO Studios, but the meeting was purely perfunctory.

"I had absolutely no aspirations to be an actress," Betty declares today. "The whole industry didn't interest me. . . I always thought show business was kind of superficial, and nothing that I wanted to do or be involved with. I just liked going in and doing my job (as a model)." When not busy modeling, she preferred to read and pursue "scholarly pursuits" rather than chase after the Holy Grail of movie fame like many of her contemporaries.

Discerning movie buffs may recall billboards for a Kim Novak movie around 1956-57 (either *The Eddy Duchin Story* or *Jeanne Engels*) in which Miss Novak's reclining body, clad in a white gown, had a particularly curvaceous appearance; that's because it was actually Betty's body inside the gown. "It was so obvious that it was me," she says. "Keith Bernard had evidently sold it to the motion picture company."

In addition to her aforementioned TV appearances while she reigned as Miss Television, Betty did appear for a few months on the popular game show *Beat the Clock* near the end of its run in the late 1950s. She would escort contestants onstage, retrieve gift items that were fumbled, and model the clothes they won.

Betty's 1956-60 magazine appearances included the following:
Jan. 1956 *Peep Show* (bosomy cover in swimsuit plus 1 page)
Feb. 1956 *Vue* (6 pages)
1956 *Detective Yearbook* (cover in saucy red 2-piece suit)
Apr. 1956 *Modern Man* (inside cover)
May 1956 *Escapade* (centerfold)
May 1956 *Night & Day* (4 pages, 9 splendid pictures: "Queen of Figures")
Hollywood Confidential #6 1956
July 1956 *Focus* (cover, and article entitled "The Search for Betty Brosmer")
July 1956 *Night & Day* (terrific cover, in one of her most famous poses, 3 pages, 8 pictures in the pool)
Figure Quarterly #14 Summer 1956 (leg-art cover in net stockings)
July 1956 *Picture Scope* (great cover, 3 pages)
Sept. 1956 *Picture Scope* (cover and 3 pages; as in several other magazines, her name is misspelled "Brasmer")
Sept. 1956 *X-Citement in Pictures* (6 pages, fine pool layout)
Oct. 1956 *Follies* (cover)
Oct. 1956 *Fury* (back cover, classic pose in underwear, holding cards in front of her bare bosom—the shot originally intended for *Playboy*)
Oct. 1956 *Modern Man* (a "must" for any Betty collector: classic Keith Bernard cover, revealing color centerfold, and 4 pages, totalling 11 pictures, plus full-length article).

Oct. 1956 *Outdoor Adventure* (outstanding back-cover boudoir pin-up)

Oct. 1956 & Nov. 1956 *Roslyn Grapevine* (advertising pin-ups in both issues as "Rita Roslyn")

Nov. 1956 *Follies* (cover)

Nov. 1956 *Fury* (4 pages of lingerie and swimsuit shots)

Nov. 1956 *Jem* (Vol. 1, No. 1; inside cover and color centerfold virtually identical to the 10/56 *Modern Man*)

Nov. 1956 *Night & Day* (2 pages with Iris Bristol)

Nov. 1956 *Real* (one of her finest centerspreads in low-cut swimsuit, and 2 pages)

Dec. 1956 *Battle Cry* (4 pages, 6 pictures)

Dec. 1956 *Figure and Beauty* (4 pages; Betty's debut appearance in a Weider muscle magazine)

Dec. 1956 *Night & Day* (2 superb full-page pictures; Betty is voted the #1 model of 1956 by *N&D* readers.)

Dec. 1956 *Photographers Showplace #2* (2 pages)

"21" Annual 1956-57 (centerfold and 3 pages, six totally gorgeous pin-ups)

Modern Man 1957 Yearbook of Queens (back cover, 4 pages, 8 pictures)

Jan. 1957 *Carnival* (cover)

Jan. 1957 *Jem* No. 2 (3 pages)

Feb. 1957 *Glamour Parade* (cover, 2 pg.)

Adam Vol. 1-6 Mar. 1957 (cover)

May 1957 *Jem* (fine color foldout plus 2 pictures)

May 1957 *Pic* (cover, 5 pages)

July 1957 *Cabaret* (1 page "Pinup Art")

Aug. 1957 *Backstage Follies* (cover, 4 pages, 8 pictures)

Oct. 1957 *Frolic* (centerfold, classically glamorous)

Dec. 1957 *Muscle Builder* (cover with Dick DuBois)

Figure Annual Vol. 8 c. 1957 (3 pages, uncredited)

1958 Night & Day Pin-Up Annual

Foto #37 Feb. 1958 (cover, color centerfold in bikini)

Apr. 1958 *Male Point of View* (color centerfold together with Iris Bristol in swimsuits plus 1 pg. each)

Apr. 1958 *Photoplay* (cover, 3 pages)

May 1958 *Pic* (cover, 4 pages, sexy layout)

Feminine Form #6 1958 (cover, centerfold, and 2 pages)

Feminine Form #7 late 1958 (great cover in tight white nightgown, 1 page)

July 1958 *Rogue* (cover)

July 1958 *"21"* (cover)

Sept. 1958 *Rogue* (5 pages)

Dec. 1958 *Rogue* (5 pages)

Best Photography #183 1959 Edition (inside back cover)

Escapade's Choicest #3 1959 (cover centerspread of the "strip poker" shot designed for *Playboy*)

Feb. 1959 *Rogue* (cover, 1 page)

Rapture No. 1 1959 (fine bikini cover)

Nov. 1959 *Monsieur* (cover, topless underneath mink stole)

Dec. 1959 *Jem* (cover)

Dec. 1959 *Men's Digest* (cover, 7 pages)

Jan. 1960 *Monsieur* (cover in slinky white furs)

Feb. 1960 *Jem* (cover in red swimsuit)

Apr. 1960 *Jem* (cover in white bikini)

May 1960 *Monsieur* (cover in gold lame pants and bra)

May 1960 *Muscle Builder* (cover as "the Muscle Man's Girl Friend" with Billy Hill)

June 1960 *Jem* (cover in white bikini)

June 1960 *Romp* (cover)

1959-1995: Role Model for a Generation

Around 1959, Betty met magazine publisher and renowned fitness guru Joe Weider in connection with some pictorial appearances she was making in his publication *Beauty and Figure*. ""I had appeared in his magazines many times before I met him," remembers Betty. "When I was doing some health-and-fitness pictures in the mid-'50s, the photographer, Bob Delmonte, told me that the publisher would probably fall madly in love with me. That was because we both loved philosophy, psychology, history, music, and comparative religions. And (Delmonte) told me that I was already (Weider's) favorite model." Two years later, she went to New York and met Weider through her agent. On the way to the meeting she recalled, "Oh, this is the guy who was supposed to fall in love with me!"

Sure enough, they did hit it off immediately. Betty remarked in another interview: "He requested me for a dozen more photo assignments, and after each session we would go out to lunch or dinner. We talked on subjects of mutual interest—psychology, philosophy and religion. There was no romance. I also gave him input to his magazines, opinions and ideas he valued a great deal. This went on for about six months, and it was then, I think, he got interested in me as a woman." Their friendship became closer, and she stayed on to live in New York just as his marriage was drawing toward an end.

The October 1960 trial of Joe and Diana Weider on opposing adultery charges, held in Manhattan Supreme Court, was a colorful affair which captured the attention of the city's tabloids for more than two weeks. Both Weiders had hired private detectives to spy on the other, seeking evidence of alleged extramarital indiscretions. Diana's attorneys presented testimony that the previous November, Joe and Betty Brosmer had been surprised by a 270-pound Canadian detective in Joe's Montreal hotel room, although they explained that the circumstances were entirely innocent.

Betty, attired demurely in a trim gray suit and glasses, took the stand to emphatically deny that there was any hanky-panky between herself and Weider. She was in Montreal "purely on business" to discuss her appearances in a magazine, *Beauty and Health*, published by Joe's brother Ben. During the raid, she testified, she was in the bathroom drawing bathwater for Joe, and shut the door in terror when the commotion began. Her attorneys successfully moved to disallow the use of pin-up photos of Betty on the ground of irrelevance, while introducing a dozen health-and-fitness photos of her from Weider magazines as evidence. Finally, on October 24, a Supreme Court jury found both Joe and Diana Weider innocent of adultery charges in companion verdicts. The outcome left the estranged couple in the same situation as before the trial, when Joe had brought suit for divorce and his wife had countersued. "That was a very difficult time," says Betty. "I was just caught in the middle. I was not really involved

with my husband at the time, I was just modeling for him." A few months later, a divorce was granted, and on April 24, 1961, Betty Brosmer—the woman with the perfect figure—married Joe Weider, the man with the perfect physique.

During the mid-to-late 1950s, Betty appeared in several 8 and 16 mm "action" shorts, and later turned up in a few feature film cameos. Even though magazine ads for the shorts promised all variety of sexy action, they are, in fact, quite innocent. "They were just modeling sessions, but they put crazy names and captions on them,"

As an associate editor, columnist, and occasional model for Weider publications, Betty has served as the ultimate example of beauty and fitness after 40.

she explains. "I heard that the companies got a lot of returns because the men were led to expect something sexier—they didn't expect to get Girl Scout sessions!" The film shorts included:

Screen Test

Pin-Ups

Late Date: According to the highly exaggerated advertisements, "Betty returns from a date, and after discouraging her too-amorous suitor, disrobes and prepares for bed."

First Movie: "Betty enacts the role of a nervous model on her first studio assignment. Hesitantly she disrobes—and as her clothing falls from her full figure—it's sheer dynamite!" Of course, in reality there was no disrobing on camera.

Pasha's Passion: In which she "portrays a sultan's delight, awaiting a visit from her 'master' in sheer Oriental attire." Betty has no recollection of this item, for which the description was probably even more inaccurate than the others.

Tempest

Daisy Mae: The ads would have us believe that in this one, Betty's a "lonesome farm maiden on a sunny afternoon, showing what they do 'down on the farm.'" Once again, the more demure truth is that she was merely posing in casual attire.

Betty Brosmer, Part 2 is a splendid 15-minute silent film short of Betty doing a variety of swimsuit poses, dating, evidently, from the late '50s.

In The Dirty Dozen (1967), photographs of Betty appear on the wall of the MP barracks. A training room wall in the

documentary *Pumping Iron* (1977) is also graced by images of Betty. That film's sequel, *Pumping Iron II: The Women* (1985), finds Betty in the Las Vegas audience watching the female competitors.

Marriage brought an end to Betty Brosmer's career as America's favorite pin-up model, but ushered in an enduring second career as Joe Weider's active partner in his health-and-fitness empire. Her ever-stunning form was used in the Weider publications for years to advertise such products as "Beauti-Breast," "Love Legs" and "Bustline Persuader." More importantly, Betty Weider has also served as a regular contributor to *Muscle and Fitness* for the past 30 years and (more recently) has been a monthly columnist ("Body by Betty" and "Health by Betty") and associate editor for the women's-fitness magazine *Shape*. In 1981, Betty and Joe co-authored the book *The Weider Book of Bodybuilding for Women*, followed three years later by *The Weider Body Book*. In addition, she is a member of the Olympic Committee on Physical Fitness.

Betty has had the opportunity to meet many memorable personalities in her work on behalf of her husbands magazines. Arnold Schwarzenegger is an old and dear friend; Betty did a swimsuit layout with him in 1967 in what was Arnold's first American photo session. Sylvester Stallone told her how his days as a "wild party kid" ended after he saw a Weider magazine with Betty on the cover. "It changed his whole life. When you can discipline yourself to train and exercise when everyone else is drinking and smoking, you feel you can do anything—you can climb any mountain."

She receives thousands of letters each year—about 75 percent from women—as a result of her columns in the magazines. One that she recalls vividly was from an obese woman who was planning to commit suicide on her 40th birthday. "She picked up a copy of *Shape* magazine at the grocery store, and felt like her hand was a magnet when she opened it up to my page. She saw that it mentioned I was in my 50s, which shocked her. She said it changed her life, she was so inspired and decided that a woman her age could lose weight and become fit. I called her up after I received the letter. It was very moving."

Working on the Weider publications and accompanying Joe to bodybuilding events around the world occupies most of Betty's full life these days. She travels to Europe once or twice a year, since the Weider magazines are published in virtually every European country and in the far East. Her fame has preceded her in some unexpected places. "I was in a taxi in Cairo once when I suddenly saw a Marilyn-like picture of myself. I've seen the same picture in Belgium, Shanghai, and other places around the world." Betty often attends Miss Olympia and other bodybuilding contests to cover them for the magazines, but never serves as a judge since she knows so many of the participants.

Betty is an accomplished decorator and designer, and an avid collector of the antiques which fill the Weiders' home. Antique cars are a particular passion: "All the old cars I couldn't have when I was young, I like to have now!" A longtime music lover, she was at one time reported to have owned some 1,000 jazz records. Billie Holiday, Ella Fitzgerald, Sarah Vaughan, and Dizzy Gillespie remain among her personal favorites. Betty works out three or four days a week in the fully-equipped gym installed in their home; on the other days, she walks a mile on a treadmill. And as a health-food devotee for well over 30 years who has long disdained soft drinks in favor of sparkling water, she watches her diet carefully.

During the mid-1970s, Betty got into a contest with Schwartzenagger and several other bodybuilders (including Franco Columbo) on a lung capacity machine. The item was being advertised in the Weider magazines, so they volunteered to try it out. Betty registered a greater lung capacity than any of them. "I couldn't believe how that happened. Everyone was surprised, they thought it was a trick!" she laughs delightedly.

A sampling of Betty's most significant magazine appearances from 1961 onward:

Jan. 1961 *Jem* (cover)

Feb. 1962 *Muscle Builder* (cover with Dick DuBois)

Fling Vol. 9 1962 ("Last Fling With Betty Brosmer" indeed turned out to be one of Betty's final outings for Keith Bernard's cameras, and the 5-page, 9-picture layout—actually shot around 1958-59—includes a couple of particularly sizzling cleavage shots that appear to reveal a bit more than she may have intended. However, *Fling* publisher Arv Miller confesses today that it was a trick: For the first and only time, he "drew in" a nipple in the shots of Betty where she is holding a towel just barely over her bosom. So this issue isn't quite the collector's item some might have thought!)

Vigor: Betty appeared in numerous early-1960s issues of this Weider publication, demonstrating exercises in leotards, and turning up in virtually every ad in the magazine.

June 1964 *Vigor* (cover with Reg Lewis and article: "The Best Physique of Your Life—After 30")

Apr. 1969 *Mr. America* (cover with Larry Parks)

May 1969 *Mr. America* (cover in bikini with Dave Draper; also featured in a "Complete Fitness Course" layout)

June 1969 *Muscle Builder/Power* (cover with Larry Scott)

July 1969 *Muscle Builder/Power* (cover with Arnold Schwarzenegger)

Sept. 1969 *Muscle Builder/Power* (cover with Draper and Schwarzenegger)

Oct. 1969 *Mr. America* (cover with Reg Lewis, a great swimsuit shot)

Nov. 1969 *Mr. America* (bikini pictures, with Schwarzenegger)

Nov. 1969 *Muscle Builder* (cover with two men and three women)

Jan. 1970 *Mr. America* (several bikini shots of Betty with Schwarzenegger)

March 1970 *Mr. America* (cover with Draper; also several bikini shots inside)

Apr. 6, 1970 *Sports Illustrated* (picture of Betty in feature on Joe Weider)

June 1970 *Muscle Builder* (cover with two bodybuilders)

Aug. 1970 *Mr. America* (cover in bikini, with Draper; also inside)

Aug. 1970 *Muscle Builder* (cover with Schwartzenegger, Draper, Frank Zane and three women)

Sept. 1976 *Muscle Builder* (cover with Frank Zane)

Feb. 1989 *Muscle and Fitness* (fine figure shot in leotards)

June 1989 *Muscle and Fitness* (splendid glamour portrait of Betty by Harry Langdon)

Feb. 1991 *Muscle and Fitness* (nice shot of Betty and Arnold)

Nov. 1991 *Muscle and Fitness* (great Langdon picture of Betty in tights with two female bodybuilders)

Jan. 1992 *Muscle and Fitness* (superb glamour portrait by Langdon)

Anyone with remaining doubts about the virtues of bodybuilding for women need only take a look at a promotional poster photographed by famed Hollywood lensman Harry Langdon in 1985. "Weider Builds Bodies" is the caption, and the radiantly beautiful Betty—her waist appearing as astonishingly tiny as it had been 30 years earlier, her body still bursting with vitality at age 50—remains nothing short of stunning. Her most recently reported measurements are 37-21-36. Now 60, Betty remains an utterly breathtaking vision quite capable of cause gasps in any setting.

In early 1993, Dell published Betty and Dr. Joyce Vedral's *Better and Better*. Promising "Six Weeks to a Great Shape at Any Age," the book offers women instructions for a 30-minute workout and sound nutrition. Best of all for her pin-up fans, the book features a gloriously robust Betty on the cover and in many inside pictures demonstrating exercises in leotards.

A perfect example of her enduring appeal across the years comes from a fan letter she received a few years ago. Betty relates the story of one man in his 20s who fell in love with her through her appearances in *Muscle and Fitness*. and showed the pictures to his father. "Oh, that's Joe Weider's wife!" declared the father with immediate recognition. Then the grandfather chimed in: "That's not Betty Weider, that's Betty Brosmer! She was my favorite model in the '50s." Betty smiles and shakes her head. "Three generations of fans!" she marvels.

Staying power is not a characteristic often associated with glamour girls, but Betty Weider has demonstrated far more than that: she has become a role model for a generation of women, demonstrating that with enough hard work and dedication, classic beauty and fitness can endure well beyond a 30th, or 40th, or 50th birthday. Now, as ever, Betty remains the living embodiment of the feminine ideal.

(Special thanks to Betty Weider for her gracious cooperation. Thanks also to two gentlemen who generously provided valuable information and materials: Harold Forsko, the world's most avid Betty Brosmer collector, and William E. Moore, president of the Joe Weider Fan Club.)

Gold's Weight Training Book (1978 book, Betty on cover)

Feb. 1979 *Muscle Builder* (cover inset, and fine feature article on Betty with one dazzling bikini photo and several photos working out)

Mar. 1979 *Muscle Builder* (cover with Mike Mentzer)

Apr. 1979 *Muscle Builder* (cover with Robby Robinson)

May 1979 *Muscle Builder* (cover with Zane)

May 1985 *Muscle and Fitness* (cover, in swimsuit, with Bob Birdsong and Cory Everson)

Dec. 1985 *Muscle and Fitness* (Betty and Diahann Carroll)

Jan. 1986 *Muscle and Fitness* (cover, in swimsuit, with Lou Ferrigno)

July 1986 *Muscle and Fitness* (perfect swimsuit picture)

Jan. 1987 *Muscle and Fitness* (Betty's column features her with Jaclyn Smith)

March 1987 *Muscle and Fitness* (Betty and Loni Anderson)

June 1987 *Muscle and Fitness* (terrific swimsuit shot of Betty and female bodybuilding champion Rachel McLish)

Feb. 1988 *Muscle and Fitness* (Betty and Brooke Shields)

May 1988 *Muscle and Fitness* (cover with Larry Scott; Betty is particularly gorgeous in a blue swimsuit; also a great full-page swimsuit shot inside)

June 1988 *Muscle and Fitness* (another great picture of Betty and Rachel)

Aug. 1988 *Muscle and Fitness* (Betty and Arnold)

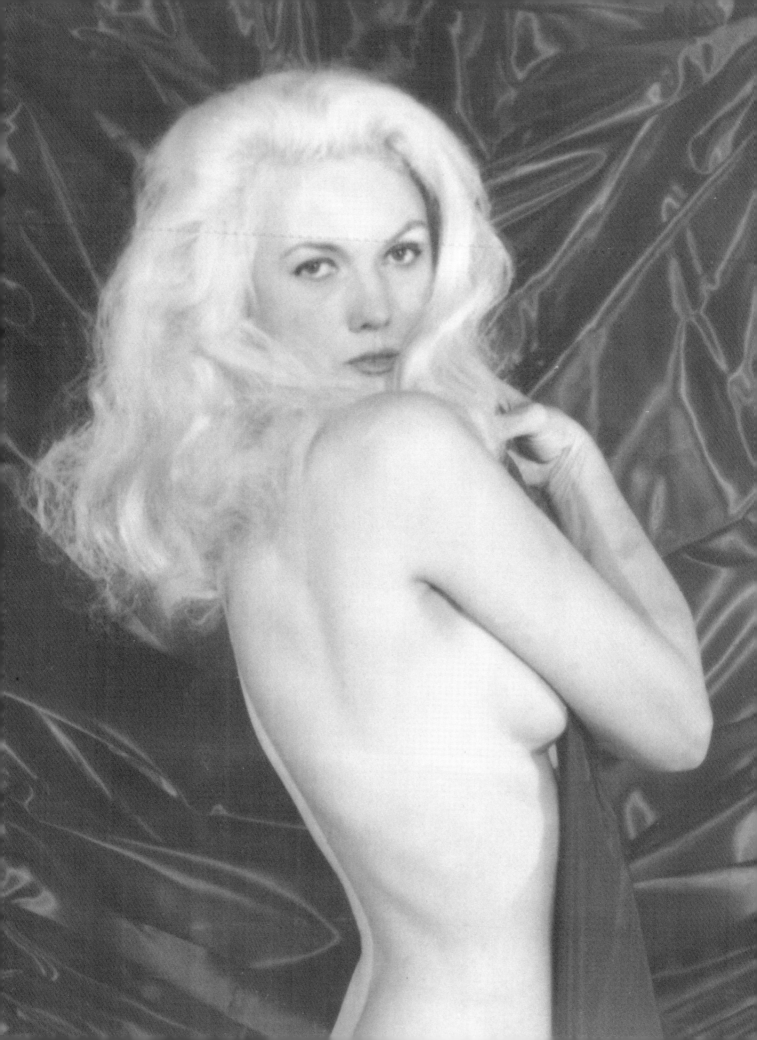

When she first burst upon the national scene, she was a delightful novelty: a curvy cutie who photographed other curvy cuties. With the passage of time, we can better appreciate the fact that Bunny Yeager—first as a model and then as glamour photographer extraordinaire—was instrumental in creating the indelibly bright, sun-kissed image of 1950s American cheesecake.

Bunny Yeager's status as a pioneer in pin-up history is secure. Had she never picked up a camera, she would rank in her own right as one of the most popular models of the immediate postwar era. The fact that she did cross over to the other side of the lens to create some of the postwar era's most wonderful works of figure art only lifted her to a still loftier perch. That she remains a woman of monumental drive and ambition is proven by her achievements in a male-dominated business, all carried out behind a warm smile and her own distinctive Florida charm.

Bunny was born Linnea Eleanor Yeager in Pitcairn, Pennsylvania, a rural town just outside of Pittsburgh. Known to everyone as Eleanor, she was named after her mother Linnea, a name that means "Little Swedish Flower That Grows In the Mountains." But she was truly a child of the beaches of Miami, where her family moved in 1946 due to the poor health of her father, a former Westinghouse draftsman.

Bunny Yeager

Born Pitcairn, Pennsylvania

The name by which she has been known ever since that move came courtesy of the silver screen. "The truth of the matter is that I saw a movie called *Weekend at the Waldorf* (a 1945 remake of *Grand Hotel* co-starring Lana Turner and Ginger Rogers)", she recalls today. "Lana Turner's character was named Bunny. From as far back as I remember, I kept scrapbooks filled with clippings of Lana Turner and Betty Grable—I had their entire lives in those scrapbooks. I really admired them.

"When I first saw her in that movie, I thought, 'I've never heard the name Bunny before.' It was so soft and feminine and so wonderful. I decided I was going to take it. So when we moved to Florida, I became Bunny. It was more exciting than being called Eleanor!"

A few years after going south, she realized that the move proved lucky in more ways than one. In Pitcairn, "I was just another too-tall girl. At 5-feet-10 in my stocking feet, I couldn't be a cheerleader, act in school plays or anything. But as a model, my height is an asset." Bunny soon got over her self-consciousness about her height to become a member of a social group called the Tip Topper Club, an organization of about 50 girls who were at least 5-foot-10.

"Miami amazed me," she later remarked. "I was so used to being cold all the time that I couldn't quite get used to the idea that you could wear a swimsuit all year round."

Soon after her arrival in Miami, Bunny enrolled in a night modeling school while attending Miami Edison High School. There she was selected as the school's "girl with the sweetest smile." Bunny began her modeling career in December 1947 after winning the title of Queen of the Trailer Parks at the Greater Miami Trailercoach and Sportsmen's Show. Bunny won $500 and a trip to Havana the following May. It was her first airplane trip, an unforgettable thrill for the teen-ager.

"I really enjoyed being a model—fashions, dresses, furs and especially bathing suits. It made you feel wonderful, like you were really someone special. People looked up to you, respected you and wanted to be like you."

She quickly began landing assignments as a department store model. Bunny was working by day as a secretary, but was certain that modeling was her future. One of her early glamour-girl jobs was being a "Fun In the Sun Girl" at the Fun In the Sun festival in July 1948. Three months later, when the *Miami Herald* published a special "Florida Welcome Section" showcasing the city's many attractions for tourists during the Orange Bowl festival, included was a full-page shot of a beaming Bunny lying on the sand representing the "Gals" of Miami Beach.

Her prize for being named Queen of the Sports Carnival in January 1949 was a dream visit to New York where she accompanied Joe DiMaggio (who, as a judge, officially crowned her) and was interviewed on a nationally-syndicated radio program. She and DiMaggio also dated. It's fascinating to see the few pictures of Bunny from this period when she had dark bangs combed forward in a page-boy; she looked startlingly like a certain Bettie in her future.

In 1949 alone, Bunny's beauty titles included Miss Personality, Miss Opa-locka (which qualified her for the Miss Florida pageant) and Queen of the Miami Boat Regatta. As Miss Personality, she was given a week's stay at one of the most lavish hotels in Miami Beach, and made radio and TV appearances with Swedish movie star Marta Toren.

"The Deauville Hotel in Miami Beach had a beauty contest almost every weekend—Miss Legs, Miss Brevity, Miss Almost-Anything," Bunny recalls. "I loved being in these contests. The crowds were always large around the Olympic-sized pool where we had to parade. They loved us!"

She was a finalist in 1949 to represent Florida in the Miss America pageant, and a contestant for the crown of Orange Bowl Queen that December. No title other than Miss America was more coveted among Florida beauties, and Bunny had scored increasingly higher in three previous attempts. When Bunny and the other unsuccessful contestants learned after the fact that the event was "fixed," they retained an attorney and successfully sued. She was modeling for the Coronet agency at the time.

A girl of many talents from an early age, already Bunny was noted in newspaper accounts as an accomplished interpretive dancer, blues and novelty singer, watercolor painter, sculptor. . . and photographer.

By early 1950, the fast-rising auburn-haired, hazel-eyed model's fame extended beyond Florida with appearances in national magazines. Among her first covers were the March 1950 *See* posed in a self-designed two-piece leopard-skin swimsuit, and the June 1950 *Laff*. Within a short time, Bunny regularly graced the pages of *Famous Models*, *Hit!*, *Cover Girl Models* and the other top cheesecake mags of the era.

Bunny the Designer

Apart from her fresh, natural beauty and long, shapely figure (36-25-37, 135 pounds), Bunny's greatest attribute as a model was her ingenuity in creating her own original designs. "I've been designing my own bathing suits ever since the day I

could fill on out to advantage," she told one interviewer in 1951. Due to her height—particularly her long legs—it was difficult to find suits to fit her properly. So making her own was a natural step.

By 1949 the bikini was scandalizing beachgoers in the south of France and elsewhere in Europe, but was commercially unavailable in America. So Bunny crafted her own; their unique quality increased her appeal.

Looking over the commercial swimsuits she wore during this period for catalogs and other modeling jobs, Bunny points out their generally unflattering quality. In contrast to the drab and conventional one- and two-piece suits that tended to make all figures look alike, Bunny's bikini designs—boldly colorful, frilly and featuring bosom-baring slits—were a sensation. One summer-1949 bikini pose was carried on the wire services and ran in dozens of newspapers around the country.

"I made swimsuits out of everything, by hand," she says today. "The thing the photographers got excited about with me was that I would come up with a new idea for a suit. They wanted to see something fresh and new, because if you had a different-looking suit they could sell the pictures more easily. So I kept trying to dream up new ideas."

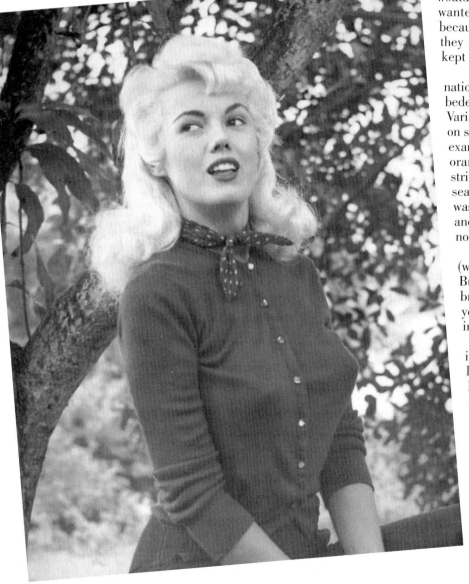

One of her favorite designs generated national publicity in 1950: a gorgeous daisy-bedecked bikini that absolutely rivets the eye. Variations on this creation would turn up later on some of Bunny's models. She cites another example of a tiger-print bikini she made from orange material and hand-painted each stripe to look like a tiger. "You really had to search for the right materials. Everything was hard in those days. I would take cloth and hand-paint my own designs, so that nobody else would have what I had."

A one-piece suit slit to the waist in front (with buttons from neck to navel) in which Bunny was photographed in 1950 was a breakthrough original design. Some 15 years later, the famous designer Halston introduced a virtually identical suit.

Conscious of the commercial possibilities of her talent and in partnership with a local dress and sportswear manufacturer, Bunny started her own swimwear firm (Bunny Yeager, Inc.) in August 1950. Her original line included a complete range of "practical" swimwear, plus cocktail swimsuits in lame, velvet and fake furs, ranging in price from $3.75 to $375. "Modeled from the world's most exquisite figure for the world's most beautiful woman. . .you. . .the American Beauty," declared a promotional brochure. Unfortunately, due to poor business guidance, the enterprise never quite

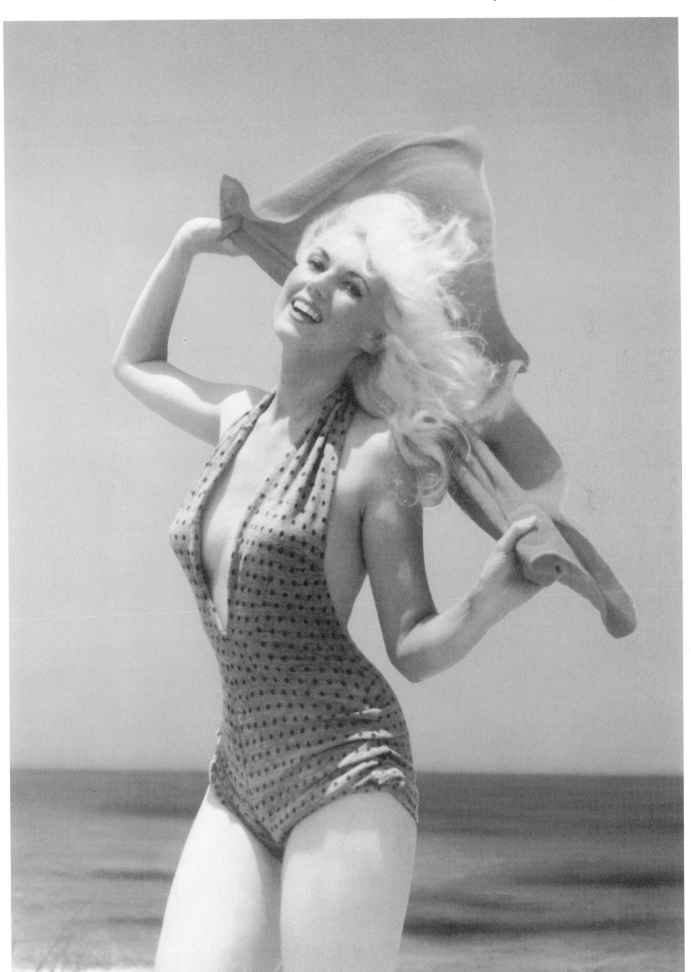

got off the ground, although she sold quite a few designs to area gift shops. Bunny's designs, however, would make pin-up history. By early 1951, just about every layout on Bunny focused on her design abilities. Making your own swimsuits isn't all that difficult, she would say—"all you need is a yard of material, scissors and imagination." Of course, the latter was the hardest to come by.

Bunny's packed professional schedule cut short several romantic relationships. In a 1951 interview, she related that the first was a soldier who had just returned from Japan and "wanted me to become a little housewife. But I didn't want to become a stay-at-home, and only worry about getting supper on the table. I wanted to go out and be busy. I can't be content like some wives to stay home all day and read magazines." Another fiance bailed out due to jealousy.

In May 1950, she married Arthur "Bud" Irwin, who approved of her career and was secure enough to know that Bunny would maintain a very full life outside the home. They had two daughters in their 27-year marriage before he passed away in 1977.

Hardly a week went by without at least one pin-up shot of Bunny in the Miami papers. Indeed, she was becoming such a symbol of the city that a March 1950 newspaper quiz inviting readers to identify pictures of 10 familiar local faces (mainly politicians, civic and sports personalities) included her. When the city issued a brochure to promote tourism, the bikini beauty waving a friendly greeting from the front was, of course, you-know-who.

In April 1950, Bunny was selected over other aspiring beauties as "the typical Florida girl" to represent the state on a 15-day trip to Mexico City celebrating Spring Festival. And the beauty titles kept coming. She was "Queen of Cheesecake" of 1951, "Miss Army-Air Force," and the "Orchid Queen" in early 1952.

Florida pin-up fanciers shuddered in late 1952 when Bunny announced that she was through with cheesecake, and would henceforth focus entirely on high-fashion modeling. Toward that end, she had her shoulder-length hair shorn to a so-called "chrysanthemum cut." Happily, this phase would be short-lived, thanks in large part to Roy Pinney and *U.S. Camera.*

Bunny's most noteworthy magazine appearances as a model included:

March 1950 *Laff* (1 page in two-piece swimsuit)
May 1950 *Hit!* (2 pages in brief bikini, looking Bettie Page-like)
June 1950 *Laff* (cover in bikini)
June-July 1950 *Famous Models* (1 page)
Oct.-Nov. 1950 *Carnival* (#1; swimsuit pictures)
Feb. 1951 *Picture Show* (beach layout)
March-Apr. 1951 *Famous Models* (several swimsuit shots)
Spring 1951 *Laff Annual* (full page)
Dec. 1951 *Cover Girl Models* (2 pages)
Aug. 1952 *U.S. Camera* (cover by Roy Pinney with Bunny in bikini)
Nov. 1952 *Hit!* (bikini poses)
Dec. 1952 *Sir* (1 page)
March 1953 *Frolic* (2 pages, 3 bikini photos)
March 1953 *Man to Man* (2 pages, 3 pictures)
Dec. 1953 *Tab* (4 pages)

May 1954 *Man to Man* (2 pages)
Apr. 1955 *Art Photography* (lengthy article/photo feature working with Bettie Page)
May 1955 *Playboy* (joint feature on Bunny working with Bettie Page)
Aug. 1955 *Eye* (10 pages posing and shooting)
Oct. 1955 *Night & Day* (3 pages in bikinis)
Sept. 1956 *Gala* (2 pages, 3 beach photos)
Feb. 1957 *Rogue* (5 pages, 7 very sexy self-portraits)
Summer 1957 *Figure Photography* (#1; 6 pages, mostly self-portraits)

July 1957 *Scamp* (#2; 3 pages, "Girl Shoots Nude" with Maria Stinger)

Night & Day 1958 Pin-Up Annual (semi-topless centerspread)

Jan. 1958 *Vue* (6 pages posing and shooting)

Sept. 1959 *Playboy* (2 splendid self-portraits in feature "Bunny's Honeys")

Nov. 1959 *Zest* (3 pages)

May 1994 *Playboy* (2 pages of revealing self-portraits in a new "Bunny's Honeys")

A Photographer Is Born

The cover of the August 1952 *U.S. Camera* was a gorgeous Roy Pinney shot of Bunny in a striking jungle-striped two-piece suit (self-made, of course), seated on a piece of coral rock with waves crashing behind her. For all the magazine covers she had graced, this was the most prestigious yet.

Bunny's dedication to her craft as a model would carry over to her second career as one of the all-time great glamour photographers.

The New York-based Pinney had long considered Bunny one of his favorite models, retaining her services on jobs every time he came to Miami. "He learned that I was going to photography school, decided that I was going to be 'The World's Prettiest Photographer,' and sold a cover to *U.S. Camera* with that title. And the title stuck.

"He really pushed me into it. I'd never planned to become a professional photographer. I was just studying so I could learn to do it better, to take pictures for my own enjoyment. On modeling jobs, I watched the photographers work, go into the darkroom and watched them develop the pictures; that was very fascinating to me. It was all simply because I thought I could create some nice pictures, too. After (*U.S. Camera*) appeared, I had no choice."

Bunny had taken her first photography courses in 1951-52 at the Lindsay-Hopkins Vocational School. Even without knowing what lay ahead, she carefully absorbed every aspect—lighting, camera angles, backgrounds, the use of props. She helped the photographers develop the pictures they took of her, agitating the film. The preparation would pay off very quickly.

She remarked in a 1950s article, "I spent seven years parading before beauty contest judges and posing for publicity stills in everything from furs and formals to spaghetti-trimmed bikinis. Somewhere along the line I became fascinated by the camera and decided that my career was on the other side of the lens. As far as I knew, every pin-up photographer was a man. But why couldn't a woman, especially one well-versed in the technique of posing, take just as interesting photographs?"

Barely a year after that public unveiling in her new endeavor, Bunny was told by her agent that a publisher wanted her to do a photography book. "But I don't know how to write a book!" she protested. "Just get your best pictures and write about them as if you were talking—tell about how you shoot girls," she was advised. "And that's what I did."

Photographing the Female Figure, published in 1954, became widely popular at about the same time that Peter Gowland's first book, *How to Photograph Women* was published. Bunny's book went through three printings, and sold between 300,000 copies (published accounts) and two million (according to Bunny).

A full discussion of Bunny's remarkable second career is beyond the scope of this volume. From Maria Stinger and Lisa Winters to Diane Webber and her ultimate model, Bettie Page (whom she photographed for *Playboy* in a classic January 1955 centerfold), Bunny captured forever on film an array of the era's most stunning women. Suffice it to say that without Bunny Yeager the photographer, the Golden Age of Glamour Girls would have seemed considerably less golden.

Bunny the Actress

An important but relatively little-known aspect of Bunny Yeager's life has been her acting career. Bunny's aspirations to get into movies were apparent as early as 1951, when she met with a visiting producer who'd seen her

magazine pictures. During the next decade and a half she was so occupied with other work that she had little time for acting; in the mid-'60s she began focusing more on this area.

Several of her films concerned Bunny's true life, such as *Bunny Yeager's Nude Camera* (1963, featuring one of her favorite *Playboy* Playmates Lisa Winters) and *Bunny Yeager's Nude Las Vegas*.

One of Bunny's most unforgettable movie experiences was the 1967 Frank Sinatra/Raquel Welch detective film *Lady in Cement*, which was shot in Miami. "I sent 75 bikini girls to his room at one time," she recalls with a smile. "The director wanted to get a lot of girls on the beach, so I just rounded up everyone I knew. They were lined up in the hallway to be interviewed. I made such an impression that they wrote in a special role for me." She turns up briefly in the film as a Swedish masseuse, wearing white bra and shorts, giving Joe E. Lewis a back rub and asking him sensuously, "why don't you call me Bunny?"

According to Bunny, her best role was as a "happy wife" in an Italian picture not released in the U.S., *Italian Taxi Driver in New York* with Dom DeLuise. "I get blown up in the end," she says. She played a call girl in another Frank Sinatra film, *Tony Rome*; an evil character guarding kidnapped children in *Aladdin* (not the Disney film of the same name, of course); a news photographer in *Nude Season*; a waitress in *Harry and Son* starring Paul Newman; a fashion-show model in *The Champ*; an extra in the newsroom in *Absence of Malice*; and had a nonspeaking part in the exploitation hit *Porky's*. She also turned up briefly in *Lenny*, *Caddyshack* and *Hardly Working*.

Bunny also had small roles in a couple of genuine movie classics, but unfortunately too small to receive any notice. In the Oscar-winning 1969 drama *Midnight Cowboy*, she originally had "a good closeup in a bikini—they framed the whole screen with my body." But after working on the scene for two full days, it was cut. "I thought I'd be discovered!" she says with a rueful smile. In the 1981 Kathleen Turner-William Hurt erotic sizzler *Body Heat*, Bunny was "just somebody on the beach" in a late-night scene.

On TV, Bunny returned to the familiar role of a Swedish masseuse twice more: in the first episode of Burt Reynolds' *B.L. Stryker*, and again on *Miami Vice*. In addition to doing a variety of TV commercials, she also had the leading role in *Light Up the Sky* at the Miami Shores Little Theatre.

Bunny began a new phase of her career in 1983, launching a performing arts newspaper called *Stage & Screen News*. "I'm the only newspaper for the film and television industry in south Florida," she declares. "When I started, there was no way you could find out what productions were going to be filming here." Her publication has enabled actors, film technicians, prop and stuntmen, and other industry professionals to learn about potential job opportunities.

In 1985, several years after the death of her first husband, Bunny married Harry Shearer; she and Harry work together on most of her photographic and publishing activities.

Bunny also served during the early 1990s as president of the Florida Motion Picture and Television Association, a nonprofit organization that promotes filmmaking in the state. "If you wanted to do a film, TV show, commercial or even a fashion model shoot in Florida, I could help you scout locations and get together the crew and actors. That's my business."

Popular interest in Bunny has resurged during the last several years, due in part to the intense Bettie Page cult. The 1987 *American Photographer* feature on Bunny helped kick this off, along with Greg Theakston's profile of her in issue No. 3 of the magazine *The Betty Pages* the following year.

By sheer coincidence, Bettie's re-emergence in late 1992 was simultaneous with a delightful magazine published by Bunny, *Betty Page in Jungleland*. It contains 33 pages of her Bettie photos in gag-strip storyboard fashion, mostly from their famous "Africa, USA" session. During this period she also agreed to provide photos for a proposed definitive biography of the Tennessee tease. During 1993, she was featured in *Interview* magazine and the Bettie Page fanzine *Fond Memories*. In 1994, Bunny's line of Bettie Page trading cards was issued by 21st Century Archives. And in early 1995 the book *Bunny's Honeys* was published, featuring 40 years of her most unforgettable models. It should also be noted that since April 1994, Bunny has served as publisher for the bimonthly magazine *Glamour Girls: Then and Now*, written and edited by this author.

Plans for the future? Bunny has plenty, even as she keeps up with the film/TV association. She intends to do a book compiling all of her Bettie Page photos. Also, an autobiography is very much on her mind; this may take dual form as a book and a documentary, which she would like to produce herself.

During the last few years she has plunged back into the art that helped make her a legend: pin-up photography. She had done relatively little of it in the 1980s, except for some shots in *Stage & Screen News*. But staying on top of the film and TV production scene in Florida provides an ideal means to connect with top young models. While the raunchy men's mags of today hold no appeal for her, there is hope of a new book collection of Bunny's glamour girls of the '90s.

Her enthusiasm for modeling and working with models is undiminished after all these years. "The excitement of posing for the first time is always special, and it shows in the pictures," she says. "Maybe it's like making love for the first time."

Today, Bunny's vintage pictures retain a wonderfully inviting quality matched by only a few of the era's other great lensmen. When you look at Bunny's best work, you can't help but smile, and there can hardly be a finer tribute to a pin-up photographer.

Bunny's imposing physical presence and beauty to this day are surpassed only by her energy and effervescence. It can be a source of pleasure to her many fans that there is more to come from the queen of pin-ups.

(Thanks to Bunny Yeager for her help and cooperation.)

"It was not only her beauty that had attracted him, the classic lines of her body or the wholesome features of her face, but the entire aura that accompanied each picture, a feeling of her being completely free with nature and herself as she walked along the seashore, or stood near a palm tree, or sat on a rocky cliff with waves crashing below. While in some pictures she seemed remote and probably unobtainable, there was a pervasive reality about her. . ."

When famed author Gay Talese turned his practiced eye to the subject of sex in America and how it absorbed young men growing up in the 1950s in *Thy Neighbor's Wife*, the lady he selected as the symbol of this obsession was Diane Webber. Little wonder, for among all the many girls who shot to fame during this era through nude modeling, only June Wilkinson and Bettie Page made such a profound and enduring impression as this ravishing brunette.

One of the most striking facts about Diane is that perhaps more than any other model, she masterfully created the illusion of physical perfection despite a less-than-perfect although lovely body. The art of illusion is, after all, at the heart of cheesecake photography; she cultivated it in part through her utter grace of movement as a dancer, but also by her total commitment to nudism and the pure beauty of the human body. She was, in more ways than one, the Classic Nude.

The daughter of an actress mother and best-selling author Guy Empey, Diane Marguerite Empey grew up just outside Hollywood. She took ballet lessons as a girl, and at 18 got a job as a chorus girl in San Francisco. Diane put her ballet training to use as a dancer with the famed Dorothy Dorben troupe.

To earn extra money, she began nude modeling. The photographer reputed to have discovered Diane was Tom Kelley, the man who "uncovered" the young Marilyn Monroe. Within a few years, she would become, in the words of one magazine, "the most famous model in the realm of figure photography."

While dancing and modelling by day, Diane worked at night operating a machine for tabulating checks. It was on this job, after finishing her tour with the Dorothy Dorben dancers, that she met a fellow employee, a strapping young college senior and soon-to-be film technician named Joe Webber, and their attraction was immediate. The two were married not long after.

According to one account, Diane in 1954 worked for a time as a receptionist at the Los Angeles TV station KHJ while she continued to study dance and drama.

Thanks to her professional training, Diane brought a special sense of style and grace which accentuated the impact of her deep brown eyes and natural California-girl

Diane Webber

Born Diane Marguerite Empey June 27, 1932
Los Angeles, California

physical and sexual appeal. The limberness of her body and her ease at moving and holding a variety of difficult positions made Diane a photographer's dream. Within a very short time after her nude debut, she found herself in demand by virtually every girlie magazine in America, and she disappointed few of them. She alternated her many appearances between the use of her married name and Marguerite Empey.

No photographer was more closely associated with Diane's swift rise to fame than Russ Meyer. One magazine observed in 1957: "The perfect blend of photographer and model was reached when Russ Meyer found Diane Webber." He recalls her today with a wry and appreciative smile.

"She did it for money," he observes. "She looked upon this whole thing as being ridiculous. Sex to her was very ethereal, in the head, very spiritual." The majority of Meyer's famous shots of Diane—including her second appearance as a *Playboy* Playmate—were taken during an intensive period around late 1955. "The reason she looked so great was that I shot her when she was two to three months pregnant. I shot her every day, tons of pictures. That's why her tits are so big."

In 1959, Meyer would engage Diane again to star in a nudie short film to accompany his big-screen directoral debut and the first "skin flick" to reach a mass audience, *The Immoral Mr. Teas*. The film was called *This Is My Body*, with languorous shots of Diane bathing outdoors. "Her breasts had fallen by then, but to her that didn't matter. The inner spirit was what mattered."

"Queen of the Nudists"

The main reason it didn't matter was that Diane and her husband were dedicated nudists, and took very seriously the philosophy of the human body as a thing of intrinsic beauty regardless of superficial appearance. In the book *The Wonderful Webbers*, Joe Webber later recalled how it began for them soon after the couple met: "Our full schedules increased the importance of finding suitable weekend recreation, and Diane's interest in photographic modeling made uneven tanning a liability." (She had been modeling professionally for two or more years before becoming a nudist.)

Through her modeling work, Diane became acquainted with members of a local nudist group, the Sundial Club, and she and Joe were accepted as members. Joe wrote: "We rolled up thousands of miles on the way to various nudist resorts. We took up badminton, shuffleboard, volleyball, and club administration. We attended meetings, dinners, prospective member interviews, and regional and national conventions. We even added to our workaday tensions a little by competing for athletic awards and beauty contests."

In 1956, Diane was officially crowned "queen of the nudists" at a convention in Spokane.

Unquestionably, this was far more than a recreational pastime to the Webbers. "The life of naturism—being active in the nudist movement—has given me a capacity for enjoyment I would not otherwise have had," Diane declared. "The people I have encountered and the experiences I have shared have all added a dimension to everyday living. I have known a richer, fuller life because of this involvement; but, most important to me, I no longer have to prove, either to nudists or to the public, that I am a 'good' nudist. I know that being a part of it has helped me enjoy a 'good' life."

The world of nudism was a very tightly enclosed circle, largely because its members faced legal harassment and social ridicule at almost every turn. This may explain the fact that when Diane's nudism became public in 1955, some veterans of the movement questioned whether she was "legitimate." Perhaps this suspicion was understandable; for example, stripper Evelyn West sought to squeeze every possible inch of press coverage out of her proclaimed nudism to the point where it seemed a mere publicity stunt. But nudism was very much a way of life to Diane, and before long that need to "prove" herself disappeared.

There was another reason why Diane faced initial resistance from the nudist "establishment." Traditional naturists, accustomed to defending themselves against charges of immorality, preached that theirs was a way of life devoted to good health and nothing more. The very idea that sex appeal entered into the equation was dismissed, as the Webbers' friend June Lange noted, as "heresy." When June's mid-1950s articles on the Webbers quoted them to the effect that "physical attraction is just as healthy, natural and pure as any other expression of nudism," the initial reaction was one of shock. But Diane and Joe strongly defended their conviction that nudism encompassed all aspects of normal human emotional needs, including sex, and succeeded in winning many converts.

The philosophy of nudism led Diane to select natural childbirth for the birth of her son John on February 10, 1956. She continued swimming and ballet exercises up to the end of her term, along with some special exercises to train the muscles used in giving birth. Just a few hours after Diane had the child at her doctor's office, the family drove home.

Diane's early magazine appearances included the following (appearances marked "MgE" are those in which she is designated as Marguerite Empey):

Sept. 1951 *Hit* (her first known magazine appearance; 1 picture)

March 1952 *Laff* (2 pages, 4 pictures)

Oct. 1952 *Famous Paris Models* (2 pages, 4 pictures)

May 1952 *Gala* (2 pages, 5 pictures)

June 1954 *Art Photography* (an anonymous brunette nude photographed by Keith Bernard in this issue who appears to be a sleek young Diane)

Feb. 1955 *Eye* (9-page layout of bikini beach pictures under the name "Marguerite Lorca")

May 1955 *Playboy* (Playmate of the Month, as Marguerite Empey)

Nov. 1955 *Art Photography* (MgE)

Dec. 1955 *Escapade* #3 (MgE; delightful seasonal cover nude under wraparound cellophane as Santa Claus makes a grab for her, and fine 5-page Keith Bernard layout)

Feb. 1956 *Playboy* (Russ Meyer is the photographer for "Marguerite's" second Playmate appearance—and Russ' second gatefold for Hefner after shooting his wife Eve; the centerfold has Diane in open shirt enjoying breakfast in bed with a full complement of jewelry, and a cup of coffee obscuring one breast)

Candid Photography 1956 (Fawcett Book #318; 3 pages by Meyer)

Aug. 1956 *Escapade*: Cover and four pages featuring Diane on a boat cruise off the California shore. (MgE)

Autumn 1956 *Classic Photography* #1 (4 pages, 7 outdoor nudes by Russ Meyer)

Nov.-Dec. 1956 *Suntan* ("The Nudist Picture Magazine"; an unadorned and blonde Diane graces the cover)

Dec. 1956 *Adam* #3 (5 pages, 9 outdoor nudes by David Mills (MgE)

Another photographer who worked extensively with Diane—including some of the most magnificently beautiful pictures ever taken of her—was Peter Gowland. "She had that kind of high-fashion, dramatic quality about her," he recalls today. "She knew how to handle her body. I had really good luck with her." Peter's wife Alice, who works closely with all his models, remarks: "The first thing that struck me about Diane was her beautiful face. She was rather short and stocky, so we didn't initially think of her as a nude model. But she had lovely skin, and of course she was a nudist. Diane had such a ladylike, classy quality—that's what I liked about her. She was simply beautiful. She was able to pose in a way that made her body look really great, hiding the flaws."

The Gowlands also admired Diane for her serious commitment to nudism. "I didn't feel she was in it for the money," said Alice. "She loved to pose for artists, because she was interested in creativity. She was an artist herself. I think that's why she did it." Because of the fact that the

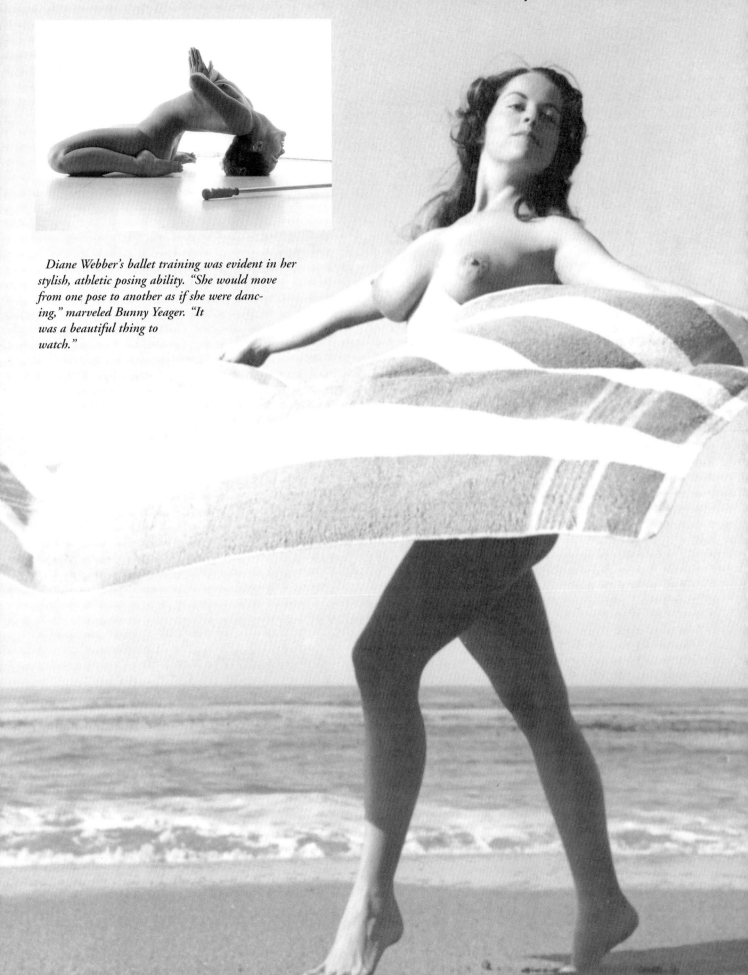

Diane Webber's ballet training was evident in her stylish, athletic posing ability. "She would move from one pose to another as if she were dancing," marveled Bunny Yeager. "It was a beautiful thing to watch."

overwhelming majority of Diane's work was in figure modeling, rather than the more lucrative fields of fashion or commercial work, "she probably didn't make that much money from it."

One of the fastest-rising pin-up photographers in the country by this time was Bunny Yeager, and she was watching this new modeling phenomenon with interest. "When I saw pictures of Diane in *Playboy* and other magazines, I thought, 'I'd just love to photograph that girl,'" Bunny recalled recently. "I figured I wouldn't be able to afford her. But I was determined, So when I was out in California doing work for the *National Enquirer*, I made arrangements to photograph her for a couple of hours on the beach. That's all I could afford. We did all these wonderful pictures of her, and each one was a classic. I don't think there was a bad picture in the bunch." Indeed, that one session may have been one of the most productive in cheesecake history; in between shots, Diane breast-fed her baby.

"She was outstanding," Bunny continues. "No matter what she did, it was like she was dancing. She would move from one pose to another as if she were dancing. It was a beautiful thing to watch." Like Meyer and the Gowlands, Bunny confirms that Diane was "a bit on the heavy side" for a model, but notes that because of her dancer's grace and great posing skill, one could hardly tell from the published photographs.

During the 1950s and early '60s, Diane appeared frequently on TV, including *Alfred Hitchcock Presents*, *Peter Gunn*, and *Studio One*. Her commercial modeling activities included ads for Capitol records, fishing tackle, reducing machines, tuna, and (ironically) bathing suits and caps. In addition, she put her years of training to work by dancing in West Coast nightclubs.

Diane continued to appear in magazines periodically into the 1960s, and occasionally turned up on television panel shows discussing nudism. She also continued an off-and-on motion picture career whose highlight was a starring role in a 1962 underwater epic called *The Mermaids of Tiburon*.

Mermaids was directed and produced by John Lamb, an ex-Navy PT boat skipper who specialized in underwater photography (see filmography). Shot in a variety of stunning underwater locations around the world, the film was challenging to make both from a technical and physical standpoint; the cast had to be insured against shark attack. The mermaids needed to hold their breaths for the time it took to complete each scene, which reportedly could mean as long as a lung-bursting three minutes.

During the early 1960s, Diane added a new element to her years of training by mastering the art of authentic Egyptian bellydancing. Before long she was teaching bellydancing classes, which she continued to do for years thereafter

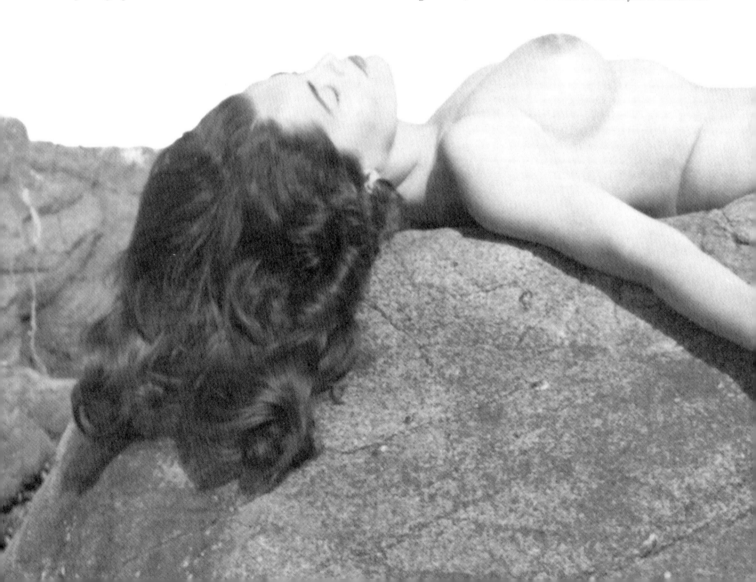

in Van Nuys; periodically she would also make public appearances with other artistic dancers whom she had trained. Peter Gowland says she was still doing this the last time he saw Diane in the late 1970s. "She had gained a lot of weight by then, but as her belly got bigger I think that helped her bellydancing."

Diane's later magazine appearances included:
 Photography for Men #1 1957 (6 pages of Russ Meyer shooting Diane for the *Playboy* centerfold.)
 Jan. 1957 *Dude* (splendid anonymous 3-page, six-picture nude layout by Bunny Yeager called "The Sea Is My Lover," with a graceful and ravishing Diane seen on the shore)

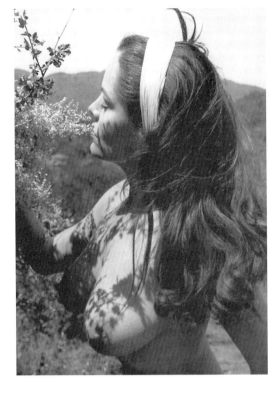

Completely dedicated to nudism, Diane used her success as a model to help promote its lifestyle and philosophy. "I have known a richer, fuller life because of this involvement," she declared.

Diane at her most voluptuous)

Apr. 1958 *Modern Man* (William Graham's studio nude study of Diane truly has the look of a piece of art) (MgE)

May 1958 *Modern Man* (gorgeous nude centerfold shot by Edward DeLong of Diane against background of a red rug)

Aug. 1958 *Gent* (4 pages, 9 pictures)

Oct. 1958 *Photo Life* (4 pages, 8 pictures)

Adam Vol. 3-1 late 1958 (3-page, 4-picture nude layout of Diane as a "Ski Lodge Beauty")

Dec. 1958 *QT* #3 (6-page layout of outdoor nudes by Russ Meyer)

1959-60 *Adam Calendar* (centerfold of Diane as outdoor waternymph)

1959 *Best Photography* (cover by Peter Gowland, nude behind giant jug, plus 3 pages)

Figure Quarterly #23 1959 (1 page, vibrant nude study by Keith Bernard)

Harem #1 c. 1959 (great centerfold, 4 pages and 6 pictures as Cleopatra)

Taboo #2 c. 1959 (7 pages, 10 nudes riding a horse and lounging on the grass)

Peter Gowland's Face and Figure Photography 1959 (8 pages on Diane)

Figure Quarterly #27 1959 (2 pages, 1 by Mario Casilli)

Shape #3 c. 1959: Inside cover, 4 pages.

1960 *Adam Calendar*

Spring 1960 *Fling Festival* Vol. 3 (one of her classic layouts, with several photos that were much-reproduced in later years; five pages including the inside back cover and 11 all-outdoor pictures, probably taken a few years earlier)

July 1960 *Mermaid* Vol. 2-4 (inside cover)

July 1960 *Monsieur* (cover and 9 pages, a gorgeous 26-photo Peter Gowland layout)

Aug. 1960 *Jem* Vol. 4-2 (3 pages)

Sept. 1960 *Hi Life*: One of her most spectacular layouts of all; 8 pages, expanding upon her 1959 *Taboo* layout as Cleopatra, with wig and slinky, almost-bare Egyptian attire)

Sept. 1960 *Monsieur* (beautiful, artsy Gowland cover of Diane nude behind fruits)

Fling Festival Vol. 4 1960 (2 pages, 5 pictures)

Winter 1960 *Figure Quarterly* #31 (artistic nude on cover by Peter Gowland, and one inside nude)

Brunette #1 c. 1961 (4 pages)

Mosaic #3 1961 (superb nude beach centerfold plus 6 pages of outdoor nudes by David Mills)

Spring 1961 *The Vagabond* #3 (spectacular, uncredited cover portrait of Diane on a boat, perhaps taken from the Bunny Yeager shooting published four years earlier)

Winter 1961 *Fling Festival* Vol. 8 (4-page, 9-picture celebration of some classic earlier poses, with no repeats from the previous year's *Fling* layout)

Jan. 1962 *Caper* (4 pages of Diane as a topless underwater mermaid for the film *Mermaids of Tiburon*; the topless scenes were used only for the film's European release)

Tonight Vol. 3-2 1963 (4 pages, 6 outdoor nudes; one great full-pager staring soulfully into the camera with provocative look on her face)

Aug. 1963 *Modern Man* & Winter 1967 *Modern Man Deluxe Quarterly* (1 page art nudes by Peter Gowland)

The Wonderful Webbers (1967): Extraordinary full-length book, discussed below.

June 1967 *Beau* (cover, classic color centerfold by Ed Delong, plus six pages, including some nudes not seen elsewhere)

Mar. 1981 *Fling* (4 pages)

Ideal Models c. 1957 (4 pages of nudes)

Jan. 1957 *Jem* #2 (color nude foldout in the water, and 1 page color)

Jan. 1957 *Playboy* (1 photo in the Playmate Review) (MgE)

Adam Vol. 1-7 1957 (4 pages, 9 pictures)

Feb. 1957 *Scan* (4 pages on a boat)

March 1957 *Foto-Rama* (back cover and 8-page, 13-picture layout)

March 1957 *Jem* #3 (cover outdoor bathing, foldout, and 5 pages)

Apr. 1957 *Caper* (centerfold, 11 pictures)

Apr. 1957 *Modern Man* (6-page, 12-picture layout)

May 1957 *Caper* (color centerfold)

May 1957 *Jem*: 2 pages, 4 pictures (MgE)

July 1957 *Monsieur* (4 pages, 8 pictures)

Adam Vol. 1-12 (3 pages, 7 pictures)

Nov. 1957 *Modern Sunbathing* (inside cover as blonde, and 2 nudes inside)

Figure Quarterly Vol. 20 c. 1958 (cover)

1958 *Playboy Calendar* (the original Playmate calendar features Diane in a classic cover shot lounging nude on the beach) (MgE)

Mermaid #1 1958 (cover, centerfold, 6 pages, 14 pictures;

Diane's filmography:

Ghost Diver (1957): Diane appears as a stuntwoman in this story of a TV adventure-show host embarked on an effort to uncover a hidden underwater South American treasure.

This Is My Body (1959): This was a film short directed by Russ Meyer and starring Diane (see biography).

The Mermaids of Tiburon (1962): Diane is top-billed as the Mermaid Queen in a murky drama about a marine biologist and a murderer who are tracking gems off the coast of Mexico when they meet up with Diane and her fellow underwater lovelies. It was shot in so-called "Aquascope" in such settings as the pearl gardens of La Paz, Mexico, kelp forests around Santa Catalina Island, coral cities of the Caribbean, the Mediterranean and Red Seas, Majorca, Hawaii, and Silver Springs, Florida. In the European print of the film, Diane swam topless in some scenes.

She Did It His Way (c. 1962): This one-hour film is set in a nudist camp and featuring Diane.

The Witchmaker (1969): In this horror flick about witch hunters in the swamps of Louisiana, Diane appears as "Nautch of Tangeier" as a witch.

Sinthia the Devil's Doll (1970): An exploitation film with Diane top-billed.

The Trial of Billy Jack (1974): This notoriously bad but money-making sequel to the smash hit *Billy Jack* has Diane appearing briefly in her real-life role as a belly-dance instructor.

During the mid-'60s, Diane was called as a government witness in a federal case involving the sending of allegedly obscene nudist magazines and other materials into Iowa. But in her testimony she strongly defended nudism and attacked puritanical views about covering the human body. In Diane's view, nudism releases inhibitions and keeps people young in thought and spirit.

In 1967, Diane's passionate devotion to the life and philosophy of nudism found a new outlet with the publication of the book *The Wonderful Webbers*. An absolute delight for any fan, this hard-cover volume is packed with scores of stunning nudes of Diane (both alone and with her family), demonstrating that she remained very nearly as alluring then as she was in her modeling prime. The book also includes a thoughtful exploration of her philosophy, some of which has been included here.

When Gay Talese tracked Diane down (after much effort) in connection with *Thy Neighbor's Wife*, Diane was still happily married and continuing her teaching. She was quite chilly towards the author, in the belief that in his focus on sex he would tarnish the chaste and pristine beauty she had celebrated through her nude modeling. All that she had done during the 1950s, she told Talese, was an expression of photographic "art."

And no one familiar with Diane's stunning photos could dispute this assertion. For an entire generation of American men, the image of a voluptuous yet uniquely graceful Diane Webber during her 1950s glory days remained etched in memory as a source of private but enduring pleasure.

(Special thanks to Peter & Alice Gowland and Russ Meyer for their recollections; also to collector and avid Diane Webber fan Dale Hilk of Waconia, Minnesota.)

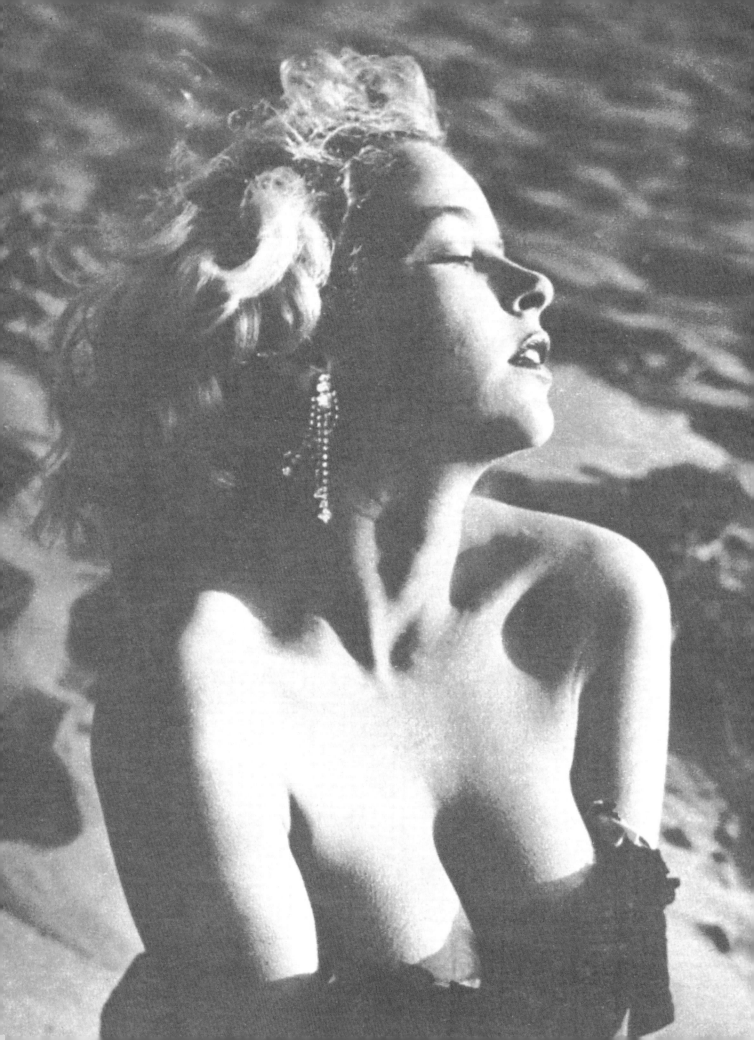

The qualities that go into the making of a genuinely unforgettable pin-up model may begin with a voluptuous figure and a winning smile, but they surely do not end there. The great models were able to establish and maintain the fragile illusion of an intimate, one-on-one communication with the unseen audience. Eve Meyer possessed all these qualities and more, and as a result she is remembered like few others.

Even beyond these attributes, Eve Meyer stands alone among top pin-up models for another reason: her sensationally productive business partnership with her husband, photographer/director Russ Meyer. Eve's keen business acumen made a huge contribution to his career as the king of nudie filmmakers.

A true Georgia peach from the Atlanta area, Eve Turner (her maiden name) came from a poor family. After leaving high school, she worked at a long succession of jobs—secretary, telephone operator, factory worker, beautician, and waitress—to help support her family.

By approximately 1949, Eve left Georgia to settle in San Francisco, where she found work as a legal secretary and got married. Her marriage did not last, but she developed the busi-ness skills that would serve her well in later years, and became secretary to the regional manager of Pepsi-Cola.

In 1951, one of the great partnerships in pin-up history was launched. Russ Meyer recalls: "Eve was brought to my attention by the lawyer for her divorce. We had a great love affair." As a World War II photographer and industrial filmmaker who was just beginning to establish his credentials as an inspired photographic glorifier of the female form, Russ realized that in this stunning blonde he had a form worthy of glorification. They were married on April 2, 1952. She quit her job with Pepsi and went to work for him.

Eve had done a bit of modelling on the side while working as a legal stenographer, including some TV commercials, but Meyer later related in a 1961 article for *Fling* that "at first, Eve was cool toward my suggestion that she be my model. In fact, you might say she was downright nasty. We dated for some five months during which time I tried to convince her to be my model. I succeeded only in convincing her to marry me. She had me remove my mustache and I managed to make her remove considerable clothing, and my camera has been clicking merrily ever since.

"Not from the start, that is, because Eve tried settling down to being merely a dutiful wife," Meyer continued. But she soon discovered that she could not be as dutiful as she wanted to be with a parade of pretty models posing in and out my studio. It was then that Eve decided to do what every red-blooded American wife would do—she eliminated the need for models by becoming my full-time model herself."

In a 1958 magazine interview with Robert Lucas, Eve offered her own recollections. When Globe Photos (which

distributed Russ' pictures during his first several years) received word of their engagement along with a picture of Eve, the company asked Russ to shoot some pictures of her and send them to New York. "We did, and on the day we were married we learned that we had sold our first cover," Eve remembered.

The repeated use of the pronoun "we" is noteworthy, for their working relationship was very much a partnership. Like at least one other renowned pin-up model, Britain's Pamela Green, Eve was intimately involved at almost every level of her photographic sessions. This included handling most of the processing in the darkroom, and doing costume design.

Once the delicious 39-25-35 form of the lovely Mrs. Meyer was first displayed for the world, the reaction was swift. Within a few months, *Night and Day*, the hottest men's magazine in the country, found itself inundated with requests for more Eve. In its July 1953 issue, the magazine declared that Eve was second only to Irish McCalla, the reigning pin-up queen, as the nation's favorite. It was hard to believe that only a few years earlier Eve (by her own account) was "skinny and homely" until after she left high school.

In addition to her splendidly-endowed form, another source of Eve's enormous appeal was her utterly natural look. While some other glamour girls wouldn't allow a photographer within telephoto range if their hair and makeup were less than impeccable, Eve—with her blonde hair tumbling casually about her shoulders and appearing drop-dead gorgeous with barely a hint of store-bought assistance—was a welcome contrast.

But while achieving cheesecake immortality, Eve was reaching for more. By 1954 she was featured on two local television programs in San Francisco with her dancing the focal point. Her dance routine with partner Jack Goshkin was a sensation. "Based on authentic Afro-Cuban rhythms, their sultry stepping is about as close to the forbidden Haitian voodoo fertility rites as film makers will let them get," reported one magazine. With bongo drums beating hypnotically, Eve and Jack, both clad in swimsuits, began swaying around each other at a progressively more frenetic rate until, at the conclusion, the drums abruptly ceased, and Jack lifted Eve up and carried her off.

By the time Eve became *Playboy*'s Playmate of the Month for June 1955, she was already a virtual legend in the glamour photography world, as was her husband. Russ Meyer smiles when he recalls those years. "Eve was the most important woman I ever knew, and loved," he declares. "We had a very good marriage for several years, until it fell apart. She was a household name in pin-ups, and I made a lot of money shooting pictures of her. It was a lot of fun." He grins wickedly and continues, "And when you were through shooting, you laid down the camera and jumped on her bones."

Eve Meyer

Born Eve Turner 1928
Died March 27, 1977

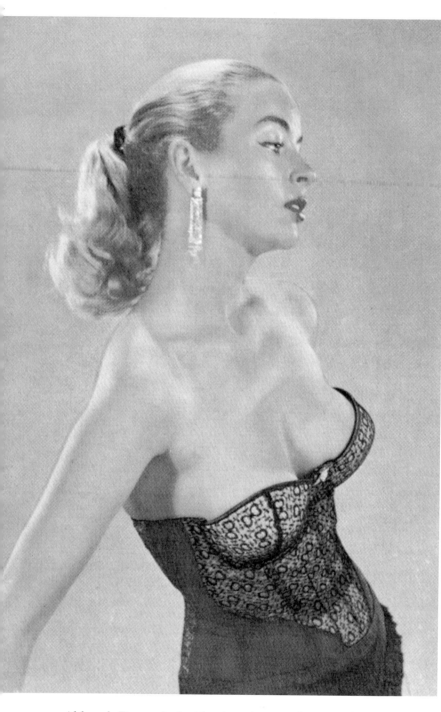

Throughout this period, Eve also handled all the family finances. This "leaves Russ more time for the things he likes best," she said. This talent would become still more significant later on.

Among Eve's major pre-1955 magazine appearances were the following:

Nov. 1952 *Night & Day* (cover, bosomy and beautiful; as Eve Turner)

Feb. 1953 *Show* (centerfold and 1 page)

March 1953 *Night & Day* (cover)

Apr. 1953 *Night & Day* (cover and 2 pages, semi-topless)

July 1953 *Night & Day* (1 page; the magazine reports over 300 reader requests for more Eve)

Aug. 1953 *Night & Day* (cover and 3 pages)

Sept. 1953 *Photo* (5 pages, 6 bikini pictures)

Oct. 1953 *Eye* (8 pages by Russ, including cheesecake shot in front of the Golden Gate Bridge)

Oct. 1953 *Night & Day* (2 pages by the fireside)

Dec. 1953 *Eye* (6 pages)

Dec. 1953 *Night & Day* (3 pages)

Dec. 1953 *Photo* (back cover in short-shorts and bulging blouse)

Feb. 1954 *Photo* (7 pages, 10 pictures as Russ poses Eve at home and near the Golden Gate Bridge)

March 1954 *Night & Day* (3 pages, 7 cleavage pictures)

March 1954 *Photo* (7 pages, 10 cheesecake pictures; the magazine reports being "swamped" by requests for more of Eve following her December appearance)

Spring 1954 *Peep Show* (cover, 4 pages, and 12 beach pictures by Russ, showing how much sizzle can be generated in shorts and a mostly unbuttoned sweater; for reasons unknown, the magazine goes out of its way to assert that the two are "not related," and babbles about how Eve "doesn't want marriage, not while her career is still in front of her.")

June 1954 *Frolic* (bikini cover and 2 pages)

July 1954 *Night & Day* (3 pages)

July 1954 *Tab* (cover in bikini and 2 pages)

Aug. 1954 *Sensation* (cover with classic rear-end pose in short-shorts and tight sweater, as in Dec. 1953 *Photo*)

Sept. 1954 *Eye* (5 pages by Russ, including some shots from the *Peep Show* layout above)

Fall 1954 *Peep Show* (6 pages)

Dec. 1954 *Night & Day* (superb cleavage cover and 3 pages of magnificent swimsuit pictures)

Dec. 1954 *Vue* (cover in blue bikini and 4 pages)

Although Eve worked with other photographers on ads, catalogs and the like (typically earning top-level pay of about $35 an hour), "for magazine stories, I pose only for Russ," she said in 1958. On each shooting, he would take at least 300 pictures. "The rapport between Russ and myself is, of course, much different than that between another photographer and myself," Eve remarked. "I think this makes for better pictures. We both know what we are trying to accomplish and both work to that end. I know that no other photographer has ever shot pictures of me comparable to the many that Russ has done." The couple's favorite spot for her posing was the rocky coast below the Golden Gate Bridge.

The 1954-57 period was Eve's most intensely active as a figure model. Rarely did a month go by without at least one magazine uncovering the magnificent Meyer physique. In one magazine layout, Eve credited her success as a cover girl to her husband: "Russ has an extraordinary ability of being able to accentuate a girl's best features." Of course, with all due credit to RM's unquestioned skills, Eve was one model with almost nothing other than "best features."

Eventually, the work became a grind for Eve. Years later, she told *Los Angeles Times* reporter Jane Wilson: "We

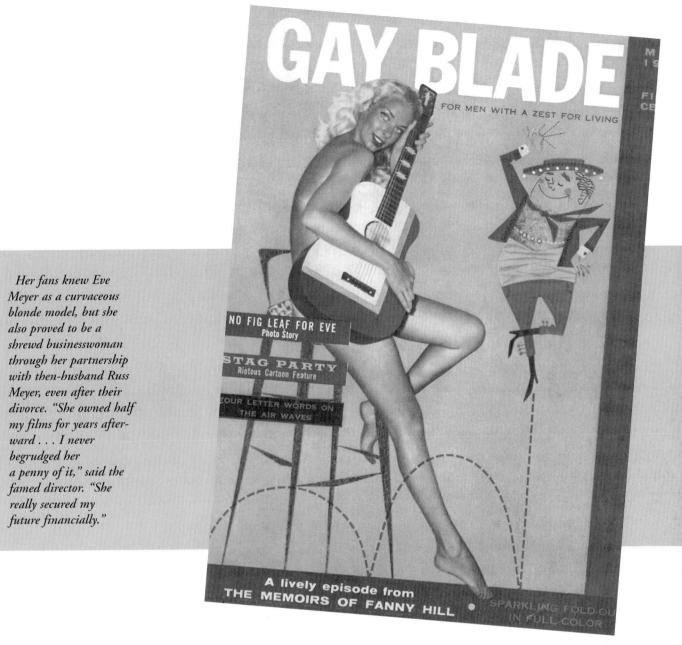

Her fans knew Eve Meyer as a curvaceous blonde model, but she also proved to be a shrewd businesswoman through her partnership with then-husband Russ Meyer, even after their divorce. "She owned half my films for years afterward . . . I never begrudged her a penny of it," said the famed director. "She really secured my future financially."

started out as a photographer-and-model team, and for six years we never had a vacation from it or went anywhere without Russ' camera." Modeling became an ingrained routine. "It got to be quite funny. I would call out, 'okay, Position Number 14!'" and strike a standard pose.

As the decade drew toward its end, Eve was beginning to phase out her pin-up appearances. Her marriage to Russ was also phasing out. June Wilkinson, who followed Eve and Diane Webber as Meyer's third superstar model, remembers that Eve was "Russ' soul mate, the love of his life. . . even when he was photographing me in a desolate, remote location, with me stark naked, he was never less than professional, never an untoward remark." June attributes this to his continuing loyalty to Eve. However, Meyer himself remembers that by 1958, the marriage had become frayed at the edges, and "at the end I had lustful thoughts" toward the models he was shooting, including June.

Despite the end of their marriage, Russ and Eve were about to form another great partnership. Having established himself as the premier pin-up lensman in the land, in addi-

tion to serving as photographer on a few independent films, Russ in 1959 made as auspicious motion picture debut with *The Immoral Mr. Teas*, which made history as the first "nudie movie" to become a mainstream hit. Its executive producer was none other than Eve Meyer. Her sharp-eyed financial advice was the key reason for this distinction.

That same year, Eve was featured in her own debut nudie film appearance, *Operation Dames* (see filmography). It was inevitable that Russ would himself direct her on the big screen, and the opportunity came with *Eve and the Handyman*. While hardly the breakthrough that *Teas* had been, it quickly proved one of the most popular films of its kind at that time, thanks in large measure to the magnetic appeal of the honey-blonde beauty.

"For a month, I worked harder than I have ever worked in my life," she told Jane Wilson of her *Handyman* experience. "I did my own hair and makeup, and I also did all the cooking for the crew. Every morning, I would get up at five, cook breakfast for everyone, make and pack lunches for everyone, drive 50 miles to the locations, do my 'acting' all day, and then

drive home again and cook dinner for everyone."

When Russ Meyer struck erotic cinema gold once again in 1964 with *Lorna*, not only was Eve once again listed as executive producer, but the film bore the legend "Eve Productions," of which she became co-owner by 1965. All of RM's remaining 1960s films were issued under the same caption. In addition to keeping the books, Eve was responsible for developing markets for the films.

Russ and Eve had been separated for years before their divorce was made official in 1969. As part of the divorce settlement, she won distribution rights to all the films he had completed. "She owned half of my films for years afterward, a 50 percent shareholder," says Russ. "I never begrudged her a penny of it." He told another interviewer that Eve "was pretty sharp. She knew how to deal with distributors. She worked at a time when we were really making a lot of money on *Vixen* (Meyer's 1969 classic and the biggest hit of his career). She really secured my future financially. She made wise investments."

In her 1971 *Los Angeles Times* interview, Eve described the broad scope of her business activities. Operating with an office staff of four and utilizing 17 sub-distributors who sold directly to exhibitors, her company earned a profit of $1 million in 1970. She constantly worked at getting exhibitors to show older Meyer films, collected rentals, and sometimes went to court when money was not forthcoming. Eve also tried to drum up new business by distributing non-Meyer films which also tended to be sexually oriented, but not as profitable. Her foresight was demonstrated when she put a 35 percent investment in a company that sounded like an early antecedent of MTV by producing three-minute music videos.

Eve's magazine appearances from 1955 onward included:

Jan. 1955 *Brief* (8 pages in bikinis and tight sweater)

Feb. 1955 *Night & Day* (inside cover, cleavage shot)

Apr. 1955 *Night & Day* (1 page, in shorts and halter top)

June 1955 *Playboy* (centerfold as Playmate of the Month, by Russ)

Aug. 1955 *Night & Day* (1 page, 4 pictures)

Sept. 1955 *Picture Scope* (5 pages doing her dance routine with Jack Goshkin)

Oct. 1955 *Vue* (3 pages wearing a cactus bra after winning the "Cactus Queen" contest in Tucson)

Dec. 1955 *Night & Day* (cover with Meg Myles)

Dec. 1955 *Picture Digest* (4 pages)

Mar. 1956 *Night & Day* (cover with Tempest Storm)

July 1956 *Photographers Showplace* No. 1 (2 pages of excellent cheesecake by Russ)

Sept. 1956 *Follies* (centerfold, 2 pages)

Nov. 1956 *Jem* No. 1 (4 pages, 1 color)

Dixie Sparkle (entire 34-page digest magazine devoted to Eve, with mostly semi-nude photos)

Apr. 1957 *Tab* (splendid cover in bikini bottom and open sweater)

May 1957 *Gay Blade* (cover, 7 pages, and 14 total pictures as Russ follows his mostly-unclad wife around the house)

June 1957 *Glamour Parade* (centerfold, 4 pages)

June 1957 *Monsieur* #2 (centerfold)

July 1957 *Figure Photography* #1 (6 pages, 18 pictures of Russ shooting Eve on the beach, by the Bay Bridge, and in the studio)

July 1957 *Jem* (4 pages of beach cheesecake)

July 1957 *Ogle* #2 (4 pages from the same shooting as *Gay Blade* above, focusing on Eve and her guitar)

Aug. 1957 *Night & Day* (4 pages, 10 pictures)

Sept. 1957 *Relax* (centerfold, 2 pages)

Jan. 1958 *Ho!* (4 pages, 9 pictures)

Snap #1 1958 (6 pages)

Sept. 1958 *Modern Man* (cover, 4 pages)

1959 *Night & Day Giant Pin-Up Annual* (terrific oversized centerfold topless)

Jan. 1959 *Picture Scope* (2 pages of vintage RM shots)

Aug. 1959 *Photo Life* (5 pages from her nudie film *Operation Dames*)

July 1961 *Caper* (cover)

Sept. 1961 *Caper* (5 pages by Russ, including 3 pages color, shot in the Bahamas)

Mar. 1964 *Fling* (2 pages, including 1 terrific color nude in Harem Girl Calendar)

June 1967 *Playboy* (1 picture from *Eve and the Handyman*)

Eve Meyer's filmography:

Artists and Models (1955) — This Dean Martin-Jerry Lewis comedy includes a quickie, unbilled appearance by Eve at the Artists & Models Ball.

The Desperate Women (c. 1957/58) — Russ Meyer photographed this trashy warning on the dangers of teenage pregnancy and abortion, directed by Louis Appleton; small role for Eve.

Operation Dames (1959) — Eve is top-billed in this low-budget film about an American USO troupe of three men and four women caught behind North Korean lines after an enemy counterattack. They run into an American patrol that tries to get them to safety. The highlight is Eve's nude dip in the river. (This film became available on video for the first time in 1992.)

Eve and the Handyman (c. 1960) — Russ Meyer directs his wife in the finest film record available of her voluptuous appeal. Eve seems to be an undercover agent conducting surveillance on a nondescript handyman as he goes through his day. In addition to her trench-coated title role, Eve also appears in several other personas: a sexy waitress; a hitchhiker in a spectacularly form-fitting dress who discards more and more pieces of clothing in order to catch a ride; and a hot blonde playing pinball and writhing seductively to maneuver the ball. At the end, the "real" Eve confronts her prey, whom we learn she has been stalking for marital purposes.

A successful businessperson and still a very beautiful woman in her 40s, Eve in late 1975 was reported to be completing a book on her long collaboration with Russ entitled, *This Doll Was Not X-Rated*. Sadly, it would never see the light of day.

Eve Meyer's life ended tragically on March 27, 1977 in the worst aviation disaster in history. She was one of more than 300 passengers on a Pan Am 747 charter flight from Los Angeles to Tenerife in the Canary Islands. The plane was taxiing for takeoff when a KLM jet barreled down the fog-covered runway and rammed into it. A total of 574 persons were killed.

(Special thanks to Russ Meyer for his recollections.)

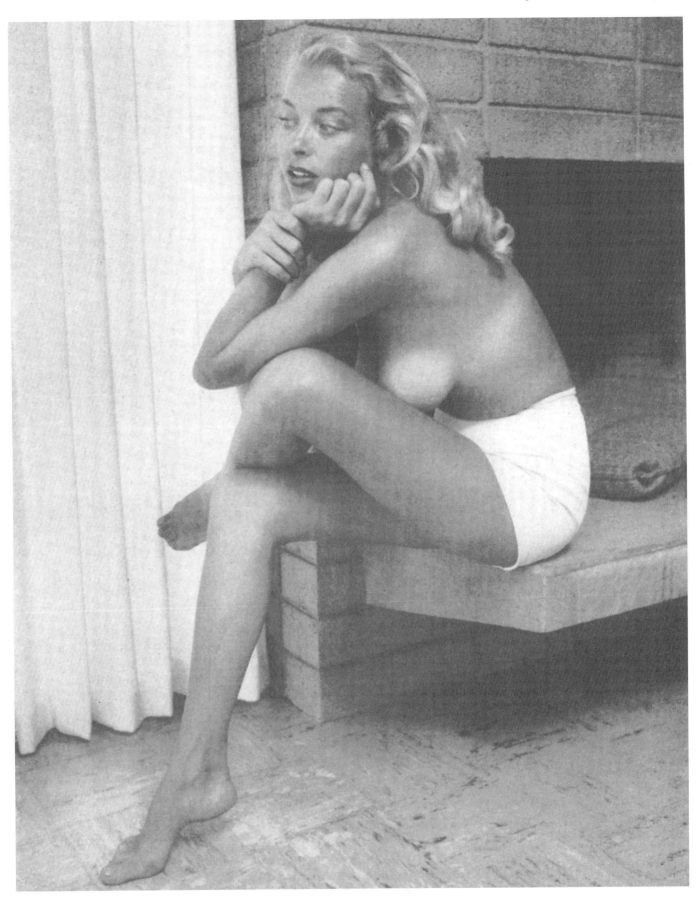

The Strippers

The fabulous world of burlesque, already fading in 1950, was approaching extinction by decade's end, at least in the form that generations had known. Paradoxically, however, the '50s also saw the emergence of some of the most sensational striptease artists to ever set foot on a runway. Lili St. Cyr achieved her greatest fame in this decade, and new superstars included Tempest Storm and Candy Barr. These performers helped ensure that the art of striptease would survive the collapse of the industry that had given it birth.

The burlesque circuit in the '50s was a chain of about 50 theaters operated out of Boston and heavily concentrated in the East and Midwest. Strippers who worked the circuit typically toured 50 weeks a year in a schedule far more grueling than glamorous, yet these women brought world-class sex appeal in person to many thousands of fans who could never hope to see their fantasy movie or pin-up queens except on the screen or the printed page. Competition from television and rising costs led burlesque theaters to cut back and finally close down, but strippers moved into nightclubs and other venues.

Constantly under legal attack for the alleged lewdness of their performances, the top strippers of the '50s actually offered saucy but restrained sensuality that would appear modest by today's standards. They provided the extra spice that made the decade's glamour scene all the more alluring.

"Hate the world that strikes you down,
A warped lesson quickly learned.
Rebellion, a universal sound,
Nobody cares. . . No one's concerned.

Fatigued by unyielding strife,
Self-pity consoles the abused,
And the bludgeoning of daily life
Leaves a gentle mind. . . confused."

— "A Gentle Mind. . . Confused"
by Candy Barr

The life and times of Candy Barr compose a series of extraordinary journeys that few would have survived with their soul intact. Yet Candy Barr has emerged from these journeys battered but unbowed, a ferociously proud spirit that refuses to be crushed. She is a lady of rare quality, and her story has the sprawling dimensions of the Texas she has called home for nearly all of her 60 years.

To various journalists attempting to chronicle her life, Candy has been invoked as a symbol of many things: a victim of 1950s sexual repression and Texas injustice; an unwitting forerunner of X-rated cinema stars; and an innocent strand of the web of personalities surrounding the assassination of President Kennedy. Far more than a symbol, however, Candy stands on her own as an utterly remarkable woman, and let no one rush to judgment on the meaning of her life without hearing the true account as she tells it.

Candy Barr
Born Juanita Slusher July 6, 1935
Edna, Texas

1935-1955: From Edna to Las Vegas

Born Juanita Slusher in the rural town of Edna in southwestern Texas, Candy's childhood was less than idyllic. As she told *Oui* magazine in 1976: "My mother died when I was nine. My father, who had five children then [including herself], married a woman who had four children. Then they had another two children together. It was a very confusing family situation. We were worked very hard and disciplined very harshly."

After running away several times, young Juanita left for good when she was in ninth grade. She lived for a time with one sister in Oklahoma City, and then with another sister in Dallas. The youngster was forced into prostitution for a time, when explicit photographs were taken and distributed in order to advertise her wares.

It was in Dallas in 1951 that 16-year-old Juanita unwittingly took the first step on the road to stardom. She was waiting tables in nightclubs, and began posing for photographers. At a rather shady joint called the Round-Up Club where she

frequently went jitterbugging, Juanita met an older man and wound up going to a hotel with him. That night, compelling her to perform at gunpoint, he made her the star of what became the most famous "stag movie" of the era.

The plot of *Smart Alec* was simple: A traveling businessman invites a pretty young blonde into his motel room, plies her with liquor, they engage in some heavy petting, and then get down to hot and heavy sex. The opening section of the short film (featuring the foreplay) is just moderately sexy, so it is startling when the action becomes explicit. The film became a sensation, screened in countless bachelor parties and other private affairs over the next two decades. Against her will, Juanita was a star, although she did not reap a dime from her labors.

"It's still being shown to this day," says Candy. "It couldn't have been more than five years ago that my brother went to a drive-in, and came back and said, 'Guess what I saw?' I said, 'Oh, God! Did you watch it?' And he said, 'Hell, yes!'" she relates, laughing.

The film itself, however, is no laughing matter to her. "No matter how many times you tell people, they won't accept that it's not Candy Barr in that movie. She didn't even exist then. It makes me kind of sick. 'Fuck the kid, fuck the kid.' If you go to bed with a 16-year-old kid, they'll take you to court. But here you see people watching it thinking, 'That's Candy Barr.' That's not Candy Barr, that's a teenage girl in that room, a child. The whole attitude makes me want to vomit. Maybe it is a fuck picture, but it's sad, because that is a young girl, no matter who it had been." Later, Juanita cooperated with the FBI in prosecuting the "filmmaker" for exploitation of a minor. (Years later, she sued *Playboy* for running a still photograph from the film.)

As a runaway scratching to survive, she worked part time as a carhop; at the Trolley Courts hotel in Dallas, she also worked as a hotel maid by day and turned tricks by night. In about 1952 she married Billy Joe Dabbs, who happened to be a professional safecracker. Candy later related to *Oui* magazine that she was sent by Dabbs and his cohorts to buy nitroglycerin, fuses and caps, and to case store safes. "I just thought it was part of my job," she remarked. He was in and out of jail, and Juanita obtained a divorce. Billy Joe was shot to death after his release from the last in a series of incarcerations.

Juanita also made ends meet by entertaining at business conventions and stag parties, which she refers to as "smokers:" "You were there to get $20 for letting guys take the towel from your belly without touching you. . . I was a working girl." According to a 1976 profile of Candy in *Texas Monthly*, the stakes at these events were somewhat higher. "There was a banker who paid five hundred every time he put a hand on Candy," said one participant.

Candy makes no bones about the fact that during those hard times, she turned tricks in order to survive. Nude photos of the underaged beauty were widely circulated in the Dallas area. She hastens to note that she was not a $100-a-night girl. "I was worth more than that—maybe $100 an hour!" she laughs.

Juanita became a cigarette girl at a Dallas club called the Theater Lounge owned by Barney Weinstein, who, around 1953, asked her if she'd like to get on stage and dance. Afterward, Barney put the promising newcomer into his "school for strippers," which had graduated such stars as Lee Sharon. After she finished the "course," Barney's brother Abe Weinstein signed her to a three-year contract at his Colony Club. Within a few months, the scantily clad young beauty was top-billed, and was dubbed for the first time "Candy Barr" (selected because she liked Snickers and Millionaires). From 1955 onward, her theme song was "The Yellow Rose of Texas."

Soon Candy was one of the hottest striptease artists in the country, earning $100,000 a year, and little wonder: she embodied the devastating combination of baby-faced blonde innocence, big green eyes and voluptuous curves (5-foot-4, 38-22-36). "People told me I looked like a wild filly up there saying, 'Break me if you can,'" she later recalled. When she hit Las Vegas, the town flipped; as she herself noted, "the whole town started buzzing about this little girl from Texas with a ponytail and big tits." When the world discovered that this was the same little girl who starred in *Smart Alec*, a legend was in the making.

While she has been wrongly identified in the years since as a burlesque performer, Candy today is quick to set the record straight. "I didn't know anything about burlesque at all. I only worked at one burlesque theater in my life, and that was years later. And I never wore a G-string in my life, never owned one. I always wore net panties." Candy's venue was nightclubs, usually of the top-drawer variety.

Did she model herself after any other striptease dancers? "Good gracious alive, no!" she replies. Candy says she had very little contact with other strippers, and the only other headliner she ever worked with was Lili St. Cyr. "My act wasn't like anybody else's," she boasts. "It's like the ads said: 'Always imitated, but never duplicated!'"

1956-57: Hotter Than a Pistol

The legend was abetted by events beginning early in the morning of January 27, 1956. Three years earlier, Candy had married Troy Phillips, who became her agent and manager. In December 1955 they had a daughter, named Troylene. But the union was stormy. Following one quarrel, she put him out of the house, and he stayed away for two weeks. When he came back (carrying a gun, she later told police) he broke down her locked bedroom door. She was able to calm Phillips down, and he left peacefully. But concerned by the violence, she purchased a .22 rifle and put a new lock on the door.

Two nights later, shortly after Candy had returned from work, she heard Phillips at the door; she refused to open it, and he burst in. "I began to run," Candy later recounted. "Then I thought about the rifle. I grabbed it, ran into the hall and started up the stairs. But I heard him coming after me. I turned and shot once." Phillips was wounded in the belly. When police arrived, Candy (so the stories go) was smiling over him clad only in bra and panties, later pulling on a man's shirt and trousers to go to the jailhouse. No charges were pressed, and the incident generated enormous publicity for Candy. When photographers showed up to find her dressed only in a man's shirt, Candy supposedly smiled sweetly and said, "Make it sexy, boys!" Today, she says this was a total fabrication. "I never said any such thing; how ridiculous."

"Some men are programmed to think that when women say they'll do something, they won't do it," says Candy. "This is who I am. When I say I'm gonna do something—listen! When I get to that point, it was because I was pushed to that point in the first place and I had to react to it. . . He had been pre-warned. He continued the process of trying to retrieve me, and I just shot him."

She smiles, and confides: "Then I picked his pockets. He was playing gin, gambling, and when I had him down, he was trying to find his jacket to get to his gun. I put the rifle behind his head and said, 'just behave.' And he behaved. I computed the cost of a lawyer and bail, and I just picked his pockets. There was $900. They took him out, and later he filed charges (against the police) because they kept the money. Later on, I asked him, 'Did you ever get that money back from the police?' And he said, 'Why, hell, no!' And I said, 'I took it.' He said, 'Oh, God, did you?'" She laughs delightedly at the memory.

After the incident, numerous magazine pictorials featured Candy posing suggestively with holster and six-shooters, leading readers to the conclusion that the props were inspired by the shooting. She notes pointedly that the "pistol-packin' mama" attire had been a part of her act for some time, and says she was not aware of any effort to "play it up" for publicity. A song was even written about her during this time, "The Ballad of Candy Barr," and Abe Weinstein was trying to maximize the incident's promotional value. According to Gary Cartwright's *Texas Monthly* piece, due to Phillips' reputation for acting violently when drunk, and because he wasn't badly hurt, the bond for Candy was set at only $5,000, which enraged Weinstein. The promoter reportedly arranged with the sheriff to raise the bail to $100,000, which he paid, and then held a press conference. The result was near-record business for the Colony in the days immediately following the shooting.

The initial charge of assault with intent to murder was rejected by the grand jury after Phillips urged that she be freed. "It was all a mistake," he admitted. "I was bad drunk. I deserved to get shot." Shortly afterward, the couple was divorced, but it is Troy Phillips' name that Juanita Phillips carries to this day.

"She epitomized the conflict between sex as joy and sex as danger,'" wrote Gary Cartwright. "The body was perfect, but it was the innocence of the face that lured you on. I know the secret, it said, I can enjoy sex without guilt. But the cap pistols in her hand were a clear warning of danger."

A small-town girl who suddenly found herself in the limelight, Candy was barely aware of how far her fame had spread. "I didn't even know I was a star," she says today. "My God, if I'd only known, what I could have done with it! Working for peanuts. I had a car, had a nice place, life was la-de-da good, as far as I knew. God, I was simple!

"I couldn't have cared less if the house was full or not, I just wanted to dance. People were happy, they were enjoying themselves. I would've danced for nothing. I danced away every night, except Sunday. After finishing a show at the Colony Club Saturday night, I went right down the street with a partner, danced for 30 minutes, then I'd go back to the club and do the next show." She told another interviewer in 1973: "I did that because I enjoyed dancing—taking my clothes off didn't matter one way or another . . . I came into the world naked— if I felt there was something wrong with it, that'd be different."

Today, watching videotapes of Candy performing on stage, one can see the joy she felt while performing, totally absorbed as she sways and twirls with the music. A film short she made at the time captures the essence of Candy's timeless appeal. Clad in bra and panties, she removes her stockings and brassiere, then stands with arms akimbo, fluttering her eyelashes and flashing a heart-meltingly innocent little-girl smile at the camera. Then she drops her arms to expose her perfectly firm bare breasts. The body is nothing short of magnificent, but it is that wonderful smile that draws the viewer in.

Candy says she cared little for the primping and fretting about appearances that consumed most of her colleagues. "Vain, I am not. I went on stage sometimes without makeup. I never wore false eyelashes, rouge or [eye] shadow. And I didn't have time to bother much with my hair. I just brushed it back and put a little band around it. That's how come the ponytail." Of course, it was that youthful, fresh-faced, girl-next-door appearance that was essential to her appeal, particularly in contrast to the dark, sultry look of Tempest Storm and Blaze Starr, and the "hard" appearance of other top stripteasers such as Jennie Lee.

Inevitably for a stunningly beautiful and renowned performer, Hollywood beckoned, and on one occasion Candy almost answered the call. She was offered a featured role by a director still known for his B-movies. Candy tells the story: "Whenever he hired an actress for a role, he and his wife

would always invite her over to their place. And after they had you for dinner, they HAD YOU FOR DINNER," she says suggestively, without elaboration. "I went along, but I turned down the role. The part wasn't bad, but I didn't care for the fringe benefits." The role ultimately went to one of Hollywood's top blonde bombshells.

"I've always been a very stringent human being with principles and morals. When they ask me to play games to get a role, I just put 'em on hold. Putting me in a movie is one thing, but when they want my body, too, that's extra pay, they ought to know that. I'm no whore—I quit being that a long time ago."

Candy's fame grew with her frequent girlie-magazine appearances. During the 1954-57 period, these included:

Dec. 1954 *Modern Man* (1 page, reclining topless with pasties, in an article on the "School for Strippers")

Cabaret Yearbook #1 c. 1955

June 1955 *Cabaret* (1 page, classic picture opening negligee)

Sept. 1955 *Cabaret* (one of Candy's most revealing pictorials—6 pages and 13 pictures, including 5 fully-nude studies)

Figure Quarterly #10 1955 (1 page, art nude study)

Cabaret Quarterly #3 1956

Adam #2 1956 (centerfold and classic 2-page layout featuring fetchingly topless Candy dressed only in her strategically placed gun holster, cowgirl hat and boots, with discussion of her shooting incident)

July 1956 *Headquarter Detective* (cover feature: "Stripper Shoots Husband")

Fall 1956 *Escapade's Choicest* (color centerfold)

Sept. 1956 *Modern Man* (nude color centerfold, 5 pages, 11 pictures, one of her finest layouts: "The Shootingest Stripper in Texas")

Nov. 1956 *Jem #1* (splendid cover "portrait", and even more beautiful nude title-page study, plus one page)

Dec. 1956 *Photographers Showplace #2* (2 pictures by Keith Bernard)

Jan. 1957 *Jem #2* (title page, nude)

March 1957 *Jem #3* (centerfold in stage outfit plus one page)

May 1957 *Jem* (1 page color)

June 1957 *Satan* (2 pages)

Cabaret Quarterly #6 1957 (3 pages)

July 1957 *Jem* (1 page color nude)

Into the Darkness

On October 27, 1957, Candy's life took a fateful turn.

Because of her notoriety, Dallas police had been paying Candy periodic visits and occasionally picking her up for vagrancy, which she understandably regarded as harassment. Acting on a tip, detectives from the Texas state Criminal Intelligence Division and the Narcotics Squad obtained a search warrant and entered her apartment building that evening, waiting for an opportune moment. When a messenger boy delivered a telegram, they followed him and bolted in, finding a marijuana cigarette on her apartment floor. Based on evidence allegedly obtained from her tapped telephone, police arrested her boyfriend. She quickly volunteered that if they let him go she would show them where the rest of the marijuana was, all of which she said she was holding for a friend. It was an Alka-Seltzer bottle of grass—less than one ounce.

Candy's version of the episode, as told to *Oui*, was that a burlesque dancer girlfriend had given her "a little package she wanted me to keep." While Candy talked to her boyfriend on the phone, the police, who had moved into a room across the hall, entered, and raided a closet in which she asserted they planted drug-related paraphernalia. "It was a set-up," she declared.

Today, she declines to discuss what happened, except to make it absolutely clear that she "didn't know the first thing" about drugs. "I'm not saying I never used pot, but people didn't have a label on that as a drug back then. . . I just knew it was an illegal thing." By all accounts, the Dallas Police Department was absolutely determined to bring down Candy Barr, whom the "decent folk" of the city viewed as the symbol of all that was wicked.

Out on bond, Candy continued to strip at the Colony Club. But in February 1958, on Valentine's Day, a jury of eleven men and one woman found her guilty of a narcotics charge. The four-day trial was a colorful affair with photographers desperately snapping away; according to more than one account—which Candy says may well be true—Judge Joe B. Brown himself borrowed a camera during a recess to shoot the lovely defendant. Her attorneys charged the state with using "Gestapo" tactics, including illegal wiretapping. The sentence, however, was deadly serious, and shocking: 15 years in prison. Even in a state known for outrageous sentencing, this was in a class of its own.

"I was so very ill, I just sat there and could not believe what was taking place," she recalls. (Candy was in and out of the hospital with hepatitis during this period.) "I did not even understand the drug charge, had no concept. Later in life, I realized that they won on (the charge of) possession only. Well, I had it in my possession. They couldn't have cared less—that's what they wanted it to be, in my possession." According to Candy, "they had such a tight net, nobody could have slipped through."

The most dominant element of Candy's personality, her defiant refusal to give an inch when she believes she is right, contributed to her sentence. The chief prosecutor offered her two years for a guilty plea, and her response was passionate. "You have the power to do with me what you want, she seemed to say, but you're not going to break me."

Candy's lawyer quickly filed for a new trial and she was

freed on $15,000 bond. Determined to pay her own legal expenses, she returned to the stage, and found herself more in demand than ever. From March until the following January, she performed in the top clubs in Las Vegas and on the Sunset Strip in Los Angeles. On January 14, 1959, a divided State Court of Criminal Appeals upheld Candy's verdict. Judge Lloyd Davidson fired off a bitter dissent:

"So the time has come in this state when peace officers can kick in the door of one's home and search and ransack it at will and without any lawful authority to do so and in total disregard of the law, and the owner of that home. . . must submit to such outrage and deprivation of her constitutional right against such unlawful search before she can show that she was innocent of any unlawful connection with the property so found. If that is equal justice under law, I want no part of it. . . If a conviction obtained under such circumstances is due process of law, then there is no due

process of law."

In April, shortly after she was to report to Texas authorities for incarceration, she was released on bond again pending a final appeal to the U.S. Supreme Court. In the interim, Candy found time for one more flirtation with Hollywood. When she agreed to serve as Joan Collins' "coach" for a striptease routine in the film *Seven Thieves*, their sessions together generated features in dozens of magazines. "She did the moves just like I taught her. . . she didn't put it across the same as me, but she did all right." Sadly, the climactic part of the scene, in which Joan peeled off her stockings, was cut by the studio as "too hot" for the time. In her autobiography, Joan later described Candy as "a down-to-earth girl with an incredibly gorgeous body and an angelic face. She taught me more about sensuality than I had learned in all my years under contract."

Mickey Cohen: Knight in Tarnished Armor?

While performing in early 1959 at Chuck Landis' Club Largo on the Sunset Strip, Candy acquired an ardent new suitor: Mickey Cohen, the most notorious mobster in the Western United States. Cohen had gone from the New York underworld to winning the favor of Al Capone in Chicago; his later partnership with Benny Siegel in Las Vegas was portrayed in the 1991 film *Bugsy*. After taking over the Vegas operations upon Siegel's murder, Cohen went on to become the king of the rackets in Hollywood. He went to prison for a time in 1952 on tax charges, and beat several raps for murder and assault. Cohen was such a Hollywood institution that his celebrity exceeded that of most movie stars.

According to several sources, by 1959 Cohen was weary of the gangster life and was eager to carve out a new image. Shortly before he assumed the role of Candy's self-proclaimed savior, Cohen attracted new attention during the tragic Lana Turner-Johnny Stompanato cause celebre in which Lana's daughter fatally shot mobster Stompanato. Cohen defended his slain friend and released a bundle of torrid letters Lana had written to Johnny. No one in Hollywood believed him capable of changing his stripes, but Cohen appeared determined to prove them wrong, and Candy Barr was his opportunity.

After watching her perform at the Largo, L.A. police hauled Candy into county jail as a fugitive from Texas as her bonding company's terms for furnishing the marijuana-charge bond had expired. Thoroughly smitten with Candy and sympathetic to her plight, Cohen, declaring that "there's an injustice being done to this girl," stepped in to personally guarantee the bond. Mickey and Candy became a steady couple in Hollywood, and the pairing generated a feverish new round of media attention. He paid her attorneys' fees of $15,000, lavished her with various gifts, and at one point told reporters he was going to marry Candy, although she responded that this came as a surprise to her. (Cohen's own divorce was not yet final.) In his colorful autobiography, Mickey recounts their brief but eventful relationship, during which she angrily tried to sock him in the jaw at one point and he made various threats against her. Nevertheless, Cohen was hooked. "Yeah,

I was really head over heels for her," he admitted.

In October, the Supreme Court refused to review her case. Faced with the imminent prospect of Candy's imprisonment, Cohen then provided her with $1,200, a phony birth certificate and Social Security card so that she and Troylene could hide in Mexico. She soon grew restless and returned to the States. By that time, the relationship was over. "He's a nice guy, but we just weren't meant for each other," said Candy at the time. She returned the two mink coats and diamond rings he had given her.

While declining to discuss Cohen, Candy remarks that their time together "seemed like seven years, but it was only about nine months." The high-profile relationship made a lot of people nervous: Candy says the FBI and police had her under particularly close watch because they suspected the mob might have it in for her —a suspicion that Mickey indirectly confirmed in his autobiography. Given the fact that he had previously escaped repeated attempts on his life and that several of his friends and associates had met untimely ends, this fear was legitimate. Cohen himself later went to prison in 1962 with a 15-year sentence for income tax evasion (he actually served 11 years); Candy was taken by authorities to Los Angeles to testify at his trial.

Less than a week before Candy was to begin serving her sentence, she received word that her divorce from Troy Phillips was at last final. Almost immediately, she married wealthy Hollywood beautician Jack Sahakian, who had dyed her hair for the Mexican foray and had become a close friend. Her wedding night could hardly have been more symbolic of a life filled with travail: her room was robbed of all her jewels and furs. And then, she related to *Oui*, "I was lying on my bed, still in shock, when the FBI came in and put me under arrest." The marriage was short-lived, partly because the terms of her parole upon release from prison didn't allow her to leave Texas, and Sahakian was a Californian.

Three Years and Four Months

Candy entered Texas State Penitentiary for Women (in Huntsville) on December 3, 1959. "When I finally went to prison," she told Gary Cartwright in 1976, "it was with a great sense of relief. Otherwise, I would have been dead or laying on some gangster's couch." She served three years and four months, and was released on April 1, 1963. "I knew they'd release me on April Fool's Day," she says today with a trace of bitterness. "The humor is funny. It's like they orchestrated the whole thing." The lesson she learned from her arrest and imprisonment was somber: "You don't fight the system." Candy pauses thoughtfully. "Sad, sad, sadness, I'll tell you that."

> "As I restlessly lie on my bed of horror
> in this isolation I've grown to fear
> each sound causes my heart to race.
> The clicking of tense heels in dark corridors
> ECHO!!!
> Like the dull thud of tiny daggers piercing
> my heart.

I listen for my door to open.
They're here now.
Soon I'll be taken to another room where
 straps will bind me.
My body will be filled with agonizing pain from
 that cruel discovery. . . electricity. . .
WHY do they persist in his torture???
Why won't they listen?
Why won't they believe me?
I tell them I'm not insane.
My day begins and ends already used.
I live in a world barren and confused.

Why?
In this black cell of prison I sleep,
 and dream as time goes by,
From youthful years to gray I creep
 without mind to tell me why.

Why?"

—"Insanity?", by Candy Barr

Candy declines to discuss the implication of the above poem that she was subjected to electroshock therapy; "the poems speak for themselves," she declares. She spent her time in prison productively: working as a seamstress, studying high school equivalency courses, and singing in the prison choir. Additionally, she seriously pursued the poetry she had dabbled in for years, and read extensively.

"I finally found a book that didn't make me feel so strange—by Spinoza." (Benedict Spinoza, the Dutch philosopher of the 1600s best known for his belief that the universe is divided into mind and matter, separate elements that cannot interact. According to Spinoza, these are the only "attributes" of God that we can know.) She found particular inspiration in his doctrine that "all things in the universe are infinite and universal, and everything goes back to God. Spinoza was ostracized by society, and I really identified with that."

"I learned how to survive amongst all the elements. I learned the game, how to function in it, until I could get ahead of that sucker."

Some accounts have left the impression that Candy "found religion" while in prison, but she makes clear that it had been part of her life since she was a child. "I wanted to be a missionary since I was seven years old. I grew up with religion, it's in my heart." She scorns skeptics who question how one who has led a life such as hers can be sincere in her religious convictions. Those convictions—like every other belief she has developed in a very full lifetime—are deeply rooted and fiercely defended.

That the inner Candy is complex and perhaps truly unknowable can hardly be doubted. "I tried to tell [people] about multiple personalities years and years ago, and they thought I was a lunatic, whoever 'they' are," she relates. "They said, 'well, golly, I don't know how to read you.' I said,

you never will read me. I am a self-made multiple schizoid. Then they finally found somebody who had 14 or 15 different personalities—I wasn't a lunatic after all. I can drift into three, four, five personalities at one time—and control all of 'em. I've always done it."

Parole, and Jack Ruby

Upon leaving prison and returning to Edna, the stringent terms of her parole confined her to a radius of 36 miles of her home and barred her from returning to the strip clubs. Alone and without any means of support, she received a little help from some of her friends, one of whom was Dallas nightclub owner Jack Ruby. Candy had known Ruby since she was a teen-ager; while she had never worked for him due to her exclusive contract with the Colony, Candy "went over to his place socially most every night," she told Diana Clapton in 1973. After her release Ruby gave her gifts and spent considerable time talking to her. "He was very dear to me," she later said. Seven months later, on November 24, 1963, Jack Ruby shot and killed Lee Harvey Oswald.

"He came down that summer, bought me an air conditioner and a couple of dogs [for breeding] when he heard I couldn't work," she recalls. "He spent three days in my home town, then went back to Dallas. The next thing I know, he's on television shooting Lee Harvey Oswald. It was the furthest thing from my mind. I wasn't ready for a drug bust, so I sure wasn't ready to see Jack take that kind of action."

Within 24 hours after Ruby shot Oswald, federal investigators "swooped down on me like locusts. Good God, I was on the floor [with shock]." After they questioned her for "about 10 minutes, I called my brother and my brother called my daddy. He went to the sheriff's office, and he stopped it, right then and there. My daddy came in on his charging white stallion," she relates with a smile, "and he took control. When my daddy says, 'don't fuck with me,' you don't bother him, because he is serious. . . Strong, strong, strong character."

Of the assassination investigators, she says, "I don't have any answers for 'em. They were trying to involve me in something that I didn't know anything about. If I'd known something like that was going to take place, if I'd even had an inkling. . . " She pauses. "Back then, that place [Dallas] was so corrupt, it was like a nightmare. Judge Brown [the judge in Candy's trial] was the one who tried Jack Ruby. They ought to just let it go, let it rest. No one's ever going to be satisfied."

In July 1967, Texas Gov. John Connolly pardoned Candy, thus freeing her to leave Texas and to dance again. Candy's return to the stage took place on August 14 at, appropriately enough, Club Largo on the Sunset Strip. Her six-month engagement at the Largo pleased her fans, but the times were different, and so was the woman. *The Los Angeles Times* remarked sympathetically that "she seems a young woman with an aura of sadness and sorrow who is doing the thing she knows best."

One unfortunate byproduct of her 1967 Largo engagement was being sued by another club that claimed she had promised to perform there. As a result, she was subsequent-

ly "blacklisted" by the American Guild of Variety Artists, and the lack of a union card cost her later opportunities to appear on television or accept other work locally.

She appeared again in Las Vegas and the Colony Club in Dallas for several months. In 1969 she settled into retirement in Brownwood, Texas, returning very briefly to dancing only during one period a few years later to help pay her father's medical bills when he was in the hospital. "There was no magic there anymore. The attitude of people was different, everything was different. They didn't know what entertainment really was at all. Finally, I had no feeling at all."

"Audiences used to get excited, to have fun. Now you just see a whole field of passive voyeurs. The atmosphere is pitiful." She notes now that "people couldn't touch you when I was working, it was against the law. Now they can put money in your crotch."

Sometime during the late 1960s, there was a fourth marriage, but like the others it didn't last long. "I don't know what 'long' is—if it was anything more than a week, it seemed like a long time to me," she chuckles. The profession into which Jack Ruby had invited her, dog-breeding, was Candy's primary source of income during this period. "But then I couldn't do it anymore, it was too draining. If she wasn't satisfied with a prospective buyer, she wouldn't sell the dog, "no matter how much the person wanted it, or how much I needed the money."

Her father, whose character she had so admired, died. She found herself fighting authorities in Brownwood, including another attempted drug bust which was ultimate-

ly thrown out; "they made me very ill. . . I lost everything I'd acquired, which wasn't a whole lot."

In 1972, some of the poetry Candy had been writing in bits and pieces through the years was collected in the self-published book "A Gentle Mind. . . Confused." It is a touching, revealing glimpse into the heart of a woman who had endured much, and learned hard lessons along the way. There are passionate love poems, philosophical musings, tributes to her parents, religious hymns, and poignant slices from a remarkable life. Three poems are included here. The cover-jacket photographs are breathtakingly beautiful portraits, and attest to the fact that Candy was then perhaps even more of a vision than in her youth.

The Oui Pictorial: Revelation

She emerged one more time, for a startling and remarkable new nude pictorial (more revealing than any she had posed for 20 years before) and interview for *Oui* magazine in 1976, looking truly magnificent and at least a decade younger than her 41 years. Why did she agree to pose? "I am proud that I'm still in good shape, but the real reason I agreed to pose is that it gives me a chance to tell my story," she told the magazine. "When I started out, I was a dumb sucker. I got in a lot of trouble through plain ignorance. Now my head is in the right place, and I can talk about my life."

The *Oui* feature proved a turning point in her life, she says today. Because she made the mistake of allowing the magazine to print her address at the time, Candy was deluged with fan mail and even visitors, some of whom traveled hundreds of miles to see her. What she heard from these fans came as a revelation. "I found out that they loved me because they lusted after me. I went into shock. I was depressed for six months. Because I danced my heart out for these people. I painted pictures, watercolors, I really did, and these babies were sitting out there getting excited because my titties bounced."

Well, I never knew I was on the cover of magazines, until the *Oui* layout opened up a whole world of enlightenment to me." Did she get any satisfaction from the fact that she so many people remembered her fondly? "That's vanity. Hell, no."

Another result of the magazine feature was Candy's liaison with Hugh Hefner. On Valentine's Day in 1977, Hef flew her out to Los Angeles and, in her phrase, they "got together—we snuck off to a room together and did it." The *Playboy* publisher later talked about it in an interview, which "totally embarrassed me." Alluding to tales that Hefner in those days filmed his sexual escapades, she chuckles as she recalls thinking while they were together, "you be cool, girl, you're on 'Candid Camera!'" Even though she had sued the magazine only a few years earlier for its unauthorized use of a photo still from *Smart Alec*, Candy retains a fondness for Hefner, who has sent her Christmas cards for years.

"I must have been a jewel, I'll tell you that," she muses. "I never knew I was beautiful back in the early days, And then I began to comprehend the attitude of people towards

me. In the late '70s, after *Oui*, I was stunned. But then I got to understanding a little better, and it made things a little simpler for me. It gives me an insight into things that make me grow.

"And then it makes me sad. I always said that if God had given me a voice as pretty as my picture was, I'd be in good shape. A lot of people say I could've made something useful of my life. . . "

Candy's post-1957 magazine appearances:

Apr. 1958 *Bare* (2 pages)

May 1958 *Gala* (cover in bikini, 2 pages; "Texas Tornado")

Candid #1 1958 (1 page, topless)

Candid #3 1958 (2 pages)

Fling #7 1958 (7 pages, 4 color, by Keith Bernard)

May 1958 *Gala* (bikini cover, 2 pages)

Sept. 1958 *Vue* (6-page, 11-picture layout not long after her marijuana bust: "Iron Bars for Candy Barr")

Fall 1958 *King #1* (3 pages)

Best Photography #183, 1959 Edition (3 pages, including wonderful picture by Keith Bernard, with Candy clad only in leotards and sprawled on a white rug listening to records)

Jan. 1959 *Foto-Rama* (cover, 4 pages in action on stage)

Jan. 1959 *Modern Man* (gorgeous color nude centerfold by Bruno Bernard)

March 1959 *Modern Man* (reprise of topless pose in leotards)

Spring 1959 *Modern Man Quarterly* (topless centerfold by Bruno Bernard)

May 1959 *Monsieur* (1 page semi-nude)

Adam Vol. 3-8, mid-1959 (1 page topless)

Form #4, c. 1959 (2 pages)

Sept. 1959 *Hush-Hush* (four pages and article focusing on her marijuana bust and relationship with Mickey Cohen)

Nov. 1959 *Zest* (5 pages; "The Strange Case of the Stripper and the Helpful Hoodlum")

Fling Festival #2 Winter 1959 (3 pages, 7 pictures)

Dec. 1959 *Modern Man* (nude by Bruno Bernard)

Revels #2, c. 1959/60 (8 pages, 15 pictures)

Adam 1960 calendar (breathtaking topless pose holding a towel)

Confidential Detective Annual #4 1960 (lengthy cover feature, "Will Candy Barr Wiggle Out of Jail?")

Don Juan #1 c. 1960 (5 pages, 11 pictures)

Feb. 1960 *Modern Man* (3 pages teaching Joan Collins how to strip for Joan's film *Seven Thieves*)

Showcase #2 1960 (4 pages)

Mar. 1960 *Photo Life* (5 pages with Joan Collins)

May 1960 *Vue* & June 1960 *Pose!* (4 pages in each with Joan Collins)

July 1960 *The Lowdown* (4 pages)

Showcase #2 1960 (5 pages)

Oct. 1960 *The Men's Digest* (another "Strip School" feature on Candy and Joan)

Winter 1960 Figure Quarterly #31 (nude by Bernard)

1960 Adam Annual (centerfold, topless)

Modelette Annual #2 c. 1961 (3 pages)

Jan. 1961 *Touch* (3 pages, 6 pictures)

Fling Festival No. 7 1961 (3 pages: "Candy Is Dandy")

Fling Festival No. 8 1962 (4 pages)

Sept. 1963 *Sir* ("From G-String to Jail", 6 pages)

Winter (year-end) 1966 *Cabaret Queens* (vintage color centerfold by Bruno Bernard, plus 3 pages)

Winter 1967 *Modern Man Deluxe Quarterly* (topless shot by

Bruno Bernard, lying in bed)

 May 1969 *Night & Day* (2 pages, 8 nude pictures, "The Return of Candy Barr")

 Dec. 1973 *Bachelor* ("Candy Barr Today," a fascinating interview by Diana Clapton with three vintage nudes, including one full-pager)

 June 1976 *Oui* (new 7-page nude layout including 8 stunning new figure studies, and full-length interview)

 Dec. 1976 *Texas Monthly* (vintage cover of Candy in shoot-'em-up attire, and Gary Cartwright's in-depth profile)

 Fling Favorites #4 1982 (2 pages, 6 pictures, fine retrospective)

 Sept.-Oct. 1982 *Erotics* (centerfold)

 It should be noted that a widely-publicized nudie film released in 1962 with Candy billed as one of the stars, *My Tale Is Hot*, is more than a bit misleading. Her "part" in the film is nothing more than vintage footage of her performing on stage. (She was well into her prison sentence when it was released.) "I had nothing to do with it, and I never even heard about it until a few years ago," she says. Also, during the 1961-65 period, many burlesque theaters ran a "Candy Barr vs. Virginia Bell" film short featuring separate footage of the two strippers on stage.

"What I do or do not know
What I can or cannot do
Who I have been or who I will be,
Does not concern you;
Only who I am.

It is not necessary to exploit that which is
 valuable only to self.
The chapters of my yesterdays are secure. My past
 is not your affair. I am not curious of yours.
It is from the first meeting that I began
 to know YOU;
Not from the yesterdays related by another.
I know who I am, where I am; from
 whence I came. And, where I am going.

You see me as YOU are; Hear me as YOU hear;
But know me, as you learn me.
Until then,
Allow me my place in the present."

— "Pattern", by Candy Barr

1977-95: Survivor

During the 1970s, realizing that the extraordinary events of her life all but demanded an autobiography, Candy agreed to work with a writer on such a book, under the working title *Bits and Pieces*. She says the project ran aground when the fellow appeared intent on "juicing up" the facts of her life. According to Candy, this included cooking up phony stories about an abusive father, an abortion, a rape in prison, and lesbian advances by her warden—all figments of his imagination. Determined to tell the truth, she angrily called a halt to the book.

"I couldn't understand why he wanted to invent all this stuff when there's so much to tell about that actually happened," remarks Candy. "I mean, this is a story that has everything: Sex! Violence! Drugs! Gangsters! Who needs any more?" she laughs.

Of still greater interest to her many fans was word in the late 1970s that a motion picture biography of Candy was in the works, with *Playboy* Playmate Daina House touted as the likely star. Unfortunately, nothing came of it. In 1982, Candy signed a contract with Hollywood producer Mardi Rustam who also wanted to take her life story to the big screen.

In 1992, Candy Barr was all over American movie screens, but in a manner that left her disgusted. In March, the motion picture *Ruby* starring Danny Aiello as her old friend Jack Ruby was released. The film also featured a stripper called "Candy Cane" who was based in part on Candy, but also a composite of several other women. Because the film character did so many things that had nothing to do with the real Candy's experience, she refused any cooperation with the project.

Meanwhile, the long-awaited movie about Candy's life was moving forward with Texas-born Farrah Fawcett set for the title role. She again refused to help once it became clear that the script would distort the facts of her life. But then, no mere movie could hope to match the reality of Candy Barr.

An autobiographical book that promised to tell the truth at last got underway in 1992. In a case of deja vu, however, by the following year she once again was faced with half-witted storyline complaints: The account of her stay in prison wasn't juicy enough ("everyone wonders why I'm not a lesbian"); her story is "too depressing;" and it could be seen as "male-bashing." She shakes her head in astonishment. "Depressing? If anyone's life isn't depressing, it's mine. It's so colorful, it's like Technicolor up on the screen!" As for the charge of male-bashing, she responds, "good gracious alive! All the men in the world didn't do this to me—just certain men."

In spite of all the disappointments, she retains a fierce and justifiable pride in her utter uniqueness. "When you're a Texas legend, they can't take that away from you. There's only one Candy Barr."

Today, Candy Barr—or, as she is mostly known, Juanita Phillips—lives with her beloved pets in a modest home in a small rural Texas town. She calls it her "bisexual" home, because she performs all the chores, even those traditionally done by men. There are family portraits and religious paintings, but nothing visible to indicate the remarkable life experience of the home's occupant. Juanita remains a lovely woman, the silvery hair and a few well-earned wrinkles failing to obscure the beauty underneath. The Texas accent is still rich and full, and in moments of glee her laughter fills the room.

She has lived quietly for the past two decades. Having seen first-hand the horrors of drug abuse from a few of her fellow prison inmates, Juanita has spent time working with drug addicts. She would became discouraged, however, when they would go straight for just long enough to clear their veins, then return to drugs. She rarely goes out to see a show or a movie, and although a lifelong music lover (Neil Diamond, Nat "King" Cole and jazz pianist Ahmad Jamal among her favorites, in addition to a longtime love of the blues), she sold her stereo some time ago.

"People are programmed to think, 'if I'm not getting dicked every night, then I'm not popular, or I'm getting old.' I don't have that problem. I don't do something just to do something. I can spend time being by myself. If you go out with a bunch of drinkers, and you don't drink, they think you're boring, or that you're not having fun.

"I've had the highs. The biggest rush to me is spiritual pictures, because it's real. Watching people shoot pool, or drink beer, isn't."

"I look back on [my career], and I can't relate to it. I can't relate to living it. I don't know if that person really existed, as such." Asked if she considers herself a survivor, she replies, "I don't know about that. I'm an exister."

She is far more than that, however. Despite being victimized time and again, she refuses to indulge in feelings of vindictiveness. "I haven't got time for that. That's the devil's emotion." Above all, she has never allowed all the hard times to wilt her feisty, fighting spirit, or to turn her from the rock-hard con-

victions she has developed and nourished through a lifetime.

"Sometimes I wonder why I was born into this world in the first place, to be a play toy for leeches, the devil's disciples. It just puzzles me what God's plan was for me. As long as I can remember, that's just the way it's been."

"Considering everything, God's done well for me."

(Special thanks to Juanita Phillips for her generous cooperation; and to collector Don Frailey of Woodside, CA.)

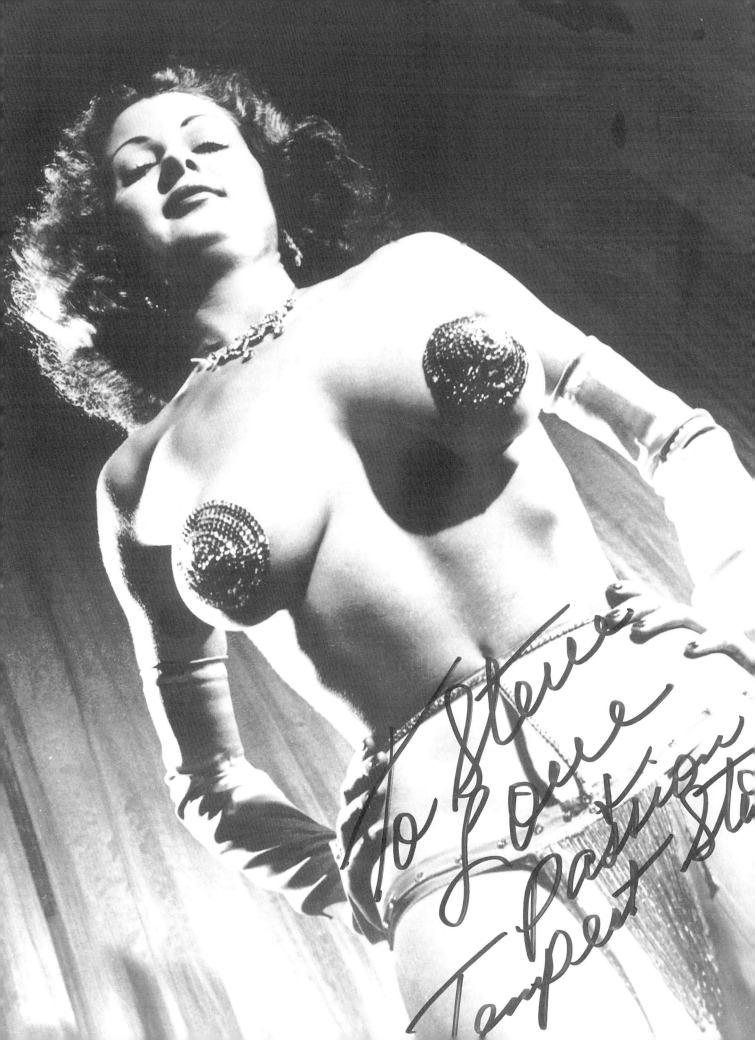

In most fields of entertainment, brevity is a hallmark of the career of a glamour girl. Cinematic sex symbols seldom remain so for more than 10 or 15 years without appearing ridiculous; and pin-up models able to stay successful for more than a decade are more rare than a smogless day in Los Angeles. But in the world of burlesque, the great ones endure. Few women fit this description more aptly than Tempest Storm.

For some 40 years now she has trod runways from New York to San Francisco, and scores of less illustrious stops along the way. Much has changed in that time; the glory days of burlesque were already fading when she burst on the scene, and are only a distant memory now. But with Tempest, the calendar seems magically frozen, at least if one looks with slightly forgiving eyes. Just as her figure has retained its curvaceous yet firm countours, so too has her distinctive style—decidedly sensuous yet always classy—remained intact.

When Annie Blanche Banks was growing up in Eastman, Georgia, a life as an entertainer could hardly have seemed a more distant prospect. In her autobiography *The Lady Is a Vamp*, she describes the rural poverty of her childhood on a sharecropper's farm, and the misery of having to deal with a hard-drinking stepfather with a salacious eye for her rapidly-developing young body. When her stepfather unsuccessfully made a move on her not long after a devastating experience in which the 14-year-old was raped by five men in succession, she resolved to get away.

Blanche got a job as a waitress and rented a room in town. When her stepfather threatened to get the sheriff to force her back home, she quickly married a young soldier just to prevent that from happening. She left him the next day. Several months later, Blanche moved to Macon, but after her stepfather found her there and made the same threat, she agreed to accompany another young soldier to Fort Benning in Columbus. Just after her 16th birthday, she became pregnant and had an abortion.

At 18, she married for the second time, to a soldier on leave from the Army, but this didn't last much longer than her initial union of convenience. On the rebound, she fell in love with her (married) boss at the hosiery mill where she was working, and in a misguided effort to lure him from his wife, deliberately got pregnant. However, the relationship got her fired, and led to another abortion—a botched job that almost killed her.

It was at this point—upon her 19th birthday—that she met Jim Crowley, an apparently kindly and prosperous Californian who invited her to come west with him. Years of dreaming about Hollywood made her answer an easy one. Crowley turned out to be a heel, but Blanche was at last where she'd longed to be. After working for a time as a wait-

Tempest Storm

Born Annie Blanche Banks March 1, 1928
Eastman, Georgia

ress in cocktail lounges, she tried to break into show business in 1949, but with her then-crooked teeth and lack of experience, no one was interested. "At the modeling agencies, I was a joke, a freak with a forty-inch bosom that would never fit into their high-fashion dresses," she wrote in her autobiography.

Blanche's first break into show business occurred while working at The Paddock, a Los Angeles cocktail lounge. In the fall of 1950, she overcame initial jitters and jumped at the chance to try out for the chorus line at the nearby Follies Theater. The buxom 5-5½, 120-pound 22-year-old appeared before Lillian Hunt, a well-known trainer of chorus girls and strippers, who in short order directed Blanche to take her clothes off. Blanche self-consciously asked if her breasts were too large; Lillian laughed and replied that some women "would kill to have what you've got. God didn't make boobs too big for my business."

Blanche was hired, and promptly thrust into the chorus line. After only four shows Lillian told her she wanted her to step out as a featured stripper. Looking at Blanche's bosom, Lillian acknowledged, "we need someone to knock their damned eyes out. And you're it." The budding star, on the verge of making some real money for the first time instead of just scraping by, was finally able to have her teeth straightened.

Blanche made her debut as a stripper in November 1950 at the El Rey Theater in Oakland. The audience response was electric. "I had no idea I'd be such a big hit," she confesses today. She asked Pete DeCenzie, owner of the El Rey, "'who are these people standing in line for?' Pete told me, 'they're coming for you.' I was making $350 a week then, but after I saw the crowds I got Lillian [who was acting as her agent] to raise my salary!"

Since she was clearly on her way, an appropriate stage name was needed, and after passing on Sunny Day, Lillian noted that she could dance up a storm and they settled on Tempest Storm. Not only would that become the name by which she would be known around the world, but in 1957 it became her legal name.

Soon after her start as a headliner, Tempest was booked into the Tropics nightclub in Denver. "The first thing I know, people were standing in line to see me!" she recalls today, the wonder still evident in her voice. "They were standing knee deep in the snow for blocks. It was just amazing to me."

With stardom came the succession of celebrity romances that occupy much of *The Lady Is a Vamp*. Mickey Rooney was the first, and during their three-month relationship Tempest makes it clear that she took maximum advantage of the publicity it brought her. More publicity came her way when she was selected as the winner of Hollywood gossip writers' humorous "Mickey Awards" as the girl with "The Two Biggest Props in Hollywood." Dean Martin and Jerry Lewis accompanied her to the awards dinner, and the *Movietone News* short

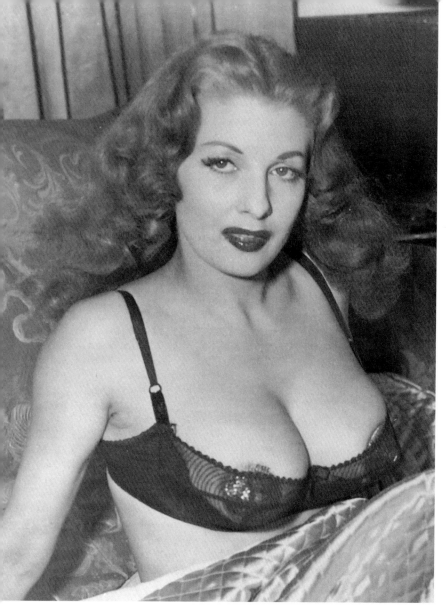

of the event ran in theaters around the country during 1951 as "Hollywood at Play."

"The Mickey Awards really got me started," she recalls. "You don't know how many times I would go to the movie theaters to see that newsreel with me in it! It was unbelievable. There were a lot of other big-busted women around, but they chose me. I guess I was in the right place at the right time."

"In the beginning, I was a very shy, insecure person," she remarks. "Now, that sounds odd for someone who takes her clothes off for a living, but it's true. When I started in the business, I wanted to go to Las Vegas to be a chorus girl. Taking off my clothes wasn't my idea. When I was in the chorus line in Los Angeles, I just thought this was a stepping stone to get me closer to Las Vegas where I could get into a big show. Then it sort of snowballed on me and my career took off. There came a point of no return when the big money started rolling in."

Anyone researching Tempest's career is struck by the number of magazine articles claiming erroneously that she was born in Daytona Beach, Florida. Today, she explains, "I would tell people that I was from Florida, because I was so self-conscious about my Southern accent. Whenever I

opened my mouth, people would ask me where I was from, which just irritated me. So I decided to keep my mouth shut until I lost the accent." It wasn't until later that it dawned on her that "Florida is in the South, too!"

Ironically, a few years later when she did a production of *Bus Stop* in the role of Cherie, she said, "I had to get back my Southern accent. That was funny."

Burlesque Queen

By 1952, Tempest had risen to become one of the biggest names in burlesque, perhaps rivaled only by Lili St. Cyr (a lady who was on considerably less than friendly terms with Tempest, as the latter's book makes clear). One man who helped speed that process was Russ Meyer, who photographed Tempest extensively in the course of producing a glossy magazine and a full-length movie based around the El Rey theater. These were the first quality professional glamour pictures taken of Tempest, and they appeared in a number of widely-circulated magazines, including *French Peep Show*.

Meyer today remains an unabashed Tempest admirer, and notes with pride that she still refers to him as "her photographer" (one magazine claimed that he "discovered" her at "a political ice cream social," which was just an amusing piece of PR). Indeed, Tempest was the first major star associated with Meyer, since the *Peep Show* pictures were published before Russ began shooting his lovely wife Eve. Some of the most famous photographs ever taken of Tempest were shot by Meyer for the magazine *Art Photography* (see magazine listings). It was during this period that the naturally brunette Tempest became a flaming redhead.

The man who put Tempest and Meyer together was Pete DeCenzie. A few years later, he would help Meyer begin his feature film directoring career by serving as a partner on Meyer's breakthrough nudie film *The Immoral Mr. Teas*. She recalls DeCenzie as "a terrific promoter who really knew how to generate publicity. I adored him and his wife Yvonne. He'd bring me into the El Rey about every two months." The two had a falling out a decade later when he objected to a lavish production number she had planned. "We never spoke after that until he passed away," Tempest recalls with regret.

During her first few years in the business, Tempest spent most of her time shuttling between the El Rey and the Follies, with occasional forays to other venues such as the Tropics in Denver. Around 1952, she made an effort to diversify her career by opening a nightclub, Streets of Paris, in San Francisco. The club ran for about a year, but after it ran into the red she gave it up. In 1953, she opened a burlesque theater, the Capital, in Portland. This one was profitable, but proved too time-consuming; she sold out and decided to stick to stripping.

If Tempest doubted that she was creating a stir, this was extinguished during an engagement in Denver by a planned photo shoot at the University of Colorado that resulted in a mob scene and near-riot of some 1,500 ardent fans. She narrowly escaped the campus without serious injury, other than bearing the teeth marks of one overexcited admirer.

In early 1953, after a passionate affair with Sammy Davis, Jr. (the first of Sammy's numerous relationships with world-class beauties), Tempest married Johnny Del Mar, a singer/burlesque straight man turned bartender who had become her manager. Tempest bought the aforementioned theater in Portland, renovated it and performed there. Johnny's ex-wife began harassing and physically threatening Tempest, who had the woman arrested and tried to have her placed in a mental institution. The judge decided she was not enough of a threat to be put away, and the ex-wife sued them for false arrest, a suit eventually settled out of court. The press had a field day with the episode, leading Tempest to sell the theater and move to San Francisco.

This marriage, too, was not long for the world when it became clear that Johnny was a violent drinker and a womanizer. A divorce was granted in early 1955. After a post-divorce affair with actor Hugh O'Brien, Tempest became involved in what she called one of the most important relationships of her life, with the great Nat "King" Cole. This brought her face to face with the racism of the time even more directly than her affair with Sammy Davis. Although their affair ended, Cole remained a cherished friend to the end of his life in 1964.

Meanwhile, Tempest's celebrity dalliances continued. One was with then-Senator John F. Kennedy. Another, which proved a publicity bonanza, was with Elvis Presley. She met Elvis around mid-1957 during her first headliner Las Vegas engagement at the Dunes Hotel, a time when her salary had soared to $3,500 per week. Their affair was brief, but the photos of the two sex symbols together sent Tempest's price still higher.

Although it didn't seem so at the time, an early landmark in Tempest's career was Irving Klaw's 1955 feature film *Teaserama*, featuring Tempest and pin-up legend Bettie Page. Tempest's sensuous solo numbers showcased her trademark style, as she thrust her torso downward and seductively ran her hands up her legs. Tempest also had a well-remembered 10-minute sequence with Bettie in which the brunette bombshell acted as her maid—helping the regal star on with her clothes, brushing her hair, etc. But when Tempest "catches" Bettie playfully mimicking her, she makes the vixen pay by pulling her hair.

"I didn't want to do the film, I think they talked me into it," she says today. "I think my agent Dave Coyle made the arrangement for me to appear. I didn't get much money for it—not much more than $50." Although some later articles said that she and Bettie became good friends and would occasionally correspond and see each other, Tempest sets the record straight. "I never saw her after that film, or spoke to her. I often wondered what had happened to her." Bettie's recent re-emergence as a living cult phenomenon surprised Tempest as much as anybody else. "It's really unbelivable."

Tempest's filmography:

Hollywood Peepshow (1952, also known as *French Peep Show*) — Tempest and eight other dancers in action on stage at the El Rey theater, photographed by Russ Meyer. She says it was not widely seen in theaters, and mostly ran between shows at burlesque houses.

Teaserama (released in early 1955) — The wonderful video reissue of the previously lost cult classic opens with the trailer announcing Tempest as "the biggest attraction in burlesque today—so big we had to use widescreen. . ." and "the girl with the 40-plus bust who goes 3-D two better!"

Following a routine by Bettie Page, Tempest rises from bed in black bra and panties. She slowly and seductively puts on her stockings, bending to display her renowned cleavage. After slipping into high-heeled shoes, she claps her hands to summon Bettie as her maid. Bettie helps her mistress into a corset, combs her hair, and helps Tempest on with full-length gloves and glamorous evening gown. While Tempest's back is turned, Bettie playfully mimics her regal walk, but is caught in the act and has to pay when Tempest pulls her hair in retaliation.

Later, Tempest has two memorable solo numbers. In the first, she comes on stage in black lingerie and cape, and after some slow shimmies removes the cape. Several times, she dramatically thrusts her torso downward as her hair flies, slowly moving back up while caressing her body. In the final routine, Tempest starts in a black evening gown with gloves which she seductively removes along with her bra (leaving net pasties). Along with some deep knee bends, her most eye-catching movement is standing with back to the audience, leaning all the way back to demonstrate her suppleness.

Desert Dance (c. 1957) — 8 mm "adult movie" of a Tempest performance, which was advertised in magazines for years afterward.

Tempest Storm (c. 1964-65) — 50" 8 mm film devoted to Tempest's stage act, sold through magazines together with an all-Tempest magazine and an LP record.

Burlesque was a natural breeding ground for personal rivalries, and Tempest had one for a time with Evelyn West, one of the top strippers of the late 1940s who reached a peak of popularity in the '50s. Evelyn, with a 39-and-a-half-inch bosom that she sometimes claimed as 45 inches, was perhaps the first dancer to insure her bust, and was always publicized thereafter as the girl with the "$50,000 Treasure Chest." In 1954, an enterprising theater owner billed Tempest under the same slogan. Evelyn saw red, brandished her $50,000 insurance policy with Lloyd's of London, and proclaimed that she was "the one, the only and the original." The tiff quieted when it appeared that Tempest was not responsible for the billing. Surely no exotic dancer had less need to steal another's thunder; Tempest's natural qualities were quite capable of doing the job.

As it turned out, Tempest in 1952 had actually taken out two insurance policies on her breasts for $25,000 each. During the same period, she had her mighty bosom cast in plaster of Paris by West Coast sculptor Sal Dirigio.

In 1955, Tempest took things a step further by insuring her body for $1 million with Lloyd's. "To demonstrate what

she is insuring," reported *Modern Man*, "she peeled off for the benefit of newsmen, one of whom checked her two-dimension attributes with a tape measure. Her bustline came to an eye-opening 41 inches, which even the French would admit is 'formidable.'" Tempest regarded the policy as more than a mere publicity stunt, recalling all too well the melee at the University of Colorado; after all, her astounding anatomy was her professional lifeblood, and who could possibly gaze upon it and claim it was worth anything less than a million?

At least for the press, Tempest was modest about her remarkable physical proportions. "I just grew and grew. It was embarrassing when I was a kid, but now I'm glad."

Particularly during the late '50s, many burlesque rivalries were built around bosom size, with such mammoth-mammaried stars as Virginia Bell, Jennie Lee, and Cherrie Knight claiming to have the biggest assets in the business. "There was a big-bust rivalry during those days, but I never got caught up in it," says Tempest. "It takes more than a big pair of tits to make you a star."

Tempest's major 1951-55 magazine appearances included:

Oct.-Nov. 1951 *Peep Show* (#5) (4 pages, 12 pictures in shorts and tight sweater, plus some in show attire at the El Rey; shot by Russ Meyer)

Feb. 1952 *Famous Paris Models* (cover)

Mar. 1952 *Gala* (cover)

The French Peep Show (1952) (back cover, title page, and 2 pages built around the movie and the El Rey)

May-June 1952 *Peep Show* #8 (2 pages in action)

June 1952 *Frolic* (2 pages, 3 pictures)

July 1952 *Night & Day* (1 page by Russ Meyer)

Sept. 1952 *Candid Whirl* (2 pages)

Oct. 1952 *Frolic* (cover, 2 pages)

Oct. 1952 *Frolic* (sensational cover in stage attire, and 2 pages)

Oct. 1952 *Night & Day* (3 pages, proclaimed the "Bust of the Year")

May 1953 *Gala* (2 pages)

May 1953 *Night & Day* (splendid cover, busting out of bikini)

Sept. 1953 *He* (inside cover)

Nov. 1953 *Gala* (3 pages)

Feb. 1954 *Cover Girl Models* (4 pages)

Apr. 1954 *Cover Girl Models* (2 pages)

Apr. 1954 *He* (cover)

June 1954 *Art Photography* (6 pages, 12 pictures by Russ Meyer as he ingeniously devises a way to capture the vivid action of Tempest's bumps and grinds with the still camera)

July 1954 *Tab* (3 pages and account of her tiff with Evelyn West)

Aug. 1954 *Modern Man* (1 page)

Dec. 1954 *Eyeful* (2 pages)

(Note: In about 1954, Tempest graced the cover of an album by Kermit Schaefer, Burlesque Show)

Cabaret Yearbook (#1, early 1955) (cover in modified G-string and halter top, and 1-page topless portrait)

Spring 1955 *Cabaret Yearbook* (#2) (2 pages and 3 topless pictures of Tempest at her most alluring)

Oct. 1955 *Cabaret* (Tempest magnificently graces the cleavage-oriented cover, and appears inside on 3 pages, including 3 topless pictures)

Even while achieving fame and fortune as a burlesque queen, Tempest continued to cast her eye longingly on opportunities in "mainstream" show business, in part because of the fact that many people continued to look down on her chosen profession. In 1956, she told *Cabaret* that she was determined to become a musical comedy star on Broadway, and was willing to go back to school to study acting. "Even if my studies lead to nothing, I think what I'll learn in dramatic school will make me a better performer in my own business, burlesque," she remarked.

In late 1956, Tempest's superstar status was confirmed yet again when she signed a 10-year contract for $100,000 a year, calling on her to perform for the Bryan and Engle theater chain for 25 weeks annually. The agreement provided ample publicity, financial security, and a new degree of freedom. "Sure, I have considered giving up burlesque for an acting career, but now there are many ideas being worked out along both sides," said Tempest after the signing. "The million loot was certainly a fine bit of persuasion in favor of burlesque. But the nicest part of it all is that I still have the rest of the year to study drama, accept other offers which are pending, or just relax."

During this period, Tempest was personally involved with Frank Engle, who helped run the theater network. "One Christmas, I was booked at Canton, Ohio, about the last place in the world I wanted to be then. When I came back to my hotel room that night, there was a giant Christmas tree and a $30,000 diamond necklace and earrings from Frank. I said to him, 'Where's my sable coat?'" she laughs in recollection. "I was just like a little kid, I wanted everything at once."

The romance with Engle was serious enough that they were engaged and made plans for a spectacular wedding. Then, just before making the big announcement, she learned that he was already married. "I sued him for breach of promise and got a big cash settlement. But I kept working at his theaters. He was very good to me professionally."

Sensation in Vegas

Few events in Tempest's career evoke fonder memories than her first appearance as a headliner in Las Vegas, where she'd always dreamed of performing. The 1957 Minsky revue at the Dunes hotel was truly an epic production. "They spent $100,000 for a lounge show. Minsky brought in choreographer Robert Sidney, who had worked with Betty Grable and later with Joey Heatherton. He put up this huge revolving cutout of me outside in shorts and a sweater. Walter Winchell would fly in every weekend to see the show. I was the talk of the Strip."

She glows while describing the act. "I did the big production number with two guys. There was a cocktail lounge, a chaise lounge, French windows, and special lighting. Pink and black in satin was the color scheme. A guy in a tuxedo would escort me in. Then he'd appear in the doorway in flesh-colored tights and a Western hat. I'd be reclining on the chaise lounge, wearing a chiffon gown slit up to the thigh. We'd do movements to each other. Then I'd take my 90-inch-long fox and pull it up slowly through my legs to the music.

"I tell you, it was incredible and exciting to the audience. In fact, Betty Grable, when she was appearing at the Desert

Inn, used to come in and say, 'Robert certainly never gave me anything like that to do! Tempest, teach me how to do it and I'll go home and try it out with Harry James!'"

The climax of the act was particularly memorable. "I'd be totally nude at that point except for a fox draped across me—I'd take off one G-string, but I still had another one on. On the chaise lounge, there was a long candle. I'd run my hand up the candle and flip the light off at the end of the act. When that happened, the audience would just roar, and I asked, 'what is going on?' Finally, I realized that it was because the candle looked like a guy's penis! It was a fabulous number, and it created a sensation."

As a result of the show's success, Tempest "really ruled the roost" in Las Vegas with regular appearances into the 1970s. While other strippers played Vegas over the years, Tempest and Lili St. Cyr were the only two to establish themselves as enduring stars in that intensely competitive setting.

She toured in a road production of *Bus Stop*, but the only movie roles she was offered (which she turned down) were as a stripper. Tempest took singing lessons, cut a demo record, and even landed a contract with Roulette Records. "I quit burlesque for about six months [in 1957-58] to concentrate on my singing career," she says. But the album—to be called *Kickin' Up a Storm*—never happened. However, while pursuing her singing aspirations, it did help precipitate Tempest's next important relationship.

For a burlesque queen of Tempest's stature, the rewards were many. A *Cabaret* profile in 1957 described some of them: she owned two Cadillac convertibles, one on the East Coast and one on the West. Her clothes were tailored by such designers as Oleg Cassini, Christian Dior and Don Loper, and her stunning gowns by Jacques of Hollywood. She bought completely new costumes every year and these cost from $600 to $1000. Hanging in Tempest's wardrobe closets were four mink stoles and two mink coats. Her diamond collection included a seven-carat diamond ring, matched diamond necklace and a diamond dinner ring with 16 diamonds clustered in a platinum setting. Not bad for a little girl from Eastman.

Obsessive perfectionism was one of the keys to Tempest's success. "The musicians hated me," she laughs today. "I wanted my music absolutely right, and I let them

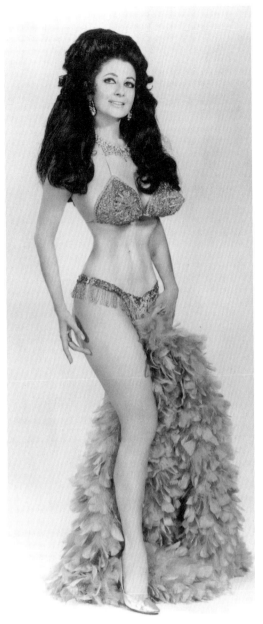

know if they missed a note. I tell you, I was terrible. I was completely caught up in my career. I was always thinking up different numbers, different music and costumes. I was so preoccupied with all this that I really didn't have time for anything else."

One byproduct of this single-mindedness was that Tempest kept her distance from other strippers—indeed, she says the the only ones she ever watched perform were Lili St. Cyr and Blaze Starr. "I was a loner, I kept to myself. I figured that this was the best way to stay out of trouble. I've seen it happen, when girls become friends and they'll turn around and cut that person's throat." She recalls many episodes like the time one stripper put itching powder in the outfit of another girl who was getting "too much applause."

"They say I clawed my way to the top, that I stepped on everybody," she notes. "Well, that's the only way you can be if you're going to be successful." This ferocious determination has not dimmed with time. "If I could turn back the clock—wow. They said I stepped on people this trip—well, just give me another chance!"

Herb Jeffries, who had first achieved fame in the 1940s as vocalist with Duke Ellington, began dating Tempest in 1958. They were married May 21, 1959, an event that received considerable attention because of the general belief that Jeffries was black (actually, his mother was an Irish redhead and his father a dark-skinned Latin). While far more enduring than her previous marriages, the union could aptly be described as a stormy one. She filed for divorce in 1962, but then reconciled. Shortly thereafter, she learned that she was pregnant, forcing her to cancel numerous lucrative engagements which she estimated at about $100,000. Daughter Patricia Ann was born later that year. Tempest and Jeffries were divorced in 1969; in 1970, Tempest made the difficult decision to allow Jeffries to have custody of Patty.

In 1971, Tempest scored a small victory for freedom of expression when she challenged Orlando, Florida's law against topless dancing. For three nights in a row, she performed in pasties rather than the prescribed flesh-colored net bra, and three nights in a row she was arrested; two weeks later, the judge dismissed all charges, and the law was a thing of the past.

One of the highlights of Tempest's career occurred in 1973 during an unlikely college tour with the rock group The James Gang featuring Joe Walsh. After performing before enthusiastic college students around the country who had never seen an act like Tempest's, she became the first (and apparently still the only) exotic dancer to perform in New York's Carnegie Hall. Dancing before a sold-out house, she left the stage with cheers ringing in her ears. "My principles had been confirmed in one of the world's greatest centers of art," she wrote. "People understood that I was an artist."

This theme of respect recurs throughout any conversation with Tempest. "You even look at Minsky's show at the Dunes hotel. They've got big stars across the street packing an 1100-seat theater, and I'm packing an 1100-seat house. But let me tell you, there's a hell of a lot of difference in our salaries. The singer across the street might have been getting $30,000, while I was getting $5,000. I thought I was certainly entitled to the same amount when I'm packing the room. But they don't look at it that way. They've got just a certain amount that they're going to spend on a person who takes her clothes off."

It's an attitude that continues to rankle a woman whose pride is as striking as her beauty. "I'm an entertainer, I'm not just a stripper. I have to use all my adrenaline to go out and entertain these people as if I were a singer. I have to project my charisma and personality. What makes us so different? We're all on stage, selling our bodies for profit. Doesn't everybody?"

Tempest's main magazine appearances from 1956 on:

Winter 1956 *Cabaret Quarterly* (#4) (3 pages, 8 pictures)
Jan. 1956 *Gala* (2 pages)
Mar. 1956 *Night & Day* (cover in leopard-skin bikini)
Apr. 1956 *Cabaret* (1 picture, great topless shot)
Apr. 1956 *Frolic* (cover)
June 1956 *Night & Day* (cover, busting out of bikini)
July 1956 *Cabaret* (cover, 4 pages, and 11 pictures; "Can Tempest Storm Make Broadway?")
Aug. 1956 *Glamor Parade* (#1) (2 pages and 4 pictures, with one page color)
Oct. 1956 *Tab* (2 pages)
Cabaret Quarterly #6 1957 (1 page)
Modern Man Yearbook of Queens 1957 (4 pages, 9 pictures)
Feb. 1957 *Glamour Parade* (3 pages)
Feb. 1957 *Tab* (back cover and 4 pages)
Mar. 1957 *Cabaret* (1 page pin-up art by Russ Meyer from the same shooting as the 1954 *Art Photography* layout)
Mar. 1957 *Foto-Rama* (3 pages; "5000 Guys Are Warm for Storm!")
Adam #1-8 mid-1957 (4 pages, 12 sizzling pictures)
July 1957 *Cabaret* (classic Tempest layout, 5 pages and 7 pictures by William C. Thomas highlighting her magnificent bosom)
Tall c. 1958 (back cover, 4 pages)
Jan. 1958 *Follies* (color centerfold in leopard-skin bikini, plus 3 pages)

Foto #40 mid-1958 (2 pages of Tempest's sculptured form)
May 1958 *Pic* (3 pages, including the famous shot of Tempest with Elvis)
June 1958 *Man to Man* (3 pages and 5 fine pictures; "the Jane Russell of Burlesque")
Modern Man 1959 Yearbook of Queens
Striparama #2 1961 (4 pages, 15 pictures)
Sept. 1988 *Fling* (Interview by publisher Arv Miller)

1975-95: Times Change, But Tempest Is Eternal

After a series of other romantic relationships, including one with singer Englebert Humperdinck, Tempest in 1975 fell in love with Marty Caplan, who owned a number of burlesque and porno theaters. Like so many of her previous involvements, it was tempestuous and filled with breakups and reconciliations. In 1980, she toured for seven months with the show *Burlesque, U.S.A.* The following year, she learned that Caplan was seriously ill. She devoted most of the next few years to him, cutting her professional appearances back sharply until a successful 1985 engagement at the Reno Hilton reconfirmed that the magic was still there. He died of cancer later that year.

During late 1985 and early 1986, Tempest toured with the show *Sugar Daddies* (not to be confused with her ex-

lover Mickey Rooney's long-running hit *Sugar Babies*). Then producers built another show around her, *Hot and Stormy*, and it ran successfully to the end of the year.

"Basically I've done just about the same thing over the years. Just the production and sets would differ. I couldn't take my G-string off [in the 1980s revues], which was good, but I could go bare-busted. I'd make sure that everything was right from the lighting to the music. I never really had a gimmick—my gimmick was me."

In 1987, Tempest's autobiography *The Lady Is a Vamp* was published. While some of her long-time fans felt that it dwelled too heavily on her many celebrity romances at the expense of her remarkable experiences in burlesque, the book was well-reviewed and let everyone know that the queen was still very much around and retained every bit of her legendary aura.

However, she says she was "not at all happy" with the book or its promotion, and its sales were disappointing. One missed opportunity was a feature article in *People* magazine that was killed just before it was ready to run. "I was so excited because I thought this could put my book on the best-seller list." It was vetoed by a young editor from Australia who'd never heard of her. It was a bitter reminder of an episode a few years earlier when she was set to do a celebrity ad for Kowasaki motorcycles until a young member of the company's board dismissed the idea by saying, "she's been around for years."

It is particularly startling for Tempest's fans to learn that she was to be the subject of a full-length pictorial in *Playboy* in 1986 until much the same thing happened. "They sent a female photographer to see my show in Reno, and when she saw me she flipped. They flew me to L.A. to do a photo shoot at a big mansion [not the Playboy Mansion], and shot me all day long. When they showed Hef the pictures, he got all excited. Unfortunately, a couple of his young directors said, 'well, she's gorgeous and has a great body, but our younger readers wouldn't know who she is.' My God, can you believe that? Never mind what I looked like, just to turn me down because of that."

She notes thoughtfully, "years ago, I could crook my little finger and get on the front page. Now I'm figuring, what do I have to do, stand on my head? Short of shooting somebody, what does it take?" she laughs.

All of Tempest's revues of the 1980s were lavish events with first-class music, a chorus line, comedians, and specialty performers to recapture the flavor of classic burlesque. In top-of-the-line venues like the Reno Hilton, management made sure she got the best suites, limousines, and all the related perks to which she'd become accustomed. "I was in seventh heaven." But times were changing, and when her show closed in Lake Tahoe in 1989 it was made clear that the revue would not be invited back—even though it was playing to packed houses right up to the final night. Management was looking to save money, and the kind of prouduction values for shows like *Burlesque U.S.A.* couldn't be duplicated without a serious investment of money. Tempest heard the same story in Vegas and Reno.

And so, in late 1989, she went back into the trenches to begin a three-year run at strip clubs in Miami. "I did pretty much the same act I'd done for years, performing seven days a week. It was sort of like culture shock. I was there from 12 every day till midnight. On Friday and Saturday there were 2 a.m. shows, and by the time I got home it was 4:00. Then I'd grab a few hours' sleep before I'd have to get up and begin putting my makeup on for the next day's shows. It doesn't leave much time for a personal life."

Tempest continued this routine until January 1993. "I was robbed seven times during that period. After the last time, I said, I'm getting out of here."

Even though the advent of upscale strip clubs catering to well-heeled patrons has revitalized the business during the last few years, this is of little use to Tempest. "I was invited to judge a contest at one of these places. There were 35 girls on stage at one time, and they had a wardroom mistress, showers, and a tanning room. They're making all kinds of money. But look at what they're doing—nude pole climbing, table dancing, and lap dancing where the girl spreads everything in front of the guy although he can't touch. Let me tell you, I thought I'd seen it all. I couldn't do that."

As a result, Tempest faced a professional crossroads. With a wealthy boyfriend who can well support her "shopaholic" habits, she is still determined to remain active and independent. She would like to do a book on health and fitness for women over 40, and surely her continuing firm-bodied allure would seem a potent selling point. A possible book on the Mitchell brothers in San Francisco, the controversial kings of X-rated cinema and strip clubs who have been "very important in my career," is another project that intrigues her. And talk continues about a new burlesque revue built around Tempest if only the right bookings can be found.

Meanwhile, she moved back into the limelight in 1994-95 with appearances at the Glamourcon national conventions. And to the surprise and delight of fans who recognize Tempest's enduringly powerful sex appeal, in mid-1995 she agreed to pose for her first nude magazine layout in over 35 years.

"Some people ask me what makes me different or special. I think part of it was the combination of naughtiness and innocence. That may be what kept me on top for so long. I think people are tired of the vulgarity where there's no art or imagination. Back when I was starting my career, I said to myself, 'I'm a woman. What would embarrass me if I was sitting in the audience?' So all through my career, I censored myself, and I think that helped keep me on top."

Usually with sex symbols, she observes, "at 30 you're over the hill. But I take care of myself, don't drink, and don't smoke. Gravity is not going to get me! If I ever looked in the mirror and it cracked, forget it, I'm gone!" she declares laughingly. "I think it's all in the attitude, and I've got a whole lot of attitude!"

"I've lived a life that is just incredible. There's nothing I haven't done, nothing I haven't had. I had some of the most powerful men in the world. I was thinking the other day, what the hell is left for me to do?" she laughs. "I've lived a life and a half, and I'd like to live it all over again!"

(Thanks to Tempest Storm for her time and generosity.)

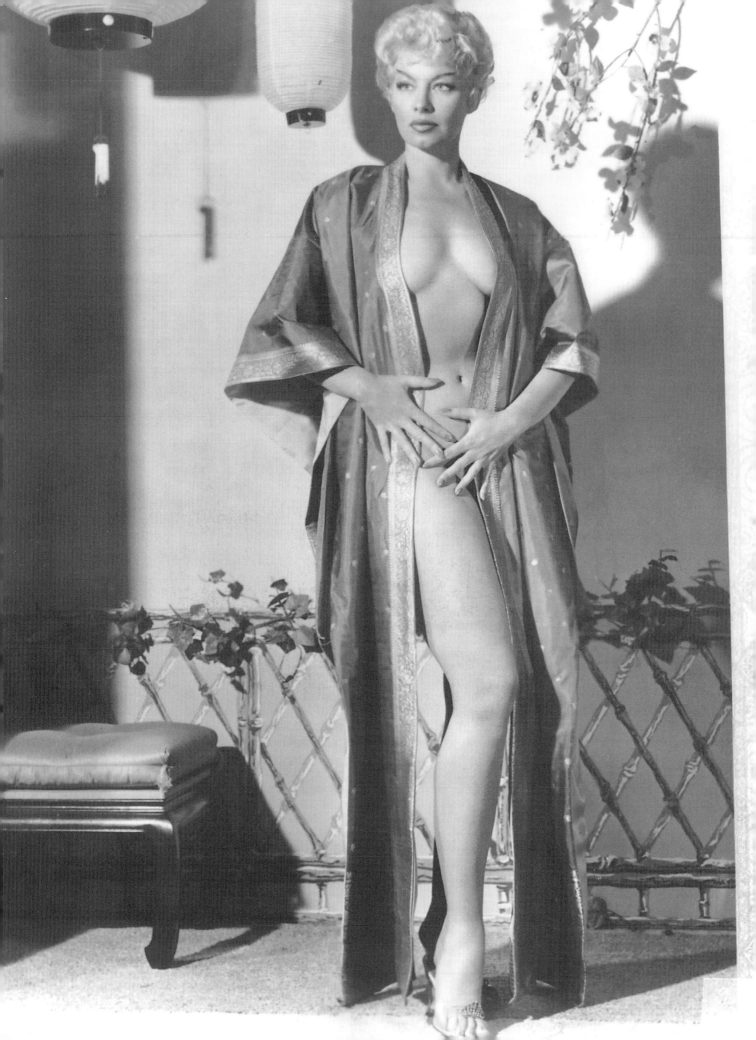

Every field of entertainment has its designated royalty, earned through years of distinction and unique personal qualities. In the Hollywood of the 1940s and 1950s, it was Gable, Tracy and Hepburn. Alfred Lunt and Lynn Fontanne ruled Broadway; Martha Graham, the realm of classical dance. And when burlesque was the arena, no one could possibly dispute the fact that Lili St. Cyr reigned as the Queen of the Runways.

Stars such as Gypsy Rose Lee and Ann Corio had done much during earlier years to elevate the art of striptease from the connotations of sleaze that many Americans associated with it. Lili, however, lifted it to an entirely new level, combining her Greek goddess beauty with a serene, timelessly lovely dance style and personal image that could not have been more distant from the brassy burlesque clichés. In a sense, when Lili was on stage, she moved in a world of her own.

Born Marie Van Shaak of German-Italian ancestry, Lili's family moved to Pasadena when she was about two years old. As a young girl, she took ballet lessons three times a week. After graduating from high school, she went to work at a Pasadena restaurant, where the young beauty was spotted by photographer Jack Powell. For the next two years the teenager was a popular photographer's model.

As Lili later recalled, her sister (known professionally as Dardy Orlando) indirectly got her started in show business. "I had not the slightest notion of becoming an entertainer the day my mother asked me to accompany my younger sister to an audition some years back," she wrote. "We lived in Pasadena, but unlike most youngsters there, I hadn't been bitten by the show business bug. But when the immortal producer, N.T.G. (Nils T. Granlund), took one look at my sister, he turned to me and said, 'Well, you both might as well go to work.' It was as simple as that."

Lili's professional career began as a chorus line dancer at the Florentine Gardens, a plush nightclub in Hollywood. Her fellow dancers there included future Hollywood bombshells Yvonne DeCarlo and Marie McDonald. "I saw I was in a rut after a year, and begged N.T.G. to let me do some specialty numbers which I had already begun working out myself," she recalled. Granlund billed her as "The American Venus," and featured her in the title role of the mini-musical *Eve and the Apple*.

After two years at the Florentine Gardens, young Marie went to San Francisco to appear at the swank Music Box nightclub with the Duncan Sisters. Rosetta and Vivian Duncan, long-time entertainers on the Broadway and London stages, owned the theater, and they hired Marie initially to throw gardenias to the customers. Lili has credited them with "giving me a big push up the ladder." Another important early ally was New York talent agent Miles

Lili St. Cyr

Born Marie Van Shaak June 3, 1918
Minneapolis, Minnesota

Ingalls, who signed on with Lili after seeing her at the Florentine Gardens.

While earning $27.50 a week, she saw featured nude dancers in the show earning upwards of $500 a week. Putting two and two together, Lili decided where her course would lead.

She began on the road to legend in 1940. Famed producer Ivan Fehnova was looking for a beautiful new attraction to grace his show at the Hollywood Theatre in San Diego, and a theatrical agent sent over the budding young dancer. At the first sight of the enchantingly lovely 5-foot-9, green-eyed blonde, Fehnova was won over, and without even seeing her on stage gave her the job and the new name Lili Marie.

The newcomer made her debut at the Music Box. However, as Fehnova later recalled, she was a catastrophe performing to "Spring Song." "Oh my God, it was brutal," he said. "Here was this girl, so beautiful. But she had absolutely nothing. NOTHING." She told him honestly, "I needed a job, and I thought I could bluff it through." Fehnova fired her on the spot. Moments later, he changed his mind and asked her back for a rehearsal. Even though awkward and totally untrained, the youngster had a certain something, and Fehnova worked with her to help bring it out.

At midnight, Lili made her second appearance, clad only in a G-string. Fehnova had devised a special gimmick: attached to the G-string was a fishline, invisible to the audience. At the crucial moment, a boy in the balcony was to press a lever on the reel and the G-string would go flying off, and the lights would simultaneously go dark. In its 1952 account of the episode, *Modern Man* related that the boy didn't press the actuating lever properly: the G-string flipped into the air and plopped directly into the martini of a noisy front-row customer. The flub brought down the house, and a star was born. For years afterward, the accidental maneuver—never again repeated—was known as "flying the G."

In a 1955 magazine article, Lili recalled her introduction to burlesque. "The strip act itself didn't bother me; when I finished disrobing—artistically, of course—I was no more nude than many girls you see on the beaches. It was the audience that gave me butterflies in my stomach that first night. It's a sensation I never overcame; I still get stage fright just before going on." Today, Lili recalls: "At first, I was more terrified of getting on and off stage at the right time and handling myself—I wasn't concerned about the audience. It was only later on that I developed stage fright. All alone on stage, more was expected of me."

For the next five years after her 1940 debut, Lili worked tirelessly with Fehnova, practicing three to four hours every day. Rigorous Russian ballet training was a regular part of the regimen. His initial judgment had been entirely on target—the once-gawky kid soon became an exceptionally graceful, highly skilled dancer. For a time, she borrowed his

name and called herself Lili Fehnova. Deciding that this sounded too much like a ballerina, she changed it to Lili St. Cyr. "I liked Lili because it has always meant to me an adventurous woman, like Lillie Langtry or Lillian Russell," she later said. "The St. Cyr I took out of a beautiful story I had read about France."

"From the beginning, she had a natural grace and poise that many ballet dancers work years to get," said Fehnova. "She had lovely arms and was intrinsically graceful. She radiated personality."

After her burlesque beginnings at the Hollywood Theatre, she moved to Chicago to play at the 606 Club and Colosimo's, then to the Latin Quarter in Miami, and Leon & Eddie's in New York. Her act continually became more lavish and memorable; its early focal point was portraying the great female "sirens" of history, from Eve to Cleopatra and Salome. The Gayety vaudeville theater in Montreal became her professional home for an extended period during the mid-1940s.

Lili's favorite routines during the 1940s included "The Wolf Woman," "Afternoon of a Faun," "The Ballet Dancer," and "In a Persian Harem." One popular number, "The Love Bird," was set in the jungle amidst a tribe of beautiful savage women whose only companions were the wild birds whom they worshipped. In another, "The Chinese Virgin," a Chinese lord sealed his lovely bride in a chastity belt before he departed for battle. In "Leda and the Swan," she depicted both the queen and her lover, the prince transformed into a swan. Little wonder that Lili was called "the most European-minded American in the theatrical world."

By the time World War II was over and the nation was ready to kick back and have some fun, Lili was packing them in every night with an act that defied precedent. Not only did she disdain the traditional bumps and grinds, she began her performance nude except for a G-string, and then proceeded to dress with the help of her maid—a "strip in reverse." Her favored venue was Ciro's in Hollywood, which became "the showplace of the nation" thanks largely to Lili.

The Queen of Las Vegas

While she first made her reputation in San Francisco and Hollywood, it was in Las Vegas that Lili truly forged her legend. El Rancho Vegas, which would later become Lili's Vegas "headquarters," had been the very first resort casino to open on the Strip (then merely the lonely L.A. Highway three miles from downtown) in April 1941. It was followed by the Last Frontier and then Benjamin "Bugsy" Siegel's fabulous Flamingo, which opened in December 1946. As the desert nights were emblazoned in neon by one lavish new postwar hotel after another, the town became a mecca for some of the top entertainers in the country—drawn in part by the breathtaking salaries which casino profits made possible. During these pioneering early years, Lili St. Cyr was one of the stars who truly brought the glitter to Las Vegas.

"Vegas was like a little Western town in those days," Lili recalled wistfully. "It was more charming. Everybody knew everybody. It was like a second home to me—I had my own cabin, it was another world." Millionaire interior decorator Tom Douglas caught her act, and helped her adapt it to more lavish proportions.

The act devised by Lili and Douglas at El Rancho Vegas took place on a $15,000 stage set that was the most spectacular the town had ever seen up to that point. It began with Lili taking a bubble bath in a specially-designed, transparent glass tub (most of her trademark bubble baths were taken in a specially designed Venetian tub). She thoroughly washed herself, rising while covering herself with a tiny towel. Next she stepped into a succession of stunning gowns by Marusia and hats by Kenneth, both top West Coast designers. The show was a dazzler, and it firmly established Lili's position atop the burlesque world. "Men just loved to see a girl take a bath on stage," Lili later wrote. "The bath became a must in my act. . . I never could eliminate it."

In the 1949 version of her act, Lili was performing with ballet dancer Paul Valentine at Hollywood's Florentine Gardens (Valentine was also Lili's third husband, preceded by motorcycle racer Cordy Milne and Richard Hubert, head waiter at the Florentine Gardens). Dressed in a flimsy harem garment, she portrayed a slave girl captured by a trader. After a series of dance movements depicting her flight against her captor, she fell in love with the trader. Then she portrayed the courtship in undulating movements to slow music. Another of her favorite routines during this period featured Lili in giant Indian headdress, apparently nude except for her long blonde hair cascading Godiva-like down her body.

Although their marriage did not survive, Valentine was helpful to Lili by furthering her ballet training. Perhaps no other burlesque star put so much effort into developing her stage artistry. From the perspective of the 1990s, Lili remarked: "The ballet training was very important. It gave me assurance that I would avoid awkward moves. Without it, I might never have had the courage to go on stage."

When Valentine filed for divorce from Lili in August 1949 after nearly three years of marriage, he declared: "Everybody in the country could see more of her than I did." Lili's intense devotion to her craft made a sustained relationship very difficult. "I worked non-stop," she recalled. "I had to work every week to make the expenses—I did my own sets and costumes, I couldn't afford to take time off. In more than 30 years, I only took two real vacations." Marriage #4 to New York restaurateur Armando Orsini (1950-53) met the same fate.

Lili's most noteworthy pre-1955 magazine appearances included:

Feb. 1, 1946 *About Town* (cover, appearing at the Florentine Gardens)

Summer 1946 *Bits of Beauty* No. 1 (cover, 2 pages)

Sept. 1948 *Picture Show* (2 pages, including famous shot clad only in giant Indian headdress)

Nov. 1948 *Night & Day* No. 1 (cover)

Apr. 1949 *Flirt* (2 pages, 6 pictures)

Jan. 1950 *Night & Day* (2 pages)

Apr. 1950 *Taboo* (3 pages in ballet attire dancing on the Malibu beach with Paul Valentine)

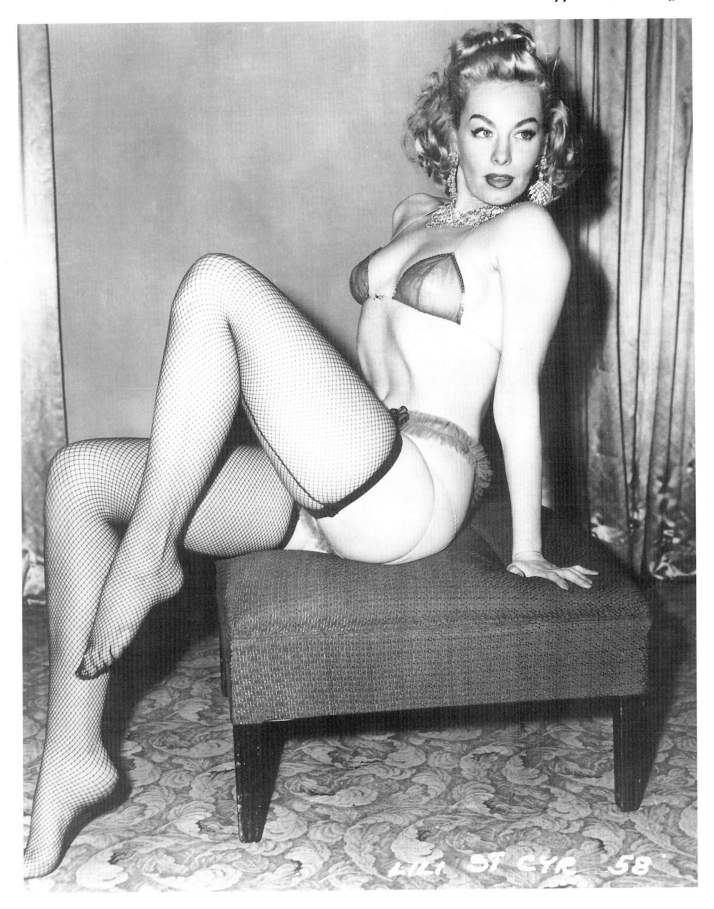

VaVaVoom!
275

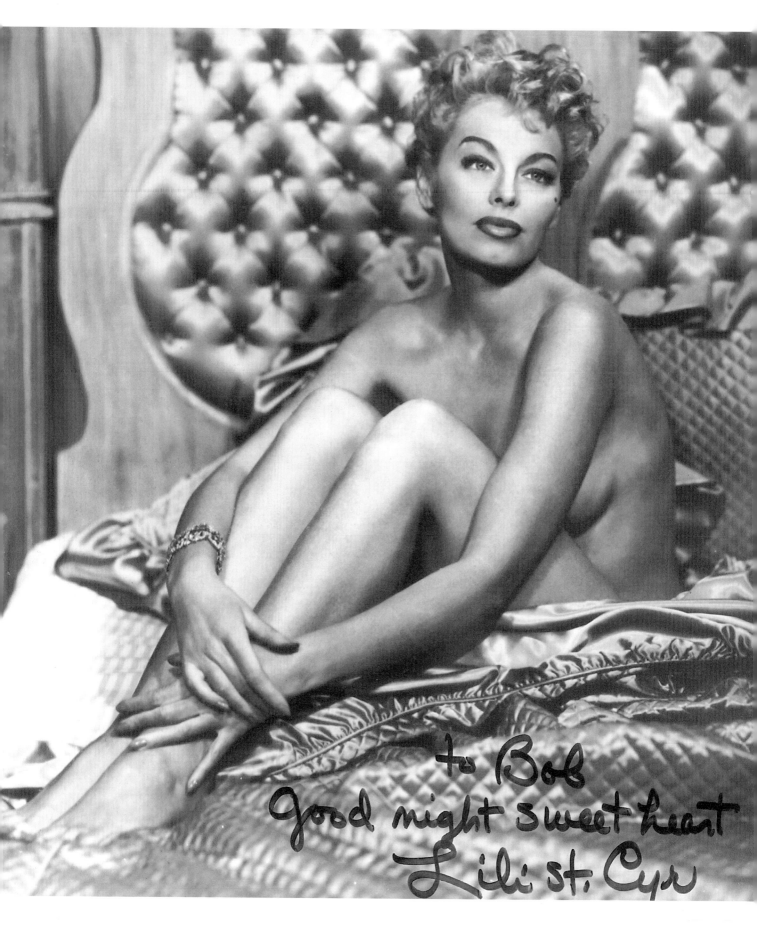

to Bob
good night sweet heart
Lili st. Cyr

Sept.-Oct. 1950 *Gala* (4 pages)

Dec. 1950 *Night & Day* (terrific 3-page semi-nude layout on stage)

Feb. 1951 *Big Time* (three-page layout with four fine cheese-cake pictures in this oversized magazine)

July 1951 *Night & Day*

Sept.-Oct. 1951 *Famous Models* (6 pages, 9 pictures from her act)

Jan. 1952 *Modern Man* (6 pages, "Queen of the Strippers," pictures by Bernard of Hollywood)

Feb. 1952 *Modern Man* (back cover, teaser for next issue)

Feb. 1952 *Night & Day* (cover)

Mar.-Apr. 1952 *Hit!* (4 pages, "Too Much Gal for Hollywood")

Mar. 1952 *Modern Man* (6 pages, 12 pictures by Bernard of Hollywood, with an excellent retrospective of Lili's career to date)

May 1952 *Pix* (2 pages)

Nov. 1952 *Cover Girl Models* (8 pages, 10 fine glamour pictures by Bernard of Hollywood)

Nov. 1952 *Show* (2 pages, taking a bath on stage)

Nov. 19, 1952 *People Today* (cover)

Modern Man Annual #2 1953 (truly classic back cover by Keith Bernard: apparently nude, holding an odd stringed instrument, one leg athletically and erotically stretched upward along a tree)

Sept. 1953 *Art Photography* (cover and back cover)

Nov. 1953 *Night & Day* (3 pages)

Nov. 1953 *Tab* (3 pictures in "Battle of the Lilies" along with Lilly Christine)

Jan. 25, 1954 *Tempo* (cover in eye-grabbing pink harem-girl attire, and 1 inside picture)

Feb. 1954 *Eye* (7 pages, 9 pictures, including some fine action shots on stage, showing off her exceptionally lithe form)

Apr. 1954 *He* (inside cover)

Apr. 1954 *Modern Man* (5 pages and 7 pictures by Bernard of Hollywood, "At Home With Lili St. Cyr." Perhaps the best is a splendid shot of a beaming Lili emerging from her bath with a tiny towel clutched to her body. The closing picture—with a flirtatiously smiling Lili in lingerie kicking up her feet on a sofa—is also memorable)

Spring 1954 *Peep Show* (4 pages, 7 pictures taking her "$5,000 bath" in that see-through glass tub)

May 1954 *Sir* (3 pages)

June 1954 *Cover Girl Models* (2 pages from that same classic session as the *Modern Man Annual* #2, seemingly nude with Godiva-like hair covering her breasts and that stringed instrument in her lap)

Aug. 1954 *Uncensored* (cover shot in action)

Dec. 1954 *Foto Rama* (4 pages, America's No. 1 Pin-Up Queen")

By this point, Lili was generally acknowledged to have supplanted Ann Corio and Gypsy Rose Lee as the epitome of burlesque performance. In the words of one magazine, "she's called the most beautiful and exotic entertainer who ever drew gasps as she shed diaphanous garments before breathless audiences!"

Indeed, Lili was truly a vision during these prime years—and her "prime" extended far longer than virtually any of her fellow exotics. The body was perfection itself: 5-foot-9, 118 pounds, 36-24-35, her muscles ideally toned. Her skin complexion was flawless, her hair a lustrous blonde. And those green eyes, containing both a regal sense of distance but also a coolly inviting sensuality. Proclaimed another magazine: "To millions of men of all nationalities, Lili is the symbol of love."

On October 18, 1951, Lili was arrested in Los Angeles after her "Interlude Before Evening" show at Ciro's for "shedding practically everything." The formal charge was "lewd and lascivious performance," and it was alleged that her act stimulated sex crimes and constituted a "corruption of public morals." This could hardly have been more ironic, for never in burlesque history has there been a classier, more elegant stripper than Lili St. Cyr. Lili offered to take a bubble bath in the courtroom to demonstrate her act. "I'm ready to demonstrate the decency of my act any place, any time," she declared while smiling at a panel of 30 prospective jurors, but this proved unnecessary. Attorney Jerry Geisler, well practiced in defending the glitterati of Hollywood, represented Lili in Beverly Hills court. The jury decided that her dance was "art" after an hour's deliberation.

"This is a real victory for the profession. I'm just delighted!" Lili declared after the verdict. "My heart was pounding so hard." Then she embraced Geisler, and shook hands with the jurors (10 women and two men) who crowded around her after court adjourned.

Lili Goes to Hollywood

In 1953, as Lili performed on New York's 52nd Street before sold-out houses at the Samoa, word began to circulate that the queen was preparing to abdicate her throne to enter the world of 3-D filmmaking. Fortunately, Lili had no intention of leaving, but there was more than a grain of truth to the rumor: Hollywood had beckoned, and Lili had answered the call.

It was after a nightclub performance that year that Lili was approached by Walter Cain, Howard Hughes' right-hand man. Always a man with impeccable taste in women, Hughes saw Lili as his next star. Shortly thereafter, without ever meeting the mysterious millionaire, she was signed to a seven-year contract with RKO Studios. "Sure, I'd like to be a movie star—name me a girl who doesn't," she said at the time.

After two live-action films of Lili in performance, *Carmenesque* provided her big-screen debut in early 1954, and this 3-D extravaganza by Sol Lesser was a custom-built showcase for Lili and her dancing skills. No stage production of the Bizet opera could approach Lili's interpretation of the Carmen story (sans music) for sheer seductive power.

Son of Sinbad was the production with which Lili became the third burlesque star (following Gypsy and Ann Corio; Sally Rand began stripping after her brief movie career) to be featured in a "mainstream" Hollywood production. Although actually filmed before *Carmenesque*, it was not released until 1955. Lili enjoyed substantial screen time amidst a bevy of scantily-attired beauties opposite Dale Robertson as Sinbad.

While easy on the eyes, however, the film was not a success.

Lili subsequently appeared in several more films, including another one (*Boudoir Secrets*) built entirely around her. It was in 1966 that she landed what was billed as the best role of her Hollywood career in *Runaway Girl*—although recently she dismissed it as "a lousy movie." "I didn't like working in Hollywood," she declared. "You can't

be your own person—they swallow you up. I was used to doing my own hair and costumes, and I resented them doing it for me. They took away my independence, and made me feel like a Barbie doll. On stage, I had a designated space in which to work, and the freedom. In films, you always have to answer to other people."

Lili's complete known filmography:

Love Moods (1952) — Filmed live at the Follies Theater on Hollywood's Sunset Strip and released in February 1952, showcasing Lili and her famous bubble bath in living color. This is truly definitive Lili: as in *Bedroom Fantasy*, she starts off in a lavish evening gown as she is assisted in undressing by her maid. She slips from one outfit into another, performing graceful ballet moves across the stage in a sheer black nightie. After a few more changes, the maid prepares her bubble bath and she climbs in, kicking up her legs in delight as the Lawrence Welk-like bubbles fill the air. Finally, the maid provides her with a towel, she twirls around while drying herself, and she's off for an evening with her boyfriend after donning a glamorous white evening gown with expensive jewelry.

Strip-o-Rama (1953) — "The Three Most Exotic Stars in One Great Show," Lili, Georgia Sothern and Rosita Royce. Also featuring Betty Page; filmed in color.

(In 1953, Lili was reported to have shot scenes for two films by producer Al Zugsmith, who was later to be associated with Mamie Van Doren: *Female of the Town* and *Girl of the South Pacific*. However, evidently neither was ever completed.)

Bedroom Fantasy (1954) — Filmed at Hollywood's Follies Theater, this features Lili performing some ballet-like movements while preparing for bed. She romps around on satin sheets and talks to her lover on the phone.

Carmenesque (1954) — A guaranteed treat for any Lili fan: Sol Lesser's 3-D production features Lili's unique and sensuous dance interpretation of the Carmen story. Lili does a mean tango here, and one of the film's highlights is her steamy (for the era) bedroom scene with her toreador.

The Miami Story (1954) — Lili is reported to have made an appearance in this documentary-style crime melodrama starring Barry Sullivan. She is not billed, so her scenes may

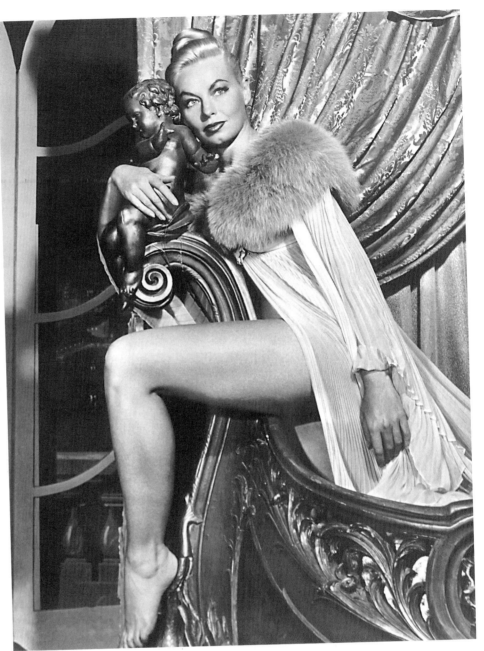

have wound up on the cutting room floor.

Varietease (1954) — Lili is the headliner in this Irving Klaw production which also features strip performances by Betty Page and several others. This film was rediscovered in early 1993 and is available from Something Weird Video.

Son of Sinbad (1955) — Dale Robertson portrays the seafaring hero in this mediocre Arabian Nights adventure. Lili is third-billed (behind Sally Forrest) as Nerissa, one of Sinbad's seductive adversaries and the favorite of the caliph's harem. A Howard Hughes production behind the scenes, it bore two Hughes trademarks: after being filmed in 1953, it sat on the shelf for two years while he heated up the publicity machine; and it was jam-packed with gorgeous females.

Boudoir Secrets (1955) — In this one-woman show, Lili depicts (through dance) a bride's happiness on her wedding night.

Josette of New Orleans (1958) — "Sexy! Sultry! Sensational!" Lili stars as a dancer who gets involved with a gangster and horse racing.

The Naked and the Dead (1958) — Critics were sharply divided over this adaptation of Norman Mailer's novel of World War II soldiers in the Pacific, starring Aldo Ray, Cliff Robertson and Raymond Massey. However, there was no debate about Lili, whose striptease performance was regarded by some as the best thing in the movie (although much more footage of her strip was filmed than was actually shown in the released version). Lili's figure was also painted on a poncho by her soldier-lover, who embraced it at every opportunity.

While male fans loved Lili's classic blonde beauty and well-toned body, women came to her shows to admire her lavish gowns and jewelry and the unrivaled sophistication of her act.

I, Mobster (1959) — Lili appears as herself in this above-average crime drama starring Steve Cochran and Lita Milan.

Runaway Girl (1966) — Typecasting, but who could possibly complain? Lili stars as a stripper who grows tired of the burlesque circuit. She hops a bus to nowhere, seeking a peaceful escape, and by happenstance becomes a grape picker at a vineyard in California. The Motion Picture Guide picks up the plot: "The workers are suspicious of her, and the vineyard manager and his brother begin to compete for her affection. St. Cyr tells the women she works with who she really is and gives them jewelry and perfumes. The dancer's manager shows up to take her back to the night clubs and the strip joints, but St. Cyr decides to marry the manager and stay on at the vineyard." Jock Mahoney co-stars as the vineyard manager.

Lili's talent clearly ran in the family. One sister, Dardy Orlando, was a major burlesque star in her own right before marrying Harold Minsky, the son of one of burlesque's great impresarios. She retired in the mid-1950s. Another sister, Barbara Moffett, danced with the Earl Carroll troupe for years, and later wed toy manufacturer Louis Marx.

Lili's fifth marriage, to rugged Broadway and film actor Ted Jordan (featured in the original stage production of *The Caine Mutiny* and the nephew of famed bandleader Ted Lewis), was the event of the 1954-55 season in Las Vegas. The wedding cake was in the shape of a mushroom cloud, with the inscription: "Happy wedding to the Anatomic Bomb, Lili St. Cyr." By the mid-1950s, Lili had become (in the words of one magazine) "as much a fixture in Las Vegas as the roulette wheels." She asserted that after completing her contractual engagements, she would hang up her G-string—but of course actually doing this proved unthinkable.

Beldon Kattleman, head of El Rancho Vegas, had a special wedding gift for Lili: a five-year contract guaranteeing her 12 weeks of work per year at $4,000 per week, or $240,000 over the term of the contract.

In August, 1956 Jordan got into a wild brawl over Lili with a South African millionaire who had been an ardent ringside customer at her performances. The fight careened all the way through an El Rancho Vegas steakhouse. The marriage ended soon thereafter.

Jordan's 1989 book *Norma Jean: A Hollywood Love Story* spins the tale of his purported lengthy 1940s affair with the young Marilyn Monroe, along with briefer discussion of his relationship with Lili. Jordan illustrates the well-documented fact that Marilyn was a great admirer of Lili's, noting that Monroe saw her perform a number of times and borrowed a few of her beauty and glamour tricks. He also claims that Marilyn and Lili were also lovers and that Marilyn continued to pursue her for years. This assertion appears to have scant credibility in light of Jordan's many blatant factual errors.

In 1959, Joe Albert (Strong Boy) Zomar, a film studio special effects man (who specialized in explosions) became husband #6—until their 1964 divorce. Lili remained on friendly terms with all of her ex-husbands, perhaps in part

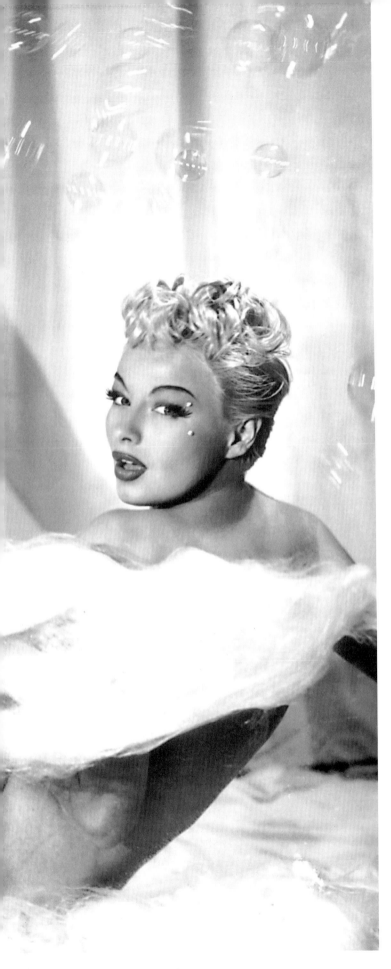

because she never asked for alimony.

Despite all her marriages, Lili made the decision from the outset not to have any children. Her rather lurid 1965 autobiography. . . *And Men My Fuel*. . . makes the claim that she had at least seven abortions (at another point in the book this figure increases to eleven), and includes the comment: "I despise children and the thought of having any has always petrified me with shivering fear."

In the January 1957 *Cabaret*, Milton Schuster, for over a quarter-century the exclusive booker for the Midwestern burlesque circuit, made his selections of the top ten strippers of all time, and Lili was his choice for number one. "There isn't a bump or a grind in her act," he noted. "But she does things to her audiences that no one in the early days of burlesque dreamed could be done. Yet it is all in good taste, and in a manner that can truly be called art. Lili puts her personality across the footlights without resorting to a single cliche of the stripper's trade. But she knows her business, and she makes the right kind of impression on an audience. She's a blonde blowtorch, and I suppose you could say that she is the atomic age version of the stripper."

Another experienced burlesque observer (and one with a familial affection), Harold Minsky, remarked: "She's not a stripper in the ordinary sense, but she immediately excites the audience. There's class in everything she does, from the stately way she lifts a mirror to the lithe movements of her hands over her body."

The highest-paid of all exotic dancers with a rate of $5,000 a week, Lili by 1954 was earning a total of more than $200,000 annually including her income from movies. Maintaining her commitment to quality was an expensive proposition, as evidenced by one account: Her stage props cost $2,500; she wore $5,000 worth of jewelry; her Dior gowns cost from $500 to $1,000 each, with many costume changes; the bath towels used in each act cost $35 each, and she wore out $50 worth of hosiery and bras each week. As Lili noted, women came to her shows to see the dazzling array of dresses and jewelry, while men came to see her remove them. Offstage as well, Lili's tastes were expensive, which helps explain why she always seemed to be scrambling for money despite her vast earnings.

"My act was unique," Lili says proudly today. "I went to the trouble and expense to provide the very best props and design. I provided the curtains, lights, and the story-lines. I felt I needed them all to make my act special. This made it creative and fun for me as well as for the audience."

Great performers have a knack for good timing, and this was certainly true of Lili in 1956. Grace Kelly married Prince Rainier II of Monaco on April 19, and almost immediately thereafter Lili unveiled her "Wedding in Monaco" act. Produced by Leroy Prinz and in rehearsal long before the royal wedding, the show was hailed as "the sensation of the season" at El Rancho Vegas.

The show began to the strains of the "Wedding March," with Lili stepping from a palace balcony to a luxurious royal bedroom to prepare for her wedding night. "Wearing a white silk evening gown and traditional white gloves, she is a picture of loveliness against the background of red damask

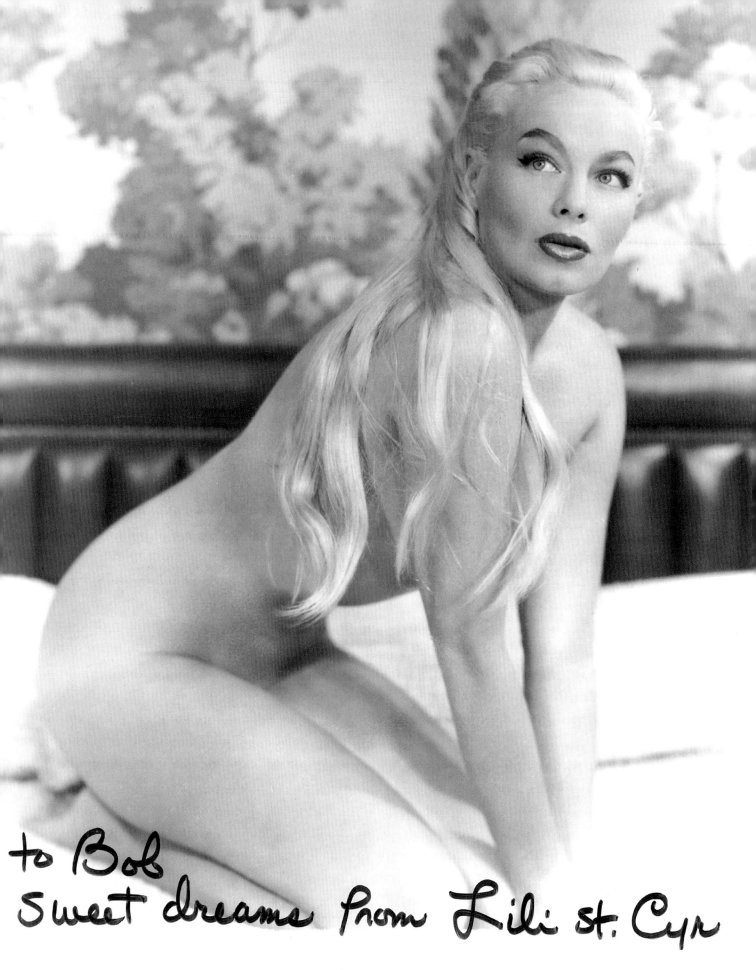

to Bob
Sweet dreams from Lili St. Cyr

VaVaVoom!
282

tapestry, a real marble fireplace and gold cupid statuettes," related *Modern Man*. She removed her clothes down to her scanties—and she tossed them into the audience.

After standing before the window in a filmy negligee, she removed it and stepped into her bath (a replica of a Louis XVI bathtub)—always a staple of every Lili St. Cyr performance. Following her bath and wrapped in a white towel, she dried herself with sensuous gyrations before the fireplace. Next, a revolving stage turned and Lili's magnificent royal bed appeared, and she stretched her nude body atop it anticipating the big event. Sadly, in 1960, the end of an era for Lili and Las Vegas came when El Rancho Vegas was destroyed by fire.

During the late 1940s and much of the 1950s, Lili worked virtually 365 days a year in all the top venues (both nightclubs and burlesque theaters) from Los Angeles to New York, including 10-12 weeks per year in Las Vegas. By the mid-'50s she had earned the right to take two to three months off to travel in Europe. On each trip, she took special pleasure in rummaging through antique shops, buying "truckloads" of items and shipping them home.

One of Lili's most heavily-publicized movie roles was in 1958's *The Naked and the Dead*. However, despite the fact that the studio made the most of Lili's appeal in advertising the film, her scenes were badly cut in the version finally released.

On November 1, 1958, Lili took an overdose of sleeping pills and was found on the floor of her hotel bungalow in Las Vegas, shortly after she and Ted Jordan had separated. It was one of at least three suicide attempts she made over the years. "The reason I attempted suicide is that I had nothing to live for," she wrote. "I had no hope. Yet Fate wouldn't permit it." Failed romances were associated with each suicide attempt. It also seems that despite her international acclaim, Lili derived little genuine pleasure from her career. Watching films of her stage performances, one sees a master entertainer at work, but it is a cool, emotionless mastery. After each attempt to end her life, Lili returned to work after a short stay in the hospital.

While continuing to demonstrate her total command of the burlesque runway, she put her experience to good use by opening a shop on Hollywood Boulevard called "The Undie World of Lili St. Cyr." Where Frederick's of Hollywood left off with provocative lingerie, Lili's store picked up. At least as far back as early 1955, she had begun to design and market her own frilly creations, and within a few years the mail-order demand was such that the store became the next logical step. By 1960, advertisements for the store's wares were running in some national men's magazines, including *Sir Knight*. Perhaps the most popular item was Lili's so-called Scanti-Panties—"scandalously brief panties expertly tailored of sheerest 100% nylon with contoured French shadow panel. Maximum comfort with minimum coverage—perfect for street wear, stage or photography."

Another very appropriate commercial tie-in during the late '50s was provided by Chris Martin, the world's largest manufacturer of bubblebath products. Since no one in the world was more famous for her bubblebaths, Lili was made a partner and vice president of "Bubbly Relations."

In 1963, after burglars stole $10,000 of Lili's furs, wigs and costume jewelry, the ever-lovely and elegant 45-year-old legend declared that this would not stop her from opening in Las Vegas' Silver Slipper with her renowned bathtub act. "I just hope I don't catch cold without my furs," she quipped.

Lili's burlesque career continued until the late 1960s. The 1966 film *Runaway Girl* constituted a very fitting symbolic climax to a remarkable show business career, although she continued to perform on a reduced schedule for a few more years. After retirement, Lili refocused her energies on her Hollywood shop. She sold the enterprise to a lingerie shop (now located on Santa Monica Boulevard), and as of this printing she retains an interest in it.

Lili's most significant magazine appearances after 1954:
Cabaret Yearbook #1 Winter 1955 (3 pages, 4 pictures, including one in that Indian headdress)
Modern Screen Pin-Ups #1 1955
Jan. 1955 TV *Girls & Gags* (inside back cover)
March 1955 *Picture Scope* (cover, 3 pages)
Apr. 1955 *Night & Day* (3 pages focusing on her new film *Boudoir Secrets*)
Spring 1955 *Cabaret Yearbook* #2 (1 page)
Spring 1955 *Pix Annual* (2 pages)
May 1955 *Cabaret* (4 pages, 7 pictures)
July 1955 *Vue* (3 pages)
Aug. 1955 *Cabaret* (back cover, teaser for next issue)
Aug. 1955 *Modern Man* (cover, 4 pages)
Sept. 1955 *Cabaret* (6 pages, 9 pictures, and bylined article, "How to Tame a Wolf." The photos are spectacular—particularly a full-page portrait of a bare Lili in the bath—and her text is fascinating—one of her best-ever magazine features.)
Cabaret Quarterly #4 Winter 1956 (5 pages, 11 pictures, including a gorgeous full-page color nude in which Lili is barely covered with a white mink; also a good article)
Pix Annual Winter 1956 (2 pages)
Jan. 1956 *Confidential* ("When Lili St. Cyr Tried Suicide")
Apr. 1956 *Cabaret* (1 page; Lili is selected as the #1 stripper)
Apr. 1956 *Escapade* (3 pages, 5 pictures, including the classic shot seen on the back cover of the *Modern Man Annual* #2 Also a beautiful color painting of a nude Lili)
Aug. 1956 *Modern Man* (A must for any fan of Lili: gorgeous color centerfold plus 5 pages and 13 total semi-nude pictures by Bruno Bernard—the focus is on her sensational "Wedding in Monaco" act.)
Adam No. 1 Oct. 1956 (cover)
Nov. 1956 *Jem* No. 1 (1 page color)
Cabaret Quarterly #6 1957 (1 page color)
Ideal Models (c. 1957; cover in lingerie)
Jan. 1957 *Cabaret* (absolutely magnificent color nude centerfold—one of the finest-ever portraits of Lili— she is honored as the best stripper of all time)
Feb. 1957 *Suppressed* ("The Brawl over Lili St. Cyr")
Feb. 1957 *Uncensored* ("The Night the Cops Called on Lili St. Cyr")
Mar. 1957 *Cabaret* (1 page: color reproduction of Keith Bernard's timeless shot of Lili with her leg up a tree)
Mar. 1957 *Gala* (4 pages)
Apr. 1957 *After Hours* #2 (cover and 2 pages in action)

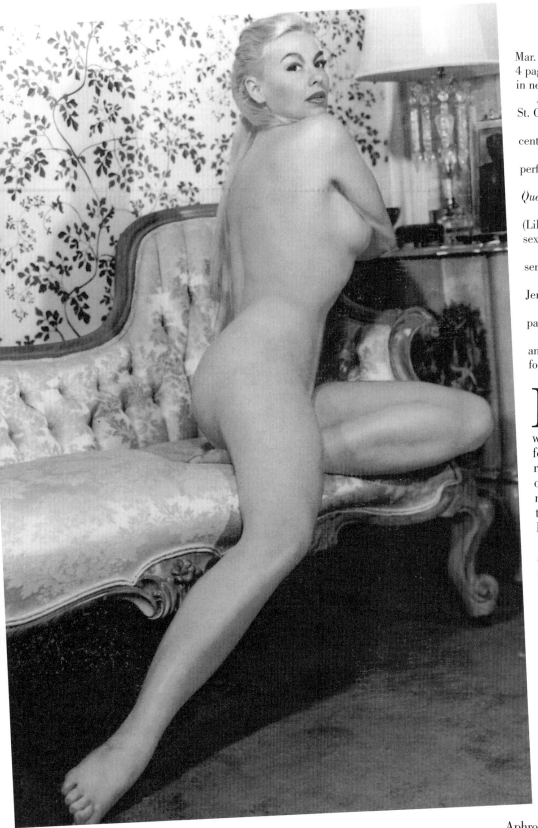

Mar. 1958 *Follies* (color centerfold plus 4 pages, 9 pictures either semi-nude or in negligee of her own design)

Apr. 1958 *TV Scandals* ("What Lili St. Cyr Did to Mike Wallace")

Aug. 1958 *Modern Man* (topless centerfold by Bruno Bernard)

Caper's Choicest 1959 (4 pages in performance)

Modern Man 1959 *Yearbook of Queens* (4 pages, 7 pictures)

May 1959 *Movie Stars TV Closeup* (Lili is cited for having "Hollywood's sexiest legs")

Candida Vol. 2-2 1960 (1 page semi-nude)

July 1961 *The Lowdown* ("How Jerry Geisler Stripped Lili St. Cyr!")

Striparama Vol. 2-6 1963 (2 pages)

March 1966 *Millionaire* (2 pages and 4 vintage pictures, with article focusing on her film *Runaway Girl*)

Looking back on her career in 1992, Lili paused thoughtfully when asked what she remembered most fondly. "I felt necessary," she replied. "Everyone depended on me. My dressing room was my home. I felt like an important person. I think that's what I miss the most."

Escapade in 1956 offered an effective summary of the eternal Lili St. Cyr appeal. "The alluring Lili is a highly trained dancer whose every movement and every posture combines the grace of Salome with the potency of controlled atomic energy. And yet, there is a curious, unattainable quality about this fabulous beauty. Rather than being the embodiment of sex, she is the 'disembodiment' of that universal urge. She is the stuff that dreams, rather than realizations, are made of. She could be the 20th century reincarnation of the Aphrodite deified by Pierre Louys."

The queen now lives quietly in Los Angeles. Her subjects continue to honor her legacy of artistic dancing and unforgettable beauty.

(Special thanks to Lili St. Cyr, and to her loyal friend Bob Bethia of San Marino, CA for his assistance.)

Apr. 1957 *Exposed* ("Lili St. Cyr and Her Wedding Nights")
Aug. 1957 *Cabaret* (1 page color in bra and panties)
Aug. 1957 *Caper* (2 pages, 6 pages on stage)
Feb. 1958 *Inside Story* ("Strip for Action!")

The 100 Sexiest Movie Performances of the "Va Va Voom" Era

Eroticism in film can come in many forms: The sophisticated sensuality of a Rita Hayworth driving men mad with desire by removing only one glove; the still more elegant style of a Grace Kelly stimulating libidos without discarding anything at all; or the direct approach of a Brigitte Bardot baring both her body and sexual desire. Each strategy provides its own distinctive pleasures for the true cinemaphile.

The women profiled in "Va Va Voom" appeared in hundreds of movies, and many hundreds more feature other sex symbols from the same era. For a fan seeking out the best of these film performances on video, which movies should be the top priorities? The list below offers some suggestions.

For my bimonthly publication *Glamour Girls: Then and Now*, I sent survey ballots to several hundred knowledgeable movie/glamour girl collectors across the U.S. and Europe to rank the sexiest movie performances of all time. This list represents the 100 highest-ranking performances of the "Va Va Voom" era—meaning stars of the 1950s plus other films featuring the women covered in this book. Actresses such as Jean Harlow, Ann-Margret and Raquel Welch who ranked high in the survey but fall outside of this era are not included here. A few stars primarily associated with other decades, including Hayworth and Jane Russell (from the 1940s) and Natalie Wood (1960s), *are* included because they each had 1950s films which received support in the survey.

The films range in quality from classic to abysmal, but the sensual performances of the actresses all left an indelible impression on generations of glamour lovers. The top 100:

1. Brigitte Bardot in "And God Created Woman" (1957)
2. Jayne Mansfield in "The Girl Can't Help It" (1956)
3. Marilyn Monroe in "The Seven-Year Itch" (1955)
4. Marilyn Monroe in "Gentlemen Prefer Blondes" (1953)
5. Rita Hayworth in "Gilda" (1946)
6. Anita Ekberg in "La Dolce Vita" (1961)
7. Jayne Mansfield in "Promises, Promises" (1963)
8. Sophia Loren in "Boy On a Dolphin" (1957)
9. Marilyn Monroe in "Some Like It Hot" (1959)
10. Mamie Van Doren in "High School Confidential" (1958)
11. June Wilkinson in "Career Girl" (1959)
12. Jane Russell in "The Outlaw" (1943)
13. Sophia Loren in "Marriage, Italian Style" (1964)
14. Marilyn Monroe in "Bus Stop" (1956)
15. Elizabeth Taylor in "Cleopatra" (1963)
16. Lana Turner in "The Postman Always Rings Twice" (1946)
17. Stella Stevens in "The Silencers" (1966)
18. Mamie Van Doren in "Three Nuts In Search of a Bolt" (1964)
19. Jayne Mansfield in "Will Success Spoil Rock Hunter?" (1957)
20. Marilyn Monroe in "Niagara" (1952)
21. Dorothy Dandridge in "Carmen Jones" (1954)
22. June Wilkinson in "Florida Connection" (1975)
23. Kim Novak in "Vertigo" (1958)
24. Mamie Van Doren in "Untamed Youth" (1957)
25. Julie Newmar in "Lil' Abner" (1959)

26. Sophia Loren in "Yesterday, Today and Tomorrow" (1957)
27. Kim Novak in "Picnic" (1956)
28. Anita Ekberg in "Boccario '70" (1962)
29. Meg Myles in "Satan In High Heels" (1961)
30. Gina Lollobrigida in "Trapeze" (1956)
31. Gina Lollobrigida in "Solomon and Sheba" (1959)
32. Elizabeth Taylor in "Butterfield 8" (1960)
33. Nancy Kwan in "The World of Suzie Wong" (1961)
34. Jayne Mansfield in "Too Hot to Handle" (1959)
35. Elizabeth Taylor in "Cat On a Hot Tin Roof" (1958)
36. Diana Dors in "I Married a Woman" (1957)
37. Joi Lansing in "Who Was That Lady?" (1960)
38. Carroll Baker in "Baby Doll" (1956)
39. Natalie Wood in "Bob & Carol & Ted & Alice" (1969)
40. Ava Gardner in "The Barefoot Contessa" (1954)
41. June Wilkinson in "Macumba Love" (1962)
42. Rhonda Fleming in "Queen of Babylon" (1956)
43. Anita Ekberg in "Zarak" (1956)
44. Yvette Vickers in "Attack of the Giant Leeches" (1959)
45. Mamie Van Doren in "Sex Kittens Go to College" (1960)
46. Grace Kelly in "Rear Window" (1954)
47. Lili St. Cyr in "Son of Sinbad" (1955)
48. Rita Hayworth in "Salome" (1953)

49. Natalie Wood in "The Great Race" (1965)
50. Marilyn Monroe in "There's No Business Like Show Business" (1954)

51. Silvana Mangano in "Bitter Rice" (1949)
52. Janet Leigh in "Psycho" (1960)
53. Ava Gardner in "One Touch of Venus" (1948)
54. Tina Louise in "God's Little Acre" (1958)
55. Sandra Giles in "Daddy-o" (1958)
56. Stella Stevens in "The Ballad of Cable Hogue" (1970)
57. Marilyn Monroe in "Let's Make Love" (1960)
58. Virginia Bell in "Bell, Bare and Beautiful" (1964)
59. Eve Meyer in "Eve and the Handyman" (1960)
60. Marion Michaels in "Liane of the Jungle" (1956)
61. Susan Hayward in "David and Bathsheba" (1951)
62. Sophia Loren in "Madame Sans-Gene" (1961)
63. Maureen O'Hara in "The Quiet Man" (1950)
64. Martine Carol in "Caroline Cherie" (1950)
65. Kim Novak in "Bell, Book and Candle" (1958)
66. Carroll Baker in "The Carpetbaggers" (1964)
67. Gina Lollobrigida in "Bread, Love and Dreams" (1954)
68. Isabel Sarli in "Female" (1969)
69. Mamie Van Doren in "The Girl In Black Stockings" (1957)
70. Greta Thyssen in "Terror Is a Man" (1959)
71. Grace Kelly in "To Catch a Thief" (1955)
72. Marilyn Monroe in "The Prince and the Showgirl" (1957)
73. June Wilkinson in "The Playgirls and the Bellboy" (1961)
74. Joi Lansing in "A Hole In the Head" (1959)
75. Mamie Van Doren in "Teacher's Pet" (1959)

76. Deborah Kerr in "From Here to Eternity" (1953)
77. Marilyn Monroe in "The Misfits" (1961)
78. Brigitte Bardot in "Contempt" (1963)
79. Kim Novak in "The Amorous Adventures of Moll Flanders" (1965)
80. Rita Hayworth in "The Loves of Carmen" (1952)
81. Sylva Koscina in "Hercules" (1959)
82. Nancy Kwan in "Flower Drum Song" (1961)
83. June Wilkinson in "Frankenstein's Great Aunt Tilly" (1983)
84. Diana Dors in "The Long Haul" (1957)
85. Natalie Wood in "Rebel Without a Cause" (1955)
86. Angie Dickinson in "Big Bad Mama" (1974)
87. Cleo Moore in "Over-Exposed" (1956)
88. Angie Dickinson in "Pretty Maids All In a Row" (1971)
89. Diane Webber in "The Mermaids of Tiburon" (1962)
90. Natalie Wood in "Gypsy" (1962)
91. Anne Francis in "Forbidden Planet" (1956)
92. Judy Holliday in "Born Yesterday" (1950)
93. Sophia Loren in "Houseboat" (1958)
94. Julie Adams in "Creature from the Black Lagoon" (1954)
95. Brigitte Bardot in "Love Is My Profession" (1958)
96. Sabrina in "Satan In High Heels" (1961)
97. Irish McCalla in "She Demons" (1958)
98. Joan Collins in "Land of the Pharaohs" (1955)
99. Debra Paget in "Journey to the Lost City" (1959)
100. Mara Corday in "Tarantula" (1955)

More Favorite Movie Bombshells of the "Va Va Voom" Era

Chelo Alonso: "The Cuban H-Bomb" was an international dancing sensation with a distinctively sensual Afro-Cuban feeling until launching a new career from 1959-67 in a series of mythological and Biblical big-screen costume dramas (minimal costume in Chelo's case) in which she played spies, slaves, princesses and exotic dancers with her own explosive style.

Carroll Baker: "Miss Florida Fruits & Vegetables 1949" worked as a dancer before reaching Hollywood in 1953, and stirring controversy as the star of the 1956 hit "Baby Doll;" Carroll became a more conventional blonde bombshell in 1960s films like "The Carpetbaggers."

Martine Carol: Before Gina Lollobrigida and Brigitte Bardot, this sultry French blonde was the sex queen of European cinema following her 1943 debut, thanks to her penchant for taking on-screen baths in pictures like "Caroline Cherie" (1951); died in 1967.

Joan Collins: Following her stage debut at 13 in 1946, Joan was a tantalizing young dish from her British film debut in 1952, and her Liz Taylor-like beauty never failed to dazzle even when the movies were less than memorable; after re-emerging as a sexual tigress in late-'70s films, Joan landed the role of a lifetime as Alexis in TV's "Dynasty" from 1981-88.

Dorothy Dandridge: Lena Horne called her "our Marilyn Monroe;" a former child performer from the late '30s, Dorothy broke through with the steamy lead performance in the 1954 film "Carmen Jones" and as a top nightclub songstress; exceptionally lovely and talented but haunted by racism and personal tragedies, she died in 1965.

Angie Dickinson: Angie followed the traditional glamour route from beauty contest winner to enchanting blonde starlet; five years after her movie debut in 1954, she scored a hit opposite John Wayne in "Rio Bravo," won fame for having the loveliest legs in Hollywood, and enjoyed TV success in the 1970s series "Police Woman."

Diana Dors: Britain's foremost platinum bombshell was born Diana Fluck, and offered up cheesecake for every occasion in films from 1946 onward and in offscreen 1950s pin-ups, developing a bawdy Mae West-like image; after the glamour faded, Diana emerged as a respected character actress and author of several entertaining books.

Joi Lansing: Born Joyce Wassmansdoff in Salt Lake City to a devout Mormon family, Joi made her movie debut in 1947 and after many bit roles, attained greater fame on TV in "The Bob Cummings Show" (1955-60) and in hundreds of other guest appearances showcasing her blonde-bombshell looks and 39-23-35 curves, until her death in 1972.

Gina Lollobrigida: A finalist for the 1947 Miss Italy title, Gina had surpassed Martine Carol by 1952 as the sex goddess of the European cinema, and the name "Lollo" became synonymous with "bosom" in popular usage; after venturing to Hollywood, hits like "Trapeze" and "Solomon and Sheba" maintained the impeccably lovely Gina's popularity through the 1960s before she turned her professional focus to photography.

Tina Louise: Native New Yorker Tina tantalized Broadway, nightclub and TV audiences with her thespian and singing talents--along with her sultry redheaded allure and 37-24-36 curves--before breaking through on stage in 1957 with "Lil' Abner" and on the big screen the following year in the steamy "God's Little Acre;" her stint as Ginger on "Gilligan's Island" carried her appeal to a new level, and her classic glamour remains intact in the '90s.

Cleo Moore: Even in an era of colorful Hollywood personalities, Baton Rouge-born Cleo stood out; the curvy (38-23-36) blonde bombshell gained more fame for her pin-up appearances than for the series of lurid melodramas in which she starred for director Hugo Haas from 1952-57, and rivaled Mansfield and Van Doren with her flair for outrageous publicity stunts; Cleo died in 1973.

Terry Moore: The woman born Helen Koford in Los Angeles went from child actress to girl-next-door starlet before secretly marrying Howard Hughes and advancing to sexier movie roles in "Come Back, Little Sheba" and "Peyton Place"; Terry made a dramatic 1980s return with a book on her relationship with Hughes and a nude layout at age 55 in Playboy.

Rita Moreno: Wonderfully fiery and talented performer born Rosita Dolores Alverio in Puerto Rico; Rita made her film debut in 1945 at age 13, with her many subsequent pictures including "The King and I" (1956) and her Oscar-winning performance in "West Side Story" (1961); still a lovely and capable actress today.

Barbara Nichols: Whenever a movie or TV producer in the 1950s or '60s needed a tough-talking blonde floozie with sex appeal and humor, New York-born Barbara was the first choice; the voluptuous blonde was a

pin-up model and showgirl from 1949-51 before breaking into TV, Broadway and then movies, frequently portraying strippers.

Sheree North: Born Dawn Shirley Bethel in Hollywood, Sheree's life has been a series of adventures: USO dancer at 11, chorus girl at 13, sexy calendar model at 16, dancing star at 17 of innocently provocative 8 mm film shorts that were briefly banned by the Postal Service, Las Vegas dancer, a Broadway sensation in 1953, and then being hired by 20th Century Fox at 21 to "replace" Marilyn Monroe until the studio resolved a contract dispute with Monroe. Sheree went on to become a respected character actress into the '90s.

Kim Novak: She began modeling at 14 and winning titles like "Queen of Lake Michigan," until venturing to Hollywood in 1954 and becoming a top box office attraction, equally convincing as an endearing small-town beauty ("Picnic") or an eerily captivating enchantress ("Vertigo"); in the 1960s Kim showed that class can coexist with sex appeal in two semi-nude Playboy pictorials, and she remains a symbol of timeless Hollywood glamour.

Debra Paget: Leggy, auburn-haired stunner who was born Debralee Griffin in Denver; she made her movie debut in 1948 before turning 15, and achieved her greatest success opposite Elvis Presley in "Love Me Tender" and with turbo-powered dances in Las Vegas and in the film "Journey to the Lost City" (1959) which drew the wrath of censors.

Isabel Sarli: The undisputed sex queen of South American cinema, Isabel got her start as Miss Argentina in 1956; her dark, intoxicating beauty and extraordinary figure became internationally renowned in a long series of sex-drenched film epics that extended through the 1970s.

Elaine Stewart: Enchantingly lovely brunette who was born Elsa Stainberg in Montclair, NJ; Elaine was a successful model before her 1951 film debut and big breakthrough in 1952's "The Bad and the Beautiful"; in 1959 she also graced Playboy with a stylish semi-nude layout.

Elizabeth Taylor: Perhaps the loveliest child actress ever, Elizabeth matured early (37-19-36 at age 17) and became the last true Hollywood goddess, defining classic glamour in films of the '50s and '60s.

More Top Pin-Up Models of the "Va Va Voom" Era

Dane Arden: Well-remembered by Playboy readers as the Sept. 1956 Playmate (shot by Peter Gowland) under her real name of Elsa Sorensen, this Copenhagen-born 38-24-35 blonde also appeared in scores of magazines as Dane Arden as late as 1966.

Jane Dolinger: One of the most fascinating of all figure models, shapely brunette Jane's many semi-nude magazine appearances from 1958-71 were coupled with her other career as author of several books and scores of magazine articles about her adventures in Africa, South America, and around the world.

Virginia Gordon: "West Virginia Ginnie" launched her career as Playboy's Miss January 1959, and while the 37-22-36 brunette appeared in a huge array of other men's magazines through 1962, she also starred in many 1960s nudie movies including two early Francis Ford Coppola productions.

Pamela Green: Known to some admirers as "the Bettie Page of Britain," this sleek blonde nude model was not only sensationally popular in Harrison Marks' magazines and other British publications from 1951 to the '70s, but was also featured in the 1960 cult movie classic "Peeping Tom," and was Marks' business partner in his publishing empire.

Terry Higgins: The daughter of an Air Force colonel, Terry's pert, youthful blonde beauty and 39-24-37 figure made her one of the nation's hottest nude models (and a top Las Vegas and Los Angeles showgirl) from the age of 18 in 1959 through 1962.

Jean Jani: In addition to her popularity as Playboy's July 1957 Playmate as photographed by Peter Gowland, this voluptuous 38-23-34 brunette extended a nude modeling career that ran through 1961 by also posing in many magazines as blonde alter ego "Joan Brennan."

Mickey Jines: Adorably cute Texas-born redhead whose nude modeling

career ran for a decade following her debut as a teenager in 1959; she also enjoyed a successful career as a stripper.

Lynn Lampert: One of the 1950s' most stunning blondes, Lynn burst on the scene as winner of the 1951 Mrs. Texas beauty pageant and became perhaps the definitive swimsuit model in magazines from 1954-57.

Rochelle Lofting: Born in La Rochelle, France (after which she was named) to British and French parents, this statuesque brunette burst into British pin-up fame in 1955 thanks to her startling 42-23-36 vital statistics, and appeared in many magazines in addition to London stage productions through 1959.

Bonnie Logan: Although born in Wisconsin, this 40-24-36 brunette's exotic appearance exuded a Mediterranean allure during her nude modeling career from 1958-63, including appearances under other names such as Laura Lee.

Joyce Nizzari: A favorite of Hugh Hefner, svelte brunette Joyce graced the magazine's December 1958 centerfold (courtesy of photographer Bunny Yeager) at age 18, and also appeared in several Hollywood films and various TV shows through 1967.

Paula Page: Imposing British blonde who was one of the "biggest" (46-23-38) models of the era, posing under various names for Harrison Marks and other photographers from 1957-63, and also appearing in numerous nudie film shorts.

Janet Pilgrim: Born Charlane Karalus, this 36-24-36 blonde earned her place in pin-up history in her first modeling experience as Playboy's original "girl-next-door" Playmate in July 1955, and as the only model to return for two subsequent Playmate appearances.

Rosina Revelle: Few British pin-up models of the 1950s are remembered more fondly than Rosina; her 1957 nude debut at age 16 made her an overnight sensation thanks to a sultry beauty owing much to her part-Maltese heritage and a stunning 46-25-36 figure; after posing in many publications under various identities, she retired from modeling at age 18.

Elaine Reynolds: New Jersey-born Elaine made an immediate impression as Playboy's October 1959 Playmate with her brunette allure and 41-25-37 dimensions; she appeared in many other magazines as "Elaine Ray" through 1963.

Maria Stinger: One of Bunny Yeager's most popular models, Philadelphia-born Maria won fame as "the Marilyn Monroe of Miami" in her many magazine appearances and several nudie movie roles from 1953-63; tragically, she committed suicide in late 1967.

Lisa Winters: A breathtakingly lovely blonde with an exquisite figure, Lisa was discovered at age 19 by Bunny Yeager to become Playboy's Miss December 1956, and became such a favorite of both readers and High Hefner that she was honored as Playmate of the Year in 1957; Lisa was later featured in the film "Bunny Yeager's Nude Camera."

More Top Strippers of the "Va Va Voom" Era

Honey Bee: This New Orleans-born brunette stripper was renowned for her wild dancing style as captured in a 1958 film constantly publicized as "the greatest burlesque movie ever made," and a surgically-enhanced 44-inch bosom.

Virginia Bell: In the bosom-obsessed 1950s, no burlesque queen "measured up" more spectacularly than the woman billed as "Virginia (Ding Dong) Bell, 48-24-36," who dominated men's magazines from 1957-60, starred in the hit 1964 nudie film "Bell, Bare and Beautiful," and remained a superstar of stripdom until retiring in the early 1970s.

Sherry Britton: One of the classiest of all strippers, Sherry's burlesque career began at age 13 in 1937, and after her 48-inch brunette tresses helped make her a top New York attraction and World War II pin-up, Sherry performed in dramatic stage roles while continuing her strip career through the 1950s.

Lilly Christine: Acclaimed internationally as "the Cat Girl," Lilly's feline grace, acrobatic dancing skills, classic blonde beauty and bronzed body

made her the toast of New Orleans and Broadway from 1949 to the early '60s.

Dixie Evans: Known as "the Marilyn Monroe of Burlesque" during her heyday from 1952-60, Dixie later became the leading ambassador for classic burlesque when she took over from the late Jennie Lee as head of Exotic World, the Strippers' Hall of Fame and Museum.

Cherrie Knight: Like Jennie Lee a Kansas City native with a 44-inch bust, brunette Cherrie was a Los Angeles-based stripping sensation of the '50s who also starred in many popular nudie films through 1962.

Jennie Lee: No star peeler had a greater flair for the outrageous than the blonde Kansas City-born "Bazoom Girl" whose 44-inch bosom and zaftig charms were accompanied by a genius for publicity throughout a career that ran from 1945 to the '80s; Jennie also organized the first union specifically for strippers, and founded the Strippers' Hall of Fame and Museum.

Tura Satana: Unique as a Tokyo-born stripper who enjoyed great success on U.S. stages throughout the 1950s, the statuesque redhead stunned audiences as the karate-chopping villainess in the 1966 Russ Meyer classic "Faster, Pussycat! Kill! Kill!"

Blaze Starr: She rose up from the hills of West Virginia to become one of the last great legends of burlesque in a career that made her Baltimore's foremost showbiz heroine from 1950 into the '80s; part of her legend was retold in the 1989 Paul Newman film "Blaze."

More Top Glamour Queens of the "Va Va Voom" Era

Mara Corday: A showgirl starting at age 15, the brunette beauty became one of America's hottest swimsuit and lingerie models from 1949-54; after making her movie debut in 1952, Mara starred in the cult favorites "Tarantula" (1954) and "The Black Scorpion" (1957), and became a Playboy Playmate in Oct. 1958.

Vikki Dougan: Born Deidre Tooker in New York City, Vikki was one of the city's highest-paid fashion models before coming to Hollywood for TV and movie roles; she won enduring pin-up fame as "The Back" by posing in a startling reverse-cleavage dress seen in hundreds of magazines, although her sleek, sultry beauty transcended such classically '50s publicity gimmicks.

Zsa Zsa Gabor: Before becoming a self-parody, this Budapest-born blonde was a genuine glamour queen in the '50s thanks more to her sophisticated allure and jet-setting lifestyle than to her movies ("Queen of Outer Space").

Sandra Giles: Oklahoma-born, Texas-raised Sandra used her blonde appeal and 38-24-36 dimensions to become a popular pin-up model and movie/TV starlet starting in 1957, also garnering wide publicity for her custom-designed convertible covered completely in pink rugging material which she drove all over Hollywood.

Joy Harmon: A curvaceous (41-22-36) blonde bombshell in the Mansfield mold, Joy began appearing on TV and in magazine pin-ups at age 19 in 1957; her biggest movie success came in the 1965 cult film "Village of the Giants" and as the salaciously sexy woman who deliberately inflamed Paul Newman and other chain-gang prisoners with helpless desire in 1967's "Cool Hand Luke."

Arline Hunter: A former California beauty queen, this shapely redhead became one of the country's hottest pin-up models in 1953 thanks in part to her Marilyn Monroe-like sex appeal; she put this partial resemblance to use by starring in the notorious nudie film "The Apple Knockers and the Coke" in which she was billed for years as Marilyn herself, and was later featured in other nudie pictures as well as several "mainstream" movies and TV roles.

Eartha Kitt: "Confessions of a Sex Kitten" was the name of her 1992 autobiography, and no one could purr more seductively than this talented North Carolina-born black singer/actress who became a sensation following her Broadway debut in 1952.

Abbe Lane: Born in New York City, Abbe moved from teen modeling to Broadway roles starting at age 15 in 1948; bandleader Xavier Cugat hired the voluptuous, hip-swaying redhead as his singer in 1950, and they also co-starred as husband and wife on international stages, TV and movies until their early-1960s divorce; Abbe continued singing and acting, and became a published novelist in 1993.

Julie London: A movie starlet starting in 1944, Julie made her breakthrough in 1955 as a smoky-voiced ballad singer ("Cry Me a River") whose album covers were just as sexy as her vocals.

Marion Michaels: The "German Brigitte Bardot," Marion, a breathtakingly lovely blonde nymphette, was born in East Prussia and was selected from 12,000 other girls at age 15 to become the barely-clad star of the adventure film "Liane, Jungle Goddess" (1956) and—following its international success—a sequel, "Liane, the White Slave."

Laya Raki: The daughter of a Javanese mother and German father, Laya was born in Indonesia and after getting her start as a teenage stripteaser entertaining Allied soldiers in Berlin, the exotic 38-23-36 brunette became the glamour queen of the German film industry starting in 1953; particularly after she went blonde a few years later, she also became a favorite in international men's magazines.

Juli Reding: Native Texan Juli took full advantage of Hollywood's appetite for voluptuous (40-23-35) blonde bombshells by breaking into movies and TV in 1958, including the 1960 cult film "Tormented," and appearing in many girlie-magazine layouts before retiring to marry a wealthy attorney.

Sabrina: One of those wonderfully absurd sex symbols who could only have emerged in the 1950s, the woman born Norma Ann Sykes was a rising young beauty queen and pin-up model in London before exploding into overnight British TV stardom in 1955 as the ultimate "dumb blonde" on the program "Before Your Very Eyes"; her classic blonde beauty, stunning 41-19-36 curves, and knack for outrageous publicity enabled her to remain a popular glamour queen until her retirement in 1969.

Greta Thyssen: Crowned Miss Denmark of 1951, Greta came to Hollywood at Howard Hughes' suggestion in 1952, and after appearing in several Three Stooges film shorts she put her bewitching blonde beauty and 39-19-35 vital statistics to work posing semi-nude for Russ Meyer and other photographers; Greta appeared in a dozen movies including the 1959 horror favorite "Terror Is a Man" and in many TV roles.

Barbara Valentin: Known as "the German Jayne Mansfield" following her breakthrough in 1959 at age 18, Austrian-born Barbara rivaled Jayne in sizzling blonde beauty, physical dimensions (41-24-36), willingness to display her curves for photographers, and penchant for provocative publicity stunts; unlike her American counterpart, Barbara later went on to attain respectability as an actress in several 1970s films for German director Rainer Werner Fassbinder.

Monique Van Vooren: Brussels-born Monique made her European film debut in 1949, and after Broadway success in 1954 she utilized her sophisticated Continental charms and 40-inch bosom (earning her the nickname "the Belgian Bulge") to carve out a successful career as a nightclub chanteuse, pin-up model, and occasional film actress; in 1974 she re-emerged with a featured role in the sexually explicit picture "Andy Warhol's Frankenstein."

Yvette Vickers: The Kansas City-born daughter of jazz saxophonist Chuck Vedder, Yvette followed a teenage bit role in the 1950 film classic "Sunset Boulevard" by attaining success in modern ballet; the pert, kittenish blonde became an unforgettable cult film "bad girl" in "Reform School Girl" (1957), "Attack of the 50-Foot Woman" (1958) and "Attack of the Giant Leeches" (1959), was photographed by Russ Meyer to become Playboy's Miss July 1959, and has been a favorite in cult-movie conventions in recent years.

♥